ART LOVER'S
TRAVEL GUIDE
TO
AMERICAN
MUSEUMS
2001

ART LOVER'S TRAVEL GUIDE TO AMERICAN MUSEUMS 2001

BY JUDITH SWIRSKY

ABBEVILLE PRESS PUBLISHERS
NEW YORK LONDON PARIS

ISBN 0-7892-0689-7

First Edition

10 9 8 7 6 5 4 3 2 1

Library of Congress Cataloging-in-Publication Data available upon request.

The 2001 issue of On Exhibit's *Art Lover's Travel Guide to American Museums* is dedicated to Dr. Leo J. Swirsky and Marjorie Swirsky Zelner. They made dreams into reality and will forever be my inspiration.

CONTENTS

ACKNOWLEDGMENTS

Even in the somewhat solitary process of writing a book, the help, counsel, and encouragement of others is essential. I owe a debt of thanks to Marjorie and Larry Zelner, who have solved numerous technical problems for us with their expertise.

In the years to come, On Exhibit promises to continue providing the art-loving traveler—and art professional—with the most factual, timely, and comprehensive guide available to the hundreds of treasure houses that preserve America's artistic heritage. I ththank the thousands of art lovers and hundreds of participating museums who have enthusiastically supported our effort.

acoustiguide

Acoustiguide is pleased to participate in the 2001 edition of *On Exhibit: The Art Lover's Travel Guide*. Since Acoustiguide invented the audio tour in 1957, our goal has been to help make the world's great artworks accessible to the widest possible audience. It's a vision that we share with the author and publisher of this volume.

As you read through this book, you'll find Acoustiguide audio programs at a host of leading American museums. Where audio tours are available, you'll find this symbol ⌒. Among our many clients are: the Museum of Modern Art, New York, the Solomon R. Guggenheim Museum, The Frick Collection, New York, the Brooklyn Museum of Art, the National Gallery of Art, the Fine Arts Museums of San Francisco, the Detroit Institute of Art, the Virginia Museum of Fine Arts, the Walker Art Center, Storm King Art Center, and the Museum of Contemporary Art, Chicago.

We would like to thank Judith Swirsky for making *On Exhibit* a comprehensive guide for museum-goers throughout the country, and Abbeville Press for making this book a reality.

Wherever your travels take you, be sure to ask for an Acoustiguide.

Barbara Roberts
President and CEO
Acoustiguide

Acoustiguide Discount Coupon on Page 349

INTRODUCTION

Celebrating its eighth successful year of annual publication, On Exhibit's *Art Lover's Travel Guide to American Museums* is the comprehensive guide to art museums nationwide. Easy to use, up to date, and completely reliable, it is the ultimate museum reference.

Written for those who travel on business or for pleasure and love to explore interesting art museums, *On Exhibit's* annual travel guides allow you to "know before you go" with complete assurance. With this guide in hand, you will never again miss a "little gem" of a museum or an important exhibition for lack of information.

I encourage you to join the thousands of art lovers who are loyal fans of *On Exhibit*. Like them, you are certain to be completely delighted with this quick, yet comprehensive overview of America's artistic riches.

IMPORTANT INFORMATION ON HOW TO USE THIS GUIDE

- The On Exhibit *Art Lover's Travel Guide* has been designed to be reader-friendly.

- All museums are listed alphabetically by state, and then by city within each state.

- Most permanent collection and museum facility information is expressed in easily recognized standard abbreviations. These are explained in the front of the book—and, for your convenience, on the back of the enclosed bookmark.

- NOTE THE EXCLAMATION POINT ("!"). This is the symbol used to remind you to call or check for information or any other verification.

- All museums offering group tours require some advance notice. It is suggested that arrangements be made WELL in advance of your visit. When calling be sure to check on group size requirements and fee information. A group tour phone number is only included in cases where it is different from the regular museum number.

- As a reminder, it is recommended that students and seniors always present proper I.D.'s in order to qualify for museum fee discounts wherever they are offered (age requirements for both vary!).

- Admission and/or advance ticket requirements are included in the listings for certain special exhibitions.

- Please note that exhibitions at most college and university museums are only scheduled during the academic year. Due to the constraints of space student or faculty exhibits are rarely listed.

ON EXHIBIT

- Some museums that have no exhibition listings simply did not have the information available at press time, others did not respond to our request for information, and therefore have abbreviated listings.

- Every effort has been made to check the accuracy of all museum information, as well as exhibition schedules, at the time of publication. All hours, fees, days closed, and especially exhibitions, including those not already marked as tentative, are nonetheless subject to change at any time. We strongly suggest that you call to confirm any exhibition you wish to see.

- If you find any inaccuracies, please accept our apologies — but do let us know. Finally, if we have inadvertently omitted your favorite museum, a letter to us would be most appreciated, so we can include it in the 2002 edition.

EXPLANATION OF CODES

The coding system we have developed for this guide is made up primarily of standardized, easy to recognize abbreviations. All codes are listed under their appropriate categories.

MAIN CATEGORIES

AM	American	IND	Indian
AF	African	IMPR	Impressionist
AN/GRK	Ancient Greek	JAP	Japanese
AN/R	Ancient Roman	LAT/AM	Latin American
AS	Asian	MEX	Mexican
BRIT	British	MED	Medieval
BYZ	Byzantine	NAT/AM	Native American
CH	Chinese	OC	Oceanic
CONT	Contemporary	OM	Old Masters
DU	Dutch	OR	Oriental
EGT	Egyptian	P/COL	Pre-Columbian
EU	European	P/RAPH	Pre-Raphaelite
FL	Flemish	REG	Regional
FR	French	REN	Renaissance
GER	German	RUSS	Russian
IT	Italian	SP	Spanish

MEDIUM

CER	Ceramics	PHOT	Photography
DEC/ART	Decorative Arts	POST	Posters
DRGS	Drawings	PTGS	Paintings
GR	Graphics	SCULP	Sculpture
PER/RMS	Period Rooms	W/COL	Watercolors

ON EXHIBIT

SUBJECT MATTER

AB	Abstract	FIG	Figurative
ANT	Antiquities	FOLK	Folk Art
ARCH	Architectural	LDSCP	Landscape
CART	Cartoon	PRIM	Primitive
EXP	Expressionist	ST/LF	Still Life
ETH	Ethnic		

REGIONS

E	East	S	South
MID/E	Middle East	W	West
N	North		

PERM/COLL Permanent Collection

The punctuation marks used for the permanent collection codes denote the following:

The colon (":") is used after a major category to indicate sub-listings with that category. For example, "AM: ptgs, sculp" indicates that the museum has a collection of American paintings and sculpture.

The semi-colon (";") indicates that one major category is ending and another major category listing is beginning. For example, "AM: ptgs; SP: sculp; DU; AF" indicates that the museum has collections that include American paintings, Spanish sculpture, and works of Dutch and African origin.

A number added to any of the above denotes century, i. e., "EU: ptgs 19,20" means that the collection contains European painting of the nineteenth and twentieth centuries.

MUSEUM SERVICES

!	CALL TO CONFIRM OR FOR FURTHER INFORMATION
Y	Yes
☎	Telephone number
Ⓟ	Parking
♿	Handicapped Accessibility; "yes" means facility is completely accessible
¶	Restaurant Facilities
ADM	Admission
SUGG/CONT	Suggested Contribution—Pay What You Wish, But You Must Pay Something
VOL/CONT	Voluntary Contribution—Free Admission, Contribution Requested
F	Free
F/DAY	Free Day
SR CIT	Senior Citizen, with I.D. (Age may vary)
GT	Group Tours
DT	Drop in Tours
MUS/SH	Museum Shop
H/B	Historic Building
S/G	Sculpture Garden
TBA	To Be Announced
TENT!	Tentatively Scheduled
ATR!	Advance Tickets Required—Call
CAT	Catalog
WT	Exhibition Will Travel—see index of traveling exhibitions
🎧	Acoustiguide Tour Available

HOLIDAYS

ACAD!	Academic Holidays—Call For Information
LEG/HOL!	Legal Holidays—Call For Information
THGV	Thanksgiving
MEM/DAY	Memorial Day
LAB/DAY	Labor Day
Mo	Monday
Tu	Tuesday
We	Wednesday
Th	Thursday
Fr	Friday
Sa	Saturday
Su	Sunday

19

MUSEUMS AND EXHIBITIONS BY STATE

ALABAMA

BIRMINGHAM

Birmingham Museum of Art

2000 8th Ave. North, Birmingham, AL 35203
☎: 205-254-2566 or 2565 **◙** www.artsBMA.org
Open: 10-5 Tu-Sa, 12-5 Su **Closed:** Mo, 1/1, THGV, 12/25
& ℗ **Museum Shop** ⅋: Terrace cafe
Group Tours: 205-254-2318 **Docents** **Tour times:** 11:30 & 12:30 Tu-Fr; 2:00 Sa, Su **Sculpture Garden**
Permanent Collection: AM: ptgs; EU: ptgs; OR; AF; P/COL; DEC/ART; PHOT; CONT; glass; REN: Kress Coll.

The Birmingham Museum of Art, with over 18,000 works in its permanent collection, is the largest municipal museum in the Southeast. In addition to the most extensive Asian art collection in the South, the museum houses the finest collection of Wedgwood china outside of England. "Art & Soul", an 8 minute video presentation, is available to familiarize visitors with the museum. **NOT TO BE MISSED:** Multi-level outdoor Sculpture Garden featuring a waterwall designed by sculptor Elyn Zimmerman and two mosaic lined pools designed by artist Valerie Jaudon; Hitt Collection of 18th C French paintings & decorative arts; Beeson collection of Wedgwood finest outside of England; Contemporary Glass; Kress Collection of Renaissance Art.

DAPHNE

American Sport Art Museum and Archives

Affiliate Institution: U.S. Sports Academy
One Academy Dr., Daphne, AL 36526
☎: 334-626-3303 **◙** www.asama.org
Open: 10-2 Mo-Fr **Closed:** Sa, Su, LEG/HOL, ACAD!
& ℗: Free **Museum Shop**
Group Tours: 334-626-3303 **Docents** **Tour times:** Available upon request
Permanent Collection: ptgs, sculp, gr all on the single theme of American sports heros

One of the largest collections of sports art in the world may be found at this museum which also features works highlighting an annual sport artist of the year. Of special interest is the two-story high mural on an outside wall of the Academy entitled "A Tribute to the Human Spirit." Created by world-renowned Spanish artist Cristobal Gabarron, the work pays tribute to Jackie Robinson on the 50th anniversary of his breaking the color barrier in major league baseball. Works by former "Sport Artists of the Year " are on display daily. **NOT TO BE MISSED:** "The Pathfinder", a large sculpture of a hammerthrower by John Robinson where the weight of the ball of the hammer is equal to the rest of entire weight of the body of the figure.

DOTHAN

Wiregrass Museum of Art

126 Museum Ave., Dothan, AL 36302-1624
☎: 334-794-3871 **◙** www.wiregrassmuseumoart.org
Open: 10-5 Tu-Sa, 1-5 Su **Closed:** Mo, LEG/HOL!
Sugg./Contr.: Yes, $1 per person
& ℗: At the Dothan Civic Center parking lot and adjacent to the Museum. **Museum Shop**
Group Tours: 334-794-3871
Permanent Collection: REG

Wiregrass Museum of Art - continued

Featured on the main floor galleries of this regional visual arts museum are a variety of works that reflect the ever changing world of art with emphasis on solo exhibits showcasing important emerging artists of the south. The museum, located in the South East corner of Alabama, approximately 100 miles from Montgomery, recently renovated four galleries for the display of decorative arts, African art and works on paper. **NOT TO BE MISSED:** ARTventures, a "hands on" gallery for children, schools, & families

ON EXHIBIT 2001

11/11/2001 to 12/30/2001 SUNLIGHT AND SHADOW: AMERICAN IMPRESSIONISM, 1885-1945
The artists represented in this exhibition made valuable contributions to the art of their era.

FAYETTE

Fayette Art Museum
530 Temple Ave. N., Fayette, AL 35555

☎: 205-932-8727
Open: 9-noon &1-4 Mo, Tu, Th, Fr and by appointment **Closed:** Sa, Su, LEG/HOL!
Vol./Contr.: Yes
& ℗: Free **Group Tours:** 205-932-8727 **Docents** **Tour times:** daily during museum hours
Permanent Collection: AM: ptgs 20; FOLK

Housed in a 1930's former school house, this collection consists mostly of 3,600 works of 20th century American art. Six folk galleries, opened in 1996. **NOT TO BE MISSED:** One of the largest collections of folk art in the Southeast

GADSDEN

Gadsden Museum of Art
2829 W. Meighan Blvd., Gadsden, AL 35904

☎: 205-546-7365
Open: 10-4 Mo-We & Fr, 10am-8pm Th, 1-5 Su **Closed:** Sa, LEG/HOL
Vol./Contr.: Yes
& ℗: Free **Docents**
Permanent Collection: EU: Impr/ptgs; CONT; DEC/ART

Historical collections and works by local and regional artists are housed in this museum.

HUNTSVILLE

Huntsville Museum of Art
300 Church Street South, Huntsville, AL 35801

☎: 256-535-4350 ◙ www.hsv.tis.net/hma
Open: 10-5 Tu-Sa, 1-5 Su **Closed:** Mo LEG/HOL!
&: Totally accessible with wheelchairs available ℗: Paid parking in garage across the street **Museum Shop**
Docents **Tour times:** selected S afternoons
Permanent Collection: AM: ptgs, drgs, phot, sculp, folk, dec/art, reg 18-20; EU: works on paper; OR; AF

Focusing on American paintings and graphics from the 18th through the 20th century, as well as works by regional artists, the Huntsville Museum promotes the recognition and preservation of artistic heritage in its own and other Southeastern states, and serves as the leading visual arts center in North Alabama. Major touring exhibtions are scheduled each year.

ALABAMA

MOBILE

Mobile Museum of Art
4850 Museum Dr. Langan Park and 300 Dauphin Street (downtown), Mobile, AL 36608

☎: 334-343-2667 ◙ www.mobilemuseumofart
Open: 10-5 Tu-Sa, 1-5 Su **Closed:** Mo, THGV, 12/25
 ⑨: Free at main Museum **Museum Shop**
Docents Tour times: unguided, guides by res. **Sculpture Garden**
Permanent Collection: AM: 19; AF; OR; EU; DEC/ART; CONT/CRAFTS

Beautifully situated on a lake in the middle of Langan Park, this museum offers the visitor an overview of 2,000 years of culture represented by more than 5500 pieces in its permanent collection. **NOT TO BE MISSED:** Boehm porcelain bird collection; 20th-century decorative arts collection

Mobile Museum of Art Downtown
300 Dauphin St., Mobile, AL 36602

☎: 334-343-2667
Open: 10-5 Tu-Sa, 1-5 Su
 ⑨: Metered and lot parking available.

A renovated early 1900's hardware store is home to this downtown art museum gallery.

MONTGOMERY

Montgomery Museum of Fine Arts
One Museum Dr. P.O. Box 230819, Montgomery, AL 36117

☎: 334-244-5700 ◙ fineartsmuseum.com
Open: 10-5 Tu-Sa, till 9 Th, Noon-5 Su **Closed:** Mo, LEG/HOL!
 ⑨: Free **Museum Shop** ⫙: Tu-Sa 11-2
Docents Tour times: 1 Sa, Su; 6:30 Th
Permanent Collection: AM: ptgs, gr, drgs 18-20; EU: ptgs, gr, sculp, dec/art 19; CONT/REG; BLOUNT COLLECTION OF AM ART

Set in a picturesque, English-style park, the Museum is noted for its holdings of 19th and 20th century American paintings in the Blount Collection, its Southern regional art, and its Old Master prints. **NOT TO BE MISSED:** "A Peaceable Kingdom with Quakers Bearing Banners" by Edward Hicks, "New York Office" by Edward Hopper, interactive gallery for children

ON EXHIBIT 2001
11/11/2000 to 01/07/2001 ARTNOW: DAVID BIERK
Bierk's paintings are created as personal homage to the works of such historical painters as Albert Bierstadt, Henri Fantin, Caravaggio and Jusepe de Ribera. Viewers will experience a fusion of past and present in Bierk's works.

Anchorage Museum of History and Art

121 W. Seventh Avenue, Anchorage, AK 99519-6650

☎: 907-343-4326
Open: 9-6 Mo-Su mid May-mid Sept; 10-5 Tu-Sa rest of year **Closed:** Mo winter, 1/1, THGV, 12/25
ADM: Adult: $5.00 **Children:** Free under 18 **Seniors:** $4.50 **Museum Shop** ¶: Cafe
Group Tours: 907-343-6187 **Docents** **Tour times:** 10, 11, 1, 2, Alaska Gallery summer
Permanent Collection: ETH

The Anchorage Museum of History and Art is dedicated to the collection, preservation, and exhibition of Alaskan ethnology, history and art.

ON EXHIBIT 2001

11/19/2000 to 02/25/2001 WRAPPED IN PRIDE: GHANIAN KENTE AND AFRICAN AMERICAN IDENTITY
Asante strip-woven cloth, or kente, is the most popular and best known of all African textiles. This exhibition examines the history and use of traditional kente cloth and explores the impact contemporary kente production had in other African countries and the United States.

Totem Heritage Center

Affiliate Institution: Ketchikan Museums
601 Deermount, Mail to 629 Dock Street, Ketchikan, AK 99901

☎: 907-225-5900 ◙ www.city.ketchikan.ak.us
Open: 8-5 Daily (5/1-9/30); 1-5 Tu-Fr (10/1-4/30-no adm fee) **Closed:** 1/1, EASTER, VETERAN'S DAY, THGV, 12/25
ADM: Adult: $4.00 **Children:** Free under 6
ﬤ ℗ **Museum Shop**
Group Tours: 907-225-5900 **Docents**
Permanent Collection: ETH

The Totem Heritage Center houses a world-renowned collection of original, unrestored totem poles, recovered from abandoned Tlingit and Haida villages near Ketchikan. These poles give silent testimony to the skill and artistry of 19th century Native carvers. The Center also features changing exhibits of Northwest Coast Native arts, interpretive panels, classes in Northwest Coast Native Art traditions, and special cultural programs throughout the year. **NOT TO BE MISSED:** A new Pole, "Honoring Those who Give" carved by Tlingit carver Nathan Jackson to commemorate the founding of the Totem Heritage Center will be dedicated in August 1999, and visitors will see it at the entrance to the Center in 2000.

MESA

Mesa Southwest Museum
53 N. Macdonald, Mesa, AZ 85201

(: 480-644-2230 ◙ www.ci.mesa.azus/parkspec/msm/index.html
Open: 10-5 Tu-Sa, 1-5 Su **Closed:** Mo, LEG/HOL!
Free Day: Varies **ADM: Adult:** $6.00 **Children:** $3.00 (3-12) **Students:** $5.00 **Seniors:** $5.00
& ℗: Street parking in front of the museum & covered parking directly behind the museum on the first level of the parking garage. Handicapped spaces located in front of the museum. **Museum Shop**
Group Tours: 480-644-3553 or 3071 **Docents** **Tour times:** Reserved in Advance
Permanent Collection: ETH; P/COL; CER

The Museum explores the Southwest's history from before the time of the dinosaurs to today. The expansion, opening May 27, 2000 treats visitors to an eye-popping, mind-expanding multi-sensory experience.

ON EXHIBIT 2001

04/01/2001 to 05/27/2001 DINE "THE PEOPLE" LIFE AND CULTURE OF THE NAVAJO
The Bill and Dorothy Harmsen Collection of Western Americana, courtesy of the Colorado Historical Society. No other group has had such a major impact on the aesthetics of Western America as the Navajo. Weavings and jewelry have been collected and traded for years. The rhythm in design is repeated in easel painting and basketry.

PHOENIX

Heard Museum
2301 North Central Avenue, Phoenix, AZ 85004

(: 602-252-8840 ◙ www.heard.org
Open: 9:30-5 daily **Closed:** LEG/HOL!
ADM: Adult: $7.00 **Children:** Free under 4, 4-12 $3.00 **Seniors:** $6.00 **Students:** $3.00
& ℗: Free **Museum Shop** ¶ **Sculpture Garden**
Group Tours: 602-251-0230 **Docents** **Tour times:** Many times daily!
Permanent Collection: NAT/AM; ETH; AF; OR; OC; SO/AM

The collection of the decorative and fine arts of the Heard Museum, which spans the history of Native American Art from the pre-historic to the contemporary, is considered the most comprehensive collection of its kind in the entire country. Named after the Heards who founded the museum based on their great interest in the culture of the native people of Arizona, the museum is housed in the original structure the Heards built in 1929 adjacent to their home called Casa Blanca. **PLEASE NOTE:** A new branch of the museum called Heard Museum North is now open at the Boulders Resort in Scottsdale (phone 602-488-9817 for information). **NOT TO BE MISSED:** Experience the cultures of 21 Native American tribes in the interactive exhibit "We are America's First People."

ON EXHIBIT 2001

10/07/2000 to 03/11/2001 CELEBRATING NATIVE CULTURES: THE PHOTOGRAPHY OF JERRY JACKA
Arizona Highways is celebrating its 75th anniversary with these photographs showing the vitality of Native American art and culture.

01/13/2001 to 04/06/2001 TO HONOR AND COMFORT
A poignant exhibition which examines the long history and contemporary expression of Native American quiltmaking. *Will Travel*

Phoenix Art Museum

1625 N. Central Ave., Phoenix, AZ 85004-1685

☎: 602-257-1880 ◎ www.phxart.org
Open: 10-5 Tu-Su, till 9pm Th **Closed:** Mo, 1/1, 7/4, THGV, 12/25
Free Day: Th **ADM: Adult:** $7.00 **Children:** $2.00 6-18 **Students:** $5.00 full time **Seniors:** $5.00
& ℗ **Museum Shop** ‖: Art Museum Café
Group Tours: 602-257-4356 **Docents** **Tour times:** 2:00 daily & 6:00 on Th; Gallery Talks 12:00 daily
Permanent Collection: AM: Western, cont; AS; EU: 18-19;CONT Lat/Am; Fashion

The new 160,000 sq ft. Phoenix Art Museum is double its former size. The classically progressive design of the Museum integrates art and architecture with the southwestern landscape, accommodating large traveling exhibitions, a collection of over 100,000 works and a growing arts audience. Visitors enjoy an audiovisual orientation theater, an interactive gallery for children, a Museum Store, and an audioguide to the collection. **NOT TO BE MISSED:** "Artworks Gallery" for children and their families; Thorne miniature rooms of historic interiors.

ON EXHIBIT 2001

09/30/2000 to 01/26/2001 WAY HAUTE WEST

01/27/2001 to 05/06/2001 NORMAN ROCKWELL: PICTURES FOR THE AMERICAN PEOPLE
The most comprehensive exhibition assembled of Rockwell's work including 70 paintings done in 60 years and all 322 'Saturday Evening Post' covers. *Will Travel*

04/07/2001 to 07/01/2001 FRIDA KAHLO, DIEGO RIVERA, AND TWENTIETH CENTURY MEXICAN ART: THE JACQUES AND NATASHA GELMAN COLLECTION
115 masterpieces in painting and sculpture by the greatest Mexican artists of this century. In addition to portraiture the collection includes still life, abstract impressionism and the forces influencing Mexican Modernism.

06/23/2001 to 09/23/2001 Dates Tentative 2001 PHOENIX TRIENNIAL
The latest developments in contemporary art of the Southwest are recognized here. The works are specifically from Southern California, Arizona, New Mexico and Texas.

10/20/2001 to 11/18/2001 36TH ANNUAL COWBOY ARTIST OF AMERICA SALE & EXHIBITION
Regarded as one of the most prestigious exhibitions and sales in the country, this exhibition unveils more than 100 new, important (and often quite costly) works that have never before been on public view.

PRESCOTT

Phippen Museum

Affiliate Institution: Art of the American West
4701 Hwy 89 N, Prescott, AZ 86301

☎: 520-778-1385 ◎ www.phippenmuseum.com
Open: 10-4 Mo, & We-Sa, 1-4 Su **Closed:** Tu, 1/1, THGV, 12/25
ADM: Adult: $3.00 **Children:** Free under 12 **Students:** $2.00 **Seniors:** $2.00
& ℗: Free **Museum Shop** **Docents**
Permanent Collection: PTGS, SCULP

The Phippen is dedicated to excellence in exhibitions, and presents several stellar exhibits each calendar year featuring art of the American West. **NOT TO BE MISSED:** 3 foot high bronze of Father Kino by George Phippen; Spectacular view and historic wagons in front of the museum.

ARIZONA

Fleischer Museum

17207 N. Perimeter Dr., Scottsdale, AZ 85255

☎: 480-585-3108 ◙ www.fleischer.org
Open: 10-4 Daily **Closed:** LEG/HOL!
Vol./Contr.: yes
& ℗: Free **Museum Shop**
Group Tours: 480-563-6292 **Docents Tour times:** Mo-Fr; 10-4 by Reservation Only **Sculpture Garden**
Permanent Collection: AM/IMPR; ptgs, sculp (California School)

Located in the 261 acre Perimeter Center, the Fleischer Museum was, the first museum to feature California Impressionist works. More than 80 highly recognized artists represented in this collection painted in "plein air" from the 1880's-1940's, imbuing their landscape subject matter with the special and abundant sunlight of the region. Russian & Soviet Impressionism from the Cold War era are represented in the permanent collection as well. **NOT TO BE MISSED:** "Mount Alice at Sunset" by Franz A. Bischoff, "Mist Over Point Lobos" by Guy Rose, "Spanish Boats" by Arthur G. Rider, "In the Orchard, c.1915-1917" by Joseph Raphael.

Scottsdale Museum of Contemporary Arts

7380 E. Second St., Scottsdale, AZ 85251

☎: 480-994-2787 ◙ www.scottsdalearts.org
Open: 10-5 Tu-Sa; till 9 Th, 12-5 Su **Closed:** Mo, LEG/HOL!
Free Day: Tu **ADM: Adult:** $5.00 **Children:** Free under 15 **Students:** $3.00
& ℗: Free **Museum Shop**
Group Tours: 602-874 4641 **Docents Tour times:** 1:30 Su Oct-Apr, 3:00 Su (outdoor sculp) Nov-Apr **Sculpture Garden**
Permanent Collection: CONT; REG

Four exhibition spaces and a beautiful outdoor sculpture garden are but a part of this community oriented multi-disciplinary cultural center. The opening of a new museum called Gerard L. Cafesjian Pavilion will be a new and exciting concept with walls extending to the very limits of the city under the auspices of Scottsdale Museum of Contemporary Arts. **NOT TO BE MISSED:** "The Dance" a bronze sculpture (1936) by Jacques Lipchitz; "Ambient Landscape" by Janet Taylor; "Time/Light Fusion" sculpture (1990) by Dale Eldred..

Sylvia Plotkin Judaica Museum

10460 N. 56th St., Scottsdale, AZ 85253

☎: 480-951-0323 ◙ www.TempleBethIsrael.com and www.sylviaplotkinjudaicamuseum.org
Open: 10-3 Tu-Th, Noon-3 (most) Su; OPEN AFTER FRI. EVENING SERVICES **Closed:** Mo, Fr, Sa, LEG/HOL!; JEWISH HOL! JUL & AUG
Sugg./Contr.: ADM: Adult: $2.00
& ℗: In front & side of building **Museum Shop**
Group Tours: 480-443-4150 **Docents Tour times:** by appt **Sculpture Garden**
Permanent Collection: JEWISH ART AND CEREMONIALS; TUNISIAN SYNAGOGUE PERIOD ROOM, Biblical Garden

Considered to be one of the most important centers of Jewish art and culture in the Southwest, the Sylvia Plotkin Judaica Museum has artifacts spanning 5000 years of Jewish history and heritage. The Museum hosts 3 special exhibitions a year, features guest speakers, Lecture Series, and interactive programs. It is advised to call ahead for summer hours. **NOT TO BE MISSED:** Reconstructed Tunisian Synagogue; To-scale replica of a portion of the Western Wall in Jerusalem

TEMPE

ASU Art Museum

Affiliate Institution: Arizona State University

Nelson Fine Arts Center & Mathews Center, Tempe, AZ 85287-2911

☎: 602-965-2787 ◙ http://asuam.fa.asu.edu

Open: SEPT THRU MAY: 10-9 Tu, 10-5 We-Sa, 1-5 Su; SUMMER: 10-5 Tu-Sa, 1-5 Su **Closed:** Mo, LEG/HOL!

Vol./Contr.: Yes

& ℗: Metered parking or $3.00 lot weekdays till 7; Free Tu after 7 and weekends; physically-challenged parking in front of Nelson Center on Mill Ave. **Museum Shop**

Group Tours: 602-965-2787

Permanent Collection: AM: ptgs, gr; EU: gr 15-20; AM: crafts 19-20; LAT/AM: ptgs, sculp; CONT; AF; FOLK

For more than 40 years the ASU Art Museum, founded to broaden the awareness of American visual arts in Arizona, has been a vital resource within the valley's art community. The ASU Art Museum consists of both the Nelson Center and the Matthews Center. **NOT TO BE MISSED:** Significant ceramics collection— new acquisitions on exhibition Jan – May; important and challenging collections and exhibitions of contemporary art.

TUCSON

Center for Creative Photography

Affiliate Institution: University of Arizona

Tucson, AZ 85721-0103

☎: 520-621-7968 ◙ www.ccparizona.edu/ccp.html

Open: 9-5 Mo-Fr; 12-5 Sa, Su **Closed:** Most LEG/HOL!

Sugg./Contr.: $2.00

& ℗: Pay parking in the Visitors' Section of the Park Avenue Garage on NE corner of Speedway & Park with direct pedestrian access under Speedway to the Center's front door. **Museum Shop**

Group Tours: education dept

With more than 60,000 fine prints in the permanent collection, the singular focus of this museum, located on the campus of the University of Arizona, is on the photographic image, its history, and its documentation.

Tucson Museum of Art and Historic Block

140 N. Main Ave., Tucson, AZ 85701

☎: 520-624-2333 ◙ www.tucsonarts.com

Open: 10-4 Mo-Sa, 12-4 Su; **Closed:** Mo (Mem-Lab/Day), LEG/HOL!

Free Day: Su **ADM: Adult:** $2.00 **Children:** Free 12 & under **Students:** $1.00 **Seniors:** $1.00

& ℗: Free lot on north side of building; pay lot on east side of building; commercial underground parking garage under city hall across street **Museum Shop** ₶: Café a La C'Art Mo-Fr 11-3

Group Tours: 520-696-7450 **Docents** **Tour times:** We, Th 11 am Historic Block **Sculpture Garden**

Permanent Collection: P/COL; AM: Western; CONT/SW; SP: colonial; MEX

Past meets present in this museum and historic home complex set in the Plaza of the Pioneers. The contemporary museum building itself, home to more than 5,000 works in its permanent collection, is a wonderful contrast to five of Tucson's most prominent historic homes that are all situated in an inviting parklike setting. One, the historic 1860's Edward Nye Fish House on Maine Ave., has recently opened as the museum's John K. Goodman Pavilion of Western Art. **PLEASE NOTE:** 1. Tours of the Historic Block are given at 11am W & T from 10/1 through 5/1. 2. Free art talks are offered at 1:30 on M & T in the Art Education Building. **NOT TO BE MISSED:** Modern & contemporary collection

ARIZONA

Tucson Museum of Art and Historic Block- continued
ON EXHIBIT 2001

10/14/2000 to 01/07/2001 LIGHT ON GLASS
Examples of contemporary glass in the Museum collection and on loan from local artists.

11/11/2000 to 01/07/2001 CONTEMPORARY SOUTHWEST IMAGES XV: THE STONEWALL FOUNDATION SERIES JOANNE KERRIHARD
Kerrihard's paintings combine techical proficiency with an emotional intensity that is both unique and, in its disarmingly simple presentation, deeply moving,

12/15/2000 to 01/21/2001 ARTISTS OF THE AMERICAN WEST
These hand colored lithographs and wood engravings of Indians, trappers, traders, settlers and railroad construction feature artists including John J. Audubon, Albert Bierstadt, Karl Bodmer, George Catlin, Frederick Remington and John Mix Stanley.

01/20/2001 to 03/18/2001 DIRECTIONS: ALICE BRIGGS
Alice Brigg's latest architectural installation piece "Memoirs of a Survivor" includes five panels alternating monochomatic drawings based on the work of Albrecht Durer, Jorge Borges' "Library," and Plato's "Allegory of the Cave."

01/20/2001 to 03/18/2001 GARNER TULLIS AND THE ART OF COLLABORATION
Garner Tullis is one of America's most respected printers. He has created prints with more than two hundred painters and sculptors.

02/10/2001 to 04/01/2001 DAN BATES
Detailed and lifelike Western sculptures in bronze, specializing in old west cavalry scenes.

03/31/2001 to 05/27/2001 COLOR & FIRE: DEFINING MOMENTS IN STUDIO CERAMICS, 1950-2000
Survey of the major stylistic movements in ceramic history during last half of the 20th century.

06/09/2001 to 08/05/2001 ARIZONA BIENNAL '01

University of Arizona Museum of Art
Olive and Speedway, Tucson, AZ 85721-0002

☎: 520-621-7567 **◉** http://artmuseumarizonaeru/art/arthtml
Open: MID AUG-MID MAY: 9-5 Mo-Fr & Noon-4 Su; MID MAY-MID AUG: 10-3:30 Mo-Fr & Noon-4
Closed: Sa, LEG/HOL!, ACAD
♿ **℗:** $1.00 per hour in the UA garage at the NE corner of Park and Speadway (free parking Su only).
Museum Shop Docents Tour times: Upon request
Permanent Collection: IT: Kress Collection 14-19; CONT/AM: ptgs, sculp; CONT/EU: ptgs, sculp; OR: gr; CONT: gr; AM: ptgs, gr

With one of the most complete and diverse university collections, the Tucson based University of Arizona Museum of Art features Renaissance, later European and American works in addition to outstanding contemporary creations by Lipchitz, O'Keeffe and Zuñiga. **NOT TO BE MISSED:** 61 plaster models & sketches by Jacques Lipchitz; 26 panel retablo of Ciudad Rodrigo by Gallego (late 15th C); Georgia O'Keeffe's "Red Canyon;" Audrey Flack's "Marilyn"

FORT SMITH

Fort Smith Art Center
423 North Sixth St., Fort Smith, AR 72901

℡: 501-784-2787
Open: 9:30-4:30 Tu-Sa **Closed:** Su, Mo, EASTER, 7/4, THGV, 12/21 - 1/1
ADM: Adult: $1.00 ♿: To lower floor ℗: Free **Museum Shop**
Permanent Collection: CONT/AM: ptgs, gr, sculp, dec/arts; PHOT; BOEHM PORCELAINS

Located mid-state on the western border of Oklahoma, the Fort Smith Art Center, housed in a Victorian Second Empire home, features regional and nationally recognized artists in changing monthly exhibits. **NOT TO BE MISSED:** Large Boehm Porcelain Collection.

LITTLE ROCK

Arkansas Arts Center
9th & Commerce, MacArthur Park, Little Rock, AR 72203

℡: 501-372-4000 🖸 www.arartscenter.org
Open: 10-5 Mo-Sa, till 8:30 Fr, Noon-5 Su **Closed:** 12/25
Vol./Contr.: $2.00
♿ ℗: Free **Museum Shop** �11 **Sculpture Garden**
Permanent Collection: AM: drgs 19-20; EU: drgs; AM: all media; EU: all media; OR; CONT/CRAFTS

The state's oldest and largest cultural institution, features a permanent collection of over 10,000 objects that includes a nationally recognized collection of American and European drawings, contemporary American crafts and objects of decorative art. **NOT TO BE MISSED:** "Earth," a bronze sculpture by Anita Huffington.

PINE BLUFF

Arts & Science Center for Southeast Arkansas
701 Main St., Pine Bluff, AR 71601

℡: 870-536-3375
Open: 8-5 Mo-Fr, 1-4 Sa, Su **Closed:** 1/1, EASTER, 7/4, THGV, 12/24, 12/25
♿ ℗ **Docents**
Permanent Collection: EU: ptgs 19; AM: ptgs, gr 20; OM: drgs; CONT/EU: drgs, DELTA ART; REG

The Museum, whose new building opened in Sept. '94, is home to a more than 1,000 piece collection of fine art that includes one of the country's most outstanding permanent collections of African American artworks. The museum also contains a noted collection of American drawings (1900 to the present) which are always on view. **NOT TO BE MISSED:** Collection of African/American art by Tanner, Lawrence, Bearden and others; Art Deco & Art Nouveau bronzes.

CALIFORNIA

Bakersfield Museum of Art

1930 "R" St., Bakersfield, CA 93301

☏: 661-323-7219

Open: 10-4 Tu-Sa, 12-4 Su **Closed:** Mo, LEG/HOL!
Free Day: 3rd Fri each month, 12-4 **ADM: Adult:** $4.00 **Children:** Free under 12 **Students:** $1.00 **Seniors:** $2.00
♿ Ⓜ: Free **Museum Shop**
Permanent Collection: PTGS; SCULP; GR; REG

Works by California regional artists are the main focus of the collection at this museum, a facility which is looking forward to the results of an expansion project due to start in early 1999. Besides the sculptures and flowers of the museum's gardens where, with 3 days notice, box lunches can be arranged for tour groups, visitors can enjoy the 7-9 traveling exhibitions and 1 local juried exhibitions presented annually.

Judah L. Magnes Memorial Museum

2911 Russell St., Berkeley, CA 94705

☏: 510-549-6950 ▣ www.jfed.org/magnes/magnes.htm
Open: 10-4 Su-Th **Closed:** Fr, Sa, JEWISH & FEDERAL/HOL!
Vol./Contr.: ADM: Adult: $5.00
♿: Most galleries, restroom Ⓜ: Free **Museum Shop**
Group Tours: 510-549-6938 (by appt.) **Docents** **Tour times:** 10-4 Su-Th **Sculpture Garden**
Permanent Collection: FINE ARTS; JEWISH CEREMONIAL ART, RARE BOOKS & MANUSCRIPTS; ARCHIVES OF WESTERN U.S. JEWS

Founded in 1962, the Judah L. Magnes Memorial Museum is the first Jewish museum to be accredited by the American Association of Museums. Literally thousands of prints, drawings and paintings by nearly every Jewish artist of the past two centuries are represented in the permanent collection, which also includes ceremonial and folk pieces and textiles from antiquity to the present, from around the world, as well as rare books and manuscripts, and western U.S. Jewish history documents. The Museum aims to increase intercultural dialogue, too, through its collections and exhibits. **NOT TO BE MISSED:** "The Jewish Wedding" by Trankowsky; ceremonial objects 16-20th C.; changing exhibitions.

University of California Berkeley Art Museum & Pacific Film Archive

Affiliate Institution: University of California

2626 Bancroft Way, Berkeley, CA 94720-2250

☏: 510-642-0808 ▣ www.bampfa.berkeley.edu
Open: 11-5 We-Su, 11-9 Th **Closed:** Mo, Tu, LEG/HOL!
Free Day: Th 11-Noon, 5-9 **ADM: Adult:** $6.00 **Children:** Free under 12 **Students:** $4.00, 12-18 **Seniors:** $4.00
♿ Ⓜ: Parking next to the museum on Bancroft Way, on Bowditch between Bancroft and Durant, and at Berkeley Public Parking, 2420 Durant Ave. **Museum Shop**
Group Tours: 510-642-5188 **Sculpture Garden**
Permanent Collection: AM: all media 20; VISUAL ART; AS; CH: cer, ptgs; EU: Ren-20

The UC Berkeley Art Museum is the principal visual arts center for the University of California at Berkeley. Since its founding in the 1960's with a bequest of 45 Hans Hoffman paintings, the BAM has become one of the largest university art museums in the US. International in scope, the Museum's 13,000 work collection emphasizes twentieth-century painting, sculpture, photography and conceptual art, with especially significant holdings in Asian art. **NOT TO BE MISSED:** Contemporary collection including masterpieces by Calder, Cornell, Frankenthaler, Still, Rothko, and others.

University of California Berkeley Art Museum & Pacific Film Archive - continued
ON EXHIBIT 2001

09/2000 to 06/2001 GOTTARDO PIAZZONI AND THE CALIFORNIA LANDSCAPE
An exhibition featuring the eight Piazzoni paintings from the BAM collection that have hung in Hertz hall for years. It will bring together these works with other outstanding paintings and works on paper from the last half of the 19th century and the first half of the 20th century depicting the California landscape. Other artists included will be Richard Yelland, William Keith, and Albert Bierstadt among others.

10/11/2000 to 01/16/2001 AMAZONS IN THE DRAWING ROOM: THE ART OF ROMAINE BROOKS
The first major American exhibition since the early 1980's to examine the work of Romaine Brooks (1874-1970), heiress and expatriate American artist who specialized in portraiture. In the nearly 30 years since her death, Brooks' artistic reputation has continued to grow, due in part to the feminist recovery of overlooked female artists and, more recently, to scholars of gay and lesbian cultural history who have been interested in the links between Brooks' sexuality and her art. This exhibition will feature drawings and paintings — including the famous 'amazon' portraits of the 1920's — as well as the little-known photographs and sketchbooks by the artist.

11/29/2000 to 01/14/2001 TACITA DEAN/MATRIX 189
Tacita Dean will present "Banewl," a 16mm film of the total eclipse of the sun on August 11, 1999, as experienced at a dairy farm in Cornwall. Using four cameras, the film slowly moves through the event from the overcast morning to the appearance of the partially eclipsed sun later in the day. Shot in anamorphic film, the film takes place entirely within the time frame of the eclipse.

01/04/2001 to 03/26/2001 THE MULE TRAIN: A JOURNEY OF HOPE REMEMBERED
Dr. Martin Luther King, Jr. announced the Poor People's Campaign in December, 1967, in which 1,500 people would travel to Washington, D.C. from all around the United States to petition the government for an "economic bill of rights." The most symbolic of the groups that would be going to the capital was one to come from Marks, Mississippi, and would be made up of mule-drawn wagons rather than buses, cars, and vans. This exhibition explores this remarkable event in American history through a series of black and white photographs that capture the fears and faith of those who marched for social change.

01/28/2001 to 03/18/2001 ERNESTO NETO/MATRIX 190
Brazilian artist Ernesto Neto creates sculptural works and installations that engage the body on multiple levels, often incorporating sensuous materials that provoke viewers into interaction. Neto's previous works have included "huggable" sculptural pieces, and large-scale and womb-like installations made from synthetic fabrics, that audiences are able to enter and explore. For this exhibition his first solo museum exhibition on the West Coast Neto will create a new site-specific installation in the Phyllis Wattis MATRIX Gallery.

01/31/2001 to 04/29/2001 MUNTADAS: ON TRANSLATION
This exhibition consists of three major works by this internationally renowned conceptual artist. "On Translation: The Audience" is part of an on-going series by the artist addressing aspects of translation and mediation that are part of any communication project. Accompanying this new work by Muntadas will be "The Board Room," one Muntadas most well-known installations. Based on an analysis of the typical architecture of a corporate board room, this work addresses the merging of religious ideology and mass media. Also in the exhibition will be "Between the Frames," a work which constitutes a "portrait of the art world by means of interviews with artists, dealers, museum directors, curators, docents, collectors, and critics."

02/07/2001 to 05/27/2001 JOE BRAINARD: A RETROSPECTIVE
This will be the first large-scale touring exhibition of the work of artist and writer Joe Brainard. Brainard, who was born in Arkansas in 1942, worked prolifically, producing thousands of paintings, assemblages, collages, book covers, and illustrations between 1965 and 1979. His subject matter was eclectic, ranging from erotica and camp humor to extravagantly ornamental decorative works evocative of fabric or wallpaper design. Joe Brainard: A Retrospective will provide a fresh perspective on the artist's work and times, bringing to light his distinctive style and vision that crosses boundaries between art and illustration, high and low, personal and public, and between the visual and literary arts.

CALIFORNIA

CLAREMONT

Montgomery Gallery

Affiliate Institution: Pomona College

330 N. College Way, Claremont, CA 91711-6344

☎: 909-621-8283 ⊙ www.pomona.edu/montgomery

Open: 12-5 Tu-Fr; 1-5 Sa & Su **Closed:** Mo, ACAD!, LEG/HOL!, SUMMER

& ℗: Free, street

Permanent Collection: KRESS REN: ptgs; GR; DRGS, PHOT; NAT/AM: basketry, cer, beadwork

Important holdings include the Kress Collection of 15th- and 16th-century Italian panel paintings; over 5,000 examples of Pre-Columbian to 20th-century American Indian art and artifacts, including basketry, ceramics, and beadwork; and a large collection of American and European prints, drawings, and photographs.

ON EXHIBIT 2001

Fall 2000 to Spring 2001! CLIFF MCCARTHY: PHOTOGRAPHS FROM TOKYO 1945

Fall 2000 to Spring 2001! PROJECT SERIES 7: ELIZABETH SAVERI

Fall 2000 to Spring 2001! WORK BY DENISE MARIKA

01/20/2001 to 04/08/2001 WORK BY MOWRY BADEN: INTERACTIVE SCULPTURES

DAVIS

Richard L. Nelson Gallery & The Fine Arts Collection, UC Davis

Affiliate Institution: Univ. of California

Davis, CA 95616

☎: 530-752-8500 ⊙ http:a>t.ucdavis.edu/nelson/

Open: Noon-5 Mo-Fr, 2-5 Su **Closed:** Sa, LEG/HOL! ACAD/HOL; SUMMER!

Vol./Contr.: Yes

& ℗: On campus on lots 1, 2, 5, 6 (Handicapped), & 10; $4.00 parking fee charged weekdays **Museum Shop**

Sculpture Garden

Permanent Collection: DRGS, GR, PTGS 19; CONT; OR; EU; AM; CER

The gallery, which has a 2,500 piece permanent collection acquired primarily through gifts donated to the institution since the 1960's, presents an ongoing series of changing exhibitions. **NOT TO BE MISSED:** "Bookhead" and other sculptures by Robert Arneson; Deborah Butterfield's "Untitled" (horse).

ON EXHIBIT 2001

01/08/2001 to 03/23/2001 FROM THE TIME OF BEETHOVEN

Works on paper from The Fine Arts Collection featuring the art of the late 18th and early 19th century featuring Daniel Havell, Jonas Suyderhoff, Benjamin West and others.

01/21/2001 to 02/10/2001 8TH ANNUAL ARTISTS VALENTINES

With over 100 participating artists, this popular exhibit and silent auction benefits the varied programs of NELSON ARTfriends.

04/02/2001 to 06/29/2001 FROM THE TIME OF MAHLER

Works on paper from The Fine Arts Collection featuring art from the late 19th and early 20th Century featuring Pierre Bonnard, Gustave Dore, Ferdnand Khnopff, and others.

Richard L. Nelson Gallery & The Fine Arts Collection, UC Davis - continued
04/08/2001 to 05/18/2001 HARVEY HIMELFARB: RECENT PHOTOGRAPHS
Recent photographs by UC Davis Emeritus Professor of Photography Harvey Himelfarb feature fabricated studio images along with images of landscapes modified by human use. Himelfarb currently lives and works on Orcas Island, near Seattle, Washington.

04/26/2001 to 10/18/2001 WHY NOT PIRANESI?
Etchings from The Fine Arts Collection by Giovanni Piranesi (1720-1778).

06/01/2001 to 06/29/2001 ANNUAL MASTER OF FINE ARTS EXHIBITIONS
Artists to be announced.

DOWNEY

Downey Museum of Art
10419 Rives Ave., Downey, CA 90241

☎: 562-861-0419
Open: Noon-5 We-Su **Closed:** Mo, Tu LEG/HOL!
Vol./Contr.: Yes
 Ⓟ: Ample free off-street parking
Permanent Collection: REG: ptgs, sculp, gr, phot 20; CONT

With over 400 20th century and contemporary works by Southern California artists, the Downey Museum has been the primary source of art in this area for over 35 years.

FRESNO

Fresno Art Museum
2233 N. First St., Fresno, CA 93703

☎: 559-441-4220 ⊙ fresnoartmuseum.com
Open: 10-5 Tu-Fr; Noon-5 Sa, Su **Closed:** Mo LEG/HOL!
ADM: Adult: $4.00 **Children:** Free 15 & under **Students:** $2.00 **Seniors:** $2.00
 Ⓟ: Free **Museum Shop** �**:** ! Th ONLY 12-2:00
Group Tours: 559-485-4810 **Sculpture Garden**
Permanent Collection: P/COL; MEX; CONT/REG; AM: gr, sculp

In addition to a wide variety of changing exhibitions, pre-Columbian Mexican ceramic sculpture, French Post-impressionist graphics, and American sculptures from the permanent collection are always on view. **NOT TO BE MISSED:** Hans Sumpfsumpf Gallery of Mexican Art containing pre-Columbian ceramics through Diego Rivera masterpieces.

ON EXHIBIT 2001
01/24/2001 to 04/29/2001 RODIN: SCULPTURE FROM THE IRIS AND B. GERALD CANTOR COLLECTION
This exhibition of Rodin, a sculptor of the 19th century, will present examples of some of his most famous work, including the "The Kiss," "The Thinker," and "The Head of Balzac." The late B. Gerald Cantor, founder of the international securities firm Cantor Fitzgerald, began the Cantor Collection in 1945. Iris Cantor now heads the Cantor Foundation.
Will Travel

CALIFORNIA

Fresno Metropolitan Museum

1555 Van Ness Ave., Fresno, CA 93721

☎: 209-441-1444 ◙ www.fresnomet.org
Open: 11-5 Tu-Su (open Mo during some exhibits!) **Closed:** Mo, LEG/HOL
Free Day: Th 5-8 **ADM: Adult:** $5.00 **Children:** Free 2 & under **Students:** $4.00 **Seniors:** $4.00
♿ ⓟ: Ample parking in free lot adjacent to the museum **Museum Shop** ‖: boxed lunches available during
select exhibitions
Group Tours: 209-441-1444 **Docents** **Tour times:** 9-4 daily during most exhibitions
Permanent Collection: AM: st/lf 17-20; EU; st/lf 17-20; EU; ptgs 16-19; PHOT (Ansel Adams)

Located in the historic "Fresno Bee" building, the Fresno Metropolitan Museum is the largest cultural center in the central San Joaquin Valley. **PLEASE NOTE:** The museum offers $1.00 admission for all ages on the first Wednesday of the month. **NOT TO BE MISSED:** Oscar & Maria Salzar collection of American & European still-life paintings 17-early 20.

HANFORD

Ruth and Sherman Lee Institute for Japanese Art at the Clark Center

15770 Tenth Avenue, Hanford, CA 93230

☎: 559-582-4915 ◙ www.shermanleeinstitute.org
Open: Tu-Sa 1-5pm **Closed:** Leg/Hols!
Sugg./Contr.: Yes
♿ ⓟ **Group Tours:** 559-582-4915 **Docents** **Tour times:** Sa 1pm
Permanent Collection: Buddhist Paintings; sculp, Edo Paintings, folding screens (byohu)

California Japanese art institute named for Ruth and Sherman Lee. The announcement of The Ruth & Sherman Lee Institute for Japanese Art was made at a dinner in NY hosted by the center founders, Willlars and Elizabeth Clark. Several special exhibitions per year are planned.

IRVINE

Irvine Museum

18881 Von Karman Ave. 12th Floor, Irvine, CA 92612

☎: 949-476-2565 ◙ www.ocartsnet.org/irvinemuseum
Open: 11-5 Tu-Sa **Closed:** Su, Mo, LEG/HOL!
♿ ⓟ: Free parking with validation
Group Tours: 949-476-0294 **Docents** **Tour times:** 11:15 Th
Permanent Collection: California Impressionist Art 1890-1930

Opened in Jan. 1993, this museum places its emphasis on the past by promoting the preservation and display of historical California art with particular emphasis on the school of California Impressionism (1890-1930).

ON EXHIBIT 2001
09/23/2000 to 01/20/2001 ALONG EL CAMINO REAL: THE CALIFORNIA MISSIONS IN ART
Although the missions in Baja California are older, the first in what is now the state of California was founded in San Diego in 1769. By 1850 when California became the 31st state, most missions were abandoned and in ruins. In the 1890's artists began to paint them as relics of a romantic past.

Museum of Contemporary Art, San Diego
700 Prospect St., La Jolla, CA 92037-4291
☎: 858-454-3541; DT619-234-1001 ◙ www.mcasandiego.org
Open: 11-5 M & Tu; 11-8 Th - Summer Hours: 11-8 M, Tu, Th, & Fr; 11-5 Sa & Su **Closed:** Mo, We, 1/1, THGV, 12/25
Free Day: 1st Tu, Su of month
ADM: Adult: $4.00 **Children:** Free under 12 **Students:** $2.00 **Seniors:** $2.00
& **℗:** 2 hour free street parking at La Jolla; validated $2.00 2 hour parking at America Plaza garage for downtown location during the week plus some metered street parking and pay lots nearby. **Museum Shop**
�11: Museum Cafe (at La Jolla location) 858-454-3945
Group Tours: ex 151 **Docents Tour times:** 2:00 Tu; 6-8 Thurs.; 2-4 Sa & Su **Sculpture Garden**
Permanent Collection: CONT: ptgs, sculp, drgs, gr, phot ♫

Perched on a bluff overlooking the Pacific Ocean, this 50 year old museum recently underwent extensive renovation and expansion, the results of which New York Times architecture critic, Paul Goldberger, describes as an "exquisite project." Under the direction of noted architectural wizard, Robert Venturi, the original landmark Scripps house, built in 1916, was given added prominence by being cleverly integrated into the design of the new building. Additional exhibition space, landscaping that accommodates outdoor sculpture, a cafe and an expanded bookstore are but a few of the Museum's new features. Both this and the downtown branch at 1001 Kettner Blvd. at Broadway in downtown San Diego (phone: 619-234-1001), operate as one museum with 2 locations where contemporary art (since the 1950's) by highly regarded national and international artists as well as works by emerging new talents may be seen. **PLEASE NOTE:** 1. Self-guided "Inform" audio tours of the Museum's permanent collection are available to visitors free of charge. 2. Downtown admission fees: *Free admission*

ON EXHIBIT 2001
09/24/2000 to 01/7/2001 ULTRABAROQUE: ASPECTS OF POST-LATIN AMERICAN ART
Explores the presence of Baroque styles, themes, and concepts in contemporary artistic expressions from Latin America. This exhibition will also explore essentially Baroque elements such as diversity and hybridization. Throughout the exhibition, UltraBaroque will provide a framework from which to understand the layers, fragments, and visual excess that also characterize the state of contemporary global culture. Includes Miguel Colderon, Maria Fernanda Cardoso, Rochelle Costi, Einar and Jamex de la Torre, Arturo Duclos, Jose Antonio Hernandez-Diez, Yishai Jusidman, Inigo Manglano-Ovalle, Lia Menna Barreto, Franco Mondini Ruiz, Ruben Ortiz Torres, Nuno Ramos, Valeska Soares, Meyer Vaisman, and Andriana Varejao. *Bilingual*

Laguna Art Museum
307 Cliff Drive at Coast Highway, Laguna Beach, CA 92651-9990
☎: 949-494-8971 ◙ www.lagunaartmuseum.org
Open: 11-5 Tu-Su **Closed:** Mo
Free Day: 1st Th 5-9 **ADM: Adult:** $5.00 **Children:** Free under 12 **Students:** $4.00 **Seniors:** $4.00
& **℗:** metered and non-metered street parking **Museum Shop Docents Tour times:** 2 PM daily
Permanent Collection: Cont & Hist California art

An independent nonprofit museum with an emphasis on American Art and particularly the art of California. Temporary exhibitions change quarterly.

ON EXHIBIT 2001
11/05/2000 to 01/07/2001 L.A. FREEWAY AT LAM
The museum will participate in the 7th celebration of Experimental Media Arts including, video, CD-Roms and websites as well as public art incorporating media arts.

CALIFORNIA

Laguna Art Museum- continued

11/12/2000 to 01/07/2001 TANISLAV SZUKALSKI
An artist, anthropologist and self proclaimed genius Tanislav Szukalski was hailed as Poland's greatest living artist in the '20s. Major sculptures, drawings and texts of political and scientific views.

01/21/2001 to 03/24/2001 AFTERGLOW IN THE DESERT: THE ART OF FERNAND LUNGREN
Lungren as an under-recognized illustrator turned painter. His early work of Paris, London and the Nile, magazine illustrations and Indian pueblos were critical and popular successes. His later work focusing on the vast deserts of the southwest were not.

01/21/2001 to 07/08/2001 STEPHEN HENDEE
Imagine a collaboration between creators of "Spider Man," the set designers for "2001: A Space Odyssey" and computer artists involved with "Tron." STephen Hendee creates glowing, room-sized installations.

04/22/2001 to 07/08/2001 CALIFORNIA HOLIDAY: E. GENE CRAIN COLLECTION
A focused and spectacular collection of California art from 1930-1990 with works by later generations of watercolor painters.

LANCASTER

Lancaster Museum/Art Gallery

44801 North Sierra Hwy, Lancaster, CA 93534

C: 805-723-6250
Open: 11-4 Tu-Sa, 1-4 Su **Closed:** Mo LEG/HOL! & 1-2 WEEKS BEFORE OPENING OF EACH NEW EXHIBIT!
&: Wheelchair accessible **P:** Ample and free **Museum Shop**
Permanent Collection: REG; PHOT

About 75 miles north of Los Angeles, in the heart of America's Aerospace Valley, is the Lancaster Museum, a combined history and fine art facility that serves the needs of one of the fastest growing areas in southern California. The gallery offers 8 to 9 rotating exhibitions annually.

LONG BEACH

University Art Museum

Affiliate Institution: California State University, Long Beach
1250 Bellflower Blvd., Long Beach, CA 90840

C: 562-985-5761 **O** www.csulb.edu/~uam
Open: 12-8 Tu-Th, 12-5 Fr-Su: Call for Summer Hours **Closed:** Mo, ACAD/HOL!
Sugg./Contr.: Adult: $3.00 **Students:** $1.00
&: located in North Campus Center **P:** Free **Museum Shop** **¶:** on campus
Group Tours: 562-985-7601 **Docents** **Tour times:** res req **Sculpture Garden**
Permanent Collection: CONT: drgs, gr; SCULP

Walking maps are available for finding and detailing the permanent site-specific Monumental Sculpture Collection located throughout the 322 acre campus of this outstanding university art facility. **NOT TO BE MISSED:** Extensive collection of contemporary works on paper.

ON EXHIBIT 2001

01/22/2001 to 03/11/2001 DOUBLE VISION: PHOTOGRAPHS FROM THE STRAUSS COLLECTION
86 fine art photographs from this collection. Included are 68 of the most famous artists of today. *Will Travel*

LOS ANGELES

Autry Museum of Western Heritage

4700 Western Heritage Way, Los Angeles, CA 90027-1462

☎: 323-667-2000 ◙ www.autry-museum.org
Open: 10-5 Tu-Su and some Mo hols: Th until 8! **Closed:** Mo, THGV, 12/25
ADM: Adult: $7.50 **Children:** $3.00 (2-12) **Students:** $5.00 **Seniors:** $5.00
& ⓟ: Free **Museum Shop** ¶: Golden Spur Cafe for breakfast & lunch (9am-4pm)
Permanent Collection: FINE & FOLK ART

Fine art is but one aspect of this multi-dimensional museum that acts as a showcase for the preservation and understanding of both the real and mythical historical legacy of the American West. **NOT TO BE MISSED:** Los Angeles Times Children's Discovery Gallery; Spirit of Imagination.

ON EXHIBIT 2001

to Spring THE JEWISH WEST (working title)

to Fall HOW THE WEST WAS WORN: WESTERN COSTUMES (working title)

to Summer AUDUBON IN THE WEST: IN SEARCH OF AMERICA'S ANIMALS

07/23/2000 to 01/01/2001 ON GOLD MOUNTAIN
The Chinese have been emigrating to America since the time of the California Gold Rush. Based on a book by Lisa See, this explores four generations of a Chinese American family from 1867 to the present. Sandy Lydon, an Asian scholar believes this may well be the most important exhibit ever mounted in the US focused specifically on the history of the Chinese in America.

10/14/2000 TO 01/21/2001 BLUE GEM, WHITE METAL: CARVINGS AND JEWELRY FROM THE C.G.WALLACE COLLECTION

02/24/2001 to 06/10/2001 OUT OF THE MIST: HUUPKWANUM-TUPAAT, TREASURES OF THE NUU-CHAH-NULTH CHIEFS

06/23/2001 to 09/30/2001 JOHN JAMES AUDUBON IN THE WEST: THE LAST EXPEDITION, MAMMALS OF NORTH AMERICA

29/00/2001 to 01/21/2001 FOUNDERS DAY EXHIBITION

California African-American Museum

600 State Drive, Exposition Park, Los Angeles, CA 90037

☎: 213-744-7432 ◙ www.caam.ca.gov
Open: 10-5 Tu-Su **Closed:** Mo 1/1, THGV, 12/25
&: Restrooms, parking, ramps ⓟ: Limited ($5.00 fee) next to museum **Museum Shop**
Permanent Collection: BENJAMIN BANNISTER: drgs; TURENNE des PRES: ptgs; GAFTON TAYLOR BROWN: gr; AF: masks; AF/AM: cont. NOTE: The permanent collection is not on permanent display!

The primary goal of this museum is the collection and preservation of art and artifacts documenting the Afro-American experience in America. Exhibitions and programs focus on contributions made to the arts and various other facets of life including a vital forum for playwrights and filmmakers. The building itself features a 13,000 square foot sculpture court through which visitors pass into a spacious building topped by a ceiling of tinted bronze glass.

CALIFORNIA

Gallery 825/Los Angeles Art Association

Affiliate Institution: Los Angeles Art Association
825 N. La Cienega Blvd., Los Angeles, CA 90069
(: 310-652-8272 ◙ LAAA.org
Open: Noon-5 Tu-Sa **Closed:** Su, Mo, LEG/HOL!
Vol./Contr.: $5.00 for workshops and lectures
占.: But very limited **℗:** Rear of building

Gallery 825/Los Angeles Art Association is a non-profit visual arts organization committed to supporting Southern California contemporary artists in furthering and achieving their diverse artistic visions. We provide exposure, education, and resources as well as foster public awareness through our unique and collaborative environment. Founded in 1925, Gallery 825/LAAA has launched many stellar careers of a wide variety of celebrated artists and played a central role in the formation of LA's now thriving art community.

J. Paul Getty Museum

1200 Getty Center Drive, Los Angeles, CA 90049-1681
(: 310-440-7300 ◙ www.getty.edu
Open: 11-7 Tu-We, 11-9 Th-Fr, 10-6 Sa-Su **Closed:** Mo LEG/HOL!
占.: Fully accessible **℗:** Advance parking reservations are a must! Call 310-440-7300. Please note that while museum admission if free there is a $5.00 charge for parking. **Museum Shop** **¶:** Full service and cafés
Permanent Collection: AN/GRK; AN/R; EU: ptgs, drgs, sculp; DEC/ART; AM: phot 20; EU: phot 20; Illuminated Manuscripts

As of 12/16/97 the long-awaited new Getty Museum will be open in its Los Angeles site. The museum complex, situated on one of the great public viewpoints in Los Angeles, consists of a set of 6 buildings, designed by Richard Meier, that are joined by a series of gardens, terraces, fountains and courtyards. An electric tram transports visitors from the parking area up the hill to the central plaza where a grand staircase welcomes their arrival. **PLEASE NOTE:** 1. The J Paul Getty Museum at the Villa in Malibu will be closed for renovation until 2001. Upon reopening it will serve as a center devoted to the display, study and conservation of classical antiquities. 2. Advance parking reservations at the new facility are a MUST! There is a $5.00 per car parking charge. For information and reservations call 310-440-7300. **NOT TO BE MISSED:** "Irises" by Vincent Van Gogh, 1889; Pontormo's "Portrait of Cosimo I de Medici," c1537; "Bullfight Suerte de Varas" by Goya, 1824 (recently acquired).

ON EXHIBIT 2001

10/11/2000 to 01/07/2001	**RAPHAEL AND HIS CIRCLE: DRAWINGS FROM WINDSOR CASTLE**
10/21/2000 to 01/21/2001	**MEXICO FROM EMPIRE TO REVOLUTION PART I**
10/24/2000 to 02/18/2001	**VOYAGES AND VISIONS; EARLY PHOTOGRAPHS FROM THE WILSON FAMILY COLLECTION**
10/31/2000 to 01/07/2001	**RAPHAEL AND HIS INFLUENCES ACROSS THE CENTURIES**
11/21/2000 to 02/04/2001	**THE ART OF GIVING IN THE MIDDLE AGES**
12/05/2000 to 07/29/2001	**MAKING A RENAISSAINCE PAINTING**
01/23/2001 to 04/15/2001	**A MANY SIDED ART: TRENDS IN NINETEENTH CENTURY DRAWING (working title)**
02/20/2001 to 05/06/2001	**ILLUMINATED LITURGICAL MANUSCRIPTS (working title)**
02/20/2001 to 05/06/2001	**SHAPING THE GREAT CITY: MODERN ARCHITECTURE IN CENTRAL EUROPE**
02/24/2001 to 05/20/2001	**MEXICO FROM EMPIRE TO REVOLUTION PART II**

J. Paul Getty Museum- continued
03/06/2001 to 06/24/2001 AUGUST SANDER: GERMAN PORTRAITS, 1918-1933

05/01/2001 to 07/05/2001 THE SECRET LIFE OF DRAWINGS: TRANSFER PROCESSES IN PRINTS, PAINTINGS, AND FRESCOES 1500 - 1900 (working title)

07/10/2001 to 10/28/2001 WALKER EVANS AND THE AMRICAN TRADITION

08/28/2001 to 12/02/2001 THE GLADZOR GOSPELS

Laband Art Gallery
Affiliate Institution: Loyola Marymount University
7900 Loyola Blvd., Los Angeles, CA 90045
☎: 310-338-2880 ▣ www.lmu.edu/colleges/cfa/art/laband
Open: 11-4 We-Fr, Noon-4 Sa **Closed:** Su, Mo, Tu, JUN - AUG.; LEG/HOL, ACAD/HOL, RELIGIOUS/HOL
Vol./Contr.: Yes
Ġ �11: The Lair (cafeteria), Lion's Den (coffee bar)
Permanent Collection: FL: om; IT: om; DRGS; GR

The Laband Art Gallery usually features exhibitions relating to Latin and Native American subjects, current social and political issues, Jewish & Christian spiritual traditions, and contemporary representational art.

Los Angeles County Museum of Art
5905 Wilshire Blvd., Los Angeles, CA 90036
☎: 323-857-6000 ▣ www.lacma.org
Open: 12-8 Mo, Tu, Th; 12-9 Fr; 11-8 Sa, Su **Closed:** We, 1/1, THGV, 12/25
ADM: Adult: $7.00 **Children:** $1.00 6-17, Free under 5 **Students:** $5.00 **Seniors:** $5.00
Ġ ℗: Paid parking available in lot at Spaulding and Wilshire directly across the street from the entrance to the museum (FREE after 6pm). **Museum Shop** �11: Plaza Café and Pentimento
Group Tours: 323-857-6108 **Docents** **Tour times:** Frequent & varied (call for information) **Sculpture Garden**
Permanent Collection: AN/EGT: sculp, ant; AN/GRK: sculp, ant; AN/R: sculp, ant; CH; ptgs, sculp, cer; JAP: ptgs, sculp, cer; AM/ART; EU/ART; DEC/ART

The diversity and excellence of the collections of the Los Angeles Museum offer the visitor to this institution centuries of art to enjoy from ancient Roman or pre-Columbian art to modern paintings, sculpture, and photography. Recently the Museum completed the first phase of the reorganization and reinstallation of major portions of its renowned American, Islamic, South & Southeast Asian and Far Eastern galleries, allowing for the display of many works previously relegated to storage. Always striving to become more accessible, the Museum's hours of operation have been changed to create a better "business-and-family-friendly" schedule. **NOT TO BE MISSED:** George de La Tour's "Magdelene with the Smoking Flame," 1636-1638; "Under the Trees" by Cezanne.

Los Angeles Municipal Art Gallery
Affiliate Institution: Barnsdall Art Park
4800 Hollywood Blvd., Los Angeles, CA 90027
☎: 213-485-4581
Open: 12:30-5 We-Su, till 8:30 Fr **Closed:** Mo, Tu, 1/1, 12/25
ADM: Adult: $1.50 Ġ: handicapped parking ℗: Free, in Park **Museum Shop** **Docents** **Tour times:** house only
$2.00 **Adult:** 1.00 Sr; We-Su Noon, 1, 2, 3
Permanent Collection: CONT: S/Ca art

The Los Angeles Municipal Art Gallery in the Barnsdall Art Park is but one of several separate but related arts facilities. **NOT TO BE MISSED:** Frank Lloyd Wright Hollyhock House

CALIFORNIA

Museum of African American Art

4005 Crenshaw Blvd. 3rd Floor, Los Angeles, CA 90008
℄: 213-294-7071
Open: 11-6 Th-Sa, Noon-5 Su **Closed:** Mo-We, 1/1, EASTER, THGV, 12/25
&: Elevator to third floor gallery location **℗:** Free **Museum Shop**
Permanent Collection: AF: sculp, ptgs, gr, cer; CONT/AM; sculp, ptgs, gr; HARLEM REN ART

Located on the third floor of the Robinsons May Department Store, this museum's permanent collection is enriched by the "John Henry Series" and other works by Palmer Hayden. Due to the constraints of space these works and others are not always on view. The museum requests that you call ahead for exhibition information. **NOT TO BE MISSED:** "John Henry Series" and other works by Palmer Hayden (not always on view).

Museum of Contemporary Art, Los Angeles

250 S. Grand Ave., Los Angeles, CA 90012
℄: 213-626-6222 **◙** MOCA-LA.org
Open: 11-5 Tu, We, Fr-Su; 11-8 Th **Closed:** Mo, 1/1, THGV, 12/25
ADM: Adult: $6.00 **Children:** Free under 12 **Students:** $4.00 **Seniors:** $4.00
&: wheelchairs available **℗:** For California Plaza Parking Garage (enter from Lower Grand Ave): weekday parking fee of $2.75 every 20 minutes charged before 5pm & $4.40 flat rate after 5 PM weekdays and weekends; For The Music Center Garage enter Grand Ave. between Temple & 1st. **Museum Shop** **‖:** Cafe 8:30-4 Tu-F; 11-4:30 Sa, Su
Group Tours: 213-621-1751 **Docents** **Tour times:** 12, 1 & 2 daily; 6:00 Th
Permanent Collection: CONT: all media ∩

The Museum of Contemporary Art (MOCA) is the only institution in Los Angeles devoted exclusively to art created from 1940 to the present by modern-day artists of international reputation. The museum is located in two unique spaces: MOCA at California Plaza, the first building designed by Arata Isozaki; and The Geffen Contemporary at MOCA, (152 North Central Ave. L.A. CA 90013), a former warehouse redesigned into museum space by architect Frank Gehry.

ON EXHIBIT 2001

10/29/2000 to 02/18/2001 ON THE EDGE (working title)
Contemporary artists living in the Pacific Rim whose work addresses the specific topographic conditions, experiences and the landscape of this geographic and geopolitically dynamic region.

12/10/2000 to 04/01/2001 STAN DOUGLAS
Videos, films, photographs by the Vancouver based artist whose multi-disciplinary works address historical narratives and explore the results of mass media, particularly television and film.

04/02/2001 to 07/15/2001 MINIMAL ART
This is the first large scale historical examination of the emergence and foundations of "minimal" art in the U.S. Key selections and bodies of work by 20-30 artists that were first presented in the pivotal exhibitions of the period.

UCLA Hammer Museum

Affiliated Institution: University of California, Los Angeles
10899 Wilshire Blvd., Los Angeles, CA 90024-4201
℄: 310-443-7000 **◙** hammer.ucla.edu
Open: 11-7 Tu, We, Fr, Sa; 11-9 Th; 11-5 Su **Closed:** Mo, 1/1, 7/4, THGV, 12/25
Free Day: Th **ADM: Adult:** $4.50 **Children:** Free under 17 **Students:** $3.00 **Seniors:** $3.00
& **℗:** Museum underground paid visitor parking available at $2.75 for the first three hours with a museum stamp, $1.50 for each additional 20 minutes, and a flat $3.00 rate after 6:30 T. Parking for the disabled is available on levels P1 & P3.
Museum Shop
Group Tours: 310-443-7041 **Docents** **Tour times:** PERM/COLL: 2:00 Su; CHANGING EXHS: Sa & Su 1pm, Th 6pm
Sculpture Garden
Permanent Collection: EU: 15-19

UCLA Hammer Museum- continued

With the largest collection of works by Honore Daumier in the country (more than 10,000) plus important collections of Impressionist and Post-Impressionist art, the UCLA Hammer Museum is considered a major U.S. cultural resource. Opened in 1990, the museum is now part of UCLA. It houses the collections of the Wight Art Gallery and the Grunwald Center for the Graphic Arts (one of the finest university collections of graphic arts in the country with 35,000 works dating from the Renaissance to the present). **NOT TO BE MISSED:** Five centuries of Masterworks: over 100 works by Rembrandt, van Gogh, Cassatt, Monet, and others; The UCLA Franklin D. Murphy Sculpture Garden, one of the most distinguished outdoor sculpture collections in the country featuring 70 works by Arp, Calder, Hepworth, Lachaise, Lipchitz, Matisse, Moore, Noguchi, Rodin and others.

ON EXHIBIT 2001

10/04/2000 to 01/07/2001 THE UN-PRIVATE HOUSE
"The Un-Private House" examines 26 recently built homes by a roster of international architects whose designs reflect the transformation of the private house in response to changing cultural conditions and recent architectural innovations. This major exhibition was organized by Terence Riley, Chief Curator, Department of Architecture and Design at the Museum of Modern Art, New York. Among the social phenomena—and subsequent architectural responses—that the exhibition examines are changing demographic patterns, shifting definitions of privacy in light of the proliferation of various types of media, and new concepts of work and leisure. "The Un-Private House" includes 25 models, along with computer generated and digitally enhanced photographs and drawings. Architects included in the exhibition are: Shigeru Ban; Michael Bell; Preston Scott Cohen; Xaveer de Geyter Architectenbureau; Francois de Menil; Neil Denari; Diller + Buresh Architects; Thomas Hanrahan and Victoria Meyers; Hariri & Hariri; Herzog & de Meuron; Steven Holl Architects; Kolatan/MacDonald Studio; Frank Lupo/Daniel Rowan; MVRDV; Michael Maltzan Architecture; Office for Metropolitan Architecture; Joel Sanders; Scogin Elam and Bray Architects; SANAA/Kazuyo Sejima, Ryue Nishizawa & Associates; Clorindo Testa; Bernard Tschumi; UN Studio/Van Berkel & Bos; and Simon Ungers with Thomas Kinslow.

USC Fisher Gallery

Affiliate Institution: University of Southern California
823 Exposition Blvd., Los Angeles, CA 90089-0292
☏: 213-740-4561 ◙ www.usc.edu/FisherGallery
Open: Noon-5 Tu-Fr, 11-3 Sa (closed during summer) **Closed:** Mo, LEG/HOL! SUMMER
& ℗**:** Visitor parking on campus for $6.00 per vehicle ¶**:** on USC campus
Group Tours: 213-740-5537
Permanent Collection: EU: ptgs, gr, drgs; AM: ptgs, gr, drgs; PTGS 15-20, ARMAND HAMMER COLL; ELIZABETH HOLMES FISHER COLL.

Old master paintings from the Dutch and Flemish schools as well as significant holdings of 19th century British and French are two of the strengths of USC Fisher Gallery. A Program on Saturdays entitled "Families at Fisher" was implemented in 1997. It includes art tours and a variety of hands-on activities. **PLEASE NOTE:** The permanent collection is available to museums, scholars, students, and the public by appointment.

Watts Towers Arts Center

1727 E. 107th St., Los Angeles, CA 90002
☏: 213-847-4646
Open: Art Center: 10-4 Tu-Sa, Noon-4 Su **Closed:** Mo, LEG/HOL!
& ℗**:** Visitors parking lot outside of Arts center **Museum Shop**
Permanent Collection: AF; CONT; WATTS TOWER

Fantastic lacy towers spiking into the air are the result of a 33 year effort by the late Italian immigrant visionary sculptor Simon Rodia. His imaginative use of the "found object" resulted in the creation of one of the most unusual artistic structures in the world. **PLEASE NOTE:** Due to earthquake damage, the towers, though viewable, are enclosed in scaffolding for repairs that are scheduled to be completed by April 2001. **NOT TO BE MISSED:** Watts Towers "Day of the Drum Festival" and Jazz Festival (last weekend in Sept.).

41

CALIFORNIA

Frederick R. Weisman Museum of Art

Affiliate Institution: Pepperdine Center for the Arts, Pepperdine University
24255 Pacific Coast Highway, Malibu, CA 90263

☎: 310-456-4851 ◙ www.pepperdine.edu
Open: 11-5 Tu-Su **Closed:** Mo, LEG/HOL!, 12/25-1/1
& **Ⓟ:** Free
Group Tours: 310-317-7257 **Docents** **Tour times:** call for specifics! **Sculpture Garden**
Permanent Collection: PTGS, SCULP, GR, DRGS, PHOT 20

Opened in 1992, this museum's permanent collection and exhibitions focus primarily on 19th & 20th-century art. **NOT TO BE MISSED:** Selections from the Frederick R. Weisman Art Foundation.

ON EXHIBIT 2001

01/20/2001 to 03/25/2001 RODIN'S OBSESSION: THE GATES OF HELL, SELECTIONS FROM THE IRIS AND B. GERALD CANTOR COLLECTION
Rodin is considered the father of modern sculpture. He broke with Academic convention to create a new vision of expressive human form.

05/2001 to 08/2001 JULIAN STANCZAK: A RETROSPECTIVE
Colorful Op Art paintings explore the subtleties of human perception.

Monterey Museum of Art

559 Pacific St. (Location 2 -720 Via Mirada), Monterey, CA 93940
☎: 831-372-5477; Loc. 2: 831-372-3689 ◙ www.montereyart.org
Open: 11-5 We-Sa, 1-4 Su, till 8pm; 3rd Th of the month **Closed:** Mo, Tu, LEG/HOL
Free Day: 1st Su of month **ADM: Adult:** $3.00 **Children:** Free under 12
& **Ⓟ:** Street parking and paid lots nearby to main museum **Museum Shop**
Docents **Tour times:** 2, Su; 1, Sa & Su for La Mirada
Permanent Collection: REG/ART; AS; PACIFIC RIM; FOLK; ETH; GR; PHOT

With a focus on its ever growing collection of California regional art, the Monterey Museum has added a modern addition to its original building, La Mirada, the adobe portion of which dates back to the late 1700's when California was still under Mexican rule. **PLEASE NOTE:** The admission fee for La Mirada, located at 720 Via Mirada, is $3.00. **NOT TO BE MISSED:** Painting and etching collection of works by Armin Hansen.

Hearst Art Gallery

Affiliate Institution: St. Mary's College
Box 5110, Moraga, CA 94575
☎: 510-631-4379 ◙ http://gaelnet.stmarys-ca.edu/gallery org
Open: 11-4:30 We-Su **Closed:** Mo, Tu, LEG/HOL!
Vol./Contr.: $1.00
& **Ⓟ:** Free **Museum Shop** �"I: Café
Group Tours: 925-631-4069
Permanent Collection: AM: Calif. Ldscp ptgs 19-20; IT: Med/sculp; EU: gr; AN/CER; CHRISTIAN RELIGIOUS ART 15-20

Hearst Art Gallery - continued

Contra Costa County, not far from the Bay Area of San Francisco, is home to the Hearst Art Gallery. Located on the grounds of St. Mary's College, one of its most outstanding collections consists of many cultures and centuries. **PLEASE NOTE:** The museum is closed between exhibitions. **NOT TO BE MISSED:** 150 paintings by William Keith (1838 - 1911), noted California landscape painter

ON EXHIBIT 2001

01/13/2001 to 02/24/2001 INSTRUMENTS FOR A NEW NAVIGATION: MORRIS GRAVES

03/18/2001 to 04/23/2001 THE ARTIST AND THE BIBLE: 20th CENTURY WORKS ON PAPER

05/10/2001 to 05/20/2001 SAINT MARY'S COLLEGE STUDENT EXHIBITION

06/09/2001 to 08/13/2001 CALIFORNIA LANDSCAPE EXHIBITION

09/09/2001 to 10/15/2001 WOMEN TO WOMEN: WEAVING CULTURE, SHAPING HISTORY

11/01/2001 to 12/16/2001 KENRO IZU: LIGHT OVER ANGKORA

NEWPORT BEACH

Orange County Museum of Art

Newport Beach, 50 San Clemente Dr., Newport Beach, CA 92660

✆: 949-759-1122 **◉** www.ocma.net
Open: 11-5 Tu-Su **Closed:** Mo, 1/1, THGV, 12/25, 7/4, EASTER
ADM: Adult: $5.00 **Children:** Free inder 16 **Students:** $4.00 **Seniors:** $4.00
& **Ⓟ:** Free **Museum Shop** **❚❙:** 11:00-3:00 Tu-Fr
Group Tours: 949-759-1122, ext 204 **Docents** **Tour times:** 1:00 Tu-Su **Sculpture Garden**
Permanent Collection: REG: Post War Ca. art

The Orange County Museum of Art, with its late 19th and 20th century collection of California art, is dedicated to the enrichment of cultural life of the Southern California community through providing a comprehensive visual arts program that includes a nonstop array of changing exhibitions and stimulating education programs. Additional exhibitions are on view at the Museum's South Coast Plaza Gallery, 3333 Bristol Street in Costa Mesa (open free of charge, 10-9 Mo-Fr, 10-7 Sa & 11-6:30 Su)

ON EXHIBIT 2001

08/05/2000 to 02/11/2001 CHRIS BURDEN: A TALE OF TWO CITIES
This miniature reconstruction shows two city-states at war using over 5,000 war toys from the United States, Japan and Europe. The whole tableau is set on a sand base, which acts simultaneously as a metaphor for both the desert and the ocean.

10/14/2000 to 01/14/2001 TONY DELAP
Drawings, paintings, sculpture of over 40 years with his love of the properties of wood and as a master illusionist. *Will Travel*

01/06/2001 to 04/01/2001 STILL LIFES FROM THE COLLECTION
On view at the satellite gallery in South Coast Plaza.

01/13/2001 to 04/01/2001 EDWARD CURTIS: SOUNDS AND STRUCTURES
Forty photographs documenting the domestic environments and architecture of the people of the American Southwest. These show how the native architecture melded with the landscape in which they lived.

02/03/2001 to 05/06/2001 HOWARD BEN TRE: INTERIOR/EXTERIOR
A pioneer in the use of cast glass as a sculptural medium. The exhibition focuses on architectonic pieces to recent figurative ones. Fountains and seating in glass are accompanied by maquettes, working drawings and photographs.

03/31/2001 to 06/17/2001 AMERICAN STORIES
At the satellite gallery in South Coast Plaza.

CALIFORNIA

OAKLAND

Oakland Museum of California
Oak & 10th Street, Oakland, CA 94607-4892

☎: 510-238-2200 or 888-625-6873 **◙** www.museumca.org
Open: 10-5 We-Sa; 12-5 Su; 10-9 first Fr of each month; closed Mo and Tu **Closed:** Mo, Tu, 1/1, 7/4, THGV, 12/25
Free Day: 2nd Su of month **ADM: Adult:** $6.00 **Children:** Free 5 & under **Students:** $4.00, 6-17 **Seniors:** $4.00
& ℗**:** Entrance on Oak & 12th St. small fee charged **Museum Shop** ⅋
Group Tours: 510-238-3514 **Docents** **Tour times:** weekday afternoons on request; 12:30 weekends **Sculpture Garden**
Permanent Collection: REG/ART; PTGS; SCULP; GR; DEC/ART

The art gallery of the multi-purpose Oakland Museum of California features works by important regional artists that document the visual history and heritage of the state. Of special note is the Kevin Roche—John Dinkaloo designed building itself, a prime example of progressive museum architecture complete with terraced gardens. **NOT TO BE MISSED:** California art; Newly installed "On-line Museum" database for access to extensive information on the Museum's art, history and science collections (open for public use 1:00-4:30 Th).

ON EXHIBIT 2001

09/30/2000 to 05/13/2001 CALIFORNIA SPECIES: BIOLOGICAL ART AND ILLUSTRATION
Juried group show of biological and botanical artworks in various media depicting California species, celebrating the biological diversity and uniqueness of California's environment. The exhibition documents the materials, tools, sketches, intermediate steps and comments of some of the artists.

10/14/2000 to 01/24/2001 SECRET WORLD OF THE FORBIDDEN CITY: SPLENDORS FROM CHINA'S IMPERIAL PALACE
Art objects never before exhibited in North America. A glimpse at the opulence and heritage of the Chinese Imperial Court under the Qing Dynasty (1644-1911). Popularly known as the Forbidden City, it was built in the early 1400's. A sequence of palaces with 9,999 rooms, with courtyards, fortified walls and protective moat within the heart of Beijing, the Forbidden City is the largest palatial complex in the world. Visitors enter a world of ceremony and ritual, birth and death, banquets and processionals all revolving about the Emperor.

11/11/2000 to 04/29/2001 FIRED BY IDEALS: AREQUIPA POTTERY
This exhibition will present 100 pieces of Arts and Crafts Arequipa Pottery primarily from the museum's collections. This pottery was produced by the Arequipa Sanatorium for tubercular women located in Marin County during the years 1911-23.

03/03/2001 to 05/26/2001 CAPTURING LIGHT: PHOTOGRAPHIC MASTERPIECES FROM THE COLLECTION
Exhibition of the finest photographs from the Museum's permanent collections, by approximately 100 noted American photographers working in California during the past 150 years.

05/12/2001 to 05/13/2001 ANNUAL CALIFORNIA WILDFLOWER SHOW
A profusion of native flowers gathered in the field, brought into the museum and sorted, identified and labeled by botanists.

06/23/2001 to 09/23/2001 HALF PAST AUTUMN: THE ART OF GORDON PARKS
A retrospective exhibition of the art of this American renaissance man, which brings together for the first time his works as photojournalist, filmmaker, novelist, poet, and musician. Features more than 220 photographs, along with Parks's books, films, music, and poetry in this "tone poem" of the life and art of Gordon Parks. *Single Artist Show*

06/23/2001 to 09/23/2001 MADE IN OAKLAND: THE ART FURNITURE OF GARRY KNOX BENNETT
The first large-scale retrospective of the thirty-year career of Garry Knox Bennett, whose unconventional work links furniture, design and sculpture. The 45 works in the exhibition, created using unique combinations of materials and intricate details, range from large-scale desks and trestle tables to playful clocks and ingenious lamps. *Single Artist Show*

10/13/2001 to 11/25/2001 DIAS DE LOS MUERTOS (working title)
For the eighth consecutive year, altars created by artists, community groups and students celebrate the tradition Los Dias de los Muertos, Days of the Dead. History Special Gallery.

Oakland Museum of California- continued

10/31/2001 to 01/13/2002 ELMER BISCHOFF
The most comprehensive retrospective to date of the work of Elmer Bischoff, who played an important role with Richard Diebenkorn and David Park in launching the Bay Area Figurative movement. The exhibition of 50 paintings and 20 works on paper traces the evolution of Bischoff's career, from his early abstract-surrealist efforts to the non-objective acrylics of the 1980's, with special emphasis on the distinctive figurative paintings that brought him acclaim.

10/31/2001 to 01/13/2002 WRAPPED IN PRIDE: GHANIAN KENTE AND AFRICAN AMERICAN IDENTITY
Exhibition of Asante strip-woven cloth, or kente, the most popular and best known of all African textiles, linked to royalty in Africa and to black racial pride in the U.S. Focuses on the history and use of kente in Africa as well as contemporary kente and its manifestations.

OXNARD

Carnegie Art Museum

424 S. C St., Oxnard, CA 93030
☎: 805-385-8157 **◙** www.vcnet.com/carnart
Open: 10-5 Th-Sa, 1-5 Su (Museum closed between exhibits) **Closed:** Mo-We, MEM/DAY, LAB/DAY, THGV, 12/25
Sugg./Contr.: ADM: Adult: $4.00 **Children:** Free under 6 **Students:** $2.00 **Seniors:** $2.00
℗: Free parking in the lot next to the museum
Group Tours: 805-385-8171
Permanent Collection: CONT/REG; EASTWOOD COLL

Originally built in 1906 in the neo-classic style, the Carnegie, located on the coast just south of Ventura, served as a library until 1980. Listed NRHP. **NOT TO BE MISSED:** Collection of art focusing on California painters from the 1920's to the present.

PALM SPRINGS

Palm Springs Desert Museum

101 Museum Drive, Palm Springs, CA 92262
☎: 760-325-7186 **◙** www.psmuseum.org
Open: 10-5 Tu-Sa, Noon-5 Su; hours change in summer **Closed:** Mo, LEG/HOL!
ADM: Adult: $7.50 **Children:** Free 5 & under **Students:** $3.50 **Seniors:** $6.50
♿: North entrance outdoor elevator **℗:** Free parking in the north and south Museum lots, both with handicap parking; Free parking in the shopping center lot across the street from the museum. **Museum Shop ⁕:** Toor Gallery Café open Tu - Sa 10 - 5, Su 12 - 5
Docents Tour times: 2 Tu-Su (Nov-May) **Sculpture Garden**
Permanent Collection: CONT/REG

Contemporary American art with special emphasis on the art of California and other Western states is the main focus of the 4,000 piece fine art and 2000 object Native American collection of the Palm Springs Desert Museum. The museum, housed in a splendid modern structure made of materials that blend harmoniously with the surrounding landscape, recently added 25,000 square feet of gallery space with the opening of the Steve Chase Art Wing and Education Center. **NOT TO BE MISSED:** William Holden and George Monntgomery Collections and Leo S. Singer Miniature Room Collection.

ON EXHIBIT 2001

08/12/2000 to 02/11/2001 DESERT VOLCANOES
Organized by the Palm Springs Desert Museum, this exhibition is funded by the Museum's Natural Science Council.

01/17/2001 to 03/21/2001 AN AMERICAN FOCUS: THE ANDERSON GRAPHIC ARTS COLLECTION
This exhibiton was organized by the Fine Arts Museums of San Francisco.

CALIFORNIA

Palm Springs Desert Museum - continued

03/21/2001 to 08/13/2001 STEPHEN WILLARD: CALIFORNIA DESERT PHOTOGRAPHY
One of the Southwest's premier landscape photographers. This is the first presentation of his work since the Museum acquired it in 1999/2000. This exhibition was organized by the Palm Springs Desert Museum. *Single Artist Show*

04/11/2001 to 06/10/2001 AFTERGLOW IN THE DESERT: THE PAINTINGS OF FERNAND LUNGREN
This exhibition was organized by the University Art Museum, University of California, Santa Barbara. The Palm Springs showing and educational programs are funded in part by the Museum's Western Art Council. *Single Artist Show*

04/11/2001 to 06/10/2001 WATER: ALLAN HOUSER
A great nephew of the Apache Warrior, Geronimo, he was the first free born Apache after they were detained by the U.S. Government. He started making wood carvings, then a bronze casting and then elegant abstract shapes suggestive of natural forms. Forty-six watercolors dating from 1950-1980 and 7 bronze sculptures are included in this exhibition organized by the Allan Houser Foundation, Santa Fe, New Mexico. The Palm Springs showing and educational programs are funded in part by the Museum's Western Art Council. *Single Artist Show*

06/30/2001 to 11/04/2001 DINE "THE PEOPLE" LIFE AND CULTURE OF THE NAVAJO
The Bill and Dorothy Harmsen Collection of Western Americana, courtesy of the Colorado Historical Society. No other group has had such a major impact on the aesthetics of Western America as the Navajo. Weavings and jewelry have been collected and traded for years. The rhythm in design is repeated in easel painting and basketry.

PALO ALTO

Palo Alto Art Center
1313 Newell Rd., Palo Alto, CA 94303
☎: 650-329-2366 ◙ www.city.palo-alto.ca.us/artcenter
Open: 10-5 Tu-Sa, 7-9 Th, 1-5 Su **Closed:** Mo, 1/1, 7/4, 12/25
Sugg./Contr.: Yes, $1.00 per person
♿ Ⓟ **Museum Shop**
Group Tours: 650-329-2370 **Docents Tour times:** call for information **Sculpture Garden**
Permanent Collection: CONT/ART; HIST/ART

Located in a building that served as the town hall from the 1950's to 1971, this active community art center's mission is to present the best contemporary fine art, craft, design, special exhibitions, and new art forms.

PASADENA

Norton Simon Museum
411 W. Colorado Blvd., Pasadena, CA 91105
☎: 626-449-6840 ◙ www.nortonsimon.org
Open: 12-6 Mo, We, Th, Sa, Su; 12-9 Fr **Closed:** Tu, 1/1 THGV, 12/25
ADM: Adult: $6.00 **Children:** Free under 18 **Students:** Free **Seniors:** $3.00
♿ Ⓟ: Free **Museum Shop** ‖: Garden Café
Group Tours: ex 245 **Sculpture Garden**
Permanent Collection: EU: ptgs 15-20; sculp 19-20; IND: sculp; OR: sculp; EU/ART 20; AM/ART 20 ◠

Thirty galleries with 1,000 works from the permanent collection that are always on display plus a beautiful sculpture garden make the internationally known Norton Simon Museum home to one of the most remarkable and renowned collections of art in the world. The seven centuries of European art on view from the collection contain remarkable examples of work by Old Master, Impressionist, and important modern 20th century artists. **NOT TO BE MISSED:** IMP & POST/IMP Collection including a unique set of 71 original master bronzes by Degas.

Pacific Asia Museum

46 N. Los Robles Ave., Pasadena, CA 91101

☎: 626-449-2742 ◙ www.westmuse.org/Pacasiamuseum
Open: 10-5 We-Su; 10-8 Th **Closed:** Mo, Tu, 1/1, MEM/DAY, 7/4, THGV, 12/25, 12/31
ADM: Adult: $5.00 **Children:** Free under 12 **Students:** $3.00 **Seniors:** $3.00
♿ ℗: Free parking **Museum Shop**
Group Tours: 626-449-2742 **Docents Sculpture Garden**
Permanent Collection: AS: cer, sculp; CH: cer, sculp; OR/FOLK; OR/ETH; OR/PHOT

The Pacific Asia Museum, which celebrated its 25th anniversary in '96, is the only institution in Southern California devoted exclusively to the arts of Asia. The collection, housed in the gorgeous Chinese Imperial Palace-style Nicholson Treasure House built in 1925, features one of only two authentic Chinese style courtyard gardens in the U.S. open to the public. **NOT TO BE MISSED:** Chinese courtyard garden, Carved Jade, Ceramics, Japanese paintings.

ON EXHIBIT 2001
11/18/2000 to 01/07/2001 NOBUYO OKUDA (JAPANESE SCULPTURE)

RIVERSIDE

Riverside Art Museum

3425 Mission Inn Ave., Riverside, CA 92501

☎: 909-684-7111
Open: 10-4 Mo-Sa **Closed:** Su, Last 2 Weeks Aug; LEG/HOL!
Sugg./Contr.: ADM: Adult: $2.00
♿: Access to lower floors only ℗: Limited free parking at museum; metered street parking **Museum Shop**
❘❙: Open weekdays
Docents Tour times: daily upon request
Permanent Collection: PTGS, SCULP, GR

Julia Morgan, the architect of the Hearst Castle, also designed this handsome and completely updated museum building. Listed on the NRHP, the museum is located in the Los Angeles and Palm Springs area. Aside from its professionally curated exhibitions, the museum displays the work of area students during the month of May.

UCR/California Museum of Photography

Affiliate Institution: Univ. of California, Riverside
3824 Main St., Riverside, CA 92521

☎: 909-784-FOTO ◙ www.cmp.ucr.edu
Open: 11-5 Tu-Su **Closed:** Mo, 1/1, THGV, 12/25
Free Day: We **ADM: Adult:** $2.00 **Children:** Free under 12 **Students:** $1.00 **Seniors:** $1.00
♿ ℗: Street parking and several commercial lots and garages nearby **Museum Shop**
Group Tours: 909-787-4787 **Docents Tour times:** 1, 3 Sa
Permanent Collection: PHOT 19-20; CAMERA COLLECTION

Converted from a 1930's Kress dimestore into an award winning contemporary space, this is one of the finest photographic museums in the country. In addition to a vast number of photographic prints the museum features a 10,000 piece collection of photographic apparatus, an internet gallery, a community media lab, and digital studio. **NOT TO BE MISSED:** Junior League of Riverside Family Interactive Gallery; Internet Gallery, Permanent Collections room.

CALIFORNIA

SACRAMENTO

Crocker Art Museum

216 O St., Sacramento, CA 95814

☎: 916-264-5423 ◙ www.crockerartmuseum.org
Open: 10-5 Tu-Su, till 9 Th **Closed:** Mo, LEG/HOLS!
ADM: Adult: $5.50 **Children:** $3.00 7-17, Free under 6 **Seniors:** $4.50
♿ ℗: On-site metered parking & city parking lots **Museum Shop**
Group Tours: 916-264-5537 **Docents** **Tour times:** 10-1 We-Fr, 5-8 Th, 12-4 Sa, 12-3 Su, on the hour
Permanent Collection: PTGS: REN-20; OM/DRGS 15-20; CONT; OR; SCULP

This inviting Victorian Italianate mansion, the oldest public art museum in the West, was built in the 1870's by Judge E. B. Crocker. It is filled with his collection of more than 700 European and American paintings displayed throughout the ballroom and other areas of the original building. Contemporary works by Northern California artists are on view in the light-filled, modern wing whose innovative facade is a re-creation of the Crocker home. Of special interest are two paintings, created by Charles Christian Nahl, that were commissioned for the spaces they still occupy. Both "Fandango" and "Sunday Morning in the Mines" are in their original frames (designed by I. Magnin of department store fame) and are so elaborate that one actually includes a high relief depiction of a pan of gold dust. **NOT TO BE MISSED:** Early California painting collection.

SAN DIEGO

Mingei International Museum

1439 El Prado Balboa Park - Plaza de Panama, San Diego, CA 92101

☎: 619-239-0003 ◙ www.mingei.org
Open: 10-4 Tu-Su **Closed:** Mo, LEG/HOL!
Free Day: 3rd Tu of month **ADM: Adult:** $5.00 **Children:** $2.00 (6-17) **Students:** $2.00 **Seniors:** $5.00
♿ ℗: Parking a short distance from the museum in the Balboa Park lots **Museum Shop**
Docents **Tour times:** by appt
Permanent Collection: FOLK: Jap, India, Af, & over 80 other countries; international doll coll. 🎧

In Aug. 1996, this museum, dedicated to furthering the understanding of world folk art, moved its superb collection into a new 41,000 square foot facility on the Balboa Park Plaza which is also close to the site of San Diego Museum of Art, the Timken Museum of Art, and numerous other art related institutions. It is interesting to note that Mingei, the name of this museum, founded in 1974 to further the understanding of arts of people from all cultures, is a combination of the Japanese words for people (min) and art (gei).

ON EXHIBIT 2001

09/02/2000 to 02/04/2001 **CERAMICS OF TATSUZO SHIMAOKA—A NATIONAL LIVING TREASURE OF JAPAN—A RETROSPECTIVE**
A 60-year retrospective of an artist who continues the 5000 year, unbroken tradition of the art of pottery in Japan.

11/12/2000 to 05/2001 VILLAGE INDIA—ART OF COMPASSION AND DEVOTION—SELECTIONS FROM THE PERMANENT COLLECTION OF MINGEI INTERNATIONAL

02/2001 to 08/2001 (tentative) JEWELRY FROM FOUR CONTINENTS—THE COLLECTION OF COLETTE AND JEAN-PIERRE GHYSELS

05/2001 to 09/2001 (tentative) VENINI—GLASS & DESIGN

Fall 2001 (tentative) GEORGE NAKASHIMA WOODWORKER—A RETROSPECTIVE

10/2001 to 05/2002 I HEAR AMERICA SINGING

Museum of Photographic Arts
1649 El Prado, Balboa Park, San Diego, CA 92101

☎: 619-238-7559 **◙** www.mopa.org
Open: 10-5 Daily **Closed:** Mo LEG/HOL!
ADM: Adult: $6.00 **Children:** Free under 12 **Students:** $4.00 **Seniors:** $4.00
 & **℗:** Free in Balboa Park **Museum Shop**
Group Tours: 619-238-7559 ext. 301 **Docents** **Tour times:** 1:00 Su
Permanent Collection: PHOT

The Museum of Photographic Arts, dedicated exclusively to the care and collection of photographic works of art and film, is housed in Casa de Balboa, a structure built in 1915 for the Panama-California Exposition located in the heart of beautiful Balboa Park (designated as the number one urban park in America). The museum's major areas of strength are in modern and contemporary work, specifically in social documentary photography and photojournalism. **NOT TO BE MISSED:** Film series in the brand new state-of-the-art Joan and Irwin Jacobs Theater.

Call 619-238-7559 and press 3 for schedule.

ON EXHIBIT 2001

10/22/2000 to 01/21/2001 THE MODEL WIFE
This exhibit offers intimate perspectives, over an unbroken chain of 100 years, on marital relations through the work of nine photographers whose spouses served as models: Baron Adolph de Meyer, Alfred Stieglitz, Edward Weston, Harry Callahan, Emmet Gowin, Lee Friedlander, Masahisa Fukase, Nicholas Nixon, and Seichi Furuya. A 220-page lavishly illustrated catalogue accompanies the exhibition. *Will Travel*

01/28/2001 to 04/08/2001 BEATRICE HELG
Using an intimate knowledge of music, an acute sence of light, as well as elements of architecture, drawing and theater design, Beatrice Helg creates a series of images in this exhibition that stretch beyond the two-dimensional layout of a photograph. Metalwork, plexiglass and drawings of other industrial objects are among the materials that Helg uses. *Single Artist Show*

01/28/2001 to 04/08/2001 DAIDO MORIYAMA: STRAY DOG
Each of the 150 photographs in this ground-breaking exhibition captures the rapidly changing cultural climate of post-World War II Japan, depicting the more vulgar aspects of society. Recognized as one of Japan's most significant photographers, Moriyama's unique perspective on street life transforms the mundane into something captivating and rare.

04/15/2001 to 07/22/2001 INSIDE OUT: 50 YEARS OF COLLECTING, THE EASTMAN HOUSE COLLECTION
In seven sections, the exhibition demonstrated how still and moving images have been informed by cultural and personal needs and aspirations, including exploration, tourism, news reporting, science, snapshots and art photography.

07/29/2001 to 10/21/2001 PHILLIP SCHOLZ RITTERMAN: TRANSLATING THE VIEW (working title)
A culmination of photographs that spans more than two decades of Philipp Scholz Rittermann's work on industrial shipyards, cast-off machinery, brutally arid landscapes and luminous night studies. *Single Artist Show*

07/29/2001 to 10/29/2001 CONNIE IMBODEN: BEAUTY OF DARKNESS
This exhibition of photographic images is a study in transformation, mutation and transubstantiation with a focus on the human form. Imboden's dissembled nudes floating in warm, dark water are an unprecedented exploration of the human body. *Single Artist Show*

10/28/2001 to 01/06/2002 BILL BRANDT: A RETROSPECTIVE
Assembled mostly from vintage prints taken from the forties through the sixties. Taken with an old wooden plate camera, which is included in the exhibition, Brandt demonstrates the relationship of photography to sculpture and modernist abstraction. *Single Artist Show*

CALIFORNIA

San Diego Museum of Art

1450 El Prado, Balboa Park, San Diego, CA 92101

☎: 619-232-7931 ⊙ www.sdmart.com
Open: 10-4:30 Tu-Su **Closed:** Mo, 1/1, THGV, 12/25
Free Day: 3rd Tu in month
ADM: Adult: $8.00; military (w/ I.D.) $6 **Children:** $3.00 (6-17) **Students:** $6.00 **Seniors:** $6.00
⑤ ⓟ: Parking is available in Balboa Park and in the lot in front of the museum. **Museum Shop**
🍴: Cafe 10-3 Tu-Fr; 9-4:30 Sa, Su (619-696-1990)
Docents Tour times: Many times daily **Sculpture Garden**
Permanent Collection: IT/REN; SP/OM; DU; AM: 20 EU; ptgs, sculp 19; AS; AN/EGT; P/COL

Whether strolling through the treasures in the sculpture garden or viewing the masterpieces inside the Spanish Colonial style museum building, a visit to this institution, located in San Diego's beautiful Balboa Park, is a richly rewarding and worthwhile experience. The museum also features the Image Gallery, interactive multimedia access to the permanent collection. **NOT TO BE MISSED:** Frederick R. Weisman Gallery of Calif. art; world-renowned collection of South Asian paintings

ON EXHIBIT 2001

01/27/2001 to 05/22/2001 AMERICAN IMPRESSIONISTS ABROAD AND AT HOME
39 works by 27 artists will illuminate the training that American Impressionists undertook abroad and at home; the complex attractions of Europe and America; the significance of the subjects they depicted and their various responses to French Impressionism.

02/24/2001 to 05/27/2001 BELLEROCHE

05/26/2001 to 08/19/2001 TOULOUSE LAUTREC AND THE 1960S

06/30/2001 to 08/26/2001 GRANDMA MOSES IN THE 21ST CENTURY

09/15/2001 to 11/11/2001 FREDERICK CARL FRIESEKE: AN AMERICAN IMPRESSIONIST

11/10/2001 to 01/13/2002 THE FRAME IN AMERICA: 1860-1960
The tools, materials and methods used in gilding and frame manufacturing. Included are Whistler's reed frames, Renaissance frames by Stanford White and painted frames by American Modernists John Marin and Lee Gatch.

Timken Museum of Art

1500 El Prado, Balboa Park, San Diego, CA 92101

☎: 619-239-5548 ⊙ gort.uscd.edu/sj/timken
Open: 10-4:30 Tu-Sa, 1:30-4:30 Su **Closed:** Mo, LEG/HOL!; MONTH OF SEPT
Vol./Contr.: Yes
⑤ **Docents Tour times:** 10-12 Tu-Th
Permanent Collection: EU: om/ptgs 13-19; AM: ptgs 19; RUSS/IC 15-19; GOBELIN TAPESTRIES

Superb examples of European and American paintings and Russian Icons are but a few of the highlights of the Timken Museum of Art located in beautiful Balboa Park, site of the former 1915-16 Panama California Exposition. Treasures displayed within the six galleries and the rotunda of this museum make it a "must see." **NOT TO BE MISSED:** "Portrait of a Man" by Frans Hals; "The Magnolia Flower" by Martin Johnson Heade

Asian Art Museum of San Francisco

Affiliate Institution: The Avery Brundage Collection

Golden Gate Park, San Francisco, CA 94118

☎: 415-379-8801 ⊙ www.asianart.org
Open: 9:30-5 Tu-Su, till 8:45pm 1st We each month **Closed:** Mo, LEG/HOL!
ADM: Adult: $7.00 **Children:** $4.00 (12-17) **Students:** $5.00 **Seniors:** $5.00
&. ℗: Free parking throughout Golden Gate Park plus all day $3.00 weekend parking in the UCSF garage located at the corner of Irving St. & Second Ave. ¶
Group Tours: 415-379-8839 **Docents** **Tour times:** frequent daily tours!
Permanent Collection: AS: arts; MID/E: arts; BRUNDAGE COLLECTION (80 % OF THE HOLDINGS OF THE MUSEUM)

With a 12,000 piece collection that covers 40 countries and 6,000 years, the Asian Art Museum, opened in 1966 as a result of a gift to the city by industrialist Avery Brundage, is the largest of its kind outside of Asia. **PLEASE NOTE:** There are special hours during major exhibitions. Please call for specifics.

ON EXHIBIT 2001

10/25/2000 to 01/14/2001 BETWEEN THE THUNDER AND THE RAIN: CHINESE PAINTINGS FROM THE OPIUM WAR THROUGH THE CULTURAL REVOLUTION (1840-1979)
Featuring more than 120 works from a private collection the exhibition documents the divergent artistic transformation shaped by this turbulent era of issues, styles and personalities.

02/21/2001 to 05/13/2001 TAOISM AND THE ARTS OF CHINA
An exploration of one of China's primary indigenous philosophies and religions, critical to understanding Chinese culture, both historically and today. Thirty-three of the 130 works will be borrowed from the People's Republic of China, only two of these have been previously exhibited in the West.

06/27/2001 to 10/07/2001 SPIRIT OF ZEN: PAINTINGS AND CALLIGRAPHY FROM THE 17TH THROUGH THE 20TH CENTURY, SELECTED FROM AMERICAN COLLECTIONS
A manifestation of the Zen teaching of internal discipline and external unity expressed in the dramatic ink brushwork of the monks.

08/01/2001 to 10/07/2001 EMPIRE OF THE SULTANS: OTTOMAN ART FROM THE KHALILI COLLECTION
Featuring more than 6 centuries of Ottoman rule (late 13th century to 1922) it showcases every aspect of Ottoman art. *Will Travel*

Cartoon Art Museum

814 Mission St., San Francisco, CA 94103

☎: 415-CAR-TOON
Open: 11-5 We-Fr, 10-5 Sa, 1-5 Su **Closed:** Mo, Tu, 1/1, 7/4, THGV, 12/25
ADM: Adult: $5.00 **Children:** $2.00 (6-12) **Students:** $3.00 **Seniors:** $3.00
&.: Sidewalk ramps & elevator; museum all one level ℗: Fifth & Mission Garage **Museum Shop**
Group Tours: 415-227-8671 **Docents** **Tour times:** Upon request if available
Permanent Collection: CARTOON ART; GRAPHIC ANIMATION

The Cartoon Art Museum, founded in 1984, is located in a new 6,000 square foot space that includes a children's and an interactive gallery. With a permanent collection of 11,000 works of original cartoon art, newspaper strips, political cartoons, and animation cells, this is one of only 3 museums of its kind in the country and the only West Coast venue of its kind. **PLEASE NOTE:** Children under 5 are admitted free of charge.

CALIFORNIA

Coit Tower

1 Telegraph Hill, San Francisco, CA

☎: 415-274-0203

Open: WINTER: 9-4:30 daily; SUMMER: 10-5:30 daily ℗: very limited timed parking
Permanent Collection: murals

Though not a museum, art lovers should not miss the newly restored Depression-era murals that completely cover the interior of this famous San Francisco landmark. Twenty-five social realist artists working under the auspices of the WPA participated in creating these frescoes that depict rural and urban life in California during the 1930's. Additional murals on the second floor may be seen only at 11:15 on Saturday mornings. The murals, considered one of the city's most important artistic treasures, and the spectacular view of San Francisco from this facility are a "must see" when visiting this city.

Fine Arts Museums of San Francisco

Affiliate Institution: M. H. de Young Memorial Museum & California Palace of Legion of Honor
Calif. Palace of the Legion of Honor, Lincoln Park, San Francisco, CA 94118-4501

☎: 415-863-3330 ◙ www.thinker.org

Open: See museum description **Closed:** Most holidays that fall on Mo, when the museum is regularly closed
Free Day: de Young: 1st We; Palace: 2nd We
ADM: Adult: $7.00 **Children:** $3.00 (12-17), under 12 free **Students:** $10 Annual Pass **Seniors:** $5.00
♿ ℗: Free parking in the park **Museum Shop** ‖: 2 Cafes open 10am-4pm
Group Tours: 415-750-3638 **Docents** **Tour times:** We-Su (de Young) & Tu-Su (Palace)!
Permanent Collection: De Young: PTGS, DRGS, GR, SCULP; AM: dec/art; BRIT: dec/art; AN/EGT; AN/R; AN/GRK; AF; OC. CA. Palace of Legion of Honor: EU: 13-20; REN; IMPR: drgs, gr ۩

The de Young Museum: Situated in the heart of Golden Gate Park, the de Young features the largest collection of American art on the West Coast ranging from Native American traditional arts to contemporary Bay Area art.

The California Palace of the Legion of Honor: One of the most dramatic museum buildings in the country, the recently renovated and reopened Palace of the Legion of Honor houses the Museum's European art, the renowned Achenbach graphic art collection, and one of the world's finest collections of sculpture by Rodin.

The hours for each museum are as follows: **de Young:** hours 9:30-5 We-Su, open till 8:45 with free adm. 1st We of the month **Palace of the Legion of Honor:** hours 9:30-5:00 Tu-Su with free adm. 2nd We of month. **NOT TO BE MISSED:** Rodin's "Thinker" & The Spanish Ceiling (Legion of Honor); Textile collection (de Young); Gallery One, a permanent art education center for children & families (de Young).

ON EXHIBIT 2001

09/24/2000 to 01/07/2001 THE KINGDOMS OF EDWARD HICKS—DE YOUNG
The first major exhibition of Hicks life and work. More than 50 paintings ranging from his "Peaceable Kingdom " variants to other historical subjects showing the entire range of Hick's artistic interests.

Friends of Photography, Ansel Adams Center

250 Fourth St., San Francisco, CA 94103

☎: 415-495-7000

Open: 11-5 Tu-Su, 11-8 1st Th of the month **Closed:** Mo, LEG/HOL!
ADM: Adult: $5.00 **Children:** $2.00 (12-17) **Students:** $3.00 **Seniors:** $2.00
♿: Restrooms, ramp (front of bldg), wheelchair lift (side of bldg) ℗: Several commercial parking facilities located nearby **Museum Shop** **Docents** **Tour times:** 1:15 & 2 Sa
Permanent Collection: PHOT; COLLECTION OF 125 VINTAGE PRINTS BY ANSEL ADAMS AVAILABLE FOR STUDY ONLY

Founded in 1967 by a group of noted photographers including Ansel Adams, Brett Weston, and Beaumont Newhall, the non-profit Friends of Photography is dedicated to expanding public awareness of photography and to exploring the creative development of the media.

Mexican Museum

Affiliate Institution: Fort Mason Center, Bldg. D.
Laguna & Marina Blvd., San Francisco, CA 94123

☎: 415-441-0404 ◉ www.mexicanmuseum.org
Open: 11-5 We-Su **Closed:** Mo, Tu, LEG/HOL!
Free Day: 1st We of month
ADM: Adult: $4.00 **Children:** Free under 10 **Students:** $3.00 **Seniors:** $3.00
 Ġ ℗: Free **Museum Shop**
Permanent Collection: MEX; MEX/AM; FOLK; ETH; LATIN AMERICAN MODERN PRE CONQUEST : MORE THAN 300 OBJECTS FROM THE NELSON ROCKEFELLER COLLECTION OF MEX/FOLK ART (over 10,000 pieces in total)

With more than 10,000 objects in its collection, the Mexican Museum, founded in 1975, is the first institution of its kind devoted exclusively to the art and culture of Mexico, Latin America and its people. Plans are underway to open in a new museum building in the Yerba Buena Gardens district in 2002. This 66,000 square foot facility will house the most extensive collection of Mexican and Mexican-American art in the U.S. **NOT TO BE MISSED:** "Family Sunday," a hands-on workshop for children offered once per exhibition (quarterly) (call 415-202-9721 to reserve).

Museo Italoamericano

Ft. Mason Center, Bldg. C, San Francisco, CA 94123

☎: 415-673-2200 ◉ www.well.com/~museo
Open: Noon-5 We-Su, till 7pm 1st We of the month **Closed:** Mo, Tu, LEG/HOL!
Free Day: 1st We of month
ADM: Adult: $2.00 **Children:** Free **Students:** $1.00 **Seniors:** $1.00
 Ġ ℗: Free **Museum Shop**
Permanent Collection: IT & IT/AM: ptgs, sculp, phot 20

This unique museum, featuring the art of many contemporary Italian and Italian-American artists, was established in 1978 to promote public awareness and appreciation of Italian art and culture. Included in the collection are works by such modern masters as Francesco Clemente, Sandro Chia, and Luigi Lucioni. **NOT TO BE MISSED:** "Tavola della Memoria," a cast bronze sculpture from 1961 by Arnaldo Pomodoro.

San Francisco Art Institute Galleries

800 Chestnut St, San Francisco, CA 94133

☎: 415-771-7020 ◉ www.sfa.edu
Open: 10-5 Tu-Sa, till 8 Th, 12-5 Su **Closed:** Su, Mo, LEG/HOL
 Ġ ℗: Street parking only ‖: Café, separate from Gallery

Founded in 1871, the Art Institute is the oldest cultural institution on the West Coast, and one of San Francisco's designated historical landmarks. The main building is a handsome Spanish colonial style structure designed in 1926 by architect Arthur Brown. Featured in the Walter/Bean Gallery are exhibitions by artists from the Bay Area and across the nation. The views of San Francisco and the Bay are among the best. **NOT TO BE MISSED:** Mural by Diego Rivera.

CALIFORNIA

San Francisco Craft & Folk Art Museum

Landmark Building A, Fort Mason, San Francisco, CA 94123-1382

☎: 415-775-0990

Open: 11-5 Tu-Sa, till 7pm 1st We of the month **Closed:** Mo, 1/1, MEM/DAY, 7/4, LAB/DAY, THGV, 12/25
Free Day: 10-2 every Sa, till 7 pm 1st We of month **ADM: Adult:** $3.00, fam $5.00 **Students:** $1.00 **Seniors:** $1.00
&: Limited to first floor only **℗:** Free **Museum Shop** **⑪:** Right next door to famous Zen vegetarian restaurant,
Greens **Group Tours:** 415-775-0991 **Docents** **Tour times:** 1:30 1st We, 2nd Fr, and 3rd Sa of month
Permanent Collection: No permanent collection

Six to ten witty and elegant exhibitions of American and international contemporary craft and folk art are presented annually in this museum, part of a fascinating, cultural waterfront center in San Francisco. **PLEASE NOTE:** Group tours are free of charge to those who make advance reservations.

San Francisco Museum of Modern Art

151 Third St., San Francisco, CA 94103-3159

☎: 415-357-4000 **◙** www.sfmoma.org
Open: 11-6 Th-Tu, till 9 Th, Summer Mem/Day to Lab/Day 10-6 **Closed:** We, 1/1, 7/4, THGV, 12/25
Free Day: 1st Tu of month, half price Th 6-9 pm **ADM: Adult:** $9.00 **Children:** Free under 12 with adult **Students:**
$5.00 **Seniors:** $6.00
& **℗:** Pay garages at Fifth & Mission, the Moscone Center Garage (255 Third St.), and the Hearst Garage at 45 Third St.
Museum Shop **⑪:** Caffé Museo open 10-6 daily (except We), till 9pm Th
Group Tours: daily (call 415-357-4096) or inquire in lobby
Permanent Collection: AM: ab/exp ptgs; GER: exp; MEX; REG; PHOT; FAUVIST: ptgs; S.F. BAY AREA; VIDEO ARTS

A trip to San Francisco, if only to visit the new home of this more than 60 year old museum, would be worthwhile for any art lover. Housed in a light filled architecturally brilliant and innovative building designed by Mario Botta, the museum features the most comprehensive collection of 20th century art on the West Coast. It is interesting to note that not only is this structure the largest new American art museum to be built in this decade, it is also the second largest single facility in the U.S. devoted to modern art. **PLEASE NOTE THE FOLLOWING:** 1. Admission is half price from 6-9 on Thursday evenings; 2. Spotlight tours are conducted every Thursday and live jazz in the galleries is provided on the 3rd Thursday of each month; 3. Special group tours called "Modern Art Adventures" can be arranged (415-357-4191) for visits to Bay Area private collections, artists' studios, and a variety of museums and galleries in the area. **NOT TO BE MISSED:** "Woman in a Hat" by Matisse, one of 30 superb early 20th c. works from the recently donated Elise Hass Collection.

ON EXHIBIT 2001

10/07/2000 to 01/15/2001 CELEBRATING MODERN ART: THE ANDERSON COLLECTION
This exhibition includes more than 330 paintings by 140 artists providing a exciting and diverse overview of a century of artistic achievement. The five areas of focus are the New York School, art in California, contemporary art, modern sculpture and 20th century drawings.

11/03/2000 to 01/02/2001 MESSENGERS OF MODERNISM: AMERICAN STUDIO JEWELRY, 1940-1960
The designers of this jewelry drew from a variety of contemporary art movements including Surrealism, Cubism, Constructivism and Primitivism to establish a new form of creative expression, the development of Modernism. *Dates Tentative*

11/03/2000 to 03/07/2001 A HIDDEN PICASSO
A recent discovery of a nightclub scene beneath one of Picasso's earliest Paris paintings led to this glimpse of his creative process. X-ray examination revealed at least two other works. Also shown will be the radiograph and related drawings from his early Paris experience.

11/10/2000 to 01/02/2001 HIROSHI SUGIMOTO: THE ARCHITECTURE SERIES
Sugimoto has now turned his eye to landmarks of modern architecture from around the world bringing out their solidity, evocative capacity and presence. *Dates Tentative*

08/03/2001 to 01/13/2002 ANSEL ADAMS AT 100
The exhibition will offer an aesthetic reappraisal of Adams as an artist and working photographer presenting a look at some of his lesser known works.

54

Yerba Buena Center for the Arts
701 Mission St., San Francisco, CA 94103-3138

☎: 415-978-ARTS (2787) ◙ www.YerbaBuenaArts.org
Open: 11-6 Tu-Su, till 8pm Th and Fr **Closed:** LEG/HOL!
Free Day: 1st Th of month
ADM: Adult: $5.00 **Children:** $3.00 **Students:** $3.00 **Seniors:** $3.00 Free, Th
& **ⓟ:** There is a public parking garage at 5th and Mission Sts. one block away from the Center.
⫴: Café on 1st floor
Group Tours: ex 115 **Docents** **Tour times:** 1, Sa; 6:30, Th
Permanent Collection: No permanent collection

Opened in 1993 as part of an arts complex that includes the San Francisco Museum of Modern Art, the Cartoon Art Museum, and the Ansel Adams Center for Photography, this fine arts and performance center features theme-oriented and solo exhibitions by a diverse cross section of Bay Area artists. **NOT TO BE MISSED:** The building itself designed by prize-winning architect Fumihiko Maki to resemble a sleek ocean liner complete with porthole windows.

ON EXHIBIT 2001

11/4/2000 to 01/28/2001 UNDER EIGHTEEN
A institution wide project which explores ideas about youth and adolescence. The visual arts components include: Grennan and Sparandio & Young Artists at Work
The artists work with lay persons in various industries to discover the impact of art beyond art experts. Juvenilia: A whimsical look at childhood artwork done by some of todays most prominent artists including Tracey Moffat, Alexis Rockman and Fred Wilson
Tom Friedman: A first large scale exhibit of his work which he approaches as an ongoing investigation employing conventions of the 60s and 70s while pricking holes in their hyperbole.

02/10/2001 to 05/06/2001 ANDREA ROBBINS AND MAX BECKER: GERMAN INDIANS
Photographs of various encampments and reenactments of ceremonies at a German pow-wow with formal portraits of festival participants. A deliberate allusion to 20th century portraits done by Edward Curtis.

02/10/2001 to 05/06/2001 CAMERON JAMIE: BACKYARD WRESTLING AND OTHER PROJECTS
Jamie has researched Mexican wrestling for years. He feels that it is a form of theatre that speaks about popular mythology. These have grown into a form of performance art.

02/10/2001 to 05/06/2001 LAYLAH ALI: PAINTINGS FROM THE GREENHEADS SERIES
An ambiguous narrative in which masked, cartoon like characters with green heads and brown skin demonstrate the complexities of living.

02/10/2001 to 05/06/2001 PIERRE ET GILLES
A visual world in which artifice and reality are inseparable. They use make-up, costumes and lighting to exaggerate the staged feeling of their painted photographs. They explore the ideal of beauty combining kitsch with rarified expressions of the sublime.

02/19/2001 to 05/06/2001 NIKKI S. LEE
The Korean born artist takes photographs of herself as a lesbian, yuppie, tourist, swing dancer, punk, hispanic and East Village Japanese. She offers real life selves in the guise of real-life pictures.

05/19/2001 to 08/12/2001 ROOTS, RHYMES AND RAGE: THE HIP HOP STORY
The history and impact of the hip hop culture from its identity as a mere musical form with its roots in South Brooklyn into its surge into pop music and its larger impact on mainstream America.

CALIFORNIA

Egyptian Museum and Planetarium

Rosicrucian Park, 1342 Naglee Ave., San Jose, CA 95191

℡: 408-947-3636 ◙ www.rosicrucian.org
Open: 10-5 Mo-Su **Closed:** 1/1, THGV, 12/25
ADM: Adult: $7.00 **Children:** $3.50 (7-15) **Students:** $5.00 **Seniors:** $5.00
℗: Free **Museum Shop**
Group Tours: 408-947-3633 **Docents** **Tour times:** rock tomb only periodically during day
Permanent Collection: ANT: ptgs, sculp, gr

Without question the largest Egyptian collection in the West, the Rosicrucian is a treasure house full of thousands of objects and artifacts from ancient Egypt. Even the building itself is styled after Egyptian temples and, once inside, the visitor can experience the rare opportunity of actually walking through a reproduction of the rock tombs cut into the cliffs at Beni Hasan 4,000 years ago. **NOT TO BE MISSED:** A tour through the rock tomb, a reproduction of the ones cut into the cliffs at Beni Hasan 4,000 years ago; Egyptian gilded ibis statue in Gallery B.

San Jose Museum of Art

110 S. Market St., San Jose, CA 95113

℡: 408-294-2787 ◙ www.sjmusart.org
Open: 10-5 Tu-Su, till 8pm Th **Closed:** Mo, LEG/HOL
Free Day: 1st Th, **Seniors:** 1st Tu; half price 5-8 pm Tu
ADM: Adult: $7.00 **Children:** Free under 5 **Students:** $4.00 **Seniors:** $4.00
₠ ℗: Paid public parking is available underground at the Museum and at several locations within 3 blocks of the museum. **Museum Shop** ❙❙: The Museum Café at SJMA
Group Tours: 408-291-6840, 408-291-5393 school tours **Docents** **Tour times:** 12:30 & 2:30 Tu-Su & 6:30 Th
Sculpture Garden
Permanent Collection: AM: 19-21; NAT/AM; CONT

Contemporary art is the main focus of this vital museum. Housed in a landmark building that once served as a post office/library, the museum added 45,000 square feet of exhibition space in 1991 to accommodate the needs of the cultural renaissance now underway in San Jose. **PLEASE NOTE:** Signed tours for the deaf are given at 12:30 on the 2nd Sa of the month.

ON EXHIBIT 2001

10/29/2000 to 01/07/2001 DALE CHIHULY: THE GEORGE R. STROEMPLE COLLECTION
A large number of examples of this glassmaker's work.

12/15/2000 to 02/11/2001 THE EUREKA FELLOWSHIP AWARDS 1999-2001

01/21/2001 to 04/15/2001 CARMEN LOMAS GARZA: A RETROSPECTIVE
Universal themes of love, family, death and faith are expressed with her memories of her Texas childhood. *Will Travel Brochure*

01/28/2001 to 04/01/2001 DUANE HANSON: VIRTUAL REALITY
Life sized hyper-realistic sculpture of everyday people. *Will Travel Brochure*

03/04/2001 to 06/03/2001 CONTEMPORARY DEVOTION
Universal issues of piety and faith are reframed in a contemporary context. A unique site-specific altar installation by a local artist will be featured. *Brochure*

03/04/2001 to 06/03/2001 EL FAVOR DE LOS SANTOS: THE RETABLO COLLECTION OF NEW MEXICO STATE UNIVERSITY
The most comprehensive exhibition to date of 19th century retablos—small devotional paintings on tin.

San Jose Museum of Art - continued

04/22/2001 to 07/08/2001 TONY DELAP: A RETROSPECTIVE
His work is fashioned by two passions: a love of the medium of wood; a fascination with illusionism and magic.
Will Travel

04/29/2001 to 07/22/2001 JO WHALEY: NATURA MORTA
40 photographs illustrating human's uneasy relationship with nature as it relates to science and technology.

06/24/2001 to 09/23/2001 RECENT ACQUISITIONS FROM THE PERMANENT COLLECTION (working title)

07/29/2001 to 10/14/2001 URBAN INVASION: THE PAINTINGS OF CHESTER ARNOLD AND JAMES DOOLIN
These two exhibitions examine contemporary urban society at the edge of destruction from related, but distinct points
of view.

10/14/2001 to 01/27/2002 AN AMERICAN DIARY: PAINTINGS BY ROGER SHIMOMURA
Translations of his Grandmother's wartime diaries during the three years she spent at an internment camp for the
Japanese. Each painting is accompanied by its corresponding diary entry.

10/14/2001 to 01/27/2002 DEBORAH ORAPALLO: THE POETRY OF EVERYDAY OBJECTS (working title)
Orapallo expresses profound themes of time, memory, domesticity, survival and escape thru the commonplace, mundane
things—clocks, train tracks, inner tubes, toys, houses, tickets and pennies which take on unusual symbolic power in
her work.

11/04/2001 to 02/24/2002 LIFE SYSTEMS: PHOTOGRAPHS BY CATHERINE WAGNER (working title)
Wagner's current work examines life from the inside out. Employing modern imaging technology, she focuses on
microscopic representations of organic images to investigate the fundamental nature of life.

12/08/2001 to 02/25/2002 FIRST IMPRESSIONS: THE PAULSON PRESS
The first museum showing of prints from the Paulson Press.

SAN MARINO

Huntington Library, Art Collections and Botanical Gardens

1151 Oxford Rd., San Marino, CA 91108

☎: 626-405-2141 ◙ www.huntington.org
Open: 12-4:30 Tu-Fr, 10:30-4:30 Sa, Su; JUNE-AUG: 10:30-4:30 Tu-Su **Closed:** Mo, LEG/HOL!
Free Day: 1st Th of month **ADM: Adult:** $8.50 **Children:** Free under 12 **Students:** $6.00 (12-18) **Seniors:** $8.00
& ℗: ample free parling **Museum Shop** ¶: 1-4 Tu-Fr; 11:30-4:00 Sa, Su; ENG.TEA Noon-3:45 Tu-Fr;
10:45-3:45 Sa, Su
Group Tours: 626-405-2215 **Docents** **Tour times:** Garden Tours at noon at posted intervals **Sculpture Garden**
Permanent Collection: BRIT: ptgs, drgs, sculp, cer 18-19; EU: ptgs, drgs, sculp, cer 18; FR: ptgs, dec/art, sculp 18; REN:
ptgs; AM: ptgs, sculp, dec/art 18-20

The multi-faceted Huntington Library, Art Collection & Botanical Gardens makes a special stop at this
complex a must! Known for containing the most comprehensive collections of British 18th & 19th century
art outside of London, the museum also houses an outstanding American collection as well as one of the
greatest research libraries in the world. A new installation of furniture and decorative arts, designed by
California architects Charles & Henry Greene, opened recently in the Dorothy Collins Brown Wing which
had been closed for refurbishing for the past 3 years. The Christopher Isherwood Archive is now at the
Huntington (not an exhibition; only available to researchers, exhibit planned for 2004). **NOT TO BE
MISSED:** "Blue Boy" by Gainsborough; "Pinkie" by Lawrence; Gutenberg Bible; 12 acre desert garden;
Japanese garden.

CALIFORNIA

Huntington Library, Art Collections and Botanical Gardens - continued
ON EXHIBIT 2001
09/08/2000 to 01/28/2001 "A MIROUR POLISSHED BRYGHT": REFLECTIONS OF CHAUCER, 1400-2000

The 600th anniversary of Geoffrey Chaucer's death will be commemorated in this exhibition, the centerpiece of which will be The Huntington's 15th century illuninated manuscript of "The Canterbury Tales." Chaucer (c. 1343 - 1400) is considered by scholars to be second only to Shakespeare among English poets. His principal work, "The Canterbury Tales," was authored in 1387. *Single Artist Show*

12/01/2000 to 05/13/2001 FROM THIS WORLD TO OTHERS: ONE THOUSAND YEARS OF THE ART AND SCIENCE OF ASTRONOMY
This exhibition from the Library's holdings will illustrate three critical components of our evolving conceptions, portrayals, and connection with the heavens, and how these changing ideas were represented technologically and artistically during the past millennium. These three aspect themes are: Knowing the Universe, Observing the Universe, and Exploring the Universe.

02/25/2001 to 05/2001 SELECTIONS FROM THE DARWIN COLLECTION

Summer 2001 ,TBA! TAKING THE LONG VIEW: PANORAMIC PHOTOGRAPHY AND THE AMERICAN WEST

06/14/2001 to 09/16/2001 THE GREAT WIDE OPEN: PANORAMIC PHOTOGRAPHS AND WESTERN SPACES

10/02/2001 to 12/16/2001 LURE OF THE WEST
Native Americans by Catlin, Remington, Bierstadt and the Taos School.

10/23/2001 to 01/27/2002 EYE OF THE STORM: ODYSSEY OF A CIVIL WAR SOLDIER

SAN SIMION

Hearst Castle
750 Hearst Castle Rd., San Simion, CA 93452-9741
☎: 800-444-4445 ◙ www.hearstcastle.org
Open: 8:20-3:20 (to reserve a tour call toll free 1-800-444-4445) **Closed:** 1/1, THGV, 12/25
ADM: Adult: $14.00 **Children:** $8.00 (6-12); children under 6 free
♿: Call 805-927-2070 to arrange for wheelchair-accessible tours
ⓟ: Free **Museum Shop** ⑪
Group Tours: 1-800-401-4775 **Sculpture Garden**
Permanent Collection: IT/REN: sculp, ptgs; MED: sculp, ptgs; DU; FL; SP; AN/GRK: sculp; AN/R: sculp; AN/EGT: sculp

One of the prize house museums in the state of California is Hearst Castle, the enormous (165 rooms) and elaborate former estate of American millionaire William Randolph Hearst. The sculptures and paintings displayed throughout the estate, a mixture of religious, secular art and antiquities, stand as testament to the keen eye Mr. Hearst had for collecting. **PLEASE NOTE:** A 10% discount for groups of 12 or more (when ordered in advance for any daytime tour) has recently been implemented. Evening Tours are available for a fee of $25 adults and $13 for children ages 6-12 (hours vary according to the sunset). There are 4 different daytime tours offered. All last approximately 1 hour & 50 minutes, include a walk of 1/2 mile, and require the climbing of 150 to 400 stairs. All tickets are sold for specific tour times. Be sure to call 1-800-444-4445 to reserve individual tours. For foreign language tours call 805-927-2020 for interpreters when available. Hours of operation may vary according to the season! **NOT TO BE MISSED:** Antique Spanish ceilings; a collection of 155 Greek vases; New IWERKS Theater presentation at the Visitor Center shows the 40 minute film "Hearst Castle: Building the Dream" on a 5-story high screen.

SANTA ANA

Bowers Museum of Cultural Art

2002 N. Main Street, Santa Ana, CA 92706

☎: 714-567-3600 ◙ www.bowers.org
Open: 10-4 daily, 11-8 first Th of month **Closed:** Mo, 1/1 THGV, 12/25
ADM: Adult: $8.00 **Children:** $4.00 5-14, Free under 5 **Students:** $6.00 **Seniors:** $6.00
♿ ℗: Parking in lot on 20th St. **Museum Shop** ‖: Topaz Cafe
Group Tours: 714-567-3680 **Docents** **Tour times:** Call, times vary
Permanent Collection: Af: Pac/Oc: Pre/Col: Cal artifacts and Cal Plein Air

This museum was founded to contain a record of Orange County and California history and is devoted to promoting human understanding through art. Although the museum was erected in 1932 with funds established by Charles W. Bowers in 1924, it was not opened to the public until 1936. The Spanish Colonial-style buildings, and spacious grounds retain their flavor of the county's early heritage. The patio's entrance contains a life-size statue of Juan Rodriguez Cabrillo. **NOT TO BE MISSED:** In depth collection of William and Alberta McClosky.

ON EXHIBIT 2001

10/07/2000 to 01/24/2001 EGYPTIAN TREASURES FROM THE BRITISH MUSEUM
Covering a time span of 3000 years the exhibition contains a wide range of objects, large and small, from temple and tomb of outstanding quality.

02/2001 TO 06/2001 ROMAN GLASS: REFLECTIONS ON CULTURAL CHANGE
How the craft of glassmaking was influenced by historical events and changing social values in the ancient Roman world.

07/2001 TO 09/2001 REMINGTON, RUSSELL AND THE LANGUAGE OF WESTERN ART

SANTA BARBARA

Santa Barbara Museum of Art

1130 State St., Santa Barbara, CA 93101-2746

☎: 805-963-4364 ◙ www.sbmuseart.org
Open: 11-5 Tu-Sa, 11-9 Fr, Noon-5 Su **Closed:** Mo, 1/1, THGV, 12/25
Free Day: Th and 1st Su of month **ADM: Adult:** $5.00 **Children:** Free under 6 **Students:** $2.00 **Seniors:** $3.00
♿ ℗: 2 city parking lots each one block away from the museum **Museum Shop** ‖
Group Tours: 805-884-6489 **Docents** **Tour times:** 2:00 daily, overview of collection; daily at noon special exhibitions
Permanent Collection: AN/GRK; AN/R; AN/EGP; AM; AS; EU: ptgs 19-20; CONT; PHOT; CA:reg ♫

The Santa Barbara Museum, offers a variety of collections that range from antiquities of past centuries to contemporary creations of today. **PLEASE NOTE:** In addition to a rich variety of special programs such as free Family Days, the museum offers a monthly bilingual Spanish/English tour. **NOT TO BE MISSED:** Collection of representative works of American Art.

ON EXHIBIT 2001

10/28/2000 to 01/14/2001 FROM AZACETA TO ZUNICA: SELECTIONS FROM THE COLLECTION OF 20TH CENTURY LATIN AMERICAN ART
Highlights from the collection of modern and contemporary art from Mexico, Central and South America.

11/24/2000 to 02/11/2001 PHOTO-SECESSION
Evocotive and timeless, romantic and moody, these photographs left no question as to whether photography was art.

12/09/2000 to 01/21/2001 PICTURING THE PAST: PIRENESI TO PEARLSTEIN
18th to 20th century prints, drawings and photographs all of which use classical ruins as their subject matter.

CALIFORNIA

Santa Barbara Museum of Art - continued

02/03/2001 to 04/15/2001 MASTER DRAWINGS FROM THE COLLECTION OF ALFRED MOIR
Works by Italian Masters from the 16th to 18th century.

04/20/2001 to 06/17/2001 FROM THE SUN KING TO THE ROYAL TWILIGHT: PAINTING IN EIGHTEENTH CENTURY FRANCE FROM MUSEE DE PICARDI, AMIENS
A rich overview of painting from the end of Louis XIV reign to the fall of the monarchy.

05/21/2001 to 08/12/2001 GORDON KENNETH GRANT
A 60th anniversary retrospective of the work of this mural painter and silver craftsman.

University Art Museum, Santa Barbara
Affiliate Institution: University of California
Santa Barbara, CA 93106-7130
☎: 805-893-2951 ◙ www.uamucsb.edu
Open: 12-8 Tu, We-Su 12-5 **Closed:** Mo, LEG/HOL!
Ġ.: Wheelchair accessible **℗:** Lot 22 for nominal fee **Museum Shop**
Group Tours: call edu dept **Docents Tour times:** for groups of 12 or less no appointment required; architectural drawing collection by appt only 805-893-2724
Permanent Collection: IT: ptgs; GER: ptgs; FL: ptgs; DU: ptgs; P/COL; ARCH/DRGS; GR; OM: ptgs; AF

Outstanding among the many thousands of treasures in the permanent collection is one of the world's finest groups of early Renaissance medals and plaquettes. **NOT TO BE MISSED:** 15th through 17th century paintings from the Sedgwick Collection; Morgenroth Collection of Renaissance medals and plaquettes.

SANTA CLARA

deSaisset Museum
Affiliate Institution: Santa Clara University
500 El Camino Real, Santa Clara, CA 95053-0550
☎: 408-554-4528 ◙ www.scu.edu/deSaisset
Open: 11-4 Tu-Su **Closed:** Mo, LEG/HOL!
Ġ. **℗:** Free in front of museum parking permit available at front gate
Permanent Collection: AM: ptgs, sculp, gr; EU: ptgs, sculp, gr 16-20; AS: dec/art; AF; CONT: gr, phot, IT/REN: gr

Serving Santa Clara University and the surrounding community, the de Saisset, since its inception in 1955, has been an important Bay Area cultural resource. **PLEASE NOTE:** It is wise to call ahead as the museum may have limited hours between rotating exhibitions. **NOT TO BE MISSED:** California history collection.

ON EXHIBIT 2001
01/27/2001 to 06/24/2001 ALASKA GOLD: LIFE ON THE NEW FRONTIER, 1898-1906
The story of two brothers who left their ranch at the turn of the century and lived for six years as gold miners on a Bering Sea beach near Nome, Alaska.

01/27/2001 to 06/24/2001 FATHER HUBBARD: GLACIER PRIEST
Co-sponsored by SCU 150th Anniversary,

01/27/2001 to 06/24/2001 SYMBOL AND ALLEGORY UNRAVELED: ECLESIASTICAL GARMENTS AND LITURGICAL ACCESSORIES FROM MISSION SANTA CLARA
Co-sponsored by Sybase, Inc.

Triton Museum of Art

1505 Warburton Ave., Santa Clara, CA 95050

📞: 408-247-3754 🔲 www.TritonMuseum.org
Open: 10-5 We-Su, til 9pm Tu **Closed:** Mo, LEG/HOL
Vol./Contr.: $2.00
♿ ℗: Free **Museum Shop**
Group Tours: ext 14 **Sculpture Garden**
Permanent Collection: AM: 19-20; REG; NAT/AM; CONT/GR

Located in a seven acre park adjacent to the City of Santa Clara, the Triton has grown by leaps and bounds to keep up with the cultural needs of its rapidly expanding "Silicon Valley" community. The museum is housed in a visually stunning building that opened its doors to the public in 1987. **NOT TO BE MISSED:** The largest collection in the country of paintings by American Impressionist Theodore Wores; Austen D. Warburton Collection of American Indian Art and Artifacts.

ON EXHIBIT 2001

11/17/2000 to 01/07/2001 RUTH TUNSTALL GRANT

SANTA CRUZ

Museum of Art and History at the McPherson Center

705 Front St., Santa Cruz, CA 95060

📞: 831-429-1964 🔲 www.santacruzmah.org
Open: 11-5 Tu-Su; 11-7 Th **Closed:** Mo, LEG/HOL!
Free Day: 1st Fr of month **ADM: Adult:** $3.00 ($2 for county residents) **Children:** Free **Seniors:** $3.00
♿ ℗: Adjacent parking lot **Museum Shop** 🍴: Indoor courtyard/cafe
Group Tours: 831-429-1964, ext 10 **Docents** **Tour times:** Noon usually 1st Fr
Permanent Collection: CONT

Presenting visual and cultural experiences focused on regional history and modern art; art and history exhibitions from the permanent collection; changing exhibitions from the permanent collection; changing exhibitions of nationally and internationally renowned artists; group exhibitions that demonstrate various art techniques, mediums, crafts, and historic periods.

ON EXHIBIT 2001

09/23/2000 to 01/02/2001 CHINATOWN DREAMS: THE PHOTOGRAPHS OF GEORGE LEE
Lee began taking photos of his neighborhood as a young boy, capturing faces of the aging Chinese immigrants whose lives were spent on the fringes of the Santa Cruz mainstream. Reminiscent of the works of Dorothea Lange and other WPA photographers, Lee's images in Chinatown Dreams presents a rare glimpse of a Santa Cruz that has almost been forgotten. *Single Artist Show*

01/2001 to 04/2001 CALIFORNIA PAINTINGS: SELECTION FROM MILLS COLLEGE ART MUSEUM, 1910-1940
Mills College Art Museum is developing a traveling exhibition from its collection of early 20th century paintings by California artists. Among the works to be included, which have been exhibited only rarely in recent years, are canvases by many acclaimed California Impressionists: Maurice Braun, Anne Bremer, Clark Hobart, John O'Shea, Joseph Raphael, Granville Redmond, and William Wedt, as well as a generous number of very interesting early California women artists.

02/10/2001 to 05/27/2001 COASTAL VOICES: SPANNING A CENTURY OF DAVENPORT AND NORTH COAST HISTORY
This exhibition takes an insider's look at the region through the personal stories, photographs, and collections of long time North Coast residents. It includes the history of the cement plant and the many immigrants it drew to the isolated region. With videos, early photographs, scrapbooks, costumes, and artifacts, this exhibit presents the past which continues to shape and influence present day life along the rugged and beautiful North Coast.

CALIFORNIA

Museum of Art and History at the McPherson Center - continued
04/27/2001 to 08/12/2001 DRESSING UP: WOMEN'S APPAREL FROM THE PERMANENT COLLECTION 1850-1900
Santa Cruz County had its fair share of dressmakers, milliners, and women's apparel shops in the 19th century. It was a wondrous fashion period with elaborate forms and luxuriant fabrics, exciting styling, and fascinating details. Along with the costume display will be historical research into many of the shops and stores that dressed the fine ladies of Santa Cruz County.

06/2001 to 09/2001 SI-CHEN YUAN: STILL LIFES
S. C. Yuan was an artist of tremendous contradictions in his life and in his art. Born in Hangchow, China in 1911, he lived and worked in the Monterey/Carmel area until his death by his own hand in 1974. The still lifes on exhibit are examples of the deep pleasure he found in manipulation the rich texture of oil paint and sumptuous color to produce exuberant, indelible portraits of flowers and fruit. *Single Artist Show*

SANTA MONICA

Santa Monica Museum of Art Bergamot Arts Center
2525 Michigan Ave. Building G1, Santa Monica, CA 90404
☎: 310-586-6488 ◉ www.netvip.com/smmoa
Open: 11-6 Tu-Sa, Salons 7:30 when scheduled **Closed:** Mo, Tu Mo, Su, 1/1, 7/4, THGV, 12/25
ADM: Adult: $3.00 **Students:** $2.00 **Seniors:** $2.00
♿ ℗: Free at Bergamot Arts Center; on-site parking for the disabled **Museum Shop** ⊪: "Gallery Cafe" at Bergamot Station
Permanent Collection: NO PERMANENT COLLECTION

Located in a renovated trolley station in the historic Bergamot Arts Center Station area, this museum, devoted to the display of art by living artists, is the only art museum in the area dedicated to making contemporary art more accessible to a culturally and economically diverse audience.

SANTA ROSA

Sonoma County Museum
425 Seventh St., Santa Rosa, CA 95401
☎: 707-579-1500
Open: 11-4 We-Su **Closed:** Mo, Tu, LEG/HOL!
ADM: Adult: $2.00 **Children:** Free under 12 **Students:** $1.00 **Seniors:** $1.00
♿ ℗: Free **Museum Shop**
Permanent Collection: AM: ptgs 19 ; REG

The museum is housed in a 1909 Post Office & Federal Building that was restored and moved to its present downtown location. It is one of the few examples of Classical Federal Architecture in Sonoma County. **NOT TO BE MISSED:** Collection of works by 19th century California landscape painters.

Iris and B. Gerald Cantor Center for Visual Arts at Stanford University
Affiliate Institution: Stanford University
Stanford, CA 94305-5060

☎: 650-723-4177 **◙** www.stanford.edu/dept/ccva/
Open: 11-5 We-Su; 11-8 Th **Closed:** Mo, Tu, 1/1, 7/4, THGV, 12/25
Vol./Contr.: Yes ♿ **Ⓟ:** Metered parking at the Museum, free weekends **Museum Shop** ⁇
Group Tours: 650-723-3469 **Docents** **Tour times:** Many tours call for info! **Sculpture Garden**
Permanent Collection: PHOT; PTGS; SCULP (RODIN COLLECTION); DEC/ART; GR; DRGS; OR; CONT/EU

The Iris and Gerald Cantor Center for Visual Arts included the beautifully restored historic museum building, a new 42,000 sq. ft. wing with spacious galleries, an auditorium, café, and bookshop, an enhanced Rodin sculpture garden and new gardens for 20th and 21st century sculpture. With diverse collections and a superb schedule of special exhibition, educational programs and event,. the Cantor Arts Center is a major cultural resource for the campus and community. There is also a large collection of outdoor art throughout the campus which includes sculpture by Calder, Segal, Moore, and other artists as well as the Papua, New Guinea Sculpture Garden. **NOT TO BE MISSED:** Largest Rodin sculpture collection outside the Musee Rodin in Paris.

ON EXHIBIT 2001

11/01/2000 to 01/11/2001 FACE UP: CONTEMPORARY PORTRAITS (working title)
Artists include Andy Warhol, Robert Arneson and Chuck Close.

11/29/2000 to 04/04/2001 ERNESTINE REUBEN (working title)
Platinum prints on handmade paper of Rodin's sculpture,

01/10/2001 to 03/04/2001 RECENT ACQUISITIONS ON PAPER

01/17/2001 to 03/04/2001 ASTRACTION ON THE MOVE: LICHTESPIEL OPUS !
Presentation of the 1919-1925 film by Walter Ruttman.

01/18/2001 to 07/29/2001 GIFTS TO THE PERMANENT COLLECTION FROM MONA AND NATHAN OLIVIERA (working title)
A selection of works by many artists given to the Cantor arts Center by retired professor and artist Oliviera.

03/21/2001 to 06/17/2001 EYE SEEING EYE (working title)
The role of visual means to describe and contribute to the human eye,

03/28/2001 to 06/17/2001 THE GILDED AGE: TREASURES FROM THE SMITHSONIAN AMERICAN ART MUSEUM
Works by Saint-Gaudens, Thayer, Sargent, Homer, Hassam and Cassatt.

07/11/2001 to 09/30/2001 EUROPEAN MASTERWORKS: PAINTINGS AND SCULPTURE FROM THE SMITH COLLEGE MUSEUM OF ART
Fifty-seven works from this distinguished collection including Ingres, Corot, Courbet, Gauguin, Monet, Kirchner, Kandinsky and Picasso.

08/15/2001 to 12/02/2001 PRINTS FROM A BAY AREA PRIVATE COLLECTION (working title)
Late 19th and early 20th century prints.

10/17/2001 to 01/06/2002 ART OF THE NDEBELE (working title)
Beadwork, painting, adornment and photographs from the Ndebele of South Africa.

10/31/2001 to 07/02/2002 MEN AT WORK (working title)
Paintings by Kristina Branch.

CALIFORNIA

STOCKTON

Haggin Museum
1201 N. Pershing Ave., Stockton, CA 95203
℃: 209-462-1566
Open: 1:30-5 Tu-Su; Open to groups by advance appt! **Closed:** Mo, 1/1, THGV, 12/25
Sugg./Contr.: ADM: Adult: $2.00 **Children:** $1.00 **Students:** $1.00 **Seniors:** $1.00
&.: Call in advance to arrange for use of elevator, ground level entry ℗: Free street parking where available **Museum Shop Docents Tour times:** 1:45 Sa, Su
Permanent Collection: AM: ptgs 19; FR: ptgs 19; AM: dec/art; EU: dec/art

Wonderful examples of 19th century French and American paintings from the Barbizon, French Salon, Rocky Mountain, and Hudson River Schools are displayed in a setting accented by a charming array of decorative art objects. **NOT TO BE MISSED:** "Lake in Yosemite Valley" by Bierstadt; "Gathering for the Hunt" by Rosa Bonheur.

VENTURA

Ventura County Museum of History & Art
100 E. Main St., Ventura, CA 93001
℃: 805-653-0323
Open: 10-5 Tu-Su, till 8pm Th **Closed:** Mo, 1/1, THGV, 12/25
ADM: Adult: $3.00 **Children:** Free under 16 **Students:** $3.00 **Seniors:** $3.00
&. ℗: No charge at adjacent city lot **Museum Shop Docents Tour times:** 1:30 Su; "ask me" docents often on duty
Permanent Collection: PHOT; CONT/REG; REG

Art is but a single aspect of this museum that also features historical exhibitions relating to the history of the region. **NOT TO BE MISSED:** 3-D portraits of figures throughout history by George Stuart. Mr. Stuart has created nearly 200 figures which are rotated for viewing every 4 months. He occasionally lectures on his works (call for information)!

Aspen Art Museum

590 N. Mill St., Aspen, CO 81611

☎: 970-925-8050 **◉** www.aspen.com/art & destinationaspen.com/art
Open: 10-6 Tu-Sa, 12-6 Su, till 7pm Th **Closed:** Mo, 1/1, THGV, 12/25, !
Free Day: Fr; reception and gallery tour each Th 5-7
ADM: Adult: $3.00 **Children:** Free under 12 **Students:** $2.00 **Seniors:** $2.00
& ℗ **Museum Shop Docents Sculpture Garden**
Permanent Collection: SCULP

Located in an area noted for its natural beauty and access to numerous recreational activities, this museum, with its emphasis on contemporary art, offers the visitor a chance to explore the cultural side of life in the community. A free reception is offered every Thursday evening from 5-7pm for refreshments and gallery tours. **PLEASE NOTE:** The galleries may occasionally be closed between exhibits.

CU Art Galleries

Affiliate Institution: University of Colorado/Boulder
Campus Box 318, Boulder, CO 80309

☎: 303-492-8300 **◉** www.colorado.edu/cuartgalleries
Open: 8-5 Mo-Fr, till 8 Tu, 11-4 Sa; ; SUMMER:10-4:30 Mo-Fr, 12-4 Sa **Closed:** Su Su
Sugg./Contr.: $3.00
& ℗: Paid parking in Euclid Auto Park directly south of the building ¶: within walking distance
Group Tours: 303-735-2368
Permanent Collection: PTGS 19-20; GR 19-20; PHOT 20; DRGS 15-20; SCULP 15-20

The visual arts museum of the University of Colorado at Boulder includes in the permanent collection more than 5000 objects ranging from medieval illuminated manuscripts to contemporary prints. **NOT TO BE MISSED:** works from the permanent collection.

Leanin' Tree Museum of Western Art

6055 Longbow Dr., Boulder, CO 80301

☎: 1-800-777-8716 ext 299 **◉** www.leanintree.com
Open: 8-4:30 Mo-Fr, 10-4 Sa, Su **Closed:** LEG/HOL!
Vol./Contr.: Yes
& ℗: Free **Museum Shop**
Group Tours: 303-530-1442 ext 299 **Docents Tour times:** 8-4:30 Mo-Fr, 10-4 Sa, Su
Permanent Collection: WESTERN: sculp, ptgs, reg; CONT/REG; Largest collection of ptgs by actualist Bill Hughes (1932-1993) in the country.

This unusual fine art museum, just 40 minutes from downtown Denver, is housed in the corporate offices of Leanin' Tree, producers of greeting cards. With 200 original oil paintings and 75 bronze sculptures by over 90 artists, Leanin' Tree is home to the largest privately owned collection of contemporary cowboy and western art on public view in America.

COLORADO

Colorado Springs Fine Arts Center

Affiliate Institution: Taylor Museum for Southwestern Studies

30 W. Dale St., Colorado Springs, CO 80903

☎: 719-634-5581

Open: 9-5 Tu-Fr, 10-5 Sa, 1-5 Su **Closed:** Mo, LEG/HOL!

Free Day: Sa 10-5 **ADM: Adult:** $3.00 **Children:** $1.00 (6-12) **Students:** $1.50 **Seniors:** $1.50

& ℗ **Museum Shop** ‖: 11:30-3:00 Tu-Fr (summer only)

Group Tours: 719-475-2444 **Docents** **Tour times:** by arrangement **Sculpture Garden**

Permanent Collection: AM: ptgs, sculp, gr 19-20; REG; NAT/AM: sculp; CONT: sculp

Located in an innovative 1930's building that incorporates Art Deco styling with a Southwestern Indian motif, this multi-faceted museum is a major center for cultural activities in the Pikes Peak region. **NOT TO BE MISSED:** Collection of Charles Russell sculpture and memorabilia; hands-on tactile gallery called "Eyes of the Mind;" New sculpture acquisitions: "The Family," by William Zorach, "Hopi Basket Dancers," by Doug Hyde, "Resting at the Spring," by Allan Houser, "Prometheus" by Edgar Britton.

Gallery of Contemporary Art

Affiliate Institution: University of Colorado Springs

1420 Austin Bluffs Pkwy. (Shipping, Mail P.O.Box 1730), Colorado Springs, CO 80918

☎: 719-262-3567 ◉ harpy.uccs.edu/gallery/framesgallery.html

Open: 10-4 Mo-Fr, 1-4 Sa **Closed:** Su, LEG/HOL!

ADM: Adult: $1.00 **Children:** Free under 12 **Students:** $0.50 **Seniors:** $0.50

& ℗: pay parking in adjacent lot ‖: adjacent plaza **Docents**

This non-collecting university art gallery, one of the most outstanding contemporary art centers in the nation, concentrates on cutting edge exhibitions of contemporary art with approximately 6 exhibitions throughout the year. Located on the second floor of the University science building, this is the only museum in the Colorado Springs (Pikes Peak) region to focus solely on contemporary art.

Denver Art Museum

100 West 14th Ave. Pkwy., Denver, CO 80204

☎: 720-856-5000 ◉ www.denverartmuseum.org

Open: 10-5 Tu-Sa, 10-9 We, 12-5 Su **Closed:** Mo, LEG/HOL!

Free Day: Sa (Colorado residents only)

ADM: Adult: $6.00 **Children:** Free under 12 **Students:** $4.50 **Seniors:** $4.50

& ℗: Public pay lot located south of the museum on 13th St.; 2 hour metered street parking in front of the museum

Museum Shop ‖: Palettes Tu-Sa 10-5; We 10-9, 12-3 Su; Palettes Express open 10-5 Tu-Sa, We till 8, Su 12-5

Group Tours: 720-913-0075 **Docents** **Tour times:** 1:30 Tu-Su, 11 Sa, 12 and 1 We & Fr **Sculpture Garden**

Permanent Collection: Arch; Design; Graphics, Asian, Modern & Contemp. Native Arts (with famed Am Ind Coll); New World (pre-columbian & spanish colonial; Paintings and Sculpture (Am. European, Western)

With over 40,000 works featuring 19th century American art, a fine Asian and Native American collection, and works from the early 20th century Taos group, in addition two newly renovated floors house the European, American and Western Paintings, sculpture, design and textiles. **PLEASE NOTE:** The Museum offers many free family related art activities on Saturday. Call 720-913-0049 for specifics! Some special exhibitions have ticketed and timed entry. **NOT TO BE MISSED:** The outside of the building itself is entirely covered with one million Corning Glass tiles.

Denver Art Museum- continued

ON EXHIBIT 2001

to 03/04/2001 CLAY AND BRUSH: CHINESE PAINTED POTTERY FROM THE SZE HONG COLLECTION

10/21/2000 to 03/04/2001 PAINTERS AND THE AMERICAN WEST
This exceptional collection has been assembled by Philip Anschutz with a consciousness of the history and an eye for the aesthetic beauty and quality of the works. Included are Russell, Bierstadt, and Remington as well as Moran, O'Keeffe, Catlin, Pollock and Ramsey.

11/03/2000 to 05/06/2001 DEEP ROOTS: SIX CONTEMPORARY AMERICAN INDIAN ARTISTS
Works in a variety of media by 1999 winners of the Community Spirit Awards.

11/18/2000 to 11/18/2001 SUNKEN TREASURES: MING DYNASTY CERAMICS FROM A CHINESE SHIPWRECK
From the cargo of a ship sunk in the 16th century and discovered in 1995. Most of the ceramics were made in South China and painted in under glaze porcelain blue.

11/18/2000 to 03/11/2001 AGNES MARTIN
Although generally characterized as a minimalist, Martin demonstrates a subtle, independent and refined style. Paintings and drawings of the past five decades will be shown. *Only Venue*

11/18/2000 to 03/11/2001 COLLECTING IDEAS: WORKS FROM THE COLLECTION OF POLLY AND MARK ADDISON
An outstanding private collection including sculpture, painting, photography and video.

12/16/2000 to 06/17/2001 TEXTILE ART: RECENT ACQUISITIONS
17th century to today from Europe, Japan, Indonesia and America including tapestries, quilts, embroideries, batiks and fiber sculpture.

02/10/2001 to 04/29/2001 IKAT: SPLENDID SILKS FROM CENTRAL ASIA
Examples of Ikat textiles, created by a method of weaving in which warp threads are tie-dyed before being set up on a loom, will be on loan from one of the most significant private collections of its kind. Traditionally woven and used by nomadic Uzbek peoples, the manufacture of these textiles has influenced contemporary fashion designer Oscar de la Renta textile manufacturer Brunschwig et Fils and others. *Will Travel*

02/17/2001 to 09/02/2001 THE DENVER SALON
Fine art photographers formed in 1993, conducting bold experiments and seeking higher ideals in photograph.,

03/03/2001 to 04/29/2001 WINSLOW HOMER: FACING NATURE
Homer's response to the natural world from the coast of Maine, the Adirondacks, the Bahamas and the coastline of England can be thought of as metaphors for the relationship of man and nature.

03/03/2001 TO 9/30/2001 GIANTS OF MELANESIA: MONUMENTAL ART FROM THE SOUTH PACIFIC
Rarely seen works from the Museum's exceptional holdings of Oceanic art.

03/24/2001 to 03/17/2002 CHINA MEETS THE SOUTHWEST
Pottery from opposite sides of the globe. Native American pieces paired with ancient Chinese examples from the Sze Hong Collection.

04/14/2001 to 08/26/2001 YOKO ONO: EX IT
Yoko Ono has arranged 100 pine coffins (60 for men, 30 for women, and 10 for children). There is an opening at the head of each and trees indigenous to Colorado grow there. Birds and human voices will be heard while the light cycles between brightness and darkness.

04/21/2001 to 08/12/2001 BETWEEN THE LINES: WOODWORKS BY ROLAND BERNIER
Mixed media works exploring how letters come together to form words.

COLORADO

Denver Art Museum - continued

05/05/2001 to 07/29/2001 AMERICAN DESIGN, 1975-2000
Covering the fields of modern design including architecture, decorative design, graphics and industrial design, including Robert Venturi, Frank Gehry, Maya Lin, Steven Holl and others the exhibition will examine the great traditions of modern design. *Dates Tentative*

06/23/2001 to 09/09/2001 EUROPEAN MASTERPIECES: SIX CENTURIES OF PAINTINGS FROM THE NATIONAL GALLERY OF VICTORIA, AUSTRALIA

10/27/2001 to 01/20/2002 EASELS IN THE SHIPYARD: THE IMPRESSIONISTS OF COS COB
Artist colonies sprang up in scenic spots on both coasts but primarily in the East. Sixty impressionist style works from Cos Cob, Connecticut including works by Childe Hassam, Theodore Robinson, J. Alden Weir, and John Twactman.

Museo de las Americas

861 Santa Fe Drive, Denver, CO 80204
☎: 303-571-4401
Open: 10-5 Tu-Sa **Closed:** Su, Mo, 1/1, 7/4, THGV, 12/25
ADM: Adult: $3.00 **Children:** Free under 10 **Students:** $1.00 **Seniors:** $2.00
 Ġ ℗ **Museum Shop**
Group Tours: Call to arrange for certain exhibitions
Permanent Collection: SPANISH COLONIAL ART; CONT LAT/AM

The Museo de las Americas, opened in 7/94, is the first Latino museum in the Rocky Mountain region dedicated to showcasing the art, history, and culture of the people of the Americas from ancient times to the present. **PLEASE NOTE:** Bilingual tours are available with admission price—call ahead to reserve.

ON EXHIBIT 2001

12/15/2000 to 03/10/2001 TALES IN TEXTILES: MOLAS FROM PANAMA
Decorative panels which comprise the front and back of Kuna women's blouses. These have gained world renown in textile art.

ENGLEWOOD

Museum of Outdoor Arts

7600 E. Orchard Rd. #160 N., Englewood, CO 80111
☎: 303-741-3609
Open: 8:30-5:30 Mo-Fr; some Sa from JAN-MAR & SEPT-DEC! **Closed:** LEG/HOL!
Sugg./Contr.: $3.00 adults, guided tour $2.00
 Ġ ℗ **Group Tours:** 303-741-3609, ext 290 **Sculpture Garden**
Permanent Collection: SCULP

Fifty-five major pieces of sculpture ranging from contemporary works by Colorado artists to pieces by those with international reputations are placed throughout the 400 acre Greenwood Plaza business park, located just south of Denver, creating a "museum without walls." A color brochure with a map is provided to lead visitors through the collection.

Sangre de Cristo Arts & Conference Center & Children's Center

210 N. Santa Fe Ave., Pueblo, CO 81003

☎: 719-543-0130
Open: 11-4 Mo-Sa **Closed:** Su LEG/HOL!
ADM: Adult: $4.00 **Children:** $3.00 **Students:** $3.00 **Seniors:** $3.00
& ℗: 2 free lots **Museum Shop** ⅋ **Sculpture Garden**
Permanent Collection: AM: Regional Western 19-20; REG: ldscp, cont

The broad range of Western Art represented in the collection covers works from the 19th and early 20th century through contemporary Southwest and modern regionalist pieces. **NOT TO BE MISSED:** Francis King collection of Western Art; Art of the "Taos Ten"

A. R. Mitchell Memorial Museum of Western Art

150 E. Main St. P.O. Box 95, Trinidad, CO 81082

☎: 719-846-4224
Open: early APR-through SEPT: 10-4 Mo-Sa; OCT-MAR by appt. **Closed:** Su, 7/4
Vol./Contr.: Yes
&: Main floor and restrooms ℗: Street parking on Main St.; parking in back of building **Museum Shop**
Docents Tour times: often available upon request
Permanent Collection: AM: ptgs; HISP: folk; AM: Western

Housed in a charming turn of the century building that features its original tin ceiling and wood floors, the Mitchell contains a unique collection of early Hispanic religious folk art and artifacts from the Old West, all of which is displayed in a replica of an early Penitente Morada. The museum is located in southeast Colorado just above the New Mexico border. **NOT TO BE MISSED:** 250 works by Western artist/ illustrator Arthur Roy Mitchell.

CONNECTICUT

BRIDGEPORT

Discovery Museum
4450 Park Ave., Bridgeport, CT 06604

C: 203-372-3521 ◙ www.discoverymuseum.org
Open: 10-5 Tu-Sa, 12-5 Su (Open 10-5 Mo during JUL & AUG) **Closed:** Mo! LEG/HOL!
ADM: Adult: $7.00 **Children:** $5.50 **Students:** $5.50 **Seniors:** $5.50
& ℗: Free on-site parking **Museum Shop** ₦: Cafeteria
Permanent Collection: AM: ptgs, sculp, phot, furniture 18-20; IT/REN & BAROQUE: ptgs (Kress Coll)

18th to 20th century American works provide the art focus in this interactive art and science museum. **NOT TO BE MISSED:** 14 unique hands-on exhibits that deal with color, line, and perspective in a studio-like setting.

Housatonic Museum of Art
900 Lafayette Blvd., Bridgeport, CT 06608-4704

C: 203-332-5000 ◙ www.hctc.com
Open: Mo-Fr 8:30-5:30 Th til 7; 9-3 Sa; 12-4 Su **Closed:** LEG/HOL! ACAD!
Vol./Contr.: $7.00
& ℗: Free parking in student lot; call ahead to arrange for handicapped parking. ₦: college cafeteria
Group Tours: 203-332-5062 **Docents Sculpture Garden**
Permanent Collection: AM 19-20; EU: 19-20; AF; CONT: Lat/Am; CONT: reg; ASIAN; CONT: Hispanic

With a strong emphasis on contemporary and ethnographic art, the Housatonic Museum displays works from the permanent collection and from changing exhibitions.

BROOKLYN

New England Center for Contemporary Art, Inc.
Route 169, Brooklyn, CT 06234

C: 860-774-8899
Open: (Open from 4/15-12/15 only) 10-5 Tu-Fr; Noon-5 Sa, Su **Closed:** Mo, THGV
& ℗: Free and ample **Museum Shop Sculpture Garden**
Permanent Collection: AM: cont/ptgs; CONT/SCULP; OR: cont/art

In addition to its sculpture garden, great emphasis is placed on the display of the contemporary arts of China in this art center which is located on the mid-east border of the state near Rhode Island. **NOT TO BE MISSED:** Collection of contemporary Chinese art; Collection of artifacts from Papua, New Guinea.

COS COB

Bush-Holley Historic Site
Affiliate Institution: The Historical Society of the Town of Greenwich
39 Strickland Rd., Cos Cob, CT 06807

C: 203-869-6899
Open: 12-4 We-Fr, 11-4 Sa, 1-4 Su (April-Dec); 11-4 Sa, 1-4 Su (Jan-March) **Closed:** Mo, Tu, 1/1 THGV, 12/25
Free Day: Visitorís Center is always free **ADM: Adult:** $6.00 **Children:** Free under 12 **Students:** $4.00 **Seniors:** $4.00
&: quite limited! ℗ **Museum Shop**
Docents Tour times: as above
Permanent Collection: DEC/ART 18-19; AM: Impr/ptgs

Bush-Holley Historic Site- continued

American Impressionist paintings are the important fine art offerings of the 1732 Bush-Holley House. It was in this historical house museum, location of the first American Impressionist art colony, that many of the artists in the collection resided while painting throughout the surrounding countryside. **NOT TO BE MISSED:** "Clarissa," by Childe Hassam.

ON EXHIBIT 2001

09/27/2000 to 02/28/2001 AFRICAN AMERICANS OF GREENWICH
The first exhibition in Greenwich to explore the history of a racial-ethnic community in depth. African Americans have contributed to the economy and culture of Greenwich for over 300 years. There will be a Hands-on History Gallery aimed at children and families.

03/08/2001 to 09/09/2001 ART COLONY IN THE HOLLEY HOUSE
The story of artists of this period and their work. Included are John Twachtman, Childe Hassam, Ernest Lawson and Elmer Livingston MacRae. Photographs and other artifacts will tell the story of the establishment of the art colony and the lives of the artists who spent their summers there. *Will Travel*

FARMINGTON

Hill-Stead Museum

35 Mountain Rd., Farmington, CT 06032

☎: 860-677-4787
Open: MAY-OCT: 10-5 Tu-Su, NOV-APR: 11-4, Tu-Su **Closed:** Mo, LEG/HOL!
ADM: Adult: $7.00 **Children:** $4.00 (6-12) **Students:** $6.00 **Seniors:** $6.00
&.: First floor only ℗ **Museum Shop**
Group Tours: 860-677-2940 **Docents** **Tour times:** hour long tours on the hour & half hour
Permanent Collection: FR: Impr/ptgs; GR:19; OR: cer; DEC/ART

Hill-Stead, located in a suburb just outside of Hartford, is a Colonial Revival home that was originally a "gentleman's farm." Designed by Theodale Pope at the turn of the century, the museum still houses her father's magnificent collection of French and American Impressionist paintings, Chinese porcelains, Japanese woodblock prints, and original furnishings. **PLEASE NOTE:** Guided tours begin every half hour, the last one being 1 hour before closing. **NOT TO BE MISSED:** Period furnishings, French Impressionist paintings, Sunken garden.

GREENWICH

Bruce Museum

Museum Drive, Greenwich, CT 06830-7100

☎: 203-869-0376
Open: 10-5 Tu-Sa, 1-4 Su **Closed:** LEG/HOL! Mo except during school vacations
ADM: Adult: $3.50 **Children:** Free under 5 **Students:** $2.50 **Seniors:** $2.50
& ℗ **Museum Shop**
Permanent Collection: AM: ptgs, gr, sculp 19; AM: cer, banks; NAT/AM; P/COL; CH: robes ◠

In addition to wonderful 19th century American works of art, the recently restored and renovated Bruce Museum also features a unique collection of mechanical and still banks, North American and pre-Columbian artifacts, and an outstanding department of natural history. Housed partially in its original 1909 Victorian manor, the museum is just a short stroll from the fine shops and restaurants in the charming center of historic Greenwich. **NOT TO BE MISSED:** Two new acquisitions: namely, "The Kiss," a 23 1/2" bronze sculpture by Auguste Rodin, and an oil painting entitled "The Mill Pond, Cos Cob, CT" by Childe Hassam.

HARTFORD

Wadsworth Atheneum Museum of Art

600 Main Street, Hartford, CT 06103-2990

☎: 860-278-2670 ◉ www.wadsworthatheneum.org

Open: 11-5 Tu-Su, till 8 on some 1st Th of month **Closed:** Mo, 1/1, 7/4, THGV, 12/25
Free Day: Th all day; Sa 11-12 **ADM: Adult:** $7.00 Some exhibitions have an additional admission fee. **Children:** $3.00
6-17: Free under 6 **Students:** $5.00 **Seniors:** $5.00
&: wheelchairs thru Avery ent on Atheneum Square ℗: limited metered street parking, Free Parking Travelers outdoor
lot #7, Sa and Su only. Commercial lots nearby
Museum Shop ⅠⅠ: Lunch Tu-Sa, Brunch Su, dinner till 8 1st Th (860-728-5989 to reserve). Coffee wine bar daily till 4:30
Group Tours: ext 3046 **Docents** **Tour times:** We 12:30: Sa, Su 1, 2:30 **Sculpture Garden**
Permanent Collection: AM pntgs, sculp, drgs, dec/art;FR: Impr/ ptgs SP, IT; DU;: 17; REN, CER, EU: OM 16-17:EU:
dec/art

Founded in 1842, the Wadsworth Atheneum is the oldest museum in continuous operation in the country. In addition to the many wonderful and diverse facets of the permanent collection, a gift in 1994 of two important oil paintings by Picasso; namely, "The Women of Algiers" and "The Artist" makes the collection of works by Picasso one of the fullest in New England museums. The museum is also noted for its collection of Hudson River School landscape paintings, collection of Thomas Cole, Caravaggio, Salvador Dali, Joan Miro, Piet Mondrian and many others. **NOT TO BE MISSED:** Caravaggio's "Ecstasy of St. Francis," Wallace Nutting collection of pilgrim furniture, Colonial Period rooms; African-American art (Fleet Gallery); Elizabeth B. Miles English Silver Collection; Hudson River School collection; 4 Sol Lewitt Wall drawings.

ON EXHIBIT 2001

10/01/2000 to 02/18/2001 BUSTLES AND BOWS: FASHIONS FROM THE 1870'S
Painted by Manet, Monet and Renoir, parasols, shimmering silks, muslins and flirty fans wore these at Argenteuil.

10/13/2000 to 01/07/2001 CHRISTIAN JANKOWSKI/MATRIX 142
This Berlin-based video artist drew attention at the 1999 Venice Bienniale. He will create a new work especially for the Wadsworth Atheneum.

10/28/2000 to 10/07/2001 SNAP! PHOTOGRAPHY FROM THE COLLECTIONS
A survey of photography from the 1930's to today through a diverse collection of about 70 works. Five broad themes are studied: the human figure, landscape and cityscape, domesticity and interiors, transformation, and pictures with words.

12/07/2000 to 06/08/2001 ETHIOPIA AWAKENING (working title)
The black political leaders gained hopes for freedom that had previously been unimaginable before. They realized that freedom is best realized through strong, autonomous communities and institutions. This spauned the Harlem Renaissance and the changing definitions of freedom among African-Americans. *Dates Tentative*

01/12/2001 to 03/04/2001 LITHOGRAPHS BY JAMES MCNEILL WHISTLER FROM THE COLLECTION OF STEVEN BLOCK
Whistler is less well known for the beautiful lithographs he produced in his later career. His central interest was a radical exploration of line, form and color.

01/27/2001 to 04/29/2001 GAUGUIN'S "NIRVANA": PAINTERS AT LE POULDU, 1889-1890
Gauguin sought isolated locations and found a temporary refuge in Le Pouldu, a rustic fishiing village in Brittany. He was joined there by Meyer de Haan with whom he shared many interests. Thirty interrelated works by Gauguin, de Haan and others are assembled here.

01/27/2001 to 04/29/2001 SOL LEWITT/"INCOMPLETE OPEN CUBES"/MATRIX 143
For the first time 30 structures will be installed in the Museum's old Master galleries stimulating comparisons with art of earlier centuries. *Catalogue*

03/11/2001 to 09/16/2001 THE FORBIDDEN STITCH: CHINESE EMBROIDERY
The forbidden stitch was so called because needleworkers went blind and because it was named for the Imperial enclave: The Forbidden City. Imperial robes, fan and pillow covers as well as slippers will be on display.

Wadsworth Atheneum Museum of Art - continued

06/09/2001 to 09/23/2001 PICASSO: THE ARTIST'S STUDIO
Picasso's studio was the center of his world. His imagination and capacity for experimentation are revealed in his paintings of it.

06/16/2001 to 01/20/2002 BIRMINGHAM TOTEM (working title)
Last in a 4-part series exploring the changing definitions of freedom throughout the history of African-Americans.

MIDDLETOWN

Davison Art Center

Affiliate Institution: Wesleyan University
301 High St., Middletown, CT 06459-044nm
☎: 860-685-2500 **◙** www.wesleyan.edu/dac/home.html
Open: Noon-4 Tu-Fr; 2-5 Sa, Su (SEPT-early JUNE); closed June-August **Closed:** Mo, ACAD! LEG/HOL!
Vol./Contr.: Yes **℗:** On street **Group Tours:** 860-685-2500
Permanent Collection: GR 15-20; PHOT 19-20; DRGS

Historic Alsop House (1830), on the grounds of Wesleyan University, is home to a fine permanent collection of prints, photographs and drawings.

NEW BRITAIN

New Britain Museum of American Art

56 Lexington St., New Britain, CT 06052
☎: 860-229-0257
Open: 1-5 Tu-Fr, 10-5 Sa, Noon-5 Su **Closed:** Mo, 1/1, EASTER, 7/4, THGV, 12/25
ADM: Adult: $3.00 **Children:** Free under 12 **Students:** $2.00 **Seniors:** $2.00
&: Entrance, elevators, restrooms **℗:** Free on street parking **Museum Shop**
Permanent Collection: AM: ptgs, sculp, gr 18-20

The New Britain Museum, only minutes from downtown Hartford, and housed in a turn of the century mansion, is one of only five museums in the country devoted exclusively to American art. The collection covers 250 years of artistic accomplishment including the nation's first public collection of illustrative art. A recent bequest by Olga Knoepke added 26 works by Edward Hopper, George Tooker and other early 20th century Realist artworks to the collection. **PLEASE NOTE:** Tours for the visually impaired are available with advance notice. **NOT TO BE MISSED:** Thomas Hart Benton murals; Paintings by Child Hassam and other important American Impressionist masters.

NEW CANAAN

Silvermine Guild Art Center

1037 Silvermine Rd., New Canaan, CT 06840
☎: 203-966-5617
Open: 11-5 Tu-Sa, 1-5 Su **Closed:** Mo, 1/1, 7/4, 12/25 & HOL. falling on Mondays
ADM: Adult: $2.00 **&:** Ground level entries to galleries **℗:** Ample and free **Museum Shop** **Sculpture Garden**
Permanent Collection: PRTS: 1959-present

Housed in an 1890 barn, and established as one of the first art colonies in the country, the vital Silvermine Guild exhibits works by well known and emerging artists. Nearly 30 exhibitions are presented yearly.

CONNECTICUT

NEW HAVEN

Yale Center for British Art

Affiliate Institution: Yale University

1080 Chapel St., New Haven, CT 06520-8280

☎: 203-432-2800 ◙ www.yale.edu/ycba

Open: 10-5 Tu-Sa, Noon-5 Su **Closed:** Mo, LEG/HOL!

& ⓟ: Parking lot behind the Center and garage directly across York St. **Museum Shop**

Group Tours: 203-432-2858 **Docents Tour times:** Introductory & Architectural tours one Sa per mo.

Permanent Collection: BRIT: ptgs, drgs, gr 16-20

With the most comprehensive collection of English paintings, prints, drawings, rare books and sculpture outside of Great Britain, the Center's permanent works depict British life and culture from the 16th century to the present. The museum, celebrated its 20th anniversary in 1998, is housed in the last building designed by the late great American architect, Louis Kahn. **NOT TO BE MISSED:** "Golden Age" British paintings by Turner, Constable, Hogarth, Gainsborough, Reynolds.

ON EXHIBIT 2001

10/11/2000 to 01/07/2001 THE SCHOOL OF LONDON AND THEIR FRIENDS: COLLECTION OF ELAINE AND MELVIN MERIANS

This collection has never been shown publically. These artists including Lucian Freud, David Hockney, Leon Kossoff, Frank Auerbach, Michael Andrews, R. B. Kitaj and Paula Rego are among those who renewed painting in Britain in the 1950's-70's. *Will Travel*

02/16/2001 to 04/29/2001 THE PAUL MELLON BEQUEST: TREASURES OF A LIFETIME

05/17/2001 to 09/02/2001 THE LINE BEAUTY: BRITISH DRAWINGS AND WATERCOLORS OF THE EIGHTEENTH CENTURY

06/16/2001 to 09/02/2001 SNOWDON

09/27/2001 to 12/30/2001 HOLBEIN TO HOCKNEY: MASTERPIECE OF BRITISH PAINTING FROM AMERICAN COLLECTIONS

09/27/2001 to 12/30/2001 'WILDE AMERICK': DISCOVERY AND EXPLORATION OF THE NEW WORLD, 1500-1800

Yale University Art Gallery

Affiliate Institution: Yale University

1111 Chapel St., New Haven, CT 06520

☎: 203-432-0600 ◙ www.yale.edu/artgallery

Open: 10-5 Tu-Sa, 2-5 Su **Closed:** Mo, 1/1, 7/4, MONTH OF AUGUST, THGV, 12/25

&: Entrance at 201 York St. wheelchairs available, barrier free ⓟ: Metered street parking plus parking at Chapel York Garage. 201 York St. **Museum Shop**

Group Tours: 203-432-0620 education dept. **Docents Tour times:** Noon We & other! **Sculpture Garden**

Permanent Collection: AM: ptgs, sculp, dec/art; EU: ptgs, sculp; FR: Impr, Post/Impr; OM: drgs, gr; CONT: drgs, gr; IT/REN: ptgs; P/COL; AF: sculp; CH; AN/GRK; AN/EGT

Founded in 1832 with an original bequest of 100 works from the John Trumbull Collection, the Yale University Gallery has the distinction of being the oldest museum in North America. Today over 100,000 works from virtually every major period of art history are represented in the outstanding collection of this highly regarded university museum. **NOT TO BE MISSED:** "Night Cafe" by van Gogh.

Yale University Art Gallery - continued
ON EXHIBIT 2001
12/15/2000 to 03/23/2001 CALL AND RESPONSE : JOURNEYS OF AFRICAN ART
The ways in which migration and forms of interchange on the African continent have transformed African art and aesthetics.

01/16/2001 to 04/01/2001 ANCIENTS AND MODERNS IN ASIAN ART I

01/30/2001 to 03/25/2001 FROM CALIGULA TO CONSTANTINE: TYRANNY AND TRANSFORMATION IN ROMAN PORTRAITURE

04/17/2001 to 09/02/2001 ANCIENTS AND MODERNS IN ASIAN ART II

04/18/2001 to 08/19/2001 ART FOR YALE: DEFINING MOMENTS

NEW LONDON

Lyman Allyn Museum of Art at Connecticut College
625 Williams St., New London, CT 06320
☎: 860-443-2545 ◎ http://lymanallyn@concoll.edu
Open: 10-5 Tu-Sa, 1-5 Su **Closed:** Mo, LEG/HOL!
Free Day: 1st Su of each month is Family 1st Su
ADM: Adult: $4.00 **Children:** Free under 6 **Students:** $3.00 **Seniors:** $3.00
&: ℗: Free **Museum Shop** ⫙: Bookstore Cafe
Group Tours: 860-444-1715 **Docents** **Tour times:** 2 weekly **Sculpture Garden**
Permanent Collection: AM: ptgs, drgs, furn, Impr/ptgs; HUDSON RIVER SCHOOL: ptgs; 19th c. landscape, AM/CT DEC ART. Am Imp paintings, Contemp Amer Art

Founded in 1926 by Harriet U. Allyn as a memorial to her whaling merchant father, Lyman Allyn, Lyman Allyn Art Museum was established for the community of southeastern Connecticut to use, enjoy, and learn about art and culture. The Museum is housed in a handsome Neo-Classical building designed by Charles A. Platt, architect of The Freer Gallery of Art in Washington DC, the Lyme Art Association Building, and several buildings on the campus of Connecticut College, with whom the Museum has recently affiliated. **NOT TO BE MISSED:** 19th century Deshon Allyn House open by appointment only, Toy and Doll Museum at 165 State Street, New London.

ON EXHIBIT 2001
to 04/2002 THE MANTESI SHIPS; MARITIME FOLK ART

02/09/2001 to 03/23/2001 BEYOND THE MOUNTAINS: THE CONTEMPORARY AMERICAN LANDSCAPE
Artists including Amenoff, Dickson and Katz show the diverse, inventive, unique and romantic.

CONNECTICUT

Slater Memorial Museum

Affiliate Institution: The Norwich Free Academy
108 Crescent St., Norwich, CT 06360
☎: 860-887-2506 ◙ norwichfreeacademy.com
Open: SEPT-JUNE: 9-4 Tu-Fr & 1-4 Sa-Su; JULY-AUG: 1-4 Tu-Su **Closed:** Mo, LEG/HOL! STATE/HOL!
ADM: Adult: $3.00 **Children:** Free under 12 **Seniors:** $2.00
ⓟ: Free along side museum. However parking is difficult between 1:30-2:30 during the week to allow for school buses to operate. **Museum Shop**
Group Tours: ex 218
Permanent Collection: AM: ptgs, sculp, gr; DEC/ART; OR; AF; POLY; AN/GRK; NAT/AM

Dedicated in 1888, the original three story Romanesque structure has expanded from its original core collection of antique sculpture castings to include a broad range of 17th through 20th century American art. This museum has the distinction of being one of only two fine arts museums in the U.S. located on the campus of a secondary school. **NOT TO BE MISSED:** Classical casts of Greek, Roman and Renaissance sculpture.

Florence Griswold Museum

96 Lyme St., Old Lyme, CT 06371
☎: 860-434-5542 ◙ www.flogris.org
Open: April thru Dec: 10-5 Tu-Sa, 1-5 Su; Feb through March : 1-5 We-Su **Closed:** Mo, LEG/HOL!
ADM: Adult: $5.00 **Children:** Free under 12 **Students:** $4.00 **Seniors:** $4.00
&: Ground floors ⓟ: Ample and free **Museum Shop**
Docents Tour times: daily upon request
Permanent Collection: AM: Impr/ptgs; DEC/ART

The beauty of the Old Lyme, Connecticut countryside in the early part of the 20th century attracted dozens of artists to the area. Many of the now famous American Impressionists worked here during the summer and lived in the Florence Griswold boarding house, which is now a museum that stands as a tribute to the art and artists of that era. The site includes 11 landscaped acres, gardens, river frontage, and the Hartman education center. **NOT TO BE MISSED:** The Chadwick Studio: restored early 20th century artists' studio workplace of American Impressionist, William Chadwick. Free with admission, the Studio is open in the summer only.

Aldrich Museum of Contemporary Art

258 Main St., Ridgefield, CT 06877
☎: 203-438-4519
Open: 12-5 Tu-Su, Fr 12-8 **Closed:** Mo, LEG/HOL!
Free Day: Tu **ADM: Adult:** $5.00 **Children:** Free under 12 **Students:** $2.00 **Seniors:** $2.00
& ⓟ: Free **Museum Shop**
Group Tours: edu dept **Docents Tour times:** 2:00 Su **Sculpture Garden**

The Aldrich Museum of Contemporary Art, one of the foremost contemporary art museums in the Northeast, offers the visitor a unique blend of modern art housed within the walls of a landmark building dating back to the American Revolution. One of the first museums in the country dedicated solely to contemporary art, the Aldrich exhibits the best of the new art being produced. **NOT TO BE MISSED:** Outdoor Sculpture Garden.

Aldrich Museum of Contemporary Art- continued

ON EXHIBIT 2001

09/24/2000 to 01/07/2001 GLEE!: PAINTING NOW
Glee examines the renewed confidence which contemporary painters have in the face of cutting edge technologies. Painting is flourishing.

01/21/2001 to 05/28/2001 JANINE ANTONI
Antoni was the winner of the 1999 Larry Aldrich Foundation Award. Her installations and performances focus on the female body as both object and subject.

01/21/2001 to 05/28/2001 PAPER
A survey of contemporary work where paper is used not as a support for paint or pencil, but as a sculptural medium in its own right.

STAMFORD

Whitney Museum of American Art at Champion

Atlantic St. & Tresser Blvd., Stamford, CT 06921

☎: 203-358-7630
Open: 11-5 Tu-Sa **Closed:** Su, Mo, 1/1, THGV, 7/4, 12/25
♿: No stairs; large elevator from parking garage ℗: Free parking in the Champion garage on Tresser Blvd.
Museum Shop
Group Tours: 203-358-7641 **Docents** **Tour times:** 12:30 Tu, Th, Sa

The Whitney Museum of American Art at Champion, the only branch of the renowned Whitney Museum outside of New York City, features changing exhibitions of American Art primarily of the 20th century. Many of the works are drawn from the Whitney's extensive permanent collection and exhibitions are supplemented by lectures, workshops, films and concerts.

STORRS

William Benton Museum of Art, Connecticut State Art Museum

Affiliate Institution: University of Connecticut
245 Glenbrook Rd. U-140, Storrs, CT 06269-2140

☎: 860-486-4520 ◙ www.benton.uconn.edu
Open: 10-4:30 Tu-Fr; 1-4:30 Sa, Su **Closed:** Mo, LEG/HOL
♿: Entrance at rear of building; museum is fully accessible ℗: Weekdays visitor's may park in the campus parking garage or metered lot on Grenbrook Road; Weekends or evenings park in metered or unmetered spaces of in any campus lot. Handicapped spaces in visitor's lot behind the Museum. **Museum Shop**
Group Tours: 860-486-1711 or 486-4520
Permanent Collection: EU: 16-20; AM: 17-20; KATHE KOLLWITZ: gr; REGINALD MARSH: gr

One of New England's finest small museums. Its Collegiate Gothic building, on the national register of Historic Places, is the setting for a wide variety of culturally diverse changing exhibitions. Call ahead for exhibition information and programs. **NOT TO BE MISSED:** Newly discovered as a best kept secret in Connecticut.

DELAWARE

DOVER

Sewell C. Biggs Museum of American Art

406 Federal Street P. O. Box 711, Dover, DE 19903

☎: 302-674-2111 ◙ www.biggsmuseum.org
Open: 10-4 We-Sa; 1:30-4:30 Su **Closed:** Mo, Tu, LEG/HOL!
Vol./Contr.: Yes
& **℗:** Free
Docents Tour times: time Varies
Permanent Collection: AM; pntgs, sculp, Dec/Arts

A collection of about 500 objects assembled by one man. The focus is on the arts of Delaware and the Delaware Valley.

ON EXHIBIT 2001

11/11/2000 to 02/25/2001 JOHN MCCOY: AMERICAN PAINTER

WILMINGTON

Broughton Masterpiece Presentations — First USA Riverfront Arts Center

800 South Madison Street, Wilmington, DE 19801

☎: 888-395-0005, 302-777-1600 ◙ www.broughtonmasterpiece.com
Open: 9 am-7 pm (last tour at 5 pm) **Closed:** Mo
& **℗:** Free **Museum Shop** **⑪:** Coffee shop
Group Tours: 888-395-0005, 302-777-1600

The Broughton Masterpiece Presentation international cultural exchange program features major, grand-scale international art exhibitions from the world's leading art, scientific historic and cultural institutions, and private collections. Call for current exhibition information. Past internationally-acclaimed exhibitions have included "Nicholas and Alexandra: The last Imperial Family of Tsarist Russia" (1998/1999) and "Splendors of Meiji: Treasures of Imperial Japan (1999)." **NOT TO BE MISSED:** Faberge — The largest collection of masterpieces ever presented together. (September 9, 2000 - February 18, 2001).

ON EXHIBIT 2001

09/09/2000 to 02/18/2001 FABERGE
The largest collection of masterpieces ever presented together.

Delaware Art Museum

2301 Kentmere Pkwy., Wilmington, DE 19806

☎: 302-571-9590 ◙ www.delart.org
Open: 9-4 Tu & Th-Sa, 10-4 Su, 9-9 We **Closed:** Mo, 1/1, THGV, 12/25
Free Day: We 4-9, Sa 9-12 **ADM: Adult:** $7.00 **Children:** Free 6 & under **Students:** $2.50 **Seniors:** $5.00
& **℗:** Free behind museum **Museum Shop** **⑪:** The Museum Cafe
Group Tours: 302-571-9590 **Docents Tour times:** 5:30pm We; 12:15pm Th; 10am & 11am Sa
Permanent Collection: AM: ptgs 19-20; BRIT: P/Raph; GR; SCULP; PHOT; John Sloan and the Eight

Begun as a repository for the works of noted Brandywine Valley painter/illustrator Howard Pyle, the Delaware Art Museum has grown to include other collections of note especially in the areas of Pre-Raphaelite painting and 19th & 20th centrury American art. **NOT TO BE MISSED:** "Summertime" by Edward Hopper; "Milking Time" by Winslow Homer; "Mermaid" by Howard Pyle.

Delaware Art Museum- continued

ON EXHIBIT 2001

to 01/07/2001 ALICE IN WONDERLAND FAMILY TEA PARTY

to 01/07/2001 THE DEFINING MOMENT: VICTORIAN NARRATIVE PAINTINGS FROM THE FORBES MAGAZINE COLLECTION
Including Pre-Raphaelite Millias, Academicians, Frith, Redgrave, Tissot and Holl, the works are held at Old Battersea House in London. They capture a particularly dramatic moment in time.

01/19/2001 to 03/18/2001 LINDA MCCARTNEY'S SIXTIES: PORTRAIT OF AN ERA

02/09/2001 to 04/22/2001 AN AMERICAN CENTURY OF PHOTOGRAPHY: FROM DRY-PLATE TO DIGITAL— FROM THE HALLMARK PHOTOGRAPHIC COLLECTION

05/11/2001 to 08/05/2001 AMERICAN IMPRESSIONISTS ABROAD AND AT HOME
Thirty-nine works by 27 artists will illuminate the training that American Impressionists undertook abroad and at home; the complex attractions of Europe and America; the significance of the subjects they dipicted and their various responses to French Impressionism.

WASHINGTON

Art Museum of the Americas
201 18th St. NW, Washington, DC 20006
℃: 202-458-6016
Open: 10-5 Tu-Su **Closed:** Mo, LEG/HOL!
Vol./Contr.: Yes **℗:** Metered street parking **Museum Shop** **Group Tours:** 202-458-6301
Permanent Collection: 20th C LATIN AMERICAN & CARIBBEAN ART

Established in 1976, and housed in a Spanish colonial style building completed in 1912, this museum contains the most comprehensive collection of 20th century Latin American art in the country. **NOT TO BE MISSED:** The loggia behind the museum opening onto the Aztec Gardens.

Arthur M. Sackler Gallery
1050 Independence Ave. SW, Washington, DC 20560
℃: 202-357-2700 ◙ www.si.edu/asia
Open: 10-5:30 Daily **Closed:** 12/25
&: All levels accessible by elevator **℗:** Free 3 hour parking on Jefferson Dr; some metered street parking **Museum Shop**
Group Tours: 202-357-4880 ex 245 **Docents** **Tour times:** 11:30 daily
Permanent Collection: CH: jade sculp; JAP: cont/cer; PERSIAN: ptgs; NEAR/E: an/silver

Opened in 1987 under the auspices of the Smithsonian Institution, the Sackler Gallery, named for its benefactor, houses some of the most magnificent objects of Asian art in America.

ON EXHIBIT 2001
10/29/2000 to 04/22/2001 ASIAN TRADITIONS IN CLAY: THE HAGUE GIFTS
Three major Asian ceramic traditions are examined here: glazed earthenware from Islamic Iran; low temperature works from Iran and Iraq; glazed stoneware from the Khmer Empire. The technologies are explained.

12/03/2000 to 03/25/2001 INDIA THROUGH THE LENS: PHOTOGRAPHY 1840-1911
The art of the panoramic photograph, British passion for documentation in architecture and ethnography, the work of Felice Beato, who recorded the aftermath of the Indian Mutiny of 1857; the photographs of Samuel Bourne who traveled across India in search of the picturesque, the maharajas of princely India, ceremonial durbars of British imperial India and works by Lala Deen Days.

12/03/2000 to 05/06/2001 PERSEPOLIS: DOCUMENTING AN ANCIENT IRANIAN CAPITAL, 1923-1935
Photographs, sketchbooks, watercolors, scale drawings, paper casts or "squeezes" of inscriptions recorded by Ernst E. Herzfeld (1879-1948) as part of the team which excavated Persepolis.

06/17/2001 to 09/09/2001 WORSHIPING THE ANCESTORS: CHINESE RITUAL AND COMMEMORATIVE PORTRAITS
Portraits were commissioned in China in great number and variety. One set were ancestor images. Featured are ancient jade, inscribed ancient bronze, four inscribed bamboo slips, handscroll rubbing and a group of writing tools.

10/21/2001 to 01/13/2002 CULTURAL DILEMMAS: ZU BING AND THE WRITTEN WORD
Recognized as one of the most important artists to emerge in the last 15 years, taking the meaning of language and humankind's struggle as the theme of his work.

Corcoran Gallery of Art
17th St. & New York Ave. NW, Washington, DC 20006-4804
℃: 202-639-1700 ◙ www.corcoran.org
Open: 10-5 Mo & We-Su, till 9pm Th **Closed:** Tu, 1/1, 12/25
ADM: Adult: $3.00 **Children:** Free under 12 **Students:** $1.00 **Seniors:** $1.00
& ℗: Limited metered parking on street; commercial parking lots nearby **Museum Shop** ¶l: Cafe 11-3 daily & till 8:30 Th; Gospel Brunch 11-2 Su (202-639-1786)
Group Tours: 202-786-2374 **Docents** **Tour times:** Noon daily; 7:30 Th; 10:30, 12 & 2:30 Sa, Su
Permanent Collection: AM & EU: ptgs, sculp, works on paper 18-20

Corcoran Gallery of Art - continued

The beautiful Beaux Art building built to house the collection of its founder, William Corcoran, contains works that span the entire history of American art from the earliest limners to the cutting edge works of today's contemporary artists. In addition to being the oldest art museum in Washington, the Corcoran has the distinction of being one of the three oldest art museums in the country. Recently the Corcoran became the recipient of the Evans-Tibbs Collection of African-American art, one of the largest and most important groups of historic American art to come to the museum in nearly 50 years. **PLEASE NOTE:** There is a special suggested contribution fee of $5.00 for families. **NOT TO BE MISSED:** "Mt. Corcoran" by Bierstadt; "Niagra" by Church; Restored 18th century French room Salon Dore.

ON EXHIBIT 2001

05/2001 TO 08/2001 THE LAST FRONTIER: PHOTOGRAPHS FROM THE ROBERT LEWIS COLLECTION

10/28/2000 to 01/01/2001 JACK BOUL

11/18/2000 to 02/19/2001 ANDY WARHOL: SOCIAL OBSERVER

12/09/2000 to 03/05/2001 MEDIA/METAPHOR: NEW STORIES IN CONTEMPORARY ART: THE 46TH CORCORAN BIENNIAL

02/03/2001 to 04/22/2001 WAYNE THIEBAUD: A SELECTION OF PRINTS

05/2001 TO 08/2001 THE LAST FRONTIER: PHOTOGRAPHS FROM THE ROBERT LEWIS COLLECTION

05/02/2001 TO 05/14/2001 2001 ALL SENIOR EXHIBITION

05/12/2001 to 07/30/2001 THE ANSCUHTZ COLLECTION: AMERICAN PAINTERS AND THE WEST

06/09/2001 to 08/21/2001 ARTHUR TRESS: RETROSPECTIVE

08/2001 TO 10/2001 FRANCIS CRISS: AMERICAN MODERNIST: PAINTINGS FROM THE 1930'S

Dumbarton Oaks Research Library & Collection

1703 32nd St. NW, Washington, DC 20007-2961

☎: 202-339-6401 ◉ www.doaks.org
Open: 2-6 Tu-Su, Apr-Oct; 2-5 Nov-Mar **Closed:** Mo, LEG/HOL
ADM: Adult: $4.00 **Children:** $3.00 **Seniors:** $3.00
♿.: Partial access to collection Ⓟ: On-street parking only **Museum Shop**
Group Tours: 202-339-6409
Permanent Collection: BYZ; P/COL; AM: ptgs, sculp, dec/art; EU: ptgs, sculp, dec/art

This 19th century mansion, site of the international conference of 1944 where discussions leading to the formation of the United Nations were held, is best known for its rare collection of Byzantine and Pre-Columbian art. Beautifully maintained and now owned by Harvard University, Dumbarton Oaks is also home to a magnificent French Music Room and to 16 manicured acres that contain formally planted perennial beds, fountains and a profusion of seasonal flower gardens. **PLEASE NOTE:** 1. Although there is no admission fee to the museum, a donation of $1.00 is appreciated. 2. With the exception of national holidays and inclement weather, the museum's gardens are open daily. Hours and admission from Apr to Oct. are 2-6pm, $3.00 adults, $2.00 children & seniors. From Nov. to Mar. the gardens are open from 2-5pm with free admission. **NOT TO BE MISSED:** Music Room; Gardens (open daily Apr-Oct, 2-6pm, $3.00 adult, $2.00 children/seniors; 2-5pm daily Nov-Mar, Fr).

DISTRICT OF COLUMBIA

Federal Reserve Board Art Gallery

2001 C St., Washington, DC 20551

☎: 202-452-3686
Open: 11-2 Mo-Fr or by reservation **Closed:** LEG/HOL! WEEKENDS
&: Off 20th St. **℗:** Street parking only
Permanent Collection: PTGS, GR, DRGS 19-20 (with emphasis on late 19th C works by Amer. expatriots); ARCH: drgs of Paul Cret PLEASE NOTE: The permanent collection may be seen by appointmemt only.

Founded in 1975, the collection, consisting of both gifts and loans of American and European works of art, acquaints visitors with American artistic and cultural values. **NOT TO BE MISSED:** The atrium of this beautiful building is considered one of the most magnificent public spaces in Washington, DC.

Freer Gallery of Art

Jefferson Dr. at 12th St. SW, Washington, DC 20560

☎: 202-357-2700 **◙** www.si.edu/asia
Open: 10-5:50 Daily **Closed:** 12/25
&: Entry from Independence Ave. **℗:** Free 3 hour parking on the Mall **Museum Shop**
Group Tours: 202-357-4880 ext. 245 **Docents** **Tour times:** 11:30 Daily
Permanent Collection: OR: sculp, ptgs, cer; AM/ART 20; (FEATURING WORKS OF JAMES McNEILL WHISTLER; PTGS

One of the many museums in the nation's capitol that represent the results of a single collector, the Freer Gallery, renowned for its stellar collection of the arts of all of Asia, is also home to one of the world's most important collections of works by James McNeill Whistler. **NOT TO BE MISSED:** "Harmony in Blue and Gold," "The Peacock Room" by James McNeill Whistler.

ON EXHIBIT 2001

04/30/2000 to 01/02/2001 BRUSHING THE PAST: LATER CHINESE CALLIGRAPHY FROM THE GIFT OF ROBERT HARTFIELD ELLSWORTH
A selection of works including seal carvers; theorists and painters; and collectors.

Hillwood Museum

4155 Linnean Ave. NW, Washington, DC 20008

☎: 202-686-8500 or toll free @ 1-877-HILLWOOD
Open: BY RESERVATION ONLY: 9am - 5pm Tu-Sa. **Closed:** Su, Mo, FEB & LEG/HOL except Veterans Day
ADM: Adult: $10.00 **Children:** $5.00 **Students:** $5.00 **Seniors:** $10.00
& **℗:** Free **Museum Shop** **�11:** Reservations recommended for cafe (202) 686-8893
Group Tours: 202-686-5807 **Docents:** Docent and self-guided in mansion. Docent garden tours in spring and fall; self-guided year round **Sculpture Garden**
Permanent Collection: RUSS: ptgs, cer, dec/art; FR: cer, dec/art, glass 18-19

The former home of Marjorie Merriweather Post, heir to the Post cereal fortune, is filled primarily with the art and decorative treasures of Imperial Russia which she collected in depth over a period of more than 40 years. It also has an extensive collection of 18th century French furniture and porcelain. **NOT TO BE MISSED:** Some 90 works by Carl Faberge including two imperial Easter eggs, Russian and French porcelain; 25 acres of woods and glorious gardens surrounding the mansion. Children under 6 are not permitted in the mansion.

Hirshhorn Museum and Sculpture Garden

Affiliate Institution: Smithsonian Institution
Independence Ave. at Seventh St. NW, Washington, DC 20560

☎: 202-357-2700 **◙** www.si.edu/hirshhorn
Open: Museum: 10-5:30 Daily; Plaza: 7:30am-5:30 pm, S/G: 7:30am-dusk **Closed:** 12/25
&: Through glass doors near fountain on plaza **℗:** metered parking nearby, commercial lots nearby **Museum Shop**
�11: Plaza Café MEM/DAY to LAB/DAY only
Group Tours: 202-357-3235 **Docents** **Tour times:** 10:30-12 Mo-Fr; 1 2 Sa, Su **Sculpture Garden**
Permanent Collection: CONT: sculp, art; AM: early 20th; EU: early 20th; AM: realism since Eakins

Hirshhorn Museum and Sculpture Garden - continued

Endowed by the entire collection of its founder, Joseph Hirshhorn, this museum focuses primarily on modern and contemporary art of all kinds and cultures in addition to newly acquired works. One of its most outstanding features is its extensive sculpture garden. **PLEASE NOTE:** No tours are given on holidays. **NOT TO BE MISSED:** Rodin's "Burghers of Calais;" works by Henry Moore and Willem de Kooning, third floor.

Howard University Gallery of Art

2455 6th St. NW, Washington, DC 20059

☎: 202-806-7070

Open: 9:30-4:30 Mo-Fr; 1-4 Su (may be closed some Su in summer!) **Closed:** Sa, LEG/HOL!

&: ℗: Metered parking; Free parking in the rear of the College of Fine Arts evenings and weekends

Permanent Collection: AF/AM: ptgs, sculp, gr; EU: gr; IT: ptgs, sculp (Kress Collection); AF

In addition to an encyclopedic collection of African and African-American art and artists there are 20 cases of African artifacts on permanent display in the east corridor of the College of Fine Arts. **PLEASE NOTE:** It is advisable to call ahead in the summer as the gallery might be closed for inventory work. **NOT TO BE MISSED:** The Robert B. Mayer Collection of African Art.

Kreeger Museum

2401 Foxhall Rd. NW, Washington, DC 20007

☎: 202-338-3552 ☑ www.kreegermuseum.com

Open: Tours only at 10:30 & 1:30 Tu-Sa **Closed:** Su, Mo, LEG/HOL! & AUG; call for information on some additional closures

Vol./Contr.: $5.00/person

&: Limited to first floor only ℗: Free parking

Group Tours: 202-338-3552 Sculpture Garden

Permanent Collection: EU: ptgs, sculp 19,20; AM: ptgs, sculp 19,20; AF; P/COL

Designed by noted American architect Philip Johnson as a stunning private residence for David Lloyd and Carmen Kreeger, this home has now become a museum that holds the remarkable art collection of its former owners. With a main floor filled with Impressionist and post-Impressionist paintings and sculpture, and fine collections of African, contemporary, and Washington Color School art on the bottom level, this museum is a "must see" for art lovers traveling to the D.C. area. **PLEASE NOTE:** Only 35 people for each designated time slot are allowed on each 90 minute tour of this museum at the hours specified and only by reservation. Children under 12 are not permitted. **NOT TO BE MISSED:** Collection of 9 Monet Paintings.

National Gallery of Art

4th & Constitution Ave. NW, Washington, DC 20565

☎: 202-737-4215 ☑ www.nga.gov

Open: 10-5 Mo-Sa, 11-6 Su **Closed:** 1/1, 12/25

&: ℗: Limited metered street parking; free 3 hour mall parking as available. **Museum Shop** �11: 3 restaurants plus Espresso bar

Group Tours: 202-842-6247 **Docents** **Tour times:** daily!

Permanent Collection: EU: ptgs, sculp, dec/art 12-20: OM; AM: ptgs, sculp, gr 18-20; REN: sculp; OR: cer ☊

The two buildings that make up the National Gallery, one classical and the other ultra modern, are as extraordinary and diverse and the collection itself. Considered one of the premier museums in the world, more people pass through the portals of the National Gallery annually than almost any other museum in the country. Self-guided family tour brochures of the permanent collection as well as walking tour brochures for adults are available for use in the museum. In addition, advance reservations may be made for tours given in a wide variety of foreign languages. **NOT TO BE MISSED:** The only Leonardo Da Vinci oil painting in an American museum collection.

DISTRICT OF COLUMBIA

National Gallery of Art - continued

ON EXHIBIT 2001

09/17/2000 to 02/19/2001 SMALL NORTHERN EUROPEAN PORTRAITS FROM THE WALTERS ART GALLERY

10/01/2000 to 02/04/2001 ART FOR THE NATION: COLLECTING FOR A NEW CENTURY

10/08/2000 to 01/28/2001 ART NOUVEAU, 1890-1914

10/22/2000 to 02/25/2001 PRINTS ABOUND: PARIS IN THE 1890'S FROM THE COLLECTIONS OF VIRGINIA AND IRA JACKSON AND THE NATIONAL GALLERY OF ART

01/28/2001 to 04/22/2001 ALFRED STEIGLITZ AND MODERN ART IN AMERICA

05/06/2001 to 07/29/2001 CY TWOMBLY: THE SCULPTURE

06/03/2001 to 10/07/2001 THE UNFINISHED PRINT (working title)

09/30/2001 to 01/06/2002 VIRTUE AND BEAUTY: LEONARDO'S GINEVRA DI BENCI AND RENAISSANCE PORTRAITS OF WOMEN

10/07/2001 to 01/13/2002 AELBERT CUYP

10/21/2001 to 01/27/2002 HENRY MOORE

11/18/2001 to 04/07/2002 A CENTURY OF DRAWING (working title)

National Museum of African Art

Affiliate Institution: Smithsonian Institution
950 Independence Ave. SW, Washington, DC 20560
✆: 202-357-4600 **◎** www.si.edu/nmafa
Open: 10-5:30 Daily **Closed:** 12/25
♿: **Ⓟ:** Free 3 hour parking along the Mall **Museum Shop Docents**
Permanent Collection: AF/ART

Opened in 1987, The National Museum of African Art is dedicated to the collection, exhibition, conservation and study of the arts of Africa.

National Museum of Women in the Arts

1250 New York Ave. NW, Washington, DC 20005
✆: 202-783-5000 **◎** www.nmna.org
Open: 10-5 Mo-Sa, 12-5 Su **Closed:** 1/1, THGV, 12/25
ADM: Adult: $3.00 **Children:** Free **Students:** $2.00 **Seniors:** $2.00
♿ **Ⓟ:** Paid parking lots nearby **Museum Shop ╫:** Cafe 11:30-2:30 Mo-Fr
Group Tours: 202-783-7370 **Docents Tour times:** during open hours
Permanent Collection: PTGS, SCULP, GR, DRGS, 15-20; PHOT

Unique is the word for this museum established in 1987 and located in a splendidly restored 1907 Classical Revival building. The approximately 2600 works in the permanent collection are the result of the personal vision and passion of its founder, Wilhelmina Holladay, to elevate and validate the works of women artists throughout the history of art. **NOT TO BE MISSED:** 18th C botanical drawings by Maria Sybilla Merian; Lavinia Fontana "Portrait of a Noblewoman" c 1580; Frida Kahlo's "Self Portrait" dedicated to Leon Trotsky 1937.

ON EXHIBIT 2001

11/16/2000 to 02/04/2001 JULIE TAYMOR: PLAYING WITH FIRE
Taymor's work has always been a mix of dance, music and puppetry. The designer of "The Lion King," this is the first museum retrospective devoted to her.

84

National Portrait Gallery
Affiliate Institution: Smithsonian Institution
F St. at 8th, NW, Washington, DC 20560-0213

℡: 202-357-2700 **◙** www.npg.si.edu
Open: 10-5:30 Daily **Closed:** CLOSED FOR MAJOR RENOVATION JANUARY 2000 WILL REOPEN 2003
&: Through garage entrance corner 9th & G ST. **℗:** Metered street parking; some commercial lots nearby
Museum Shop **❙❙:** 11-3:30
Group Tours: 202-357-2920 ex 1 **Docents** **Tour times:** inquire at information desk **Sculpture Garden**
Permanent Collection: AM: ptgs, sculp, drgs, photo

Housed in the Old Patent Office built in 1836, and used as a hospital during the Civil War, this museum allows the visitor to explore U.S. history as told through portraiture.

Four traveling exhibitions during the museum's closure including "Portraits of the Presidents," "Notable Americans from the National Portait Gallery," "Modern American Portrait Drawings," and "Women of our Time: Photographs from the National Gallery." **NOT TO BE MISSED:** Gilbert Stuart's portraits of George and Martha Washington; Self Portrait by John Singleton Copley.

Philips Collection
1600 21st St. NW, Washington, DC 20009-1090

℡: 202-387-2151 **◙** www.phillipscollection.org
Open: 10-5 Tu-Sa, 12-7 Su, 5-8:30 Th for "Artful Evenings," (12-5 Su Summer) **Closed:** Mo, 1/1, 7/4, THGV, 12/25
ADM: Adult: $7.50 **Children:** Free 18 & under **Students:** $4.00 **Seniors:** $4.00
& **℗:** Limited metered parking on street; commercial lots nearby **Museum Shop**
❙❙: Cafe 10:45-4:30 Mo-Sa; 12-4:30 Su
Group Tours: ext 247 **Docents** **Tour times:** 2:00 We & Sa
Permanent Collection: AM: ptgs, sculp 19-20; EU: ptgs, sculp, 19-20

Housed in the 1897 former residence of the Duncan Phillips family, the core collection represents the successful culmination of one man's magnificent obsession with collecting the art of his time. **PLEASE NOTE:** The museum fee applies to weekends only. Admission on weekdays is by contribution. Some special exhibitions may require an additional fee **NOT TO BE MISSED:** Renoir's "Luncheon of the Boating Party;" Sunday afternoon concerts that are free with the price of museum admission and are held Sept. through May at 5pm; "Artful Evenings" ($5.00 pp) for socializing, art appreciation, entertainment, drinks and refreshments.

ON EXHIBIT 2001
09/23/2000 to 01/21/2001 DEGAS TO MATISSE: MASTERWORKS FROM THE DETROIT INSTITUTE OF ARTS
Included are 57 works on paper, sculptures and paintings by Cezanne, Seurat, Matisse, Renoir, Degas, Picasso and Gauguin. Works from the Tannahill collection at Detroit and those in the Philips collection will be juxtaposed.

05/06/2001 to 08/19/2001 OVER THE LINE; THE ART AND LIFE OF JACOB LAWRENCE

09/22/2001 to 01/13/2002 IMPRESSIONIST AND POST IMPRESSIONIST STILL-LIFE PAINTING

DISTRICT OF COLUMBIA

Renwick Gallery of the Smithsonian American Art Museum
Affiliate Institution: Smithsonian Institution
Pennsylvania Ave. at 17th St. NW, Washington, DC 20560

☎: 202-357-2700 **◎** http://AmericanArt.si.edu
Open: 10-5:30 Daily **Closed:** 12/25
&: Ramp that leads to elevator at corner 17th & Pa. Ave. **ⓟ:** limited street parking, commercial lots and garages nearby
Museum Shop
Group Tours: 202-357-2531 (no **Group Tours** June-Oct) **Docents** **Tour times:** Available November-May only
Permanent Collection: CONT/AM: crafts; AM: ptgs

The Renwick Gallery of the National Museum of American Art, Smithsonian Institution, is dedicated to exhibiting American crafts of all historic periods and to collecting 20th century American crafts. The museum, which celebrated its 25th anniversary in 1997, rotates the display of objects from its permanent collection on a quarterly basis. It is housed in a charming French Second Empire style building across Pennsylvania Avenue from the White House that was designed in 1859 and named not for its founder, William Corcoran, but for its architect, James Renwick, Jr. **NOT TO BE MISSED:** Grand Salon furnished in styles of 1860's & 1870's.

ON EXHIBIT 2001
10/06/2000 to 01/21/2001 AMISH QUILTS FROM THE COLLECTION OF FAITH AND STEPHAN BROWN
Made from 1880's-1950 most of these come from Holmes County, Ohio, the largest Amish settlement in the Midwest. The Amish had no use for art; beauty was dependent on function.

10/06/2000 to 01/21/2001 SPIRITS OF THE CLOTH: CONTEMPORARY QUILTS BY AFRICAN AMERICAN ARTISTS
Vibrant and intricate fabric images of African dance and stories of creation to designs used to educate children in mathematics.

Sewall-Belmont House
144 Constitution Ave. NW, Washington, DC 20002

☎: 202-546-3989
Open: 10-3 Tu-Fr; Noon-4 Sa, Su **Closed:** Mo, 1/1, THGV, 12/25
Vol./Contr.: Yes
ⓟ: Limited street parking only **Docents** **Tour times:** 10-3 Tu-Fr; Noon-4 Sa, Su
Permanent Collection: SCULP, PTGS

Paintings and sculpture depicting heroines of the women's rights movement line the halls of the historic Sewall-Belmont House. One of the oldest houses on Capitol Hill, this unusual museum is a dedicated to the theme of women's suffrage.

Smithsonian American Art Museum
8th & G Sts. N.W., Washington, DC 20560

☎: 202-357-2700 **◎** http://AmericanArt.si.edu
Closed: 12/25
& **ⓟ:** Metered street parking with commercial lot nearby **Museum Shop**
Group Tours: 202-357-3095 **Docents** **Tour times:** weekdays at Noon & 2
Permanent Collection: AM: ptgs, sculp, gr, cont/phot, drgs, folk, Impr; AF/AM

The National Museum of American Art of the Smithsonian Institution, the first federal art collection, represents all regions, cultures and traditions in the United States. Today the collection contains over 38,000 works in all media, spanning more than 300 years of artistic achievement. The Old Patent Office Building, which houses the Smithsonian American Art Museum and the National Portrait Gallery, was built in the Greek Revival Style between 1836 and 1867 and is considered one of the finest neoclassical structures in the world. **NOT TO BE MISSED:** both on view in the Renwick Gallery: George Catlin's 19th C American-Indian paintings; on view at A Aldridge Folk art center in Williamsburg, VA: Thomas Moran's Western Landscape paintings; James Hampton's "The Throne of the Third Heaven of the Nation's Millennium General Assembly."

BOCA RATON

Boca Raton Museum of Art

801 W. Palmetto Park Rd., Boca Raton, FL 33486

☎: 561-392-2500
Open: 10-4 Tu, Th, Fr; 12-4 Sa, Su; till 9pm We **Closed:** Mo, LEG/HOL!
Sugg./Contr.: ADM: Adult: $3.00 Children: Free under 12 **Students:** $1.00 **Seniors:** $2.00
& **Ⓟ:** Free **Museum Shop**
Group Tours: 561-392-2500 **Docents Tour times:** daily! **Sculpture Garden**
Permanent Collection: PHOT; PTGS 20

An AAM accredited institution, the Museum boasts over 3000 works of art of the highest quality and distinction, including a superb assembly of modern masters Braque, Demuth, Glackens, Matisse and Picasso, to name but a few. Recent donations include superb photography from the 19th century to present, African and Pre-Columbian art and a broad range of contemporary sculpture portraying a variety of styles and media.

International Museum of Cartoon Art

201 Plaza Real, Boca Raton, FL 33432

☎: 561-391-2200 ◘ www.cartoon.org
Open: 10-6 Tu-Sa, 12-6 Su **Closed:** varies
ADM: Adult: $6.00 **Children:** 6-12 $3; Free under 5 **Students:** $4.00 **Seniors:** $5.00
& **Ⓟ:** Parking throughout Mizner Park in which the museum is located **Museum Shop** ⅋: Cafe
Group Tours: ext 118 **Sculpture Garden**
Permanent Collection: CART

Started by Mort Walker, creator of the "Beetle Bailey" cartoon comic, and relocated to Florida after 20 years of operation in metropolitan NY, this museum, with over 160,000 works on paper, 10,000 books, 1,000 hours of animated film, and numerous collectibles & memorabilia, is dedicated to the collection, preservation, exhibition and interpretation of an international collection of original works of cartoon art. **PLEASE NOTE:** On the many family weekends planned by the museum, event hours are 10-5 Sa, and 12-5 Su with admission at $4.00 per person. Call for information and schedule of programs.

ON EXHIBIT 2001

11/11/2000 to 02/25/2001 THE LEGACY OF MORT WALKER: 50 YEARS OF BEETLE BAILEY
This retrospective will focus on the pivotal themes in museum founder Mort Walker's work, tracing the evolution of the strip and its interpretation of American life and culture, as well as examining Walker's tremendous impact on cartoon art as a whole.

THE LEGACY OF MORT WALKER FAMILY DAYS: 01/13/2001 Major Laughs & General Fun 02/10/2001 From the Heart of Camp Swampy

CORAL GABLES

Lowe Art Museum

Affiliate Institution: University of Miami
1301 Stanford Dr., Coral Gables, FL 33124-6310

☎: 305-284-3535 ◘ www.lowemuseum.org
Open: 10-5 Tu, We, Fr, Sa; 12-7 Th; 12-5 Su **Closed:** Mo, 1/1, THGV, 12/25
Free Day: 1st Tu of month **ADM: Adult:** $5.00 **Children:** Free under 12 **Students:** $3.00 **Seniors:** $3.00
& Ⓟ **Museum Shop**
Group Tours: 305-284-3621 **Docents Tour times:** by appt **Sculpture Garden**
Permanent Collection: REN & BAROQUE: ptgs, sculp (Kress Collection); AN/R; SP/OM; P/COL; EU: art; AS: ptgs, sculp, gr, cer; AM: ptgs, gr; LAT/AM; NAT/AM; AF

FLORIDA

Lowe Art Museum - continued

Established in 1950, the Lowe recently underwent a multi-million dollar expansion and renovation. Its superb and diverse permanent collection is recognized as one of the major fine art resources in Florida. More than 10,000 works from a wide array of historical styles and periods including the Kress Collection of Italian Renaissance and Baroque Art, 17th-20th century European and American art, Greco-Roman antiquities, Asian, African, pre-Columbian and Native American art. **NOT TO BE MISSED:** Kress Collection of Italian Renaissance and Baroque art.

ON EXHIBIT 2001

12/06/2000 to 02/11/2001 JULIAN STANCZAK RETROSPECTIVE
This show examines the artist's contribution to the development of post-war American painting as it relates to the "Op Art" movement.

DAYTONA BEACH

Museum of Arts and Sciences
1040 Museum Blvd., Daytona Beach, FL 32014
📞: 904-255-0285 🖸 www.moas.org
Open: 9-4 Tu-Fr, 12—5 Sa, Su **Closed:** Mo, LEG/HOL!
ADM: Adult: $5.00 **Children:** $2.00 **Students:** $1.00
♿ ℗: Free **Museum Shop**
Group Tours: 904-255-0285 ext.16 **Docents** **Tour times:** daily 904-255-0285 ext. 22 **Sculpture Garden**
Permanent Collection: REG: ptgs, gr, phot; AF; P/COL; EU: 19; AM: 18-20; FOLK; CUBAN: ptgs 18-20; OR; AM: dec/art, ptgs, sculp 17-20

The Museum of Arts and Sciences recently added a wing designed to add thousands of square feet of new gallery space. A plus for visitors is the lovely nature drive through Tuscawillgo Park leading up to the museum. **NOT TO BE MISSED:** The Dow Gallery of American Art, a collection of more than 200 paintings, sculptures, furniture, and decorative arts (1640-1910).

Southeast Museum of Photography
Affiliate Institution: Daytona Beach Community College
1200 West International Speedway Blvd., Daytona Beach, FL 32120-2811
📞: 904-254-4475 🖸 www.dbcc.cc.fl.us/dbcc/htm/smp/smphome.htm
Open: Mo, We-Fr 9:30-4:30, Tu 9:30-7, Sa & Su 12-4 **Closed:** LEG/HOL!
♿ ℗: On college campus **Museum Shop**
Group Tours: 904-947-5469 **Docents** **Tour times:** 20 minute "Art for Lunch" tours!

Thousands of photographs from the earliest daguerrotypes to the latest experiments in computer assisted manipulation are housed in this modern 2 floor gallery space opened in 1992. Examples of nearly every photographic process in the medium's 150 year old history are represented in this collection. Changing exhibitions of contemporary and historical photographs. **NOT TO BE MISSED:** Kidspace, a Saturday afternoon program for children and parents where many aspects of the photographic process can be experienced.

DELAND

DeLand Museum of Art
600 N. Woodland Blvd., DeLand, FL 32720-3447
☎: 904-734-4371
Open: 10-4 Tu-Sa, 1-4 Su **Closed:** Mo, LEG/HOL!
ADM: Adult: $2.00 **Children:** under 12 free
♿: Fully handicapped accessible **Ⓟ:** Free and ample **Museum Shop** **Docents**
Permanent Collection: AM: 19-20; CONT: reg; DEC/ART; NAT/AM

The DeLand, opened in the New Cultural Arts Center in 1991, is located between Daytona Beach and Orlando. It is a fast growing, vital institution that offers a wide range of art and art-related activities to the community and its visitors. **PLEASE NOTE:** The permanent collection is not usually on display.

ON EXHIBIT 2001
12/29/2000 to 02/25/2001 LOOKING BACK/MOVING FORWARD
Group retrospective of images marking a collective moment in time as we pass from one century into the next.

12/29/2000 to 02/25/2001 SOUTHERNMOST ART & LITERARY PORTRAITS

03/02/2001 to 06/10/2001 4TH FLORIDA CRAFTSMEN EXHIBITION

03/30/2001 to 06/10/2001 NOTHINGS CARVED IN STONE

06/15/2001 to 08/05/2001 DELAND THEN AND NOW

06/15/2001 to 08/05/2001 FOLK ART: OUTSIDE THE MENNELLO

FT. LAUDERDALE

Museum of Art, Fort Lauderdale
1 E. Las Olas Blvd., Ft. Lauderdale, FL 33301-1807
☎: 954-525-5500 **◉** www.MUSEUMOFART.org
Open: 10-5 Tu-Sa, Noon-5 Su **Closed:** Mo, LEG/HOL!
ADM: Adult: $10.00 **Children:** 5-18 $2.00, Free under 5 **Students:** $6.00 **Seniors:** $8.00 (also includes groups)
♿: Parking area & ramp near front door; wheelchairs available **Ⓟ:** Metered parking ($.75 per hour) at the Municipal Parking facility on S.E. 1st Ave. bordering the museum on the East side. **Museum Shop** **⊪**: Moa Café
Group Tours: ex 239/241 **Docents** **Tour times:** 1:00 Tu, Th, Fr (Free with admission) **Sculpture Garden**
Permanent Collection: AM: gr, ptgs, sculp 19-20; EU: gr, ptgs, sculp 19-20; P/COL; AF; OC; NAT/AM

Aside from an impressive permanent collection of 20th-century European and American art, this museum is home to the William Glackens collection, the most comprehensive collection of works by the artist and others of his contemporaries who, as a group, are best known as "The Eight" and/or the Ashcan School. It also is home to the largest collection of CoBrA art in the U.S. **NOT TO BE MISSED:** The William Glackens Collection and the Palace of Gold & Light: Treasures from the Topicapi Istanbul — through Feb. 2001.

ON EXHIBIT 2001
12/15/2000 to 03/20/2001 PUBLIKULTURE

12/15/2000 to 02/04/2001 JAKE FERNANDEZ

FLORIDA

Samuel P. Harn Museum of Art

Affiliate Institution: Univ. of Florida
SW 34th St. & Hull Rd., Gainesville, FL 32611-2700
☎: 352-392-9826 ◙ www.arts.ufl.edu/harn
Open: 11-5 Tu-Fr, 10-5 Sa, 1-5 Su **Closed:** Mo, LEG/HOL
Vol./Contr.: Yes
& ℗ **Museum Shop**
Docents Tour times: 2:00 Sa, Su; 12:30 We; Family tours 2nd S of mo.
Permanent Collection: AM: ptgs, gr, sculp; EU: ptgs, gr, sculp; P/COL; AF; OC; IND: ptgs, sculp; JAP: gr ; CONT

The Samuel P. Harn Museum of Art provides the most advanced facilities for the exhibition, study and preservation of works of art. The Harn offers approximately 15 changing exhibitions per year. The museum's collection includes the arts of the Americas, Africa, Asia as well as contemporary international works of art. Exciting performance art, lectures and films are also featured. **NOT TO BE MISSED:** Approximately 15 changing exhibitions per year: the new art Bishop study center and library & related video, & CD-ROM resource center of the permanent collection.

Cummer Museum of Art & Gardens

829 Riverside Ave., Jacksonville, FL 32204
☎: 904-356-6857 ◙ www.cummer.org
Open: 10-9 Tu & Th; 10-5 We, Fr, Sa; 12-5 Su **Closed:** Mo, 1/1, EASTER, 7/4, THGV, 12/25
ADM: Adult: $6.00 **Children:** $1.00 (5 & under) **Students:** $3.00 **Seniors:** $4.00
&: Ramps, restrooms, etc. ℗: Opposite museum at 829 Riverside Ave. **Museum Shop**
Group Tours: 904-356-6857 **Docents Tour times:** 10-3 Tu-Fr (by appt); 3 S (w/o appt); 7 Th **Sculpture Garden**
Permanent Collection: AM: ptgs; EU: ptgs; OR; sculp; CER; DEC/ART; AN/GRK; AN/R; P/COL; IT/REN

The Cummer Museum of Art & Gardens is located on the picturesque bank of the St. Johns River. Adjacent to the river are two-and-one-half acres of formal gardens. The museum's permanent collection ranges in date from 2,000 BC to the present, with particular strength in 18th and 19th-century American and European paintings. The Wark collection of 18th-century Meissen porcelain is one of the two finest collections in the world. Art Connections, a nationally-acclaimed interactive education center, also schedules an impressive array of activities for children through adults. **NOT TO BE MISSED:** One of the earliest and rarest collections of Early Meissen Porcelain in the world

Jacksonville Museum of Contemporary Art

4160 Boulevard Center Dr., Jacksonville, FL 32207
☎: 904-398-8336
Open: 10-4 Tu, We, Fr; 10-10 Th; 1-5 Sa, Su **Closed:** Mo, LEG/HOL!
& ℗: Free and ample **Museum Shop Sculpture Garden**
Permanent Collection: CONT; P/COL

The finest art from classic to contemporary is offered in the Jacksonville Museum, the oldest museum in the city. **PLEASE NOTE:** There is a nominal admission fee for non-museum member visitors. **NOT TO BE MISSED:** Collection of Pre-Columbian art on permanent display

Hibel Museum of Art

5353 Parkside Drive, Jupiter, FL 33458
℡: 1-800-771-3362 ◙ www.hibel.org
Open: 10-5 Tu-Sa, 1-5 Su **Closed:** Mo, 1/1, 7/4, THGV, 12/25
& ℗: Free **Museum Shop**
Group Tours: 1-800-771-3362 **Docents** **Tour times:** Upon request if available **Sculpture Garden**
Permanent Collection: EDNA HIBEL: all media

The 25 year old Hibel Museum is the world's only publicly owned nonprofit museum dedicated to the art of a single living American woman. Hibel's Renaissance—and Impressionist-style paintings, drawings, sculptures, original graphics, and porcelain art have been exhibited over 60 years in more than 20 countries.

ON EXHIBIT 2001
09/2001 to 10/2001 THE EYE OF THE PAINTER

Polk Museum of Art

800 E. Palmetto St., Lakeland, FL 33801-5529
℡: 941-688-7743
Open: 9-5 Tu-Fr, 10-5 Sa, 1-5 Su **Closed:** Mo, LEG/HOL!
Vol./Contr.:$3.00 &: "Hands-On" for visually impaired ℗ **Museum Shop Sculpture Garden**
Permanent Collection: P/COL; REG; AS: cer, gr; EU: cer, glass, silver 15-19: AM: 20; PHOT

Located in central Florida about 35 miles east of Tampa, the 37,000 square foot Polk Museum of Art, built in 1988, offers a complete visual and educational experience to visitors and residents alike. The Pre-Columbian Gallery, with its slide presentation and hands-on display for the visually handicapped, is but one of the innovative aspects of this vital community museum and cultural center. **NOT TO BE MISSED:** "El Encuentro" by Gilberto Ruiz; Jaguar Effigy Vessel from the Nicoya Region of Costa Rica (middle polychrome period, circa A.D. 800-1200).

ON EXHIBIT 2001
11/11/2000 to 01/21/2001 CROSSING BOUNDARIES: CONTEMPORARY ART QUILTS
The Art Quilt Network is made up of American and Canadian quiltmakers. Membership is limited to 60. *Will Travel*

Gulf Coast Museum of Art

12211 Walsingham Road, Largo, FL 33778
℡: 727-518-6833 ◙ www.gulfcoastmuseum.org
Open: 10-4 Tu, We, Fr, & Sa; 10 - 7 Th; 12-4 Su **Closed:** Mo, LEG/HOL!
ADM: Adult: $3.00 **Children:** $1.00; 12 and under free **Students:** $2.00 **Seniors:** $2.00
& ℗: Free **Museum Shop**
Group Tours: by res **Docents** **Tour times:** call for information **Sculpture Garden**
Permanent Collection: CONT FLORIDA ART: 1960 - present; CONT/CRAFTS

Founded in 1936, the Gulf Coast Museum of Art is a collecting, exhibiting and teaching institution dedicated to the visual arts. Located in central Pinellas County in The Florida Botanical Gardens at Pinewood Cultural Park, the museum presents a diverse, and ever-changing exhibition schedule.

FLORIDA

Maitland Art Center

231 W. Packwood Ave., Maitland, FL 32751-5596

☎: 407-539-2181 ◙ www.maitartcenter.org
Open: 9-4:30 Mo-Fr; 12-4:30 Sa, Su **Closed:** LEG/HOL!
Vol./Contr.: Yes
& ℗: Across the street from the Art Center with additional parking just west of the Center **Museum Shop**
Docents Tour times: Upon request if available
Permanent Collection: REG: past & present

The stucco buildings of the Maitland Center are so highly decorated with murals, bas reliefs, and carvings done in the Aztec-Mayan motif, that they are a "must-see" work of art in themselves. One of the few surviving examples of "Fantastic" Architecture remaining in the southeastern U.S. the Center is listed in the N.R.H.P. **NOT TO BE MISSED:** Works of Jules Andre Smith (1890 - 1959), artist and founder of the art center.

ON EXHIBIT 2001

01/25/2001 to 02/25/2001 JULES ANDRE SMITH AND CENTRAL FLORIDA
The first of two exhibits of the works created by Andre Smith and and centered on the works created by Andre Smith and centered on the life in the 1940's that tied Eatonville and Maitland together as neighbors.

04/27/2001 to 07/08/2001 DOROTHY GILLESPIE
The personal collection of this national artist will be featured in the galleries—works by Oicassi, Rauschenberg, Hopper—while the Center's main garden will feature her outdoor sculptures.

07/16/2001 to 08/31/2001 FROM THE VAULT
Museums collect to preserve the cultural heritage.

09/07/2001 to 10/28/2001 THE PHOTOGRAPHY COLLECTION OF BILL LOVING

11/02/2001 to 12/23/2001 THE OISEAUX SISTERS
The Oseaux Sisters (french for birds) migrate seasonally from their New York studios to Gulfport, Fl. Their work incorporates humor, movement and metaphor in mixed media.

Museum of Art and Science/Brevard

1463 Highland Ave., Melbourne, FL 32935

☎: 407-242-0737 ◙ www.artandscience.org
Open: 10-5 Tu-Sa, 1-5 Su **Closed:** Mo, LEG/HOL!
Free Day: Th 1-5 **ADM: Adult:** $5.00 **Children:** $2.00 **Students:** $2.00 **Seniors:** $3.00
& ℗: Free in front of the museum **Museum Shop**
Group Tours: 407-254-7782 **Docents Tour times:** 2-4 Tu-Fr; 12:30-2:30 Sa; 1-5 Su
Permanent Collection: OR; REG: works on paper

Serving as an actively expanding artistic cultural center, the 20 year old Brevard Museum of Art and Science is located in the historic Old Eau Gallie district of Melbourne near the center of the state. The Children's Science Center features more than 35 hands on exhibits teaching concepts of physical science.

Lilia Fontana Miami-Dade Community College Kendall Campus Art Gallery

11011 Southwest 104th St., Miami, FL 33176-3393

☎: 305-237-2322 ◙ www.mdcc.edu
Open: 8-4 Mo, Th, Fr; 12-7:30 Tu, We **Closed:** Sa, Su, LEG/HOL!, ACAD!, first 3 weeks of Aug
♿ **Ⓟ:** Free in student lots **Ⅱ Docents**
Permanent Collection: CONT: ptgs, gr, sculp, phot; GR: 15-19

With over 750 works in its collection, the Kendall Campus Art Gallery is home to original prints by such renowned artists of the past as Whistler, Tissot, Ensor, Corot, Goya, in addition to those of a more contemporary ilk by Hockney, Dine, Lichtenstein, Warhol and others. **NOT TO BE MISSED:** "The Four Angels Holding The Wings," woodcut by Albrecht Durer, 1511.

ON EXHIBIT 2001

11/30/2000 to 01/25/2001 ART TRENDS: MIAMI'S TREK II

05/10/2001 to 06/15/2001 BREAKING BOUNDARIES: 20 YEARS OF THE ATLANTIC CENTER FOR THE ARTS
The creative cross pollination of the Atlantic Center at New Smyrna Beach, Florida. The work of writers, dancers, composers and painters demonstrates the magic of the creative process.

06/28/2001 to 07/27/2001 RAY AZCUY

Miami Art Museum

101 W. Flagler St., Miami, FL 33130

☎: 305-375-3000
Open: 10-5 Tu-Fr; till 9 third Th; 12-5 Sa, Su **Closed:** Mo, 1/1, THGV, 12/25
Free Day: 3rd Th of month 5-9; by contrib Tu **ADM: Adult:** $5.00 **Children:** Free under 12 **Students:** $2.50 **Seniors:** $2.50
♿**:** Elevator on N.W. 1st St. **Ⓟ:** Discounted rate of $2.40 with validated ticket at Cultural Center Garage, 50 NW 2nd Ave. **Museum Shop**
Group Tours: 305-375-4073 **Docents Tour times:** by res **Sculpture Garden**
Permanent Collection: In October 1996 MAM's first 14 gifts of art were unveiled. Since then, the permanent collection has grown to include almost 100 objects, reflecting the museum's commitment to international art with specific emphasis on art of the western hemisphere from the 1940's to the present. The collection, valued in excess of $4.5 million, includes paintings, sculptures, works on paper, and photographs, and mixed-media pieces. Artists in the collection include Jose Bedia, Gene Davis, Jean Dubuffet, Edouard Duval-Carrie, Helen Frankenthaler, Adolph Gottlieb, Ann Hamilton, Alfredo Jaar, Ana Mendieta, Robert Rauschenberg, Gerhard Richter, James Rosenquist, Susan Rothenberg, Lorna Simpson, and Frank Stella.

MAM exhibits, and collects, preserves and interprets international art, with an emphasis on art of the western hemisphere. The focus is on works from the 1940's to the present complemented by art from other eras for historical perspective.

Bass Museum of Art

2121 Park Ave., Miami Beach, FL 33139

☎: 305-673-7530 ◙ ttp://ci.miami-beach.fl.us/culture/bass/bass/html
Open: 10-5 Tu-Sa, 1-5 Su, 1-9 2nd & 4th We of the month **Closed:** Mo LEG/HOL!
ADM: Adult: $5.00 **Children:** Free under 6 **Students:** $3.00 **Seniors:** $3.00
♿ **Ⓟ:** On-site metered parking and street metered parking **Museum Shop Sculpture Garden**
Permanent Collection: PTGS, SCULP, GR 19-20; REN: ptgs, sculp; MED: sculp, ptgs; PHOT; OR: bronzes

Bass Museum of Art - continued

Just one block from the beach in Miami, in the middle of a 9 acre park, is one of the great cultural treasures of Florida. Located in a stunning 1930 Art Deco building, the Museum is home to more than 6 centuries of artworks including a superb 500 piece collection of European art donated by the Bass family for whom the museum is named.

Expansion and renovation plans are underway which will result in the addition of state-of-the-art gallery space, a cafe and new Museum Shop. **PLEASE NOTE:** On occasion there are additional admission fees for some special exhibitions. **NOT TO BE MISSED:** "Samson Fighting the Lion," woodcut by Albrecht Durer

Wolfsonian/Florida International University

1001 Washington Ave., Miami Beach, FL 33139
☎: 305-531-1001 ◘ www.wolfsonian.org
Open: 10-6 Mo, Tu, Fr, Sa; 10-9 Th; 12-5 Su **Closed:** We
ADM: Adult: $5.00 **Children:** Free under 6 **Students:** $3.50 **Seniors:** $3.50
& ℗: Metered street parking, valet parking at the Hotel Astor (opposite the museum at 956 Washington Ave), and 3 near-by Municipal lots **Museum Shop**
Permanent Collection: AM & EU: furn, glass, cer, metalwork, books, ptgs, sculp, works on paper, & industrial design 1885-1945

Recently opened, The Wolfsonian, which contains the 70,000 object Mitchell Wolfson, Jr. collection of American and European art and design dating from 1885-1945, was established to demonstrate how art and design are used in cultural, social and political contexts. It is interesting to note that the museum is located in the heart of the lively newly redeveloped South Beach area.

ON EXHIBIT 2001

09/27/2000 to 04/15/2001 PRINT, POWER AND PERSUASION: GRAPHIC DESIGN IN GERMANY 1890-1945
Before about 1890, graphic design as a profession did not exist. It was in German-speaking countries in Central Europe that innovations in printing and typecasting opened up whole new avenues — and careers — in the design of posters, magazines and advertising.

11/15/2000 to 04/01/2001 DREAMS AND DISILLUSION: KAREL TIEGE AND THE CZECH AVANT-GARDE
A graphic designer and architectural theorist, Karel Tiege was an innovator in many artistic areas, including book design, poetry, stage sets and collage.

12/15/2001 to 04/07/2002 ALUMINUM BY DESIGN

NAPLES

Philharmonic Center for the Arts

5833 Pelican Bay Blvd., Naples, FL 34108
☎: 941-597-1900 ◘ www.naplesphilcenter.org
Open: OCT-MAY: 10-4 Mo-Fr, (10-4 Sa theater schedule permitting) **Closed:** Su Sa, LEG/HOL!
Free Day: call for schedule **ADM: Adult:** $4.00 **Children:**$2.00 **Students:** $2.00
& ℗: Free **Museum Shop**
Group Tours: ex 279 **Docents** **Tour times:** OCT & MAY: 11am Th & Sa; NOV-APR: 11am Mo thru Sa
Sculpture Garden

Four art galleries, two sculpture gardens, and spacious lobbies where sculpture is displayed are located within the confines of the beautiful Philharmonic Center. Museum quality temporary exhibitions are presented from October through May of each year. **PLEASE NOTE:** Free Family Days where gallery admissions and the 11am docent tour are offered free of charge are scheduled for the following Saturdays: 1/3, 2/7, 3/7, 4/4, 5/2, /16.

NORTH MIAMI

Joan Lehman Museum of Contemporary Art

770 NE 125th St., North Miami, FL 33161

☎: 305-893-6211 ◙ www.mocanomi.org
Open: 11-5 Tu-Sa; 12-5 Su; museum also 7-10pm last Fri of month during free Jazz at MOCA **Closed:** 1/1, THGV, 12/25
Free Day: Mem Day, Tu
ADM: Adult: $5.00 **Children:** Free under 12 **Students:** $3.00 **Seniors:** $3.00
& ℗: Free parking to the east, south and west of the museum. **Museum Shop**
Group Tours: by appt **Docents** **Tour times:** 2pm Sa & Su
Permanent Collection: CONT

In operation since 1981, the museum was, until now, a small but vital center for the contemporary arts. In 1996, the museum opened a new state-of-the-art building renamed The Joan Lehman Museum of Contemporary Art in honor if its great benefactor. Part of a new civic complex for North Miami, the museum provides an exciting and innovative facility for exhibitions, lectures, films and performances. **PLEASE NOTE:** Special language tours in Creole, French, German, Italian, Portuguese and Spanish are available by advance reservation. Among the artists in the permanent collection are John Baldesarri, Dan Flavin, Dennis Oppenheim, Alex Katz, Uta Barth, Teresita Fernandez, Garry Simmons, and Jose Bedia.

ON EXHIBIT 2001

12/15/2000 to 01/28/2001 TRAVELS IN HYPER-REALITY: MAKING ART IN MIAMI

02/11/2001 to 04/29/2001 MYTHIC PROPORTIONS: PAINTING IN TH EIGHTIES

03/03/2001 to 04/22/2001 PABLO CANO'S "TO SIN OR NOT TO SIN"
Marionette performance and exhibition.

05/12/2001 to 07/08/2001 THE UNCANNY
A fasinating exhibition features works that test the viewer's belief in what they see.

OCALA

Appleton Museum of Art

4333 NE Silver Springs Blvd., Ocala, FL 34470-5000

☎: 352-236-7100 ◙ www.fsu.edu/~svad/Appleton/AppletonMuseum.html
Open: 10-6pm Daily **Closed:** Mo, 1/1, Easter Su; 12/25
ADM: Adult: $6.00 **Children:** Free under 18 **Students:** $2.00 **Seniors:** $4.00
&: ℗: Free **Museum Shop**
Group Tours: 352-236-7100 x113 **Docents** **Tour times:** 1:15 Mo-Fr
Permanent Collection: EU; PR/COL; AF; OR; DEC/ART; ISLAMIC CERAMICS; ANTIQUITIES

The Appleton Museum of Art in central Florida is home to one of the finest art collections in the Southeast. Situated among acres of tall pines and magnolias, the dramatic building sets the tone for the many treasures that await the visitor within its walls. With the addition of The Edith-Marie Appleton Wing in 1/97, the museum became one of the largest art institutions in Florida. "From antiquities to the art of our times—A World of Art at your Doorstep." **NOT TO BE MISSED:** Rodin's "Thinker," Bouguereau's "The Young Shepherdess" and "The Knitter;" 8th-century Chinese T'ang Horse

FLORIDA

Appleton Museum of Art - continued

ON EXHIBIT 2001

11/18/2000 to 02/04/2001 DISTANT SHORES: THE ODYSSEY OF ROCKWELL KENT
The first major exhibition of his wilderness sojourns.

03/03/2001 to 04/22/2001 FLORIDA PHOTOGENESIS: THE WORKS OF EXPERIMENTAL PHOTOGRAPHERS
The history of a group of photographic artists who beginning in the 60's created an experimental aspect of the discipline.

03/03/2001 to 04/22/2001 IMAGES OF THE MICCOSUKEE
The 1930's photographs of Florence Stiles Randle and Phyllis Sheffield Schoenfeld.

03/03/2001 to 04/22/2001 LADIES, LANDSCAPES AND ROYAL RETAINERS: JAPANESE ART FROM A PRIVATE COLLECTION

ORLANDO

Orlando Museum of Art
2416 North Mills Ave., Orlando, FL 32803-1483
☎: 407-896-4231 **◙** www.OMArt.org
Open: 9-5 Mo-Sa, 12-5 Su **Closed:** Mo, LEG/HOL!
Free Day: Orange, Osceola and Seminole county residents are admitted free 12-5 Th **ADM: Adult:** $4.00
Children: $3.00 (4-11) **Students:** $4.00 **Seniors:** $4.00
& **Ⓟ:** Free on-site parking on campus in front of Museum. Overflow lot 1/8 mile away. **Museum Shop**
Group Tours: ex 248 **Docents** **Tour times:** 2:00, Th, Su
Permanent Collection: P/COL; AM; 19-20; AM gr 20; AF

Designated by the state of Florida as a "Major Cultural Institution" the Orlando Museum, established in 1924, recently completed its major expansion and construction project making it the only museum in the nine county area of central Florida capable of providing residents and tourists with world class exhibits. **NOT TO BE MISSED:** Permanent Collection of Art of the Ancient Americas (1200 BC to 1500 AD) complete with hands on exhibit.

ON EXHIBIT 2001

12/23/2000 to 02/25/2001 LATINO ART: TREASURES FROM THE SMITHSONIAN'S MUSEUM OF AMERICAN ART
The goal of the exhibition is to convey the wide range of artists of Latin Heritage living in the US from the 17th-20th C and their ability to convey the vitality of Latino artistic traditions and innovations. *Will Travel*

12/07/2001 to 03/03/2002 AMERICAN IMPRESSIONISTS ABROAD AND AT HOME
Thirty-nine works by 27 artists will illuminate the training that American Impressionists undertook abroad and at home; the complex attractions of Europe and America; the significance of the subjects they depicted and their various responses to French Impressionism.

PALM BEACH

Society of the Four Arts
Four Arts Plaza, Palm Beach, FL 33480
☎: 561-655-7226 ◙ www.fourarts.org
Open: 12/1-4/8: 10-5 Mo-Sa, 2-5 Su **Closed:** Museum closed May-Nov.
Sugg./Contr.: ADM: Adult: $3.00 ♿ **Ⓟ:** Free **Sculpture Garden**
Permanent Collection: SCULP

Rain or shine, this museum provides welcome relief from the elements for all vacationing art fanciers by presenting monthly exhibitions of paintings or decorative arts. **NOT TO BE MISSED:** Philip Hulitar Sculpture Garden and the Botanical Garden

ON EXHIBIT 2001
01/05/2001 to 02/04/2001 A PERSONAL GATHERING: PAINTINGS AND SCULPTURES FROM THE COLLECTION OF WILLIAM I. KOCH

02/16/2001 to 04/08/2001 REMINGTON, RUSSELL AND THE LANGUAGE OF WESTERN ART

PENSACOLA

Pensacola Museum of Art
407 S. Jefferson St., Pensacola, FL 32501
☎: 850-432-6247 ◙ www.artsnwfl.org/pma
Open: 10-5 Tu-Fr, 10-4 Sa **Closed:** Su, Mo, LEG/HOL!
Free Day: Tu **ADM: Adult:** $2.00 **Students:** $1.00 **Seniors:** $2.00
♿ **Ⓟ:** Free **Museum Shop**
Docents Tour times: check for availability
Permanent Collection: CONT/AM: ptgs, gr, works on paper; Glass:19,20

Now renovated and occupied by the Pensacola Museum of Art, this building was in active use as the city jail from 1906-1954.

SARASOTA

John and Mable Ringling Museum of Art
5401 Bay Shore Rd., Sarasota, FL 34243
☎: 941-359-5700 or 351-1660 (recording 24hr.) ◙ www.ringling.org
Open: 10-5:30 Daily **Closed:** 1/1, THGV, 12/25
ADM: Adult: $9.00 **Children:** Free 12 & under **Seniors:** $8.00
♿**:** All art & circus galleries; first floor only of mansion **Ⓟ:** Free **Museum Shop** ❙❙**:** Banyan Café 11-4 daily
Group Tours: 941-359-5725 **Docents Tour times:** call 941-351-1660 (recorded message) **Sculpture Garden**
Permanent Collection: AM: ptgs, scupl; EU: ptgs, sculp 15-20; DRGS; GR; DEC/ART; CIRCUS MEMORABILIA

Sharing the grounds of the museum is Ca'd'Zan, the winter mansion of circus impresario John Ringling and his wife Mable. Their personal collection of fine art in the museum features one of the country's premier collections of European, Old Master, and 17th century Italian Baroque paintings. Currently undergoing complete restoration to be completed in the fall of 2001. **NOT TO BE MISSED:** The Rubens Gallery - a splendid group of paintings by Peter Paul Rubens.

FLORIDA

Florida International Museum

100 Second St. North, St. Petersburg, FL 33701
☎: 727-822-3693 ◉ www.floridamuseum.org
Open: 9-6 Mo-Sa; 12-6 Su **Closed:** 1/1, THGV, 12/25
ADM: Adult: $13.95 **Children:** $5.95 **Students:** College Students $7.95 **Seniors:** $12.95
&: wheelchairs at no extra charge ℗: An abundance of nearby garage, street, and surface car parks. Museum parking garage **Museum Shop**
Group Tours: Call for reservations and information **Docents** **Tour times:** Mo-Su last tour at 4:30
Permanent Collection: Kennedy Galleries

The Florida International Museum is centered in the cultural heart of Tampa Bay-Downtown St. Petersburg. Opened in January 1995, it has been visited by over two million people in just five exhibitions, making it Florida's premier museum for blockbuster exhibitions. The museum was organized in 1992 for the purpose of creating a major international cultural center within a 300,000 square foot former department store building that has undergone a multi-million dollar renovation. The museum is a Smithsonian Institution affiliate and hosts temporary exhibits from the Smithsonian in addition to its permanent Kennedy Galleries.

Museum of Fine Arts

255 Beach Dr. N.E., St. Petersburg, FL 33701-3498
☎: 727-896-2667 ◉ www.fine-arts.org
Open: 10-5 Tu-Sa, 1-5 Su, till 9pm 3rd Th **Closed:** Mo, THGV, 12/25, 1/1
ADM: Adult: $6.00 ($4 for groups of 10 or more) **Children:** Free 6 & under **Students:** $2.00 **Seniors:** $5.00
& ℗: Free parking also available on Beach Dr. & Bayshore Dr. **Museum Shop**
Docents **Tour times:** 10 (seasonal), 11, 1, 2, 3 (seasonal) Tu-Fr; 11 to 2 hourly Sa; 1 & 2 Su **Sculpture Garden**
Permanent Collection: AM: ptgs, sculp, drgs, gr; EU: ptgs, sculp, drgs, gr; P/COL; DEC/ART;
P/COL; OR; STEUBEN GLASS; NAT/AM; AS: art; AF/ART

With the addition in 1989 of 10 new galleries, the Museum of Fine Arts, considered one of the premier museums in the southeast, is truly an elegant showcase for its many treasures that run the gamut from Dutch and Old Master paintings to one of the finest collections of photography in the state. **PLEASE NOTE:** Spanish, Italian, German, Croatian, and French language tours are available by advance appointment. **NOT TO BE MISSED:** Paintings by Monet, Gauguin, Cezanne, Morisot, Renoir, and O'Keeffe, Pre-Columbian Collection, Steuben Glass.

ON EXHIBIT 2001

11/12/2000 to 01/14/2001 AMERICAN ART FROM THE JOHN WILLIAM AND DELORES G. BECK COLLECTION
Private Florida collection that centers on mid-nineteenth to early twentieth-century American art.

01/28/2001 to 04/08/2001 ABRAHAM BLOEMART (1566-1651) AND HIS TIME

10/14/2001 to 01/06/2002 AMERICANOS; PORTRAITS OF THE LATINO COMMUNITY IN THE UNITED STATES

Salvador Dali Museum

1000 Third St. South, St. Petersburg, FL 33701
☎: 727-823-3767 ◉ www.Salvadordalimuseum.com
Open: 9:30-5:30 Mo-Sa, 12-5:30 Su; 9:30-8:00 Th **Closed:** THGV, 12/25
ADM: Adult: $9.00 **Children:** Free 10 & under **Students:** $7.00 **Seniors:** $7.00
& ℗: Free **Museum Shop**
Group Tours: tours 9:30-3:30 Mo-Sa **Docents** **Tour times:** ! Call for daily schedule
Permanent Collection: SALVADOR DALI: ptgs, sculp, drgs, gr

Salvador Dali Museum- continued

Unquestionably an extensive and comprehensive collection of Salvador Dali's works, the museum holdings amassed by Dali's friends A. Reynolds and Eleanor Morse include 95 original oils, 100 watercolors and drawings, 1,300 graphics, sculpture, and other objects d'art that span his entire career. **NOT TO BE MISSED:** Outstanding docent tours that are offered many times daily.

ON EXHIBIT 2001

09/23/2000 to 04/15/2001 ALL DALI (working title)
The permanent collection on display throughout the entire museum.

04/28/2001 to 09/09/2001 A DISARMING BEAUTY: THE VENUS DE MILO IN TWENTIETH CENTURY ART
Exhbit exploring the ways in which Surrealist artists initiated the practice of using the Venus de Milo in their work as an iconic and thematic presence.

TALLAHASSEE

Florida State University Museum of Fine Arts

Fine Arts Bldg. Copeland & W. Tenn. Sts., Tallahassee, FL 32306-1140
☎: 850-644-6836 ◘ www.fsu.edu/~svad/FSUMuseum/FSU-Museum.html
Open: 10-4 Mo-Fr; 1-4 Sa, Su (closed weekends during Summer Semester) **Closed:** LEG/HOL! Acad!
& **℗:** Metered parking in front of the building with weekend parking available in the lot next to the museum.
Group Tours: 850-644-1299 **Docents** **Tour times:** Upon request if available
Permanent Collection: EU; OR; CONT; PHOT; GR; P/COL: Peruvian artifacts; JAP: gr

With 7 gallery spaces, this is the largest art museum within 2 hours driving distance of Tallahassee. **NOT TO BE MISSED:** Works by Judy Chicago.

Lemoyne Art Foundation, Inc.

125 N. Gadsden, Tallahassee, FL 32301
☎: 850-222-8800 ◘ www.lemoyne.org
Open: 10-5 Tu-Sa, 1-5 Su **Closed:** Mo, Major Holidays!
Vol./Contr.:$1.00 **Children:** Free 12 & under
& **℗:** parking lot adjacent to the Helen Lind Garden and Sculptures; also, large lot across street available weekends and evenings **Museum Shop**
Group Tours: 850-222-8800 **Docents** **Tour times:** daily when requested **Sculpture Garden**
Permanent Collection: CONT/ART; sculp

Located in an 1852 structure in the heart of Tallahassee's historic district, the Lemoyne is named for the first artist known to have visited North America. Aside from offering a wide range of changing exhibitions annually, the museum provides the visitor with a sculpture garden that serves as a setting for beauty and quiet contemplation. **NOT TO BE MISSED:** Three recently acquired copper sculptures by George Frederick Holschuh.

ON EXHIBIT 2001

01/19/2001 to 02/25/2001 RETROSPECTIVE: LINDA VAN BECK
Acrylics and water media and George F. Holschuh Sculpture Collection.

03/02/2001 to 04/08/2001 FLORIDA OBSERVED: MESSAGES FROM THE LAND

05/25/2001 to 06/30/2001 BEYOND THE FRINGE

07/13/2001 to 08/24/2001 COSTUMES OF THE CARRIBEAN AND ART OF THE ISLANDS

09/07/2001 to 10/12/2001 RUTH DESHAISES RETROSPECTIVE

FLORIDA

Tampa Museum of Art

600 North Ashley Dr., Tampa, FL 33602
☎: 813-274-8130 ◙ www.tampamuseum.com
Open: 10-5 Tu-Sa, 10-8 Th, 1-5 Su **Closed:** 1/1, 7/4, 12/25
ADM: Adult: $5.00 **Children:** 6-18 $3.00; Free under 6 **Students:** $3.00 with I.D. **Seniors:** $4.00
&: Wheelchairs available, follow signs to handicapped entrance ℗: Covered parking under the museum for a nominal
hourly fee. Enter the garage from Ashley Dr. & Twiggs St. **Museum Shop** �𝄙: Within walking distance, 1-2 blocks
Group Tours: 813-274-8698 **Sculpture Garden**
Permanent Collection: PTGS: 19-20; GR: 19-20; AN/GRK; AN/R; PHOT

One of the Southeast's finest museums, there are changing exhibitions that range from contemporary to classic, and a renowned permanent collection of Greek and Roman antiquities. Compementing these exhibitions are a wide range of classes, lectures, lunchtime seminars and walking tours. The Guilders Museum Store offers unique gifts, books, jewelry and children's items. Tampa Museum of Art truly offers something for everyone. **NOT TO BE MISSED:** Joseph V. Noble Collection of Greek & Southern Italian antiquities on view in the Barbara & Costas Lemonopoulos Gallery.

ON EXHIBIT 2001

09/24/2000 to 01/14/2001 BOLDLY STATED!: CONTEMPORARY PAINTINGS FROM THE PERMANENT COLLECTION

12/05/2000 to 01/28/2001 TRANSATLANTIC DIALOGUE: CONTEMPORARY ART IN AND OUT OF AFRICA

12/09/2000 to 02/04/2001 BEST SHOTS: GREAT MOMENTS IN NFL PHOTOGRAPHY

01/28/2001 to 04/15/2001 THE NARRATIVE IN TAMPA MUSEUM OF ART COLLECTIONS

02/06/2001 to 04/22/2001 THE DEFINING MOMENT: VICTORIAN NARRATIVE PAINTINGS FROM THE FORBES COLLECTION
A specific moment rendered in paint, accompanied by an aptly selected title, can weave a sometimes complex narrative that does not have literary familiarity.

02/11/2001 to 04/15/2001 JAMES VANDERZEE: THE HARLEM YEARS
VanDerZee captured the Harlem Renaissance and explored the dramatic and social impact of the photographic medium.

Summer 2001, TBA! UNDERCURRENT/OVERVIEW 5

08/2001 to 11/2001 HIGHLIGHTS OF IBERIAN CULTURE: THE SHELBY WHITE AND LEON LEVY COLLECTION

09/16/2001 to 12/02/2001 CRAFT IS A VERB
A significant view of the development of contemporary craft since the 1950's. 104 examples showing the creative range.

USF Contemporary Art Museum

Affiliate Institution: College of Fine Arts
4202 E. Fowler Ave., Tampa, FL 33620
☎: 813-974-4133 ◙ www.usfeam.usf.edu
Open: 10-5 Mo-Fr, 1-4 Sa **Closed:** Su, STATE & LEG/HOL!
& ℗: parking pass available for puchase from museum security guard $2.00 daily **Museum Shop**
Permanent Collection: CONT: phot, gr

Located on the Tampa campus, the USF Contemporary Art Museum houses one of the largest selections of contemporary prints in the Southeast. **PLEASE NOTE:** The museum is occasionally closed between exhibitions!

USF Contemporary Art Museum- continued

ON EXHIBIT 2001

01/12/2001 to 01/27/2001 ABORIGINAL BARK PAINTINGS AND NATIVE AMERICAN BEADWORK

01/12/2001 to 01/27/2001 IONA FOLEY: DREAMTIME, OUR TIME: THE ETERNAL CIRCLE

02/09/2001 to 03/17/2001 WILLIAM WEGMAN

03/18/2001 to 07/14/2001 CONTEMPORARY ART FROM CUBA: IRONY AND SURVIVAL ON THE UTOPIAN ISLAND

VERO BEACH

Center for the Arts, Inc.
3001 Riverside Park Dr., Vero Beach, FL 32963-1807

℄: 561-231-0707 ◙ www.verocfta.org
Open: 10-4:30 Mo-Sa; 10-8 Th ; 1-4:30 Su **Closed:** Mo! 12/25
Sugg./Contr.: Yes
& ℗: Free **Museum Shop**
Group Tours: ex 117 **Docents** **Tour times:** 1:30-3:30 Sa, Su/ July-Oct; Wed-Su/ Nov-June **Sculpture Garden**
Permanent Collection: AM/ART 20

Considered the premier visual arts facility within a 160 mile radius on Florida's east coast, The Center, which offers national, international and regional art exhibitions throughout the year, maintains a leadership role in nurturing the cultural life of the region. **NOT TO BE MISSED:** "Transpassage T.L.S.," 20 ft. aluminum sculpture by Ralph F. Buckley, "American Eagle," Marshall M. Fredericks, 10 ft. bronze.

WEST PALM BEACH

Norton Museum of Art
1451 S. Olive Ave., West Palm Beach, FL 33401

℄: 561-832-5196 ◙ www.norton.org
Open: 10-5 Tu-Sa, 1-5 Su **Closed:** Mo, 1/1, MEM/DAY, 7/4, THGV, 12/25
Free Day: We 1:30-5 **ADM: Adult:** $6.00 **Children:** Free 12 & under **Students:** $2.00 (13-21)
& ℗: Free **Museum Shop** ‖: Open Seasonally 11:30-2:30 Mo-Sa & 1-3 Su
Group Tours: 561-659-6555 **Docents** **Tour times:** 12:30-1:30 weekdays, 2-3pm daily **Sculpture Garden**
Permanent Collection: American, Chinese, Contemporary, European, Old Masters, Photography

Started in 1940 with a core collection of French Impressionist and modern masterpieces, as well as fine works of American painting, the newly-renovated and expanded Norton's holdings also include major pieces of contemporary sculpture, and a noteworthy collection of Asian art. It is no wonder that the Norton enjoys the reputation of being one of the finest small museums in the United States. **PLEASE NOTE:** An admission fee may be charged for special exhibitions. **NOT TO BE MISSED:** Paul Manship's frieze across the main facade of the museum flanked by his sculptures of Diana and Actaeon.

ON EXHIBIT 2001

10/28/2000 to 01/07/2001 AMERICAN SPECTRUM: PAINTING AND SCULPTURE FROM THE SMITH COLLEGE MUSEUM OF ART

01/06/2001 to 03/11/2001 THE TRIUMPH OF FRENCH PAINTING

01/20/2001 to 02/11/2001 AMERICAN HOLLOW

Norton Museum of Art- continued

02/24/2001 to 04/29/2001 AN AMERICAN IN EUROPE: THE PHOTOGRAPHY COLLECTION OF BARONESS JEANE VON OPPENHEIM FROM THE NORTON MUSEUM OF ART

03/31/2001 to 06/03/2001 BURN: ARTISTS PLAY WITH FIRE

09/08/2001 to 11/04/2001 THE PHOTOGRAPHY OF ALFRED STEIGLITZ: GEORGIA O'KEEFFE'S ENDURING LEGACY

WINTER PARK

Charles Hosmer Morse Museum of American Art

445 Park Avenue North, Winter Park, FL 32789

(: 407-645-5311 **◙** www.morsemuseum.org
Open: 9:30-4 Tu-Sa, 1-4 Su **Closed:** Mo, 1/1, MEM/DAY, LAB/DAY, THGV, 12/25
Free Day: Open House Easter weekend, July 4th, Christmas Eve **ADM: Adult:** $3.00 **Children:** Free under 12
Students: $1.00 **⅘** **℗** **Museum Shop**
Docents **Tour times:** available during regular hours
Permanent Collection: Tiffany Glass; AM: ptgs (19 and early 20); AM: art pottery 19-20

Late 19th and early 20th century works of Louis Comfort Tiffany glass were rescued in 1957 from the ruins of Laurelton Hall, Tiffany's Long Island home, by Hugh and Jeannette McKean. These form the basis of the collection at this most unique little-known gem of a museum which has recently moved into new and larger quarters. Along with the Tiffany collection, the Museum houses a major collection of American art pottery, superb works by late 19th and early 20th century artists, including Martin Johnson Heade, Robert Henri, Maxfield Parrish, George Innis, and others. **NOT TO BE MISSED:** Tiffany chapel for the 1893 Chicago World's Columbian Exposition, opened in March 1999; the "Electrolier," elaborate 10' high chandelier, centerpiece of the Chapel; the Baptismal Font, also from the Chapel, which paved the way for Tiffany's leaded glass lamps; 2 marble, concrete and Favrile glass columns designed 100 years ago by Tiffany for his Long Island Mansion.

Cornell Fine Arts Museum

Affiliate Institution: Rollins College
1000 Holt Ave., Winter Park, FL 32789-4499

(: 407-646-2526 **◙** www.rollins.edu/cfam
Open: 10-5 Tu-Fr; 1-5 Sa, Su **Closed:** Mo, 1/1, THGV, 7/4, LAB/DAY, 12/25
Vol./Contr.: Yes
⅘ **℗:** parking in the adjacent lot **¶:** Café Cornell nearby in Social Science Bldg
Group Tours: 407-646-1536
Permanent Collection: EU: ptgs, Ren-20; SCULP; DEC/ART; AM: ptgs, sculp 19-20; PHOT; SP: Ren/sculp, pr Eu & AMo, dr; watch key coll

Considered one of the most outstanding museums in Florida, the Cornell, located on the campus of Rollins College, houses fine examples in many areas of art including American 19th C landscape painting, French portraiture, works of Renaissance and Baroque masters, and contemporary prints. **NOT TO BE MISSED:** Paintings from the Kress Collection; Cosimo Roselli, etc. "Christ with the Symbols of the Passion," by Lavinia Fontana, 1581.

Albany Museum of Art
311 Meadowlark Dr., Albany, GA 31707

(: 912-439-8400 **◉** www.albanymuseum.com
Open: 10-5 Tu-Sa, till 7pm Th; 1-4 Su **Closed:** Mo, LEG/HOL!
Sugg./Contr.: Yes
& ℗ **Museum Shop**
Group Tours: 912-439-8400 **Docents**
Permanent Collection: AM: all media 19- 20; EU: all media 19-20; AF: 19-20

The Albany Museum of art is a landmark in the southwestern Georgia cultural landscape. The AMA is the only institution accredited by the American Assocaition of Museums in a 100-mile radius, and houses one of the largest collections of sub-Saharan African art in the southeast. The American and European Art collection include painitngs by Edward Henry Potthast and Joseph Henry Sharp and 160 European drawings from the 18th and 17th centuries. A new children's wing houses AMAzing Space, a hands-on participatory gallery. **NOT TO BE MISSED:** A 1500 piece collection of African art that includes works from 18 different cultures, and a hands-on gallery for children.

ON EXHIBIT 2001
12/03/2000 to 02/04/2001 THE HUMAN FACTOR: FIGURATION IN AMERICAN ART, 1950-1995
Paintings, sculpture, prints and drawings from the collection of the Sheldon Memorial Art Gallery provides a mini survey of the of the aesthetics, issues and ideas in figurative works. Included are Alice Neel, George Segal and Robert Longo.
Will Travel

12/07/2000 to 02/04/2001 PASSION AND PRECISION: STEPHEN SCHATZ AND BRYAN HAYNES
Exibition of figurative works by two locals artists will complement "The Human Factor" exhibition.

03/01/2001 to 05/30/2001 THE WALTER O. EVANS COLLECTION OF AFRICAN AMERICAN ART
On display from this major Detroit collection will be important works from 19th century artists Edward Bannister and Henry Tanner through such modern masters as Elizabeth Catlett and Romare Bearden.

03/29/2001 to 09/02/2001 MANABONI: A RETROSPECTIVE
A retrospective of work by this Georgia bird artists.

06/07/2001 to 07/22/2001 PHOTOGRAPHS OF INDIA BY FRED ACQUILINO
For the past 14 years, this NY artist has been persuing a personal project of photographing India in black & white using large format equipment.

08/02/2001 to 10/03/2001 CROSSROADS QUILTERS
Hand-sewn quilts, vivid photographs, and interpretive text panels.

Georgia Museum of Art
Affiliate Institution: The University of Georgia
90 Carlton St., Athens, GA 30602-1719

(: 706-542-4662 **◉** www.uga.edu/gamuseum
Open: 10-5 Tu, Th, Fri, & Sa, 10-9 We, 1-5 Su **Closed:** Mo, LEG/HOL!
Sugg./Contr.: $1.00
& ℗ **Museum Shop** ⅞ On Display Cafe open 10-2:30 Mo-Fr
Group Tours: 706-542-1318 **Docents** **Tour times:** by appt.
Permanent Collection: AM: sculp, gr; EU: gr; JAP: gr; IT/REN: ptgs (Kress Collection); AM: ptgs 19-20

Georgia Museum of Art- continued

The Georgia Museum of Art, which moved to a new facility on Carlton St. on the east campus of the University of Georgia in September of '96, has grown from its modest beginnings, in 1945, of a 100 piece collection donated by Alfred Holbrook, to more than 7,000 works now included in its permanent holdings. **NOT TO BE MISSED:** Paintings from the permanent collection on view continually in the C.L. Morehead Jr. Wing.

ATLANTA

Atlanta International Museum at Peachtree Center

285 Peachtree Center Avenue, Atlanta, GA 30303
✆: 404-688-2467
Open: 11-5 Tu-Sa **Closed:** Su, Mo, LEG/HOL!
Free Day: We 1-5 **ADM: Adult:** $3.00 **Children:** $3.00 **Students:** $3.00 **Seniors:** $3.00
& ℗: pay in Baker Street Garage **Museum Shop** ⑪: In Marriott Hotel
Permanent Collection: International Focus of Art and Design

The Atlanta International Museum celebrates cultural diversity and minority pride.

Hammonds House Galleries and Resource Center

503 Peoples St., Atlanta, GA 31310-1815
✆: 404-752-8730
Open: 10-6 Tu-Fr; 1-5 Sa, Su **Closed:** Mo, LEG/HOL!
ADM: Adult: $2.00 **Children:** $1.00 **Students:** $1.00 **Seniors:** $1.00
&: wheelchair access from Oak St. ℗: Free **Museum Shop**
Docents **Tour times:** Upon request
Permanent Collection: AF/AM: mid 19-20; HAITIAN: ptgs; AF: sculp

As the only fine art museum in the Southeast dedicated to the promotion of art by peoples of African descent, Hammonds House features changing exhibitions of nationally known African-American artists. Works by Romare Bearden, Sam Gilliam, Benny Andrews, James Van Der Zee and others are included in the 125 piece collection. **NOT TO BE MISSED:** Romare Bearden Collection of post-60's serigraphs; Collection of Premeiro Contemporary Haitian Artists.

High Museum of Art

1280 Peachtree St. N.E., Atlanta, GA 30309
✆: 404-733-HIGH ◙ www.high.org
Open: 10-5 Tu-Th, 10-5 Sa; 12-5 Su; Fr extended hours, 10-9 **Closed:** Mo, 1/1, THGV, 12/25
ADM: Adult: $6.00 **Children:** $2.00 6-17; Free under 6 **Students:** $4.00 **Seniors:** $4.00
& ℗: Parking on deck of Woodruff Art Center Building on the side of the museum and neighborhood lots; some limited street parking **Museum Shop** ⑪: Mo 8:30-3; Tu-Fr 8:30-5, weekends 10-5
Group Tours: 404-733-4550 **Docents** **Tour times:** ! by appt
Permanent Collection: AM: dec/art 18-20; EU: cer 18; AM: ptgs, sculp 19; EU: ptgs, sculp, cer, gr, REN-20; PHOT 19-20 ; AM; cont (since 1970); self taught and folk

The beauty of the building, designed in 1987 by architect Richard Meier, is a perfect foil for the outstanding collection of art within the walls of the High Museum of Art itself. Part of the Robert W. Woodruff Art Center, this museum is a "must see" for every art lover who visits Atlanta. **PLEASE NOTE:** Admission, hours and Cafe hours vary with timed and dated tickets. **NOT TO BE MISSED:** The Virginia Carroll Crawford Collection of American Decorative Arts; The Frances and Emory Cocke Collection of English Ceramics; T. Marshall Hahn collection of Folk Art.

High Museum of Art - continued

ON EXHIBIT 2001

11/04/2000 to 01/28/2001 CHORUS OF LIGHT: PHOTOGRAPHS FROM THE SIR ELTON JOHN COLLECTION
At both the Midtown and Downtown galleries this distinguished collection is being shown for the first time. 380 photographs by all the renowned photographers including Cartier-Bresson, Avedon, Arbus, Evans, Kertesz, Modotti, Penn, Ray, Stieglitz, and Weston to name a few.

12/16/2000 to 06/24/2001 EMILE GALLE: GLASS FROM THE HIGH MUSEUM OF ART COLLECTION
A leading glass artist in the late 19th century influencing many including Tiffany. His brilliant colored, cut, engraved, enameled, mosaic and cameo glass will be shown.

02/24/2001 to 05/19/2001 Downtown THE ART OF WILLIAM EDMONDSON
His work will be shown alongside those of photographers Weston and Kanaga. His art is inspired by devout religion, his community, African American folklore and popular culture.

03/03/2001 to 05/27/2001 DEGAS AND AMERICA: THE EARLY COLLECTORS
Ballerinas before the dance, men racing on horseback and portraits of friends and fellow artists.

03/03/2001 to 09/27/2001 THE LENORE AND BURTON GOLD COLLECTION OF 20TH CENTURY ART (working title)
A diverse group of paintings, sculpture and works on paper.

04/07/2001 to 10/08/2001 Downtown PAINTINGS FROM THE AGE OF MICHELANGELO IN THE KRESS COLLECTION

05/12/2001 to 01/06/2002 Downtown NEW TREASURES, OLD FAVORITES: SELF TAUGHT ART AT THE HIGH
A companion exhibition to the "Let it Shine" featuring the growing folk art collection.

06/02/2001 to 09/08/2001 100 YEARS OF DIFFERENCE: THE HAMPTON PROJECT
An unusual and important historical documentary by Frances Benjamin Johnston and Carrie Mae Weems.

06/23/2001 to 09/02/2001 Midtown LET IT SHINE: SELF TAUGHT ART FROM THE T. MARSHALL HAHN COLLECTION
This collection is one of the best in the country of self taught artists in paintings, sculpture and drawing. The social and aesthetic history of southern self-taught art and the historical development of a Southern art will be studied.

06/30/2001 to 12/02/2001 Midtown BENTWOOD FURNITURE FROM THE HIGH MUSEUM OF ART COLLECTION
Examples of Austrian and German Bentwood furniture.

09/22/2001 to 01/26/2002 Downtown PICTURES TELL THE STORY: ERNEST C. WITHERS
Withers could be called the original photographer of the Civil Rights Movement. *Will Travel*

High Museum of Folk Art & Photography Galleries at Georgia-Pacific Center
133 Peachtree Street, Atlanta, GA 30303

☎: 404-577-6940 **◉** www.high.org
Open: 10-5 Mo-Sa **Closed:** Su, LEG/HOL!
& **℗:** Paid parking lot in the center itself with a bridge from the parking deck to the lobby; other paid parking lots nearby **Museum Shop**
Group Tours: 404-733-4550 **Docents Tour times:** call 404-733-4468
Permanent Collection: Occasional exhibits along with traveling exhibitions are drawn from permanent collection.

Folk art and photography are the main focus in the 4,500 square foot exhibition space of this Atlanta facility formally called The High Museum of Art at Georgia-Pacific Center.

GEORGIA

Michael C. Carlos Museum
Affiliate Institution: Emory University
571 South Kilgo St., Atlanta, GA 30322
☎: 404-727-4282 ◙ www.cc.emory.edu/CARLOS
Open: 10-5 Mo-Sa, Noon-5 Su **Closed:** 1/1, THGV, 12/25
Sugg./Contr.: ADM: Adult: $5.00
ᵫ ℗: Visitor parking for a small fee at the Boisfeuillet Jones Building; free parking on campus except in restricted areas. Handicapped parking Plaza level entrance on So. Kilgo St. **Museum Shop ⅼ:** Caffé Antico
Group Tours: 404-727-0519 **Docents Tour times:** 2:30 Sa, Su
Permanent Collection: AN/EGT; AN/GRK; AN/R; P/COL; AS; AF; OC; WORKS ON PAPER 14-20

Founded on the campus of Emory University in 1919 (making it the oldest art museum in Atlanta), this distinguished institution changed its name in 1991 to the Michael C. Carlos Museum in honor of its long time benefactor. Its dramatic 35,000 square foot building, opened in the spring of 1993, is a masterful addition to the original Beaux-Arts edifice. The museum recently acquired one of the largest (1,000 pieces) collections of sub-Saharan African art in America. **NOT TO BE MISSED:** Carlos Coll. of Ancient Greek Art; Thibadeau Coll. of pre-Columbian Art; recent acquisition of rare 4th c Volute-Krater by the Underworld painter of Apulia.

ON EXHIBIT 2001
to Summer 2001 MYSTERIES OF THE MUMMIES: THE ART AND ARCHEOLOGY OF DEATH IN ANCIENT EGYPT
An important acquisition of the Museum of sumptuously decorated coffins from the Niagara Falls Museum in Canada. Among the finest in Egypt.

through 10/2001 NOGUCHI BEGINNINGS
Sulptor Isamu Noguchi, son of a Japanese poet and an American writer was born in the U.S. but spent his chidhood in Japan.

01/13/2001 to 04/08/2001 A SEAL UPON THINE HEART: GLYPTIC ART OF THE ANCIENT NEAR EAST
Cylinder seals from Mesopotamia are featured.

Ogelthorpe University Museum
Affiliate Institution: Ogelthorpe University
4484 Peachtree Road, NE, Atlanta, GA 30319
☎: 404-364-8555 ◙ www.museum.oglethorpe.edu
Open: 12-5 We-Su **Closed:** Mo, Tu, LEG/HOL!
ᵫ ℗: Free **Museum Shop Group Tours:** 404-364-8552 **Docents**
Permanent Collection: Realistic figurative art, historical, metaphysical and international art

Established in 1993, this museum, dedicated to showing realistic art, has already instituted many "firsts" for this area including the opening of each new exhibition with a free public lecture, the creation of an artist-in-residence program, and a regular series of chamber music concerts. In addition, the museum is devoted to creating and sponsoring its own series of original and innovative special exhibitions instead of relying on traveling exhibitions from other sources. **NOT TO BE MISSED:** 14th century Kamakura Buddha from Japan.

AUGUSTA

Morris Museum of Art
One 10th Street, Augusta, GA 30901-1134
☎: 706-724-7501 ◙ www.themorris.org
Open: 10-5:30 Tu-Sa, 12:30-5:30 Su **Closed:** Mo, 1/1, THGV, 12/25
Free Day: Su **ADM: Adult:** $3.00 **Children:** Free under 6 **Students:** $2.00 **Seniors:** $2.00 Free with museum membership **ᵫ ℗:** Free marked spaces in West Lot; paid parking in city lot at adjacent hotel **Museum Shop**
Group Tours: 706-724-7501
Permanent Collection: REG: portraiture (antebellum to contemporary), still lifes, Impr, cont; AF/AM

Morris Museum of Art- continued

Rich Southern architecture and decorative appointments installed in a contemporary office building present a delightful surprise to the first time visitor. Included in this setting are masterworks from antebellum portraiture to vivid contemporary creations that represent a broad-based survey of 250 years of painting in the South. **NOT TO BE MISSED:** The Southern Landscape Gallery

ON EXHIBIT 2001

09/14/2000 to 01/03/2001 THE SPORTING VIEW
Paintings, drawings and illustrations dealing with the topics of hunting and fishing showcase the role of these sports in American art history. The works have been selected from the collection of 19th and 20th century sporting art assembled by Robert Mayo of Virginia.

11/26/2000 to 02/04/2001 THE PEOPLE'S CHOICE

01/11/2001 to 04/09/2001 KESLER WOODWARD, NORTH AND SOUTH
South Carolina native Kesler Woodward, who has spent more than 25 years as an artist and art professor in Alaska, showcases new work from both the Southeast and the far North.

04/26/2001 to 09/30/2001 RECONSTRUCTIONS: MODERNISM, PAINTING IN THE SOUTH, AND THEREAFTER
A major reinstallation of the museum's 20th century galleries examines the influences of modernism, the response of Southern artists to abstract expressionism, and late century narrative works in the magic realist vein.

10/11/2001 to 11/25/2001 LINE LANGUAGE: TWENTIETH CENTURY FIGURATIVE DRAWINGS FROM THE MINT MUSEUM OF ART COLLECTION
Artists consider drawing to be the most basic skill but also recognize it as a highly respected art form. This exhibition of some 75 works on paper offers a spectrum of figurative (human and animal) interpretations, including works by Chaim Gross, Elliot Daingerfield, Norman Rockwell, Isabel Bishop, Thomas Hart Benton and others.

12/07/2001 to 03/11/2002 IN MY TIME: THE PAINTINGS OF WEST FRASER
Scenes of Charleston and the low country, and other works by the South Carolina plein air artist.

COLUMBUS

Columbus Museum

1251 Wynnton Rd., Columbus, GA 31906
℃: 706-649-0713 ◉ www.columbusmuseum.com
Open: 10am-5pm Tues-Sa; 1-5pm Su; 10-8 Third Thur **Closed:** Mo, LEG/HOL!
Free Day: Th 5:30-8:30 **Vol./Contr.:** Yes
♿ ⓟ: $2.00 **Museum Shop** ⅼⅼ: The Place for Taste Café Tues-Fri 11:30am-2pm
Group Tours: 706-649-0713
Permanent Collection: PTGS; SCULP; GR 19-20; DEC/ART; REG; FOLK

The Columbus Museum is unique in the Southeast for its dual presentation of American art and regional history. The Museum features changing art exhibitions and two permanent galleries, Chattahoochee Legacy (the history of the Chattahoochee Valley) and Transformations (a hands-on children's discovery gallery). **NOT TO BE MISSED:** "Fergus, Boy in Blue" by Robert Henri; A hands-on discovery gallery for children.

ON EXHIBIT 2001

09/24/2000 to 09/23/2001 FDR IN GEORGIA: A PRESIDENT'S CHATTAHOOCHEE LEGACY

12/03/2000 to 02/25/2001 TREASURES FROM THE GEORGIA MUSEUM OF ART

01/14/2001 to 03/14/2001 GEORGE CRESS

04/01/2001 to 06/17/2001 CONTEMPORARY REPRESENTIONAL FIGURE PAINTING

GEORGIA

Columbus Museum- continued

04/21/2001 to 04/22/2001 OLD FRIENDS: DOCENT'S CHOICE

05/06/2001 to 08/12/2001 THE HUMAN CONDITION: RECENT WORK BY ART ROSENBAUM, GARY CHAPMAN, AND DALE KENNINGTON

07/08/2001 to 09/02/2001 THE GIST OF DRAWING: WORKS ON PAPER BY JOHN SLOAN

09/23/2001 to 01/06/2002 AN AMERICAN CENTURY OF PHOTOGRAPHY: FROM DRY PLATE TO DIGITAL— THE HALLMARK PHOTOGRAPHIC COLLECTION

10/2001 to 10/2002 NATIVE AMERICAN ART OF THE ANCIENT SOUTHEAST

SAVANNAH

Telfair Museum of Art

121 Barnard St., Savannah, GA 31401

☎: 912-232-1177
Open: 10-5 Tu-Sa, 1-5 Su **Closed:** Mo, LEG/HOL!
Free Day: Su **ADM: Adult:** $6.00 **Children:** $1.00 (6-12) **Students:** $2.00 **Seniors:** $5.00
占: Use President St. entrance **Ⓟ:** Metered street parking and 7 visitor spots **Museum Shop**
Docents **Tour times:** 2 pm daily
Permanent Collection: AM: Impr & Ashcan ptgs; AM: dec/art; BRIT: dec/art; FR: dec/art

Named for its founding family, and housed in a Regency mansion designed in 1818 by architect William Jay, this museum features traveling exhibitions from all over the world. The Telfair, which is the oldest public art museum in the Southeast, also has major works by many of the artists who have contributed so brilliantly to the history of American art. The Telfair will break ground in late 1999 for a new building on Telfair Square. **NOT TO BE MISSED:** American Impressionist collection; Original Duncan Phyfe furniture; casts of the Elgin Marbles.

ON EXHIBIT 2001

11/2000 to 01/2001 GEORGIA TRIENNIAL

Contemporary Museum

2411 Makiki Heights Drive, Honolulu, HI 96822
☏: 808-526-1322 ◉ www.tcmhi.org
Open: 10-4 Tu-Sa, Noon-4 Su **Closed:** Mo, LEG/HOL!
ADM: Adult: $5.00 **Children:** Free under 12 **Students:** $3.00 **Seniors:** $3.00
♿ ℗: Free but limited parking **Museum Shop** ❚❙: Cafe **Docents** **Tour times:** 1:30 Tu-Su **Sculpture Garden**
Permanent Collection: AM: cont; REG

Terraced gardens with stone benches overlooking exquisite vistas compliment this museum's structure which is situated in a perfect hillside setting. Inside are modernized galleries in which the permanent collection of art since 1940 is displayed. **PLEASE NOTE:** The museum's other gallery location where exhibitions are presented is: The Contemporary Museum at First Hawaiian Center, 999 Bishop St., Honolulu, HI 96813 (open 8:30-3 Mo-Tu, 8:30-6 Fr), which mainly features works by artists of Hawaii. **NOT TO BE MISSED:** David Hockney's permanent environmental installation "L'Enfant et les Sortileges" built for a Ravel opera stage set.

Honolulu Academy of Arts

900 S. Beretania St., Honolulu, HI 96814-1495
☏: 808-532-8700 ◉ www.honoluluacademy.org
Open: 10-4:30 Tu-Sa, 1-5 Su **Closed:** Mo, LEG/HOL!
Free Day: 1st We **Vol./Contr.: ADM: Adult:** $7.00 **Children:** Free under 12 **Students:** $4.00 **Seniors:** $4.00
♿: Ward Ave. gate (call 532-8759 to reserve handicap) ℗: Lot parking at the Academy Art Center for $1.00 with validation; some street parking also available **Museum Shop** ❚❙: 11:30-2:00 Tu-Sa (808-532-8734)
Group Tours: 808-532-3876 **Docents** **Tour times:** 11:00 Tu-Sa; 1:15 Su **Sculpture Garden**
Permanent Collection: OR: all media; AM: all media; EU: all media; HAWAIIANA COLLECTION

Thirty galleries grouped around a series of garden courts form the basis of Hawaii's only general art museum. This internationally respected institution, features extensive notable collections that span the history of art and come from nearly every corner of the world. **PLEASE NOTE:** Exhs. may be seen in the main museum and in the Museum's Academy Art Center, 1111 Victoria St. (808-532-8741). **NOT TO BE MISSED:** James A. Michener coll. of Japanese Ukiyo-e Woodblock prints; Kress Collection of Italian Renaissance Paintings.

ON EXHIBIT 2001

12/20/2000 to 02/18/2001 FAMILY TIES IN ASIAN TEXTILES: CHILDREN'S AND ADULT'S COSTUMES FROM CHINA AND JAPAN

01/31/2001 to 04/01/2001 SMITHING METALS - TRANSFORMING THE ORDINARY: FRANCES PICKENS

02/06/2001 to 06/22/2001 A SENSE OF PLACE: PHOTOGRAPHS BY ROWENA OTREMBA

02/27/2001 to 03/23/2001 DUNCAN DEMPSTER: RECENT WORKS

03/27/2001 to 04/17/2001 BEVERLY NOMURA: NEW WORKS

03/27/2001 to 04/27/2001 FIGURATIVELY SPEAKING: NEW WORKS BY KAY MURA, JODI ENDICOTT, ROCHELE LUM, VICKY CHOCK, EXTER SHIMAZU, JOHN HAMBLIN AND MICAHEL HARADA

05/2001 to 06/2001 BAMBOO MASTERWORKS: JAPANESE BASKETS FROM THE LLOYD COTSEN COLLECTION

06/19/2001 to 08/05/2001 ARTISTS OF HAWAI'I 2001

11/16/2001 to 01/06/2002 CHARLES BARTLET'S "The Hour of Prayer": A PORTFOLIO OF PROGRESSIVE PROOFS

IDAHO

Boise Art Museum

670 S. Julia Davis Dr., Boise, ID 83702

☎: 208-345-8330 ◙ www.boiseartrmuseum.org
Open: 10-5 Tu-Fr; 12-5 Sa, Su; Open 10-5 Mo JUNE thru AUG **Closed:** Mo, LEG/HOL!
ADM: Adult: $4.00 **Children:** $1.00 (grades 1-12) **Students:** $2.00 **Seniors:** $2.00
& ℗: Free **Museum Shop**
Docents **Tour times:** 12:15 Tu; 5:30pm third We **Sculpture Garden**
Permanent Collection: REG; GR; OR; AM

The Boise Art Museum, in its parkland setting, is the only art museum in the state of Idaho. New Permanent Collection galleries and an atrium sculpture court have recently been added to the museum. **NOT TO BE MISSED:** "Art in the Park," held every September, is one of the largest art and crafts festivals in the region.

ON EXHIBIT 2001
08/25/2000 to 10/28/2001 A CERAMIC CONTINUUM: FIFTY YEARS OF THE ARCHIE BRAY INFLUENCE
The contribution of the Archie Bray Foundation for Ceramic Art to its residency program and ceramic art showing 85 works.
Will Travel

CARBONDALE

University Museum
Affiliate Institution: Southern Illinois University at Carbondale
Carbondale, IL 62901-4508
☏: 618-453-5388 ◎ www.museum@siu.edu
Open: 9-3 Tu-Sa, 1:30-4:30 Su **Closed:** Mo, ACAD & LEG/HOL!
♿ ℗: Metered lot just East of the Student Center (next to the football stadium) **Museum Shop**
Docents Tour times: Upon request if available **Sculpture Garden**
Permanent Collection: AM: ptgs, drgs, gr; EU: ptgs, drgs, gr, 13-20; PHOT 20; SCULP 20; CER; OC; DEC/ART

Continually rotating exhibitions feature the fine and decorative arts as well as those based on science related themes of anthropology, geology, natural history, and archaeology. Also history exhibits. **NOT TO BE MISSED:** In the sculpture garden, two works by Ernest Trova, "AV-A-7 and AV-YELLOW LOZENGER," and a sculpture entitled "Starwalk" by Richard Hunt. New: Formal Japanese Garden.

ON EXHIBIT 2001
to 05/13/2001 PROCESSES OF ART II: FIBER, METAL, WOOD
Processes used to create fiber-weaving and handwork, metal-cast large and small works, and wood-carving and fabrication.

CHAMPAIGN

Krannert Art Museum
Affiliate Institution: University of Illinois
500 E. Peabody Dr., Champaign, IL 61820
☏: 217-333-1860 ◎ http://www.art.uiuc.edu/kam/
Open: 9-5 Tu-Fr, till 8pm We (SEPT-MAY), 10-5 Sa, 2-5 Su **Closed:** Mo, LEG/HOL!
Vol./Contr.: Yes
♿: Ramps, elevators ℗: On-street metered parking **Museum Shop** ⅼⅼ: Cafe/bookstore
Group Tours: 217-333-8642 Dorothy Fuller, Ed. Coord. **Docents Tour times:** !
Permanent Collection: P/COL; AM: ptgs; DEC/ART; OR; GR; PHOT; EU: ptgs; AS; AF; P/COL; ANT

Located on the campus of the University of Illinois, Krannert Art Museum is the second largest public art museum in the state. Among its 8,000 works ranging in date from the 4th millennium B.C. to the present, is the highly acclaimed Krannert collection of Old Master paintings. **NOT TO BE MISSED:** "Christ After the Flagellation" by Murillo; "Portrait of Cornelius Guldewagen, Mayor of Haarlem" by Frans Hals; Reinstalled Gallery of Asian Art.

CHICAGO

Art Institute of Chicago
111 So. Michigan Ave.. Chicago, IL 60603-6110
☏: 312-443-3600 ◎ www.artic.edu
Open: 10:30-4:30 Mo & We-Fr; 10:30-8 Tu; 10-5 Sa & Su **Closed:** 12/25, THGV
Sugg./Contr.: ADM: Adult: $8.00 **Children:** $5.00 **Students:** $5.00 **Seniors:** $5.00
♿ ℗: Limited metered street parking; several paid parking lots nearby **Museum Shop**
ⅼⅼ: Cafeteria & The on the Park
Group Tours: 312-443-3933 **Docents Sculpture Garden**
Permanent Collection: AM: all media; EU: all media; CH; Korean; JAP; IND; EU: MED; AF; PHOT; architecture + textiles; South American

Art Institute of Chicago - continued

Spend "Sunday in the park with George" while standing before Seurat's "Sunday Afternoon on the Island of La Grande Jatte," or any of the other magnificent examples of the school of French Impressionism, just one of the many superb collections housed in this world-class museum. Renowned for its collection of post-World War II art, the museum also features the Galleries of Contemporary Art, with 50 of the strongest works of American and European art (1950's-1980). **NOT TO BE MISSED:** "American Gothic" by Grant Wood; "Paris Street; Rainy Day" by Gustave Caillebotte.

ON EXHIBIT 2001

08/19/2000 to 01/15/2001 SKYSCRAPERS: THE NEW MILENNIUM

02/28/2001 to 05/28/2001 APPLIQUED, EMBROIDERED AND PIERCED BEDCOVERINGS

03/03/2001 to 05/20/2001 THE IDEA OF LOUIS SULLIVAN

03/24/2001 to 10/21/2001 2001: BUILDING FOR SPACE TRAVEL

06/02/2001 to 09/16/2001 EDWARD WESTON'S LAST YEARS IN CARMEL

09/22/2001 to 01/03/2002 VAN GOGH & GAUGUIN: THE STUDIO OF THE SOUTH

12/08/2001 to 07/28/2002 ALL ABOARD! ARCHITECTURE, DESIGN, AND RAIL TRAVEL FOR THE 21st CENTURY

Arts Club of Chicago

201 East Ontario St., Chicago, IL 60611
℄: 312-787-8664
Open: 11-6 Mo-Fr; 11-4 Sa **Closed:** Su

Chicago Cultural Center

78 East Washington St., Chicago, IL 60602
℄: 312-744-6630 ◙ www.cityofchicago.org
Open: 10-7 Mo-We, 10-9 Th, 10-6 Fr, 10-5 Sa, 11-5 Su **Closed:** All HOL
&: through the 77 E. Randolph St. entrance ℗: Commercial facilities in area **Museum Shop** ⑪: Corner Bakery
Group Tours: 312-744-8032 **Docents** **Tour times:** 1:15pm Tu-Sa
Permanent Collection: No

Located in the renovated 1897 historic landmark building originally built to serve as the city's central library, this vital cultural center, affectionately called the "People's Place," consists of 8 exhibition spaces, two concert halls, two theaters, a cabaret performing arts space, and a dance studio. The facility, which serves as Chicago's architectural showplace for the lively and visual arts, features daily programs and exhibitions. There are architectural tours of the building at 1:15pm Tu-Sa. **NOT TO BE MISSED:** The world's largest Tiffany stained-glass dome in Preston Bradley Hall on the third floor.

ON EXHIBIT 2001

11/11/2000 to 01/01/2001 MADELEINE DOERING: PHOTOGRAPHS

11/18/2000 to 01/01/2001 KAREN LEBERGOTT: PAINTINGS

11/18/2000 to 01/01/2001 TOM McDONALD: SCULPTURE

01/01/2001 TO 03/04/2001 CITY 2000 PHOTO EXHIBITION
A retrospective exhibition of 366 photographs representing the "best of the best" of the yearlong documentary photography project. The project began as midnight approached on January 1, 2000, when a team of Chicago's finest photographers started an unprecedented project to record the city for an archive being created for the future.

Chicago Cultural Center- continued

01/20/2001 to 03/25/2001 IN BETWEEN: ART FROM POLAND, 1945-2000
A major initiative of the Chicago Department of Cultural Affairs, this exhibition brings to the United States the first comprehensive survey of Polish art since World War II.

01/27/2001 to 03/25/2001 FRANCIS CHAPIN RETROSPECTIVE

03/24/2001 to 05/20/2001 HERBERT MIGDOLL: PHOTOGRAPHS

03/31/2001 to 05/27/2001 CHRISTOPHER ROMER: SCULPTURE

03/31/2001 to 05/27/2001 DAVE RICHARDS: MIXED MEDIA CONSTRUCTIONS

04/14/2001 to 09/23/2001 IRISH ART NOW: FROM THE POETIC TO THE POLITICAL
This exhibition testifies to the profound social, economic and cultural changes Ireland has experienced in the 1990s. The artists have initiated a dialogue with their own society and others using painting, photography, sculpture, video and installation. Subjects range from the personal and poetic to the political. *Will Travel*

05/2001 to 06/2001 CON/TEXTUAL: ART & TEXT IN CHICAGO
This often overlooked aspect of Chicago's art production will include numerous approaches to art that incorporate text in the form of installations, sculpture and sound pieces as well as more conventional paintings, drawings and embroidery. *Catalog*

07/14/2001 to 09/23/2001 HOLLYWOOD ICONS, LOCAL DEMONS: GHANAIAN POPULAR PAINTINGS BY MARK ANTHONY

10/20/2001 to 12/30/2001 HERBERT LIST: THE MAGIC EYE

David and Alfred Smart Museum of Art

Affiliate Institution: The University of Chicago
5550 S. Greenwood Ave., Chicago, IL 60637
☎: 773-702-0200 **◙** www.smartmuseum.uchicago.edu
Open: 10-4 Tu-Fr; 12-6 Sa, Su; till 9pm Th **Closed:** Mo, LEG/HOL!
& ℗: Free parking on lot on the corner of 55th St. & Greenwood Ave. after 4:00 weekdays, and all day on weekends.
Museum Shop ¶: Museum Café
Group Tours: 773-702-4540 **Docents Tour times:** 1:30 Su during special exhibitions **Sculpture Garden**
Permanent Collection: AN/GRK: Vases (Tarbell Coll); MED/SCULP; O/M: ptgs, sculp (Kress Coll); OM: gr (Epstein Coll); SCULP:20

Among the holdings of the Smart Museum of Art are Medieval sculpture from the French Romanesque church of Cluny III, outstanding Old Master prints by Durer, Rembrandt, and Delacroix from the Kress Collection, sculpture by such greats as Degas, Matisse, Moore and Rodin, and furniture by Frank Lloyd Wright from the world famous Robie House.

ON EXHIBIT 2001

12/16/2000 to 04/08/2001 BERNARD MEADOWS: DRAWINGS FROM THE LAZAROF COLLECTION

01/09/2001 to 04/22/2001 THE THEATRICAL BAROQUE

01/25/2001 to 03/25/2001 LANDSCAPES OF RETROSPECTION: THE MAGOON COLLECTION OF BRTISH DRAWINGS AND PRINTS, 1739-1854

04/19/2001 to 06/10/2001 BEN SHAHN'S NEW YORK: THE PHOTOGRAPHY OF MODERN TIMES

05/08/2001 to 10/07/2001 BETWEEN EAST AND WEST: GANDHARAN SCULPTURE

06/28/2001 to 09/09/2001 THE COMPLETE GRAPHIC WORK OF H. C. WESTERMANN

10/04/2001 to 12/2001 KARL TEIGE AND THE CZECH AVANT-GARDE

ILLINOIS

Martin D'Arcy Museum of Art

Affiliate Institution: The Loyola Univ. Museum of Medieval, Renaissance and Baroque Art
6525 N. Sheridan Rd., Chicago, IL 60626

℡: 773-508-2679 ◙ darcy.luc.edu
Open: 12-4 Tu-Sa during the school year; Summer hours 12-4 We & Fr **Closed:** Sa, Su, Mo, ACAD!, LEG/HOL!
& ⓟ: $3.00 visitor parking on Loyola Campus
Group Tours: 773-508-2679 **Tour times:** by request only
Permanent Collection: MED & REN & Baroque; ptgs, sculp, dec/art

Sometimes called the "Cloisters of the Midwest," The Martin D'Arcy Museum of Art is the only museum in the Chicago area focusing on Medieval, Renaissance and Baroque art. Fine examples of Medieval, Renaissance, and Baroque ivories, liturgical vessels, textiles, sculpture, paintings and secular decorative art of these periods are included in the collection. **NOT TO BE MISSED:** A pair of octagonal paintings on verona marble by Bassano; A German Renaissance Collectors Chest by Wenzel Jamitzer; A silver lapis lazuli & ebony tableau of the Flagellation of Christ that once belonged to Queen Christina of Sweden.

Mexican Fine Arts Center Museum

1852 W. 19th St., Chicago, IL 60608-2706

℡: 312-738-1503 ◙ www.mfacmchicago.org
Open: 10-5 Tu-Su **Closed:** Mo, LEG/HOL!
& **Museum Shop**
Group Tours: ex 16
Permanent Collection: MEX: folk; PHOT; GR; CONT

Mexican art is the central focus of this museum, the first of its kind in the Midwest, and the largest in the nation. Founded in 1982, the center seeks to promote the works of local Mexican artists and acts as a cultural focus for the entire Mexican community residing in Chicago. A new expansion project is underway that will triple the size of the museum. **NOT TO BE MISSED:** Nation's largest Day of the Dead exhibit and two annual performing arts festivals.

Museum of Contemporary Art

220 East Chicago Ave., Chicago, IL 60611-2604

℡: 312-280-2660 ◙ www.mcachicago.org
Open: We, Th, Fr, Sa, Su 10-5; Tu 10-8 **Closed:** Mo, 1/1, THGV, 12/25
Free Day: Tu **ADM: Adult:** $7.00 **Children:** Free 12 & under **Students:** $4.50 **Seniors:** $4.50
& ⓟ: On-street and pay lot parking available nearby **Museum Shop** ⑪: Puck's at the MCA - 11-8 Tu, Th, Fr; 11-5 W; 10-5 Sa, Su
Group Tours: 312-397-3898 **Docents** **Tour times:** several times daily! **Sculpture Garden**
Permanent Collection: CONTINUALLY CHANGING EXHIBITIONS OF CONTEMPORARY ART

Some of the finest and most provocative cutting-edge art by both established and emerging talents may be seen in the building and sculpture garden, located on a prime 2 acre site with a view of Lake Michigan. Brilliantly designed, the building is the first American project for noted Berlin architect Josef Paul Kleihues. On the second floor visitors can enjoy a spectacular view of the sculpture garden and lakefront while dining on contemporary fusion cuisine. **NOT TO BE MISSED:** An entire room devoted to sculptures by Alexander Calder.

ON EXHIBIT 2001

10/14/2000 to 01/07/2001 ISAAC JULIEN
A most recent video installation "The Long Road to Mazatlan (1999)" and photos which look at attitudes of masculinity and desire in relation to the mythologies of the West.

11/18/2000 to 02/04/2001 EDWARD RUSCHA
Paintings, drawings and books from 1960 to the present.

Museum of Contemporary Art - continued

01/20/2001 to 03/21/2001 PAWEL ALTHAMER
Commisioned site specific work by the Polish artist.

01/24/2001 to 05/20/2001 SHARON LOCKHART
The largest and most significant presentation of this photographer and filmmaker to date.

01/27/2001 to 04/21/2001 AA BRONSON AND GENERAL IDEA
Bronson and his partners formed General Idea in the tradition of art movements such as Dada, Futurism and Fluxus. It eventually turned to the AIDS crisis in the 80's.

01/27/2001 to 08/2001 ALEXANDER CALDER IN FOCUS: WORKS FROM THE LEONARD AND RUTH HORWICH FAMILY LOAN
Fifteen works from the 1920's to the 1960's spanning almost the entirety of Calder's career and demonstrating his extraordinary range.

02/02/2001 to 05/20/2001 GILBERT AND GEORGE "1999"
The artists reflect and project into the current century their hopeful vision of the world around them. They include photographs and images of their neighborhood in London's East End, a city map, graffiti, street signs, a neighborhood youth and a homeless person.

03/2001 to 05/2001 TONY FITZPATRICK: MAX AND GABY'S ALPHABET
Four color etchings which will appeal to all ages. A delightful children's alphabet.

03/03/2001 to 06/03/2001 KATHARINA FRITSCH
New work by this German artist. This work consists of small, identical multiples of golden shafts of wheat to form an enormous heart shaped field.

05/05/2001 to 07/29/2001 CONTEMPORARY ART AND THE ARCHITECTURAL UNCANNY
Ten international artists in various media making familiar exterior and interior spaces unfamiliar and unsettling.

06/23/2001 to 09/02/2001 MATTA IN AMERICA: PAINTINGS AND DRAWINGS OF THE 1940'S
Matta worked as a bridge with European Surrealists in exile in the U.S. and younger American artists who would become known as abstract expressionists.

06/30/2001 to 09/23/2001 H.C.WESTERMANN
A retrospective of this unique artist described as Pop-Artist, neo-dada, and figurative sculptor.

10/20/2001 to 01/20/2002 WILLIAM KENTRIDGE
A survey of his animated films, drawings and theater productions focusing on the complex and violent history of his native South Africa.

Museum of Contemporary Photography, Columbia College Chicago

600 South Michigan Ave., Chicago, IL 60605-1996

✆: 312-663-5554 **◎** www.mocp.org
Open: 10-5 Mo-We, Fr; 10-8 Th; 12-5 Sa **Closed:** Su, LEG/HOL!
Vol./Contr.: Yes
& **℗:** Pay nearby
Group Tours: 312-344-7793 **Tour times:** N/A
Permanent Collection: CONT/PHOT

The basis of the permanent collection of this college museum facility is a stimulating and innovative forum for the collection, creation and examination of photographically related images, objects and ideas.

ILLINOIS

Oriental Institute Museum

Affiliate Institution: University of Chicago

1155 E. 58th St., Chicago, IL 60637-1569

☎: 773-702-9520 ▣ www.oi.uchicago.edu/OI/MUS
Open: 10-4 Tu-Sa, 12-4 Su, till 8:30pm We **Closed:** Mo, 1/1, 7/4, THGV, 12/25
Vol./Contr.: Yes
&: Accessible by wheelchair from west side of building ℗: On-street or coin operated street level parking on Woodlawn
Ave. between 58th & 59th Sts. (1/2 block east of the institute) **Museum Shop**
Group Tours: Call for appointment - 773-702-9507 **Docents** **Tour times:** 2:30 Su
Permanent Collection: AN: Mid/East

Hundreds of ancient objects are included in the impressive comprehensive collection of the Oriental Institute. Artifacts from the ancient Near East, dating from earliest times to the birth of Christ, provide the visitor with a detailed glimpse into the ritual ceremonies and daily lives of ancient civilized man. **NOT TO BE MISSED:** Ancient Assyrian 40 ton winged bull; 17' tall statue of King Tut; Colossal Ancient Persian winged bulls.

Polish Museum of America

984 North Milwaukee Ave., Chicago, IL 60622

☎: 773-384-3352 **Open:** 11-4 Mo-Su
Sugg./Contr.: ADM: **Adult:** $2.00 **Children:** $1.00
&: Wheelchairs available by reservation 312-384-3352 ℗: Free parking with entrance from Augusta Blvd.
Permanent Collection: ETH: ptgs, sculp, drgs, gr

The promotion of Polish heritage is the primary goal of this museum founded in 1935. One of the oldest and largest ethnic museums in the U.S., their holdings range from the fine arts to costumes, jewelry, and a broad ranging scholarly library featuring resource information on all areas of Polish life and culture. **NOT TO BE MISSED:** Polonia stained glass by Mieczyslaw Jurgielewicz.

Terra Museum of American Art

664 N. Michigan Ave., Chicago, IL 60611

☎: 312-664-3939 ▣ www.terramuseum.org
Open: 10-8 Tu, 10-6 We-Sa, 12-5 Su **Closed:** Mo, 1/1, 7/4, THGV, 12/25
Free Day: Tu & 1st Su **ADM: Adult:** $7.00 **Children:** Free under 14 **Students:** Free **Seniors:** $3.50
& **Museum Shop**
Group Tours: 312-654-2255 **Docents** **Tour times:** 12 weekdays; 12 & 2 weekends

With over 800 plus examples of some of the finest American art ever created, the Terra, located in the heart of Chicago's "Magnificent Mile," reigns supreme as an important repository of a glorious artistic heritage. **NOT TO BE MISSED:** "Gallery at the Louvre" by Samuel Morse; Maurice Prendergast paintings and monotypes.

ON EXHIBIT 2001

12/10/2000 to 02/25/2001 ART AND NATURE: THE HUDSON RIVER SCHOOL PAINTINGS FROM THE ALBANY INSTITUTE OF HISTORY & ART
Beginning with Thomas Cole in 1825 and ending by the late 1870s, the Hudson River School artists became recognized as the first school of American painting. The exhibition features twenty-seven paintings by Thomas Cole, Asher B. Durand, John Kensett, Homer D. Martin, David Johnson, John Casilear and George Inness. Hudson River School artists were known for their dramatic depictions of nature and subjects ranging from sublime views of the wilderness to pastoral scenes and allegorical pictures with moral message.

University Museum, Southern Illinois University
Affiliate Institution: So. Illinois Univ. at Edwardsville
Box 1150, Edwardsville, IL 62026-1150

✆: 618-650-2996
Open: 9-3 Tu-Sa, 1:30-4:30 Su **Closed:** Mo, LEG/HOL
 ⑂ **Ⓟ:** Metered lot just East of the Student Center (next to the football stadium) **Sculpture Garden**
Permanent Collection: DRGS; FOLK; CER; NAT/AM

Works in many media from old masters to young contemporary artists are included in the permanent collection and available on a rotating basis for public viewing. The museum is located in the western part of the state not far from St. Louis, Missouri. **NOT TO BE MISSED:** Louis Sullivan Architectural Ornament Collection located in the Lovejoy Library.

Mary and Leigh Block Museum
Affiliate Institution: Northwestern University
1967 South Campus Drive, On the Arts Circle, Evanston, IL 60208-2410

✆: 847-491-4000 **Ⓞ** www.nwu.edu/museum
Open: Noon-5 Tu-We, Noon-8pm Th-Su **Closed:** Mo, LEG/HOL!
 ⑂ **Museum Shop** **Group Tours:** 847-491-5209 **Sculpture Garden**
Permanent Collection: EU: gr, drgs 15-19; CONT: gr, phot; architectural drgs (Griffin Collection)

In addition to its collection of works on paper, this fine university museum features an outdoor sculpture garden (open free of charge year round) which includes outstanding examples of 20th-century works by such artistic luminaries as Joan Miro, Barbara Hepworth, Henry Moore, Jean Arp and others. **NOT TO BE MISSED:** The sculpture garden is one of the major sculpture collections in the region.

ON EXHIBIT 2001
01/02/2001 to 03/04/2001 MANUSCRIPT ILLUMINATION IN A MODERN AGE

02/26/2001 to 04/14/2001 NOW: THE PHOTOGRAPHS OF ALAN COHEN

03/12/2001 to 04/29/2001 DAVID SMITH: TWO INTO THREE DIMENSIONS

4/23/2001 to 06/10/2001 WAYNE MILLER PHOTOGRAPHS: CHICAGO 1948-49

05/14/2001 TO 07/08/2001 DEPARTMENT OF ART THEORY AND PRACTICE: A TEN YEAR RETROSPECTIVE

09/2001 to 11/2001 THE LAST EXPRESSION: ART FROM AUSCHWITZ
Drawing from archives, museums and sites of former concentration camps, this exhibition presents a comprehensive view of artwork created during the Holocaust by inmates of concentration camps and ghettos. It includes "official" art commissioned by Nazi authorities as well as semi-official and subversive works created by inmates to either document the indignities and misery of camp existence or to give expression to diverse experiences.

09/2001 to 10/2001 THE PRINTS OF RIVERHOUSE EDITIONS
Riverhouse Editions was founded in 1988 by Jan and William van Straaten in Clark, Colorado. Riverhouse publishes works by artists seminal to an understanding of contemporary art. Sol LeWitt, Lynda Benglis, Komar and Melamid, Fred Tomaselli, Judy Ledgerwood, and others are often inspired by the atelier's location on the banks of the Elk River.

11/2001 to 12/2001 NO! ART AND THE AESTHETICS OF DOOM

11/2001 to 12/2001 THE RUDOLPH H. AND FANNIA WEINGARTNER COLLECTION OF PRINTS BY SCULPTORS

ILLINOIS

Freeport Arts Center

121 No. Harlem Ave, Freeport, IL 61032

☎: 815-235-9755 **Open:** 10-6 Tu, 10-5 We-Su **Closed:** Mo, 1/1, EASTER. 7/4, THGV, 12/25
Free Day: We **ADM: Adult:** $3.00 **Children:** $2.00 **Students:** $2.00 **Seniors:** $2.00
&: Except for three small galleries **Ⓟ:** behind museum
Docents Tour times: any time, if scheduled 2 weeks in advance
Permanent Collection: EU: 15-20; AM: 19-20; CONT: ptgs, sculp; P/COL; AN/R; NAT/AM; AN/EGT; AS; AF; OC

The Freeport Arts, located in northwestern Illinois, has six permanent galleries of paintings, sculpture, prints, and ancient artifacts, as well as temporary exhibitions featuring the work of noted regional artists. It houses one of the largest Florentine mosaic collections in the world. **NOT TO BE MISSED:** Especially popular with children of all ages are the museum's antiquities and the Native American galleries. FAC has one of the finest collections of pietre dure (Florentine mosaics) in the world.

ON EXHIBIT 2001

01/14/2001 to 03/04/2001 **ART OF THE PHILIPPINES**

06/08/2001 to 07/29/2001 **PAINTINGS BY HAL MARTIN**

08/03/2001 to 09/23/2001 **PAINTINGS BY CAROLYN MASTROIANNI**

09/28/2001 to 11/11/2001 **PAINTINGS BY DUANE SMITH**

01/13/2002 to 03/03/2002 **PAINTINGS BY TOM LOCKER**

Mitchell Museum

Richview Rd., Mount Vernon, IL 62864

☎: 618-242-1236 **◉** cedarhurst.org
Open: 10-5 Tu-Sa, 1-5 Su **Closed:** Mo, LEG/HOL!
Vol./Contr.: Yes
& Ⓟ Museum Shop Sculpture Garden
Permanent Collection: AM: ptgs, sculp (late 19-early 20)

Works from the "Ashcan School," with paintings by Davies, Glackens, Henri, Luks, and Maurice Prendergast, comprise one of the highlights of the Mitchell Museum, located in south central Illinois, which also features over 60 large-scale sculptures in Cedarhurst Sculpture Park. All are located on a 90-acre estate. **NOT TO BE MISSED:** Sculpture park.

ON EXHIBIT 2001

02/24/2001 to 04/15/2001 **SCOTTISH SPIRIT**

04/21/2001 to 06/10/2001 **A CARNIVAL OF ANIMALS: BEASTS, BIRDS, AND BUGS IN ORIGINAL ILLUSTRATIONS FROM CHILDREN'S BOOKS**

09/22/2001 to 11/11/2001 **ZELDA BY HERSELF**

PEORIA

Lakeview Museum of Arts and Sciences
1125 West Lake Ave., Peoria, IL 61614

☎: 309-686-7000 **◉** www.lakeview-museum.org
Open: 10-5 Tu-Sa, 1-5 Su **Closed:** Mo, LEG/HOL!
Free Day: Tu **ADM: Adult:** $2.50 **Children:** $1.50 **Students:** $1.50 **Seniors:** $1.50
& **℗:** Free **Museum Shop Sculpture Garden**
Permanent Collection: DEC/ART; AM: 19-20; EU:19

A multi-faceted museum that combines the arts and sciences, the Lakeview offers approximately 6 changing exhibitions per year. **PLEASE NOTE:** Prices of admission may change during special exhibitions! **NOT TO BE MISSED:** Discovery Center and Planetarium, a particular favorite with children.

ON EXHIBIT 2001
11/04/2000 to 01/07/2001 THE POTTERS OF MATA ORTIZ: TRANSFORMING A TRADITION
Innovative ceramic vessels by contemporary Mexican potters inspired by traditional Casas Grandes ceramics. Also shown will be rugs, kachina dolls and Illinois Native American materials.

QUINCY

Quincy Art Center
1515 Jersey St., Quincy, IL 62301

☎: 217-223-5900
Open: 1-4 Tu-Su **Closed:** Mo, LEG/HOL!
Vol./Contr.: Yes
& **℗:** Free **Museum Shop**
Group Tours: 217-223-6900 **Docents Tour times:** Often available upon request
Permanent Collection: PTGS; SCULP; GR

The Quincy Art Center is housed in an 1887 carriage house designed by architect Joseph Silsbee who was a mentor and great inspiration to Frank Lloyd Wright. A modern wing added in 1990 features gallery, studio, and gift shop space. Located in the middle of the state, the museum is not far from the Missouri border. **NOT TO BE MISSED:** The Quincy Art Center, located in an historic district that 'Newsweek' magazine called one of the most architecturally significant corners in the country, is composed of various buildings that run the gamut from Greek Revival to Prairie Style architecture.

ROCK ISLAND

Augustana College Museum of Art
7th Ave. & 38th St. Art & Art History Dept., Rock Island, IL 61201-2296

☎: 309-794-7469 **◉** www.augustana.edu
Open: Noon-4 Tu-Sa (SEPT-MAY) **Closed:** Su, Mo ACAD! & SUMMER
&: Call ahead for access assistance **℗:** Parking available next to Centennial Hall at the northwest corner of Seventh Ave. & 38th St.
Group Tours: 309-794-7231
Permanent Collection: SWEDISH AM: all media

Swedish-American art is the primary focus of this college art gallery.

ROCKFORD

Rockford Art Museum

711 N. Main St., Rockford, IL 61103

C: 815-968-2787 **◎** RAM-artmuseum.rockford.org
Open: 11-5 Tu-Fr, 10-5 Sa, 12-5 Su **Closed:** Mo, LEG/HOL!
Vol./Contr.: Yes
& **Ⓟ:** Free **Museum Shop**
Docents **Tour times:** by res **Sculpture Garden**
Permanent Collection: AM: ptgs, sculp, gr, dec/art 19-20; EU: ptgs, sculp, gr, dec/art 19-20; AM/IMPR; TAOS ART,
GILBERT COLL: phot; AF/AM; self-taught; contemporary glass

With 17,000 square feet of exhibition space, this is one of the largest arts institutions in the state of Illinois. Up to 12 exhibitions are presented annually, as are works from the over 1,200 piece permanent collection of 20th century American art. **NOT TO BE MISSED:** "The Morning Sun" by Pauline Palmer, 1920; ink drawings and watercolors by Reginald Marsh (available for viewing only upon request); plaster casts by Lorado Taft, c. 1900.

Rockford College Art Gallery / Clark Arts Center

5050 E. State, Rockford, IL 61108

C: 815-226-4034
Open: ACAD: 2-5 Daily **Closed:** ACAD! & SUMMER
&: Elevator at west side of Clark Arts Center **Ⓟ:** Free; near Clark Arts Center
Permanent Collection: PTGS, GR, PHOT, CER 20; ETH; REG

Located on a beautiful wooded site in a contemporary building, this museum presents a stimulating array of exhibitions that look at historic as well as contemporary artwork from around the country.

SPRINGFIELD

Springfield Art Association

700 North Fourth St., Springfield, IL 62702

C: 937-325-4673 **◎** www.spfldmus-of-art.org
Open: 9-5 Tu-Th, Fr, 9-9 We, 9-3 Sa, 2-4 Su **Closed:** Mo, LEG/HOL! (including Lincoln's birthday; 12/25-1/1)
& **Ⓟ:** Free
Group Tours: 937-324-3729 **Docents** **Tour times:** by appt
Permanent Collection: AM: ptgs, gr, cer, dec/art; EU: ptgs; CH; JAP

Fanciful is the proper word to describe the architecture of the Italianate structure that houses the Springfield Art Association, a fine arts facility that has been important to the cultural life of the city for nearly a century.

ANDERSON

Anderson Fine Arts Center
32 West 10th Street, Anderson, IN 46016

☎: 765-649-1248 **◎** www.andersonart.org
Open: 10-5 Tu-Sa, till 8:30 Th, 12-5 Su **Closed:** Mo, LEG/HOL!
Free Day: Tu, 1st Su **ADM: Adult:** $2.50, fam $6.50 **Children:** $1.25 **Students:** $1.25 **Seniors:** $2.00
& **℗** **Museum Shop** **↿↾:** Garden on the Green; Caffé Pietro
Group Tours: 765-649-1248
Permanent Collection: REG: all media; AM: all media 20

With an emphasis on education, this museum presents children's exhibitions annually; from May to the end of June.

BLOOMINGTON

Indiana University Art Museum
Affiliate Institution: Indiana University
Bloomington, IN 47405

☎: 812-855-IUAM **◎** www.indiana.edu/~iuam
Open: 10-5 We-Sa, 12-5 Su **Closed:** Mo, Tu, LEG/HOL!
Vol./Contr.: Yes
&: north entrance **℗:** Indiana Memorial Union pay parking lot one block west of the museum **Museum Shop**
↿↾: Coffee Shop
Group Tours: 812-855-1045 **Docents** **Tour times:** 2:00 Sa **Sculpture Garden**
Permanent Collection: AF; AN/EGT; AN/R; AN/GRK; AM: all media; EU: all media 14-20; OC; P/COL; JAP; CH; OR

Masterpieces in every category of its collection, from ancient to modern, make this one of the finest university museums to be found anywhere. Among its many treasures is the best university collection of African art in the United States. **NOT TO BE MISSED:** The stunning museum building itself designed in 1982 by noted architect I.M. Pei.

COLUMBUS

Indianapolis Museum of Art - Columbus Gallery
390 The Commons, Columbus, IN 47201-6764

☎: 812-376-2597
Open: 10-5 Tu-Th & Sa, 10-8 Fr, 12-4 Su **Closed:** Mo, LEG/HOL!
Vol./Contr.: Yes
& **℗:** Free

In an unusual arrangement with its parent museum in Indianapolis, four exhibitions are presented annually in this satellite gallery, the oldest continuously operating satellite gallery in the country. The Gallery is uniquely situated inside a shopping mall in an area designated by the city as an "indoor park." **NOT TO BE MISSED:** Jean Tingely sculpture in mall.

ON EXHIBIT 2001
11/07/2000 to 01/14/2001 CRECHES FROM THE COLLECTION OF XENIA MILLER
The creches are from 20 different countries and in a wide range of media including stone, ceramic, papier-mache, wood, cloth, metal, majolica and porcelain.

INDIANA

Midwest Museum of American Art
429 S. Main St., Elkhart, IN 46516

☎: 219-293-6660
Open: 11-5 Tu-Fr; 1-4 Sa, Su **Closed:** Mo, LEG/HOL!
Free Day: Su **ADM: Adult:** $3.00 **Children:** Free under 5 **Students:** $1.00 **Seniors:** $2.00
♿ ℗: Free city lot just north of the museum **Museum Shop**
Docents **Tour times:** 12:20-12:40 Th Noontime talks-free
Permanent Collection: AM/IMPR; CONT; REG; SCULP; PHOT

Chronologically arranged, the permanent collection of 19th and 20th century paintings, sculptures, photographs, and works on paper, traces 150 years of American art history with outstanding examples ranging from American Primitives to contemporary works by Chicago Imagists. The museum is located in the heart of the mid-west Amish country. **NOT TO BE MISSED:** Original paintings by Grandma Moses, Norman Rockwell, and Grant Wood; The Vault Gallery (gallery in the vault of this former bank building)

ON EXHIBIT 2001
04/06/2001 to 05/27/2001 JIM HUNTINGTON: PAPER-ROCK-SCISSORS
An artist's dialogue in stone, steel and on paper (Primal spirit)(Native Son)(Modern Faith).

07/20/2001 to 09/02/2001 DICHROmISM IN LIGHT: THE SCULPTURE OF RAY HOWLETT

10/19/2001 to 12/02/2001 23RD ELKHARDT JURIED REGIONAL

Evansville Museum of Arts & Science
411 S.E. Riverside Dr., Evansville, IN 47713

☎: 812-425-2406 ▣ ·http://www.emuseum.org
Open: 10-5 Tu-Sa, Noon-5 Su **Closed:** Mo, 1/1, 7/4, LAB/DAY, THGV, 12/25
Vol./Contr.: $2.00 Adults/$1.00 Children
♿: Wheelchairs available; ramps; elevators ℗: Free and ample parking
Museum Shop Sculpture Garden
Permanent Collection: PTGS; SCULP; GR; DRGS; DEC/ART

Broad ranging in every aspect of its varied collections, the Evansville Museum is a general museum with collections in art, history, and science. **NOT TO BE MISSED:** "Madonna and Child" by Murillo; Kolh Planetarium; Transportation Hall (EMTRAL)- Evansville Museum Transportation Center.

ON EXHIBIT 2001
12/03/2000 to 01/14/2001 50th MID-STATES ART EXHIBITION: A GOLDEN JUBILEE
A juried exhibition of contemporary painting, drawing, printmaking and sculpture for artists from Ohio, Missouri, Kentucky and Tennessee.

12/03/2000 to 01/28/2001 GIAMBOLOGNA: RENAISSANCE SCULPTURE
The closing Millennial exhibit is the most important classical art shown in Evansville. The Museum has the original maquette of the "Neptune" figure created for the "Fountain of Neptune" in the Piazza Publico in Bologna.

FORT WAYNE

Fort Wayne Museum of Art

311 E. Main St., Fort Wayne, IN 46802-1997

☎: 219-422-6467 ▣ www.fwmoa.org
Open: 10-5 Tu-Sa, 12-5 Su **Closed:** Mo, 1/1, 7/4, THGV, 12/25
Free Day: 1st Su **ADM: Adult:** $3.00 **Children:** $2.00 (K-college) **Students:** $2.00 **Seniors:** $3.00
♿ ℗: Parking lot adjacent to building with entrance off Main St. **Museum Shop**
Group Tours: 219-422-6467 x319 **Sculpture Garden**
Permanent Collection: AM: ptgs, sculp, gr 19-20; EU: ptgs, sculp, gr 19-20; CONT

Since the dedication of the new state-of-the-art building in its downtown location in 1984, the Fort Wayne Museum, established more than 75 years ago, has enhanced its reputation as a major vital community and nationwide asset for the fine arts. Important masterworks from Durer to de Kooning are included in this institution's 1,300 piece collection. **NOT TO BE MISSED:** Outdoor sculptures, including "Helmholtz" by Mark di Suvero; bronze maquettes by Paul Manship; paintings by George Inness, Thomas Moran, Larry Rivers, and Janet Fish.

ON EXHIBIT 2001

11/11/2000 to 01/14/2001 PAULA WILMOT KRAUS (FOCUS SERIES)
Black and white photography.

11/18/2000 to 01/14/2001 BEYOND THE MOUNTAINS—THE CONTEMPORARY AMERICAN LANDSCAPE
Twenty artists depict the landscape from light, weather and terrain. Each has discovered the wonder, beauty and character unique to the American landscape.

01/20/2001 to 03/11/2001 DOUG CALISCH (FOCUS SERIES)
Sculptures.

01/20/2001 to 03/18/2001 ON THE ROAD WITH THOMAS HART BENTON
How drawing, one of Benton's greatest talents, and travel combined to produce some of his most significant works. *Will Travel*

03/16/2001 to 05/13/2001 NICK CAVE (FOCUS SERIES)
Wearable costume sculptures.

03/24/2001 to 05/27/2001 LINDA MCCARTNEY'S SIXTIES : PORTRAIT OF AN ERA

03/24/2001 to 05/27/2001 MYTH OBJECT AND THE ANIMAL: WILLIAM MORRIS /GLASS INSTALLATION
Sculptures of birds and beasts as well as 2 site specific installations in glass.

06/02/2001 to 08/19/2001 PAINTINGS BY VERA KLEMENT
After emigrating from Europe in 1938 she studied Abstract Expressionism. In 1964 she redefined her painting style to create a unique one of her own.

INDIANAPOLIS

Eiteljorg Museum of American Indians and Western Art

500 W. Washington St. White River State Park, Indianapolis, IN 46204

☎: 317-636-9378 ▣ www.eiteljorg.org
Open: 10-5 Tu-Sa, 12-5 Su (Open 10-5 Mo JUNE-AUG) **Closed:** Mo, 1/1, THGV, 12/25, Easter
Free Day: about 5 per year! **ADM: Adult:** $5.00 **Children:** Free 4 & under **Students:** $2.00 **Seniors:** $4.00
♿ ℗: Free **Museum Shop**
Group Tours: ext 150 **Docents Tour times:** 1 pm daily
Permanent Collection: NAT/AM & REG artifacts : ptgs, sculp, drgs, gr, dec/art

INDIANA

Eiteljorg Museum of American Indians and Western Art - continued

The Eiteljorg, one of only two museums east of the Mississippi to combine the fine arts of the American West with Native American artifacts, is housed in a Southwestern style building faced with 8,000 individually cut pieces of honey-colored Minnesota stone. **NOT TO BE MISSED:** Works by members of the original Taos Artists Colony; 4 major outdoor sculptures including a 38' totem pole by 5th generation Haida carver Lee Wallace and George Carlson's 12-foot bronze entitled "The Greeting."

ON EXHIBIT 2001

04/08/2000 to 01/07/2002 FROM ONE HAND TO ANOTHER: NATIVE AMERICAN TREASURES FROM THE CHILDREN'S MUSEUM

04/21/2000 to 05/20/2001 SEEING WHAT THE HEART KNOWS: THE ART OF HOWARD TERPNING

09/09/2000 to 01/7/2001 REMINGTON AND RUSSELL: MASTERPIECES OF THE AMERICAN WEST FROM THE AMON CARTER MUSEUM

starting 03/24/2001 NEW INSTALLATION OF THE PERMANENT TAOS GALLERY (title tba)

06/09/2001 to 09/30/2001 IQQAIPAA: CELEBRATING INUIT ART, 1948-1970

Indianapolis Museum of Art

1200 W. 38th St., Indianapolis, IN 46208-4196
✆: 317-923-1331 ◻ www.ima-art.org
Open: 10-5 Tu-Sa, till 8:30pm Th, 12-5 Su **Closed:** Mo, Thanksgiving, Christmas, New Year's Day
Vol./Contr.: Special Exhibitions only, $5.00
& ℗: Outdoor parking lots and parking garage of Krannert Pavilion **Museum Shop** ¶: 11am-1:45pm Tu-Sa; (Brunch Su by reservation 926-2628)
Group Tours: 317-923-1331 **Docents Tour times:** 12 & 2 Tu-Su; 7pm Th
Permanent Collection: AM: ptgs; EU/OM; ptgs EU/REN:ptgs; CONT; OR; AF; DEC/ART; TEXTILES

Situated in a 152 acre park as part of a cultural complex, the Indianapolis Museum is home to many outstanding collections including a large group of works on paper by Turner, and world class collections of Post Impressionist, Asian, and African art. **PLEASE NOTE:** 1. There is an admission fee for most special exhibitions. 2. The museum IS OPEN on 7/4. 3. Historic Lilly House closed for restoration. **NOT TO BE MISSED:** Gardens of Oldfields Estate, Clowes Collection of Old Masters, Glick Contemporary Glass Collection.

ON EXHIBIT 2001

10/14/2000 to 10/21/2001 CROSSROADS OF AMERICAN SCULPTURE
Multicolored steel constructions, dynamic kinetic pieces and famous masterworks are exhibited in the 100 works. Included are Smith, Rickey, Chamberlain, Indiana, Wiley and Nauman.

04/22/2001 to 06/24/2001 POP IMPACT: FROM JOHNS TO WARHOL
Inspiration for the Pop Art movement came from new merchandise, flashy graphics of advertising and the crudeness of consumerism. Included also are Rauschenberg, Oldenburg, and Lichtenstein.

04/22/2001 to 06/24/2001 RAVE REVIEWS: 100 YEARS OF GREAT AMERICAN ART
Works shown at the National Academy of Design from 1826-1926 include Cole, Mount, Johnson, Sargent and Homer. Reviews of those exhibitions will be shown.

09/22/2001 to 01/13/2002 THE ART OF DIPLOMACY: GIFTS TO THE TSARS 1500-1700 TREASURES FROM THE KREMLIN
Magnificent and valuable works of art most never before shown outside Russia.

LAFAYETTE

Greater Lafayette Museum of Art

101 South Ninth St., Lafayette, IN 47901

☎: 765-742-1128 ⊙ www.glmart.org
Open: 11-4 Tu-Su **Closed:** Mo, LEG/HOL!
 ♿: Free 10th St. entrance **Museum Shop**
Group Tours: ask for paige@glmart.org **Docents** **Tour times:** 11-4 Tu-Su
Permanent Collection: AM: ptgs, gr, drgs, art pottery 19-20; REG: ptgs, works on paper; LAT/AM: gr

Art by regional Indiana artists, contemporary works by national artists of note, and a fine collection of art pottery are but three of several important collections to be found at the Greater Lafayette Museum of Art. **NOT TO BE MISSED:** Arts and craft items by Hoosier artists at museum store; Baber Collection of contemporary art.

ON EXHIBIT 2001

11/28/2000 to 01/07/2001 **CHILDREN IN INDIANA ART**

11/28/2000 to 01/07/2001 **SID CHAFETZ**

01/20/2001 to 02/25/2001 **INDIANA NOW**

01/20/2001 to 03/04/2001 **JAN MYERS AND DOUG WINSLOW**

03/10/2001 to 04/15/2001 **A SHARED JOURNEY: CONFRONTING CANCER THROUGH ART**

04/28/2001 to 05/27/2001 **NEW ARTISTS**

04/28/2001 to 08/12/2001 **THE MAGIC OF MAJOLICA**

08/25/2001 to 10/28/2001 **A MASTERFUL EYE: PHOTOGRAPHY OF VERN CHEEK**

11/03/2001 to 01/25/2002 **DIVINE BOVINES: COWS AND OTHER BARNYARD ANIMALS IN INDIANA ART**

MUNCIE

Ball State University Museum of Art

2000 University Ave., Muncie, IN 47306

☎: 765-285-5242
Open: 9-4:30 Mo-Fr; 1:30-4:30 Sa, Su **Closed:** !, LEG/HOL
 ♿: Metered street parking and metered paid garages nearby
Group Tours: 765-285-5242
Permanent Collection: IT/REN; EU: ptgs 17-19; AM: ptgs, gr, drgs 19-20; DEC/ART; AS; AF; OC; P/COL

5000 years of art history are represented in the 9,500 piece collection of the Ball State University Museum of Art. In addition to wonderful explanatory wall plaques, there is a fully cataloged Art Reference Terminal of the permanent collection.

INDIANA

NOTRE DAME

Snite Museum of Art
Affiliate Institution: University of Notre Dame
Notre Dame, IN 46556
℡: 219-631-5466 **◉** www.nd.edu/~sniteart
Open: 10-4 Tu, We; 10-5 Th-Sa; 1-5 Su **Closed:** Mo, LEG/HOL!
Vol./Contr.: Yes
Ġ: **℗:** Available southeast of the museum in the visitor lot **Museum Shop**
Group Tours: 219-631-4435 **Sculpture Garden**
Permanent Collection: IT/REN; FR: ptgs 19; EU: phot 19; AM: ptgs, phot; P/COL: sculp; DU: ptgs 17-18

With 17,000 objects in its permanent collection spanning the history of art from antiquity to the present, this premier university museum is a "must see" for all serious art lovers. **NOT TO BE MISSED:** AF; PR/COL & NAT/AM Collections.

RICHMOND

Richmond Art Museum
350 Hub Etchison Pkwy, Richmond, IN 47374
℡: 765-966-0256
Open: 10-4 Tu-Fr; 1-4 Sa, Su **Closed:** Mo, LEG/HOL!
Ġ: Northwest entrance wheelchair accessible **℗:** Free **Museum Shop**
Docents Tour times: !
Permanent Collection: AM: Impr/ptgs; REG

Aside from its outstanding collection of American Impressionist works, the Richmond Art Museum, celebrating its 100th birthday on June 14, 1998, has the unique distinction of being housed in an operating high school. **NOT TO BE MISSED:** Self portrait by William Merritt Chase, considered to be his most famous work.

SOUTH BEND

South Bend Regional Museum of Art
120 S. St. Joseph St., South Bend, IN 46601
℡: 219-235-9102 **◉** www.sbt.infi.net/-sbrma
Open: 11-5 Tu-Fr; 12-5 Sa, Su **Closed:** Mo, LEG/HOL!
Sugg./Contr.: ADM: Adult: $3.00
Ġ: **℗:** Free street parking. Also Century Center lot or other downtown parking garages. **Museum Shop** **❙❙:** Cafe
Permanent Collection: AM: ptgs 19-20; EU: ptgs 19-20; CONT: reg

Since 1947, the South Bend Regional Museum of Art has been serving the artistic needs of its community by providing a wide variety of regional and national exhibitions year-round. This growing institution recently completed a reconstruction and expansion project adding, among other things, a Permanent Collections Gallery and a cafe. **NOT TO BE MISSED:** Permanent site-specific sculptures are situated on the grounds of Century Center of which the museum is a part.

ON EXHIBIT 2001
07/08/2000 to 01/14/2001 TOY TOWN : PATRICE BOVO
The facades of Bovo's architectural sculptures are constructed mainly from vintage game pieces and puzzles.

12/09/2000 to 01/21/2001 THE OBJECT CONSIDERED
Contemporary still life from 31 artists from Ohio, Indiana and Illinois.

Swope Art Museum

25 S. 7th St., Terre Haute, IN 47807

☎: 812-238-1676 ◙ www.swope.org
Open: 10-5 Tu-Fr; 12-5 Sa, Su; 10-8pm Th **Closed:** Mo, LEG/HOL
Vol./Contr.: Yes
&: Ground floor is accessible; elevator to 2nd floor ℗: Pay lot on Ohio Blvd. (behind the museum) **Museum Shop**
Group Tours: Call to make appointment - 812-238-1676 **Tour times:** None
Permanent Collection: AM: ptgs, sculp, drgs 19-20;

The Swope Art Museum opened in 1942 as a museum devoted to contemporary American art and has expanded from the original core collection to include significant 19th and 20th century American works. The museum's historic 1901 exterior and Art Deco interior have been recently restored and renovated. **NOT TO BE MISSED:** Paintings by Grant Wood, Thomas Hart Benton, Edward Hopper; meticulously restored 1941-42 interior.

ON EXHIBIT 2001

02/02/2001 to 03/11/2001 PORTRAIT PHOTOGRAPHY FROM HOLLYWOOD'S GOLDEN AGE: THE ROBERT DANCE COLLECTION

07/14/2001 to 08/26/2001 57TH ANNUAL WABASH VALLEY JURIED EXHIBITION

09/28/2001 to 11/94/2001 PHILIP KOCH

12/07/2001 to 01/06/2002 WABASH CURRENTS: 3 ARTISTS

Brauer Museum of Art at Valparaiso University

Affiliate Institution: Valparaiso University
Valparaiso, IN 46383

☎: 219-464-5365

The museum is part of a Center for the Arts, which includes music and drama as well.

Purdue University Galleries

Affiliate Institution: Creative Arts Bldg. #1
West Lafayette, IN 47907

☎: 765-494-3061
Open: STEWART CENTER:10-5 & 7-9 Mo-Fr, 1-5 Su; UNION GALLERY:10-5 Mo-Fr
Closed: Sa, Academic holidays
& ℗: Visito r parking in designated areas (a $3.00 daily parking permit for campus garages may be purchased at the Visitors Information Services Center); some metered street parking as well; Free parking on campus after 5 and on weekends.
Permanent Collection: AM: ptgs, drgs, gr; EU: ptgs, gr, drgs; AM: cont/cer

In addition to a regular schedule of special exhibitions, this facility presents many student and faculty shows.

IOWA

CEDAR FALLS

James & Meryl Hearst Center for the Arts

304 W. Seerly Blvd., Cedar Falls, IA 50613
☎: 319-273-8641 ◙ www.ci.cedar-fallsici.us/human-lersure/hearst-center
Open: 10-9 Tu, Th; 10-5 We, Fr; 1-4 Sa, Su **Closed:** Mo, 1/1, 7/4, THGV, 12/25
ઙ **℗:** Free **Museum Shop**
Group Tours: 319-268-5504 **Sculpture Garden**
Permanent Collection: REG

Besides showcasing works by the region's best current artists, the Hearst Center's permanent holdings include examples of works by such well knowns as Grant Wood, Mauricio Lasansky, and Gary Kelly. **NOT TO BE MISSED:** "Man is a Shaper, a Maker," pastel by Gary Kelly; "Honorary Degree," lithograph by Grant Wood.

ON EXHIBIT 2001

12/03/2000 to 01/28/2001 CURRENT WORKS IN CLAY
The recent works of ceramist Joanne Schnabel exploring geometric and organic forms.

CEDAR RAPIDS

Cedar Rapids Museum of Art

410 Third Ave. S.E., Cedar Rapids, IA 52401
☎: 319-366-7503 ◙ www.crma.org
Open: 10-4 Tu-We & Fr-Sa, 10am-7pm Th, Noon-4 Su **Closed:** Mo, LEG/HOL!
ADM: Adult: $4.00 **Children:** Free under 7 **Students:** $3.00 **Seniors:** $3.00
ઙ: Entrance ramp 3rd Ave **℗:** Lot behind museum building; some metered parking on street **Museum Shop**
Group Tours: education office **Docents Tour times:** !
Permanent Collection: REG: ptgs 20; PTGS, SCULP, GR, DEC/ART, PHOT 19-20

Spanning a city block, the Cedar Rapids Museum of Art houses 16 galleries in one wing and a Museum Shop, art library and multi-media center in another. A regionally focused museum, it was observed by The Other Museums that, "No museum of art in this country is more deeply rooted in its own community." **NOT TO BE MISSED:** Museum includes restored 1905 Beaux Art building, formerly the Carnegie Library (free to the public); collections of Grand Wood & Marvin Cone paintings, Malvina Hoffman sculptures, & Mauricio Lasansky prints and drawings.

DAVENPORT

Davenport Museum of Art

1737 W. Twelfth St., Davenport, IA 52804
☎: 319-326-7804
Open: 10-4:30 Tu-Sa, 1-4:30 Su, till 8pm Th **Closed:** Mo, LEG/HOL!
Sugg./Contr.: Yes
ઙ **℗:** Free **Museum Shop Sculpture Garden**
Permanent Collection: AM/REG; AM: 19-20; EU: 16-18; OM; MEXICAN COLONIAL; HATIAN NAIVE

Works by Grant Wood and other American Regionalists are on permanent display at the Davenport Museum, the first public art museum established in the state of Iowa (1925). **NOT TO BE MISSED:** Grant Wood's "Self Portrait."

DES MOINES

Des Moines Art Center
4700 Grand Ave., Des Moines, IA 50312-2099

☎: 515-277-4405 **◙** under construction
Open: 11-4 Daily, 12-4 Su, 11-9 Th & 1st Fr of the month **Closed:** Mo, LEG/HOL!
&: North door of north addition (notify info. desk prior to visit) **℗:** Free **Museum Shop**
¶: 11-2 lunch Tu-Sa; dinner 5:30-9 Th (by res.), 5-8 1ST Fr (light dining)
Group Tours: ex. 15
Permanent Collection: AM: ptgs, sculp, gr 19-20; EU: ptgs, sculp, gr 19-20; AF

Its parklike setting is a perfect compliment to the magnificent structure of the Des Moines Art Center building, designed originally by Eliel Saarinen in 1948, with a south wing by the noted I.M. Pei & Partners added in 1968. Another spectacular wing, recognized as a masterpiece of contemporary architecture, was designed and built, in 1985, by Richard Meier & Partners. **NOT TO BE MISSED:** "Maiastra" by Constantin Brancusi; Frank Stella's "Interlagos."

ON EXHIBIT 2001

11/11/2000 to 01/21/2001 TONY OURSLER: MID-CAREER SURVEY

Hoyt Sherman Place
1501 Woodland Ave., Des Moines, IA 50309

☎: 515-243-0913
Open: 8-4 Mo-Tu & Th-Fr; Closed on We from OCT.1-end of MAY **Closed:** Sa, Su, LEG/HOL!
&: Ramp, chairlift, elevator **℗:** Free **Museum Shop**
Docents Tour times: often available upon request
Permanent Collection: PTGS; SCULP; DEC/ART 19; EU; sculp; B.C. ARTIFACTS

A jewel from the Victorian Era, the Hoyt Sherman Art Galleries offer an outstanding permanent collection of 19th century American and European art, complimented by antique decorative arts objects that fill its surroundings. Listed NRHP. **NOT TO BE MISSED:** Major works by 19th century American masters including Church, Innes, Moran, Frieseke and others.

DUBUQUE

Dubuque Museum of Art
701 Locust St., Dubuque, IA 52001

☎: 319-557-1851
Open: 10-5 Tu-Fr; 1-4 Sa, Su **Closed:** Mo, 1/1, EASTER, 7/4, THGV, 12/25
Vol./Contr.: Adult: $3.00 **Children:** Free under 12 **Students:** $2.00 **Seniors:** $2.00
& ℗ Museum Shop
Group Tours: 319-557-1851 **Docents Tour times:** daily upon request
Permanent Collection: REG

ON EXHIBIT 2001

11/15/2000 to 02/15/2001 CONCETTA MORALES
On paper and canvas she utilizes both drawing and painting to create mixed-media compositions.

12/01/2000 to 03/15/2001 PATHWAYS OF PASTEL
Various stylistic methods of using pastel in highly representational and finely rendered imagery reflect both drawing and use as with a pallet knife.

03/01/2001 to 06/15/2001 ELLEN WAGENER
The agrarian landscape is shown in pastel.

IOWA

Dubuque Museum of Art- continued
04/06/2001 to 05/19/2001 BEYOND THE HORIZON
Sudlow and Jacobshagen: Sudlow paints the Kansas Prairie, Jacobshagen focuses on landscape in Nebraska.

06/01/2001 to 08/15/2001 FAMILY HOLDINGS: TURKISH NOMAD WEAVINGS
Sixty-five objects representing a century of tradition and most areas of Turkey.

07/01/2001 to 09/15/2001 DOUGLAS ECKHEART
Hills, fields and wooded areas are transformed into patterns of undulating lines, circles and geometric compositions.

FORT DODGE

Blanden Memorial Art Museum
920 Third Ave. South, Fort Dodge, IA 50501

☎: 515-573-2316
Open: 10-5 Tu-Fr, till 8:30 Th, 1-5 Sa & Su **Closed:** Mo and Holidays
Vol./Contr.: Yes
&: Entrance on north side of building; elevator as of spring '97
℗: Street parking and limited parking area behind the museum **Museum Shop**
Permanent Collection: AM: ptgs, sculp, gr 19-20; EU: ptgs, sculp, drgs, gr 15-20; OR: 16-20; P/COL

Established in 1930 as the first permanent art facility in the state, the Blanden's neo-classic building was based on the already existing design of the Butler Institute of American Art in Youngstown, Ohio. Listed NRHP. **NOT TO BE MISSED:** "Central Park" by Maurice Prendergast, 1901; "Self-Portrait in Cap & Scarf" by Rembrandt (etching, 1663).

GRINNELL

Faulconer Gallery And Print and Drawing Study Room
Affiliate Institution: Grinnell College
1108 Park St., Grinnell, IA 50112

☎: 515-269-4660 ▣ www.grinell.com/faulconergallery
Open: 1-5 Su-Fr during the academic year **Closed:** Sa, Call for exhibition schedule
& ℗: Available at 6th Ave. & High St.
Group Tours: 515-269-4660 **Tour times:** Su 2:15pm
Permanent Collection: WORKS ON PAPER (available for study in the Print & Drawing Study Room)

1,400 works on paper, ranging from illuminated manuscripts to 16th century European prints and drawings to 20th century American lithographs, are all part of the study group of the Grinnell College Collection that started in 1908 with an original bequest of 28 etchings by J. M. W. Turner. A new gallery, designed by Cesar Pelli, exhibits historic and contemporary art in changing exhibitions. **NOT TO BE MISSED:** Temporary exhibitions of historic and contemporary art.

ON EXHIBIT 2001
02/03/2001 to 04/15/2001 ORGANIC ABSTRACTION IN SCULPTURE

02/03/2001 to 04/22/2001 PATIENT PROCESS
Eight Midwestern abstract artists all of whom use elaborately complex processes for creating their work. The time and care are central to the power of the work.

IOWA CITY

University of Iowa Museum of Art
150 North Riverside Dr. 112 Museum of Art, Iowa City, IA 52242-1789
☎: 319-335-1727 ◙ www.uiowa.edu/~artmus
Open: 10-5 Tu-Sa, Noon-5 Su **Closed:** Mo, 1/1, THGV, 12/25
⚐ ⓟ: Metered lots directly across Riverside Drive & north of the museum **Museum Shop**
Group Tours Sculpture Garden
Permanent Collection: AM: ptgs, sculp 19-20; EU: ptgs, sculp 19-20; AF; WORKS ON PAPER

Over 10,000 objects form the basis of the collection at this 30 year old university museum that features, among its many strengths, 19th & 20th century American and European art, and the largest group of African art in any university museum collection. **NOT TO BE MISSED:** "Karneval" by Max Beckman: "Mural, 1943" by Jackson Pollock.

ON EXHIBIT 2001
11/25/2000 to 05/27/2001 EXPERIENCING THE DEVI: HINDU GODDESSES IN INDIAN POPULAR ART

01/20/2001 to 03/18/2001 LURE OF THE WEST: TREASURES FROM THE SMITHSONIAN MUSEUM OF AMERICAN ART

MARSHALLTOWN

Central Iowa Art Association
Affiliate Institution: Fisher Community College
Marshalltown, IA 50158
☎: 515-753-9013
Open: 11-5 Mo-Fr; 1-5 Sa, Su (APR 15-OCT 15) **Closed:** Sa, Su LEG/HOL!
Vol./Contr.: Yes
⚐ ⓟ: Free parking in front of building **Museum Shop Sculpture Garden**
Permanent Collection: FR/IMPR: ptgs; PTGS; CER

You don't have to be a scholar to enjoy the ceramic study center of the Central Iowa Art Association, one of the highlights of this institution. 20th century paintings and sculpture at the associated Fisher Art Gallery round out the collection. **NOT TO BE MISSED:** The Ceramic Study Collection.

MASON CITY

Charles H. MacNider Museum
303 2nd St. S.E., Mason City, IA 50401-3988
☎: 515-421-3666
Open: 9-9 Tu & Th; 9-5 We, Fr, & Sa; 1-5 Su **Closed:** Mo, LEG/HOL!, pm 12/24, pm 12/31
⚐ ⓟ **Museum Shop**
Docents Tour times: available upon advance request during museum hours
Permanent Collection: AM: ptgs, gr, drgs, cer; REG: ptgs, gr, drgs, cer; the "Bil Baird World of Puppets"

A lovely English Tudor mansion built in 1921, complete with modern additions, is the repository of an ever growing collection that documents American art and life. Though only a short two block walk from the heart of Mason City, the MacNider sits dramatically atop a limestone ravine surrounded by trees and other beauties of nature. **NOT TO BE MISSED:** For young and old alike, a wonderful collection of Bil Baird Marionettes; "Gateways to the Sea," by Alfred T. Bricher; "Spring Tryout," by Thomas Hart Benton; "The Clay Wagon," by Arthur Dove.

IOWA

Charles H. MacNider Museum - continued

ON EXHIBIT 2001

12/07/2000 to 01/21/2001 **HONORE DAUMIER: CHRONICLER OF HIS TIME (tentative)**

01/12/2001 to 03/11/2001 **IOWA FROM THE RIVER**

01/25/2001 to 03/04/2001 **GARY KELLEY: ILLUSTRATOR (tentative)**

03/16/2001 to 04/29/2001 **CHRISTIAN PETERSEN: SCULPTOR**

04/25/2001 to 05/27/2001 **EVERYBODY TALKS ABOUT THE WEATHER: FROM THE PERMANENT COLLECTION**

07/28/2001 to 09/23/2001 **THE HUMAN FACTOR: FIGURATION IN AMERICAN ART**

11/01/2001 to 01/06/2002 **IOWA CRAFTS**

MUSCATINE

Muscatine Art Center

1314 Mulberry Ave., Muscatine, IA 52761

☎: 319-263-8282
Open: 10-5 Tu, We, Fr; 10-5 & 7-9 Th; 1-5 Sa, Su **Closed:** Mo, LEG/HOL!
Vol./Contr.: Yes
♿ ℗: Free
Docents **Tour times:** self guided
Permanent Collection: AM: ptgs, sculp, gr, drgs, dec/art 19-20; NAT/AM: ptgs

The original Musser Family Mansion built in Edwardian Style in 1908, has been joined since 1976 by the contemporary 3 level Stanley Gallery to form the Muscatine Art Center. In addition to its fine collection of regional and national American art, the center has received a bequest of 27 works by 19 important European artists including Boudin, Braque, Pissaro, Degas, Matisse and others. **NOT TO BE MISSED:** The "Great River Collection" of artworks illustrating facets of the Mississippi River from its source in Lake Itasca to its southernmost point in New Orleans.

SIOUX CITY

Sioux City Art Center

225 Nebraska St., Sioux City, IA 51101-1712

☎: 712-279-6272 ▣ www.sc-artcenter.com
Open: 10-5 Tu-We & Fr-Sa, 12-9 Th, 1-5 Su **Closed:** Mo, LEG/HOL!
♿ ℗: Metered street parking & city lots within walking distance of the museum **Museum Shop**
Group Tours: 712-279-6272 ext. 200 **Docents** **Tour times:** By reservation
Permanent Collection: NAT/AM; 19-20; CONT/REG; PTGS, WORKS ON PAPER; PHOT

Begun as a WPA project in 1938, the Center features a 800 piece permanent collection that includes regional art. A stunning new $9 million Art Center building, designed by the renowned architectural firm of Skidmore, Owings and Merril, features a three-story glass atrium and a state-of-the-art Hands-On Gallery for children. **NOT TO BE MISSED:** New facility, a hands-on gallery for children featuring creative activity stations.

ON EXHIBIT 2001

10/21/2000 to 01/28/2001 **JOHN HIMMELFARB: PAINTINGS**
Large, vibrant and curvilinear works will be exhibited in 3 tiers of hallways.

Sioux City Art Center- continued
11/22/2000 to 01/21/2001 WHAT ARE YOU LOOKING AT ?
100 photographs by Weston, Evans, Abbott, Callahan, Frank and many others.

04/07/2001 to 06/16/2001 MICHAEL DE JONG: LANDSCAPES, CITYSCAPES
A view of watercolor in 3 inch diameter appearing as mere smatterings of paint, which are vast and detailed landscapes and cityscapes.

04/07/2001 to 06/16/2001 RAPHELLE GOETHALS: LUMENS
The Belgian artist uses encaustics on birch wood panels. The vastness and subtle use of beeswax, resin and pigments draw the viewer into the work.

06/09/2001 to 09/09/2001 LOCAL PERSPECTIVES 2001
A juried exhibition of arts from Siouxland within a 100 mile radius.

06/30/2001 to 08/25/2001 JAN ZELFER-REDMOND: PAINTINGS
Layers on layers of paint with subtle indecipherable hieroglyphics hidden beneath them. They require that time be spent with them.

9/18/2001 to 11/13/2001 SKYSCAPES AND LANDSCAPES: THE EVER CHANGING LOESS HILLS, THOSE FRAGILE GIANTS OF WESTERN IOWA
The exhibition includes some of Iowa's best known artists.

09/08/2001 to 11/24/2001 LAURA YOUNG: LANDSCAPES
Previously a large scale abstractionist she became enamored with landscape during an 8 month stay in Nigeria. Now she adds to this Midwest fields and woodlands.

WATERLOO

Waterloo Museum of Art
225 Commercial St., Waterloo, IA 50701

☎: 319-291-4490 **◙** www.wplwloo.lib.ia.us/waterloo/arts.html
Open: 10-5 Mo-Sa; 1-4 Su **Closed:** LEG/HOL!
Vol./Contr.: Yes
& **℗:** Ample and free **Museum Shop**
Permanent Collection: REG: ptgs, gr, sculp; HATIAN: ptgs, sculp; AM: dec/art

This museum notes as its strengths its collection of Midwest art including works by Grant Wood and Marvin Cone, an outstanding collection of Haitian paintings, metal sculpture and sequined banners, and an American decorative arts collection with particular emphasis on pottery and American art collection. **NOT TO BE MISSED:** Small collection of Grant Wood paintings, lithographs, and drawings. The largest public collection of Haitian art in US.

KANSAS

Walker Art Collection of the Garnett Public Library

125 W. 4th Ave., Garnett, KS 66032

☎: 913-448-3388 ◙ www.kanza.net/garnett
Open: 10-8 Mo, Tu, Th; 10-5:30 We, Fr; 10-4 Sa **Closed:** Su, 1/1, MEM/DAY, 7/4, THGV, 12/25
Vol./Contr.: Yes ⅾ. ℗: Free and abundant street parking **Docents** **Tour times:** Upon request if available
Permanent Collection: AM: ptgs: 20; REG

Considered one of the most outstanding collections in the state, the Walker was started with a 110 piece bequest in 1951 by its namesake, Maynard Walker, a prominent art dealer in New York during the 1930's & 40's. Brilliantly conserved works by such early 20th century American artists as John Stuart Curry, Robert Henri, and Luigi Lucioni are displayed alongside European and Midwest Regional paintings and sculpture. All works in the collection have undergone conservation in the past few years and are in pristine condition. **NOT TO BE MISSED:** "Lake in the Forest (Sunrise)" by Corot; "Girl in Red Tights" by Walt Kuhn; "Tobacco Plant" by John Stuart Curry.

Spencer Museum of Art

Affiliate Institution: University of Kansas
1301 Mississippi St., Lawrence, KS 66045

☎: 785-864-4710
Open: 10-5 Tu-Sa, Noon-5 Su, till 9pm Th **Closed:** Mo, 1/1, 7/4, THGV & FOLLOWING DAY, 12/24, 12/25
ⅾ. ℗: Metered spaces in lot north of museum & parking anywhere when school not in session. **Museum Shop**
Group Tours: School year only
Permanent Collection: EU: ptgs, sculp, gr 17-18; AM: phot; JAP: gr; CH: ptgs; MED: sculp

The broad and diverse collection of the Spencer Museum of Art, located in the eastern part of the state not far from Kansas City, features particular strengths in the areas of European painting and sculpture of the 17th & 18th centuries, American photographs, Japanese and Chinese works of art, and Medieval sculpture. **NOT TO BE MISSED:** "La Pia de Tolommei" by Rosetti; "The Ballad of the Jealous Lover of Lone Green Valley" by Thomas Hart Benton.

Birger Sandzen Memorial Gallery

401 N. 1st St., Lindsborg, KS 67456-0348

☎: 785-227-2220 ◙ www.sandzen.org
Open: 1-5 We-Su **Closed:** Mo, Tu, LEG/HOL!
Vol./Contr.: Yes ⅾ. ℗: Free in front of gallery and in lot beside church across from the gallery **Museum Shop**
Group Tours: 785-227-2220
Permanent Collection: REG: ptgs, gr, cer, sculp; JAP: sculp

Opened since 1957 on the campus of a small college in central Kansas, about 20 miles south of Salina, this facility is an important cultural resource for the state. Named after Birger Sandzen, an artist who taught at the college for 52 years, the gallery is the repository of many of his paintings. **NOT TO BE MISSED:** "The Little Triton" fountain by sculptor Carl Milles of Sweden located in the courtyard.

ON EXHIBIT 2001

04/04/2001 to 05/27/2001 103rd ANNUAL MIDWEST ART EXHIBITION
The oldest continuous exhibition in Kansas featuring Jinx Wright group shows and Gallery collections.

LOGAN

Dane G. Hansen Memorial Museum
110 W. Main, Logan, KS 67646

☎: 785-689-4846
Open: 9-12 & 1-4 Mo-Fr, 9-12 & 1-5 Sa, 1-5 Su & Holidays **Closed:** 1/1, THGV, 12/25
♿ ⓟ: Free **Group Tours:** 785-689-4846 **Docents**
Permanent Collection: OR; REG

Part of a cultural complex completed in 1973 in the heart of downtown Logan, the Hansen Memorial Museum, a member of the Smithsonian Associates, also presents regional artists. Also, Annual Labor Day Celebration, Labor Day Sunday. Car show, live entertainment, fireworks at dark, volleyball tournament and much, much more. All Free. **NOT TO BE MISSED:** Annual Hansen Arts & Craft Fair (3rd Sa of Sept) where judges select 12 artists to exhibit in the Hansen's artist corner, one for each month of the year.

ON EXHIBIT 2001

12/08/2000 to 02/11/2001 WOMEN OF TASTE

03/16/2001 to 05/06/2001 AMERICAN LANDSCAPES, PAINE ART CENTER

05/11/2001 to 07/15/2001 OUT OF THE WOODS

07/20/2001 to 08/26/2001 BETTER CHOOSE ME, KAUFFMAN MUSEUM

08/31/2001 to 10/31/2001 SUNLIGHT AND SHADOW

11/04/2001 to 12/30/2001 SHAPED WITH A PASSION

OVERLAND PARK

Johnson County Community College Gallery of Art
Affiliate Institution: Johnson County Community College
12345 College Blvd., Overland Park, KS 66210

☎: 913-469-8500 ⊡ jccc.net/gallery
Open: 10-5 Mo, Th, Fr; 10-7 Tu, We; 1-5 Sa, Su **Closed:** LEG/HOL!; Su, June - August
♿ ⓟ: Free ⊪
Group Tours: 913-469-8500 x3789 **Sculpture Garden**
Permanent Collection: AM/ CONT: ptgs, cer, phot, works on paper

The geometric spareness of the buildings set among the gently rolling hills of the campus is a perfect foil for the rapidly growing permanent collection of contemporary American art. Sculptures by Jonathan Borofsky, Barry Flanagan, Judith Shea, Louise Bourgeois, and Magdalena Abakanowicz are joined by other contemporary works in the Oppenheimer-Stein Sculpture Collection sited over the 234-acre campus. **NOT TO BE MISSED:** Oppenheimer-Stein Sculpture Collection.

SALINA

Salina Art Center
242 S. Santa Fe, Salina, KS 67401

☎: 785-827-1431 ⊡ www.salinaartcenter.org
Open: 12-5 Tu-Sa; 1-5 Su; till 7 Th **Closed:** Mo, LEG/HOL!
♿ ⓟ: Free handicapped parking **Group Tours:** 785-827-1431 **Docents** **Tour times:** 9-5 Tu-Fr; call to schedule
Permanent Collection: No

KANSAS

Salina Art Center- continued

Recognized across the Midwest for bringing together art, artists, and audiences in innovative ways, the Salina Art Center specializes in exhibiting and interpreting contemporary art. Rotating high quality original multicultural exhibitions, traveling exhibitions (often featuring works by international artists), and a permanent Discovery Area hands-on laboratory for children are its main features. **NOT TO BE MISSED:** A state of the art movie facility, Art Center Cinema, one block from the gallery, features the best contemporary international and American film. Open Th-Su weekly. Cinema phone: 785-452-9868.

TOPEKA

Gallery of Fine Arts-Topeka & Shawnee County

1515 W. 10th, Topeka, KS 66604-1374

☎: 913-233-2040

Open: 9-9 Mo-Fr, 9-6 Sa, 2-6 Su **Closed:** LEG/HOL!

&: Ground entry via automatic doors ℗: Free ⑪: for 2002 new facility

Permanent Collection: REG: ptgs, gr 20; W/AF; AM: cer, glass paperweights

Although the fine art permanent collection is usually not on view, this active institution presents rotating exhibitions that are mainly regional in nature. **PLEASE NOTE:** Beginning 6/15/97, the museum will be closed until the year 2002 due to a major construction project that will double its exhibition space and allow for more of the permanent collection to be on display. **NOT TO BE MISSED:** Glass paperweights; Akan gold weights from Ghana and the Ivory Coast, West Africa.

Mulvane Art Museum

Affiliate Institution: Washburn University

7th & Jewell, Topeka, KS 66621-1150

☎: 785-231-1124

Open: SEPT-MAY: 10-7 Tu-We, 10-4 Th & Fr, 1-4 Sa, Su; SUMMER: 10-4 Tu-Fr & 1-4 Sa, Su **Closed:** Mo, LEG/HOL! & during exhibit installations

Vol./Contr.: Yes

& ℗: Free **Museum Shop**

Group Tours: 785-231-1010 x1322 **Docents** **Tour times:** by appointment, 10-3 Tu-Fr **Sculpture Garden**

Permanent Collection: EU: dec/art 19-20; AM: dec/art 19-20; JAP: dec/art 19-20; REG: cont ptgs; GR; SCULP; CER; PHOT

Opened in 1924, the Mulvane is the oldest art museum in the state of Kansas, located on the campus of Washburn University. In addition to an ever growing collection of works by artists of Kansas and the Mountain-Plains region, the museum counts both an international and a Japanese print collection among its holdings.

ON EXHIBIT 2001

01/26/2001 to 02/25/2001 INSTALLATIONS BY CAROL ANN CARTER AND DIANE HENK

03/10/2001 to 04/22/2001 TOPEKA COMPETITION AND HASKELL PHOTO EXHIBITION

06/02/2001 to 07/29/2001 AFRICAN AMERICAN WORKS ON PAPER

08/11/2001 to 09/30/2001 DIFFERENT REALITIES: PAINTINGS BY RANDALL EXON, ROBERT BRAWLEY, JOHN KUHN

10/13/2001 to 12/23/2001 BODY SHOW

WICHITA

Edwin A. Ulrich Museum of Art
Affiliate Institution: Wichita State University
1845 Fairmount St., Wichita, KS 67260-0046
☎: 316-978-3664 ◙ www.twsu.edu/~ulrich
Open: 12-5 Daily **Closed:** 1/1, 1/18, MEM/DAY, EASTER, 7/4, 7/5, LAB/DAY, THGV, 12/24-25
& ℗: Visitor lot available.
Group Tours: 316-978-6413 **Docents Tour times:** by appt **Sculpture Garden**
Permanent Collection: AM: 19-20; EU: 19-20; PRIM; AM: gr; EU: gr; PHOT

The Edwin A. Ulrich Museum of Art at Wichita State University is recognized among university museums for its outdoor sculpture collection and for the quality of its exhibition program. 19th and 20th century European and American sculpture, prints, drawings, and paintings form the core of the 7,300 object collection. A major aspect of the collection is the 64-piece outdoor sculpture collection, named in honor of the founding director of the museum, placed around the 330 acre campus of Wichita State University. The collection contains a cross-section of 19th and 20th century sculptures by artists such as Auguste Rodin, Henry Moore, Louise Nevelson, George Rickey, Lynn Chadwick, and Luis Jimenez, among others. The Ulrich has an outstanding exhibition program and acts as a visual laboratory for the students of the University as well as the community. Exhibitions range from established art work—often from the museum's collection—to more contemporary exhibitions highlighting prominent artists working today. **NOT TO BE MISSED:** Sculpture collection on grounds of university; Collection of marine paintings by Frederick J. Waugh; "Personnages Oiseaux" mural by Joan Miró

Indian Center Museum
650 N. Seneca, Wichita, KS 67203
☎: 316-262-5221 ◙ WWW2.SOUTHWIND.NET/~ICM/MUSEUM/ICM
Open: 10-5 Mo-Sa (closed Mo JAN-MAR) **Closed:** Su, LEG/HOL!
ADM: Adult: $2.00 **Children:** Free 6 & under **Students:** $1.00 **Seniors:** $1.00
℗: Free **Museum Shop**
Permanent Collection: NAT/AM

The artworks and artifacts in this museum preserve Native American heritage and provide non-Indian people with insight into the culture and traditions of Native Americans. In addition to the art, Native American food is served on Tuesday from 11-4. **NOT TO BE MISSED:** Blackbear Bosin's 44 foot "Keeper of the Plains" located on the grounds at the confluence of the Arkansas & Little Arkansas Rivers.

Wichita Art Museum
619 Stackman St., Wichita, KS 67203-3296
☎: 316-268-4921 ◙ www.wichitaartmuseum.org
Open: 10-5 Tu-Sa, 12-5 Su **Closed:** Mo, LEG/HOL
Vol./Contr.: $3.00
& ℗: Free **Museum Shop**
Group Tours: 316-268-4907 **Docents Tour times:** Su, 1:30pm
Permanent Collection: AM: ptgs, ge, drgs; EU: gr, drgs; P/COL; CHARLES RUSSELL: ptgs, drgs, sculp; OM: gr

Outstanding in its collection of paintings that span nearly 3 centuries of American art, the Wichita is also known for its Old Master prints and pre-Columbian art. A $10,000,000 expansion will start summer 2000. Special exhibitions throughout will feature permanent collections. The first is STARTING WITH SCULPTURE. **NOT TO BE MISSED:** The Roland P. Murdock Collection of American Art.

KANSAS

Wichita Center for the Arts

9112 East Central, Wichita, KS 67206

☎: 316-634-2787 ◙ www.wcfta.com
Open: 1-5 Tu-Su **Closed:** Mo, LEG/HOL!
& ℗: on-site free parking spaces **Museum Shop**
Permanent Collection: DEC/ART: 20; OR; PTGS; SCULP; DRGS; CER; GR

Midwest arts, both historical and contemporary, are the focus of this vital multi-disciplinary facility. **NOT TO BE MISSED:** 3,500 piece Bruce Moore Collection.

LEXINGTON

University of Kentucky Art Museum
Rose & Euclid Ave., Lexington, KY 40506-0241

☎: 859-257-5716 ◉ www.uky.edu/artmusueum
Open: 12-5 Tu-Su; 12-8 Fri **Closed:** Mo, ACAD!
Vol./Contr.: Yes
& ℗: Parking available in the circular drive in front of the Center and behind the Faculty Club on Columbia Ave.
Group Tours: 859-257-8164 **Docents** **Tour times:** By Appt
Permanent Collection: OM: ptgs, gr; AM: ptgs 19; EU: ptgs 19; CONT/GR; PTGS 20; AF; Asian; WPA WORKS

Considered to be one of Kentucky's key cultural resources, this museum houses over 3,500 art objects that span the past 2,000 years of artistic creation.

ON EXHIBIT 2001
08/22/2000 to 07/01/2001 A SILVER CELEBRATION: THE COLLECTION AT 25
Perennial collection favorites, recently conserved paintings on view for the first time, and media have been organized into groups: Real/Imagined Worlds; A Human Image; The Language of Abstraction . The installation encourages visitors to discover new ways of looking at familiar images and the scope and richness of the collection. The first part will be on view until 12/23/00, the second part will open 2/23/01 to 7/1/01.

LOUISVILLE

Photographic Archives
Affiliate Institution: University of Louisville Libraries
Ekstrom Library, University of Louisville, Louisville, KY 40292

☎: 502-852-6752 ◉ http://www.louisville.edu/library/ekstrom/special/pa-info.html
Open: 10-4 Mo-Fr, 10-8 Th **Closed:** Sa, Su, LEG/HOL!
& ℗: Limited (for information call 502-852-6505)
Permanent Collection: PHOT; GR

With 33 individual collections, and over one million items, the Photographic Archives is one of the finest photography and research facilities in the country. **NOT TO BE MISSED:** 2,000 vintage Farm Security Administration photos; more than 1,500 fine prints "from Ansel Adams to Edward Weston."

Speed Art Museum
2035 S. Third St. Louisville, KY 40208

☎: 502-634-2700 ◉ www.speedmuseum.org
Open: 10:30-4 Tu-We, Fr, Sa 10:30-5, 12-5 Su, till 8pm Th **Closed:** Mo 1/1, Kentucky Derby Day, 7/4, Thgv.
Sugg./Contr.: $4.00
& ℗: Adjacent to the museum - $3.00 fee for non-members **Museum Shop** ¶: Bristol Cafe,11:30-2 Tu-Sa
Group Tours: 502-634-2725 **Docents** **Tour times:** 2pm Sa, 1 & 3pm Su, 7pm Th **Sculpture Garden**
Permanent Collection: AM: dec/art; PTGS; SCULP: GR; PRIM; OR; DU:17; FL:17; FR: ptgs 18; CONT

Founded in 1927, and located on the main campus of the University of Louisville, the newly renovated Speed Art Museum is the largest (over 8,000 works) and the most comprehensive (spanning 6,000 years of art history) public art collection in Kentucky. Free "Especially For Children" tours are offered at 1:00 pm each Saturday. **PLEASE NOTE:** A fee is charged for selected exhibitions. **NOT TO BE MISSED:** New acquisitions: "Sevre porcelains associated with King Louis XVIII; "Landscape with cottages and a Blasted Tree" by Jacob Isaacz van Ruisdael, 1653; vase by Rude Osolnick, 1996.

Speed Art Museum - continued

ON EXHIBIT 2001

10/2000 to 01/2001 CONTEMPORARY ART FROM THE PERMANENT COLLECTION

08/26/2000 to late 2001! THE CONQUESTS OF LOUIS XIV

10/17/2000 to 02/18/2001 DJAWID C. BOROWER: PORTRAITS OF MONEY
Nine paintings of imagery taken from bank notes and representing U.S. Presidents, Queen Elizabeth, and Alberto Giacometti.

04/13/2001 to 04/27/2001 JACOB LAWRENCE: THE FREDERICK DOUGLASS AND HARRIET TUBMAN SERIES OF NARRATIVE PAINTINGS
The 63 paintings (1938-40) exhibited tell the story of the two abolitionists who lived around the Civil War and each depicts a significant event in the life of its hero.

05/22/2001 to 08/12/2001 WILLIAM WEGMAN: FASHION PHOTOGRAPHS
Large scale Polaroid photographs that take inspiration from the world of haute couture featuring designer clothes on dogs.
Will Travel

09/2001 to 10/2001 GATHERING LIGHT - RICHARD ROSS PHOTOGRAPHY

11/16/2001 to 01/27/2002 NOTABLE AMERICANS FROM THE NATIONAL PORTRAIT GALLERY
Including 75 portraits by the most important portrait artists in the past 200 years.

OWENSBORO

Owensboro Museum of Fine Art
901 Frederica St., Owensboro, KY 42301

☎: 502-685-3181 **Open:** 10-4 Tu-Fr; 1-4 Sa, Su **Closed:** Mo, LEG/HOL!
Vol./Contr.: ADM: Adult: $2.00 **Children:** $1.00 & ℗: Free **Museum Shop**
Group Tours: 502-685-3181
Permanent Collection: AM: ptgs, drgs, gr, sculp 19-20; BRIT: ptgs, drgs, gr, sculp 19-20; FR: ptgs, sculp, drgs, gr 19-20; CONT/AM; DEC/ART 14-18

The collection of the Owensboro Museum, the only fine art institution in Western Kentucky, features works by important 18-20th century American, English, and French masters. Paintings by regional artists stress the strong tradition of Kentucky landscape painting. There is a restored Civil War era mansion, the John Hampdem Smith House, serves as a decorative arts wing for objects dating from the 15th to 19th century. **NOT TO BE MISSED:** 16 turn-of-the-century stained glass windows by Emil Frei (1867-1941) permanently installed in the new wing of the museum; revolving exhibitions of the museum's collection of Appalachian folk art.

PADUCAH

Yeiser Art Center
200 Broadway, Paducah, KY 42001-0732

☎: 270-442-2453 ▣ www.yeiser.org
Open: 10-4 Tu-Sa, 1-4 Su **Closed:** Mo, LEG/HOL! & JAN.
ADM: Adult: $1.00 & ℗: Free **Museum Shop**
Docents Tour times: Usually available upon request
Permanent Collection: AM, EU, AS & AF: 19-20

The restored 1905 Market House (listed NRHP), home to the Art Center and many other community related activities, features changing exhibitions that are regional, national, and international in content. **NOT TO BE MISSED:** Annual national fiber exhibition mid Mar thru Apr (call for exact dates).

ALEXANDRIA

Alexandria Museum of Art

933 Main St., Alexandria, LA 71301-1028

☎: 318-443-3458 ◙ www.themuseum.org
Open: 10-5 Tu-Fr; 1-5 Sa **Closed:** Su, Mo, LEG/HOL!
ADM: Adult: $4.00 **Children:** $2.00 **Students:** $3.00 **Seniors:** $3.00
& ℗: Free General, Handicap and Bus parking in front of building. **Museum Shop**
�: Catered lunch can be pre-arranged in atrium café.
Group Tours: 318-443-3458 ext. 18 **Docents** **Tour times:** often available upon request! **Sculpture Garden**
Permanent Collection: CONT: sculp, ptgs; REG; FOLK

The grand foyer of the new wing of the Alexandria Museum of Art, was constructed and opened to the public in March of 1998. The Museum was founded in 1977 and originally occupied the Historic Rapides Bank Building, circa 1898, listed on the National Historic Register. The expanded AMoA is the centerpiece of Alexandria's riverfront, situated on the entire 900 block of Main Street. **NOT TO BE MISSED:** Native expression exhibit of Louisiana art and children's gallery.

ON EXHIBIT 2001

01/08/2001 to 03/11/2001 PHOTOGRAPHY GUILD EXHIBITS
An exhibiton of recent works by members of the local photography guild.

03/25/2001 to 06/20/2001 ART OF THE AMERICAN WEST
Lithographs and wood engravings from Audubon, Bierstadt, Bodmer, Remington, Catlin, and Stanley, among others.

08/25/2001 to 09/27/2001 CONTEMPORARY ARTIST GUILD JURIED EXHIBITION
Third annual exhibition of works by members of the Contemporary Artist Guild.

08/25/2001 to 10/27/2001 19TH ANNUAL SEPTEMBER COMPETITION
Works by area children created during 1998 summer art programs.

11/03/2001 to 12/29/2001 LOUISIANA ARTISTS SERIES
Eighth in the series of exhibitions of works by contemporary Louisiana artists.

BATON ROUGE

Louisiana Arts and Science Center

100 S. River Rd., Baton Rouge, LA 70802

☎: 225-344-5272 ◙ www.lascmuseum.org
Open: 10-3 Tu-Fr, 10-4 Sa, 1-4 Su **Closed:** Mo, LEG/HOL!
Free Day: First Su of month **ADM: Adult:** $3.00 **Children:** $2.00 (2-12) **Students:** university $2.00 **Seniors:** $2.00
& ℗: Limited free parking in front of building and behind train; other parking areas available within walking distance
Museum Shop
Group Tours: 225-344-9478 **Sculpture Garden**
Permanent Collection: SCULP; ETH; GR; DRGS; PHOT; EGT; AM: ptgs 18-20; EU: ptgs 18-20

LASC, housed in a reconstructed Illinois Central Railroad Station, offers changing fine art exhibitions, Egyptian tomb with mummies, and a five-car train (undergoing restoration). Hands-on areas for children include Discovery Depot, an "edutainment" area, and Science Station, an interactive science gallery. The Challenger Learning Center is a simulated space station and mission control center (reservations required). LASC will open its state-of-the-art plantarium space theatre in early 2002. This advanced facility will feature planetarium shows as well as large format films. **NOT TO BE MISSED:** Works by John Marin, Charles Burchfield, Asher B. Durand; Baroque, Neo-Classic, & Impressionist Works; Native American totem pole; 2nd largest collection in the U.S. of sculpture by Ivan Mestrovic.

LOUISIANA

Louisiana Arts and Science Center- continued

ON EXHIBIT 2001

12/23/2000 to 03/17/2001 CROSSING THE THRESHOLD
As we approach a new millennium this exhibition reflects on the artistic milestones of women artists during the past 100 years. While striving for equality, the women included here will be remembered for challenging and overcoming the traditional social mores of our American culture. Artists include Louise Bourgeois, Elizabeth Catlett, Helen Frankenthaler, Nell Blaine, Agnes Martin, Nancy Spero, Lois Mailou Jones and others.

03/20/2001 to 06/03/2001 THE ART OF DONALD ROLLER WILSON
Simians, canines and felines dressed to "the nines" cavort in a fantastic realm of forests where olives or pickles float mid-air.

06/05/2001 to 07/29/2001 DONG KINGMAN: AN AMERICAN MASTER
A retrospective of the American born Chinese artist spans a career from the 1930's the 1990's.

09/28/2001 to 10/28/2001 A SENSE OF PLACE, A SENSE OF PRESENCE: A PORTRAIT OF SOUTH LOUISIANA
Photographer J. J. Meek has created a portrait of people and the changing landscape along River Road. Included are the sugar cane industry and the industrial landscape of oil refineries, factories and chemical plants.

JENNINGS

Zigler Museum
411 Clara St., Jennings, LA 70546
☎: 318-824-0114 ◙ www.JeffDavis.org
Open: 9-5 Tu-Sa, 1-5 Su **Closed:** Mo, LEG/HOL!
Sugg/Contr.: ADM: Adult: $2.00 **Children:** $1.00 ᕫ ℗: Free **Museum Shop**
Docents Tour times: Usually available upon request
Permanent Collection: REG; AM; EU

The gracious colonial style structure that had served as the Zigler family home since 1908, was formerly opened as a museum in 1970. Two wings added to the original building feature many works by Louisiana landscape artists in addition to those by other American and European artists. **PLEASE NOTE:** The museum is open every day for the Christmas festival from the first weekend in Dec. to Dec. 22. **NOT TO BE MISSED:** Largest collection of works by African-American artist, William Tolliver.

LAFAYETTE

University Art Museum
Affiliated Institution: University of Louisiana, Layfayette
Joel L. Fletcher Hall, 2nd Floor, East Lewis & Girard Park Dr., Lafayette, LA 70504
☎: 318-482-5326 ◙ www.illl.edu/vam/
Open: 9-4 Mo-Fr, 10-4 Sa, closed on Sa during summer 2000 **Closed:** Su S, 1/1, MARDI GRAS, EASTER, THGV, 12/25, LEG/HOL! ᕫ ℗: Free with validation in paylot
Group Tours: 337-482-5326 **Docents Tour times:** reservation only; Mo-Fr 9 -11:30 and 1:30 -3:30
Permanent Collection: AM/REG: ptgs, sculp, drgs, phot 19-20; JAP: gr; PLEASE NOTE: Selections from the permanent collection are on display approximately once a year (call for specifics)

The University Art Museum is situated on the beautiful campus of The University of Louisiana Lafayette, home of Cypress Lake. The UAM offers visitors art exhibitions of regional, national and international acclaim. The Permanent Collection is housed in an 18th century style plantation home on the corner of Girard Park Drive and St. Mary Boulevard. Permanent holdings include works by Henri Le Sidaner, Franz Marc, Sir Godfrey Kneller, G.P.A. Healy, Henry Pember Smith, and Adolph Rinck to name only a few. Overlooking Girard Park, touring exhibits can be seen in the more modern Fletcher Hall Gallery located in the Art & Architecture Building on the U.L. Lafayette campus.

Masur Museum of Art

1400 S. Grand, Monroe, LA 71202
(: 318-329-2237
Open: 9-5 Tu-Th, 2-5 Fr-Su **Closed:** Mo, LEG/HOL!
&: Access to first floor only **℗:** Free
Docents Tour times: call for hours **Sculpture Garden**
Permanent Collection: AM: gr 20; REG/CONT

Twentieth century prints by American artists, and works by contemporary regional artists, form the basis of the permanent collection of this museum which is housed in a stately modified English Tudor estate situated on the tree-lined banks of the Ouachita River.

Historic New Orleans Collection

533 Royal St., New Orleans, LA 70130
(: 504-523-4662 **◙** www.hnoc.org
Open: 10-4:30 Tu-Sa **Closed:** Su, Mo, LEG/HOL!
Free Day: MAIN EXHIBITION HALL Tu-Sa **ADM: Adult:** $4.00
& Museum Shop
Group Tours: 504-523-4662 **Docents Tour times:** 10, 11, 2 & 3 DAILY
Permanent Collection: REG: ptgs, drgs, phot; MAPS; RARE BOOKS, MANUSCRIPTS

Located within a complex of historic French Quarter buildings, the Historic New Orleans Collection serves the public as a museum and research center for state and local history. Merieult House, one of the oldest buildings of this complex, was built in 1792 during Louisiana's Spanish Colonial period. It is one of the few structures in the French Quarter that escaped the fire of 1794. The Williams Research Center, 410 Chartres St. part of this institution, contains curatorial, manuscript and library material relating to the history and culture of Louisiana. **NOT TO BE MISSED:** Tours of the LA. History Galleries and Founders Residence.

Louisiana State Museum

751 Chartres St. Jackson Square, New Orleans, LA 70116
(: 800-568-6968 **◙** http://lsm.crt.state.la.us
Open: 9-5 Tu-Su **Closed:** Mo, LEG/HOL!
ADM: Adult: $5.00 **Children:** Free 12 & under **Students:** $4.00 **Seniors:** $4.00
&: Presbytere, Old U.S. Mint, and Cabildo are accessible **Museum Shop**
Docents Tour times: Gallery talks on weekends - call for specifics
Permanent Collection: DEC/ART; FOLK; PHOT; PTGS; TEXTILES

Several historic buildings, located in the famous New Orleans French Quarter are included in the Louisiana State Museum complex and provide the visitor with a wide array of viewing experiences that run the gamut from fine art to decorative art, textiles, Mardi Gras memorabilia, and even jazz music. The Cabildo, Presbytere, and 1850 House (all located on Jackson Square) and the Old U.S. Mint are currently open to the public. **PLEASE NOTE THE FOLLOWING:** (1) Although the entry fee of $5.00 is charged per building visited, a discounted rate is offered for a visit to two or more sites. (2) 1850 House features special interpretive materials for handicapped visitors. **NOT TO BE MISSED:** Considered the State Museum's crown jewel, the recently reopened Cabildo features a walk through Louisiana history from Colonial times through Reconstruction. Admission to the Arsenal, featuring changing exhibits, is included in the entry fee to the Cabildo.

LOUISIANA

New Orleans Museum of Art

1 Collins Diboll Circle, City Park, P.O. Box 19123, New Orleans, LA 70119-0123

☎: 504-488-2631 ▣ www.noma.org
Open: 10-5 Tu-Su **Closed:** Mo, LEG/HOL!
Free Day: 10-noon Th for Louisiana residents only, except for some special exh
ADM: Adult: $6.00 **Children:** $1.00 (3-17) **Students:** $5.00 **Seniors:** $5.00
&. ℗: Free **Museum Shop** ¶: Courtyard Cafe 10:30-4:30 Tu-Su (children's menu available)
Docents Tour times: 11:00 & 2:00 Tu-Su and by appointment for groups of 10 or more **Sculpture Garden**
Permanent Collection: AM; OM: ptgs; IT/REN: ptgs (Kress Collection); FR; P/COL: MEX; AF; JAP: gr; AF; OC; NAT/AM; LAT/AM; AS; DEC/ART: 1st. A.D.-20; REG; PHOT; GLASS

Located in the 1,500 acre City Park, the 75 year old New Orleans Museum recently completed a $23 million dollar expansion and renovation program that doubled its size. Serving the entire Gulf South as an invaluable artistic resource, the museum houses over one dozen major collections that cover a broad range of fine and decorative art. **NOT TO BE MISSED:** Treasures by Faberge; Chinese Jades; French Art; Portrait Miniatures; New 3rd floor showcase for Non-Western Art; The stARTing point, a new hands-on gallery area with interactive exhibits and 2 computer stations designed to help children and adults understand the source of artists' inspiration.

ON EXHIBIT 2001

11/12/2000 to 01/07/2001 HENRY CASSELLI: MASTER OF THE AMERICAN WATERCOLOR
A mid-career retrospective features 125 watercolors in the Homer-Wyeth-Sargent tradition.

11/12/2000 to 01/07/2001 MAGNIFICENT, MARVELOUS MARTELE: SILVER FROM THE COLLECTION OF ROBERT AND JULIE SHELTON
NOMA is celebrating the 100th Anniversary of Martele, introduced by Gorham Siover Company at the Paris exhibtion of 1900

SHREVEPORT

Meadows Museum of Art of Centenary College

2911 Centenary Blvd., Shreveport, LA 71104-1188

☎: 318-869-5169 ▣ www.centenary.edu
Open: 12-4 Tu, We, Fr, 12-5 Th, 1-4 Sa, Su **Closed:** Mo, LEG/HOL!
&.: ℗: Free behind the building **Museum Shop**
Group Tours: 318-869-5169 **Docents Tour times:** Upon request if available
Permanent Collection: PTGS, SCULP, GR, 18-20; INDO CHINESE: ptgs, gr

This museum, opened in 1976, serves mainly as a repository for the unique collection of works in a variety of media by French artist Jean Despujols and the Centenary College collection. The Museum's galleries also boast a series of temporary exhibitions throughout the year. **NOT TO BE MISSED:** The permanent collection itself which offers a rare glimpse into the people & culture of French Indochina in 1938. Also includes American and European paintings and works on paper from the college collection.

ON EXHIBIT 2001

11/2000 to 01/2001 LOUISIANA TREASURE HOUSES

11/19/2000 to 02/01/2001 CREATING A JEWISH STYLE: WORKS FROM THE BEZALEL ACADEMY 1906-1996
Seventy-five religious and secular works created by the artisans of Bezalel Academy in Jerusalem during the 20th century.

02/24/2001 to 08/18/2001 MASTERPIECES OF THE MEADOWS: NEWLY CONSERVED WORKS FROM THE PERMANENT COLLECTION

R. W. Norton Art Gallery

4747 Creswell Ave., Shreveport, LA 71106

☏: 318-865-4201 ▣ www.softdisk.com/comp/norton
Open: 10-5 Tu-Fr; 1-5 Sa, Su **Closed:** Mo, LEG/HOL!
& ℗: Free **Museum Shop**
Docents Tour times: reg hours
Permanent Collection: AM: ptgs, sculp (late 17-20); EU: ptgs, sculp 16-19; BRIT: cer

With its incomparable collections of American and European art, the Norton, situated in a 46 acre wooded park, has become one of the major cultural attractions in the region since its opening in 1966. Among its many attractions are the Bierstadt Gallery, the Bonheur Gallery, and the Corridor which features "The Prisons," a 16-part series of fantasy etchings by Piranesi. Those who visit the museum from early to mid April will experience the added treat of seeing 13,000 azalea plants that surround the building in full bloom. **NOT TO BE MISSED:** Outstanding collections of works by Frederic Remington & Charles M. Russell; The Wedgwood Gallery (one of the finest collections of its kind in the southern U.S.).

ON EXHIBIT 2001

09/08/2001 to 11/03/2002 WEST BY SOUTHWEST

MAINE

BRUNSWICK

Bowdoin College Museum of Art
9400 College Station, Brunswick, ME 04011-8494

℃: 207-725-3275 ◙ www.bowdoin.edu/artmuseum
Open: 10-5 Tu-Sa, 2-5 Su **Closed:** Mo, LEG/HOL! ALSO CLOSED WEEK BETWEEN 12/25 & NEW YEARS DAY
Vol./Contr.: Yes
♿: Call for assistance (207) 725-3275 **℗:** All along Upper Park Row **Museum Shop** **¶:** on campus, in town
Group Tours: 207-725-3276
Permanent Collection: AN/GRK; AN/R; AN/EGT; AM: ptgs, sculp, drgs, gr, dec/art; EU: ptgs, sculp, gr, drgs, dec/art; AF: sculp; INTERIOR MURALS BY LAFARGE, THAYER, VEDDER, COX

From the original bequest of artworks given in 1811 by James Bowdoin III, who served as Thomas Jefferson's minister to France and Spain, the collection has grown to include important works from a broad range of nations and periods. **NOT TO BE MISSED:** The American collections including Gilbert Stuart's presidential portraits of Jefferson and Madison. The American collections include objects by significant artists working in every period of United States History.

ON EXHIBIT 2001
01/27/2001 to 03/18/2001 WILLIAM KENTRIDGE: WEIGHING... AND WANTING
South African artist Kentridge's 18 charcoal drawings and a laser disc video projection. Viewers respond to his beautiful drawings, emotional use of color and moving sound track. *Will Travel*

04/06/2001 to 06/03/2001 SMITHSONIAN AFRICAN AMERICAN PHOTOGRAPHY: THE FIRST 100 YEARS 1842-1942
African Americans were pioneers of the medium of photography. Julius Lion began producing daugerreotypes in New Orleans in 1840, one year after the invention of the process. Using Lion's work as a starting point, this exihibition follows the development of African American phtography through it first hundred years.

LEWISTON

Bates College Museum of Art
Affiliate Institution: Bates College
Olin Arts Center, Bates College, Lewiston, ME 04240

℃: 207-786-6158 ◙ www.bates.edu/acad/museum
Open: 10-5 Tu-Sa, 1-5 Su **Closed:** Mo, LEG/HOL!
♿. ℗: Free on-street campus parking
Group Tours: by appt
Permanent Collection: AM: ptgs, sculp; GR 19-20; EU: ptgs, sculp, gr; drgs

The recently constructed building of the Museum of Art at Bates College houses a major collection of works by American artist Marsden Hartley. It also specializes in 20th-century American and European prints, drawings, and photographs, and has a small collection of 20th century American paintings. **NOT TO BE MISSED:** Collection of Marsden Hartley drawings and memorabilia.

ON EXHIBIT 2001
11/10/2000 to 03/30/2001 ANDREW WYETH: HER ROOM

OGUNQUIT

Ogunquit Museum of American Art

181 Shore Rd., Ogunquit, ME 03907

☎: 207-646-4909 ◙ www.maineartmueums.org
Open: (open 7/1 through 9/30 ONLY) 10:30-5 Mo-Sa, 2-5 Su **Closed:** LAB/DAY
ADM: Adult: $4.00 **Children:** Free under 12 **Students:** $3.00 **Seniors:** $3.00
&: Enter lower level at seaside end of bldg; wheelchairs available ℗: Free on museum grounds **Museum Shop**
Docents Tour times: Upon request if available **Sculpture Garden**
Permanent Collection: AM: ptgs, sculp 20

Situated on a rocky promontory overlooking the sea, this museum has been described as the most beautiful small museum in the world! Built in 1952, the Museum houses many important 20th century American paintings and works of sculpture in addition to site-specific sculptures spread throughout its three acres of land. **NOT TO BE MISSED:** "Mt. Katadhin, Winter" by Marsden Hartley; "The Bowery Drunks" by Reginald Marsh; "Pool With Four Markers" by Dozier Bell; "Sleeping Girl" by Walt Kuhn.

ORONO

University of Maine Museum of Art

5712 Carnegie Hall, Orono, ME 04469-5712

☎: 207-581-3255 ◙ umaine.edu/artmuseum
Open: 9-4:30 Mo-Sa (summer hours 9-4) **Closed:** Su, STATE & LEG/HOL!
℗: Free with visitor permits available in director's office.
Group Tours: by appt
Permanent Collection: AM: gr, ptgs 18-20; EU: gr, ptgs 18-20; CONT; REG

Housed in a beautiful 1904 structure of classic Palladian design, this university art museum, located just to the north east of Bangor, Maine, features American and European art of the 18th-20th centuries, and works by Maine based artists of the past and present. The permanent collection is displayed throughout the whole university and in the Maine Center-for-the-Arts building.

PORTLAND

Portland Museum of Art

Seven Congress Square, Portland, ME 04101

☎: 207-775-6148 ◙ www.portlandmuseum.org
Open: 10-5 Tu, We, Sa, Su; 10-9 Th, Fr (open 10-5 Mo MEM/DAY to Columbus Day) **Closed:** Mo, LEG/HOL!, 12/25, 1/1, THGV
Free Day: 5-9 Fr **ADM: Adult:** $6.00 **Children:** $1.00 (6-12) **Students:** $5.00 **Seniors:** $5.00
& ℗: Nearby garages **Museum Shop** ¶: Museum Cafe
Group Tours: 207-775-6148 **Docents Tour times:** 2pm
Permanent Collection: AM; ptgs, sculp 19-20; REG; DEC/ART; gr

The Portland Museum of Art is the oldest and largest art museum in the state of Maine. Established in 1882, the outstanding museum features European and American master works housed in an award-winning building designed by renowned architect I.M. Pei & Partners. **PLEASE NOTE:** Also, there is a toll free number (1-800-639-4067) for museum recorded information.

ON EXHIBIT 2001
12/21/2000 to 03/18/2001 WILL BARNET: A TIMELESS WORLD

MAINE

Portland Museum of Art- continued

01/18/2001 to 03/18/2001 IN SEARCH OF THE PROMISED LAND: FREDERIC EDWIN CHURCH AND EXPLORATION
A showcase of the artist's career and how his interests in exploration and the natural world were manifested in his art.

03/07/2001 to 05/06/2001 RECORDING LIFE: THE PHOTOGRAPHS OF LEON LEVINSTEIN

06/21/2001 to 10/21/2001 AMERICAN IMPRESSIONISM FROM THE NATIONAL MUSEUM OF AMERICAN ART
Canvases full of light and color by Hassam, Whistler, Cassatt, Twachtman and Dewing.

ROCKLAND

Farnsworth Art Museum and Wyeth Center
352 Main St., Rockland, ME 04841-9975

℡: 207-596-6457 **◙** www.wyethcenter.com; www.farnsworthmuseum.org
Open: SUMMER: 9-5 daily; WINTER: 10-5 Tu-Sa, 1-5 Su **Closed:** THGVNG, 12/25
ADM: Adult: $9.00 **Children:** Free under 17 **Students:** $5.00 **Seniors:** $7.00
& **℗:** Free **Museum Shop Group Tours:** ex 104 **Docents**
Permanent Collection: AM: 18-20; REG; PHOT; GR

Nationally acclaimed for its collection of American Art, the Farnsworth, located in the mid coastal city of Rockland, counts among its important holdings the largest public collection of works by sculptor Louise Nevelson. The museum's 12 galleries offer a comprehensive survey of American art. Recently, the museum opened the Wyeth center, a new gallery building and study center, to house the works of Andrew, N.C. and Jamie Wyeth. The Jamison Morehouse wing offers 4 new galleries and another entrance on Main St. **NOT TO BE MISSED:** Major works by N.C., Andrew & Jamie Wyeth, Fitz Hugh Lane, John Marin, Edward Hopper, Neil Welliver, Louise Nevelson; The Olson House, depicted by Andrew Wyeth in many of his most famous works.

ON EXHIBIT 2001

10/29/2000 to 02/04/2001 AMERICAN TWENTIETH CENTURY WATERCOLORS FROM THE MUNSON-WILLIAMS-PROCTOR INSTITUTE

02/17/2001 to 06/03/2001 HAROLD GARDE: KIMONO

02/17/2001 to 06/03/2001 JOHN WISSEMAN: JAPANESE TRANSFORMATIONS

06/17/2001 to 10/14/2001 JOHN MCCOY: AMERICAN PAINTER

10/28/2001 to 02/24/2002 CHARACTERS IN HAND: PUPPETS BY MAINE PUPPETEERS

WATERVILLE

Colby College Museum of Art
Mayflower Hill, Waterville, ME 04901

℡: 207-872-3228 website:www.colby.edu/museum
Open: 10-4:30 Mo-Sa, 2-4:30 Su **Closed:** LEG/HOL!
& **℗:** Free Museum Shop
Permanent Collection: AM: Impr/ptgs, folk, gr; Winslow Homer: watercolors; OR: cer

Located in a modernist building on a campus dominated by neo-Georgian architecture, the museum at Colby College houses a distinctive collection of several centuries of American Art. Included among its many fine holdings is a 36 piece collection of sculpture donated to the school by Maine native, Louise Nevelson. **NOT TO BE MISSED:** 25 watercolors by John Marin; "La Reina Mora" by Robert Henri (recent acquisition).

ANNAPOLIS

Mitchell Gallery

Affiliate Institution: St. John's College
60 College Ave., Annapolis, MD 21404-2800
☏: 410-626-2556 website:www.sjca.edu/gallery/gallery.html
Open: 12-5 Tu-Su; 7-8 Fr; closed for the summer **Closed:** Mo, LEG/HOL!
ᕦ: **℗:** 2 hour metered street parking near the museum; parking at the U.S. Naval & Marine Corps
Stadium on Rowe Blvd. with free shuttle bus service; call ahead to arrange for handicap parking.
⊪: College Coffee Shop open 8:15-4
Permanent Collection: none

Established in 1989 primarily as a center of learning for the visual arts, this institution, though young in years, presents a rotating schedule of educational programs and high quality exhibitions containing original works by many of the greatest artists of yesterday and today.

BALTIMORE

American Visionary Art Museum

800 Key Highway & Covington in the Baltimore Inner Harbor, Baltimore, MD 21202-3940
☏: 410-244-1900 ◙ avam.org
Open: 10-6 Tu-Su **Closed:** Mo, THGV, 12/25
ADM: Adult: $6.00 **Children:** Free under 4 **Students:** $4.00 **Seniors:** $4.00
ᕦ: Fully accessible with street drop-off lane
℗: $3.00 parking in large lot across the street from the Museum; many 24-hour metered spaces on Covington.
Museum Shop **⊪:** Joy America Cafe open 11:30am-10pm Tu-Sa, Su Brunch 11-4:30 (call 410-244-6500 to reserve)
Sculpture Garden
Permanent Collection: Visionary art

Dedicated to intuition, The American Visionary Art Museum, designated by Congress, is the nation's official repository for original self-taught (a.k.a. "outsider") visionary art. Among the many highlights of the 4,000 piece permanent collection are Gerald Hawkes' one-of-a-kind matchstick sculptures, 400 original pen and ink works by postman/visionary Ted Gordon, and the entire life archive of the late Otto Billig, M.D., an expert in transcultural psychiatric art who was the last psychiatrist to Zelda Fitzgerald. **NOT TO BE MISSED:** Towering whirligig by Vollis Simpson, located in outdoor central plaza, which is like a giant playwheel during the day and a colorful firefly-like sculpture when illuminated at night; Joy America Cafe featuring ultra organic gourmet food created by four-star chef Peter Zimmer, formerly of The Inn of the Anasazi in Santa Fe, N.M.; Wildflower sculpture garden complete with woven wood wedding chapel by visionary artist Ben Wilson.

Baltimore Museum of Art

Art Museum Drive, Baltimore, MD 21218-3898
☏: 410-396-7100 ◙ www.artbma.org
Open: 10-5 We-Fr, 11-6 Sa, Su; 5-9 1st Th of month **Closed:** Mo, Tu, 1/1, 7/4, THGV, 12/25
Free Day: Th **ADM: Adult:** $6.00 **Children:** Free 18 & under **Students:** $4.00 **Seniors:** $4.00
ᕦ **℗:** Metered & limited on site; or parking on weekends at The Johns Hopkins University adjacent to Museum
Museum Shop **⊪:** Gertrudes at the BMA 410-889-3399
Group Tours: 410-396-6320 **Sculpture Garden**
Permanent Collection: Ptgs, Ren-20; OM/drgs 15-20; CONT; Sculp 15-20; dec/art; OR; p/col ;

Baltimore Museum of Art - continued
One of the undisputed jewels of this important artistic collection is the Cone Collection of works by Matisse, the largest of its kind in the Western hemisphere. Works by Andy Warhol from the second largest permanent collection of paintings by him are on regular display. **NOT TO BE MISSED:** The new installation (fall 2000) of the Cone Collection, American dec/arts; Antioch mosaics; Sculpture Garden; Am Paintings 19; OM paintings.

ON EXHIBIT 2001

09/24/2000 to 01/07/2001 ART FOR THE PRESIDENTS (working title)
The aesthetic tastes which have defined the American presidency and the ideology showcases 200 years of presidential portraiture. Divided into two sections "Regal Courts and National Identity" it illustrates the importance of regal backdrop to the American Presidency,

10/15/2000 to 01/07/2001 BOOK ARTS IN THE AGE OF DURER
Forty books and 40 loose sheets underscore the importance of Durer in the development of book arts. It also provides a history of early book production.

11/19/2000 to 05/14/2001 HEROES, LEGENDS & MYTHS: IMAGES IN EUROPEAN AND AMERICAN TOILES

02/11/2001 to 05/27/2001 BODY/SPACE

09/16/2001 to 12/30/2001 ANTIOCH: THE LOST ANCIENT CITY
Included are some of the finer mosaics and a variety of objects including coins, frescoes, glass sculpture and metalwork within their architectural and cultural environments. *Brochure*

Contemporary
100 West Centre St., Baltimore, MD 21201
℃: 410-783-5720 **◙** htttp://www.contemporary.org
Open: Tu-Fr 10am-5pm; Sa-Su 11am 5pm **Closed:** please call!
Sugg./Contr.: Yes
Group Tours: 410-783-5720, x102

The Contemporary presents the art of our time in unusual sites. The museum's innovative approach to exhibitions and education brings art directly to diverse and under-served communities, promotes creative interaction between artists and the public, and connects new art to everyday experience. Founded in 1989, the Museum has gained international acclaim for its thought provoking exhibitions and for its innovative use of spaces not typically associated with contemporary art.

ON EXHIBIT 2001

11/02/2000 to 02/12/2001 SNAPSHOTS
The relationship between fine art photography and the snapshot will be addressed in the works on view by such acclaimed artists as Walker Evans, Larry Sultan and others.

Evergreen House
Affiliate Institution: The Johns Hopkins University
4545 N. Charles St., Baltimore, MD 21210-2693
℃: 410-516-0341
Open: 10-4 Mo-Fr, 1-4 Sa, Su **Closed:** LEG/HOL!
ADM: Adult: $6.00 **Children:** Free under 5 **Students:** $3.00 **Seniors:** $5.00
ᕱ ℗: Free Museum Shop ∥: Call ahead for box lunches, high tea & continental breakfast for groups
Group Tours: 410-516-0344 (Groups more than 20 $5 pp) **Docents** **Tour times:** call for specifics
Permanent Collection: FR: Impr, Post/Impr; EU: cer; OR: cer; JAP

Evergreen House - continued

Restored to its former beauty and reopened to the public in 1990, the 48 rooms of the magnificent Italianate Evergreen House (c 1878), with classical revival additions, contain outstanding collections of French and Post-Impressionist works of art collected by its founders, the Garrett family of Baltimore. **PLEASE NOTE:** All visitors to Evergreen House are obliged to go on a 1 hour tour of the house with a docent. It is recommended that large groups call ahead to reserve. It should be noted that the last tour of the day begins at 3:00. **NOT TO BE MISSED:** Japanese netsuke and inro; the only gold bathroom in Baltimore; private theatre designed by Leon Bakst.

ON EXHIBIT 2001

10/27/2000 to 01/31/2001 THE SECOND ANNUAL COLLECTORS SERIES: THE GARRETT BOOK COLLECTION
A celebration of the Garrett Collection of 30,000 rare books and contemporary books as well.

Walters Art Gallery

600 N. Charles St., Baltimore, MD 21201

☎: 410-547-9000 ◙ www.thewalters.org
Open: 10-4 Tu-Fr; 11-5 Sa, Su; till 8pm first Th of each month **Closed:** Mo, 12/25
ADM: Adult: $5.00 **Children:** Free 6 & under; 7 to 17 $1.00 **Students:** Young Adults (18-25) $3.00 **Seniors:** $3.00
♿: Wheelchair ramps at entrances, elevators to all levels ℗: Ample parking on the street and nearby lots
Museum Shop ¶: Classic cafe 9:30-3:30 Tu-Fri; 10:30-4:30 Sa Su
Group Tours: ex 337 **Docents** **Tour times:** noon We, 1:30 Su year round
Permanent Collection: AN/EGT; AN/GRK; AN/R; MED; DEC/ART 19; OM: ptgs; EU: ptgs & sculp; DEC/ART

The Walters, considered one of America's most distinguished art museums, features a broad-ranging collection that spans more than 5,000 years of artistic achievement from Ancient Egypt to Art Nouveau. Remarkable collections of ancient, medieval, Islamic & Byzantine art, 19th century paintings and sculpture, and Old Master paintings are housed within the walls of the magnificently restored original building and in a large modern wing as well. **PLEASE NOTE:** 1. For the time being there will be a reduction in the Museum's hours of operation. Please call for updates. 2. The 1974 building will be closed until Fall 2001 for renovation and repair. **NOT TO BE MISSED:** Hackerman House, a restored mansion adjacent to the main museum building, filled with oriental decorative arts treasures.

ON EXHIBIT 2001

10/18/2000 to 01/21/2001 THE BOOK ARTS IN THE AGE OF ALBRECHT DURER

11/12/2000 to 02/18/2001 BARBARA CHASE-RIBOUD: THE MONUMENT DRAWINGS

01/04/2001 to 04/01/2001 THE FORTY-SEVEN SAMURAI

01/28/2001 to 04/22/2001 EDOUARD MANET: THE STILL LIFE PAINTINGS
Manet consider these "the touchstone of painting" and the 40 works are the entire production of this genre from the 1860's to the final period before his death.

04/02/2001 to 07/01/2001 CHERRY BLOSSOM TIME: PRINTS BY OGATA GEKKO (1859-1920)

07/05/2001 to 09/30/2001 THE LOYAL WARRIORS

09/27/2001 to 01/13/2002 REALMS OF FAITH: BYZANTINE ART FROM THE WALTERS ART GALLERY, BALTIMORE

10/03/2001 to 01/06/2002 CHARACTERS: PRINTS BY TOYOKUNI III (1786-1864)

10/20/2001 to 02/02/2002 DESIRE AND DEVOTION: INDIAN AND HIMALAYAN ART FROM THE JOHN AND BERTHE FORD COLLECTION

MARYLAND

Academy of the Arts
106 South Sts., Easton, MD 21601
℡: 410-822-ARTS ◙ WWW.ART-ACADEMY.ORG
Open: 10-4 Mo-Sa, till 9 We **Closed:** Su, LEG/HOL! month of Aug
♿ Ⓟ: Free with 2 hour limit during business hours; handicapped parking available in the rear of the Academy.
Group Tours: 410-822-5997
Permanent Collection: PTGS; SCULP; GR: 19-20; PHOT

Housed in two 18th century buildings, one of which was an old school house, the Academy's permanent collection contains an important group of original 19th & 20th century prints. This museum serves the artistic needs of the community with a broad range of activities including concerts, exhibitions and educational workshops. **NOT TO BE MISSED:** "Slow Dancer" sculpture by Robert Cook, located in the Academy Courtyard; Works by James McNeil Whistler, Grant Wood, Bernard Buffet, Leonard Baskin, James Rosenquist, and others.

Washington County Museum of Fine Arts
91 Key St. City Park, Box 423, Hagerstown, MD 21741
℡: 301-739-5727 ◙ www.washcomuseum.org
Open: 10-5 Tu-Sa, 1-5 Su **Closed:** Mo, LEG/HOL!
Vol./Contr.: Yes
♿ Ⓟ: Free and ample. **Museum Shop**
Docents **Tour times:** 2 weeks notice **Sculpture Garden**
Permanent Collection: AM: 19-20; REG; OM: 16-18; EU: ptgs 18-19; CH

In addition to the permanent collection of 19th and 20th century American art, including works donated by the founders of the museum, Mr. & Mrs. William H. Singer, Jr., the Museum has a fine collection of Oriental Art, African Art, American pressed glass, and European paintings, sculpture and decorative arts. Hudson River landscapes, Peale family paintings, and works by "The Eight," all from the permanent collection, are displayed throughout the year on an alternating basis with special temporary exhibitions. The museum is located in the northwest corner of the state just below the Pennsylvania border. **NOT TO BE MISSED:** "Sunset Hudson River" by Frederic Church.

Mead Art Museum

Affiliate Institution: Amherst College, Amherst, MA 01002-5000

☎: 413-542-2335 ◙ www.amherst.edu/~mead
Open: SEPT-MAY: 10-4:30 Weekdays, 1-5 Weekends; Summer: 1-4 Tu-Su **Closed:** LEG/HOL!; ACAD!; MEM/DAY; LAB/DAY
Vol./Contr.: yes
&. ℗
Group Tours: by Appt, 413-542-2335 **Docents Sculpture Garden**
Permanent Collection: AM: all media; EU: all media; DU: ptgs 17; PHOT; DEC/ART; AN/GRK: cer; FR: gr 19

Surrounded by the Pelham Hills in a picture perfect New England setting, the Mead Art Museum, at Amherst College, houses a rich collection of 14,000 art objects dating from antiquity to the present. **PLEASE NOTE:** Summer hours are 1-4 Tu-Su. Closed until Feb 2001 for renovations **NOT TO BE MISSED:** American paintings and watercolors including Eakins "The Cowboy" & Homer's "The Fisher Girl."

University Gallery, University of Massachusetts

Affiliate Institution: Fine Arts Center
University of Massachusetts, Amherst, MA 01003

☎: 413-545-3670
Open: 11-4:30 Tu-Fr; 2-5 Sa, Su **Closed:** JAN.
&. **Sculpture Garden**
Permanent Collection: AM: ptgs, drgs, phot 20

With a focus on the works of contemporary artists, this museum is best known as a showcase for the visual arts. It is but one of a five college complex of museums, making a trip to this area of New England a worthwhile venture for all art lovers. **PLEASE NOTE:** Due to construction of The Fine Arts Center's Atrium project, there will be no exhibitions after 5/5/98. The Gallery hopes to reopen in November with an exhibition celebrating the history of the permanent collection.

Addison Gallery of American Art

Affiliate Institution: Phillips Academy
Andover, MA 01810-4166

☎: 978-749-4015 ◙ www.andover.edu/addison
Open: 10-5 Tu-Sa, 1-5 Su **Closed:** Mo, LEG/HOL!; 12/24
&. ℗: Limited on street parking
Docents Tour times: Upon request **Sculpture Garden**
Permanent Collection: AM: ptgs, sculp, phot, works on paper 17-20

Since its inception in 1930, the Addison Gallery has been devoted exclusively to American art. The original benefactor, Thomas Cochran, donated both the core collection and the neo-classic building designed by noted architect Charles Platt. With a mature collection of more than 12,000 works, featuring major holdings from nearly every period of American art history, a visit to this museum should be high on every art lover's list. **NOT TO BE MISSED:** Marble fountain in Gallery rotunda by Paul Manship; "The West Wind" by Winslow Homer; R. Crosby Kemper Sculpture Courtyard.

MASSACHUSETTS

Boston Athenaeum

10 1/2 Beacon St., Boston, MA 02108
☎: 617-227-0270 ◘ www.botonathenaeum.org
Open: JUNE-AUG: 9-5:30 Mo-Fr; SEPT-MAY: 9-5:30 Mo-Fr, 9-4 Sa **Closed:** Su, LEG/HOL!
♿ **Museum Shop Group Tours:** ex 221
Permanent Collection: AM: ptgs, sculp, gr 19

THE BOSTON ATHENAEUM IS CLOSED FOR RENOVATION UNTIL AT LEAST SEPTEMBER 2001. CONSULT THE WEB-SITE FOR UPDATES.

The Athenaeum, one of the oldest independent libraries in America, features an art gallery established in 1827. Most of the Athenaeum building is closed to the public EXCEPT for the 1st & 2nd floors of the building (including the Gallery). In order to gain access to many of the most interesting parts of the building, including those items in the "do not miss" column, free tours are available on Tu & Th at 3pm. Reservations must be made at least 24 hours in advance by calling The Circulation Desk, 617-227-0270 ex 221. **NOT TO BE MISSED:** George Washington's private library; 2 Gilbert Stuart portraits; Houdon's busts of Benjamin Franklin, George Washington, and Lafayette from the Monticello home of Thomas Jefferson.

Boston Museum of Fine Arts

465 Huntington Ave., Boston, MA 02115
☎: 617-267-9300 ◘ www.mfa.org
Open: 10-4:45 Mo & Tu; 10-9:45 We-Fr; 10-5:45 Sa, Su **Closed:** THGV, 12/24, 12/25
ADM: Adult: $10.00 **Children:** Free 17 & under **Students:** $8.00 **Seniors:** $8.00
♿: Completely wheelchair accessible ℗: $3.50 first hour, $1.50 every half hour following in garage on Museum Rd. across from West Wing entrance. **Museum Shop** �: Cafe, & Cafeteria
Group Tours: ex 368 **Docents Tour times:** on the half hour from 10:30-2:30 Mo-Fr
Permanent Collection: AN/GRK; AN/R; AN/EGT; EU: om/ptgs; FR: Impr, post/Impr; AM: ptgs 18-20; OR: cer

A world class collection of fine art with masterpieces from every continent is yours to enjoy at this great Boston museum. Divided between two buildings the collection is housed both in the original (1918) Evans Wing, with its John Singer Sargent mural decorations above the Rotunda, and the dramatic West Wing (1981), designed by I.M. Pei. **PLEASE NOTE:** 1. There is a "pay as you wish" policy from 4pm-9:45 pm on We and a $2.00 admission fee on Th & Fr evenings. 2. The West Wing ONLY is open after 5pm on Th & Fr. **NOT TO BE MISSED:** Egyptian Pectoral believed to have decorated a royal sarcophagus of the Second Intermediate Period (1784-1570 B.C.), part of the museum's renowned permanent collection of Egyptian art.

Boston Public Library

Copley Square, Boston, MA 02117-3194
☎: 617-536-5400
Open: OCT 1-MAY 22!: 5-9 Mo-Th, 9-5 Fr-Sa, 1-5 Su **Closed:** LEG/HOL! & 5/28
♿: General library only (Boylston St.); Also elevators, restrooms
Group Tours: ex 216 **Docents Tour times:** 2:30 Mo; 6:00 Tu, Th; 11am Fr, Sa, 2:00 Su Oct-May
Permanent Collection: AM: ptgs, sculp; FR: gr 18-19; BRIT: gr 18-19; OM: gr, drgs; AM: phot 19, gr 19-20; GER: gr; ARCH/DRGS

Architecturally a blend of the old and the new, the building that houses the Boston Public Library, designed by Charles Follon McKim, has a facade that includes noted sculptor Augustus Saint-Gauden's head of Minerva which serves as the keystone of the central arch. A wing designed by Philip Johnson was added in 1973. **PLEASE NOTE:** While restoration of the McKim Building is in progress, some points of interest may temporarily be inaccessible. **NOT TO BE MISSED:** 1500 lb. bronze entrance doors by Daniel Chester French; staircase mural painting series by Puvis de Chavannes; Dioramas of "Alice in Wonderland," "Arabian Nights" & "Dickens' London" by Louise Stimson.

Boston University Art Gallery
855 Commonwealth Ave., Boston, MA 02215
☎: 617-353-3329
Open: mid SEPT to mid DEC & mid JAN to mid MAY: 10-5 Tu-Fr; 1-5 Sa, Su **Closed:** 12/25
&: Limited (no wheelchair ramp and some stairs) Ⓟ: On-street metered parking; pay parking lot nearby

Several shows in addition to student exhibitions are mounted annually in this 35 year old university gallery which seeks to promote under-recognized sectors of the art world by including the works of a variety of ethnic artists, women artists, and those unschooled in the traditional academic system. Additional emphasis is placed on the promotion of 20th century figurative art.

Institute of Contemporary Art
955 Boylston St., Boston, MA 02115-3194
☎: 617-266-5152 ◙ www.icaboston.idu
Open: 12-5 We, Fr-Su, 12-9 Th **Closed:** Mo, Tu; leg holidays
Free Day: Th after 5 **ADM: Adult:** $6.00 **Children:** Free under 12 **Students:** $4.00 **Seniors:** $4.00
& Ⓟ: pay lots nearby **Museum Shop**
Group Tours: 617-927-6602
Permanent Collection: No permanent collection

Originally affiliated with the Modern Museum in New York, the ICA, founded in 1936, has the distinction of being the oldest non-collecting contemporary art institution in the country. By presenting contemporary art in a stimulating context, the ICA has, since its inception, been a leader in introducing such "unknown" artists as Braque, Kokoschka, Munch and others who have changed the course of art history. **NOT TO BE MISSED:** Video Collection. Video viewing during open hours.

ON EXHIBIT 2001
01/17/2001 to 04/01/2001 OLAFUR ELIASSON
Icelandic born Berlin based artist using light, running water and living organisms, the artist investigates the natural world concentrating attention on a single moment.

04/18/2001 to 07/01/2001 MARLENE DUMAS WITH LAYLAH ALI, 1999/2000 ICA ARTIST PRIZE EXHIBITION
South African Dumas explores human relationships of love, desire, longing, fear, restraint and pleasure She places the viewer in the dual position of voyeur and subject. Ali addresses issues of race and power within contemporary culture using a cartoon style of gouache and ink drawings. In narratives which seem to be in the realm of children's heroes and villains she reveals social and psychological tensions.

Isabella Stewart Gardner Museum
280 The Fenway, Boston, MA 02115
☎: 617-566-1401 ◙ www.boston.com/gardner
Open: 11-5 Tu-Su **Closed:** Mo, LEG/HOL!
ADM: Adult: $10.00, weekdays: $11.00 weekends **Children:** Free under 18 **Students:** $5.00 **Seniors:** $7.00
&: Ⓟ: Street parking plus garage two blocks away on Museum Road **Museum Shop**
Ⅱ: Cafe 11:30-4 Tu-Fr 11-4 Sa, Su
Group Tours: 617-278-5147 **Docents** **Tour times:** 2:30 Fr Gallery tour **Sculpture Garden**
Permanent Collection: PTGS; SCULP; DEC/ART; GR; OM ∩

Located in the former home of Isabella Stewart Gardner, the collection reflects her zest for amassing this most exceptional and varied personal art treasure trove. **PLEASE NOTE:** 1. The admission fee of $5.00 for college students with current I.D. is $3.00 on We; 2. Children under 18 admitted free of charge; 3. The galleries begin closing at 4:45pm. **NOT TO BE MISSED:** Rembrandt's "Self Portrait;" Italian Renaissance works of art.

ON EXHIBIT 2001
09/22/2000 to 01/07/2001 REMBRANDT CREATES REMBRANDT: AMBITION AND VISION IN LEIDEN, 1629-1631
Ten paintings will illuminate Rembrandt's evolving etching and painting technique.

MASSACHUSETTS

Museum of the National Center of Afro-American Artists
300 Walnut Ave., Boston, MA 02119

✆: 617-442-8614
Open: 1-5 Tu-Su **Closed:** Mo
ADM: Adult: $4.00 **Children:** Free under 5 **Students:** $3.00 **Seniors:** $3.00
Permanent Collection: AF/AM: ptgs; sculp; GR

Art by African-American artists is highlighted along with art from the African continent itself.

Nichols House Museum
55 Mount Vernon St., Boston, MA 02108

✆: 617-227-6993
Docents Tour times: guided individualized tours Tu thru Sa from 12 noon to 4:15pm

The Nichols House Museum offers a rare glimpse into 19th and early 20th century life on Boston's Beacon Hill. The house contains furniture, decorative objects, European and Asian art accumulated over several generations. The museum is open for tours for groups as well as individuals.

BROCKTON

Fuller Museum of Art
455 Oak St., Brockton, MA 02301-1399

✆: 508-588-6000 ◙ www.fullermuseumofart.com
Open: Noon-5 Tu-Su **Closed:** Mo, 1/1, 7/4, LAB/DAY, THGV, 12/25
ADM: Adult: $5.00 **Children:** Free under 18 **Students:** $3.00 **Seniors:** $3.00
♿ Ⓟ: Free **Museum Shop**
Group Tours: ex 125 **Docents Sculpture Garden**
Permanent Collection: AM: 19-20; CONT: reg

A park-like setting surrounded by the beauty of nature is the ideal site for this charming museum that features works by artists of New England with particular emphasis on contemporary arts and cultural diversity.

ON EXHIBIT 2001
12/02/2000 to 02/11/2001 WOMEN OF TASTE: A COLLABORATION CELEBRATING QUILT ARTISTS AND CHEFS

02/24/2001 to 06/11/2001 LINO TAGLIPIETRA & CO.

03/24/2001 to 06/10/2001 CRAIG BLOODGOOD
Bloodgood creates works that can be played like games of chance, or boardgames.

06/22/2001 to 09/02/2001 MARK DION
Site specific installation dealing with the environment and histroy of the FMA

07/07/2001 to 10/14/2001 ENVIRONMENTAL ARTS, INC.

09/15/2001 to 11/25/2001 PAINTING ZERO DEGREE

09/29/2001 to 11/25/2001 RODGER KINGSTON PHOTOGRAPHS

12/08/2001 to 02/24/2002 DWELLINGS (DOMESTICITY)
Works dealing with how we view and relate to the home as a dwelling and structure we encounter everyday.

CAMBRIDGE

Arthur M. Sackler Museum

Affiliate Institution: Harvard University
485 Broadway, Cambridge, MA 02138

☎: 617-495-9400 ▣ www.artmuseums.harvard.edu
Open: 10-5 Mo-Sa, 1-5 Su **Closed:** LEG/HOL!
Free Day: Wed and Sa 10-12 **ADM: Adult:** $5.00 **Children:** Free under 18 **Students:** $3.00 **Seniors:** $4.00
&: Ramp at front and elevators to all floors ℗: Subway accessibility, Red line to Harvard stop **Museum Shop**
Group Tours: 617-496-8576 **Docents** **Tour times:** 2:00 Mo-Fr
Permanent Collection: AN/ISLAMIC; AN/OR; NAT/AM

Opened in 1985, the building and its superb collection of Ancient, Asian, and Islamic art were all the generous gift of the late Dr. Arthur M. Sackler, noted research physician, medical publisher, and art collector. Recent gifts from various alumni highlight Harvard's Sackler museum as an institution dedicated to research and scholarships. **NOT TO BE MISSED:** World's finest collections of ancient Chinese jades; Korean ceramics; Japanese woodblock prints; Persian miniatures.

Busch-Reisinger Museum

Affiliate Institution: Harvard University
32 Quincy St., Cambridge, MA 02138

☎: 617-495-2317 ▣ http://www.artmuseums.harvard.edu
Open: 10-5 Mo-Sa, 1-5 Su **Closed:** LEG/HOL!
ADM: Adult: $5.00 **Children:** Free under 18 **Students:** $3.00 **Seniors:** $4.00
&: Ramp at front and elevators to all floors ℗: Subway accessible. Redline to Harvard stop **Museum Shop**
Group Tours: 617-496-8576 **Docents** **Tour times:** 1:00 Mo-Fr
Permanent Collection: GER: ptgs, sculp 20; GR; PTGS; DEC/ART; CER 18; MED/SCULP; REN/SCULP

Founded in 1901 with a collection of plaster casts of Germanic sculpture and architectural monuments, the Busch-Reisinger later acquired a group of modern "degenerate" artworks purged by the Nazi's from major German museums. All of this has been enriched over the years with gifts from artists and designers associated with the famous Bauhaus School, including the archives of artist Lyonel Feninger, and architect Walter Gropius. **NOT TO BE MISSED:** Outstanding collection of German Expressionist Art.

ON EXHIBIT 2001
10/12/2000 to 01/14/2001 THE RICH LIFE AND THE DANCE: WEAVINGS FROM ROMAN, BYZANTINE, AND ISLAMIC EGYPT

11/03/2000 to 05/03/2001 ANTOIN SEVRUGUIN AND THE PERSIAN IMAGE
Sevruguin operated a successful studio in Tehran from 1850's-1934. These come from the Freer Gallery Collection and the Arthur M. Sackler Gallery Archives Collection and offer an important pictorial record of the social history and visual culture in Iran.

04/28/2001 to 07/22/2001 PIET MONDRIAN: THE TRANSATLANTIC PAINTINGS

Fogg Art Museum

Affiliate Institution: Harvard University
32 Quincy St., Cambridge, MA 02138

☎: 617-495-9400
Open: 10-5 Mo-Sa, 1-5 Su **Closed:** LEG/HOL!
ADM: Adult: $5.00 **Children:** Free under 18 **Students:** $3.00 **Seniors:** $4.00
&: Ramp at front and elevators to all floors ℗: Subway accessibility. Red line to Harvard stop **Museum Shop**
Group Tours: 617-496-8576 **Docents** **Tour times:** 11:00 Mo-Fr
Permanent Collection: EU: ptgs, sculp, dec/art; AM: ptgs, sculp, dec/art; GR; PHOT, DRGS

Fogg Art Museum- continued

The Fogg, the largest university museum in America, with one of the world's greatest collections, contains both European and American masterpieces from the Middle Ages to the present. Access to the galleries is off of a two story recreation of a 16th century Italian Renaissance courtyard. **NOT TO BE MISSED:** The Maurice Wertheim Collection containing many of the finest Impressionist and Post-Impressionist paintings, sculptures and drawings in the world.

MIT-List Visual Arts Center

20 Ames St. Wiesner Bldg., Cambridge, MA 02142
☎: 617-253-4680 **◙** web.mit.edu/lvac/www
Open: 12-6 Tu-Th, Sa, Su; till 8 Fr **Closed:** Mo, LEG/HOL
Sugg./Contr.: ADM: Adult: $5.00
⅙ **Ⓟ:** Corner of Main & Ames Sts. **Museum Shop** **❙❙:** Nearby restaurants
Group Tours: 617-253-4400 **Sculpture Garden**
Permanent Collection: SCULP; PTGS; PHOT; DRGS; WORKS ON PAPER

Approximately 10 temporary exhibitions of contemporary art are mounted annually in MIT's List Visual Arts Center, with an interior mural by Kenneth Noland and seating by Scott Burton. Artists featured have included Jessica Brawson, Alfredo Jaar, Lewis de Soto and Kiki Smith. **NOT TO BE MISSED:** Alexander Calder, "The Big Sail" (1965), MIT's first commissioned public outdoor sculpture.

CHESTNUT HILL

McMullen Museum of Art Boston College

Affiliate Institution: Boston College
Devlin Hall, 140 Commonwealth Ave., Chestnut Hill, MA 02167-3809
☎: 617-552-8587 or 8100 **◙** www.bc.edu:80/bc_org/avp/cas/artmuseum/
Open: FEB-MAY Mo-Fr; 12-5 Sa, Su JUNE-AUG: 11-3 Mo-Fr **Closed:** LEG/HOL!
⅙ **Ⓟ:** 1 hour parking on Commonwealth Ave.; in lower campus garage on weekends & as available on weekdays (call 617-552-8587 for availability) **❙❙:** On campus
Permanent Collection: IT: ptgs 16 & 17; AM: ptgs; JAP: gr; MED & BAROQUE TAPESTRIES 15-17

Devlin Hall, the Neo-Gothic building that houses the museum, consists of two galleries featuring a display of permanent collection works on one floor, and special exhibitions on the other. **NOT TO BE MISSED:** "Madonna with Christ Child & John the Baptist" By Ghirlandaio, 1503-1577.

ON EXHIBIT 2001
02/2001 to 05/2001 EDVARD MUNCH: PSYCHE, SYMBOL AND EXPRESSION
A rare opportunity to see works hardly ever seen on public display in the U.S.

CONCORD

Concord Art Association

37 Lexington Rd., Concord, MA 01742
☎: 978-369-2578 **Open:** 10-4:30 Tu-Sa **Closed:** Mo, LEG/HOL!
⅙ **Ⓟ:** Free street parking **Museum Shop Sculpture Garden**
Permanent Collection: AM: ptgs, sculp, gr, dec/art

Historic fine art is appropriately featured within the walls of this historic (1720) building. The beautiful gardens are perfect for a bag lunch picnic during the warm weather months. **NOT TO BE MISSED:** Ask to see the secret room within the building which was formerly part of the underground railway.

COTUIT

Cahoon Museum of American Art

4676 Falmouth Rd., Cotuit, MA 02635

☎: 508-428-7581 ◙ www.cahoonmuseum.org
Open: 10-4 Tu-Sa **Closed:** Su, Mo, LEG/HOL!; Also closed JAN.
Vol./Contr.: Yes
&: Limited to first floor only ℗: Free **Museum Shop**
Docents Tour times: Talks at various times for each special exhibits
Permanent Collection: AM: ptgs 19-20; CONT/PRIM

Named in honor of the contemporary primitive painters, R & M Cahoon, their work is shown with works by prominent American marine, landscape and still life painters. The Museum is approximately 9 miles west of Hyannis. **NOT TO BE MISSED:** Mermaid paintings of Ralph Cahoon.

ON EXHIBIT 2001

07/17/2000 to 09/15/2001 TELL ME A STORY-CHAPTER 2: NARRATIVE ART ON THE CAPE AND ISLANDS

02/01/2001 to 03/24/2001 TELL ME A STORY-CHAPTER I: NARRATIVE THEMES IN CONTEMPORARY FABRIC ARTS

03/27/2001 to 05/12/2001 A TASTE OF PROVICETOWN: WORKS FROM THE COLLECTION OF NAPI VAN DERECK
Early Provincetown paintings.

05/15/2001 to 07/14/2001 SIMPLE PLEASURES: THE ART OF MARTHA CAHOON

09/18/2001 to 11/10/2001 TWO APPLE EXHIBITS "THE APPLE OF MY EYE" AND "THE TEMPTING FRUIT"
Paintings by deceased artists and apple paintings by contemporary artists.

11/13/2001 to 12/29/2001 WINTER WONDERLAND
Including a roomful of Cahoon snow paintings.

DENNIS

Cape Museum of Fine Arts

Rte. 6A, Dennis, MA 02638-5034

☎: 508-385-4477 ◙ www.cmfa.rg
Open: 10-5 Tu-Sa, 1-5 Su, till 7:30 Th, open Mo May-Sep **Closed:** Mo, LEG/HOL!
ADM: Adult: $5.00 **Children:** Free 16 and under
& ℗: Free and ample parking **Museum Shop**
Group Tours: 508-385-4477 x16 **Docents Tour times:** We 11am, Su 1pm **Sculpture Garden**
Permanent Collection: REG

Art by outstanding Cape Cod artists, from 1900 to the present, is the focus of this rapidly growing permanent collection which is housed in the restored former summer home of the family of Davenport West, one of the original benefactors of this institution. New galleries provide wonderful new space for permanent collections and special exhibitions. On the grounds of the Cape Playhouse and Center for the Arts. **NOT TO BE MISSED:** MAJOR RENOVATION FINISHED BY 2/2001.

ON EXHIBIT 2001

04/2001 to 06/2001 AMERICAN SOCIETY OF MARINE ARTISTS EXHIBITION

MASSACHUSETTS

DUXBURY

Art Complex Museum

189 Alden St. Box 2814, Duxbury, MA 02331

℄: 781-934-6634 ◙ www.artcomplex.org
Open: 1-4 We-Su **Closed:** Mo, Tu, LEG/HOL!
Vol./Contr.: yes
&: Except for restrooms **℗:** Free **Sculpture Garden**
Permanent Collection: OR: ptgs; EU: ptgs; AM: ptgs; gr

In a magnificent sylvan setting that compliments the naturalistic wooden structure of the building, The Art Complex houses a remarkable core collection of works on paper that includes Rembrandt's "The Descent from the Cross by Torchlight." An authentic Japanese Tea House, complete with tea presentations in the summer months, is another unique feature of this fine institution. The museum is located on the eastern coast of Massachusetts just above Cape Cod. **NOT TO BE MISSED:** Shaker furniture; Tiffany stained glass window.

ON EXHIBIT 2001

09/24/2000 to 01/14/2001 SHAKER CHAIRS
An opportunity for visitors to view the collection of Shaker chairs and contemporary dtudio furniture. Unique seats installed on Museum grounds will show outdoor furniture.

01/28/2001 to 04/29/2001 DUXBURY ART ASSOCIATION ANNUAL JURIED EXHIBITION

01/28/2001 to 04/29/2001 TURE BENGTZ PRINTS

05/13/2001 to 09/16/2001 30TH CELEBRATION, EDITH WEYERHAEUSER'S FAVORITES

05/13/2001 to 09/16/2001 THE YIXING EFFECT

09/30/2001 to 01/28/2002 CHILDREN'S BOOK ILLUSTRATIONS

FITCHBURG

Fitchburg Art Museum

185 Elm St., Fitchburg, MA 01420

℄: 978-345-4207
Open: 11-4:00 Tu-Sa, 1-4 Su **Closed:** Mo, LEG/HOL!
ADM: Adult: $3.00 **Children:** Free under 18 **Seniors:** $2.00
&: 90% handicapped accessible **℗:** Free on-site parking **Museum Shop Sculpture Garden**
Permanent Collection: AM: ptgs 18-20 EU: ptgs 18-20; PRTS & DRGS: 15-20; PHOT 20; AN/GRK; AN/R; AS; ANT; ILLUSTRATED BOOKS & MANUSCRIPTS 14-20

Eleanor Norcross, a Fitchburg artist who lived and painted in Paris for 40 years, became impressed with the number and quality of small museums that she visited in the rural areas of northern France. This led to the bequest of her collection and personal papers, in 1925, to her native city of Fitchburg, and marked the beginning of what is now a 40,000 square foot block long museum complex. The museum is located in north central Massachusetts near the New Hampshire border. **NOT TO BE MISSED:** "Sarah Clayton" by Joseph Wright of Derby, 1770.

Danforth Museum of Art

123 Union Ave., Framingham, MA 01702

☎: 508-620-0050 ◙ www.e-guide.com/sites/Danforth
Open: Noon-5 We-Su **Closed:** Mo, Tu LEG/HOL! AUG!
ADM: Adult: $3.00 **Children:** Free 12 & under **Students:** $2.00 **Seniors:** $2.00
♿ **℗:** Free
Docents Tour times: 1:00 We (Sep-May)
Permanent Collection: PTGS; SCULP; DRGS; PHOT; GR

The Danforth, a museum that prides itself on being known as a community museum with a national reputation, offers 19th & 20th century American and European art as the main feature of its permanent collection. **NOT TO BE MISSED:** 19th & 20th c American works with a special focus on the works of New England artists.

Cape Ann Historical Association

27 Pleasant St., Gloucester, MA 01930

☎: 978 283-0455
Open: 10-5 Tu-Sa **Closed:** Su, Mo, LEG/HOL!; FEB
Free Day: Month of January **ADM: Adult:** $5.00 **Children:** Free under 6 **Students:** $3.50 **Seniors:** $4.50
♿ **℗:** In the lot adjacent to the museum and in the metered public lot across Pleasant St. from the museum.
Museum Shop Sculpture Garden
Permanent Collection: FITZ HUGH LANE: ptgs; AM: ptgs, sculp, DEC/ART 19-20; MARITIME COLL

Within the walls of this most charming New England treasure of a museum is the largest collection of paintings (40), drawings (100), and lithographs by the great American artist, Fitz Hugh Lane. A walking tour of the town takes the visitor past many charming small art studios & galleries that have a wonderful view of the harbor as does the 1849 Fitz Hugh Lane House itself. Be sure to see the famous Fisherman's Monument overlooking Gloucester Harbor. **NOT TO BE MISSED:** The watercolor by Fitz Hugh Lane which is his earliest known work.

DeCordova Museum and Sculpture Park

51 Sandy Pond Rd., Lincoln, MA 01773-2600

☎: 781-259-8355 ◙ www.decordova.org
Open: 11-5 Tu-Su **Closed:** Mo, LEG/HOL!
ADM: Adult: $6.00 **Children:** Free 5 & under **Students:** $4.00 **Seniors:** $4.00
♿ **℗:** Free **Museum Shop** ❙❙: Cafe open 11-4 We-Sa
Group Tours: 781-259-0505 **Docents Tour times:** We & Su 2:00 **Sculpture Garden**
Permanent Collection: AM: ptgs, sculp, gr, phot 20; REG

In addition to its significant collection of modern and contemporary art, the DeCordova features the only permanent sculpture park of its kind in New England. While there is an admission charge for the museum, the sculpture park is always free and open to the public from 8am to 10pm daily. The 35 acre park features nearly 80 site-specific sculptures. **PLEASE NOTE:** The museum IS OPEN on SELECTED Monday holidays! **NOT TO BE MISSED:** Annual open air arts festival first Sunday in June; plus other special events throughout the year. Visit the web site for details.

MASSACHUSETTS

DeCordova Museum and Sculpture Park - continued
ON EXHIBIT 2001

ongoing ABSTRACT EXPRESSIONISM/FIGURATIVE EXPRESSIONISM: COMMON GROUND
Major themes of religion and myth, psychological and emotional states, landscape, and references to history and the history of art in a first look at these two styles.

06/17/2000 to 06/19/2001 JUST THE THING! THE OBJECT IN CONTEMPORARY OUTDOOR SCULPTURE
Works that have familiar objects as their subject matter: clocks. Pianos, boats, beds, shoes, clothing, etc.

09/16/2000 to 01/21/2001 PHOTOGRAPHY IN BOSTON: 1955-1985
Boston has been an important part of the development of the history of photography. This exhibition explains why. This is the first in a series of 4 exhibitions that will document the history of the art form.

09/18/2000 to 01/21/2001 VIDEO/MEDIA EXHIBITION

02/03/2001 to 05/28/2001 AMERICA'S FUNNIEST ART VIDEOS

02/03/2001 to 05/28/2001 LIGHTEN UP: ART WITH A SENSE OF HUMOR
Works in all media explore humor in variety of contexts.

06/09/2001 to 09/03/2001 THE DECORDOVA ANNUAL EXHIBITION
Recent work by New England artists in a variety of media, styles and subjects.

09/15/2001 to 01/06/2002 CREATURE FEATURE: MONSTERS IN CONTEMPORARY ART
Monsters have a presence in art from cave paintings to the present. In addition to good versus evil, they reflect popular culture in horror, humor, satire, and Hollywood.

LOWELL

Whistler House Museum of Art and Parker Gallery
243 Worthen St., Lowell, MA 01852-1822

℃: 978-452-7641 ◙ www.valley.uml.edu/lowell/historic/museums/whistler.html
Open: May-Oct 11-4 We-Sa, 1-4 Su; Nov, Dec, Mar, Apr 11-4 We-Sa **Closed:** Mo, Tu, LEG/HOL! JAN. & FEB.
ADM: Adult: $3.00 **Children:** Free under 5 **Students:** $2.00 **Seniors:** $2.00
&: Limited to first floor of museum and Parker Gallery **℗:** On street; commercial lots nearby
Group Tours: 978-452-7641 **Docents Tour times:** Upon request **Sculpture Garden**
Permanent Collection: AM: ptgs

Works by prominent New England artists are the highlight of this collection housed in the 1823 former home of the artist. **NOT TO BE MISSED:** Collection of prints by James M. Whistler.

MEDFORD

Tufts University Art Gallery
Affiliate Institution: Tufts University
Aidekman Arts Center, Medford, MA 02115

℃: 617-627-3518
Open: SEPT to mid DEC & mid JAN to MAY: 12-8 We-Sa, 12-5 Su **Closed:** Mo, LEG/HOL!; ACAD!; SUMMER
&: Wheelchair accessible **Sculpture Garden**
Permanent Collection: PTGS, GR, DRGS, 19-20; PHOT 20; AN/R; AN/GRK; P/COL

Located just outside of Boston, most of the Tufts University Art Museum exhibitions feature works by undergraduate students and MFA candidates.

MASSACHUSETTS

NORTH ADAMS

Massachusetts Museum of Contemporary Art

87 Marshall St., North Adams, MA 01247

☎: 413-664-4481 ◙ www.massmoca.org
Open: 6/1-10/31 10-5 daily; till 8 Sa 11/1-5/31 10-4 Tu-Su **Closed:** 1/1, THGV, 12/25
ADM: Adult: $8.00 **Children:** Free under 6, $5.00
♿ once opened ℗ **Museum Shop** ❙❙: Mass Moca Café
Group Tours: 413-664-4481
Permanent Collection: The Museum has two permanent works of sound art in its collection; the majority of work shown here will be long-term loans of oversized or sited works from major museum collections.

Opened in late spring 1999, the much anticipated Massachusetts Museum of Contemporary Art (MASS MoCA), created from a 27-building historic mill complex on 13 acres in the Berkshires of Western Massachusetts, promises to be an exciting multi-disciplinary center for visual and performing arts. International in scope, MASS MoCA will offer exhibitions of work on loan from the Solomon R. Guggenheim Museum in New York City and other major museum collections, as well as special exhibitions of contemporary art.

NORTHAMPTON

Smith College Museum of Art

Elm St. at Bedford Terrace, Northampton, MA 01063

☎: 413-585-2760 ◙ www.smith.edu/artmuseum
Open: SEPT-JUNE: 9:30-4 Tu, Fr, Sa; 12-8 Th, Noon-4 We, Su; JUL & AUG: Noon-4 Tu-Su **Closed:** Mo, 1/1, 7/4, THGV, 12/25
♿: Wheelchair accessible; wheelchairs provided upon request ℗: Nearby street parking with campus parking available on evenings and weekends only; Handicapped parking behind Hillyer art building. **Museum Shop**
Permanent Collection: AM: ptgs, sculp, gr, drgs, dec/art 17-20; EU: ptgs, gr, sculp, drgs, dec/art 17-20; PHOT; DU:17; ANCIENT ART

With in-depth emphasis on American and French 19th & 20th century art, and literally thousands of superb artworks in its permanent collection, Smith College remains one of the most highly regarded college or university repositories for fine art in the nation. **PLEASE NOTE:** Print Room hours are 1-4 Tu-Fr & 1-5 Th from Sept. to May—other hours by appointment only. **NOT TO BE MISSED:** "Mrs. Edith Mahon" by Thomas Eakins; "Walking Man" by Rodin.

Words & Pictures Museum

136 West Main St., Northampton, MA 01060

☎: 413-586-8545 ◙ http://www.wordsandpictures.org
Closed: Mo
Permanent Collection: Original contemporary sequential/comic book art & fantasy illustration, 1970's - present

MUSEUM HAS CLOSED THE FACILITY. ALL EXHIBITS AND PROGRAMMING ARE SOLELY ON THE WEB.

MASSACHUSETTS

Berkshire Museum

39 South St., Pittsfield, MA 01201

☎: 413-443-7171 ◙ www.berkshiremuseum.org
Open: 10-5 Tu-Sa, 1-5 Su; Open 10-5 Mo JUL & AUG **Closed:** Mo, 1/1, Mem Day, 7/4, Labor Day, Thanksgiving, 12/25
Free Day: 3-5 We and on one's birthday **ADM: Adult:** $6.00 **Children:** $4.00 (4-18), Free under 3 **Seniors:** $5.00
&: Wheelchair lift south side of building; elevator to all floors **Ⓟ:** Metered street parking; inexpensive rates at the near-by Crowne Plaza Hotel and municipal parking garage. **Museum Shop** **Ⅱ:** Snacks at the Vendo-Mat Snack Room
Group Tours: 413-443-7171 x11 **Docents** **Tour times:** 10 am Sa in Jul, Aug
Permanent Collection: AM: 19-20; EU: 15-19; AN/GRK; AN/R; DEC/ART; PHOT; Natural Science; Aquarium

Three Museums in one—art, natural science and history—set the stage for a varied and exciting visit to this complex in the heart of the beautiful Berkshires. In addition to its rich holdings of American art of the 19th and 20th centuries, the Museum has an interactive aquarium and exciting changing exhibitions. **NOT TO BE MISSED:** "Hudson River School Collection" Special family exhibitions February thru May; newly renovated Science Galleries; Jonas Studio Dinosaur Exhibition.

Provincetown Art Association and Museum

460 Commercial St., Provincetown, MA 02657

☎: 508-487-1750 ◙ www.CapeCodAccess.com/Gallery/PAAM.html
Open: SUMMER: 12-5 & 8-10 daily; SPRING/FALL: 12-5 Fr, Sa, Su; WINTER: 12-4 Sa, Su **Closed:** Open most holidays!; open weekends only Nov-Apr
Sugg/Contr.: ADM: Adult: $3.00 **Students:** $1.00 **Seniors:** $1.00
& **Museum Shop**
Group Tours: by appt **Sculpture Garden**
Permanent Collection: PTGS; SCULP; GR; DEC/ART; REG

Works by regional artists is an important focus of the collection of this museum. **NOT TO BE MISSED:** Inexpensive works of art by young artists that are for sale in the galleries.

Mount Holyoke College Art Museum

South Hadley, MA 01075-1499

☎: 413-538-2245 ◙ www.mtholyoke.edu/offices/artmuseum
Open: 11-5 Tu-Fr, 1-5 Sa-Su **Closed:** LEG/HOL!, ACAD!
& **Ⓟ:** Free **Museum Shop**
Group Tours: 413-538-2085 **Docents** **Tour times:** by appointment at least 3 weeks prior **Sculpture Garden**
Permanent Collection: AS; P/COL; AN/EGT; IT: med/sculp; EU: ptgs; AN/GRK; AM: ptgs, dec/art, gr, phot; EU: ptgs, dec/art, gr, phot

A stop at this leading college art museum is a must for any art lover traveling in this area. Founded in 1876, it is one of the oldest college museums in the country.

THE MUSEUM WILL BE CLOSED FOR RENOVATION FROM 6/28/00 TO 01/01/02. **NOT TO BE MISSED:** Albert Bierstadt's "Hetch Hetchy Canyon;" A Pinnacle from Duccio's "Maesta" Altarpiece; Head of Faustina the Elder, 2nd century AD, Roman

SPRINGFIELD

George Walter Vincent Smith Art Museum

At the Quadrangle, Corner State & Chestnut Sts., Springfield, MA 01103

℃: 413-263-6800 **◙** www.quadrangle.org
Open: 12-4 We-Su (Tu-Su in July & Aug) **Closed:** Mo, Tu, LEG/HOL
ADM: Adult: $4.00 **Children:** $1.00 (6-18) **Students:** $4.00 **Seniors:** $4.00 Sen day We $2.00
&: First floor only **Ⓟ:** Free parking in Springfield Library & Museum lots on State St. & Edwards St.
⫪: year-round cafe
Group Tours: 413-263-6800 x472 **Docents Tour times:** by reservation
Permanent Collection: 19th C AMERICAN ART; OR; ISLAMIC Rugs; DEC/ART 17-19; CH: jade; JAP: bronzes, ivories, armour, tsuba 17-19; DEC/ART: cer; AM: ptgs 19

With the largest collection of Chinese cloisonné in the western world, the G. W. V. Smith Art Museum, built in 1895 in the style of an Italian villa, is part of a four museum complex that also includes The Museum of the Fine Arts. The museum reflects its founder's special passion for collecting the arts of 17th to 19th century Japan and American art by his contemporaries. **NOT TO BE MISSED:** Early 19th century carved 9' high wooden Shinto wheel shrine.

Museum of Fine Arts

At the Quadrangle, Corner of State & Chestnut Sts., Springfield, MA 01103

℃: 413-263-6800 **◙** www.quadrangle.org
Open: We-Su 12-4 (Tu-Su July & Aug) **Closed:** Mo, Tu, LEG/HOL
ADM: Adult: $4.00 single adm provides entry to all four museums **Children:** $1.00 (6-18) **Students:** $4.00 **Seniors:** $4.00
&: 90% accessible **Ⓟ:** Free in Springfield Library & Museum's lots on State St. and Edwards St. **Museum Shop ⫪**
Group Tours: ex 472 **Docents Tour times:** by reservation
Permanent Collection: AM: 19-20; FR: 19-20; IT Baroque; Dutch + Flemish

Part of a 4 museum complex located on The Quadrangle in Springfield, the Museum of Fine Arts, built in the 1930's Art Deco Style, offers an overview of European and American art. **NOT TO BE MISSED:** "The Historical Monument of the American Republic," 1867-1888 by Erastus S. Field, a monumental painting in the court of the museum.

ON EXHIBIT 2001

02/07/2001 to 05/06/2001 WINDOWS INTO HEAVEN: HOLY ART OF IMPERIAL RUSSIA
Icons from the Hollingsworth Collection including painted panels, carved items, metal crosses and pieces cast in bronze and silver from the era of the Romanovs.

06/06/2001 to 08/19/2001 DALE CHIHULY: SEAFORMS
Exceptional examples of American master Chihuly's glass sculptures resembling brilliant undulating marine life will be on exhibit with a number of his working drawings.

09/26/2001 to 01/06/2002 BROTHER THOMAS CERAMICS
A self taught potter whose work relies on simple forms and unique color and depth of the glazes.

STOCKBRIDGE

Chesterwood

Off Rte. 183, Glendale Section, Stockbridge, MA 01262-0827

℃: 413-298-3579 **Open:** 10-5 Daily (MAY 1-OCT 31) **Closed:** None during open season
ADM: Adult: $7.50 **Children:** $4.00 (13-18), $2.00 (6-12) **Students:** $2.50 (10 or more)
&: Limited **Ⓟ:** Ample **Museum Shop**
Group Tours: ex 11 **Docents Tour times:** hourly throughout the day **Sculpture Garden**
Permanent Collection: SCULP; PTGS; WORKS OF DANIEL CHESTER FRENCH; PHOT

Chesterwood- continued

Located on 120 wooded acres is the original studio Colonial Revival house and garden of Daniel Chester French, leading sculptor of the American Renaissance. Working models for the Lincoln Memorial and the Minute Man, his most famous works, are on view along with many other of his sculptures and preliminary models. **PLEASE NOTE:** There are reduced admission rates to see the grounds only, and a special family admission rate of $16.50 for the museum buildings, grounds and tour. **NOT TO BE MISSED:** Original casts and models of the seated Abraham Lincoln for the Memorial.

Norman Rockwell Museum at Stockbridge

Stockbridge, MA 01262

(: 413-298 4100 **◘** www.nrm.org
Open: MAY-OCT 10-5 daily ; Nov-Apr 10-4 Mo-Fr; 10-5 Sa, Su & Hols **Closed:** 1/1, THGV, 12/25
ADM: Adult: $9.00 **Children:** 18 & under free when accompanied by adult 4 per adult **Students:** $7.00 **Seniors:** $4.50
&: main building, not studio **℗:** Free **Museum Shop**
Group Tours: ex 220 **Docents** **Tour times:** tours daily on the hour **Sculpture Garden**
Permanent Collection: Am; ptgs

The Norman Rockwell Museum at Stockbridge preserves and exhibits the world's largest collection of original art by America's favorite illustrator, as well as changing exhibitions of notable illustrators past and present. Founded in 1969 with the assistance of Molly and Norman Rockwel, Rockwell's Stockbridge studio, filled with his furnishings, library and travel mementos is open May to October. "Norman Rockwell, Pictures for the American People," the museum's blockbuster exhibition co-organized with the High Museum in Atlanta, GA will be touring the country through March 2002.

ON EXHIBIT 2001
09/02/2000 to 01/28/2001 NORMAN ROCKWELL'S 322 SATURDAY EVENING POST COVERS
An archival exhibit showing his first at age 22 to his last in 1963. His covers were so popular that hundreds of thousands of magazines were added to the print run when his illustration appeared on the cover to handle increased demand.

11/11/2000 to 05/28/2001 PUSHING THE ENVELOPE: THE ART OF THE POSTAGE STAMP
The evolution of the postage stamp from early hand engraved pictures of our historical past to those which document American life past and present.

06/09/2001 to 10/08/2001 NORMAN ROCKWELL: PICTURES FOR THE AMERICAN PEOPLE
The most comprehensive exhibition assembled of Rockwell's work including 70 paintings done in 60 years and all 322 'Saturday Evening Post' covers. *Will Travel*

WALTHAM

Rose Art Museum

Affiliate Institution: Brandeis University
415 South St., Waltham, MA 02254-9110

(: 781-736-3434 **◘** www.brandeis.edu/rose
Open: 12-5 Tu-Su; 12-9 Th **Closed:** Mo, LEG/HOL!
&: Entrance & galleries accessible by elevator **℗:** Visitor parking on campus
Docents **Tour times:** by advance reservation
Permanent Collection: AM: ptgs, sculp 19-20; EU: ptgs, sculp 19-20; CONT; ptgs, drgs, sculp, phot. PLEASE NOTE: The permanent collection is not always on veiw!

The Rose Art Museum, founded in 1961, and located on the campus of Brandeis University, just outside of Boston, features one of the largest collections of contemporary art in New England. Selections from the permanent collection, and an exhibition of the works of Boston area artists are presented annually. **PLEASE NOTE:** Tours are given by advance reservation only.

Davis Museum and Cultural Center
Affiliate Institution: Wellesley College
106 Central St., Wellesley, MA 02181-8257

☎: 781-283-2051 **◎** www.wellesley.edu/DavisMuseum/davismenu.html
Open: 11-5 Tu & Fr-Sa, 11-8 We, Th, 1-5 Su **Closed:** 1/1, 12/25
&: Museum and Cafe **℗:** Free **�11:** Cafe Collins open Mo-Fr (call 781-283-3379 for hours and info.)
Group Tours: 617-283-2081
Permanent Collection: AM: ptgs, sculp, drgs, phot; EU: ptgs, sculp, drgs, phot; AN; AF; MED; REN

Established over 100 years ago, the Davis Museum and Cultural Center, formerly the Wellesley College Museum, is located in a stunning 61,000 square foot state-of-the-art museum building. One of the first encyclopedic college art collections ever assembled in the United States, the museum is home to more than 5,000 works of art. **PLEASE NOTE:** The museum closes at 5pm on We & Th during the month of Jan. and from 6/15 to 8/15). **NOT TO BE MISSED:** "A Jesuit Missionary in Chinese Costume," a chalk on paper work by Peter Paul Rubens (recent acquisition).

Sterling and Francine Clark Art Institute
225 South St., Williamstown, MA 01267

☎: 413-458-2303 **◎** www.clark.williams.edu
Open: 10-5 Tu-Su; also Mo during JUL & AUG; open MEM/DAY, LAB/DAY, COLUMBUS DAY **Closed:** Mo! 1/1, THGV, 12/25
ADM: Adult: $5.00 **Seniors:** $5.00
&: Wheelchairs available **℗** **Museum Shop** **�11**
Group Tours: 413-458-2303 ex 324 **Docents** **Tour times:** 3:00 daily during Jul & Aug
Permanent Collection: IT: ptgs 14-18; FL: ptgs 14-18; DU: ptgs 14-18; OM: ptgs, gr, drgs; FR: Impr/ptgs; AM: ptgs 19

More than 30 paintings by Renoir and other French Impressionist masters as well as a collection of old master paintings and a significant group of American works account for the high reputation of this recently expanded, outstanding 40 year old institution. **PLEASE NOTE:** Recorded tours of the permanent collection are available for a small fee. **NOT TO BE MISSED:** Impr/ptgs; works by Homer, Sargent, Remington, Cassatt; Silver coll.; Ugolino Da Siena Altarpiece; Porcelain gallery.

ON EXHIBIT 2001
09/23/2000 to 01/07/2001 REMBRANDT CREATES REMBRANDT: ART AND AMBITION IN LEIDEN, 1629-1631
Ten paintings and ten etchings show Rembrandt's evolving painting and etching styles in this period.

Williams College Museum of Art
15 Lawrence Hall Drive, Ste 2, Williamstown, MA 01267-2566

☎: 413-458-2429 **◎** www.williams.edu/WCMA
Open: 10-5 Tu-Sa, 1-5 Su (open Mo on MEM/DAY, LAB/DAY, COLUMBUS DAY) **Closed:** Mo!, 1/1, THGV, 12/25
&: **℗:** Limited in front of and behind the museum, and behind the Chapel. A public lot is available at the foot of Spring St. **Museum Shop**
Group Tours: 413-597-2038 **Docents** **Tour times:** 2:00 We & Su Jul & Aug ONLY
Permanent Collection: AM: cont & 18-19; ASIAN & OTHER NON-WESTERN CIVILIZATIONS; BRIT: ptgs 17-19; SP: ptgs 15-18; IT/REN: ptgs ; PHOT; GR/ARTS; AN/GRK; AN/R

Williams College Museum of Art- continued

Considered one of the finest college art museums in the U.S., the Museum's collection of 11,000 works that span the history of art features particular strengths in the areas of contemporary & modern art, American art from the late 18th century to the present, and non-Western art. The original museum building of 1846, a two-story brick octagon with a neoclassic rotunda, was joined, in 1986, by a dramatic addition designed by noted architect Charles Moore. **NOT TO BE MISSED:** Edward Hopper "Morning in the City."

ON EXHIBIT 2001

to 02/04/2001 DOWN THE RABBIT HOLE: ARTISTS AND WRITERS IN WONDERLAND
From the Dali illustrations to the mythological idylls of Charles Prendergast, these are places artists and writers find in their imaginations.

to 02/25/2001 ART OF ANCIENT WORLDS
Ancient sculptures, vases and artifacts.

to 07/01/2001 CELEBRATING 75 YEARS OF PERMANENT CHANGE: CONTEMPORARY WORKS FROM THE COLLECTION

07/01/2000 to 08/2001 THE ART OF LEISURE: MAURICE AND CHARLES PRENDERGAST IN THE WILLIAMS COLLEGE MUSEUM OF ART
Newly affluent Americans at the turn-of-the-century enjoyed the leisure themes of beaches, parks, New England towns, and European tourist attractions.

10/20/2000 to 08/12/2001 CELEBRATING 75 YEARS-LABELTALK 2001

11/08/2000 to 02/14/2001 ARTIST/ TEACHER: GROUP FACULTY EXHIBITION
A showcase for the diversity of art-making today.

12/12/2000 to 09/03/2001 CELEBRATING 75 YEARS-PHOTOGRAPHY EXPOSED
A strength of the collection is photography from 1850-1960. Important 19th and 20th century images will be featured.

WORCESTER

Iris & B. Gerald Cantor Art Gallery
Affiliate Institution: College of Holy Cross
1 College St., Worcester, MA 01610
℅: 508-793-3356 **◎** www.holycross.edu/visitor/cantor/cantor/html
Open: 9-Noon & 1-4 Mo & Tu, Th & Fr, and by appointment **Closed:** ACAD!, Su, LEG/ HOL!
&. **℗:** Free **Group Tours:** 205-932-8327 **Docents** **Tour times:** daily during Museum hours
Permanent Collection: Am: ptgs 20; folk

Housed in a 1930's former schoolhouse, this collection consists of more than 3500 works of 20th century American art. **NOT TO BE MISSED:** One of the largest collections of folk art in the Southeast.

Worcester Art Museum
55 Salisbury St., Worcester, MA 01609-3123
℅: 508-799-4406 **◎** www.woresterart.org
Open: 11-5 We-Fr, 10-5 Sa, 11-5 Su; Closed Su JUL & AUG **Closed:** Mo, Tu 7/4, THGV, 12/25
ADM: Adult: $6.00 **Children:** Free under 12 **Students:** $4.00 **Seniors:** $4.00
&.: Restrooms & some galleries; wheelchairs available on request **℗:** Free parking in front of museum and along side streets; handicapped parking at the Hiatt Wing entrance off Tuckerman Street. **Museum Shop**
¶: Cafe 11:30-2 We-Sa (ex. 3068)
Group Tours: ex 3061 **Docents** **Tour times:** 2:00 most Su Sep-May; 2:00 Sa **Sculpture Garden**
Permanent Collection: AM: 17-19; JAP: gr; BRIT: 18-19; FL: 16-17; GER: 16-17; DU: 17; P/COL; AN/EGT; OR: sculp; MED: sculp; AM: dec/art

Worcester Art Museum - continued

Opened to the public in 1898, the Worcester Art Museum is the second largest art museum in New England. Its exceptional 35,000-piece collection of paintings, sculpture, decorative arts, photography, prints and drawings is displayed in 36 galleries and spans 5,000 years of art and culture, ranging from Egyptian antiquities and Roman mosaics to Impressionist paintings and contemporary art. Throughout its first century, the Museum has proven itself a pioneer. Among its many "firsts," the Museum was the first American museum to purchase work by Claude Monet (1910) and Paul Gauguin (1921); the first museum to bring a medieval building to America; a sponsor of the first major excavation at Antioch, one of the four great cities of ancient Rome (1932); the first museum to organize a Members' Council (1949); and the first museum to create an Art All-State program for high school artists. **NOT TO BE MISSED:** Antiochan Mosaics; American Portrait miniatures; New Roman Art Gallery; New Contemporary Art Gallery.

ON EXHIBIT 2001

to 02/03/2001 CHUCK CLOSE: NEW WORKS

04/21/2000 to 06/17/2001 THE STAMP OF IMPULSE: ABSTRACT IMPRESSIONIST PRINTS

10/08/2000 to 02/04/2001 ANTIOCH: THE LOST ANCIENT CITY
Included are some of the finer mosaics and a variety of objects including coins, frescoes, glass sculpture and metalwork within their architectural and cultural environments. *Brochure*

12/16/2000 to 02/25/2001 FRESH WOODS AND PASTURES: NEW DUTCH LANDSCAPE DRAWINGS FROM THE PECK COLLECTION

03/31/2001 to 06/10/2001 LEWIS HINE

10/07/2001 to 01/06/2002 MODERNISM AND ABSTRACTION: TREASURES FROM THE SMITHSONIAN'S AMERICAN ART MUSEUM

MICHIGAN

University of Michigan Museum of Art

525 S. State St. at S. Univ., Ann Arbor, MI 48109

℡: 734-764-0395 ◙ www.umich.edu/~umma/
Open: 10-5 Tu-Sa, till 9 Th, 12-5 Su **Closed:** Mo, 1/1, 7/4, THGV, 12/25
Sugg/Contr.:$3.00 &.: North museum entrance & all galleries; limited access to restrooms
℗: Limited on-street parking with commercial lots nearby **Museum Shop**
Docents Tour times: 12:10-12:30 Th; 2pm Su
Permanent Collection: CONT; gr, phot; OM; drgs 6-20; OR; AF; OC; IS

This museum, which houses the second largest art collection in the state of Michigan, also features a changing series of special exhibitions, family programs, and chamber music concerts. With over 12,000 works of art ranging from Italian Renaissance panel paintings to Han dynasty Tomb figures, this 50 year old university museum ranks among the finest in the country. **NOT TO BE MISSED:** Works on paper by J. M. W. Whistler.

ON EXHIBIT 2001

12/02/2000 to 01/28/2001 ED WEST —PHOTOGRAPHS
The role of black people in South African society is shown here.

Art Center of Battle Creek

265 E. Emmett St., Battle Creek, MI 49017-4601

℡: 616-962-9511 ◙ www.artcenterofbc.org
Open: 10-5 Tu-Sa; 12-4 Su, till 7pm Th **Closed:** Mo, LEG/HOL
Sugg./Contr.: Yes &. ℗: 70 spaces with handicapped access at building **Museum Shop**
Group Tours: 616-962-9511
Permanent Collection: REG

The mission of the Art Center is to present quality exhibitions and programming in the visual arts for the education, enrichment and enjoyment of the southwestern Michigan region. **NOT TO BE MISSED:** KIDSPACE, a hands-on activity gallery for children.

Cranbrook Art Museum

1221 North Woodward Ave., Bloomfield Hills, MI 48303-0801

℡: 248-645-3323 ◙ www.cranbrook.edu/museum
Open: 11-5 Tu-Su, till 9pm Th **Closed:** Mo, LEG/HOL!
ADM: Adult: $5.00 **Children:** Free 7 and under **Students:** $3.00 **Seniors:** $3.00
&. ℗ **Museum Shop**
Group Tours: 248-645-3323 **Docents Tour times:** varies **Sculpture Garden**
Permanent Collection: ARCH/DRGS; CER; PTGS; SCULP; GR 19-20 ; DEC/ART 20

The newly restored Saarinen House, a building designed by noted Finnish-American architect Eliel Saarinen, is part of Cranbrook Academy, the only institution in the country solely devoted to graduate education in the arts. In addition to outdoor sculpture on the grounds surrounding the museum, the permanent collection includes important works of art that are influential on the contemporary trends of today. **PLEASE NOTE:** Please call ahead (248-645-3323) for specific information on tours and admission fees for Cranbrook House, Cranbrook Gardens (for the architecture & sculpture tour), Cranbrook Art Museum, and Saarinen House. **NOT TO BE MISSED:** Works by Eliel Saarinen; carpets by Loja Saarinen.

DETROIT

Detroit Institute of Arts

5200 Woodward Ave., Detroit, MI 48202

☎: 313-833-7900 ◘ www.dia.org
Open: 11-4 We-Fr; 11-5 Sa, Su **Closed:** Mo, Tu, Some Holidays
Sugg./Contr.: ADM: Adult: $4.00 **Children:** $1.00 **Students:** $1.00
&: Wheelchairs available at barrier free Farnsworth Entrance! 833-9754 ℗: Underground parking adjacent to museum; metered street parking **Museum Shop** ¶: Kresge Court Cafe (833-1932), Gallery Grille (833-1857)
Group Tours: 313-833-7981 **Docents** **Tour times:** 1:00 We-Sa; 1 & 2:30 Su
Permanent Collection: FR: Impr; GER: Exp; FL; ptgs; AS; EGT; EU: 20; AF; CONT; P/COL; NAT/AM; EU: ptgs, sculp, dec/art; AM: ptgs, sculp, dec/art ∩

With holdings that survey the art of world cultures from ancient to modern times, The Detroit Institute of Arts, founded in 1885, ranks fifth largest among the nation's fine art museums. **NOT TO BE MISSED:** "Detroit Industry" by Diego Rivera, a 27 panel fresco located in the Rivera court.

EAST LANSING

Kresge Art Museum

Affiliate Institution: Michigan State University
East Lansing, MI 48824-1119

☎: 517-355-7631 ◘ www.msu.edu/unit/kamuseum
Open: 10-5 Mo-Fr; 12-5 Sa, Su; SUMMER 11-5 Tu-Fr; 12-5 Sa, Su **Closed:** LEG/HOL! ACAD!; closed August
Vol./Contr.: Yes
&: ℗: Small fee at designated museum visitor spaces in front of the art center. **Museum Shop**
Group Tours: 517-353-9834 **Sculpture Garden**
Permanent Collection: GR 19-20; AM: cont/ab (1960'S), PHOT

Founded in 1959, the Kresge, an active teaching museum with over 6,500 works ranging from prehistoric to contemporary, is the only fine arts museum in central Michigan. **NOT TO BE MISSED:** "St. Anthony" by Francisco Zurbaran; "Remorse" by Salvador Dali; Contemporary collection.

ON EXHIBIT 2001

01/10/2001 to 03/18/2001 AMERICAN LANDSCAPE PAINTING FROM THE DETROIT INSTITUTE OF ART AND OTHER MICHIGAN COLLECTIONS

01/10/2001 to 03/18/2001 AMERICAN NAIVE PAINTINGS FROM THE GARBISCH COLLECTION OF THE FLINT INSTITUTE OF ARTS (18TH AND 19TH CENTURIES)

01/10/2001 to 03/18/2001 TWO CENTURIES OF AMERICAN PAINTING

05/06/2001 to 07/01/2001 BOTANICA: CONTEMPORARY ART AND THE WORLD OF PLANTS
Fifty contemporary artists who use forms, shapes and concepts from the plant world. Included are Kiki Smith, Bleckner, Mei Chin, Kushner, Rockman and Wool.

09/04/2001 to 10/21/2001 ART OF THE 90'S FROM THE ELI BROAD FAMILY FOUNDATION COLLECTION

10/27/2001 to 12/21/2001 THE POWER AND PASSION OF DANCE: PHOTOGRAPHS FROM THE CAROL HALSTED COLLECTION
The great dancers and choreographers of the 20th century by Bourke-White, Liebowitz, Penn, and Cartier-Bresson.

MICHIGAN

Flint Institute of Arts
1120 E. Kearsley St., Flint, MI 48503-1991
℡: 810-234-1695 ◙ www.flintarts org
Open: 10-5 Tu-Sa, 1-5 Su **Closed:** Mo, LEG/HOL!
Vol./Contr.: Yes
& ℗: Free **Museum Shop**
Group Tours: 810-234-1695 **Docents** **Tour times:** 10-5 Tu-Sa **Sculpture Garden**
Permanent Collection: AM: ptgs, sculp, gr 19-20; EU: ptgs, sculp, gr 19-20; FR/REN: IT/REN: dec/art; CH; cer, sculp

The Flint Institute of Arts, founded in 1928, has grown to become the largest private museum collection of fine art in the state. In addition to the permanent collection with artworks from ancient China to modern America, visitors to this museum can enjoy the renovated building itself, a stunning combination of classic interior gallery space housed within the walls of a modern exterior. **NOT TO BE MISSED:** Bray Gallery of French & Italian Renaissance decorative art.

Calvin College Center Art Gallery
Affiliate Institution: Calvin College
Grand Rapids, MI 49546
℡: 616-957-6271
Open: 9-9 Mo-Th, 9-5 Fr, Noon-4 Sa **Closed:** Su, ACAD!
& ℗
Group Tours: 616-957-6271 **Docents** **Tour times:** Available upon request
Permanent Collection: DU: ptgs, drgs 17-19; GR, PTGS, SCULP, DRGS 20

17th & 19th century Dutch paintings are one of the highlights of the permanent collection.

Grand Rapids Art Museum
155 N. Division, Grand Rapids, MI 49503
℡: 616-831-1000 ◙ www.gramonline.org
Open: 11-6; Fr 11-9 **Closed:** Mo, LEG/HOL!
Free Day: Fr 5-9 **ADM: Adult:** $5.00 **Children:** Free under 5 w/ adult, $1.00 6-17 **Students:** $2.00 **Seniors:** $2.00
& ℗: Less than 1 block from the museum **Museum Shop**
Group Tours: 616-831-2928
Permanent Collection: REN: ptgs; FR: ptgs 19; AM: ptgs 19-20; GR; EXP/PTGS; PHOT; DEC/ART

Located in a former Federal Building, the Grand Rapids Art Museum, founded in 1911, exhibits paintings and prints by established and emerging artists, as well as photographs, sculpture, and a collection of furniture & decorative arts from the Grand Rapids area and beyond. **NOT TO BE MISSED:** Picasso ceramics, "Ingleside" by Richard Diebenkorn, and other works. Free Fr eve, Rhythm and Blues, Cash Bar. There are admission fees for some special exhibitions.

ON EXHIBIT 2001
01/15/2001 to 05/13/2001 AMERICAN ART OF THE TWENTIETH CENTURY

01/15/2001 to 05/13/2001 MATHIAS ALTEN: MICHIGAN PAINTER

01/26/2001 to 09/29/2001 RENAISSANCE TO MODERN ART: A HERITAGE OF HUMANISM

02/16/2001 to 05/20/2001 AMERICAN MASTERS: THE RICHARD MANOOGIAN COLLECTION PART I : THE LANDSCAPE AND STILL LIFE TRADITIONS

Grand Rapids Art Museum - continued
05/25/2001 to 08/26/2001 AMERICAN MASTERS: THE RICHARD MANOOGIAN COLLECTION PART II: IMPRESSIONISTS AT HOME AND ABROAD

10/19/2001 to 01/06/2002 LIGHT SCREENS: THE LEADED GLASS OF FRANK LLOYD WRIGHT

<div align="center">

KALAMAZOO

</div>

Kalamazoo Institute of Arts
314 South Park St., Kalamazoo, MI 49007

☎: 616-349-7775 **◘** www.kiarts.org
Open: 10-5 Tu, We, Fr, Sa, 10-8 Th, 12-5 Su **Closed:** Mo, LEG/HOL
Vol./Contr.: Yes
&. Ⓟ Museum Shop
Group Tours: 616-349-7775, ext 3132 **Sculpture Garden**
Permanent Collection: sculp, ptgs, drgs, cer, gr, photo

The Kalamazoo Institute, established in 1924, is known for its collection of 20th century American art and European graphics, as well as for its outstanding art school. More than 3,000 objects are housed in a building that in 1979 was voted one of the most significant structures in the state and in 1998 underwent a significant expansion. **NOT TO BE MISSED:** The state of the art interactive gallery and permanent collection installations, including "La Clownesse Aussi (Mlle. Cha-U-Ka-O)" by Henri de Toulouse Lautrec; "Sleeping Woman" by Richard Diebenkorn; "Simone in a White Bonnet" by Mary Cassatt.

ON EXHIBIT 2001

to 02/25/2001 YOUR DOCTOR SPEAKS: THE PHARMACIA CORPORATE COLLECTION
Works of art by American artists were purchased to illustrate a series of informative messages on advances in medecine that were run in popular magazines of the day.

01/20/2001 to 03/13/2001 OUT OF THE ORDINARY: PHOTOGRAPHS BY CARLA ANDERSON & PHOTOGRAPHY FROM THE PERMANENT COLLECTION
Anderson has made an in-depth study of the of the landscape and unique vernacular architecture of the Southeastern United States. Her emotive color work has drawn much critical attention.

03/10/2001 to 05/20/2001 GOING HOME: THE ART OF DAVID DIAZ
Bold, dynamic and elaborate art styles to create richly beautiful and striking illustrations for his many moving children's books.

03/24/2001 to 05/29/2001 THE ARTIST AS EXPLORER: NATIVE AMERICAN LIFE ON THE FRONTIER
Rare prints by Catlin and Bodmer from the A.E. Edwards Collection and artifacts from Midwest Museum collections.

05/19/2001 to 07/15/2001 LAWRENCE SNIDER PHOTOGRAPHS
Photographs of the landscape and culture of China, Tibet and Thailand.

05/19/2001 to 07/15/2001 STILL LIFE PAINTINGS BY CATHERINE MAIZE AND DAVID ZIMMERMANN
Small format works with wide brush strokes.

05/25/2001 to 08/11/2001 2001 WEST MICHIGAN AREA SHOW
Juried show in all media.

09/09/2001 to 01/13/2002 A BOUNTIFUL PLENTY FROM THE SHELBURNE MUSEUM: FOLK ART TRADITIONS IN AMERICA
The collection of Electra Havemeyer Webb (1888-1960) reflects her keen eye for collecting highly significant paintings, sculpture and furniture. "The best of the best" includes trade signs, carousel figures, quilts, tobacconist figures, decoys, weather vanes and ship figureheads.

MICHIGAN

Muskegon Museum of Art
296 W. Webster, Muskegon, MI 49440

☎: 231-720-2570 ◙ www.muskegon/mma/Default.html
Open: 10-5 Tu-Fr; 12-5 Sa, Su **Closed:** Mo, LEG/HOL!
Vol./Contr.: Yes
&: **℗:** Limited street and adjacent mall lots; handicapped parking at rear of museum **Museum Shop**
Permanent Collection: AM: ptgs, gr 19-early 20; EU: ptgs; PHOT; SCULP; OM: gr; CONT: gr

The award winning Muskegon Museum, which opened in 1912, and has recently undergone major renovation, is home to a permanent collection that includes many fine examples of American and French Impressionist paintings, Old Master through contemporary prints, photography, sculpture and glass. The museum features a diverse schedule of changing exhibitions. Call for possible date changes! **NOT TO BE MISSED:** American Art Collection.

ON EXHIBIT 2001
10/21/2001 to 12/16/2001 AFRICAN AMERICAN WORKS ON PAPER
Prints, drawings and watercolors by America's greatest African American artists. *Will Travel*

Crooked Tree Arts Council
461 E. Mitchell St., Petoskey, MI 49770

☎: 616-347-4337 ◙ www.crockedtreecrg
Open: 10-5 Mo-Fr; 11-4 Sa **Closed:** Su, LEG/HOL!
& **℗:** 60 parking spaces on city lot next door to museum **Museum Shop**
Permanent Collection: REGIONAL & FINE ART

This fine arts collection makes its home on the coast of Lake Michigan in a former Methodist church built in 1890.

Meadow Brook Art Gallery
Affiliate Institution: Oakland University
Rochester, MI 48309-4401

☎: 248-370-3005
Open: 12-5 Tu-Fr; 1-5:30 Sa, Su (open evenings during theater performances) **Closed:** Mo
& **℗:** Free
Group Tours: 248-370-3005 **Sculpture Garden**
Permanent Collection: AF; OC; P/COL; CONT/AM: ptgs, sculp, gr; CONT/EU: ptgs, gr, sculp

Located 30 miles north of Detroit on the campus of Oakland University, the Meadow Brook Art Gallery offers four major exhibitions annually. **NOT TO BE MISSED:** Informative lectures in conjunction with exhibitions.

ON EXHIBIT 2001
01/12/2001 to 02/25/2001 PUNCH'S PROGRESS: A CENTURY OF AMERICAN PUPPETRY FROM THE DETROIT INSTITUTE OF ARTS

03/09/2001 to 04/08/2001 THE ART OF THE CATHARTIC CIRCLE

SAGINAW

Saginaw Art Museum
1126 N. Michigan Ave., Saginaw, MI 48602
☎ 517-754-2491
Open: Tu-Sa 10-5; Su 1-5 **Closed:** Mo, LEG/HOL!
♿ ℗: Free **Museum Shop**
Group Tours: 517-754-2491 (ask for Kara or Tim) **Docents** **Tour times:** by appointment
Permanent Collection: EU: ptgs, sculp 14-20; AM: ptgs sculp; OR: ptgs, gr, dec/art; JAP: GR; JOHN ROGERS SCULP; CHARLES ADAMS PLATT: gr

The interesting and varied permanent collections of this museum, including an important group of John Rogers sculptures, are housed in a gracious 1904 Georgian-revival building designed by Charles Adams Platt. The former Clark Lombard Ring Family home is listed on the state & federal registers for historic homes. **NOT TO BE MISSED:** T'ang Dynasty Marble Buddha.

ON EXHIBIT 2001

11/17/2000 to 01/21/2001	**COROT AND HIS CONTEMPORARIES**
12/01/2000 to 01/14/2001	**WALTER NAGEL WOOD SCULPTURES**
01/13/2001 to 12/31/2001	**PORTRAITS FROM THE PERMANENT COLLECTION**
01/19/2001 to 04/15/2001	**MORE PORTRAITS FROM THE PERMANENT COLLECTION**
02/03/2001 to 03/04/2001	**DANIELLE BODINE: PAPER CREATIONS**
02/02/2001 to 03/04/2001	**DIANNE WOLTER: PAINTINGS**
02/02/2001 to 03/04/2001	**JEAN BEACH: DIGITAL PHOTOS**
03/09/2001 to 04/29/2001	**JIM PERKINS: ARTIST IN RESIDENCE**
04/27/2001 to 07/08/2001	**BOOK ARTS**
05/03/2001 to 07/01/2001	**FIESTA! LATINO ARTISTS: JURIED SHOW**
09/07/2001 to 10/28/2001	**CoBra ARTISTS: KAREL APPEL, PIERRE ALECHINSKY**
09/07/2001 to 11/18/2001	**EMI KUMAGAI: JAPANESE BRUSH PAINTING**
11/10/2001 to 12/09/2001	**H.A.SIGG: SWISS PAINTER AND SCULPTOR**
12/20/2001 to 02/17/2002	**SUGDEN AND ELCHERT: IMAGES OF TIBET**

ST. JOSEPH

Krasl Art Center
707 Lake Blvd., St. Joseph, MI 49085
☎ 616-983-0271 ⊡ www.krasl.org
Open: 10-4 Mo-Th & Sa, 10-1 Fr, 1-4 Su **Closed:** Fr pm; Major Holidays & Sa of Blossomtime Parade in early May
♿ ℗: Free **Museum Shop**
Group Tours: 616-983-0271 **Docents** **Tour times:** by appt
Permanent Collection: ptgs, sculp

MICHIGAN

Krasl Art Center - continued

Located on the shores of Lake Michigan, site specific sculptures are placed in and around the area of the center. Maps showing location and best positions for viewing are provided for the convenience of the visitor. The center is also noted for hosting one of the finest art fairs each July. **NOT TO BE MISSED:** Blown glass chandelier by Dale Chihuly, "The Heavyweight (nicknamed lotus)" by Dr. Burt Brent, "Three Lines Diagonal Jointed-Wall" by George Rickey, "Allegheny Drift" by Michael Dunbar.

ON EXHIBIT 2001

11/22/2000 to 01/07/2001 **CARL MILLES: SCULPTURE**

01/18/2001 to 03/04/2001 **COLLARS AND CUFFS-FROM THE DETROIT INSTITUTE OF ART**

06/14/2001 to 08/05/2001 **JESUS LOPEZ: HOLOGRAMS**

06/14/2001 to 08/05/2001 **MIMI PETERSON: SCULPTURE**

TRAVERSE CITY

Dennos Museum Center

Affiliate Institution: Northwestern Michigan College
1701 East Front St., Traverse City, MI 49686
☏: 231-995-1055 **◙** dmc.nmc.edu
Open: 10-5 Mo-Sa, 1-5 Su **Closed:** LEG/HOL!
ADM: Adult: $2.00 Subject to change for special exhibitions **Children:** $1.00 **Students:** $1.00 **Seniors:** $2.00
& **℗:** Reserved area for museum visitors adjacent to the museum. **Museum Shop**
Group Tours: 231-922-1029 **Docents** **Tour times:** by appointment **Sculpture Garden**
Permanent Collection: Inuit art; CONT: Canadian Indian graphics; AM; EU; NAT/AM

With a collection of more than 1,600 works, the Dennos Museum Center houses one of the largest and most historically complete collections of Inuit art from the peoples of the Canadian Arctic. The museum also features a "hands-on" Discovery Gallery. **NOT TO BE MISSED:** The Power Family Inuit Gallery with over 880 Inuit sculptures and prints; The Thomas A. Rutkowski interactive "Discovery Gallery."

ON EXHIBIT 2001

12/03/2000 to 03/04/2001 **CLEMENT MEADMORE: SCULPTURE**
Small sculptures and maquettes.

04/07/2001 to 09/19/2001 **WOMEN OF THE NILE**
Artifacts which create a thoughtful look at the power women wielded in Egyptian society.

DULUTH

Tweed Museum of Art

Affiliate Institution: University of Minnesota
10 University Dr., Duluth, MN 55812

✆: 218-726-8222 **◎** www.d.umn.edu/tma
Open: 9-8 Tu, 9-4:30 We-Fr, 1-5 Sa-Su **Closed:** Mo, ACAD!
Sugg./Contr.: Yes
 ᵭ **℗ Museum Shop**
Group Tours: 218-726-8527 **Sculpture Garden**
Permanent Collection: OM: ptgs; EU: ptgs 17-19; F: Barbizon ptgs 19; AM: all media 19-20; CONT; AF; JAP: cer; CONT/REG

Endowed with gifts of American and European paintings by industrialist George Tweed, for whom this museum is named, this fine institution also has an important growing permanent collection of contemporary art. One-person exhibitions by living American artists are often presented to promote national recognition of their work. **NOT TO BE MISSED:** "The Scourging of St. Blaise," a 16th century Italian painting by a follower of Caravaggio.

MINNEAPOLIS

Frederick R. Weisman Art Museum at the University of Minnesota

Affiliate Institution: University of Minnesota
333 East River Road, Minneapolis, MN 55455

✆: 612-625-9494 **◎** hudson.acad.umn.edu
Open: 10-5 Tu, We, Fr; 10-8 Th; 11-5 Sa, Su **Closed:** Mo, ACAD!, LEG/HOL!
 ᵭ **℗:** Paid parking in the Museum Garage is $1.60 per hour with a weekend flat rate of $3.50 per day.
Museum Shop
Group Tours: 612-625-9656 **Docents Tour times:** 1 pm Sa, Su
Permanent Collection: AM: ptgs, sculp, gr 20; KOREAN: furniture 18-19; Worlds largest coll of works by Marsden Hartley & Alfred Maurer (plus major works by their contemporaries such as Feninger & O'Keeffe)

Housed since 1993 in a striking, sculptural stainless steel and brick building designed by architect Frank Gehry, the Weisman Art Museum offers a convenient and friendly museum experience. The museum's collection features early 20th-century American artists, such as Georgia O'Keeffe and Marsden Hartley, as well as a selection of contemporary art. A teaching museum for the University and the community, the Weisman provides a multidisciplinary approach to the arts through an array of programs and a changing schedule of exhibitions. **NOT TO BE MISSED:** "Oriental Poppies," by Georgia O'Keeffe.

Minneapolis Institute of Arts

2400 Third Ave. So., Minneapolis, MN 55404

✆: 612-870-3000 **◎** www.artsmia.org
Open: 10-5 Tu-Sa, 10-9 Th, Noon-5 Su **Closed:** Mo, 7/4, THGV, 12/25
Vol./Contr.: yes
 ᵭ **℗:** Free and ample **Museum Shop** ⅱ: 11:30-2:30 Tu-Sa
Group Tours: 612-870-3140 **Docents Tour times:** 2:00 Tu-Sa, 1:00 Sa & Su, 7pm Th
Sculpture Garden
Permanent Collection: AM: ptgs, sculp; EU: ptgs, sculp; DEC/ART; OR; P/COL; AF; OC; ISLAMIC; PHOT; GR; DRGS; JAP: gr; textiles, arch, asian

MINNESOTA

Minneapolis Institute of Arts- continued

The Minneapolis Institute of Arts is a familiar landmark located just south of downtown Minneapolis. Its architecture combines the original 1915 neo-classical structure designed by McKim, Mead and White with additions in 1974 by Kenzo Tange and in 1998 by RSP Architects. The museum is home to more than 100,000 works of art spanning 5000 years of cultural history; approximately 4000 objects are on view at any one time. Masterpieces by Rembrandt, Goya, Poussin, van Gogh, Degas and Bonnard, as well as leading contemporary artists, are some of highlights of the painting collection. The sculpture collection ranges from Egyptian, Greek and Roman examples to modern works by Calder, Picasso and Moore. Twenty-two new Asian galleries feature Chinese and Japanese screens, ceramics, bronzes, jades, paintings and woodblock prints, as well as Buudhist, Himalayan, Indian, Islamic and Southeast Asian art. Two original Chinese period rooms date from the 17th and 18th centuries, and traditional Chinese gardens are visitors favorites. In addition to 11 fascinating period rooms, the museum has extensive holdings in the decorative arts and architecture. The prints and drawing collection features work by Durer, Rembrandt, Toulouse-Lautrec, Lichtenstein, Johns and others and the photography collection documents the history of the medium from 1836 to the present. Among the more than 10,000 photogaphs are works by Stieglitz, Steichen, Evans, Adams and others. The museum also has respected collections of textiles, cearmics and Judaica, as well as African, Oceanic, Pre-Columbian and Native American art. **NOT TO BE MISSED:** Rembrandt's "Lucretia."

ON EXHIBIT 2001

08/26/2000 to 01/07/2001 BODYWORK: PHOTOGRAPHS OF NUDES
Ten internationally known artists who engaged the figure in a wide range of imagery. Their figures represent a wide range of imagery and every major photography movement.

09/02/2000 to 01/07/2001 JOHN HOWE IN MINNESOTA: THE PRAIRIE SCHOOL LEGACY OF FRANK LLOYD WRIGHT

10/21/2000 to 01/14/2001 THE ART OF TWENTIETH CENTURY ZEN
The first exhibition in America to present a survey of painting and calligraphy by Japan's greatest Zen masters of the 20th C. *Will Travel*

12/10/2000 to 03/04/2001 CHINA: FIFTY YEARS INSIDE THE PEOPLE'S REPUBLIC
Images since 1949 present a compelling view of everyday cultural and political life from the perspective of great eastern and western photographers.

12/15/2000 to 02/11/2001 CHRIS FAUST/MIKE LYNCH (working title)
The essence of the urban landscape and the physical worlds.

03/17/2001 to 06/03/2001 MICHAEL MAZUR: A PRINT RETROSPECTIVE
The graphic art produced from 1958-1998.

06/17/2001 to 09/09/2001 DEGAS AND AMERICA: THE EARLY COLLECTORS
Ballerinas before the dance, men racing on horseback and portraits of friends and fellow artists.

08/04/2001 to 10/14/2001 PLAINS INDIAN SHIRTS FROM THE NATIONAL MUSEUM OF THE AMERICAN INDIAN FROM 1830-2001

08/21/2001 to 10/14/2001 NORTH AMERICAN WOOD TURNING SINCE 1930: FROM PRESTINI TO PRESENT

12/01/2001 to 03/10/2002 JACK LENOR LARSEN: THE COMPANY AND THE CLOTH

Walker Art Center

Vineland Place, Minneapolis, MN 55403

☎: 612-375-7622 ◘ www.walkerart.org
Open: Gallery: 10-5 Tu-Sa, 11-5 Su, till 9pm Th **Closed:** Mo, LEG/HOL!
ADM: Adult: $4.00 **Children:** Free under 12 **Students:** $3.00 **Seniors:** $3.00
& ⓟ: Hourly metered on-street parking & pay parking at nearby Parade Stadium lot **Museum Shop** ⅋: **Sculpture Garden** 11:30-3 Tu-Su; Gallery 8 11:30-3, till 8 We
Group Tours: 612-375-7609 **Docents** **Tour times:** 2pm Sa, Su; 2 & 6pm Th (Free with adm.) **Sculpture Garden**
Permanent Collection: AM & EU CONT: ptgs, sculp; GR; DRGS ∩

Housed in a beautifully designed building by noted architect Edward Larabee Barnes, the Walker Art Center, with its superb 7,000 piece permanent collection, is particularly well known for its major exhibitions of 20th century art. **PLEASE NOTE:** 1. The sculpture garden is open free to all from 6am to midnight daily. There is a self-guided audio tour of the Garden available for rent at the Walker lobby desk. 2. For information on a wide variety of special needs tours or accommodations call 612-375-7609. **NOT TO BE MISSED:** Minneapolis Sculpture Garden at Walker Art Center (open 6-Midnight daily; ADM Free); "Standing Glass Fish" by F. Gehry at Cowles Conservatory (open 10-8 Tu-Sa, 10-5 Su; ADM Free).

ON EXHIBIT 2001

02/10/2001 to 05/06/2001 **PAINTING AT THE EDGE OF THE WORLD**

03/10/2001 to 06/17/2001 **YES YOKO ONO**

04/08/2001 to 07/15/2001 **FRANZ MARC**

06/10/2001 to 09/02/2001 **ALICE NEEL**

ST. PAUL

Minnesota Museum of American Art

505 Landmark Center - 75 West Fifth St., St. Paul, MN 55102-1486

☎: 651-292-4355 ◘ www.mtn.org/mmaa/
Open: 11-4 Tu-Sa, 11-7:30 Th, 1-5 Su **Closed:** Mo, LEG/HOL!
&: Elevator; restroom; special entrance ⓟ: Street parking and nearby parking facilities ⅋: 11:30-1:30 Tu-Fr; 11-1 Sa
Group Tours: 651-292-4395 **Docents** **Tour times: Group Tours** scheduled daily, regular Museum hours
Permanent Collection: AM

The Minnesota Museum of American Art, located in the Historic Landmark Center in downtown Saint Paul, is an accessible, intimate museum experience. The MMAA exhibits a diverse collection of American artists in the Permanent Collection Galleries and an exciting mix of national touring exhibitions in the Exhibition Galleries. Come enjoy installations of recently acquired sculpture, collages, and photographs by artists Louise Nevelson, George Morrison and Gordon Parks. The MMAA is within easy walking distance of the new Science Museum of Minnesota and downtown hotels.

MISSISSIPPI

BILOXI

George E. Ohr Arts and Cultural Center
136 George E. Ohr St., Biloxi, MS 39530
☎: 601-374-5547 **◙** www.georgeohr.org
Open: 9-5 Mo-Sa **Closed:** Su, 1/1, 7/4, THGV, 12/25
ADM: Adult: $2.00 **Seniors:** $1.00
&. **Ⓟ:** Free parking in the lot across the street from the museum. **Museum Shop**
Group Tours: 601-374-5547 **Docents**
Permanent Collection: George Ohr pottery

In addition to a 300 piece collection of pottery by George Ohr, a man often referred to as the mad potter of Biloxi, this museum features a gallery dedicated to the promotion of local talent and another for rotating and traveling exhibitions. **NOT TO BE MISSED:** Art Activity, a program for children from 10-12 on the 2nd Saturday of the month, led each time by a different artist using a different medium.

JACKSON

Mississippi Museum of Art
201 E. Pascagoula St., Jackson, MS 39201
☎: 601-960-1515 **◙** www.msmuseumart.org
Open: Please call for hours **Closed:** LEG/HOL
ADM: Adult: Call for Admission rates
&. **Ⓟ:** Pay lot behind museum **Museum Shop** ⅼⅼ: The Palette (open for lunch 11:00-2:00 Mo-Fr)
Group Tours: 601-960-1515 **Docents** **Tour times:** Upon request if available **Sculpture Garden**
Permanent Collection: AM: 19-20; REG: 19-20; BRIT: ptgs, dec/art mid 18-early 19; P/COL: cer; JAP: gr

Begun as an art association in 1911, the Mississippi Museum now has more than 3,400 works of art in a collection that spans more than 30 centuries.

ON EXHIBIT 2001
10/07/2000 to 01/07/2001 MISSISSIPPI WATERCOLOR SOCIETY GRAND NATIONAL WATERCOLOR EXHIBITION

10/28/2000 to 01/28/2001 CELEBRATING THE CREATIVE SPIRIT: CONTEMPORARY SOUTHEASTERN FURNITURE
This exhibition showcases exemplary objects by southeastern furniture-makers to document work that has helped to expand the horizon of furniture-making into an art form.

02/03/2001 to 05/13/2001 ANDREW WYETH: CLOSE FRIENDS
This exhibition examines his close affinity with African-American neighbors and friends from his surrounding community.

06/2001 to 07/2001 MISSISSIPPI INVITATIONAL
Art in all media will be seen in an exhibition of works by some of the state's most significant contemporary artists.

10/2001 to 11/2001 WE SHALL OVERCOME: PHOTOGRAPHS FROM AMERICA'S CIVIL RIGHTS ERA

LAUREL

Lauren Rogers Museum of Art
5th Ave. at 7th St., Laurel, MS 39441-1108

☎: 601-649-6374
Open: 10-4:45 Tu-Sa, 1-4 Su **Closed:** Mo, LEG/HOL!
&: Wheelchair accessible, elevator, restrooms **Ⓟ:** Lot at rear of museum and along side of the museum on 7th Street
Museum Shop Docents Tour times: 10-12 & 1-3 Tu-Fr
Permanent Collection: AM:19-20; EU: 19-20; NAT/AM; JAP: gr 18-19; NAT/AM: baskets; ENG: silver

Located among the trees in Laurel's Historic District, the Lauren Rogers Museum was the first art museum to be established in the state and has grown rapidly since its inception in 1922. While the original Georgian Revival building still stands, the new adjoining galleries are perfect for the display of the fine art collection of American and European masterworks. **NOT TO BE MISSED:** One of the largest collections of Native American Indian baskets in the U.S.; Gibbons English Georgian Silver Collection.

ON EXHIBIT 2001
12/14/2000 to 01/28/2001 THE ART OF STEFFEN THOMAS

02/06/2001 to 03/15/2001 AFRICAN-AMERICAN ART

03/25/2001 to 04/30/2001 EARTH, FIRE AND WATER: CONTEMPORARY FORGED METAL
Works by 16 artists across the country who use a variety of techniques from ancient blacksmithing methods to industrial welding. *Will Travel*

MERIDIAN

Meridian Museum of Art
25th Ave. & 7th St., Meridian, MS 39301

☎: 601-693-1501
Open: 1-5 Tu-Su **Closed:** Mo
Ⓟ: Free but limited
Docents Tour times: Upon request if available
Permanent Collection: AM: phot, sculp, dec/art; REG; WORKS ON PAPER 20; EU: portraits 19-20

Housed in the landmark Old Carnegie Library Building, built in 1912-13, the Meridian Museum, begun in 1933 as an art association, serves the cultural needs of the people of East Mississippi and Western Alabama. **NOT TO BE MISSED:** 18th century collection of European portraits.

MISSISSIPPI

OCEAN SPRINGS

Walter Anderson Museum of Art
510 Washington Ave. P.O. Box 328, Ocean Springs, MS 39564
(: 228-872-3164 ◙ www.walterandersonmuseum.org
Open: 10-5 Mo-Sa, 1-5 Su **Closed:** 1/1, EASTER, THGV, 12/25
ADM: Adult: $5.00 **Children:** $1.50 (6-12), Free under 6 **Students:** $3.00 **Seniors:** $3.00
&: Wheelchair accessible (& available at museum) Ⓟ: Limited free parking at the adjacent Community Center and on the street. **Museum Shop Sculpture Garden**
Group Tours: 228-772-3164, Education Director **Docents Tour times:** 228-772-3164, Education Director
Permanent Collection: Works by Walter Inglis Anderson (1903-1965), in a variety of media and from all periods of his work.

This museum celebrates the works of Walter Inglis Anderson, whose vibrant and energetic images of plants and animals of Florida's Gulf Coast have placed him among the forefront of American painters of the 20th century. **NOT TO BE MISSED:** "The Little Room," a room with private murals seen only by Anderson until after his death when it was moved in its entirety to the museum.

TUPELO

Tupelo Artist Guild Gallery
211 W. Main St., Tupelo, MS 38801
(: 662-844-ARTS
Open: 10-4 Tu-Th; 1-4 Fr **Closed:** Mo, 1/1, 7/4, THGV, 12/25
& Ⓟ
Docents Tour times: Upon request if available

Housed in the former original People's Bank Building (1904-05) this small but effective non-collecting institution is dedicated to bringing traveling exhibitions from all areas of the country to the people of the community and its visitors.

ON EXHIBIT 2001
01/05/2001 to 01/31/2001 TUPELO COLLECTS

02/01/2001 to 02/28/2001 BLACK HISTORY MONTH

COLUMBIA

Museum of Art and Archaeology

Affiliate Institution: MU campus, University of Missouri
1 Pickard Hall, Columbia, MO 65211

℡: 573-882-3591 ◉ www.research.missouri.edu/museum
Open: 9-5 Tu, We, Fr; 12-5 Sa, Su; 9-5 & 6-9 Th **Closed:** Mo, LEG/HOL!; 1/1, 12/25
Vol./Contr.: Yes
&. **℗:** Parking is available at the university visitors' garage on University Avenue; metered parking spaces on 9th St.
Museum Shop
Group Tours: 2 wks notice; 573-882-3591
Permanent Collection: AN/EGT; AN/GRK; AN/R; AN/PER; BYZ; DRGS 15-20; GR 15-20; AF; OC; P/COL; CH; JAP; OR

Ancient art and archaeology from Egypt, Palestine, Iran, Cyprus, Greece, Etruria and Rome as well as early Christian and Byzantine art, the Kress study collection, and 15th-20th century European and American artworks are among the treasures from 6 continents and five millennia that are housed in this museum. **NOT TO BE MISSED:** "Portrait of a Musician," 1949, Thomas Hart Benton.

KANSAS CITY

Kemper Museum of Contemporary Art

4420 Warwick Blvd., Kansas City, MO 64111-1821

℡: 816-753-5784 ◉ www.kemperart.org
Open: 10-4 Tu-Th, 10-9 Fr, 10-5 Sa, 11-5 Su **Closed:** Mo, 1/1, 7/4, THGV, 12/25
Vol./Contr.: Yes
&. **℗:** Free **Museum Shop** ‖: Café Sebastienne 11-2:30 Tu-Su, 6-9pm Fr
Group Tours: 816-753-5784 **Docents Sculpture Garden**
Permanent Collection: WORKS BY MODERN, CONTEMPORARY, EMERGING AND ESTABLISHED ARTISTS

Designed by architect Gunnar Birkerts, the stunning Kemper Museum of Contemporary Art (a work of art in itself) houses a rapidly growing permanent collection of modern and contemporary works, and hosts temporary exhibitions and creative programs designed to both entertain and challenge. A Museum Shop and the lively Café Sebastienne round out the Museum's amenities. **NOT TO BE MISSED:** Louise Bourgeois's bronze "Spider" sculptures; a Waterford crystal chandelier by Dale Chihuly; Ursula Von Rydingsvaard's "Bowl with Sacks;" "Ahulani" bronze sculpture by Deborah Butterfield; Frank Stella's "The Prophet;" "The History of Art" in Café Sebastienne, a 110-painting cycle by Frederick James Brown.

Nelson-Atkins Museum of Art

4525 Oak St., Kansas City, MO 64111-1873

℡: 816-751-IART ◉ www.nelson-atkins.org and www.kansascity.com
Open: 10-4 Tu-Th, 10-9 Fr, 10-5 Sa, 1-5 Su **Closed:** Mo, 1/1, 7/4, THGV, 12/25
ADM: Adult: $5.00 **Children:** $1 (6-18) **Students:** $2.00 (with ID)
&.: Elevators, ramps, restrooms, phones, wheelchairs available
℗: Free lot on 45th St; parking lot for visitors with disabilities at Oak St. Business Entrance on west side of the Museum
Museum Shop ‖: Rozzelle Court 10-3 Tu-Th, 10-8 Fr (closed 3-5), 10-3 Sa, 1-3 Su
Group Tours: 816-751-1238 **Docents Tour times:** 10:30, 11, 1,& 2 Tu-Sa; 1:30, 2, 2:30, 3 Su **Sculpture Garden**
Permanent Collection: AM: all media; EU: all media; PER/RMS; NAT/AM; OC; P/COL; OR ◠

Among the many fine art treasures in this outstanding 65 year old museum is their world famous collection of Oriental art and artifacts that includes the Chinese Temple Room with its furnishings, a gallery displaying delicate scroll paintings, and a sculpture gallery with glazed T'ang dynasty tomb figures. **NOT TO BE MISSED:** Largest collection of works by Thomas Hart Benton; Kansas City Sculpture Park; "Shuttlecocks," a four-part sculptural installation by Claes Oldenburg and Coosje van Bruggen located in the grounds of the museum.

MISSOURI

POPLAR BLUFF

Margaret Harwell Art Museum
421 N. Main St., Poplar Bluff, MO 63901
☎: 573-686-8002 ◙ www.mham.org
Open: 12-4 Tu-Fr; 1-4 Sa, Su **Closed:** Mo, LEG/HOL!
Vol./Contr.: Yes
 ⓟ **Museum Shop**
Permanent Collection: DEC/ART; REG; CONT

The 1880's mansion in which this museum is housed is a perfect foil for the museum's permanent collection of contemporary art. Located in the south-eastern part of the state, just above the Arkansas border, the museum features monthly exhibitions showcasing the works of both regional and nationally known artists.

ON EXHIBIT 2001

12/2000 to 06/2001 ETHIOPIA AWAKENING
From the Civil War to the Great War, black political leaders gained some authority and recognition from the nation for their contributions to an emerging America inclusive of the newly freed.

10/14/2000 to 01/07/2001 CHRISTIAN JANKOWSKI/MATRIX 142
This Berlin-based video artist drew attention at the 1999 Venice Biennale. He will create a new work that will go to the Wadsworth Atheneum after the exhibition tour is over.

10/28/2000 to 10/07/2001 SNAP! PHOTOGRAPHY FROM THE COLLECTIONS
In their varied use of techniques and subject, from the collection consider photograohic images as a medium. A survey of photography from the 1930's to today through a diverse collection of about 70 works. Five broad themes are studied: the human figure, landscape and cityscape, domesticity and interiors, transformation, and pictures with words.

01/12/2001 to 03/04/2001 LITHOGRAPHS BY JAMES MCNEILL WHISTLER FROM THE COLLECTION OF STEVEN BLOCK
Whistler is less well known for the beautiful lithographs he produced in his later career. His central interest was a radical exploration of line, form and color.

01/27/2001 to 04/29/2001 GAUGUIN'S "NIRVANA": PAINTERS AT LE POULDU, 1889-1890
Gauguin sought isolated locations and found a temporary refuge in Le Pouldu, a rustic fishing village in Brittany. He was joined there by Meyer de Haan with whom he shared many interests. 30 interrelated works by Gauguin, de Haan and others are assembled here.

01/27/2001 to 04/29/2001 SOL LEWITT/"INCOMPLETE OPEN CUBES"/MATRIX 143
For the first time 30 structures will be installed in the Museum's old Master galleries stimulating comparisonos with art of earlier centuries.

03/11/2001 to 09/16/2001 THE FORBIDDEN STITCH: CHINESE EMBROIDERY
The forbidden stitch was so called because needleworkers went blind and because it was named for the Imperial enclave: The Forbidden City. Imperial robes, fan and pillow covers as well as slippers will be on display.

06/09/2001 to 09/23/2001 PICASSO: THE ARTIST'S STUDIO
For Picasso his studio was the center of his world. His imagination and capacity for experimentation are revealed in his paintings of his studio.

06/16/2001 to 01/20/2002 BIRMINGHAM TOTEM (working title)
This exhibition is the last in a four part series exploring the changing definitions of freedom throughout the history of African-Americans.

SAINT JOSEPH

Albrecht-Kemper Museum of Art
2818 Frederick Avenue, Saint Joseph, MO 64506
☏: 816-233-7003 **◙** www.albrecht-kemper.org
Open: 10-4 Tu-Sa, till 8pm Th, 1-4 Su **Closed:** Mo, 1/1, EASTER, 7/4, THGV, 12/25, MEM/DAY, LAB/DAY
Free Day: Su **ADM: Adult:** $3.00 (18 & over) **Children:** Free under 6 **Students:** $1.00 **Seniors:** $2.00
&: Fully wheelchair accessible (doors, lifts, restrooms, theater) **℗:** Free on-site parking **Museum Shop**
⑪: Special Events Only; LUNCH Wed 11:30-1:30
Group Tours: 816-233-7003 **Sculpture Garden**
Permanent Collection: AM: ldscp ptgs, Impr ptgs, gr, drgs 18-20

Considered to have the region's finest collection of 18th through 20th century American art, the Albrecht-Kemper Museum of Art is housed in the expanded and transformed 1935 Georgian-style mansion of William Albrecht. **NOT TO BE MISSED:** North American Indian Portfolio by Catlin: illustrated books by Audubon; Thomas Hart Benton collection.

ON EXHIBIT 2001
11/17/2000 to 01/12/2001 SHAFER BRONZES AND CELLULOID BOXES

01/12/2001 to 02/25/2001 REFLECTIONS

03/02/2001 to 05/06/2001 OIL AND WATER: THE PAINTINGS OF DOUGLAS AND DAVID BREGA
Work of twin brothers includes Doug Brega's realistic renderings of people and places in New England, and Dave Brega's trompe l'oeil paintings.

SPRINGFIELD

Springfield Art Museum
1111 E. Brookside Dr., Springfield, MO 65807-1899
☏: 417-837-5700
Open: 9-5 Tu, We, Fr, Sa; 1-5 Su; till 8pm Th **Closed:** Mo, LOCAL & LEG/HOL!
Vol./Contr.: Yes
& **℗:** West parking lot with handicapped spaces; limited on-street parking north of the museum **Museum Shop**
Permanent Collection: AM: ptgs, sculp, drgs, gr, phot 18-20; EU: ptgs, sculp, gr, drgs, phot 18-20; DEC/ART; NAT/AM; OC; P/COL

Watercolor U.S.A. an annual national competition is but one of the features of the Springfield Art Museum, the oldest cultural institution in the city. **NOT TO BE MISSED:** New Jeannette L. Musgrave Wing for the permanent collection; John Henry's "Sun Target," 1974, a painted steel sculpture situated on the grounds directly east of the museum; paintings and prints by Thomas Hart Benton.

ST. LOUIS

Forum for Contemporary Art
3540 Washington Avenue, St. Louis, MO 63103
☏: 314-535-4660 **◙** www.forumart.org
Open: 10-5 Tu-Sa **Closed:** Su, Mo, LEG/HOL! & INSTALLATIONS
Vol./Contr.: $2.00
&: First floor accessible; elevator to third floor gallery **℗:** Metered on street or commercial lot
Group Tours: 314-535-4660 **Docents** **Tour times:** Regular Museum hours
Permanent Collection: No permanent collection. Please call for current exhibition information not listed below.

MISSOURI

Forum for Contemporary Art - continued

The Forum for Contemporary Art enriches and educated visitors by presenting a broad range of media and topics representing today's artists. Its goal is to engage people of all ages in the appreciation and interpretation of contemporary art and ideas. A new building deigned by Brad Cloepfil, Allied Works Architecture, is to open in 2002.

ON EXHIBIT 2001

11/10/2000 to 01/13/2001 STEPHAN BALKENHOF
Large scale carved wooden figures by this German sculptor.

11/17/2000 to 01/06/2001 STEPHAN BALKENHOL: NEW WORK

01/19/2001 to 03/10/2001 ENRIQUE CHAGOYA: RECENT WORK

03/23/2001 to 05/12/2001 MAPPING: BIT BY BYTE

05/25/2001 to 07/28/2001 THE ART OF MILES DAVIS

Laumeier Sculpture Park Museum

12580 Rott Rd., St. Louis, MO 63127

☎: 314-821-1209
Open: Park: 8am-1/2 hour after sunset; Museum: 10-5 Tu-Sa & Noon-5 Su **Closed:** For Sculpture Park & Museum: 1/1, THGV, 12/25
♿: Paved trails; ramps to museum & restrooms **℗:** Free **Museum Shop** **⑾:** Picnic Area
Group Tours: 314-821-1298 ($10 groups less than 25) **Tour times:** 1st & 3rd Su of month at 2pm (May-Oct)
Sculpture Garden
Permanent Collection: CONT/AM; sculp: NATIVE SCULP & ART; SITE SPECIFIC SCULP

More than 75 internationally acclaimed site-specific sculptures that complement their natural surroundings are the focus of this institution whose goal is to promote greater public involvement and understanding of contemporary sculpture. There are, for the visually impaired, 12 scale models of featured works, accompanied by descriptive braille labels, that are placed near their full sized outdoor counterparts. **NOT TO BE MISSED:** Works by Alexander Liberman, Beverly Pepper, Dan Graham, Jackie Ferrara.

ON EXHIBIT 2001

10/15/2000 to 01/14/2001 FACE OF THE GODS: ART AND ALTARS OF AFRICA AND THE AFRICAN-AMERICANS

Saint Louis Art Museum

1 Fine Arts Park, Forest Park, St. Louis, MO 63110-1380

☎: 314-721-0072 **◉** www.slam.org
Open: 1:30-8:30 Tu, 10-5 We-Su **Closed:** Mo, 1/1, THGV, 12/25
Free Day: special exh is free Tu
♿ **℗:** Free parking in small lot on south side of building; also street parking available. **Museum Shop**
⑾: Cafe 11-3:30 & 5-8 Tu; 11-3:30 We-Sa; 10-2 Su (brunch); Snack Bar also
Group Tours: ex 484 **Docents** **Tour times:** 1:30 We-Fr (30 min.); 1:30 Sa, Su (60 min.) **Sculpture Garden**
Permanent Collection: AN/EGT; AN/CH; JAP; IND; OC; AF; P/COL; NAT/AM; REN; PTGS:18-CONT; SCULP: 18-CONT

Just 10 minutes from the heart of downtown St. Louis, this museum is home to one of the most important permanent collections of art in the country. A global museum featuring pre-Columbian and German Expressionist works that are ranked among the best in the best in the world, this institution is also known for its Renaissance, Impressionist, American, African, Oceanic, Asian and Ancient through Contemporary art. **NOT TO BE MISSED:** The Sculpture Terrace with works by Anthony Caro, Pierre Auguste Renoir, Henry Moore, Alexander Calder, and Aristide Maillol; Egyptian mummy and Cartonnage on display with a full-size x-ray of the mummy.

Saint Louis Art Museum - continued

ON EXHIBIT 2001

11/04/2000 to 01/07/2001 PAINTING ON LIGHT: DRAWINGS AND STAINED GLASS IN THE AGE OF DURER AND HOLBEIN
Preparatory drawings with painted glass panels in the exhibition will examine the relationship between the designers and the glass painters. The beliefs, concerns and lives of people from all walks of life in German Renaissance society. Religion, history, sporting all come to life in the luminous meticulously crafted painted glass panels evoking the spirit of the Renaissance. *Will Travel*

12/2000 to 02/2001 CURRENTS 83: PETER DOIG

02/17/2001 to 05/13/2001 VINCENT VAN GOGH AND THE PAINTERS OF THE PETIT BOULEVARD

07/07/2001 to 09/16/2001 POP IMPRESSIONS EUROPE/USA: PRINTS AND MULTIPLES FROM THE MUSEUM OF MODERN ART

[?] to 02/25/2001 ORIENTAL CARPETS FROM THE JAMES F. BALLARD COLLECTION

10/2001 to 01/2002 ALL AROUND THE HOUSE, PHOTOGRAPHY OF AMERICAN-JEWISH COMMUNAL LIFE BY JAY WOLKE

Washington University Gallery of Art, Steinberg Hall

One Brookings Drive, St. Louis, MO 63130-4899

✆: 314-935-5490 ◙ wustl.edu/galleryofart
Open: Sept-May: 10-4:30 Mo-Fr & 1-5 Sa, Su; CLOSED mid May-early Sept. **Closed:** LEG/HOL! Occasionally closed for major installations; Call (314-935-4523)
& ℗: Free North side of the building **Museum Shop**
Group Tours: 314-935-5496 **Docents Tour times:** advance notice preferred
Permanent Collection: EU: ptgs, sculp 16-20; OM: 16-20; CONT/GR; AM: ptgs, sculp 19-20; DEC/ART; FR: academic; AB/EXP; CUBISTS

With a well-deserved reputation for being one of the premier university art museums in the nation, the more than 100 year old Gallery of Art at Washington University features outstanding examples of works by Picasso (25 in all) and a myriad of history's artistic greats, including Dupre, Daumier, Church, Gifford, Picasso, Ernst, deKooning and Pollock, among a host of other artists. **NOT TO BE MISSED:** Hudson River School Collection.

ON EXHIBIT 2001

04/05/2001 to 09/18/2001 SELECTIONS FROM THE PERMANENT COLLECTION

01/19/2001 to 03/18/2001 FAREWELL TO BOSNIA: PHOTOGRAPHS BY GILLES PERESS

01/19/2001 to 03/18/2001 CONTEMPORARY ART: SELECTIONS FROM THE WASHINGTON UNIVERSITY COLLECTION

01/19/2001 to 03/18/2001 CAUGHT BY POLITICS: ART OF THE 1930'S AND 1940'S

05/04/2001 to 05/18/2001 SELECTIONS FROM THE PERMANENT COLLECTION

MONTANA

Yellowstone Art Museum
410 N. 27th St., Billings, MT 59101

☎: 406-256-6804 **◉** yellowstone.artmuseum.org
Open: 11-5 Tu-Fr, 10-5 Sa, till 8pm Su; Open one hour earlier in summer **Closed:** Mo, LEG/HOL!
ADM: Adult: $5.00 **Children:** $2.00 6-18; Free under 6 **Students:** $3.00 **Seniors:** $2.00
&: Wheelchairs are available **℗:** Pay lot next to building is free to museum patrons. **Museum Shop**
Group Tours: 406-256-6804 **Docents** **Tour times:** Noon Th
Permanent Collection: CONT/HISTORICAL: ptgs, sculp, cer, phot, drgs, gr

Situated in the heart of downtown Billings, the focus of the museum is on displaying the works of contemporary regional artists and on showcasing artists who have achieved significant regional or national acclaim. With nearly 2,000 objects in its permanent collection, the museum is well-known for its "Montana Collection" dedicated to the preservation of art of the West. The museum collection includes work by notable artists such as Rudy Autio, John Buck, Deborah Butterfield, Clarice Dreyer, Peter Voulkos and Theodore Waddell. Additionally, the museum houses a collection of 90 abstract expressionist paintings from the George Poindexter family of New York and the largest private collection of work by cowboy author and illustrator Will James. The museum recently completed a 6.2 million dollar expansion and renovation project, adding 30,000 square feet to the original structure and an education classroom/studio, public meeting room, courtyard and enhanced museum store.

C. M. Russell Museum
400 13th St. North, Great Falls, MT 59401-1498

☎: 406-727-8787 **◉** www.cmrussell.org
Open: MAY 1-SEPT 30: 9-6 Mo-Sa & 12-5 Su; WINTER: 10-5 Tu-Sa & 1-5 Su **Closed:** 1/1, EASTER, THGV, 12/25
Free Day: Dec-Feb Su 2-5
ADM: Adult: $4.00; may increase in 2001 **Children:** Free under 6 **Students:** $2.00 **Seniors:** $3.00
& **℗: Free** **Museum Shop** **Docents** **Tour times:** 9:15 & 1:30 Mo-Fr June; 9:15, 1:30, 2:30 Jul-Aug
Permanent Collection: REG; CONT; CER

Constructed of telephone poles in 1903, the log cabin studio of the great cowboy artist C. M. Russell still contains the original cowboy gear and Indian artifacts that were used as the artist's models. Adjoining the cabin is the fine art museum with its modern facade. It houses more than 7,000 works of art that capture the flavor of the old west and its bygone way of life. The Russell Home is on the museum grounds (built 1900). **NOT TO BE MISSED:** Collection of Western Art by Charles M. Russell and many of the American greats.

ON EXHIBIT 2001
to 02/11/2001 QUILTS FROM RUSSELL'S LIFETIME
Quilts from the start of the 21st century. These have been shown around Montana. They will carry the history of the maker and the time they lived.

Paris Gibson Square Museum of Art
1400 1st Ave. North, Great Falls, MT 59401-3299

☎: 406-727-8255
Open: 10-5 Mo-Fr; Noon-5 Sa, Su; 7-9 Th; Also open Mo, MEM/DAY to LAB/DAY **Closed:** Mo LEG/HOL!
&: Wheelchair accessible; elevators **℗:** Free and ample **Museum Shop** **⊪:** Lunch Tu-Fr, reservations suggested
Group Tours: 406-727-5255 **Sculpture Garden**
Permanent Collection: REG: ptgs, sculp, drgs, gr

Contemporary arts are featured within the walls of this 19th century Romanesque building which was originally used as a high school.

Paris Gibson Square Museum of Art- continued
ON EXHIBIT 2001
11/06/2000 to 01/21/2001 DREAMING THE WORLD: VISIONARY ART IN THE WEST
Featuring Bill Ohrmann: How We Live Now; Ernio Pepion: Recent Work; Elizabeth Woods; Edgar Smith: Small Tales From the Big Sky.

02/01/2001 to 04/01/2001 HORSING AROUND Bill Stockton, Dana Boussard, Susan Barnes. OLD PAINT NOW: IMAGES OF THE HORSE IN CONTEMPORARY ART

04/09/2001 to 05/07/2001 FAR FROM CENTER: CONTEMPORARY ART IN MONTANA
Tracy Lindner, Cathryn Mallory, Sandra Del Pagetto.

05/17/2001 to 08/10/2001 BENTLY SPANG: RECENT WORK

05/17/2001 to 08/10/2001 FEATS OF CLAY
Beth Lo, Rick Pope, Paris Gibson Square Museum of Art's Teapot Invitational, Lisa Berry.

08/24/2001 to 10/21/2001 ARTS EQUINOX: A REGIONAL SURVEY OF CONTEMPORARY ART

KALISPELL

Hockaday Center for the Arts
Second Ave E. & Third St, Kalispell, MT 59901
✆: 406-755-5268
Open: 10-6 Tu-Sa, 10-8 We **Closed:** Sa, Su, Mo, LEG/HOL!
Free Day: We **ADM: Adult:** $2.00 **Children:** Free **Students:** $1.00 **Seniors:** $1.00
& ℗ **Museum Shop**
Group Tours: 406-755-5268 **Docents** **Tour times:** Upon request if available **Sculpture Garden**
Permanent Collection: CONT/NORTHWEST: ptgs, sculp, gr, port, cer

The Hockaday Center for the Arts which places strong emphasis on contemporary art is housed in the renovated Carnegie Library built in 1903. A program of rotating regional, national, or international exhibitions is presented approximately every 6 weeks. **NOT TO BE MISSED:** The Hockaday permanent collection of works by NW Montana artists and ourMuseum Shop featuring fine arts and crafts.

ON EXHIBIT 2001
to Spring RICHARD BUSWELL: RECENT PHOTOGRAPHS

MILES CITY

Custer County Art Center
Water Plant Rd., Miles City, MT 59301
✆: 406-232-0635
Open: 1-5 Tu-Su **Closed:** Mo, 1/1, EASTER, THGV, 12/25
Vol./Contr.: Yes
& ℗ **Museum Shop**
Permanent Collection: CONT/REG; 126 EDWARD S. CURTIS PHOTOGRAVURES; 81 WILLIAM HENRY JACKSON PHOTOCHROMES, 200 REGIONAL ARTIST'S WORKS ON DISPLAY

MONTANA

Custer County Art Center- continued

The old holding tanks of the water plant (c. 1914) provide an unusual location for the Custer County Art Center. Situated in the southeastern part of the state in a parkland setting overlooking the Yellowstone River, this facility features 20th century Western and contemporary art. The gift shop is worthy of mention due to the emphasis placed on available works for sale by regional artists. **NOT TO BE MISSED:** Annual Western Art Roundup & Quick Draw Art Auction 3rd weekend in May.

MISSOULA

Art Museum of Missoula
335 North Pattee, Missoula, MT 59802
☎: 406-728-0447 ◙ artmissoula.org
Open: 9-12 & 1-5 Mon-Fri **Closed:** Mo, LEG/HOL!
Vol./Contr.: $2.00
& **Ⓟ:** Limited metered on-street parking **Museum Shop**
Permanent Collection: REG: 19-20

International exhibitions and regional art of Montana and other Western states is featured in this lively community-based museum which is housed in the early 20th century Old Carnegie Library building in downtown Missoula.

ON EXHIBIT 2001

01/2001 to 02/2001 **HELEN McAUSLAN**

03/2001 to 05/2001 **CORWIN CLAIRMONT**

06/2001 to 08/2001 **RUDY AUTIO**

06/2001 to 08/2001 **THREE EDUCATORS: BLACKMER, SENSKA, TRINITAS**

09/2001 to 11/2001 **JIM TODD RETROSPECTIVE**

09/2001 to 11/2001 **JOHN HOOTON: HYAKU ME**

12/2001 to 01/2002 **ANNE APPLEBY & WES MILLS**

12/2001 to 01/2002 **DENNIS VOSS DRAWINGS**

12/2001 to 01/2002 **NOELLYN PEPOS**

Museum of Fine Arts
Affiliate Institution: School of Fine Arts
University of Montana, Missoula, MT 59812
☎: 406-243-4970
Open: 9-12 & 1-4 Mo-Fr **Closed:** Sa, Su, STATE/HOL & LEG/HOL!
& **Ⓟ:** Free on-street parking and in Springfield Library & Museum lots on State St. and Edwards St.
Permanent Collection: REG

Great American artists are well represented in this University museum with special emphasis on Western painters and prints by such contemporary artists as Motherwell and Krasner. The permanent collection rotates with exhibitions of a temporary nature.

Museum of Nebraska Art

Affiliate Institution: University of Nebraska at Kearney
24th & Central, Kearney, NE 68848
☎: 308-865-8559 **Open:** 11-5 Tu-Sa,1-5 Su **Closed: Mo,** LEG/HOL!
 ⓟ **Museum Shop Sculpture Garden**
Permanent Collection: REG: Nebraskan 19-present

The museum building, listed in the National Register of Historic Places, has been remodeled and expanded with new gallery spaces and a sculpture garden. Featured is the Nebraska Art Collection—artwork by Nebraskans from the Artist-Explorers to the contemporary scene. **NOT TO BE MISSED:** "The Bride," by Robert Henri.

Great Plains Art Collection

Affiliate Institution: University of Nebraska
215 Love Library, Lincoln, NE 68588-0475
☎: 402-472-6220 ◙ www.unl.edu/plains/artcoll
Open: 9:30-5 Mo-Fr, 10-5 Sa, 1:30-5 Su **Closed:** closed holiday weekends, between exhibits and ACAD
Vol./Contr.: Yes
 ⓟ**:** Limited metered parking
Permanent Collection: WESTERN: ptgs, sculp 19,20; NAT/AM

This collection of western art which emphasizes the Great Plains features sculptures by such outstanding artists as Charles Russell & Frederic Remington, and paintings by Albert Bierstadt, John Clymer, Olaf Wieghorst, Mel Gerhold and others. **NOT TO BE MISSED:** William de la Montagne Cary, (1840-1922), "Buffalo Throwing the Hunter."

Sheldon Memorial Art Gallery and Sculpture Garden

Affiliate Institution: University of Nebraska
12th and R Sts., Lincoln, NE 68588-0300
☎: 402-472-2461 ◙ www. Sheldon.unl.edu
Open: 10-5 Tu-Sa, 7-9 Th-Sa, 2-9 Su **Closed:** Mo, LEG/HOL!
Vol./Contr.: Yes
 ⓟ **Museum Shop**
Docents Tour times: during public hours **Sculpture Garden**
Permanent Collection: AM: ptgs 19,20,sculp, phot, w/col, drgs, gr

This highly regarded collection is housed in a beautiful Italian marble building designed by internationally acclaimed architect Philip Johnson. It is located on the University of Nebraska-Lincoln campus and surrounded by a campus-wide sculpture garden consisting of more than 30 key examples by artists of renown including di Suvero, Lachaise, David Smith, Heizer, Shea, Serra and Oldenburg. **NOT TO BE MISSED:** "Torn Notebook," a new 22 foot monumental sculpture by Claes Oldenburg and Coosje van Bruggen, 3 pieces.

NEBRASKA

Joslyn Art Museum

2200 Dodge St., Omaha, NE 68102-1292

C: 402-342-3300 ⊙ www.joslyn.org
Open: 10-4 Tu-Sa, 12-4 Su **Closed:** Mo, LEG/HOL!
Free Day: 10-12 Sa **ADM: Adult:** $5.00 **Children:** 5-17 $2.50, under 5 Free **Students:** $3.00 **Seniors:** $3.00
占: At atrium entrance **Ⓟ:** Free **Museum Shop** **⫫:** Tu-Sa 11-3:30, Su 12-3:30
Group Tours: ext 206 **Docents** **Tour times:** We, 1pm; Sa 11am
Permanent Collection: AM: ptgs 19,20; WESTERN ART; EU: 19,20

Housing works from antiquity to the present the Joslyn, Nebraska's only art museum with an encyclopedic collection, has recently completed a major $16 million dollar expansion and renovation program. **NOT TO BE MISSED:** World-renowned collection of watercolors and prints by Swiss artist Karl Bodmer that document his journey to the American West 1832-34; noted collection of American Western art including works by Catlin, Remington, and Leigh.

ON EXHIBIT 2001

10/14/2000 to 01/07/2001 AN AMERICAN CENTURY OF PHOTOGRAPHY FROM DRY-PLATE TO DIGITAL: THE HALLMARK PHOTOGRAPHIC COLLECTION
Will Travel

Nevada Museum of Art/E. L. Weigand Gallery

160 W. Liberty Street, Reno, NV 89501
(: 775-329-3333 ⊙ nevadaart.org
Open: 10-4 Tu, We, Fr: 10-7-Th; 12-4 Sa, Su **Closed:** Mo, LEG/HOL!
Free Day: Su **ADM: Adult:** $5.00 **Children:** $1.00 (6-12) **Students:** $3.00 **Seniors:** $3.00
& ℗ **Museum Shop**
Docents Tour times: 2pm Sa
Permanent Collection: AM: ptgs 19,20, NAT/AM; REG

Visit Nevada's premiere art museum and enjoy world-class exhhibitions ranging from contemporary to historic perspectives. Recipient of the 1999 National Award for Museum service awarded by the Institute of Museum and Library Services in Washington, DC.

ON EXHIBIT 2001

12/02/2000 to 02/04/2001 INSTALLATION BY TAMARA SCRONCE

12/02/2000 to 02/04/2001 WILLIAM DASSONVILLE: CALIFORNIA PHOTOGRAPHER (1879-1957)

12/02/2000 to 02/04/2001 SHEPPARD FAMILY: A LEGACY IN ART

02/09/2001 to 04/15/2001 SALTWORKS: WAYNE BARRAR

02/09/2001 to 04/15/2001 JOHN LAGATTA: ILLUSTRATOR OF THE FASHIONABLE LIFE

02/09/2001 to 05/15/2001 MEL PEKARSKY: DESERT ABSTRACTIONS

04/20/2001 to 06/24/2001 DUANE HANSON: VIRTUAL REALITY
Thirty life size figurative sculptures created between 1970s and 1996. These portray American narratives and social types. These are shown with a brutal honesty that makes the viewer return for another look. *Will Travel*

CORNISH

Saint-Gaudens

St. Gaudens Rd, Cornish, NH 03745-9704

(: 603-675-2175 ◙ www.sgnhs.org./or/abc/www.nps.gov/saga
Open: 9:30-4:30 Daily, last weekend May-Oct
Free Day: Aug 25th **ADM: Adult:** $4.00 **Children:** Free
ⓟ **Museum Shop**
Docents Tour times: adv res req **Sculpture Garden**
Permanent Collection: AUGUSTUS SAINT GAUDENS: sculp

The house, the studios, and 150 acres of the gardens of Augustus Saint-Gaudens (1848-1907), one of America's greatest sculptors.

DURHAM

Art Gallery, University of New Hampshire

Paul Creative Arts Center, 30 College Road, Durham NH 03824-3538
(: 603-862-3712
Open: 10-4 Mo-We, 10-8 Th, 1-5 Sa-Su (Sep-May) **Closed:** Fr, ACAD!
&: Limited **ⓟ:** Metered or at Visitors Center
Group Tours: 603-862-3713
Permanent Collection: JAP: gr 19; EU & AM: drgs 17-20; PHOT; EU: works on paper 19,20

Each academic year The Art Gallery of the University of New Hampshire presents exhibitions of historical to contemporary art in a variety of media. Exhibitions also include work by the University art faculty, alumni, senior art students and selections from the permanent collection.

ON EXHIBIT 2001

01/27/2001 to 03/08/2001 OFF THE TABLE - PLATES, PLATTERS AND PICTURES

01/27/2001 to 04/18/2001 INSPIRATION/IMAGINATION: 50 YEARS OF POLAROID PHOTOGRAPHY 1947-1997

03/20/2001 to 04/18/2001 ARTISTS' BOOKS BY THE BOSTON PRINTMAKERS

HANOVER

Hood Museum Of Art

Affiliate Institution: Dartmouth College
Wheelock Street, Hanover, NH 03755

(: 603-646-2808 ◙ www.dartmouth.edu/~hood
Open: 10-5 Tu, Th-Sa, 10-9 We, 12-5 Su **Closed:** Mo, LEG/HOL!
Vol./Contr.: yes
& ⓟ **Museum Shop** ¶
Group Tours: 603-646-1469
Permanent Collection: AM: ptgs 19,20; GR; PICASSO; EU: ptgs

The Museum houses one of the oldest and finest college collections in the country in an award-winning post-modern building designed by Charles Moore and Chad Floyd. **NOT TO BE MISSED:** Set of 9th century BC Assyrian reliefs from the Palace of Ashurnasirpal II.

Hood Museum Of Art - continued

ON EXHIBIT 2001

12/16/2000 to 03/11/2001 THE VOLLARD SUITE

01/13/2001 to 03/11/2001 TREASURES OF RAUNER LIBRARY (working title)

03/31/2001 to 06/17/2001 ABSTRACTION AT MID-CENTURY

06/06/2001 to 09/16/2001 LIONS AND EAGLES AND BULLS: THE ART OF EARLY AMERICAN INN SIGNS

KEENE

Thorne-Sagendorph Art Gallery

Affiliate Institution: Keene State College
Wyman Way, Keene, NH 03435-3501
☎: 603-358-2720 ◙ www.keene.edu/TSAG
Open: 12-4 Mo-We, 12-7, Tu-Fr, 12-4 Sa, Su **Closed:** ACAD!
Vol./Contr.: Yes
& **Ⓟ:** Free
Docents Tour times: by appt
Permanent Collection: REG: 19; AM & EU: cont, gr

Changing exhibitions as well as selections from the permanent collection are featured in the contemporary space of this art gallery.

ON EXHIBIT 2001

to Spring ART AND TECHNOLOGY EXHIBIT
Art and technology exhibit using computer technology.

01/2001 to TBA! IMAGES FOR ETERNITY EXHIBIT
Ancient ceramic shaft-tomb figures from West Mexico.

MANCHESTER

Currier Gallery of Art

201 Myrtle Way, Manchester, NH 03104
☎: 603-669-6144 ◙ www.currier.org
Open: 11-5 Mo, We, Th, Su; 11-8 Fr; 10-5 Sa **Closed:** Tu, LEG/HOL!
Free Day: 10-1 Sa **ADM: Adult:** $5.00 **Children:** Free under 18 **Students:** $4.00 **Seniors:** $4.00
& **Ⓟ:** Adjacent on-street parking **Museum Shop** ⫯⫯
Group Tours: 603-626-4154
Permanent Collection: AM & EU: sculp 13-20; AM: furniture, dec/art

Set on beautifully landscaped grounds, The Gallery is housed in an elegant 1929 Beaux Arts building reminiscent of an Italian Renaissance villa. **NOT TO BE MISSED:** Zimmerman House (separate admission: Adults $9, Seniors and Students $6) designed in 1950 by Frank Lloyd Wright. It is one of five Wright houses in the Northeast and the only Wright designed residence in New England that is open to the public.

NEW JERSEY

Stedman Art Gallery
Affiliate Institution: The State Univ of NJ
Rutgers Fine Arts Center, Camden, NJ 08102

(: 609-225-6245
Open: 10-4 Mo-Sa **Closed:** Su MEM/DAY, 7/4, LAB/DAY, THGV, 12/24-1/2
& ℗ ·
Permanent Collection: AM & EU: Cont works on paper

Located in southern New Jersey, the gallery brings visual arts into focus as an integral part of the human story.

Jersey City Museum
472 Jersey Ave, Jersey City, NJ 07302

(: 201-547-4514
Open: 10:30-5 Tu, Th-Sa, 10:30-8 We, closed Sa in summer **Closed:** Su, Mo, LEG/HOL!, 12/24, 12/31
&: 5 steps into building, small elevator ℗: Street
Group Tours: 201-547-4380
Permanent Collection: AUGUST WILL COLLECTION: views of Jersey City, 19; AM: ptgs, drgs, gr, phot; HIST: dec/art; JERSEY CITY INDUSTRIAL DESIGN

Established in 1901, the museum is located in the historic Van Vorst Park neighborhood of Jersey City in the 100-year old public library building. In addition to showcasing the works of established and emerging contemporary regional artists, the museum presents exhibitions from the permanent collection documenting regional history.

Museum of American Glass at Wheaton Village
1501 Glasstown Road, Millville, NJ 08332-1566

(: 609-825-6800 or 800-998-4552 ▣ http://www.wheatonvillage.org
Open: 10-5 daily(Apr-Dec), 10-5 We-Su (Jan-Mar) **Closed:** 1/1, Easter, THGV, 12/25
ADM: Adult: $7.00 **Children:** Free under 5 **Students:** $3.50 **Seniors:** $6.00
& ℗: Free **Museum Shop** ‖: 7am-9pm, PaperWaiter and Pub, adjacent to Village
Group Tours: 800-998-4552, ext. 2730 **Docents** **Tour times:** by appt **Sculpture Garden**
Permanent Collection: AM/GLASS

The finest and largest collection of American glass in the country. Over 6,500 objects on display ranging from Mason jars to Tiffany masterpieces, paperweights and fiber optics, to the world's largest bottle. **NOT TO BE MISSED:** In addition to the Museum, Wheaton Village offers: A fully operational glass factory with daily demonstrations; Crafts and Trades Row with ongoing demonstrations in pottery, woodworking, flameworking and tin, Stained Glass Studio, Down Jersey Folklife Center; unique museum stores, train ride, picnic area; and restaurant.

ON EXHIBIT 2001

2001 TBA! CARNIVAL GLASS

04/07/2001 to 10/21/2001 SILVERED GLASS

MONTCLAIR

Montclair Art Museum

3 South Mountain Ave, Montclair, NJ 07042

☎: 973-746-5555 **◉** www.montclair-art.com
Open: 11-5 Tu, We, Fr, Sa; 1-5 Th, Su; Summer hours 12-5 We-Su, 7/4-LAB/DAY **Closed:** Mo, LEG/HOL!
Free Day: Sa 11-2 **ADM: Adult:** $5.00 **Children:** Free under 12 **Students:** $4.00 **Seniors:** $4.00
&: Main floor and restroom **℗:** Free on site parking **Museum Shop** **�11:** nearby restaurants
Group Tours: 973-746-5555 x221 **Docents Tour times:** most Su, 2pm !
Permanent Collection: NAT/AM: art 18-20; AM: ldscp, portraits 19; AM; Hudson River School: Am Impressionists

Located just 12 miles west of midtown Manhattan and housed in a Greek Revival style building, this museum, founded in 1914, features an impressive American art collection of a quality not usually expected in a small suburb.

ON EXHIBIT 2001

09/09/2000 to 01/07/2001 GEORGIA O'KEEFFE: THE ARTIST'S LANDSCAPE
A touring exhibition of 40 large scale black and white photographs by Todd Webb, showing the artist in the environment which so influenced her painting, drawing, and sculpture. *Will Travel*

09/10/2000 to 01/07/2001 NATIVE SOIL: ART AND THE AMERICAN LAND
The theme of native soil as a pervasive concept that came to embody Americanism and nationalism.

09/17/2000 to 01/07/2001 LYRICAL VISIONS: IMAGES OF MUSIC AND DANCE IN AMERICAN AND NATIVE AMERICAN ART
This exhibition will explore relationships between the visual arts and the performing arts of music and dance during the 19th and 20th centuries in America. The ritual pageantry and spiritual expressions of Native American life and works by such well-known masters as Washington Allston, John George Brown, George Catlin, Edward William Demming, William Merritt Chase, Arthur B. Davies, Robert Henri, Reginald Marsh, Moses Soyer, Raphael Soyer, Abraham Walkowitz, George McNeil will be featured.

1/28/2001 to 04/15/2001 IMAGINATION TO IMAGE: PICTORIALIST PHOTOGRAPHS FROM THE MUSEUM OF SCIENCE AND INDUSTRY, CHICAGO
This traveling exhibition explores the relationship between art and science by featuring 70 works from the recently rediscovered photography collection of Chicago's Museum of Science and Industry. The show includes outstanding Pictorialist works from the 1930s by Edward J. Steichen, Clarence White, Adolf Fassbender, Eastman Kodak Co., Anne Brigman, Dorothea Lange, and others.

1/28/2001 to 04/15/2001 WHITFIELD LOVELL: PORTRAYALS
Whitfield Lovell's latest format usually includes figurative imagery of one or more persons drawn on old wood. These charcoal on wood works are set against a wall and surrounded by antique, found objects. A sense of personal history is brought into these environmental assemblages that reflects the artist's African-American heritage. *Will Travel*

1/28/2001 to 04/18/2001 AMERICAN INDIAN PORTRAITS: ELBRIDGE AYER BURBANK IN THE WEST (1897-1910)
Elbridge Ayer Burbank was a Chicago portraitist when his uncle, Edward Ayer, first president of the Field Museum of Natural History, commissioned the artist to paint a portrait from life of Geronimo in 1897. Burbank continued his Native American portrait work, and between 1897 and 1910 he created nearly 1000 oil portraits of Native Americans. This traveling exhibition from the Butler Institute of American Art is the first show of a large number of Burbank's works since the turn of the last century. *Will Travel*

10/2001 to 02/2002 PRIMAL VISIONS: ALBERT BIERSTADT DISCOVERS AMERICA
Focusing on the work of Albert Bierstadt (1830-1902), one of the most famous 19th century American artists, Primal Visions explores one of his dominant themes—the European explorers' impressions of the New World. The exhibition features fifty works by Bierstadt and his contemporaries, including Thomas and Edward Moran, Frederick E. Church, and Edward Muybridge, and highlights two rarely exhibited paintings, Autumn in the Sierras (Kings River Canyon), 1873, and The Landing of Columbus, 1892, on loan from the City of Plainfield, New Jersey.

NEW BRUNSWICK

Jane Voorhees Zimmerli Art Museum
Affiliate Institution: Rutgers, The State University of New Jersey
71 Hamilton Street, New Brunswick, NJ 08901

℡: 732-932-7237 **◎** www.zimmerlimuseum.rutgers.edu
Open: 10-4:30 Tu-Fr, Noon-5 Sa, Su **Closed:** Mo, LEG/HOL! Month of August, Mo, Tu in July
Free Day: 1st Su each month **ADM: Adult:** $3.00 **Children:** Free **Students:** $3.00 **Seniors:** $3.00
♿ **Ⓟ:** Nearby or metered **Museum Shop**
Group Tours: 732-932-7237, x636 **Docents** **Tour times:** res req
Permanent Collection: FR: gr 19; AM: 20; EU: 15-20; P/COL: cer; CONT/AM: gr; THE NORTON AND NANCY DODGE COLLECTION OF NONCONFORMIST ART FROM THE SOVIET UNION

Housing the Rutgers University Collection of more than 50,000 works, this museum also incorporates the International Center for Japonisme which features related art in the Kusakabe-Griffis Japonisme Gallery. **NOT TO BE MISSED:** The George Riabov Collection of Russian Art; The Norton and Nancy Dodge Collection of Nonconformist Russian Art from the Soviet Union.

ON EXHIBIT 2001
11/12/2000 to 01/14/2001 REALITIES AND UTOPIAS: ABSTRACT PAINTING FROM THE DODGE COLLECTION

11/12/2000 to 02/16/2001 MICHAEL MAZUR: A PRINT RETROSPECTIVE
Approximately 75 print projects by the artist.

11/12/2000 to 02/18/2001 MONOTYPES IN CONTEMPORARY PRINTMAKING FROM THE RUTGERS ARCHIVES FOR PRINTMAKING STUDIOS
Since the 1970s artists have increasingly embraced monotype printmaking because of its painterliness, change effects, and directness of expression.

NEWARK

Newark Museum
49 Washington Street, Newark, NJ 07101-0540

℡: 973-596-6550
Open: 12-5 We-Su **Closed:** Mo, Tu, 1/1, 7/4, THGV, 12/25
♿**:** Ramp entrance, elevators, wheelchair accessible, restrooms **Ⓟ:** $4.25 in the museum's adjacent parking lot
Museum Shop �11: Cafe in Engelhard Court noon-3:30 W-S (wheelchair accessible)
Group Tours: 973-596-6615 **Docents** **Tour times:** 12:30-3:30 We-Su
Permanent Collection: AM: ptgs 17-20; AM: folk; AF/AM; DEC/ARTS; GLASS; JAP; CONT; AM: Hudson River School ptgs; AF; AN/GRK; AN/R; EGT

Established in 1909 as a museum of art and science, the Newark Museum features one of the finest collection of Tibetan art in the world. The museum encompasses 80 galleries and includes the historic 1885 Ballantine House, a landmark Victorian mansion; New Jersey's first planetarium; a Mini Zoo; and an 18th-century one-room schoolhouse. **NOT TO BE MISSED:** Joseph Stella's 5-panel mural "The Voice of the City of New York Interpreted," 1920-22; the Tibetan Altar, consecrated in 1990 by His Holiness the 14th Dalai Lama.

ON EXHIBIT 2001
through 07/29/2001 DESTINATION MARS
This exhibit is a hands-on presentation that explores the past, present and future of the "Red Planet"—from science fact to science fiction.

Newark Museum - continued

08/29/2000 to 01/21/2001 KATHERINE CHOY: A PROMISE UNFULFILLED
During the late 1950s, a time of experimentation in the world of studio ceramics, Katherine Choy, a brilliant young potter whose life was cut short in 1958, was one of the few women potters in America who began to create sculptural forms in clay, pushing traditional forms and decoration beyond any limits ever attempted before. Never before has the brief, remarkable career of this ceramic artist and teacher been showcased in a museum.

10/11/2000 to 02/25/2001 NIGHT SKIES: THE ART OF DEEP SPACE
Forty astronomical photographs loaned by the National Academy of Sciences (Washington, DC) stand both as scientific records and works of art.

10/25/2000 to 02/25/2001 NARRATIVES OF AFRICAN AMERICAN ART AND IDENTITY: THE DAVID C. DRISKELL COLLECTION
This traveling exhibition features works from the collection of David C. Driskell, the distinguished art historian and artist, who, since 1951, has played a key role in researching African-American art and bringing it to the forefront. Among the more than 50 artists included in the show are such notables as Romare Bearden, Aaron Douglas, Minnie Evans, Meta Warrick Fuller, Sam Gilliam, William H. Johnson, Jacob Lawrence, Augusta Savage, Henry Osawa Tanner, Bill Traylor and James Van Der Zee. *Catalog Will Travel*

11/22/2000 to 01/02/2001 CHRISTMAS IN THE BALLANTINE HOUSE: FEASTING WITH FAMILY AND FRIENDS
The trappings and trimmings of a traditional Victorian holiday are recreated each season in the 1885 Ballantine House, a restored National Historic Landmark. The historically accurate installation, complete with period menus, offers visitors the opportunity to step back in time to learn about 19th-century life and the traditions of the day.

01/17/2001 to 12/31/2001 BEAUTIFUL WRITING: CALLIGRAPHY FROM CHINA'S IMPERIAL AGE
In collaboration with the New Jersey Performing Art Center's World Festival, The Newark Museum presents a year-long exhibition of Chinese painting and calligraphy. Objects on view include classical scrolls of the Imperial Dynasties, sixteenth to nineteenth centuries.

04/12/2001 to 06/22/2001 TIBET: MOUNTAINS AND VALLEYS, CASTLES AND TENTS FROM THE NEWARK MUSEUM COLLECTION
The Newark Museum's Tibetan Collection is one of the foremost holdings in the world. This exhibition tells the story of Tibet through photographs, film and rare historical and personal objects. Government documents, aristocratic jewelry and the unique portable accoutrements of nomads are shown for the first time in New York. *Will Travel*

04/18/2001 to 07/28/2001 SANTOS: SCULPTURE BETWEEN HEAVEN AND EARTH
On loan from El Museo del Barrio in New York, some 45 examples of Puerto Rican santos (altar figures) from its distinguished collection. Works on paper depicting santos complement these small-scale sculptures.

05/05/2001 continuing PICTURING AMERICA
This major reinterpretation and reinstallation of the outstanding American art collection presents major developments in art, history and culture through a display of superb paintings, sculptures, photographs and decorative arts objects, including furniture.

09/2001 continuing GLASS IN THE ANCIENT MEDITERRANEAN: THE EUGENE SCHAEFER COLLECTION OF ANCIENT GLASS
Objects from this acclaimed collection, part of the Museum's classical holdings, trace the use of glass from its beginning as a rare and magical medium in ancient Egypt and Mesopotamia, through the colorful perfume containers of ancient Greece to its mass production under the Romans.

09/26/2001 to 01/20/2002 DUTCH OPULENCE AND INTIMACY: THE ART OF HOME AND PRIVATE LIFE, 1640-1700
This major traveling exhibition explores Dutch family life during its Golden Age when artists actively helped shape ideals and practices of home that have affected western attitudes to this day.

NEW JERSEY

Newark Public Library
5 Washington Street, Newark, NJ 07101

☎: 973-733-7745
Open: 9-5:30 Mo, Fr, Sa, 9-8:30 Tu, We, Th **Closed:** LEG/HOL!
&: Ramp
Permanent Collection: AM & EU: gr

Since 1903 the library can be counted on for exhibitions which are of rare quality and well documented.

OCEANVILLE

Noyes Museum of Art
Lily Lake Rd, Oceanville, NJ 08231

☎: 609-652-8848 **◙** www.noyesmuseum.org
Open: 11-4 We-Su **Closed:** Mo, Tu, LEG/HOL!
Free Day: Fr **ADM: Adult:** $3.00 **Children:** Free under 18 **Students:** $2.00 **Seniors:** $2.00
& **Ⓟ:** Free **Museum Shop Group Tours:** 800-669-2203/609-652-8848, x10 **Docents Tour times:** Schedule in advance
Permanent Collection: AM: 19th, 20th C. craft, folk; NJ: reg; VINTAGE BIRD DECOYS

Nestled in a peaceful lakeside setting, the Museum displays rotating exhibitions of American art and craft. Southern New Jersey's only fine art museum, it is a hidden treasure worth discovering and is located only 15 minutes from Atlantic City. **NOT TO BE MISSED:** Purple Martin Palace, view of Lily Lake.

ON EXHIBIT 2001
09/09/2000 to 01/07/2001 ART IN BOXES
Artists who work in box formats, simple cubes with collections of "things" or found objects.

09/23/2000 to 01/07/2001 THE PAINTED PAGE: CHILDREN'S BOOK ILLUSTRATIONS OF CHARLES SANTORE
His original drawings for "Aesop's Fables, "The Tale of Peter Rabbit and other Stories," "The Little Mermaid" and many others will be shown.

01/21/2001 to 04/01/2001 LEADING THE FIGHT AGAINST HUNGER: IMAGES OF THE FOOD BANK
Photographic images showing how people in the area are helping each other. *Will Travel*

ORADELL

Hiram Blauvelt Art Museum
705 Kinderkamack Road, Oradell, NJ 07649

☎: 201-261-0012
Open: 10-4 We-Fr, 2-5 Sa, Su **Closed:** Mo, Tu, LEG/HOL
Vol./Contr.: Yes **&** **Ⓟ:** Free **Museum Shop**
Group Tours: 201-261-0012 **Docents Tour times:** by appt **Sculpture Garden**
Permanent Collection: WILDLIFE ART; AUDUBON FOLIO; IVORY GALLERY; BIG GAME ANIMALS, EXTINCT BIRDS, REPTILES

Founded in 1957 the museum is dedicated to bringing awareness to issues facing the natural world and to showcasing the artists who are inspired by it. It is located in an 1893 shingle and turret style carriage house. The 1679 Demarest House in River Edge, NJ is also owned by the Blauvelt-Demarest Foundation. **NOT TO BE MISSED:** Carl Rungius oil.

ON EXHIBIT 2001
02/2001 to 06/2001 TERRU MILLER, PAULA WATERMAN, JULIA ROGERS AND BART WALTERS

09/2001 to 12/2001 LINDSAY SCOTT

PRINCETON

Art Museum, Princeton University
Affiliate Institution: Princeton University
Nassau Street, Princeton, NJ 08544-1018

☎: 609-258-3788　**◯**　www.princeton, edu
Open: 10-5 Tu-Sa, 1-5 Su　**Closed:** Mo, LEG/HOL!
&　**Ⓟ:** On-street or nearby garages; special parking arrangements for the handicapped are available (call ahead for information)　**Museum Shop**
Group Tours: 609-258-3043　**Docents**　**Tour times:** 2:00 Sa
Permanent Collection: AN/GRK; AN/R+Mosaics; EU: sculp, ptgs 15-20; CH: sculp, ptgs; GR; P/COL; OM: ptgs, drgs; AF

An outstanding collection of Greek and Roman antiquities including Roman mosaics from Princeton University's excavations in Antioch is but one of the features of this highly regarded eclectic collection housed in a modern building on the lovely Princeton University campus. **NOT TO BE MISSED:** Picasso sculpture, "Head of a Woman."

ON EXHIBIT 2001
11/21/2000 to 01/07/2001　CONTEMPORARY PHOTOGRAPHS

11/07/2000 to 01/07/2001　DUTCH DRAWINGS IN THE GOLDEN AGE

SUMMIT

New Jersey Center For Visual Arts
68 Elm Street, Summit, NJ　07901

☎: 908-273-9121　**◯**　www.njmuseums.com/njcva/index.htm
Open: 12-4 Mo-Fr; 7:00-9 Th; 2-4 Sa, Su　**Closed:** LEG/HOL! & last 2 weeks in August
Sugg./Contr.: Adult: $1.00　**Children:** Free under 12　**Students:** $1.00
&: Elevator, ramps, etc.　**Ⓟ:** Free　**Museum Shop**　**Docents**　**Tour times:** !　**Sculpture Garden**
Permanent Collection: non-collecting institution

The Center presents exhibitions of contemporary art by artists of national and international reputation as well as classes for people of all ages and levels of ability. **NOT TO BE MISSED:** "Melvina Edwards—Sculpture" in the NJCVA Sculpture Park

ON EXHIBIT 2001
03/23/2001 to 06/17/2001　ABOUT FACE: ANDY WARHOL PORTRAITS
Warhol (1928-1987) was fascinated by the face. His 1960's paintings of Marilyn, Liz, Jackie and others brought the portrait back into focus as a subject for post-war art. This exhibit shows how his interest in the portrait and the cult of celebrity was constant throughout his career.

05/13/2001 to 06/17/2001　NEW FACES OF NEW JERSEY

TENAFLY

African Art Museum of the S. M. A. Fathers

23 Bliss Ave, Tenafly, NJ 07670

℃: 201-894-8611 **◙** www.smafathers.org
Open: 10-5 Daily **Closed:** LEG/HOL! MO
& **Ⓟ:** Free
Docents **Tour times:** by appt
Permanent Collection: AF; sculp, dec/art

Located in a cloistered monastery with beautiful gardens in the gracious old town of Tenafly, this museum features changing collection and loan exhibitions.

ON EXHIBIT 2001
06/22/2000 to 01/07/2001 TRANSFORMATIONS: CERAMICS FROM THE PERMANENT COLLECTIONS

TRENTON

New Jersey State Museum

205 West State Street, P.O. Box 530, Trenton, NJ 08625-0530

℃: 609-292-6464 **◙** www.state.nj.us/state/museum/usidx.html
Open: 9-4:45 Tu-Sa, 12-5 Su **Closed:** Mo, State Holidays
ADM: Adult: Planetarium $1.00 **Children:** Planetarium $1.00 **Students:** $1.00 **Seniors:** $1.00
& **Ⓟ:** Free parking available in garage near museum **Museum Shop** ⊺⊦: Museum Café, 9am-3pm
Group Tours: 609-292-6347
Permanent Collection: AM: cont, gr; AF/AM

The museum is located in the Capitol Complex in downtown Trenton. The fine art collections cover broad areas of interest with a special focus on New Jersey and culturally diverse artists. **NOT TO BE MISSED:** Stieglitz Circle.

ABIQUIU

Georgia O'Keeffe Home and Studio
Affiliate Institution: The Georgia O'Keeffe Foundation
Abiquiu, NM 87510

☏: 505-685-4539
Open: open by reservation only! 1 hr Tours seasonally on Tu, Th, Fr **Closed:** Mo, We, Sa, Su LEG/HOL
ADM: Adult: $20 interior $15 ext **Students:** $15.00 **Seniors:** $15.00
Handicap access exterior only ℗: no buses
Permanent Collection: Home and studio of artist Georgia O'Keeffe

ALBUQUERQUE

University of New Mexico Art Museum and Jonson Gallery
Affiliate Institution: The University of New Mexico
Fine Arts Center, Albuquerque, NM 87131-1416

☏: 505-277-4001
Open: 9-4 Tu-Fr, 5-8 Tu, 1-4 Su, Jonson Gallery closed on weekends **Closed:** Su, Mo, Sa, LEG/HOL!
& ℗: Limited free parking **Museum Shop Sculpture Garden**
Permanent Collection: CONT; 19, 20; GR; PHOT; SP/COL; OM

In addition to changing exhibitions of work drawn from the permanent collection the Museum features significant New Mexico and regional artists working in all media.

ON EXHIBIT 2001

02/06/2001 to 04/01/2001 BASIA IRLAND

01/23/2001 to 02/04/2001 SEAN MELLYN AT TAMARIND

01/23/2001 to 03/11/2001 JUAN SANCHEZ PRINTED CONVICTIONS

02/06/2001 to 06/03/2001 HUGHIE LEE-SMITH PAINTINGS AND DRAWINGS

02/06/2001 to 06/03/2001 IN COMPANY ROBERT CREELEY'S COLLABORATIONS

03/20/2001 to TBA! ABSTRACTION/NON-OBJECTIVE ART

04/10/2001 to 06/03/2001 JIM STONE HISTORIOSTOMY

06/05/2001 to 08/24/2001 ROUTE 66

06/05/2001 to 08/24/2001 SPACE ODYSSEY 2001; TRANSCENDENTAL PAINTINGS/PHOTOS FROM THE HUBBLE TELESCOPE

06/26/2001 to 09/16/2001 VAN DEREN COKE COLLECTION

06/29/2001 to 09/16/2001 GUS FOSTER ROUTE 66 PHOTOS

10/9/2001 to 01/20/2002 ANTONELLA RUSSO/LINEA DE CONFINE

10/09/2001 to 01/20/2002 IGNATOVICH PHOTOS

NEW MEXICO

LOS ALAMOS

Art Center at Fuller Lodge
2132 Central Avenue, Los Alamos, NM 87544
☎: 505-662-9331 **◙** http://artful@losalamos.com
Open: 10-4 Mo-Sa **Closed:** Su, LEG/HOLS
占 **℗** **Museum Shop**
Group Tours: 505-662-9331 **Docents** **Sculpture Garden**

Located in historic Fuller Lodge, this art center presents changing exhibitions of local and regional fine arts and crafts. **NOT TO BE MISSED:** Galllery Shop offers fine arts and crafts by 70-plus Southwestern artists.

ROSWELL

Roswell Museum and Art Center
100 West 11th, Roswell, NM 88201
☎: 505-624-6744 **◙** www.roswellmuseum.org
Open: 9-5 Mo-Sa, 1-5 Su & HOL **Closed:** 1/1, THGV, 12/25
Sugg./Contr.: $2.00 pp
占 **℗** **Museum Shop**
Group Tours: x 22, 1 week advance notice **Docents** **Tour times:** SELF-GUIDED **Sculpture Garden**
Permanent Collection: SW/ART; HISTORY; SCIENCE; NM/ART; NAT/AM

Sixteen galleries featuring works by Santa Fe and Taos masters and a wide range of historic and contemporary art in its impressive permanent collection make this museum one of the premier cultural attractions of the Southwest. Temporary exhibitions of Native American, Hispanic, and Anglo art are often featured. **NOT TO BE MISSED:** Rogers Aston Collection of Native American and Western Art.

ON EXHIBIT 2001
09/29/2000 to 02/18/2001 2000 INVITATIONAL EXHIBITION
Features the sculpture of Chiricahua Apache artists Bob Haozous and the paintings of Mescalero Apache artists Oliver Enjady.

09/29/2000 to 02/18/2001 2000 NATIVE AMERICAN INVITATIONAL

03/24/2001 to 04/29/2001 PHOTOGRAPHING THE SOUTHWEST
An exhibit that spotlights and interprets the photography collection.

SANTA FE

Institute of American Indian Arts Museum
108 Cathedral Place, Santa Fe, NM 87501
☎: 505-988-6281 **◙** www.iaiancad.org
Open: 9-5 daily June-September; 10-5 daily Oct-May **Closed:** 1/1, 4/4, 12/25; Easter; THGV
ADM: Adult: $4.00; F NAT/AM **Children:** Free under 16 **Students:** $2.00 **Seniors:** $2.00
占 **℗:** Local garages available **Museum Shop** **Sculpture Garden**

The Museum cares for and presents the National Collection of Contemporary Indian Art which chronicles the development 1960-present. Contemporary Native American arts and crafts and Alaskan native arts are featured . **NOT TO BE MISSED:** Admission to Allan Houser Art Park with Museum adm.

Museums of New Mexico

113 Lincoln Ave., Santa Fe, NM 87501

☎: 505-827-6463 ◙ www.museumofnewmexico.org
Open: All Museums 10-5 Tu-Su!, Monuments, 8:30-5 daily **Closed:** Mo, LEG/HOL
ADM: Adult: $5 1 museum, 1 day; $10, 4 day pass all **Children:** Free under 17 **Seniors:**Free We
&: In most buildings ℗ **Museum Shop**
Group Tours: 505-476-5008 **Docents** **Tour times:** ! each Museum
Permanent Collection: (5 Museums with varied collections): TAOS & SANTA FE MASTERS; PHOT; SW/REG
;NAT/AM; FOLK; 5 State Monuments

In 1917 when it opened, the Museum of Fine Arts set the Santa Fe standard in Pueblo-Revival architecture. The Palace of the Governors, built by Spanish Colonial and Mexican governors in 1610, has the distinction of being the oldest public building in the US. Its period rooms and exhibitions of life in New Mexico during the Colonial Period are unique. Also included in the Museum are the Museum of Indian Arts and Culture and the Museum of International Folk Art. **NOT TO BE MISSED:** The entire complex.

Wheelwright Museum of the American Indian

704 Camino Lejo, Santa Fe, NM 87502

☎: 505-982-4636 ◙ www.wheelwright.org
Open: 10-5 Mo-Sa, 1-5 Su **Closed:** 1/1, 12/25, THGV
& ℗: in front of building **Museum Shop**
Docents **Tour times:** 2pm Mo, Tu, Fr, 11 Sa **Sculpture Garden**
Permanent Collection: NAT/AM, Navajo; SW Ind (not always on view)

Inside this eight sided building, shaped like a Navajo 'hooghan' or home, on a hillside with vast views, you will find breathtaking American Indian art. **NOT TO BE MISSED:** Case Trading Post Museum Shop.

TAOS

Harwood Museum of the University of New Mexico

Affiliate Institution: University of New Mexico
238 Ledoux St, Taos, NM 87571

☎: 505-758-9826 ◙ www.nmculture.org
Open: 10-5 Tu-Sa, 12-5 Su **Closed:** Mo, LEG/HOL!
Free Day: Su **ADM: Adult:** $5.00 & ℗ **Museum Shop**
Docents **Tour times:** Su, Ju-Se, 1pm
Permanent Collection: Hispanic and 19th C. Retablos; Bultos, American Mod.

Many of the finest artists who have worked in Taos are represented in this collection. Seven galleries include the Taos Society of Artists, American Modernists, The Taos Moderns, Hispanic traditional arts, mid & late 20th century art and a permanent installation of seven paintings by Agnes Martin. The landmark building is an early example of Pueblo Revivial Architecture Expansion and renovation completed in 1997. Call for changing exhibitions schedule. **NOT TO BE MISSED:** "Winter Funeral" by Victor Higgins, Agnes Martin Gallery; Hispanic Traditions Gallery.

NEW MEXICO

Millicent Rogers Museum

Museum Road, 4 miles N of Taos, 1504 Millicent Rogers Road, Taos, NM 87571

☎: 505-758-2462 ◙ http:millicentrogers,org
Open: 10-5 Daily Apr-Oct, closed Mo Nov-Mar **Closed:** 1/1, EASTER, SAN GERONIMO DAY 9/30, THGV, 12/25
Free Day: Su **ADM: Adult:** $6.00 **Children:** 6-16 $1.00 **Students:** $5.00 **Seniors:** $5.00
&: 95% ℗ **Museum Shop**
Docents Tour times: ! Sculpture Garden
Permanent Collection: NAT/AM & HISP: textiles, basketry, pottery, jewelry; REG

Dedicated to the display and interpretation of the art and material of the Southwest, the Millicent Rogers Museum places particular focus on New Mexican cultures. **NOT TO BE MISSED:** Extensive collection of pottery by Maria Martinez.

ON EXHIBIT 2001

11/17/2000 to 03/18/2001 LA CASA: DENTRO Y DE FUERO
Historic handcrafted tools and furniture from the collection.

01/26/2001 to 05/21/2001 NEW MEXICO QUILTS: A CROSS CULTURAL TRADITION
Exchanges and influences between 4 southern New Mexico counties of eastern background and 4 largely of Hispanic stock.

Albany Institute of History and Art

125 Washington Ave, Albany, NY 12210

☎: 518-463-4478 ▣ www.albanyinstitute.org
Open: 12-5 We-Su **Closed:** Mo, Tu, LEG/HOL!
Free Day: We **ADM: Adult:** $3.00 **Children:** Free under 12
♿ ℗: Nearby pay garage **Museum Shop**
Permanent Collection: PTGS: Hudson River School & Limner; AM: portraits 19; CAST IRON STOVES; DEC/ARTS: 19

Founded in 1791, this museum, one of the oldest in the nation, presents permanent displays and changing exhibitions throughout the year. There are over 20,000 objects in the permanent collection.

The Museum will be under construction and renovation beginning in April 1999 and reopening in 2001. Please call ahead for exhibition information. **NOT TO BE MISSED:** Hudson River School paintings by Cole, Durand, Church, Kensett, Casilear and the Hart Brothers.

University Art Museum

Affiliate Institution: University At Albany, State University of NY

1400 Washington Ave, Albany, NY 12222

☎: 518-442-4035 ▣ www.albany.edu/museum
Open: 10-5 Tu-Fr, 12-4 Sa, Su **Closed:** Mo, LEG/HOL!
♿ ℗: Free ❚❙: In Campus Center
Permanent Collection: AM: gr, ptng, dr 20

This museum, the largest of its kind among the State University campuses and one of the major galleries of the Capitol District, features work from student and mid-career to established artists of national reputation. **NOT TO BE MISSED:** Richard Diebenkorn, "Seated Woman," 1966 (drawing).

Schein-Joseph International Museum of Ceramic Art

Affiliated Institution: New York State College of Ceramics at Alfred University

Alfred, NY 14802

☎: 607-871-2421 ▣ www.ceramicsmuseums.alfred.edu
Open: 10am-5pm Tu-Su **Closed:** Mo, Some holidays!
Group Tours: 607-871-2421

Center for Curatorial Studies Museum

Bard College, Annandale on Hudson, NY 12504

☎: 914-758-7598 ▣ www.bard.edu/ccs
Open: 1-5 We-Su **Closed:** Mo, Tu, 12/31, 1/1, MEM/DAY, 7/4, THGV, 12/25
♿ ℗ **Group Tours:** 914-758-7598
Permanent Collection: CONT: all media; VIDEO: installation 1960-present

Housed in a facility which opened in 1992, the CCS Museum features changing exhibitions of contemporary art curated by director Amada Cruz, internationally renowned guest curators and graduate thesis candidates. In it's large multi-gallery (8) space.

NEW YORK

American Museum of the Moving Image
35th Ave at 36th St, Astoria, NY 11106

☎: 718-784-0077 **◙** www.ammi.org
Open: 12-5 Tu-Fr, 11-6 Sa-Su **Closed:** Mo, 12/25
ADM: Adult: $8.50 **Children:** $4.50 (5-18), under 4 Free **Students:** $5.50 **Seniors:** $5.50
& **Ⓟ:** street parking available **⊪:** cafe
Group Tours: 718-784-4520 **Docents Tour times:** 2:-3:00 pm insider's Tour
Permanent Collection: BEHIND THE SCREEN, combination of artifacts, interactive experiences, live demonstrations and video screenings to tell the story of the making, marketing and exhibiting of film, television and digital media. Especially popular are Automated Dialogue Replacement where visitors can dub their own voices into a scene from a movie and Video Flipbook where visitors can create a flipbook of themselves that they can pick up at the gift shop as a momento.

The only Museum in the U.S. devoted exclusively to film, television, video and interactive media and their impact on 20th century American life. **NOT TO BE MISSED:** "Tut's Fever Movie Palace," Red Grooms and Lysiane Luongs interpretation of a 1920's neo-Egyptian movie palace showing screenings of classic movie serials daily.

Schweinfurth Memorial Art Center
205 Genesee St, Auburn, NY 13021

☎: 315-255-1553
Open: 10-5 Tu-Sa, 1-5 Su (extended hours during Quilt Show) **Closed:** Mo, THGV, 12/25
Sugg./Contr.: $3.00 & **Ⓟ Museum Shop**
Permanent Collection: Non collecting institution

Regional fine art, folk art and crafts are featured in changing exhibitions at this cultural center located in central New York State. **NOT TO BE MISSED:** Made in New York gift shop featuring regional fine arts and crafts. Annual juried Quilt Show, Nov 4, 2000 - Jan 7, 2001.

QCC Art Gallery
Affiliate Institution: Queensborough Community College
222-05 56th Ave., Bayside, NY 11364-1497

☎: 718-631-6396
Open: 9-5 Mo-Fr and by appt. **Closed:** Sa, Su, ACAD!
& **Museum Shop ⊪:** 9am-2pm
Permanent Collection: AM: after 1950; WOMEN ARTISTS

The Gallery which reflects the ethnic diversity of Queensborough Community College and its regional residents also highlights the role art plays in the cultural history of people.

BINGHAMTON

Roberson Museum Science Center
30 Front St., Binghamton, NY 13905-4779
☎: 607-772-0660 ◙ www.roberson.org
Open: 10-5 Mo-Sa, 12-5 Su **Closed:** Mo, LEG/HOL!
ADM: Adult: $5.00 **Children:** Free under 4 **Students:** $3.00 **Seniors:** $3.00
♿ ⓟ **Museum Shop**
Permanent Collection: Reg TEXTILES; PHOT; PTGS; DEC/ART: late 19,20, agricultural tools and archeological materials

A regional museum featuring 19th and 20th century art, history, folklife, natural history and technology. It includes a 1907 mansion, a museum, a Planetarium, and the off-site Kopernik Observatory. **NOT TO BE MISSED:** "Blue Box" trainer circa 1942 by Edwin Link; mammoth tusk and mammoth tooth c. 9000 B.C.

BLUE MOUNTAIN LAKE

Adirondack Museum
Blue Mountain Lake, NY 12812
☎: 518-352-7653 ◙ www.adkmuseum.org
Open: Normal season Mem/Day-Col/Day!
Free Day: call for dates and times **ADM: Adult:** $10.00 **Children:** 7-16 $6.00 **Seniors:** $9.00
♿ ⓟ **Museum Shop** ‖
Permanent Collection: AM: Pntgs, GR, Drwgs, 1850-present

The Museum tells the stories of how people lived, moved, worked and played in the Adirondacks. There are 23 indoor and outdoor exhibit areas featuring special events and programs. Just an hour from Lake Placid and Lake George, the museum has a cafeteria overlooking Blue Mountain Lake.

BRONX

Bronx Museum of the Arts
1040 Grand Concourse, Bronx, NY 10456
☎: 718-681-6000
Open: 3-9 We; 10-5 Th-Fr; 12-6 Sa, Su **Closed:** Mo, Tu, THGV, 12/25
Free Day: We **Sugg/Contr.: ADM: Adult:** $3.00 **Children:** Free under 12 **Students:** $2.00 **Seniors:** $2.00
♿ ⓟ: nearby garage **Museum Shop Group Tours:** 718-681-6000, Ex132
Permanent Collection: AF: LAT/AM: SE/ASIAN: works on paper 20; CONT/AM: eth

Noted for its reflection of the ethnically diverse NYC metro area, it is the only fine arts museum in the Bronx. The collection and exhibitions are a fresh perspective on the urban experience. It is committed to stimulating audience participation in the visual arts.

Hall of Fame for Great Americans
Affiliate Institution: Bronx Community College
University Ave and W. 181 St, Bronx, NY 10453
☎: 718-289-5161 ◙ www.bcc.cuny.edu
Open: 10-5 Daily **Closed:** None
♿: Ground level entrance to Colonnade ⓟ ‖
Docents Tour times: by appt **Sculpture Garden**
Permanent Collection: COLONNADE OF 98 BRONZE BUSTS OF AMERICANS ELECTED TO THE HALL OF FAME SINCE 1900 (includes works by Daniel Chester French, James Earle Fraser, Frederick MacMonnies, August Saint-Gaudens

Hall of Fame for Great Americans- continued

Overlooking the Bronx & Harlem Rivers, this beautiful Beaux arts style architectural complex, once a Revolutionary War fort, contains a Stanford White designed library modeled after the Pantheon in Rome. 98 recently restored bronze portrait busts of famous Americans elected to the Hall of Fame since 1900 and placed within the niches of the "Men of Renown" classical colonnade allow the visitor to come face-to-face with history through art. Dedicated Memorial Day, May 30, 1901, we are currently celebrating a centennial.

BROOKLYN

Brooklyn Museum of Art

200 Eastern Parkway, Brooklyn, NY 11238

☎: 718-638-5000 ◙ www.brooklynart.org
Open: 10-5 We-Fr, 11-6 Sa, open 11-11 first Sa of month, 11-6 Su **Closed:** Mo, Tu, THGV, 12/25, 1/1
Sugg/Contr.: ADM: Adult: $4.00 **Children:** Free under 12 **Students:** $2.00 **Seniors:** $2.00
& ℗**:** Pay parking on site **Museum Shop** ⑪: open until 4 weekdays, till 5 weekends & holidays, coffee/wine bar Sa eve
Group Tours: 718-638-5000, ext 221 **Docents** **Tour times:** Th, Fr 1pm, Sa, Su, 1 & 3pm **Sculpture Garden**
Permanent Collection: EGT; AM-EU ptgs, scupl, dec/art 18-20; AS; AF; OC; NW/AM; W/COL

The Brooklyn Museum of Art is one of the nation's premier art institutions. Housed in a Beaux-Arts structure designed in 1893 by McKim, Mead & White, its collections represent virtually the entire history of art from Egyptian artifacts to modern American paintings. **NOT TO BE MISSED:** Newly renovated and brilliantly installed Charles A. Wilbour Egyptian Collection.

ON EXHIBIT 2001

09/29/2000 to 01/07/2001 MASTERPIECES OF FASHION
The Museum's fashion collection is one of the oldest and largest in the country. Here it will be divided into four main groupings: fashion and historicism; fashion and exotic inspirations; art and fashion; and American fashion.

10/06/2000 to 01/07/2001 LEE KRASNER
A major retrospective of Brooklyn born Krasner's work including paintings and collages from a fifty year period will have it's final venue here. Included are early figurative works, Abstract Expressionist paintings and oil and paper collages made in the 1970-1990's. This exhibition places her work in the painterly influences of Hans Hofmann, Willem de Kooning, Henri Matisse, and Piet Mondrian.

10/13/2000 to 01/21/2001 SCYTHIAN GOLD IN THE UKRAINE
Although known as warring barbarians, the Scythians left behind them a wealth of Greek gold pieces which were fashioned by craftsmen in the black sea region. *Will Travel*

11/10/2000 to 02/01/2001 ROBOTS, ASTRONAUTS, AND SPACE TOYS: THE ROBERT LESSER COLLECTION
Drawn from one of the most extensive collections of toy robots in the world it documents the fascination with robots in the post war period of the 20th century. The robots shown include many never shown in a museum.

11/17/2000 to 02/18/2001 NARDO DI CIONE
The exhibition will celebrate the reunion of the altarpiece "Madonna and Child Enthroned With Saints" with its "lost" uppermost panel. The pieces have been separated since 1851. Considered the most important mid-fourteenth century Italian painting in America, Other works by Nardo and his circle will also be shown.

02/02/2001 to 04/15/2001 COMMITTED TO THE IMAGE: A CENTURY OF BLACK PHOTOGRAPHERS IN AMERICA
100 Black photographers who have exhibited nationally, internationally and regionally over the past 10-15 years. Depicted are various aspects of black American life.

03/02/2001 to 05/27/2001 A FAMILY ALBUM: BROOKLYN COLLECTS
Works of art belonging to notable individuals who have ties to Brooklyn.

Brooklyn Museum of Art- continued

06/21/2001 to 09/02/2001 THE PRINT NATIONAL
A periodic survey of printmaking including, for the first time, woks digitally manipulated and created entirely with computers.

09/07/2001 to 11/11/2001 WIT AND WINE: A NEW LOOK AT ANCIENT IRANIAN CERAMICS FROM THE ARTHUR M. SACKLER FOUNDATION
Vessels from the fifth millennium B.C. to the sixth century A. D. These works show the creativity of the Iranian potter including sophisticated ornamental designs.

10/05/2001 to 01/06/2002 VITAL FORMS: AMERICAN ART IN THE ATOMIC AGE, 1940-1960
The most innovative works of the 40s and 50s which embraced a vocabulary of vital, or organic forms. Through architecture, decorative and industrial arts, graphic design, painting, photography and sculpture, Vital Forms will examine the collective use of such forms derived from nature during the post war era. *Will Travel*

11/09/2001 to 02/04/2002 THE ETERNAL IMAGE: EGYPTIAN ANTIQUITIES FROM THE BRITISH MUSEUM
Will Travel

12/07/2001 to 01/27/2002 GRANDMA MOSES IN THE 21ST CENTURY
Her work will be examined in its relationship to "high" art, folk art, and popular culture.

Rotunda Gallery

33 Clinton Street, Brooklyn, NY 11201
☎: 718-875-4047
Open: 12-5 Tu-Fr, 11-4 Sa **Closed:** Su, Mo, LEG/HOL!
♿ Ⓟ: Metered street parking; nearby pay garage
Permanent Collection: non-collecting institution

The Gallery's facility is an architecturally distinguished space designed for exhibition of all forms of contemporary art. It is located in Brooklyn Heights which is well known for its shops, restaurants and historic brownstones.

Rubelle & Norman Schafler Gallery

Affiliate Institution: Pratt Institute
200 Willoughby Ave, Brooklyn, NY 11205
☎: 718-636-3517 ▣ http://www.pratt.edu.exhibitions
Open: 9-5 Mo-Fr **Closed:** Sa, Su, L EG/HOL!
Ⓟ: on street parking only
Permanent Collection: Currently building a collection of Art and Design Works by Pratt Alumni, Faculty and Students

Varied programs of thematic, solo, and group exhibitions of contemporary art, design and architecture are presented in this gallery.

BUFFALO

Albright Knox Art Gallery

1285 Elmwood Ave, Buffalo, NY 14222
☎: 716-882-8700 ▣ www.albrightknox.org
Open: 11-5 Tu-Sa, 12-5 Su **Closed:** Mo, THGV, 12/25, 1/1
Free Day: 11-1 Sa **ADM: Adult:** $4.00 **Children:** Free under 12 **Students:** $3.00 **Seniors:** $3.00
♿ Ⓟ Museum Shop ¶
Docents Tour times: 12:15 We-Th, 1:30 Sa-Su **Sculpture Garden**
Permanent Collection: AB/EXP; CONT: 70's & 80's; POST/IMPR; POP; OP; CUBIST; AM & EU: 18-19

Albright Knox Art Gallery- continued

With one of the world's top international surveys of twentieth-century painting and sculpture, the Albright-Knox is especially rich in American and European art of the past fifty years. The permanent collection which also offers a panorama of art through the centuries dating from 3000 BC. is housed in a 1905 Greek Revival style building designed by Edward B. Green with a 1962 addition by Gordon Bunshaft of Skidmore, Owings and Merrill.

Burchfield Penney Art Center

Affiliate Institution: Buffalo State College
1300 Elmwood Ave, Buffalo, NY 14222-6003
(: 716-878-6011 **◙** www.burchfield-penney.org
Open: 10-5 Tu, Th-Sa, 10-7:30 We, 1-5 Su; open most Wed until 7:30pm **Closed:** Mo, LEG/HOL!
Vol./Contr.: $3 **Group Tours:** 716-878-6020 **Docents Tour times:** by appt
Permanent Collection: AM; W/NY: 19,20: CHARLES E. BURCHFIELD; CHARLES CARY RAMSEY, Roycroft, Photo

The Burchfield-Penney Art Center is dedicated to the art and artists of Western New York. Particular emphasis is given to the works of renowned American watercolorist Charles E. Burchfield. The museum holds the largest archives and collection in the world of his works. **NOT TO BE MISSED:** World's largest collection of work by Charles E. Burchfield; "Oncoming Spring," "Fireflies and Lightening" hand crafted objects by Roycroft Arts and Crafts community artists, sculpture by Charles Cary Rumsey.

CANAJOHARIE

Canajoharie Library and Art Gallery

2 Erie Blvd, Canajoharie, NY 13317
(: 518-673-2314 **◙** www.clag.org
Open: 10-4:45 Mo-We, Fr, 10-8:30 Th, 10-1:30 Sa **Closed:** Su, LEG/HOL!
& ℗ Museum Shop Sculpture Garden
Permanent Collection: WINSLOW HOMER; AMERICAN IMPRESSIONISTS; 'THE EIGHT'

Located in downtown Canajoharie, the gallery's collection includes 21 Winslow Homers.

ON EXHIBIT 2001

01/01/2001 to 02/22/2001	BEECH-NUT EXHIBIT
02/25/2001 to 03/15/2001	WINSLOW HOMER WATERCOLORS
03/18/2001 to 04/19/2001	GARY SHANKMAN
04/22/2001 to 05/18/2001	CENTRAL NEW YORK WATERCOLOR SOCIETY
05/20/2001 to 06/22/2001	HENRY DISPIRITO
06/24/2001 to 07/19/2001	OAKROOM ARTISTS
07/23/2001 to 09/14/2001	LANDSCAPES OF NEW YORK
09/16/2001 to 10/18/2001	KAREN ROSASCO
10/21/2001 to 11/18/2001	CANaJOHARIE INVITATIONAL
11/21/2001 to 12/31/2001	QUILTS OF THE MOHAWK VALLEY

CLINTON

Emerson Gallery

Affiliate Institution: Hamilton College
198 College Hill Road, Clinton, NY 13323
℄: 315-859-4396
Open: 12-5 Mo-Fr, 1-5 Sa, Su, closed weekends June, July & Aug **Closed:** LEG/HOL! & ACAD/HOL
& ℗
Permanent Collection: NAT/AM; AM & EU: ptgs, gr 19,20; WEST INDIES ART

While its ultimate purpose is to increase the educational scope and opportunity for appreciation of the fine arts by Hamilton students, the gallery also seeks to enrich campus cultural life in general, as well as to contribute to the cultural enrichment of the surrounding community. **NOT TO BE MISSED:** Outstanding collection of works by Graham Sutherland.

CORNING

Corning Museum of Glass

One Corning Glass Center, Corning, NY 14830-2253
℄: 800-732-6845, 607-937-5371 ◙ www.cmog.org
Open: 9-5 daily, 9-8 July & Aug **Closed:** 1/1, THGV, 12/24, 12/25!
ADM: Adult: $7.00, family $16 **Children:** $5 (6-17) **Students:** $6.00 **Seniors:** $6.00
& ℗ **Museum Shop** ‖
Group Tours: 607-974-2000 **Docents Tour times:** by reservation
Permanent Collection: GLASS: worldwide 1500 BC-present

The Museum houses the world's premier glass collection—more than 30,000 objects representing 3,500 years of achievements in glass design and craftsmanship. New hot-glass studio presents workshops, classes and demonstrations. In June 1999, the New Glass Innovation Center and the Sculpture Gallery open. **NOT TO BE MISSED:** The Hot Glass show where visitors can watch artisans make glass objects; the new Glass Innovation Center.

Rockwell Museum

111 Cedar St., Corning, NY 14830
℄: 607-937-5386 ◙ www.rockwellmuseum.org
Open: 9-5 Mo-Sa, 12-5 Su **Closed:** 1/1, THGV, 12/24, 12/25
Free Day: 12-5 Su (Dec-Apr) **ADM: Adult:** $5.00, family $12.50 **Children:** $2.50, 6-17, Free under 6 **Seniors:** $4.50
& ℗: Municipal lot across Cedar St. **Museum Shop**
Group Tours: 607-937-5386
Permanent Collection: PTGS & SCULP: by Western Artists including Bierstadt, Remington and Russell 1830-1920; Native Amer Art

Located in the 1893 City Hall of Corning, NY, and nestled in the lovely Finger Lakes Region of NY State is the finest collection of American Western Art in the Eastern U.S. The museum building is in a Romanesque revival style and served as a City Hall, firehouse and jail until the 1970s. **NOT TO BE MISSED:** Model of Cyrus E. Dallin's famous image, "Appeal to the Great Spirit."

CORTLAND

Dowd Fine Arts Gallery
Affiliate Institution: State University of New York College at Cortland
SUNY Cortland, Cortland, NY 13045
℄: 607-753-4216
Open: 11-4 Tu-Sa **Closed:** Su, Mo, ACAD!
Vol./Contr.: Yes ㅤ ℗: Adjacent to building **Docents** **Tour times:** scheduled by request **Sculpture Garden**
Permanent Collection: Am & EU: gr,drgs 20; CONT: art books

Temporary exhibitions of contemporary and historic art which are treated thematically are presented in this university gallery.

EAST HAMPTON

Guild Hall Museum
158 Main Street, East Hampton, NY 11937
℄: 631-324-0806 ▣ guild-hall.org
Open: 11-5 daily (Summer), 11-5 We-Sa, 12-5 Su (Winter) **Closed:** THGV, 12/25, 1/1, LEG/HOL!
Sugg/Contr.: $3.00; Summer Exhibitions $5 ㅤ ℗ **Museum Shop** **Group Tours:** 631-324-0806 **Sculpture Garden**
Permanent Collection: AM: 19,20:reg

Located in one of America's foremost art colonies this cultural center combines a fine art museum and a 400 seat professional theater.

EAST ISLIP

Islip Art Museum
50 Irish Lane, East Islip, NY 11730
℄: 631-224-5402 ▣ islipartmuseum.org
Open: 10-4 We-Sa, 2-4:30 Su **Closed:** Mo, Tu, LEG/HOL!
Vol./Contr.: Yes ㅤ ℗ **Museum Shop**
Group Tours: 631-224-5402 **Docents** **Tour times:** by request
Permanent Collection: AM/REG: ptgs, sculp, cont

The Islip Museum is the leading exhibition space for contemporary and avant garde art on Long Island. The Carriage House Project Space, open in the summer and fall, features cutting-edge installations and site-specific work. A satellite gallery called the Anthony Giordano Gallery is at Dowling College in Oakdale, LI.

ELMIRA

Arnot Art Museum
235 Lake St, Elmira, NY 14901-3191
℄: 607-734-3697 **Open:** 10-5 Tu-Sa, 1-5 Su **Closed:** Mo, THGV, 12/25, 1/1
ADM: Adult: $2.00 **Children:** $.50 (6-12) **Students:** $1.00 **Seniors:** $1.00
ㅤ ℗: Free **Museum Shop** **Docents**
Permanent Collection: AM: salon ptgs 19,20; AM: sculp 19

The original building is a neo-classical mansion built in 1833 in downtown Elmira. The museum's modern addition was designed by Graham Gund. **NOT TO BE MISSED:** Matthias Arnot Collection; one of last extant private collections housed intact in its original showcase.

FLUSHING

Godwin-Ternbach Museum

Affiliate Institution: Queens College
65-30 Kissena Blvd, Flushing, NY 11367

☎: 718-997-4734
Open: 11-7 Mo-Th Call! **Closed:** Sa, Su, ACAD!
ⓟ: On campus
Permanent Collection: GR: 20; ANT: glass; AN/EGT; AN/GRK; PTGS; SCULP

This is the only museum in Queens with a broad and comprehensive permanent collection which includes a large collection of WPA/FAP prints.

GLENS FALLS

Hyde Collection

161 Warren St, Glens Falls, NY 12801

☎: 518-792-1761 **◎** www.hydeartmuseum.org
Open: 10-5 Tu-Sa; 10-7 Th, 12-5 Su **Closed:** Mo, LEG/HOL!
Vol./Contr.: Yes **�** **ⓟ** **Museum Shop**
Group Tours: ext 15 **Docents** **Tour times:** 1-4 pm **Sculpture Garden**
Permanent Collection: O/M: ptgs; AM: ptgs; ANT; IT/REN; FR: 18

The central focus of this museum complex is an Italianate Renaissance style villa built in 1912 which houses an exceptional collection of noted European Old Master and significant modern European and American works of art from 4th C. through 20th C. They are displayed among an important collection of Italian Renaissance and French 18th century furniture. The collection spans western art from the 4th c B.C.-20th c. Since 1985 temporary exhibitions and year round programming are offered in the Edward Larabee Barnes Education Wing. **NOT TO BE MISSED:** "Portrait of a Young Man" by Raphael; "Portrait of Christ" by Rembrandt; "Coco" by Renoir; "Boy Holding a Blue Vase" by Picasso; "Geraniums" by Childe Hassam.

ON EXHIBIT 2001

11/05/2000 to 02/02/2001 **REALIZING COURBET**

01/28/2001 to 04/15/2001 **LET CHILDREN BE CHILDREN: LOUIS WICKES HINE'S CRUSADE AGAINST CHILD LABOR**

02/18/2001 to 05/20/2001 **WIM-WAMS OF BUGABOOS: THE LYRICAL ANGST OF TOD PARDON**

06/03/2001 to 09/02/2001 **AMERICAN ART POTTERY**

06/17/2001 to 09/09/2001 **ARTHUR B. DAVIES: DWELLER ON THE THRESHOLD**

09/03/2001 to 12/09/2001 **WATERCOLOR: IN THE ABSTRACT**

09/23/2001 to 12/30/2001 **MEDIEVAL/RENAISSANCE ART (title tba)**

HAMILTON

Picker Art Gallery

Affiliate Institution: Colgate University

Charles A Dana Center For the Creative Arts, Hamilton, NY 13346-1398

☎: 315-228-7634 ◙ www.picker.colgate.edu
Open: 10-5 Daily **Closed:** ACAD!; (also open by request!)
& ℗: 2 large lots nearby **Sculpture Garden**
Permanent Collection: ANT; PTGS & SCULP 20; AS; AF

Located on Colgate University campus, the setting of the Charles A. Dana Art Center is one of expansive lawns and tranquility.

HEMPSTEAD

Hofstra Museum

Affiliate Institution: Hofstra University

112 Hofstra University, Hempstead, NY 11549

☎: 516-463-4743 ◙ www.hofstra.edu/museum
Open: 10-5 Tu-Fr, 1-5 Sa, Su; varying hours in galleries **Closed:** Mo, EASTER WEEKEND, THGV WEEKEND, LEG/HOL
Vol./Contr.: Yes & ℗ **Museum Shop** ‖ **Sculpture Garden**
Permanent Collection: SCULP: Henry Moore, H. J. Seward Johnson, Jr, Tony Rosenthal; Paul Manship, Greg Wyatt, Mihail Chemiakin

Hofstra University is a living museum. Five exhibition areas are located throughout the 240-acre campus, which is also a national arboretum. **NOT TO BE MISSED:** Sondra Rudin Mack Garden designed by Oehme, Van Sweden and Assoc.; Henry Moore's "Upright Motive No. 9," and Tony Rosenthal's "T"s; Paul Manship's "Brisei, Group of Bears," "Atalanta;" Gregg Wyatt's "Hippomenes," "The Hofstra Victory Eagle;" Mihail Chemiakin's "Plato Having a Dialogue with Socrates."

ON EXHIBIT 2001

01/30/2001 to 04/12/2001 **PAINTED IN NEW YORK: A VIEWPOINT FOCUSING ON RECENT TRENDS IN ABSTRACT PAINTING**

05/01/2001 to 08/02/2001 **ABSTRACT EXPRESSIONISM: THEN AND NOW**

10/02/2001 to 12/14/2001 **RODIN'S OBSESSION: THE GATES OF HELL-SCULPTURE FROM THE IRIS AND B. GERALD CANTOR COLLECTION**

HUDSON

Olana State Historic Site

5720 Route 9G, Hudson, NY 12534

☎: 518-828-0135
Open: 10-4 We-Su 4/1-11/1; open MEM/DAY, 7/4, LAB/DAY, COLUMBUS DAY (open M Holidays) **Closed:** Mo, Tu; closed Nov-Mar
ADM: Adult: $3.00 **Children:** $1.00 (5-12) **Seniors:** $2.00
&! ℗: Limited **Museum Shop** **Group Tours:** 518-828-0135, x-301
Permanent Collection: FREDERIC CHURCH: ptgs, drgs; PHOT COLL; CORRESPONDENCE

Olana State Historic Site - continued
Olana, the magnificent home of Hudson River School artist Frederic Edwin Church, was designed by him in the Persian style, and furnished in the Aesthetic style. He also designed the picturesque landscaped grounds. Many of Church's paintings are on view throughout the house. The house is only open by guided tour. Visitor's Center and grounds are open 7 days a week.

HUNTINGTON

Heckscher Museum of Art
2 Prime Ave, Huntington, NY 11743

☎: 631-351-3250 ◙ www.heckscher.org
Open: 10-5 Tu-Fr, 1-5 Sa, Su, 1st Fr till 8:30 **Closed:** Mo, Thgv; Xmas
ADM: Adult: $3.00 **Children:** $1.00 **Students:** $1.00 **Seniors:** $1.00
♿: Steps to restrooms ℗ **Museum Shop** ¶: picnic tables & chairs available
Group Tours: 631-351-3250 **Docents** **Tour times:** 2:30 & 3:30 Sa, Su; 1-3 We &Th
Permanent Collection: AM:ptg & Sculp 16-present; AM:Modernist ptgs, drgs, works on paper; Eur Ptgs & Sculp 16-present

Located in a 18.5 acre park, the museum, whose collection numbers more than 900 works, was presented as a gift to the people of Huntington by philanthropist August Heckscher. **NOT TO BE MISSED:** "Eclipse of the Sun," by George Grosz (not always on view!)

ON EXHIBIT 2001
11/04/2000 to 01/14/2001 AARON COPELAND'S AMERICA
The composer Aaron Copeland is honored on the 100th anniversary of his birth by his counterparts in the visual artists including Arthur B. Dove, Georgia O'Keeffe and the American scene painters of the 30s.

ITHACA

Herbert F. Johnson Museum of Art
Affiliate Institution: Cornell University
Cornell University, Ithaca, NY 14853-4001

☎: 607-255-6464 ◙ www.museum.cornell.edu
Open: 10-5 Tu-Su **Closed:** Mo, MEM/DAY, 7/4, THGV + Fr
♿ ℗: Metered
Group Tours: 607-255-6464 **Docents** **Tour times:** 12 noon every other Th;1 Sa, Su! **Sculpture Garden**
Permanent Collection: AS; AM: gr 19,20

The Gallery, in an IM Pei building, with a view of Cayuga Lake, is located on the Cornell Campus in Ithaca, NY. **NOT TO BE MISSED:** "Fields in the Month of June," by Daubigny.

KATONAH

Caramoor Center for Music and the Arts
149 Girdle Ridge Road, Katonah, NY 10536

☎: 914-232-5035 ◙ www.caramoor.com
Open: 11-4 Tu-Sa, 1-4 Su Jun-Sep, 11-4 We-Su Oct-May, by appt Mo-Fr Nov-May **Closed:** Mo, LEG/HOL!
ADM: Adult: $6.00 **Children:** Free under 12 **Students:** $6.00 **Seniors:** $6.00
♿ ℗: Free **Museum Shop** ¶: Picnic facilities and snack bar
Docents **Tour times:** art tour at 2 We-Su May-Oct, & by request **Sculpture Garden**
Permanent Collection: FURNITURE; PTGS; SCULP; DEC/ART; REN; OR: all media

Caramoor Center for Music and the Arts - continued

Built in the 1930s by Walter Rosen as a country home, this 54 room Italianate mansion is a treasure trove of splendid collections spanning 2000 years. There are six unusual gardens including the Marjorie Carr Sense Circle (for sight-impaired individuals). Tours of the gardens are by appt spring and fall and every weekend during the festival at 2:30 pm. Caramoor also presents a festival of outstanding concerts each summer and many other programs throughout the year. At 11 Wed Apr-Nov a short recital in the music room is followed by a tour of the house. **NOT TO BE MISSED:** Extraordinary house-museum with entire rooms from European villas and palaces.

Katonah Museum of Art

Route 22 at Jay Street, Katonah, NY 10536
☾: 914-232-9555 **◙** www.katonah-museum.org
Open: 1-5 Tu-Fr, Su, 10-5 Sa: summer 12-5 Tu-Fr **Closed:** Mo, 1/1, MEM/DAY; PRESIDENTS/DAY, 7/4, THGV, 12/25
ADM: Adult: $3.00 ර **Ⓟ:** Free **Museum Shop**
Docents Tour times: 2:30pm **Sculpture Garden**
Permanent Collection: No Permanent Collection

Moved to a building designed by Edward Larabee Barnes in 1990, the museum has a commitment to outstanding special exhibitions which bring to the community art of all periods, cultures and mediums.

ON EXHIBIT 2001

10/01/2000 to 04/15/2001 IN THE SCULPTURE GARDEN: DAVID COLBERT
Geometric constructions made of steel interspersed in the Museum's Sculpture Garden.

10/15/2000 to 01/07/2001 THE ART OF THE PUZZLE: ASTOUNDING AND CONFOUNDING
Puzzle solving entails thought, imagination, knowledge and observation. 200 mechanical and jigsaw puzzles are examined and related to decorative art, mathematics, psychology and education. Puzzles will be provided to give first hand information.

01/21/2001 to 04/15/2001 CONSTELLATIONS: JAZZ AND VISUAL IMPROVISATIONS
The interplay between jazz and visual arts in the late 20th century. Included are Bearden, Rivers, Potters, Krasner, Pollock, Basquiat, Gilliam and Akiyoshi.

LONG ISLAND CITY

Isamu Noguchi Garden Museum

32-37 Vernon Blvd, Long Island City, NY 11106
☾: 718-721-1932 **◙** www.noguchi.org
Open: 10-5, We-Fr, 11-6 Sa, Su (Apr-Oct only)
ADM: Adult: $4.00 **Children:** $2.00 **Students:** $2.00 **Seniors:** $2.00
ර: 1/3 of the collection is accessible **Ⓟ:** Street parking **Museum Shop** **ⵏ:** Café
Group Tours: 718-721-1932 x203 **Docents Tour times:** 2 pm daily, not for groups **Sculpture Garden**
Permanent Collection: WORKS OF ISAMU NOGUCHI

Designed by Isamu Noguchi (1904-1988), this museum offers visitors the opportunity to explore the work of the artist on the site of his Long Island City studio. The centerpiece of the collection is a tranquil outdoor sculpture garden. The Museum is in 13 galleries of a converted warehouse and surrounding gardens. **PLEASE NOTE:** A shuttle bus runs to the museum on Sa & Su every hour on the half hour starting at 11:30am from midtown Manhattan. Please call the Museum at 718-721-1932 for information. The round trip fare is $5.00 and DOES NOT include the price of museum admission. **NOT TO BE MISSED:** Permanent exhibition of over 250 sculptures as well as models, drawings, and photo-documentation of works of Noguchi; stage sets designed for Martha Graham; paper light sculptures called Akari.

P.S.1 Contemporary Arts Center
2225 Jackson Avenue, Long Island City, NY 11101

☎: 718-784-2084
Open: 12-6 We-Su **Closed:** Mo, Tu, MEM/DAY, 7/4, LAB/DAY, THGV, 12/25
ADM: Adult: $4.00 **Children:** $2.00 **Students:** $2.00 **Seniors:** $2.00
⅃ ℗: on street and near-by garages ¶: coffee shop **Sculpture Garden**
Permanent Collection: CONT, AM

P.S.1 recognizes and introduces the work of emerging and lesser known artists. **NOT TO BE MISSED:** "Meeting" by James Turrell, 1986.

MOUNTAINVILLE

Storm King Art Center
Old Pleasant Hill Rd, Mountainville, NY 10953

☎: 914-534-3115
Open: 11-5:30 Daily (Apr-Nov 14), Special eve hours Sa, June, July, Aug **Closed:** 11/15-3/31
ADM: Adult: $7.00 **Children:** Free under 5 **Students:** $3.00 **Seniors:** $5.00
⅃: Partial, 1st floor of building and portions of 500 acres ℗ **Museum Shop**
Group Tours: 914-534-3115 x110 **Docents** **Tour times:** 2pm daily **Sculpture Garden**
Permanent Collection: SCULP: Alice Aycock, Alexander Calder, Mark di Suvero, Andy Goldsworthy, Louise Nevelson, Isamu Noguchi, Richard Serra, David Smith, Kenneth Snelson

America's leading open-air sculpture museum has a large collection of outdoor sculpture on view amid 500 acres of lawns, fields and woodlands. Works are also on view in a 1935 Normandy style building that has been converted to museum galleries. **NOT TO BE MISSED:** Momo Taro by Isamu Noguchi; Pyramidian, Mother Peace by Mark di Suvero; The Arch; Alexander Calder; XI Books and Apples, Personnage of May, Becca, The Sitting Printer by Smith.

MUMFORD

Genesee Country Village & Museum
410 Flint Hill Road, P.O. box 310, Mumford, NY 14511

☎: 716-538-6822 ◙ www.gcv.org
Open: 10-5 Tu-Su Jul, Aug; 10-4 Tu-Fr, 10-5 Sa, Su Spring and Fall, season May-Oct **Closed:** Mo
ADM: Adult: $11 **Children:** 4-16 $6.50, under 3 Free **Students:** $9.50 **Seniors:** $9.50
⅃: partial ℗: Free **Museum Shop** ¶ **Group Tours:** ext 248 **Sculpture Garden**
Permanent Collection: AM,Ptgs, sculpt;AM\SW;late 19;NAT/AM;sculpt;WILDLIFE art;EU&AM sport art 17-20

The outstanding J. F. Wehle collection of sporting art is housed in the only museum in New York specializing in sport, hunting and wildlife subjects. The collection and carriage museum are part of an assembled village of 19th century shops, homes and farm buildings.

NEW PALTZ

Samuel Dorsky Museum of Art
Affiliate Institution: State University of New York at New Paltz
New Paltz, NY 12561

☎: 914-257-3844 ◙ www.newpaltz.edu/artgallery
Open: 11-4 Tu-Fr, 1-4, Sa, Su ; 7-9 Tu eve **Closed:** Mo, LEG/HOL, ACAD HOL! ⅃ ℗ **Museum Shop**
Permanent Collection: AM; gr,ptgs 19,20; JAP: gr; CH: gr; P/COL; CONT: phot

Samuel Dorsky Museum of Art - continued

The Samuel Dorsky Museum of Art is the second largest museum in the State University system. Not only does the museum enhance the educational mission of the college, it promotes cross disciplinary research and collaboration. It serves as a cultural resource for the Hudson Valley. **NOT TO BE MISSED:** The opening of the gallery and installation of the permanent collection which spans over 4,000 years.

NEW YORK

Alternative Museum

594 Broadway, New York, NY 10012
℡: 212-966-4444 ◙ www.alternativemuseum.org
Open: Tu-Sa **Closed:** Su, Mo

This contemporary arts institution is devoted to the exploration and dissemination of new avenues of thought on contemporary art and culture and operates solely as an Internet museum.

Americas Society

680 Park Avenue, New York, NY 10021
℡: 212-249-8950 ◙ www.americas-society.org
Open: 12-6 Tu-Su **Closed:** Mo, 7/4,THGV,12/24,12/25
ADM: Adult: $3.00 **Children:** $2.00 **Students:** $2.00 **Seniors:** $2.00
& Ⓟ: Nearby pay garage **Museum Shop** **Group Tours:** 212-249-8950, x-364
Permanent Collection: No permanent collection

Located in a historic neo federal townhouse built in 1909, the goal of the Americas Society is to increase public awareness of the rich cultural heritage of our western hemisphere neighbors.

ON EXHIBIT 2001

12/05/2000 to 03/24/2001 GENEVIEVE CADIEUX
One of Canada's most significant contemporary artist she has created a body of photographic works whose subjects are nature, the human body and relationships between the sexes. They are large scale, sparse and close up framing gives them emotional weight out of proportion to what is actually depicted. Ten sculptural works and one video are included. *Will Travel*

09/2001 to 12/2001 ABSTRACT ART FROM THE RIO DE LA PLATA (1933-1953)
The first museum presentation of the development of modernist abstraction in Argentina and Uruguay illustrates this significant chapter in the history of modern art in Latin America. *Will Travel*

Asia Society

725 Park Ave, New York, NY 10021
℡: 212-517-ASIA ◙ www.asiasociety.org
Open: 11-6 Tu-Sa, 11-8 Th, 12-5 Su **Closed:** Mo, LEG/HOL!
Free Day: 6-8 **ADM: Adult:** $4.00 **Children:** $2.00, Free under 12 **Students:** $2.00 **Seniors:** $2.00
& Ⓟ: Nearby pay garages **Museum Shop**
Group Tours: 212-288-6400 **Docents** **Tour times:** 12:30 Tu-Sa, 6:30 Th, 2:30 Su
Permanent Collection: The Mr. and Mrs. John D. Rockefeller 3rd Collection of Asian Art

The Asia Society is America's leading institution dedicated to fostering understanding of Asia and communication between Americans and the peoples of Asia and the Pacific.

AXA Gallery

787 Seventh Avenue, New York, NY 10019

(: 212-554-4818 **◙** www.axa-equitable.com/gallery.html
Open: 11-6 Mo-Fr, 12-5 Sa **Closed:** Su Su; LEG/HOL
& **℗:** pay **⫞:** 3 fine restaurants located in the space overlooking the Galleria
Permanent Collection: PUBLIC ART IN LOBBY OF EQUITABLE TOWER: Roy Lichtenstein's Mural with
Blue Brushstroke

The gallery presents works from all fields of the visual arts that would not otherwise have a presence in
New York City.

Chaim Gross Studio Museum

526 LaGuardia Place, New York, NY 10012

(: 212-529-4906
Open: 12-6 Tu-Fr **Closed:** Sa, Su, Mo, LEG/HOL
& **℗:** Nearby pay parking **Museum Shop**
Group Tours: fee req, off-site lectures 212-529-4906
Permanent Collection: Sculp, wood, stone, bronze; sketches, w/c, prints

A seventy year sculpture collection of several hundred Chaim Gross (1904-1991) works housed on three
floors of the Greenwich Village building which was the artist's home and studio for thirty-five years.
The studio is left intact and is also open to the public. **NOT TO BE MISSED:** "Roosevelt and Hoover in
a Fistfight" 1932, Mahogany 72 x 20 x 1 1/2. The 1932 cubist inspired wood sculptures were done in the
only year when Gross submitted to modernist influences. The Charles A. Lindburgh Family, 1932, golden
streak epilwood.

ON EXHIBIT 2001

02/2001 to TBA! CHAIM GROSS AND THE SUBJECT OF PERFORMANCE

China Institute Gallery, China Institute in America

125 East 65th Street, New York, NY 10021-7088

(: 212-744-8181 **◙** www.chinainstitute.org
Open: 10-5 Mo & We-Sa, 1-5 Su, 10-8 Tu & Th **Closed:** LEG/HOL!, CHINESE NEW YEAR, between exhibitions
ADM: Adult: $3.00 **Children:** Free **Students:** $2.00 **Seniors:** $2.00
℗: Pay garage nearby, limited street parking **Museum Shop**
Group Tours: x, 146, 147 **Docents** **Tour times:** Varies
Permanent Collection: Non-collecting institution

China Institute Gallery presents original and and traveling exhibitions ranging from traditional Chinese
paintings, calligraphy and objects to to Chinese folk arts, textiles and architecture. Exhibitions are
accompanied by catalogs and art education programs, such a gallery tours, lectures and symposia.

ON EXHIBIT 2001

01/25/2001to 05/10/2001 LIVING HERITAGE: VERNACULAR ENVIRONMENT I CHINA
The interior spaces and furniture, photographs and architectural components.

09/13/2001 to 12/09/2001 WEST LAKE AND THE MAPPING OF SOUTHERN SONG ART
Album leaves and circle fans and explore life of West Lake in Hangzhou, Zhejiang Province.

NEW YORK

Cloisters

Affiliate Institution: The Metropolitan Museum of Art
Fort Tryon Park, New York, NY 10040
☎: 212-923-3700 ◙ www.metmuseum.org
Open: 9:30-5:15 Tu-Su (3/1-10/30), 9:30-4:45 Tu-Su (11/1-2/28) **Closed:** Mo, 1/1, THGV, 12/25
ADM: Adult: $10 inc Met Museum on the same day **Children:** Free under 12 **Students:** $5.00 **Seniors:** $5.00
占: Limited, several half-floors are not accessible to wheelchairs **Ⓟ:** Free limited street parking in Fort Tryon Park
Group Tours: 212-650-2280 **Docents** **Tour times:** 3pm Tu-Fr, 12 & 2pm Sa, 12 Su **Museum Shop**
Permanent Collection: ARCH: Med/Eu; TAPESTRIES; ILLUMINATED MANUSCRIPTS; STAINED GLASS; SCULP;
LITURGICAL OBJECTS

This unique 1938 building set on a high bluff in a tranquil park overlooking the Hudson River recreates a medieval monastery in both architecture and atmosphere. Actual 12th-15th century medieval architectural elements are incorporated within various elements of the structure which is filled with impressive art and artifacts of the era. **NOT TO BE MISSED:** "The Unicorn Tapestries;" "The Campin Room;" Gardens; Treasury.

Cooper-Hewitt, National Design Museum, Smithsonian Institution

2 East 91st Street, New York, NY 10128
☎: 212-849-8300 ◙ www.si.edu/ndm
Open: 10-9 Tu, 10-5 We, Sa, 12-5 Su **Closed:** Mo, LEG/HOL!
Free Day: Th 5-9 **ADM: Adult:** $5.00 **Children:** Free under 12 **Students:** $3.00 **Seniors:** $3.00
占 **Ⓟ:** Nearby pay garages **Museum Shop**
Group Tours: 212-849-8380 **Docents** **Tour times:** times vary; call 212-849-8389 **Sculpture Garden**
Permanent Collection: DRGS; TEXTILES; DEC/ART; CER

Cooper Hewitt, housed in the landmark Andrew Carnegie Mansion, has more than 250,000 objects which represent 3000 years of design history from cultures around the world. It is the only museum on Museum Mile with an outdoor planted garden and lawn open during regular museum hours—weather permitting.

ON EXHIBIT 2001
10/03/2000 to 03/04/2001 GREAT DESIGN: 100 MASTERPIECES FROM THE VITRA MUSEUM
A major exhibition highlighting the concepts, styles and materials central to furniture design in the modern era. Works by Thonet, Hoffman, Reitveld, Aalto Breuer and the Eames'.

Dahesh Museum

601 Fifth Avenue, New York, NY 10017
☎: 212-759-0606 ◙ www.daheshmuseum.org
Open: 11-6 Tu-Sa **Closed:** Su, Mo, LEG/HOL!
Vol./Contr.: Yes 占 **Ⓟ:** pay parking nearby **Museum Shop** **Docents** **Tour times:** lunchtime daily
Permanent Collection: Acad pntg; 19,20

More than 2000 works collected by writer, philosopher Dr. Dahesh (born Salim Moussa Achi) form the collection of this relatively new museum housed on the second floor of a commercial building built in 1911. Collections include works by Rosa and Auguste Bonheur, Jean-Leon Gerome, Alexandre Cabanel, Lord Leighton and Edwin Long.

ON EXHIBIT 2001
to Spring 2001 GEROME AND GOUPIL: A COLLABORATION
The first American exhibition devoted to Gerome's work since 1972 focusing on his paintings and the prints after them.

to Spring 2001 ORIENTALISM

222

Dahesh Museum - continued

to Fall 2001 CHARLES BARGUE
His work is essentially miniaturized costume pieces which act as theatrical vignettes.

to Summer 2001 CLASSICISM
The impact of Classical Greece and Rome on 19th century academic art. *Brochure.*

Dia Center for the Arts

548 West 22nd Street, New York, NY 10011

☎: 212-989-5566 ◙ www.diacenter.org
Open: 12-6 Th-Su, Sept-Jun **Closed:** Mo-We, LEG/HOL!
ADM: Adult: $6.00 **Children:** Free under 10 **Students:** $3.00 **Seniors:** $3.00
&. **Museum Shop** ¶: Rooftop café and video lounge **Group Tours:** 212-989-5566
Permanent Collection: not permanently on view

With several facilities and collaborations Dia has committed itself to working with artists to determine optimum environments for their most ambitious and uncompromising works which are usually on view for extended exhibition periods. **NOT TO BE MISSED:** Two Walter De Maria extended exhibitions, THE NEW YORK EARTH ROOM at the gallery at 141 Wooster Street and THE BROKEN KILOMETER at 393 Broadway. Both are open 12-6 We-Sa, closed July and August.

Drawing Center

35 Wooster Street, New York, NY 10013

☎: 212-219-2166
Open: 10-6 Tu-Fr; 11-6 Sa **Closed:** Su, Mo, 12/25, 1/1, all of AUG, THGV
Vol./Contr.: Yes &. ℗: On street and nearby pay garages **Museum Shop**
Permanent Collection: non collecting institution

Featured at The Drawing Center are contemporary and historical drawings and works on paper both by internationally known and emerging artists.

ON EXHIBIT 2001

01/08/2001 to 02/10/2001 SELECTIONS WINTER 2001
Group exhibition of emerging artists (to be announced).

02/24/2001 to 04/07/2001 DRAWINGS OF ROSEMARIE TROCKEL
The first New York Museum exhibition of this German contemporary artist. Of the 100 drawings to be shown a number will be created specifically to premiere here.

02/24/2001 to 04/07/2001 IN THE DRAWING ROOM
An emerging artist (to be announced).

04/21/2001 to 05/09/2001 BETWEEN STREET AND MIRROR: THE DRAWINGS OF JAMES ENSOR
A most important and innovative draftsman of his time the exhibition will show his shift from impressionistic style to a more personal and grotesque approach in his later work.

04/21/2001 to 06/09/2001 IN THE DRAWING ROOM
Exibition of an emerging artist.

04/21/2001 to 07/31/2001 PERFORMANCE DRAWINGS: IN THE DRAWING ROOM
Artists who explore drawing through performance /or performance through drawing.

06/20/2001 to 07/31/2001 ANA MARIA MAIOLINO
Current and past works on paper as well as films and new sculptural installation created on site.

10/27/2001 to 12/29/2001 HEAVENLY VISIONS: SHAKER GIFT DRAWINGS AND GIFT SONGS
Works created by individuals, primarily women, active in Shaker communities between 1857-1850.

NEW YORK

El Museo del Barrio

1230 Fifth Ave, New York, NY 10029-4496

📞: 212-831-7272 ◙ www.elmuseo.org
Open: 11-5 We-Su, 11-6 Th, SUMMER 6/6-9/26 **Closed:** Mo, Tu LEG/HOL!
ADM: Adult: $4.00 **Children:** Free under 12 **Students:** $2.00 **Seniors:** $2.00
& ℗: Discount at Merit Parking Corp 12-14 E 107 St.
Permanent Collection: LAT/AM: P/COL; CONT: drgs, phot, sculp

One of the foremost Latin American cultural institutions in the United States, this museum is also the only one in the country that specializes in the arts and culture of Puerto Rico. **NOT TO BE MISSED:** Santos: Sculptures between Heaven and Earth.

Frick Collection

1 East 70th Street, New York, NY 10021

📞: 212-288-0700 ◙ www.frick.org
Open: 10-6 Tu-Sa, 1-6 Su, also short hours Pres. Day, Election Day, Veteran's Day **Closed:** Mo, 1/1, 7/4, THGV, 12/24, 12/25
ADM: Adult: $7.00 **Children:** under 10 not adm **Students:** $5.00 **Seniors:** $5.00
& ℗: Pay garages nearby **Museum Shop**
Group Tours: group vst. sched but no lecture in gall. **Sculpture Garden**
Permanent Collection: PTGS; SCULP; FURNITURE; DEC/ART; Eur, Or, PORCELAINS 🎧

The beautiful Henry Clay Frick mansion built in 1913-14, houses this exceptional collection while preserving the ambiance of the original house. In addition to the many treasures to be found here, the interior of the house offers the visitor a tranquil respite from the busy pace of city life outside of its doors. **PLEASE NOTE:** Children under 10 are not permitted in the museum and those from 11-16 must be accompanied by an adult. **NOT TO BE MISSED:** Boucher Room; Fragonard Room; Paintings by Rembrandt, El Greco, Holbein, Vermeer, and Van Dyck.

ON EXHIBIT 2001

to 07/29/2001 SIX PAINTINGS FROM THE FORMER COLLECTION OF MR. AND MRS. JOHN HAY WHITNEY ON LOAN FROM THE GREENTREE FOUNDATION
Most of the paintings were left to major museums in the US but some were left to the Greentree Foundation which makes them available to museums. The artists represented are Corot, Manet, Degas, Picasso and Redon.

06/19/2000 to 08/12/2001 MASTER DRAWINGS FROM THE SMITH COLLEGE MUSEUM OF ART
Superior draftsmanship from Old Masterpieces to Mark Tobey's ECHO of 1954. Included are Bartolomeo, Boucher, Cezanne, Degas, de Kooning, Fragonard, Gainsborough, Ingres, Tiepolo, and van Gogh. *Will Travel*

12/05/2000 to 01/21/2001 RAEBURN'S THE REVEREND WALKER SKATING ON DUDDINGSTON LOCH, FROM THE NATIONAL GALLERY OF SCOTLAND

12/12/2000 to 02/25/2001 THE DRAFTSMAN'S ART: MASTER DRAWONGS FROM THE NATIONAL GALLERY OF SCOTLAND *Will Travel*

George Gustav Heye Center of the National Museum of the American Indian

Affiliate Institution: Smithsonian Institution
One Bowling Green, New York, NY 10004

📞: 212-514-3800 ◙ www.si.edu/nmai
Open: 10-5 daily, 10-8 Th **Closed:** 12/25
Vol./Contr.: Yes & ℗: Nearby pay **Museum Shop**
Group Tours: 212-514-3705 **Docents** **Tour times:** daily!
Permanent Collection: NAT/AM; Iroq silver, jewelry, NW Coast masks

The Heye Foundation collection contains more than 1,000,000 works which span the entire Western Hemisphere and present a new look at Native American peoples and cultures. Newly opened in the historic Alexander Hamilton Customs House it presents masterworks from the collection and contemporary Indian art.

George Gustav Heye Center of the National Museum of the American Indian
- continued

ON EXHIBIT 2001

10/01/2000 to 01/21/2001 WHO STOLE THE TEE PEE?
George Little Field (Plains Cree) uses this as another way of saying "What Happened to our Traditions." How have Indian artists responded to the changes—social, political, cultural and personal—that Native Americans have experienced since 1900?

12/10/2000 to 07/02/2001 PLAINS SHIRTS (working title)
Beautifully crafted beaded, quilled, painted, and ribbon shirts with headdresses, leggings, and buffalo hides from mid-19th to early 20th century.

03/04/2001 to 05/27/2001 GIFTS OF PRIDE AND LOVE: KIOWA AND COMANCHE CRADLEBOARDS
These are the most beautiful of Plains Indian bead design of the late 19th and early 20th century. Lattice cradles socialize babies by lifting them to eye level with adults.

Grey Art Gallery
Affiliate Institution: New York University Art Collection
100 Washington Square East, New York, NY 10003-6619

☎: 212-998-6780 ◙ www.nyu.edu/greyart
Open: 11-6 Tu, Th, Fr, 11-8 We, 11-5 Sa **Closed:** Su, Mo, LEG/HOL!
ADM: Adult: $2.50 **Children:** $2.50 **Students:** $2.50 **Seniors:** $2.50
& ℗: Nearby pay garages
Permanent Collection: AM: ptgs 1940-present; CONT; AS; MID/EAST

Located at Washington Square Park and adjacent to Soho, the Grey Art Gallery occupies the site of the first academic fine arts department in America established by Samuel F. B. Morse in 1835.

ON EXHIBIT 2001

11/14/2000 to 01/24/2001 BEN SHAHN'S NEW YORK: THE PHOTOGRAPHY OF MODERN TIMES
Shahn's 1930's photographs of New York City surveys his contributions to social documentary and his use of photography in other media. Paintings, drawings, prints, posters and ephemera will be included.

02/16/2001 to 04/14/2001 THE FIRST STEPS: EMERGING ARTISTS FROM JAPAN
First Steps is the third in the cutting edge works to present diverse media by emerging Japanese artists. The winners were selected from a pool of 100 finalists by an international jury.

05/01/2001 to 07/07/2001 DREAMS AND DISILLUSION: KAREL TIEGE AND THE CZECH AVANT-GARDE
A graphic designer and architectural theorist, Karel Tiege was an innovator in many artistic areas, including book design, poetry, stage sets and collage.

08/28/2001 to 10/27/2001 BETWEEN WORD AND IMAGE: IRANIAN VISUAL CULTURE IN THE 1960'S & 70'S
Featured will be selections from the Ben and Abby Weed Grey Collection of Modern Asian and Middle Eastern Art. This is one of the foremost collections of modern art from Iran. The exhibition acknowledges relationships to native Islamic and folk art as well as Western abstract styles. Documentary images by Abbas, of the Iranian Revolution will be included.

11/13/2001 to 01/26/2002 NANCY BURSON: A RETROSPECTIVE
Burson's territory has been the human face. She delves into the beautiful, the normal, the exceptional—the imprint of genetics, the traces of time and illness She was among the first to link computers with photography and is licensed by the FBI to locate missing children, and adults, sometimes years after they have disappeared.

NEW YORK

Guggenheim Museum Soho
575 Broadway at Prince St, New York, NY 10012
℃: 212-423-3500 ◙ www.guggenheim.org
Open: 11-6 Th-Mo **Closed:** Tu, We, 1/1, 12/25
♿ ℗**:** Nearby pay garages **Museum Shop** �11
Permanent Collection: INTERNATIONAL CONT ART

As a branch of the main museum uptown, this facility, located in a historic building in Soho, was designed as a museum by Arata Isozaki.

Hispanic Society of America
155th Street and Broadway, New York, NY 10032
℃: 212-926-2234 ◙ www.hispanicsociety.org
Open: 10-4:30 Tu-Sa, 1-4 Su **Closed:** Mo, LEG/HOL!
Vol./Contr.: Yes ♿**:** Limited, exterior and interior stairs ℗**:** Nearby pay garage **Museum Shop**
Group Tours: ext. 254 **Sculpture Garden**
Permanent Collection: SP: ptgs, sculp; arch; HISPANIC

Representing the culture of Hispanic peoples from prehistory to the present, this facility is one of several diverse museums located within the same complex on Audubon Terrace in NYC. **NOT TO BE MISSED:** Paintings by El Greco, Goya, Velazquez, Sorsolla.

ON EXHIBIT 2001
12/2000 to 02/2001 CHARLES V AND THE RENAISSANCE IN 16TH CENTURY SPAIN
Commemorating the anniverary of the birth of Charles V (1500-1558) this exhibition will focus on the Chales V and the flowering of the arts in 16th century Spain, incoporating objects from may media.

11/16/2000 to 02/18/2001 SPLENDOR OF ALCORA: SPANISH CERAMICS FROM THE EIGHTEENTH CENTURY, PART ONE 1727-1949

International Center of Photography
1133 Avenue of the Americas, New York, NY 10036
℃: 212-860-1777 ◙ www.icp.org
Open: 10-5 Tu-Th, 10-8 Fr, 10-6 Sa, Su **Closed:** Mo, I/I, 7/4. THGV. 12/25
Free Day: Fr 5-8, vol cont **ADM: Adult:** $6.00 **Students:** $4.00 **Seniors:** $4.00
♿ ℗**:** Nearby pay garages **Museum Shop** �11: Nearby
Group Tours: 212-860-1777 x154 **Docents**
Permanent Collection: PRIMARILY DOCUMENTARY PHOT: 20

ICP was established in 1974 to present exhibitions of photography, to promote photographic education at all levels, and to study 20th century images, primarily documentary. The uptown museum is housed in a 1915 Neo-Georgian building designed by Delano and Aldrich.

ON EXHIBIT 2001
10/07/2000 to 01/17/2001 EUGENE ATGET: THE PIONEER
The influence of this photographer whose work is considered a cornerstone in the history of documentary photography.

01/11/2001 to 03/13/2001 ANDY WARHOL: PHOTOGRAPHY
A first major exhibition to examine his photographic work and the links with it in his oeuvre.

01/11/2001 to 03/18/2001 IMAGING A FUTURE: SCIENCE AND PHOTOGRAPHY
A three year cycle of six exhibitions spanning the history of scientific imaging.

01/11/2001 to 03/18/2001 NEW HISTORIES OF PHOTOGRAPHY: A COLLABORATION BETWEEN THE INTERNATIONAL CENTER OF PHOTOGRAPHY AND THE GEORGE EASTMAN HOUSE, INTERNATIONAL MUSEUM OF PHOTOGRAPHY AND FILM.
A cycle of exhibitions providing new perspectives on the history of the medium.

International Center of Photography - continued

03/29/2001 to 06/10/2001 BEHIND CLOSED DOORS: THE ART OF HANS BELLMER
A surrealist working in Europe in the 20's and 30's. Includes photographs, early advertisements, book cover designs.

03/29/2001 to 06/10/2001 KIKI SMITH: RECENT WORK
Smith's photographs, digital prints, and video projections, two series of color photographs.

03/29/2001 to 06/19/2001 NEW HISTORIES OF PHOTOGRAPHY: THE PLEDGE OF FRIENDSHIP: AMERICAN PHOTOGRAPHY AND MALE AFFECTION (1840-1918)
Male intimacy in America in the 19th and early 20th centuries.

06/21/2001 to 09/09/2001 MIGRATIONS, HUMANITY IN TRANSITION: PHOTOGRAPHS BY SEBASTIAO SALGADO
300 photographs that document the global phenomenon of mass migration.

06/21/2001 to 09/09/2001 NEW HISTORIES OF PHOTOGRAPHY: IMAGING A FUTURE: SCIENCE AND PHOTOGRAPHY

Japan Society Gallery

333 E. 47th Street, New York, NY 10017

✆: 212-832-1155 ◙ www.jpn.org
Open: 11-6 Tu-Fr, 11-5 Sa, Su **Closed:** Mo, LEG/HOL!
Sugg./Contr.: ADM: Adult: $5.00 **Students:** $5.00 **Seniors:** $5.00
& ℗: Nearby pay garages **Group Tours:** 212-715-1253 **Sculpture Garden**
Permanent Collection: JAPANESE ART

Exhibitions of the fine arts of Japan are presented along with performing and film arts at the Japan Society Gallery which attempts to promote better understanding and cultural enlightenment between the peoples of the U.S. and Japan.

ON EXHIBIT 2001

10/18/2000 to 01/14/2001 YES YOKO ONO: FIRST AMERICAN RETROSPECTIVE OF PIONEERING AVANT-GARDE ARTIST
In her 40 year career, Ono has embraced a wide range of media creating new forms of artistic expression. Her early and central role was in "Fluxus," Conceptual Art etc. The exhibition is divided into five chronological and thematic sections: "Grapefruit: The Early Instructions;" "Half-a-Wind: Early Objects;" "Fly: Events, Performances, and Films;" "War is Over: The Peace Movement and Other Collaborations with John Lennon;" "Play it By Trust: Recent Work."

Jewish Museum

1109 5th Ave., New York, NY 10128

✆: 212-423-3200 ◙ www.thejewishmuseum.org
Open: 11-5:45 Su, Mo, We & Th, 11-8 Tu **Closed:** Fr, Sa, JEWISH/HOL, Martin Luther King Day, THGV
Free Day: Tu after 5 **ADM: Adult:** $8.00 **Children:** Free under 12 **Students:** $5.50 **Seniors:** $5.50
& ℗: Nearby pay garages **Museum Shop** ⅋: Cafe Weissman, kosher cuisine
Group Tours: 212-423-3225 **Docents** **Tour times:** 12:15, 2:15, 4:15 Mo-Th, 6:15 Tu
Permanent Collection: JUDAICA: ptgs by Jewish and Israeli artists; ARCH; ARTIFACTS

27,000 works of art and artifacts covering 4000 years of Jewish history created by Jewish artists or illuminating the Jewish experience are displayed in the original building (the 1907 Felix Warburg Mansion), and in the new addition added in 1993. The collection is the largest of its kind outside of Israel.

CULTURE AND CONTINUITY: THE JEWISH JOURNEY The centerpiece of the Museum is a core exhibition on the Jewish experience that conveys the essence of Jewish identity—the basic ideas, values and culture developed over 4000 years. **NOT TO BE MISSED:** "The Holocaust" by George Segal.

NEW YORK

Jewish Museum - continued

ON EXHIBIT 2001

to 03/01/2001 PICKLES AND POMEGRANATES: JEWISH HOMES NEAR AND FAR
Life in two late 19th century households—a Lower East Side tenement in 1897, and a house of the same period in Persia, now Iran.

09/24/2000 to 02/11/2001 MOROCCO: JEWS AND ART IN MUSLIM LAND
The exhibition will focus on the multi-cultural art and traditions of Morocco and the history of Jewish life in Morocco for more than 2,000 years. It will depict a culture from the "Outside" including Orientalist painters and photographers including Delacroix and Dehudenocq.

Metropolitan Museum of Art
5th Ave at 82nd Street, New York, NY 10028

☎: 212-879-5500 ◙ www.metmuseum.org
Open: 9:30-5:30 Tu-Th, Su; 9:30-9pm Fr, Sa **Closed:** Mo, THGV, 12/25, 1/1
Sugg./Contr.: ADM: Adult: $10.00 **Children:** Free under 12 **Students:** $5.00 **Seniors:** $5.00
& ℗: Pay garage **Museum Shop** ⅋
Group Tours: 212-570-3711 **Sculpture Garden**
Permanent Collection: EU: all media; GR & DRGS: Ren-20; MED; GR; PHOT; AM: all media; DEC/ART: all media; AS: all media; AF; ISLAMIC; CONT; AN/EGT; AN/R; AN/AGR; AN/ASSYRIAN

The Metropolitan is the largest world class museum of art in the Western Hemisphere. Its comprehensive collections includes more than 2 million works from the earliest historical artworks thru those of modern times and from all areas of the world. Just recently, the museum opened the Florence & Herbert Irving Galleries for the Arts of South & Southeast Asia, one of the best and largest collections of its kind in the world.

New and Recently Opened Installations:
SCULPTURE AND DECORATIVE ARTS OF THE QUATTROCENTO
NEW CHINESE GALLERIES
THE NEW AMARNA GALLERIES: EGYPTIAN ART 1353-1295 B.C.
PHASE 1 OF THE NEW GREEK AND ROMAN ART GALLERIES: THE ROBERT AND RENEE BELFER COURT
STUDIOLO FROM THE PALACE OF DUKE FEDERICO DE MONTEFELTRO AT GUBBIO
THE AFRICAN GALLERY
ANTONIO RATTI TEXTILE CENTER

NOT TO BE MISSED: Temple of Dendur; The 19th century European Paintings & Sculpture galleries (21 in all), designed to present the Permanent collection in chronological order and to accommodate the promised Walter Annenberg collection now on view approximately 6 months annually.

ON EXHIBIT 2001

to 01/07/2001 AMERICAN IMPRESSIONISTS ABROAD AND AT HOME
Thirty-nine works by 27 artists will illuminate the training that American Impressionists undertook abroad and at home; the complex attractions of Europe and America; the significance of the subjects they depicted and their various responses to French Impressionism.

11/28/2000 to 05/27/2001 A CENTURY OF DESIGN, PART III: 1950-1975
The third in a four part series surveying design in the 20th century by major European modernist designers.

01/25/2000 to 12/30/2001 EUROPEAN HELMETS, 1450-1650
Helmets are the earliest known body armor. Some 75 helmets will reveal the depth of the collection and a glimpse of objects rarely on display.

05/12/2000 to 01/07/2001 THE FORGOTTEN FRIEZES FROM THE CASTLE OF VELEZ BLANCO
From the Musee des Arts Decoratifs in Paris these six friezes celebrate the opening of the renovated Renaissance patio from the Fajardo castle in Southern Spain.

Metropolitan Museum of Art - continued

05/12/2000 to 01/07/2001 SCULPTURE AND DECORATIVE ARTS OF THE SPANISH RENAISSANCE
Spanish polychrome sculptures from the Museum collection dating from the early 16th to the mid-17th century.

05/16/2000 to 01/07/2001 AMERICAN MODERN: DESIGN FOR A NEW AGE 1925-1940
Objects of all kinds will be on display including clocks, furniture, appliances, etc from the first generation of American industrial designers.

09/15/2000 to 01/07/2001 THE EMBODIED IMAGE: CHINESE CALLIGRAPHY FROM THE JOHN B. ELLIOTT COLLECTION
This is the finest collection outside Asia covering the period from the beginning of writing in the fourth century to the modern era. Included also are some of the selections from the Museum's Crawford collection. The two collections represent the most important display of calligraphy ever assembled in the west.

09/19/2000 to 01/07/2001 ART AND THE EMPIRE CITY: NEW YORK , 1825-1861
During this period the arts proliferated and the exhibition examines in depth the history of the arts as New York City became the largest city in the Western Hemisphere and the center of manufacturing, culture and the arts.

09/26/2000 to 01/21/2001 EGYPTIAN ART AT ETON COLLEGE: SELECTIONS FROM THE MYERS MUSEUM
Little known outside of Eton is this fine collection of decorative arts.

10/03/2000 to 01/14/2001 THE YEAR ONE: ART OF THE ANCIENT WORLD EAST AND WEST
In celebration of the new Millennium, this exhibition from the Museum's collection of works produced 2000 years ago in the period just before and after the Year One. The richness and variety of cultures which flourished then and the numerous interconnections that existed between distant parts of the world.

10/12/2000 to 02/04/2001 THE GOLDEN DEER OF EURASIA: SCYTHIAN AND SARMATIAN TREASURES FROM THE RUSSIAN STEPPES
Gold and silver recently excavated in Bashkortostan, Russia that have never been seen in the U.S. These were created by nomadic peoples in the 5th to 4th century B.C.

10/17/2000 to 01/21/2001 ROMANTICISM AND THE SCHOOL OF NATURE: NINETEENTH CENTURY DRAWINGS AND PAINTINGS FROM THE COLLECTION OF KAREN B. COHEN
Landscapes, portraits, figure compositions, and still lifes from Prud'hon to Seurat. Featured are Couture, Gericault, Daubigny, Rousseau, and Delacroix.

11/03/2000 to 04/22/2001 MORE PRECIOUS THAN GOLD—SILVER IN ANCIENT PERU
In the period between the first millennium to the 16th century silver was one of three metals extensively worked in Peru.

11/21/2000 to 03/02/2001 THE STILL LIFES OF EVARISTO BASCHENIS AND THE MUSIC OF SILENCE
The Italian still-life painter (1617-1677) poetically painted musical instruments.

11/25/2000 to 01/07/2001 ANNUAL CHRISTMAS TREE AND NEAPOLITAN BAROQUE CRECHE
A long standing holiday tradition. Lighting ceremony Fr and Sa at 7:00.

12/07/2000 to 03/2001 CHANEL

early 2001 to TBA ! THE SHAHNAMA OF MUHAMMAD JUKI
A superb example of painting from Herat, one of the great centers of 15th century Persian art. It will be displayed unbound for the first time with all 31 of its miniatures on view.

01/30/2001 to 05/06/2001 PHOTOGRAPHY: PROCESSES, PRESERVATION, TREATMENT
Celebrating the opening of the new Sherman Fairchild Center for Works on Paper and Photograph Conservation it will explore issues of condition, preservation and treatment.

01/30/2001 to 08/19/2001 DYNASTY TO REPUBLIC: LATE 19TH AND EARLY 20TH CENTURY CHINESE PAINTINGS FROM THE ROBERT H. ELLSWORTH COLLECTION
Chinese painting created during the clashing social visions and dramatic political change marking its entry into the modern world. Of particular note are 40 works by Qi Baishi (1864-1957) one of the best known Chinese painters of all time.

NEW YORK

Metropolitan Museum of Art - continued

02/06/2001 to 05/06/2001 CORREGGIO AND PARMIGIANINO: MASTER DRAFTSMEN OF THE RENAISSANCE
These great masters of the Emilian school of early 16th century Italy will be shown together in a major selections for the first time.

mid 02/2001 to 05/2001 ! WILLIAM TROST RICHARDS IN THE METROPOLITAN MUSEUM OF ART
Associated with both the Hudson River School and the American Pre-Raphaelite movement, a small loan collection of postcard sized works of Pennsylvania, New England and the British Isles will also be shown.

02/27/2001 to 05/27/2001 TREASURY OF THE BASEL CATHEDRAL
The treasury survived until the 19th century when it was dispersed. From inventories, etc, all have been identified and over half are in the Historiches Museum Basel and in other museum collections. Works date from the early 13th to the early 16th century.

03/08/2001 to 05/27/2001 VERMEER AND THE DELFT SCHOOL
Best known for scenes of domestic life were Johannes Vermeer and Pieter de Hooch. Other Delft artists painted street scenes. They also produced history pictures in an international style, flower paintings, princely portraits and superb examples of the decorative arts casting a new light on the Delft School.

03/27/2001 to 07/01/2001 WILLIAM BLAKE, 1757-1827
The first major exhibition in more than 20 years to focus on Blake and his artistic and poetic vision.

05/01/2001 to late fall 2001 THE IRIS AND B. GERALD CANTOR ROOF GARDEN
A selection of 20th century works will be installed in the most dramatic outdoor space for sculpture in New York City.

05/01/2001 to late 07/2001 JACQUELINE KENNEDY: THE WHITE HOUSE YEARS

late 05/2001 to 11/2001 ! THE ANNENBERG COLLECTION OF IMPRESSIONIST AND POST-IMPRESSIONIST MASTERPIECES

05/29/2001 to 09/02/2001 SUMMER SELECTIONS: AMERICAN DRAWINGS AND WATERCOLORS IN THE METROPOLITAN MUSEUM OF ART

06/26/2001 to 09/16/2001 BEYOND THE EASEL: DECORATIVE PAINTINGS BY BONNARD, VUILLARD, DENIS AND ROUSSEL, 1890-1930

Mirieam and Ira D. Wallach Art Gallery

Affiliate Institution: Columbia University
Schermerhorn Hall, 8th Fl., 116th St. and Broadway, New York, NY 10027
✆: 212-854-7288
Open: 1-5 We-Sa The gallery is open only when there is an exhibition! **Closed:** Su, Mo, Tu, 1/1, week of THGV, 12/25, 6/3-10/10, MEM Day wkend
&: Enter on Amsterdam Avenue **Ⓟ:** Nearby pay garages **Docents**
Permanent Collection: non-collecting institution

Operated under the auspices of Columbia University and situated on its wonderful campus, the gallery functions to complement the educational goals of the University.

Morgan Library

29 East 36th Street, New York, NY 10016-3490
✆: 212-685-0610 **◘** www.morganlibrary.org
Open: 10:30-5 Tu-Th, 10:30-8 Fr, 10:30-6 Sa, noon-6 Su **Closed:** Mo, LEG/HOL!
Sugg./Contr.: ADM: Adult: $8.00 **Children:** Free under 12 **Students:** $6.00 **Seniors:** $6.00
&: except original Library **Ⓟ:** Nearby pay garage **Museum Shop** **❙❙:** Cafe open daily for luncheon and afternoon tea 212-685-0008, ext 401
Group Tours: 212-695-0008, ext. 390 **Docents** **Tour times:** daily ! ext 390
Permanent Collection: MED: drgs, books, ptgs, manuscripts, obj d'art

Morgan Library - continued
Both a museum and a center for scholarly research, the Morgan Library is a perfect Renaissance style gem both inside and out. Set in the heart of prosaic NY, this monument comes to the city as a carefully thought out contribution to the domain for the intellect and of the spirit. **NOT TO BE MISSED:** Stavelot Triptych, a jeweled 12th century reliquary regarded as one of the finest medieval objects in America; Pierpont Morgan's private study and Library.

ON EXHIBIT 2001

09/28/2000 to 01/07/2001 RUSKIN'S ITALY, RUSKIN'S ENGLAND
Ruskin was the most influential critic of his time dictating taste for art of the past and also determining the direction of contemporary art. Included are drawings, sketchbooks, photographs, diaries and letters, manuscripts, books and pamphlets.

01/25/2001 to 05/06/2001 JEAN POYET: ARTIST TO THE COURT OF RENAISSANCE FRANCE
The first one man show given to an illuminator (1483-1503) who served the royal courts of three French kings, Louis XI, Charles VIII, and Louis XII.

05/2001 to 08/2001 MASTER DRAWINGS FROM THE CLEVELAND MUSEUM OF ART
120 drawings from the 15th through the 20th centuries features highlights of the collection. Included is a rare sketch by Fra Filippo Lippi, Michelangelo, Fragonard, Greuze with Dürer and Rembrandt. Represented also are Murillo, Turner, Goya and Picasso as well as Byrne-Jones and Church, Cassatt, Homer and Bellows.

Museum for African Art
593 Broadway, New York, NY 10012

C: 212-966-1313 ◙ www.africanart.org
Open: 10:30-5:30 Tu-Fr; 12-6 Sa, Su **Closed:** Mo, LEG/HOL!
ADM: Adult: $5.00 **Children:** $2.50 **Students:** $2.50 **Seniors:** $2.50
&. ⓟ: Nearby pay garages **Museum Shop Group Tours:** x, 118 **Docents Tour times:** !
Permanent Collection: AF: all media

This new facility in a historic building with a cast iron facade was designed by Maya Lin, architect of the Vietnam Memorial in Washington, D.C. Her conception of the space is "less institutional, more personal and idiosyncratic." She is using "color in ways that other museums do not, there will be no white walls here."

Museum of American Folk Art
Two Lincoln Square, New York, NY 10023-6214

C: 212-595-9533 ◙ www.folkartmus.org
Open: 11:30-7:30 Tu-Su **Closed:** Mo, LEG/HOL!
&. ⓟ: pay garage nearby **Museum Shop**
Permanent Collection: FOLK: ptgs, sculp, quilts, textiles, dec/art

The museum is known both nationally and internationally for its leading role in bringing quilts and other folk art to a broad public audience. **NOT TO BE MISSED:** "Girl in Red with Cat and Dog," by Ammi Phillips; major works in all areas of folk art.

Museum of Modern Art
11 West 53rd Street, New York, NY 10019-5498

C: 212-708-9400 ◙ www.moma.org
Open: 10:30-6 Sa-Tu, Th; 10:30-8:30 Fr **Closed:** We, THGV12/25
Free Day: Fr 4:30-8:15, vol cont **ADM: Adult:** $9.50 **Children:** Free under 16 with adult **Students:** $6.50
Seniors: $6.50
&. ⓟ: Pay nearby **Museum Shop** ‼: Garden Cafe and Sette MoMA (open for dinner exc We & Su)
Group Tours: 212-708-0400 **Docents Tour times:** !Weekdays, Sa, Su 1 & 3 **Sculpture Garden**
Permanent Collection: WORKS BY PICASSO, MATISSE, Van Gogh, Warhol and Monet, DESIGN 20 ∩

Museum of Modern Art- continued

The MOMA offers the world's most comprehensive survey of 20th century art in all media as well as an exceptional film library.

MOMA Bookstore hours: 10-6:30 Sa-Tu, Th, 10-9 Fr
MOMA Design Store: 10-6:00 Sa-Tu, Th, 10-8 Fr
Garden Cafe: 11-5 Sa-Tu, Th, 11-7:45 Fr
Sette MOMA: 12-3, 5-10:30 daily exc. We
www.ticketweb.com for advance adm. tickets (service fee on ticketweb)

NOT TO BE MISSED: Outstanding collection of 20th century photography, film and design.

ON EXHIBIT 2001

through 01/2001 MoMA2000

through 01/28/2001 COLLECTION HIGHLIGHTS

09/28/2000 to 01/02/2001 OPEN ENDS

02/08/2001 to 05/08/2001 WORKSPHERES: DESIGNING THE WORKPLACE OF TOMORROW

03/04/2001 to 05/15/2001 ANDREAS GURSKY

03/22/2001 to 06/12/2001 EDITIONS FOR PARKETT

06/21/2001 to 09/11/2001 MIES IN BERLIN

10/14/2001 to 01/08/2002 ALBERTO GIACOMETTI

Museum of the City of New York

Fifth Ave. at 103rd Street, New York, NY 10029

☎: 212-534-1672 ▣ www.mcny.org
Open: 10-5 We-Sa, 1-5 Su; 10-2 Tu for pre-registered groups only **Closed:** Mo, Tu, LEG/HOL!
ADM: Adult: $5.00: family $10.00 **Children:** $4.00 **Students:** $4.00 **Seniors:** $4.00
♿: 104th St Entrance **Ⓟ:** Nearby pay garages **Museum Shop**
Group Tours: 212-534-1672 ext 206 **Docents** **Tour times:** !
Permanent Collection: NEW YORK: silver 1678-1910; INTERIORS: 17-20; THE ALEXANDER HAMILTON COLLECTION; PORT OF THE NEW WORLD MARINE GALLERY

Founded in 1933 this was the first American museum dedicated to the history of a major city. The Museum's collections encompass the City's heritage, from its exploration and settlement to the NY of today. **NOT TO BE MISSED:** Period Rooms

ON EXHIBIT 2001

11/04/2000 to 02/25/2001 EUGENE ATGET AT WORK (working title)
Over a period of thirty years Atget photographed Paris, its buildings, monuments, ancient streets, civic spaces, public parks and gardens, picturesque villages and royal gardens. He took an estimated 8,500 negatives. His approach and method and the interplay between technical procedures and interpretive strategies over the period.

National Academy Museum and School of Fine Arts
1083 Fifth Avenue, New York, NY 10128

☎: 212-369-4880
Open: 12-5 Th, We, Sa, Su; 10-6 Fr **Closed:** Mo, Tu, LEG/HOL!
Free Day: Fr, 5-8 pay as you wish **ADM: Adult:** $8.00 **Students:** $4.50 **Seniors:** $3.50
 ⓅⓎ **℗:** Nearby pay garage **Museum Shop**
Group Tours: 212-365-4586, x244
Permanent Collection: AM: all media 19-20

With outstanding special exhibitions as well as rotating exhibits of the Permanent collection, this facility is a school as well as a resource for American Art. **NOT TO BE MISSED:** The oldest juried annual art exhibition in the nation is held in spring or summer with National Academy members only exhibiting in the odd-numbered years and works by all U.S. artists considered for inclusion in even-numbered years.

National Arts Club
15 Gramercy Park South, New York, NY 10024

☎: 212-475-3424 **Open:** 1-6 daily **Closed:** LEG/HOL!
℗: Nearby pay garage, some metered street parking **Museum Shop** **❙❙:** For members
Permanent Collection: AM: ptgs, sculp, works on paper, dec/art 19,20; Ch: dec/art

The building which houses this private club and collection was the 1840's mansion of former Governor Samuel Tilden. The personal library of Robert Henri which is housed here is available for study on request.

New Museum of Contemporary Art
583 Broadway, New York, NY 10012

☎: 212-431-5328 ◙ www.newmuseum.org
Open: 12-6 We & Su, 12-8 Th-Sa **Closed:** Mo, Tu, 1/1, 12/25
Free Day: Th 6-8 **ADM: Adult:** $6.00, ARTISTS $3.00 **Children:** Free under 18 **Students:** $3.00 **Seniors:** $3.00
 Ⓟ **℗:** Nearby pay garages **Museum Shop**
Group Tours: ext 216
Permanent Collection: Semi-Permanent collection

The New Museum is the premiere contemporary art museum in New York and among the most important internationally. Located in the heart of Soho, the New Museum offers three floors of the most innovative contemporary art from around the world as well as the New Museum Bookstore featuring the best selection of art books and unique and designer created gifts.

ON EXHIBIT 2001
09/15/2000 to 01/31/2001 PIERRE ET GILLES
The first museum survey in America of unique photo-paintings done in the last two decades by this collaborative team. Included also are early works (1982-1988) inspired by mythological iconography.

10/26/2000 to 01/21/2001 ADRIAN PIPER: A RETROSPECTIVE 1965-2000
Piper's work offers insight to defeating racist and sexist attitudes. Included will be "pre-conceptual" paintings, photographs from the late 60's, installations and drawings from the 80's, and explorations of friendship, mortality and spirituality. The video portion hints at her politically charged multi-media work.

02/15/2001 to 05/13/2001 PAUL McCARTHY
The work of this Los Angeles based artist whose fusion of sculpture with performance is often controversial.

06/07/2001 to 09/16/2001 WILLIAM KENTRIDGE
This South African artist traces characters shaped by the turmoil of South Africa, European Culture and his own history and identity.

10/14/2001 to 01/22/2002 TOM FRIEDMAN

NEW YORK

New York Historical Society
170 Central Park West, New York, NY 10024

☎: 212-873-3400 ⬛ http://www.nyhistory.org
Open: 11-5 Tu-Su, Library 11-5 Tu-Sa **Closed:** Mo, LEG/HOL!
ADM: Adult: $5.00 **Students:** $3.00 **Seniors:** $3.00
♿ ⓟ: Pay garages nearby **Museum Shop**
Group Tours: 212-501-9233 **Docents** **Tour times:** 1pm & 3pm
Permanent Collection: AM: Ptgs 17-20; HUDSON RIVER SCHOOL; AM: gr, phot 18-20; TIFFANY GLASS; CIRCUS &
THEATER: post early 20; COLONIAL: portraits (includes Governor of NY dressed as a woman)

Housed in an elegant turn of the century neoclassical building is a collection of all but 2 of the 435 "Birds of
America" watercolors by John James Audubon. In addition there are 150 works from Tiffany Studios. **NOT
TO BE MISSED:** 435 original W/C by John James Audubon

ON EXHIBIT 2001
09/12/2000 to 01/21/2001 INVENTING THE SKYLINE: THE ARCHITECTURE OF CASS GILBERT
The celebrated structures of Gilbert (1859-1934) are followed from drawings through completion including the Woolworth
Building, The Custom House at Bowling Green, and the New York Life Assurance Building.

09/19/2000 to 01/14/2001 STROBRIDGE POSTERS FROM THE COLLECTION OF THE HISTORICAL SOCIETY
Large and colorful circus and theatrical posters produced from 1855-1930 from the collection of 1,000 chromolithographs.

**10/24/2000 to 02/04/2001 INTIMATE FRIENDS: THOMAS COLE, ASHER B. DURAND AND WILLIAM CULLEN
BRYANT**
Paintings, manuscripts and periodicals from the founders of the Hudson River School, the first American school of
landscape painting.

Pratt Manhattan Gallery
142 W 14th St, New York, NY 10011

☎: 718-636-3785 ⬛ www.pratt.edu/exhibitions
Open: 10-9 Mo-Th; 10-4 Fr-Su **Closed:** Su
♿: Possible but difficult ⓟ: Nearby pay garage
Permanent Collection: Not continuously on view.

Pratt Manhattan and Schafler Galleries in Brooklyn present a program of exhibitions of contemporary art,
design, and architecture in thematic exhibitions as well as solo and group shows of work by faculty, students
and alumni.

Salmagundi Museum of American Art
47 Fifth Avenue, New York, NY 10003

☎: 212-255-7740
Open: 1-5 daily **Closed:** LEG/HOL!
ⓟ: Nearby pay garage 🍴: Members Only **Group Tours:** 212-255-7740 **Docents** **Tour times:** can be arranged
Permanent Collection: AM: Realist ptgs 19,20

An organization of artists and art lovers in a splendid landmark building on lower 5th Avenue.

Sidney Mishkin Gallery of Baruch College
135 East 22nd Street, New York, NY 10010

☎: 212-802-2690 ⬛ www.baruch.cuny.edu/mishkin
Open: 12-5 Mo-We, Fr, 12-7 Th **Closed:** Sa, Su, ACAD!
♿ ⓟ: Nearby pay garages
Permanent Collection: GR; PHOT 20

The building housing this gallery was a 1939 Federal Courthouse erected under the auspices of the WPA.
NOT TO BE MISSED: Marsden Hartley's "Mount Katadin, Snowstorm," 1942.

234

Society of Illustrators Museum of American Illustration
128 East 63rd St, New York, NY 10021

☎: 212-838-2560 ◙ www.societyillustrators.org
Open: 10-5 We-Fr, 10-8 Tu, 12-4 Sa **Closed:** Su, Mo, LEG/HOL!
& ℗: Nearby pay garages **Museum Shop** ⑪: by membership @ $150/Yr
Permanent Collection: NORMAN ROCKWELL

A very specialized collection of illustrations familiar to everyone.

ON EXHIBIT 2001
12/06/2000 to 01/06/2001 THE ORIGINAL ART: CELEBRATING THE FINE ART OF CHILDREN'S BOOK ILLUSTRATION
A juried exhibition with over 200 works from the books themselves shown.

Solomon R. Guggenheim Museum
1071 Fifth Ave, New York, NY 10128

☎: 212-423-3500 ◙ www.guggenheim.org
Open: 9-6 Su-We, 9-8 Fr, Sa **Closed:** Th, 12/25,1/1
Sugg./Contr.: Fri, 6-8 pm
ADM: Adult: $12.00 **Children:** Free under 12 w/adult **Students:** $7.00 **Seniors:** $7.00
& ℗: Nearby pay garages **Museum Shop** ⑪
Group Tours: 212-423-3652 **Docents Sculpture Garden**
Permanent Collection: AM & EU: ptgs, sculp; PEGGY GUGGENHEIM COLL: cubist, surrealist, & ab/exp artworks; PANZA diBIUMO COLL: minimalist art 1960's -70's ◠

Designed by Frank Lloyd Wright in 1950, and designated a landmark building by New York City, the museum was recently restored and expanded. Originally called the Museum of Non-Objective Painting, the Guggenheim houses one of the world's largest collections of paintings by Kandinsky as well as prime examples of works by such modern masters as Picasso, Giacometti, Mondrian and others. **NOT TO BE MISSED:** Kandinsky's "Blue Mountain."

ON EXHIBIT 2001
09/15/2000 to 01/07/2001 AMAZONS OF THE AVANT-GARDE: ALEXANDRA EXTER, NATALIA GONCHAROVA, LIUBOV POPOVA, OLGA ROZANOVA, VARVARA STEPANOVA AND NADEZHADA UDALTSOVA
Six Russian women who, in paintings and works on paper, have made significant contributions to the development of modern art. These artists were of different philosophical schools and different social aspirations and aesthetic convictions. They supported the idea of cultural renewal and rejection of outmoded aesthetic canons.

10/20/2000 to 01/17/2001 GEORGIO ARMANI
Armani is recognized as one of the most original and iconic designers of the 20th century. The exhibition will present thematic groupings.

Studio Museum in Harlem
144 West 125th Street, New York, NY 10027

☎: 212-864-4900 ◙ www.studiomuseuminharlem.org
Open: 12-6 We-Th, 12-8 Fr, 10-6 Sa-Su **Closed:** Mo, Tu, LEG/HOL!
ADM: Adult: $5.00 **Children:** $1.00 (under 12) **Students:** $3.00 **Seniors:** $3.00
& ℗: pay garages nearby **Museum Shop**
Group Tours: 212-864-4500 **Docents Tour times:** varies **Sculpture Garden**
Permanent Collection: AF/AM; CARIBBEAN; LATINO

This is the premier center for the collection, interpretation and exhibition of the art of Black America and the African Diaspora. The five-story building is located on 125th Street, Harlem's busiest thoroughfare and hub of it's commercial rebirth and redevelopment.

Studio Museum in Harlem - continued

ON EXHIBIT 2001

10/11/2000 to 01/07/2001 WHITFIELD LOVELL: WHISPERS FROM THE WALLS
Mixed media installation centering on memory and history evoking a harrowing tale of post-Reconstruction.

02/04/2001 to 04/01/2001 COLLECTIONS IN CONTEXT: SELECTIONS FROM THE VAN DER ZEE ARCHIVE

02/04/2001 to 04/01/2001 GLENN LIGON: STRANGER

02/04/2001 to 04/01/2001 VIEWS FROM HARLEM

04/25/2001 to 06/30/2001 CONTEMPORARY AFRICAN AMERICAN ARTISTS' GROUP EXHIBITION

10/2001 to 01/2002 SMITHSONIAN AFRICAN-AMERICAN PHOTOGRAPHY: THE FIRST 100 YEARS & ART AND BLACK ACTIVISM

Whitney Museum of American Art
945 Madison Ave, New York, NY 10021

☎: 212-570-3676 ◙ www.echony.com/nwhitney
Open: 11-6 Tu, We, Fr, Sa, Su, 1-8 Th **Closed:** Mo, Tu, 1/1, THGV, 12/25
ADM: Adult: $12.50 **Children:** Free under 12 **Students:** $10.50 **Seniors:** $10.50
&. ℗: Nearby pay parking lots **Museum Shop** ‖
Group Tours: 212-570-7720 **Docents** **Tour times:** We-Su, & Th eve 212-570-3676 **Sculpture Garden**
Permanent Collection: AM: all media, 20

Founded by leading American art patron Gertrude Vanderbilt Whitney in 1930, the Whitney is housed in an award winning building designed by Marcel Breuer. The museum's mandate, to devote itself solely to the art of the US, is reflected in its significant holdings of the works of Edward Hopper (2,500 in all), Georgia O'Keeffe, and more than 850 works by Reginald Marsh. New directions and developments in American art are featured every 2 years in the often cutting edge and controversial Whitney Biennial. Satellite Galleries: Whitney Museum of American Art at Philip Morris, 120 Park Ave, NYC; Whitney Museum of American Art at Champion, Stamford, CT. **NOT TO BE MISSED:** Alexander Calder's "Circus."

Yeshiva University Museum
2520 Amsterdam Avenue, New York, NY 10033

☎: 212-960-5390
Open: 10:30-5 Tu-Th, 12-6 Su **Closed:** Sa, Mo, LEG/HOL!, JEWISH/HOL!
ADM: Adult: $3.00 **Children:** $2.00, 4-16 **Students:** $2.00 **Seniors:** $2.00
&.: 4th floor accessible, main floor partially accessible ℗: neighboring streets and pay lots **Museum Shop**
‖: Cafeteria on campus
Permanent Collection: JEWISH: ptgs, gr, textiles, ritual objects, cer

Major historical and contemporary exhibitions of Jewish life and ceremony are featured in this museum. **NOT TO BE MISSED:** Architectural models of historic synagogues.

NIAGARA FALLS

Castellani Art Museum-Niagara University
Niagara Falls, NY 14109

☎: 716-286-8200 ◙ www.niagara.edu/~cam
Open: 11-5 We-Sa, 1-5 Su **Closed:** Mo, Tu, ACAD!
&. ℗
Permanent Collection: AM: ldscp 19; CONT: all media; WORKS ON PAPER: 19-20; PHOT: 20

Castellani Art Museum-Niagara University- continued

Minutes away from Niagara Falls, Artpark, and the New York State Power Vista, the Castellani Art Museum features an exciting collection of contemporary art and a Permanent folk arts program in a beautiful grey marble facility. **NOT TO BE MISSED:** "Begonia," 1982, by Joan Mitchell.

NORTH SALEM

Hammond Museum

Deveau Rd. Off Route 124, North Salem, NY 10560

☎: 914-669-5033 ◙ www.hammondmuseum.org.com
Open: 12-4 We-Sa **Closed:** Su, Mo, Tu, 12/25, 1/1
ADM: Adult: $4.00 **Children:** Free under 12 **Students:** $3.00 **Seniors:** $3.00
♿ ℗ **Museum Shop** ❙❙: Apr through Oct **Docents** **Tour times:** Res
Permanent Collection: Changing exhibitions

The Hammond Museum and Japanese Stroll Garden provide a place of natural beauty and tranquility to delight the senses and refresh the spirit.

OGDENSBURG

Frederic Remington Art Museum

303/311 Washington Street, Ogdensburg, NY 13669

☎: 315-393-2425 ◙ wwwfrederivremington.org
Open: 9-5 Mo, Sa, 1-5 Su (5/1-10/31), 11-5 Tu-Sa (11/1-4/30) 1-5 Su **Closed:** NY Day, Easter, Thgv, Xmas
ADM: Adult: $4.00 **Children:** Free under 5 **Students:** $3.00 **Seniors:** $3.00
♿ ℗ **Museum Shop**
Permanent Collection: REMINGTON: ptgs, w/col, sculp, works on paper

The library, memorabilia, and finest single collections of Frederic Remington originals are housed in a 1809-10 mansion with a modern gallery addition. **NOT TO BE MISSED:** "Charge of the Rough Riders at San Juan Hill."

ONEONTA

Yager Museum

Oneonta, NY 13820

☎: 607-431-4480
Open: 11-5 Tu-Sa, 1-4 Su **Closed:** Mo, LEG/HOL!
♿ ℗ **Museum Shop**
Permanent Collection: NAT/AM: artifacts; P/COL: pottery; VAN ESS COLLECTION OF REN, BAROQUE & AM (ptgs 19); masks; shells; botanical specimens

An excellent college museum with community involvement and travelling exhibitions which reflects its unique collections ranging from fine art of the Renaissance, 19th and 20th C. American paintings, upper Susquehanna area, archeology, ethnology, Mesoamerican and North American.

NEW YORK

PLATTSBURGH

Plattsburgh State Art Museum
Affiliate Institution: State University of New York
State University of New York, Plattsburgh, NY 12901

☎: 518-564-2474 ◉ www.plattsburgh.edu/museum
Open: 12-4 daily **Closed:** LEG/HOL!
& ⓅⒺ: Free **Museum Shop** ⑪: on campus across from museum
Group Tours: 518-564-2813 **Docents** **Tour times:** by appt **Sculpture Garden**
Permanent Collection: ROCKWELL KENT: ptgs, gr, cer; LARGEST COLLECTION OF NINA WINKEL SCULPTURE

This University Museum features a 'museum without walls' with late 19th and 20th century sculptures, paintings, and graphics displayed throughout its campus and in four secure galleries. **NOT TO BE MISSED:** Largest collection of Rockwell Kent works.

POTSDAM

Roland Gibson Gallery
Affiliate Institution: State University of New York College at Potsdam
Potsdam, NY 13676-2294

☎: 315-267-3290 ◉ www.potsdam.edu/gibson
Open: 12-5 Mo-Fr, 12-4 Sa, Su, 7-9:00 Mo-Th eve and by Appt. **Closed:** LEG/HOL!
& Ⓟ **Group Tours:** 315-267-3290 **Sculpture Garden**
Permanent Collection: CONT: ALL MEDIA; WORKS ON PAPER; JAP: ptgs; ITAL: ptgs, sculp

Based on the New York State University campus in Potsdam, this is the only museum in northern New York that presents a regular schedule of exhibitions of contemporary art. **NOT TO BE MISSED:** Hollis Sigler "Expect the Unexpected."

ON EXHIBIT 2001
01/26/2001 to 02/25/2001 OYVIND FAHLSTROM: THE COMPLETE GRAPHICS AND MULTIPLES
Fahlstrom was an artist, poet, journalist, playwright, critic, filmmaker and activist.

03/12/2001 to 04/22/2001 ISSUES OF IDENTITY IN RECENT AMERICAN ART
Included are Chi, Colescott, Piper, Sherman, Simpson, Teroaka, Walker and Weems.

POUGHKEEPSIE

Frances Lehman Loeb Art Center at Vassar College
Affiliate Institution: Vassar College
124 Raymond Ave., Poughkeepsie, NY 12601

☎: 914-437-5235 ◉ vassun.vassar.edu/~orfuac/
Open: 10-5 Tu-Sa, 1-5 Su **Closed:** Mo, EASTER, THGV, 12/25-1/1
& Ⓟ **Museum Shop** **Group Tours:** 914-437-5237 **Docents** **Sculpture Garden**
Permanent Collection: AM, EU: ptgs, sculp; AN/GR & AN/R: sculp; GR: old Master to modern

Housed in a newly built facility, this is the only museum between Westchester County and Albany exhibiting art of all periods. **NOT TO BE MISSED:** Magoon Collection of Hudson River Paintings

Donald M. Kendall Sculpture Gardens at Pepsico

700 Anderson Hill Road, Purchase, NY 10577

☎: 914-253-2082
Open: 9am to dusk daily **Closed:** LEG/HOL!
 ᴕ **℗:** Free **Sculpture Garden**
Permanent Collection: 45 SITE-SPECIFIC SCULP BY 20TH CENTURY ARTISTS

Forty-five site-specific sculptures are located throughout the 168 magnificently planted acres that house the headquarters of PepsiCo, corporate sculpture gardens designed in 1970 by noted architect Edward Durell Stone. A large man-made lake and wandering ribbons of pathway invite the visitor to enjoy the sculptures within the ever-changing seasonal nature of the landscape. The garden, located at a corporate headquarters in Westchester County about 30 miles outside of NYC, is an art lover's delight.

Neuberger Museum of Art

Affiliate Institution: Purchase College, SUNY
735 Anderson Hill Rd, Purchase, NY 10577-1400

☎: 914-251-6100 ◙ www.neuberger.org
Open: 10-4 Tu-Fr; 11-5 Sa, Su **Closed:** Mo, LEG/HOL
ADM: Adult: $4.00 **Children:** Free under 12 **Students:** $2.00 **Seniors:** $2.00
 ᴕ **℗:** Free **Museum Shop** ❙❙: Museum Cafe 11:30-2:30 Tu-Fr, 12-4 Sa, Su
Group Tours: 914-251-6110 **Docents** **Tour times:** 1pm Tu-Fr; 2 and 3pm Su
Permanent Collection: PTGS, SCULP, DRGS 20; ROY R. NEUBERGER COLLECTION; EDITH AND GEORGE RICKEY COLLECTION OF CONSTRUCTIVIST ART; AIMEE HIRSHBERG COLLECTION OF AFRICAN ART; HANS RICHTER BEQUEST OF DADA AND SURREALIST OBJECTS; ANC GRK, ETR VASES GIFT OF NELSON A. ROCKEFELLER

On the campus of Purchase College, SUNY, the Neuberger Museum of Art houses a prestigious collection of 20th century American, European and African art. **NOT TO BE MISSED:** Selections from the Roy R. Neuberger Collection of 20th century American art.

ON EXHIBIT 2001

09/17/2000 to 01/07/2001 MARY FRANK: ENCOUNTERS
A comprehensive overview of works completed during the past 15 years. Franks sensual dream penetrates her current oeuvre and memory and poetic sensibilities.

09/24/2000 to 01/07/2001 PROSCENIUM: A NEON INSTALLATION BY STEPHEN ANTONAKOS

09/24/2000 to 01/07/2001 SOL LEWITT: A WALL DRAWING SPECIALLY CREATED FOR THE VAST THEATER GALLERY
The scale of this work will be an impressive event for viewers who will at appointed times be invited to view the creative process.

11/12/2000 to 01/14/2001 WOMEN OF STONE: HARRIET FEIGENGAUM

01/21/2001 to 05/20/2001 JAUNE QUICK-TO-SEE SMITH: RECENT PAINTINGS

01/28/2001 to 05/27/2001 THE SCHOOL OF LONDON AND THEIR FRIENDS: COLLECTION OF ELAINE AND MELVIN MERIANS
This collection has never been shown publicly. These artists including Lucian Freud, David Hockney, Leon Kossoff, Frank Auerbach, Michael Andrews, R.B. Kitaj and Paula Rego are among those who renewed painting in Britain in the 1950's-70's. *Will Travel*

01/28/2001 to 04/08/2001 INNUENDO: CREIGHTON MICHAEL

01/28/2001 to 05/20/2001 ROGER WELCH

NEW YORK

Neuberger Museum of Art - continued

05/20/2001 to 10/07/2001 NEUBERGER MUSEUM OF ART BIENNIAL EXHIBITION OF PUBLIC ART

06/17/2001 to 09/02/2001 MARISOL
Selections of the major works done by the sculptor since 1950's. These include figurative motifs in drawing, painting, carving and constructing.

09/09/2001 to 01/13/2002 THE LAWRENCE GUSSMAN COLLECTION OF CENTRAL AFRICAN ART (working title)
From the Neuberger, the National Museum of African Art, Washington, and the Israel Museum outstanding Central African works will travel and then the Gussman gift will be integrated into the Neuberger collection. *Will Travel*

09/23/2001 to 01/06/2002 HOWARD BEN TRE

QUEENS

Queens Museum of Art
New York City Building, Flushing Meadows Corona Park, Queens, NY 11368-3393
☎: 718-592-9700 **◙** www.queensmuse.org
Open: 10-5 We-Fr, 12-5 Sa, Su, Tu groups by appt **Closed:** Mo, Tu, 1/1, THGV, 12/25
ADM: Adult: $4.00 **Children:** Free under 5 **Students:** $2.00 **Seniors:** $2.00
&. ℗: Free **Museum Shop Docents Tour times:** Tours of Panorama 3pm Sa
Permanent Collection: CHANGING EXHIBITIONS OF 20TH CENTURY ART AND CONTEMPORARY ART

The Panorama is where all of NYC fits inside one city block. You will feel like Gulliver when you experience it for the first time. The building was built for the 1939 World's Fair and was later used for United Nations meetings. Satellite Gallery at Bulova Corporate Center, Jackson Heights, Queens. **NOT TO BE MISSED:** "The Panorama of NYC," largest architectural scale model of an Urban Area. "Tiffany in Queens: Selections from the Neustadt Museum Collection." Lamps, desk objects and a window on long term loan.

ROCHESTER

George Eastman House, International Museum of Photography and Film
900 East Ave, Rochester, NY 14607
☎: 716-271-3361 **◙** www.eastman.org
Open: 10-4:30 Tu-Sa, 1-4:30 Su **Closed:** Mo, LEG/HOL!
ADM: Adult: $6.50 **Children:** $2.50 (5-12) **Students:** $5.00 **Seniors:** $5.00
&. ℗ **Museum Shop ⅋ Group Tours:** 716-271-3361, ext 238 **Docents Tour times:** 10:30 & 2 Tu-Sa, 2 Su
Permanent Collection: PHOT: prints; MOTION PICTURES; MOTION PICTURE STILLS; CAMERAS; BOOKS

The historic home of George Eastman, founder of Eastman Kodak Co. includes a museum that contains an enormous and comprehensive collection of over 400,000 photographic prints, 21,000 motion pictures, 25,000 cameras, 41,000 books and 5,000,000 motion picture stills.

SEMI-Permanent EXHIBITIONS:
Through the Lens: Selections from the Permanent Collection
A Picture Perfect Restoration: George Eastman's House and Gardens
Enhancing the Illusion: The Origins and Progress of Photography
George Eastman in Focus
An Historical Timeline of Photo-imaging

NOT TO BE MISSED: Discovery room for children.

Memorial Art Gallery
Affiliate Institution: University of Rochester
500 University Ave, Rochester, NY 14607

☎: 716-473-7720 **◙** www.rochester.edu/MAG
Open: 12-9 Tu, 10-4 We-Fr, 10-5 Sa, 12-5 Su **Closed:** Mo, LEG/HOL!
ADM: Adult: $5.00, $2 Tu 5-9 **Children:** 6-8 $3.00, Free 5 and under **Students:** $4.00 **Seniors:** $4.00
ᕳ ⓟ Museum Shop ¶ Docents Tour times: 2pm, Fr, Sa; 7:30 pm Tu **Sculpture Garden**
Permanent Collection: MED; DU: 17; FR: 19; AM: ptgs, sculp 19,20; FOLK

The Gallery's Permanent collection of 10,000 works spans 50 centuries of world art and includes masterworks by artists such as Monet, Cezanne, Matisse, Homer and Cassatt. An interactive learning center focuses on Learning to Look. Also included is an interactive CD-ROM "tour" of the Gallery. **NOT TO BE MISSED:** "Waterloo Bridge, Veiled Sun" 1903, by Monet.

ON EXHIBIT 2001
09/24/2000 to 01/07/2001 THE ART OF WILL EDMUNDSON
In 1937, Edmundson was the first African American to have a one man exhibition at the Museum of Modern Art. He is a self-taught artist and his work is inspired by his religious beliefs, African American folklore and popular culture. 40 limestone sculptures, and 25 period photographs of him and his work.

12/08/2000 to 03/04/2001 WOODCUTS BY JAMES HAVENS: A CENTENNIAL CELBRATION
One of the 20th century's master woodcut printmakers, Havens was trained as a painter. Subjects of this exhibitions range from children to farm animals.

ROSLYN HARBOR

Nassau County Museum of Fine Art
Northern Blvd & Museum Dr, Roslyn Harbor, NY 11576

☎: 516-484-9338 **◙** www.nassaumuseum.org
Open: 11-5 Tu-Su **Closed:** Mo, LEG/HOL!
ADM: Adult: $4.00 **Children:** $2.00 **Students:** $2.00 **Seniors:** $3.00
ᕳ ⓟ: Free **Museum Shop ¶**
Group Tours: 516-484-9338, x-206 **Docents Tour times:** 2pm Tu-Sa **Sculpture Garden**
Permanent Collection: AM: gr, sculp

Situated on 145 acres of formal gardens, rolling lawns and meadows, the museum presents four major exhibitions annually and is home to one of the east coast's largest publicly accessible outdoor sculpture gardens.

ON EXHIBIT 2001
09/29/2000 to 01/14/2001 SURREALISM & SALVADOR DALI: WORKS ON PAPER

01/28/2001 to 05/06/2001 THE NAPOLEONIC WORLD

SARATOGA SPRINGS

Schick Art Gallery
Affiliate Institution: Skidmore College
Skidmore Campus North Broadway, Saratoga Springs, NY 12866-1632

☎: 518-580-5000 **◙** dom.skidmore.edu/academics/art/mosaic/schick
Open: 9-5 Mo-Fr; 9-4 Mo-Fr (summer), 1-3:30 Sa **Closed:** LEG/HOL!, ACAD!
ᕳ ⓟ: On campus **¶ Group Tours:** 518-580-5049

Theme oriented or one person exhibitions that are often historically significant are featured in this gallery located on the beautiful Skidmore Campus.

NEW YORK

SOUTHAMPTON

Parrish Art Museum
25 Job's Lane, Southampton, NY 11968
✆: 516-283-2118
Open: 11-5 Mo, Tu, Fr, Sa, 1-5 Su; Open Daily Jun 1-Sep 15 **Closed:** 1/1, EASTER, 7/4, THGV, 12/25
Sugg./Contr.: ADM: Adult: $2.00 **Students:** Free (with valid ID) **Seniors:** $1.00
&:! ℗ **Museum Shop Sculpture Garden**
Permanent Collection: AM: ptgs, gr 19; WILLIAM MERRITT CHASE; FAIRFIELD PORTER

Situated in a fashionable summer community, this Museum is a 'don't miss' when one is near the Eastern tip of Long Island. It is located in an 1898 building designed by Grosvenor Atterbury.

STATEN ISLAND

Jacques Marchais Museum of Tibetan Art
338 Lighthouse Ave., Staten Island, NY 10306
✆: 718-987-3500 ◙ www.tibetanmusem.com
Open: 1-5 We-Su (Apr-mid Nov or by appt. Dec-Mar) **Closed:** Mo, Tu, EASTER, 7/4, LAB/DAY, THGV & day after, 12/25, 1/1
ADM: Adult: $3.00 **Children:** $1.00 (under 12) **Students:** $3.00 **Seniors:** $2.50
Museum Shop Sculpture Garden TIBET; OR: arch; GARDEN, BUDDHIST, HIMALAYAN: ASIAN

This unique museum of Himalayan art within a Tibetan setting consists of two stone buildings resembling a Buddhist temple. A quiet garden and a goldfish pond help to create an atmosphere of serenity and beauty. It is the only museum in this country devoted primarily to Tibetan art.

Noble Maritime Collection
1000 Richmond Terrace, Staten Island, NY 10301
✆: 718-447-6490 ◙ www.johnanoble.com
Open: by appoint until Fall, 2000 **Closed:** Mo, Tu, We, LEG/HOL
ADM: Adult: $2.00 **Children:** under 12 **Seniors:** $1.00
& ℗
Permanent Collection: PTGS; LITHOGRAPHS; DOCUMENTS AND ARTIFACTS

John Noble wrote, "My life's work is to make a rounded picture of American Maritime endeavors of modern times." He is widely regarded as America's premier marine lithographer. The Collection, in a new site at historic Snug Harbor Cultural Center, features exhibitions, a library, printmaking studios, and progams for children & seniors in art and maritime history. The Collections have recently undergone a rehabilitation, converting a former mariner's dormitory into an elegant museum.

Snug Harbor Cultural Center
Affiliate Institution: Newhouse Center for Contemporary Art
1000 Richmond Terrace, Staten Island, NY 10301
✆: 718-448-2500
Open: 12-5 We-Su **Closed:** Mo, Tu, LEG/HOL!
ADM: Adult: $2.00 ℗: Free ¶ **Sculpture Garden**
Permanent Collection: Non-collecting institution

Once a 19th century home for retired sailors Snug Harbor is a landmarked 83 acre, 28 building complex being preserved and adapted for the visual and performing arts. The Newhouse Center for Contemporary Art provides a forum for regional and international art. **NOT TO BE MISSED:** The award winning newly restored 1884 fresco ceiling in the Main Hall.

Staten Island Institute of Arts and Sciences
75 Stuyvesant Place, Staten Island, NY 10301

☎: 718-727-1135
Open: 9-5 Mo-Sa, 1-5 Su **Closed:** LEG/HOL!
Vol./Contr.: Adult: $2.50 **Students:** $1.50 **Seniors:** $1.50
�& **Ⓟ:** Pay lot across the street **Museum Shop**
Group Tours: 718-727-1135, x24
Permanent Collection: PTGS; DEC/ART; SCULP; STATEN ISLAND: arch

One of Staten Island's oldest and most diverse cultural institutions, this facility explores and interprets the art, natural resources and cultural history of Staten Island. **NOT TO BE MISSED:** Ferry Collection on Permanent exhibition. This history of the world-famous ferry service is located in the Staten Island Ferry terminal.

STONY BROOK

Museums at Stony Brook
1208 Rte. 25A, Stony Brook, NY 11790-1992

☎: 516-751-0066 ◙ www.museumsatstonybrook.org
Open: 10-5 We-Sa, 12-5 Su, July, Aug 10-5 Mo-Sa, 12-5 Su **Closed:** Mo, Tu, 1/1, THGV, 12/24, 12/25
Free Day: We, for students **ADM: Adult:** $4.00 **Children:** $2.00, 6-17, under 6 Free **Students:** $2.00 **Seniors:** $3.00
�& Ⓟ **Museum Shop Group Tours:** EXT.248 **Docents Tour times:** !
Permanent Collection: AM:ptgs; HORSE DRAWN CARRIAGES; MINIATURE ROOMS; ANT:decoys; COSTUMES; TOYS

A museum complex on a nine acre site with art, history, and carriage museums, blacksmith shop, 19th century one room schoolhouse, carriage shed and 1794 barn. **NOT TO BE MISSED:** Paintings by William Sidney Mount (1807-1868), 100 horse drawn carriages.

SYRACUSE

Everson Museum of Art
401 Harrison Street, Syracuse, NY 13202

☎: 315-474-6064 ◙ www.everson.org
Open: 12-5 Tu-Fr; 10-5 Sa; 12-5 Su **Closed:** Mo, LEG/HOL
Sugg./Contr.: ADM: Adult: $2.00
�& **Ⓟ:** Nearby pay garages, limited metered on street **Museum Shop** ⑪
Docents Tour times: ! **Sculpture Garden**
Permanent Collection: AM:cer; AM:ptgs 19, 20; AM sculp 20; AM:Arts/Crafts Movt Objects; collection of early video works

When it was built, the first museum building designed by I.M. Pei was called "a work of art for works of art." The Everson's Syracuse China Center for the Study of Ceramics is one of the nation's most comprehensive, collections of American ceramics housed in an open-storage gallery. The installation is arranged chronologically by culture and includes samples from, the Americas, Asia and Europe. **NOT TO BE MISSED:** One of the largest, most comprehensive Permanent exhibitions of American and world ceramics.

NEW YORK

Kykuit, The Rockefeller Estate
Affiliate Institution: Historic Hudson Valley
150 White Plains Road, Tarrytown, NY 10591

℡: 914-631-9491 **◎** www.hudsonvalley.org
Open: Mo, We-Fr 10am-3pm; Sa/Su 10am-4 pm; open May through October **Closed:** Tu
ADM: Adult: $20.00 **Children:** not rec under 12 **Students:** under 18, $17.00 **Seniors:** $19.00
& **Ⓟ:** Free at Visitor's Center **Museum Shop** **�'l:** Café at Visitor's Center
Group Tours: by reservation. 914-631-9491. **Docents** **Tour times:** Individual reservation no longer required. All tours begin at Visitor's Center, Phillipsburg Manor, Route 9, Sleepy Hollow, NY **Sculpture Garden**

The 6-story stone house which was the Rockefeller home for four generations is filled with English and American furnishings, portraits and extraordinary collections of Asian ceramics. In the art galleries are paintings and sculpture by Andy Warhol, George Segal, Alexander Calder, Robert Motherwell and many others. Visitors also view the enclosed gardens and terraces with their collections of classical and 20th century sculpture and stunning river views. The Coach Barn contains horse-drawn carriages and classic automobiles. The Beaux-Arts gardens were designed by William Welles Bosworth and are filled with an extraordinary collection of modern sculpture.

Munson-Williams Proctor Institute Museum of Art
310 Genesee Street, Utica, NY 13502

℡: 315-797-0000 **◎** www.mwpi.edu
Open: 10-5 Tu-Sa, 1-5 Su **Closed:** Mo, LEG/HOL!
Sugg./Contr.: Yes & **Ⓟ** **Museum Shop** **�'l:** Mo-Fr 11:30-3
Group Tours: 315-797-0000, ext 2170 **Docents** **Tour times:** by appt **Sculpture Garden**
Permanent Collection: AM: ptgs, dec/art; EU: manuscripts, gr, drgs

The Museum is a combination of the first art museum designed by renowned architect Philip Johnson (1960) and Fountain Elms, an 1850 historic house museum which was the home of the museum's founders.

ON EXHIBIT 2001
11/18/2000 to 02/04/2001 AMERICAN IMPRESSIONISM
Led by the example of James McNeil Whistler, a generation of American artist studied abroad to absorb the new palette and compositions that were modernizing painting. Landscapes, figure, and still life paintings by Hassam, Twatchman, Dewing, Merrit Chase and Robinson marked a distinct departure from academic styles.

Hudson River Museum

511 Warburton Ave, Yonkers, NY 10701-1899

☎: 914-963-4550 ⊡ www.hrm.org
Open: 12-5 We-Su (Oct-Apr): 12-5 We, Th, Sa, Su, 12-9 Fr (May-Sept) **Closed:** Mo, Tu, LEG/HOL!
ADM: Adult: $3.00 **Children:** $1.50 under 12 **Seniors:** $1.50
&: a "Touch Gallery" for visually-impaired ℗: Free **Museum Shop** ⁋: The Hudson River Cafe overlooking the River
Group Tours: 914-963-4550 ext 40 **Docents Tour times:** by appt **Sculpture Garden**
Permanent Collection: AM: ldscp/ptgs 19,20; DEC/ART; GR: 19,20; COSTUMES; PHOT: 19,20.

The Hudson River Museum overlooking the Palisades, provides a dramatic setting for changing exhibitions of art, architecture, design, history and science—many designed for families. Discover the Hudson River's special place in American life as you enjoy the art. The Museum Shop was designed by Pop artist Red Grooms. There are Planetarium Star Shows in the Andrus Planetarium at 1:30, 2:30, 3:30 Sa, Su. **NOT TO BE MISSED:** Hiram Powers "Eve Disconsolate," marble statue, 1871 (gift of Berol family in memory of Mrs. Gella Berolzheimer, 1951). Also, woodwork and stencils in the decorated period rooms of the 1876 Glenview Mansion.

NORTH CAROLINA

Asheville Art Museum
2 S. Pack Square, Asheville, NC 28801
☎: 828-253-3227 **◙** ashevilleart.org
Open: 10-5 Tu-Sa, 1-5 Su, and until 8 Fr during the summer **Closed:** Mo, 1/1,MEM/DAY,7/4,LAB/DAY,THGV,12/25
ADM: Adult: $4.00 **Children:** 4-14 $3.00 **Students:** $3.00 **Seniors:** $3.00
& **℗:** on street **Museum Shop**
Group Tours: 800-935-0204 **Docents**
Permanent Collection: AM/REG:ptgs,sculp,crafts 20

The Museum is housed in the splendidly restored former Pack Memorial Library, a 1920 Beaux Arts Building.
NOT TO BE MISSED: The Museum's Permanent collection of 20th century American art and exciting schedule of temporary exhibitions.

Ackland Art Museum
Columbia & Franklin Sts-Univ. Of North Carolina, Chapel Hill, NC 27599
☎: 919-966-5736 **◙** www.ackland.org
Open: 10-5 We-Sa, 1-5 Su **Closed:** Mo, Tu, 12/25, 12/31, 1/1, 7/4
Sugg./Contr.: $3.00
& **℗:** in nearby municipal lots
Group Tours: 919-962-3342
Permanent Collection: EU & AM: ptgs, gr 15-20; PHOT; REG .Asian Cont, African

The Ackland, with a collection of more than 14,000 works of art ranging from ancient times to the present, includes a wide variety of categories conveying the breadth of mankind's achievements. **NOT TO BE MISSED:** Large Asian collection, only one of its kind in North Carolina.

ON EXHIBIT 2001
to 01/07/2001 BIENNIAL FACULTY EXHIBITION

10/03/2000 to 01/03/2001 DURER AND THE APOCALYPSE IN ART

Mint Museum of Art
2730 Randolph Road, Charlotte, NC 28207-2031
☎: 704-337-2000 **◙** www.mintmuseum.org
Open: 10-10 Tu, 10-5 We-Sa, 12-5 Su **Closed:** Mo, LEG/HOL
ADM: Adult: $6.00 **Children:** Free under 12 **Students:** $4.00 **Seniors:** $4.00
& **℗:** Free **Museum Shop**
Group Tours: 704-337-2032 **Docents** **Tour times:** 2 pm daily
Permanent Collection: EU & Am ptgs, REN, CONT,: CH; DEC/ART; AM pottery, glass: Brit cer

The building, erected in 1836 as the first branch of the US Mint, produced 5 million dollars in gold coins before the Civil War. In 1936 it opened as the first art museum in North Carolina. When the museum was moved to its present parkland setting the facade of the original building was integrated into the design of the new building. **NOT TO BE MISSED:** Extensive Delhom collection of English pottery, beautifully displayed.

Mint Museum of Art- continued

ON EXHIBIT 2001

08/05/2000 to 02/11/2001 ENGLAND AND AMERICA: COLLABORATION IN CLAY
Early in our ceramic history American potters turned to England for technological and artistic expertise since America had no ceramic tradition of its own. There was a deep and lengthy association with England that affected both the kinds of wares made and the methods by which they were produced. English potters were brought to this country to help establish potteries, create clay bodies and glazes, design the wares and oversee production.

11/04/2000 to 05/27/2001 OUT OF THE ORDINARY: SELECTIONS FROM THE ALLAN CHASANOFF CERAMIC COLLECTION
Functional, sculptural and decorative forms which demonstrate diverse approaches to ceramics and subject matter.

02/03/2001 to 04/22/2001 NOBLE DREAMS, WICKED PLEASURES: ORIENTALISM IN AMERICA, 1870-1930
Defined in the 19th and early 20th centuries as North Africa, the Middle East and India, the Orient has long captured the American imagination. Artists in the exhibition include John Singer Sargent, William Merritt Chase, Edward Lord Weeks, John LaFarge, Frederick Arthur Bridgeman, R. Swain Gifford, and Louis Comfort Tiffany. The high point of Orientalism, 1870-1930, coincides with a blossoming of mass culture and this exhibition juxtaposes paintings with advertisements, films and ephemera. With approximately 90 objects, the exhibition will be the first exploration of American Orientalism in all of its guises. *Catalog*

05/26/2001 to 08/12/2001 ON THE SURFACE: LATE 19TH CENTURY DECORATIVE ARTS
The last decades of the 19th century saw in America a delight in the use of surface decorations, particularly that having an "exotic" flavor. Designers of furniture, silver, glass, textiles and wallpaper all produced beautiful and lush objects. American potteries suddenly realized their own identity with what has come to be called American art pottery. The exhibition surveys the multiplicity of styles of the period (including Japanese, Medieval and Renaissance revivals, Egyptian and other Middle Eastern styles, and the influence of William Morris).

06/30/2001 TO 10/28/2001 INDUSTRIAL DESIGN: PROJECTS FROM CHARLOTTE FIRMS
The creative process of the industrial designer is the subject of the exhibition, which features the work of several Charlotte design firms. Ranging from furniture to installations, individual projects will be illustrated from start to finish, including concept drawings, prototypes, advertising and final manufactured products.

09/22/2001 to 01/06/2002 THE SPORT OF LIFE AND DEATH: THE MESOAMERICAN BALLGAME
The world's first team sport began in southern Mexico around 1500 B.C. and continued until the Spanish Conquest. Played with rubber balls in stone courts, Mesoamerican ballgames combined elements of modern day basketball, football, and soccer. The popularity of these games inspired ancient artists to create masterpieces glorifying the sport and its heroic athletes. This will be the first major traveling exhibition on the ballgame in the United States and is being organized from collections in the United States, Mexico, and Europe. *Catalog*

11/10/2001 to 03/31/2002 WILLIAM MORRIS: MYTH, OBJECT AND THE ANIMAL
A former glassblower for Dale Chihuly, William Morris is a virtuoso artist whose most elaborate series of installations are the subject of this dramatic sculptural glass exhibition. Morris' ability to make glass appear as bone, stoneware, bronze, leather and metal illustrate his extraordinary technical ability as seen in exhibition works such as Cache, Artifact Panels, Trophy Panel, Crow and Raven Vessels. The naturalism revealed in these works provoke rich story possibilities encompassing nature, archaeology, science, global culture and art.

DALLAS

Gaston County Museum of Art and History
131 W. Main Street, Dallas, NC 28034
📞 704-922-7681
Open: 10-5 Tu-Fr, 1-5 Sa, 2-5 4th Su of month **Closed:** Mo, Su, other than 4th of month, LEG/HOL!
♿ Ⓟ **Museum Shop**
Group Tours: 704-923-8103 **Docents Tour times:** Th, Sa at 3 pm
Permanent Collection: CONT; ARTIFACTS RELATING TO THE U.S, N.C. & THE SOUTHEAST

Gaston County Museum of Art and History- continued

The museum, housed in the 1852 Hoffman Hotel located in historic Court Square, features contains period rooms and contemporary galleries and furnishings. Regional history from the 1840s to the present. **NOT TO BE MISSED:** Carriage exhibit, the largest public collection of horse drawn vehicles in the Southeast.

DAVIDSON

William H. Van Every Gallery and Edward M. Smith Gallery

Davidson College, Visual Arts Center, 315 N. Main Street, Davidson, NC 28036

(: 704-892-2519 **◎** www.davidson.edu
Open: 10-6 Mo-Fr, 12-42 Sa, Su (Sep-June) **Closed:** LEG/HOL! ACAD
Vol./Contr.: Yes **&** **℗**
Permanent Collection: WORKS ON PAPER, PTGS Hist,Cont

In the fall of 1993 the Gallery moved to a new building designed by Graham Gund where selections from the 2,500 piece Permanent collection are displayed at least once during the year. The Gallery also presents a varied roster of contemporary and historical exhibitions. **NOT TO BE MISSED:** Auguste Rodin's "Jean d'Aire."

DURHAM

Duke University Museum of Art

Affiliate Institution: Duke University
Buchanan Blvd at Trinity, Durham, NC 27701

(: 919-684-5135 **◎** www.duke.edu/web/duma
Open: 10-5 Tu-Fr, 11-2 Sa, 2-5 Su (open We, 10-9 Sept-May) **Closed:** Mo, LEG/HOL!
Sugg/Cont: $3.00 **&** **℗** **Museum Shop** **Group Tour:** 919-684-5135
Permanent Collection: MED: sculp; DEC/ART; AF: sculp; AM & EU: all media

Duke University Art Museum, with its impressive collection ranging from ancient to modern works includes the Breumner collection of Medieval art, widely regarded as a one of a kind in the US, and a large pre-Columbian collection from Central and South America as well as a collection of contemporary Russian art.

FAYETTEVILLE

Fayetteville Museum of Art

839 Stampe, NC 28303

(: 910-485-5121 **◎** www.fmoa.org
Open: 10-5 Mo-Fr, 1-5 Sa, Su **Closed:** Mo, 1/1, EASTER, 7/4, THGV, 12/23-12/31
& **℗** **Museum Shop** **Group Tours:** 910-485-0548 **Docents** **Sculpture Garden**
Permanent Collection: CONT: North Carolina art; PTGS, SCULP, CER, AF artifacts

The museum, whose building was the first in the state designed and built as an art museum, also features an impressive collection of outdoor sculpture on its landscaped grounds. **NOT TO BE MISSED:** "Celestial Star Chart," by Tom Guibb.

ON EXHIBIT 2001

11/18/2000 to 01/21/2001 THE ARTISTS OF CHARLOTTE
This exhibition marks the third in a series of exhibition that will showcase artists and their works from the major metro areas of the State. Organized by the Fayetteville Museum of Art, this exhibition will feature the leading contemporary artists from the Charlotte metro area.

Fayetteville Museum of Art - continued

01/27/2001 to 03/18/2001 ANSEL ADAMS, A LEGACY: MASTERWORKS FROM THE FRIENDS OF PHOTOGRAPHY COLLECTION EXHIBITION TOUR

Organized by the Ansel Adams Friends of Photography and the Fayetteville Museum of Art, this exhibition contains more than 100 works by the most well-known and popular American photographer of our century. The pictures in the exhibition were printed, selected and exhibited in the last years of his life. They include landscapes and other images from his extensive travels in the Southwest, pictures of national parks and monuments, views of San Francisco and the Bay Area, portraits, abstract-style close-ups and other subjects.

03/25/2001 to 05/20/2001 TWENTY-NINTH ANNUAL COMPETITION FOR NORTH CAROLINA ARTISTS

This exhibition features works of artists living in or native to North Carolina. It is one of the Southeast's most distinguished and highly competitive professional exhibitions and has been held each year since the Museum was founded.

05/26/2001 to 07/29/2001 SEAGROVE POTTERY AND SELECTIONS FROM THE NORTH CAROLINA PERMANENT COLLECTION

Organized by the Fayetteville Museum of Art, this exhibition features the artists from the Seagrove area potteries. Representing over 100 potteries in a twenty-five mile radius that depicts a 200 year old tradition of pottery making. The show will, further, be complemented through the exhibiting of North Carolina artists collected by our Museum over the past twenty-eight years.

08/04/2001 to 09/16/2001 TEXTILES & TRADE: SELECTIONS FROM THE AFRICAN PERMANENT COLLECTION

Organized by the Fayetteville Museum of Art, this exhibition features works from the Museum's African Permanent Collection. The concentration will be on artifacts related to the manufacturing and use of textiles, and the impact on communication and trade.

09/22/2001 to 11/11/2001 FORM & FUNCTION: ARTISTS MICHAEL LUCERO AND SHERY MARKOVITZ

From the Mint Museum of Craft and Design's Permanent Collection, two leading contemporary artists will be showcased. Michael Lucero's unique ceramic pieces are constructed. Shery Markovitz utilizes the use of form and beadwork in her sculpture pieces.

11/17/2001 to 01/20/2002 THE ARTISTS OF RALEIGH

This exhibition marks the fourth in a series of exhibitions that showcase artists and their works from the major metro areas of the State. Organized by the Fayetteville Museum of Art, this exhibition will feature the leading contemporary artists from the Raleigh area.

GREENSBORO

Weatherspoon Art Gallery

Affiliate Institution: The University of North Carolina
Spring Garden & Tate Street, Greensboro, NC 27402-6170

☎: 336-334-5770 **◙** www.weatherspoon.uncg.edu
Open: 10-5 Tu,Th, Fr, 1-5 Sa-Su, 10-8 We **Closed:** Mo, ACAD! and vacations
& **℗** **Museum Shop** **¶¶:** Many restaurants nearby **Docents** **Tour times:** 1st Su 2pm !
Group Tours: 336-334-5907 **Sculpture Garden**
Permanent Collection: AM: 20; MATISSE PRINTS AND BRONZE SCULPTURES; OR: WOODCUTS AND PRINTS

Designed by renowned architect, Romaldo Giurgola, the Weatherspoon Art Gallery features six galleries showcasing special exhibitions and a predominantly 20th century collection of American art with works by Willem de Kooning, Alex Katz, Louise Nevelson, David Smith, and Robert Rauschenberg. **NOT TO BE MISSED:** The Cone Collection of Matisse prints and bronzes

GREENVILLE

Greenville Museum of Art Inc

802 Evans Street, Greenville, NC 27834

℅: 252-758-1946 ◎ gma.greenvillene.com
Open: 10-4:30 Th, Fr, 1-4 Su **Closed:** Mo-We LEG/HOL!
&. ℗
Permanent Collection: AM: all media 20

Founded in 1939 as a WPA Gallery, the Greenville Museum of Art focuses primarily on the achievements of 20th century American art. Many North Carolina artists are represented in its collection which also includes works by George Bellows, Thomas Hart Benton, Robert Henri, Louise Nevelson, and George Segal, to name but a few. **NOT TO BE MISSED:** Major collection of Jugtown pottery.

ON EXHIBIT 2001

01/10/2001 to 02/25/2001 GREENVILLE COLLECTS

03/15/2001 to 05/25/2001 WOMEN ARTISTS FROM THE Permanent COLLECTION

Wellington B. Gray Gallery

Affiliate Institution: East Carolina University
Jenkins Fine Arts Center, Greenville, NC 27858

℅: 919-757-6336 ◎ www.ecu.edu/art/home.html
Open: 10-5 Mo-We, Fr & Sa, 10-8 Th **Closed:** Su LEG/HOL!, ACAD/HOL
&.: Ramp, elevators ℗: Limited metered **Sculpture Garden**
Permanent Collection: CONT;AF

One of the largest contemporary art galleries in North Carolina. Reopens Jan 2000 call for information unavailable at press time **NOT TO BE MISSED:** Print portfolio, Larry Rivers 'The Boston Massacre'; African Art Collection.

ON EXHIBIT 2001

01/08/2001 to 01/27/2001 INVENTIONS AND CONSTRUCTIONS: NEW BASKETS
An exhibition sponsored by Florida craftsmen and curated by Jane Sauer. Contemporary Trends in Fiber Arts

02/09/2001 to 03/07/2001 INTERNATIONAL PHOTOGRAPHY AND DIGITAL IMAGE BIENNIAL
Biennnial competition sponsored by Qualex.

HICKORY

Hickory Museum of Art

243 Third Ave. NE, Hickory, NC 28601

℅: 704-327-8576
Open: 10-5 Tu-Fr, 10-4 Sa, 1-4 Su **Closed:** Mo LEG/HOL!
&. ℗ **Museum Shop**
Permanent Collection: AM: all media 19,20 ; ART POTTERY; AM: Impr

The second oldest art museum in North Carolina and the first in the southeast US to collect American art, the museum is located in one of Hickory's finest examples of neo-classic revival architecture. **NOT TO BE MISSED:** William Merritt Chase painting (untitled).

Wilkes Art Gallery

800 Elizabeth Street, North Wilkesboro, NC 28659

☎: 910-667-2841
Open: 10-5 Tu-Fr, 12-4 Sa **Closed:** Su, Mo 1/1, EASTER, EASTER MONDAY, 7/4, 12/25
&: Entrance ways & bathrooms ℗ **Museum Shop**
Permanent Collection: REG & CONT: all media

This 80 year old neighborhood facility which was formerly the Black Cat presents monthly changing exhibitions often featuring minority artists.

RALEIGH

North Carolina Museum of Art

2110 Blue Ridge Road, Raleigh, NC 27607-6494

☎: 919-715-5923 ◙ www.ncartmuseum.org
Open: 9-5 Tu-Th, Sa, 9-9 Fr, 11-6 Su **Closed:** Mo, LEG/HOL!
& ℗ **Museum Shop** ¶: Cafe serves lunch daily & dinner Fr 5:30-8:45
Group Tours: 919-839-6262, ext. 2145 **Docents** **Tour times:** 1:30 daily
Permanent Collection: EU/OM: ptgs; AM: ptgs 19; ANCIENT ART; AF; REG; JEWISH CEREMONIAL ART

The Kress Foundation, in 1960, added to the museum's existing Permanent collection of 139 prime examples of American and European artworks, a donation of 71 masterworks. This gift was second in scope and importance only to the Kress bequest to the National Gallery in Washington, D.C. **NOT TO BE MISSED:** Kress Collection.

ON EXHIBIT 2001

10/21/2000 to 01/07/2001 DESIGNING IN RAFFIA: KUBA EMBROIDERIES FROM THE CONGO
Exhibiting this collection as a group will enable the design and technique to be appreciated.

North Carolina State University Gallery of Art & Design

Cates Ave. University Student Center, Raleigh, NC 27695-7306

☎: 919-515-3503 ◙ www.fis.ncsu.edu/visualarts
Open: 12-8 We-Fr, 2-8 Sa, Su **Closed:** Mo, Tu, ACAD!
& ℗ ¶ **Group Tours:** 919-515-3503
Permanent Collection: AM: cont, dec/art, phot, outsider art, textiles, ceramics, paintings

The Center hosts exhibitions of contemporary arts and design of regional and national significance and houses research collections of photography, historical and contemporary ceramics, textiles, glass and furniture.

TARBORO

Blount Bridgers House/Hobson Pittman Memorial Gallery

130 Bridgers Street, Tarboro, NC 27886

☎: 252-823-4159 ◙ www2.coastalnet.com/ng3f3w5rm
Open: 10-4 Mo-Fr, 2-4 Sa, Su **Closed:** LEG/HOL!, good Fri, Easter
ADM: Adult: $2.00 & ℗: Street **Docents** **Tour times:** Mo-Fr 10-4, Sa, Su, 2-4
Permanent Collection: AM: 20; DEC/ART

Blount Bridgers House/Hobson Pittman Memorial Gallery- continued

In a beautiful North Carolina town, the 1808 Plantation House and former home of Thomas Blount houses decorative arts of the 19th Century and the Hobson Pittman (American, 1899-1972) Collections of paintings and memorabilia. **NOT TO BE MISSED:** "The Roses," oil, by Hobson Pittman.

WILMINGTON

St. John's Museum of Art

114 Orange Street, Wilmington, NC 28401
☏: 910-763-0281 **◙** www.stjohnsmuseum.com
Open: 10-5 Tu-Sa, 12-4 Su **Closed:** Mo, LEG/HOL!
Vol./Contr.: ADM: Adult: $3.00 **Children:** $1.00 under 18
&: Ramp, elevators **℗** **Museum Shop Docents**
Permanent Collection: AM: ptgs, sculp

Housed in three architecturally distinctive buildings dating back to 1804, St. John's Museum of Art is the primary visual arts center in southeastern North Carolina. The Museum highlights two centuries of North Carolina and American masters. **NOT TO BE MISSED:** Mary Cassatt color prints.

WINSTON-SALEM

Reynolda House, Museum of American Art

Reynolda Road, PO Box 11765, Winston-Salem, NC 27116
☏: 336-725-5325, 888-663-1149 **◙** www.reynoldahouse.org
Open: 9:30-4:30 Tu-Sa, 1:30-4:30 Su **Closed:** Mo, 1/1, THGV, 12/25
ADM: Adult: $6.00 **Children:** $3.00 **Students:** $3.00 **Seniors:** $5.00
& **℗** **Docents**
Permanent Collection: AM: ptgs 18-present; HUDSON RIVER SCHOOL; DOUGHTY BIRDS

Reynolda House, an historic home designed by Charles Barton Keen, was built between 1912 and 1917 by Richard Joshua Reynolds, founder of R.J. Reynolds Tobacco Company, and his wife, Katharine Smith Reynolds. **NOT TO BE MISSED:** Costume Collection.

ON EXHIBIT 2001
Spring 2001 BUTTONS AND BOWS: FASHION INFORMING PORTRAITURE

Southeastern Center for Contemporary Art

750 Marguerite Drive, Winston-Salem, NC 27106
☏: 910-725-1904 **◙** www.secca.org
Open: 10-5 Tu-Sa, 2-5 Su **Closed:** Mo, LEG/HOL!
ADM: Adult: $3.00 **Children:** Free under 12 **Students:** $2.00 **Seniors:** $2.00
&: Main floor in the galleries only. Not accessible to 2nd floor **℗:** Free **Museum Shop**
Group Tours: 910-725-1904, Ext 14 **Sculpture Garden**
Permanent Collection: Non-collecting institution

Outstanding contemporary art being produced throughout the nation is showcased at the Southeastern Center for Contemporary Art, a cultural resource for the community and its visitors.

FARGO

Plains Art Museum

704 First Avenue North, Fargo, ND 58102-2338

☎: 702-232-3821 ◙ www.plainsart.org
Open: 10-5 Mo, 10-8 Tu, Th, 10-6 We-Fr, Sa, 12-6 Su **Closed:** Mo, LEG/HOL!
ADM: Adult: $3.00 **Children:** $2.00 **Students:** $2.50 **Seniors:** $2.50
& ℗ **Museum Shop** ⅋
Group Tours: ext 101
Permanent Collection: AM/REG;NAT/AM;AF;PHOT 20

The historically significant warehouse which has been turned into a state of the art facility. It blends the old with the new with a result that is both stunning and functional. Large Permanent collection. 9,000 feet of exhibit space. **NOT TO BE MISSED:** Hannaher's Inc. Print Studio: a working printmaking studio and revolving exhibit on third floor.

ON EXHIBIT 2001

03/2000 to 06/2001 A STORY OF LAND AND PEOPLE: ARTISTIC EXPLORATION AND INNOVATION SINCE LEWIS AND CLARK

10/26/2000 to 01/07/2001 HIDDEN TREASURES: LOCAL COLLECTIONS REVEALED
Many local art patrons have expressed an interest in sharing their collections with the community for a short time. Themes such as collecting, connoisseurship and care of private collections will be explored. An eclectic mixture will be pesented, decorative arts to contemporary conceptual work.

12/07/2000 to 02/11/2001 ENDI POSKOVIC
An internationally known printmaker, Poskovic will be the first artist brought to the museum to do a special exhibition and printmaking residency. A Bosnian by birth, Poskovic's technically exquisite mixed process prints explore a wealth of issues, some touching on the recent events in former Yugoslavia.

01/18/2001 to 02/25/2001 NANCY RANDALL
This exhibition explores the artist's journey of aging—termed a warrior's quest by Randall. Her art is about the transformation of myths through time and among cultures; not unlike the transformation of the individual from infancy to old age. Using 6 large-scale mixed media drawings, etchings and an original digital music score the installation will immerse viewers in the artist's journey.

03/15/2001 to 05/20/2001 THEODORE WADDELL: A RETROSPECTIVE
One of Montana's most important contemporary artists, featuring 45–55 paintings, sculptures, and works on paper. Waddell's unique body of work can stand among contemporary greats even though it represents subjects uniquely western and of Montana—the rodeo, cattle, hunting, and a rough and ready lifestyle. Different from other shows because it traces the artist's work all the way back to his minimalist roots and also hits on his most recent sculpture.

04/26/2001 to 06/24/2001 TERRY KARSON & SARA MAST
This husband and wife team from Montana blend their work seamlessly into a meditation on a world overrun with disposable objects. Mast is a painter and Karson a sculptor and graphic designer. Their colorful, joint installation of paintings and "collections" questions what we consider of value in modern society. What might be interpreted as junk and debris is manipulated and repackaged as art.

07/12/2001 to 09/09/2001 FRITZ SCHOLDER
Native Minnesotan, and internationally recognized artist Scholder will collaborate with the Museum in an exhibition/residency. This exhibit will survey work that addresses the themes of Eros and Death and will include some new large-scale work. Scholder will spend a week at the Museum to visit with local artists, create a limited edition print and participate in a gala dinner. *Catalog*

GRAND FORKS

North Dakota Museum of Art
Affiliate Institution: University of North Dakota
Centennial Drive, Grand Forks, ND 58202

☎: 701-777-4195 **◙** www.ndmoa.com
Open: 9-5 Mo-Fr, 1-5 Sa, Su **Closed:** 7/4, THGV, 12/25
 ♿ **Ⓟ:** Metered on street **Museum Shop** **‼:** Coffee bar **Sculpture Garden**
Permanent Collection: CONT: Nat/Am; CONT: reg ptgs, sculp; REG HIST (not always on display)

In ARTPAPER 1991 Patrice Clark Koelsch said of this museum, "In the sparsely populated state that was the very last of all the US to build an art museum, . . . (The North Dakota Museum of Art) is a jewel of a museum that presents serious contemporary art, produces shows that travel internationally, and succeeds in engaging the people of North Dakota."

BUILDING FOR THE 21ST CENTURY: The Museum in cooperation with 2 local architectural firms, will sponsor a year long series of lectures and seminars addressing the building or re-building of urban spaces from a global perspective.

AKRON

Akron Art Museum
70 East Market Street, Akron, OH 44308-2084

☎: 330-376-9185 ◙ www.akronartmuseum.org
Open: 11-5 daily **Closed:** Mo, LEG/HOL!
 ₱: $2.00; free for members
Group Tours: 330-376-9185, ext 229 **Docents** **Tour times:** Museum hours, free guided tour 2:30 S **Sculpture Garden**
Permanent Collection: EDWIN C. SHAW COLLECTION; AM: ptgs, sculp, phot

Conveniently located in the heart of downtown Akron, the Museum offers three floors of galleries exhibiting art from collections across the country and abroad. The museum's own collection presents a distinctive look at some of the finest regional, national and international art from 1850 to the present, with special focus on contemporary art and photography. **NOT TO BE MISSED:** Claus Oldenberg's "Soft Inverted Q," 1976; The Myers Sculpture Courtyard.

ATHENS

Kennedy Museum of Art
Affiliate Institution: Ohio University
Lin Hall, Athens, OH 45701-2979

☎: 740-593-1304 ◙ www.ohiou.edi/museum
Open: 12-5 Tu, We, Fr; 12-8 Th; Sa, Su, 1-5 **Closed:** Mo, LEG/HOL!
Vol./Contr.: yes
 & ₱
Permanent Collection: NAT/AM; AM art

Housed in the recently renovated 19th century Lin Hall, the Museum collections include the Edwin L. and Ruth Kennedy Southwest Native American, American textiles and jewelry, and the Martha and Foster Harmon Collection which is on long term loan.

ON EXHIBIT 2001

12/17/2000 to 02/04/2001 THE INTIMATE COLLABORATION: PRINTS FROM THE TEABERRY PRESS
The output of this press produced an outstanding stylistic and methodological trends including Abstract Impressionism, Minimalism, conceptualism, Geometric Abstraction, and Realism. *Will Travel Brochure*

12/17/2000 to 02/04/2001 WALT KUHN: AN IMAGINARY HISTORY OF THE WEST
Painted between 1918 and 1920 as a series, the West remained an interest for all of his life.

CANTON

Canton Museum of Art
1001 Market Ave. N., Canton, OH 44702

☎: 330-453-1034 ◙ www.cantonart.org
Open: 10-5 & 7-9 Tu-Th, 10-5 Fr, Sa, 1-5 Su **Closed:** Mo, 1/1, THGV, 12/25
Vol./Contr.: Yes
 & ₱ **Museum Shop**
Group Tours: 330-453-7666 **Sculpture Garden**
Permanent Collection: WORKS ON PAPER; AM & EU: ptgs 19-20; CER: after 1950

Located in the Cultural Center for the Arts, the Canton Museum of Art is the only visual arts museum in Stark County. A mix of Permanent with traveling exhibitions creates a showcase for a spectrum of visual art. **NOT TO BE MISSED:** Painting by Winslow Homer "Girl Picking Clover."

OHIO

Canton Museum of Art - continued

ON EXHIBIT 2001

11/24/2000 to 01/21/2001 **AESTHETIC ECLECTICS: FRAN AND TOM LEHNERT**

11/25/2000 to 02/25/2001 **BY HAND OR BY WHEEL: PERMANENT COLLECTION**

02/02/2001 to 02/25/2001 **CANTON ARTISTS LEAGUE: LOCALPALOOZA**

02/22/2001 to 06/01/2001 **ALICE SHILLE—OHIO ARTIST**

04/22/2001 to 07/22/2001 **TOOLS OF THE TRADE: DRAWING WITH CRAYON, INK AND PENCIL—PERMANENT COLLECTION**

06/09/2001 to 08/11/2001 **POTTERS OF MATA ORTIZ: SANDY SMITH PHOTOS OF ORTIZ POTTERS**
Will Travel

08/19/2001 to 10/28/2001 **AMERICAN LANDSCAPES FROM THE PAINE ART CENTER & ARBORETUM**
The Paine Museum started collecting prints of the Depression era including Thomas Hart Benton and Grant Wood, as well as Edward Redfield. All the artists painted and studied directly from nature. *Will Travel*

08/19/2001 to 10/28/2001 **GEORGE ORR: A POTTER BEFORE HIS TIME**

08/19/2001 to 10/28/2001 **STILL LIFES: PERMANENT COLLECTION**

11/22/2001 to 02/24/2002 **VIOLA FREY: CLAY FIGURES AND DRAWINGS**

11/22/2001 to 02/24/2002 **SUMMERTIME AND THE LIVING IS EASY: PERMANENT COLLECTION**

CINCINNATI

Cincinnati Art Museum

935 Eden Park Drive, Cincinnati, OH 45202-1596
☏: 513-639-2995 ◉ www.cincinarttiartmuseum.org
Open: 10-5 Tu-Sa, 12-6 Su **Closed:** Mo, 1/1, THGV, 12/25
Free Day: Sa **ADM: Adult:** $5.00 **Children:** Free under 17 **Students:** $4.00 **Seniors:** $4.00
 ⧉ ⓟ: Free **Museum Shop** ⑾
Group Tours: 513-639-2975 **Docents** **Tour times:** 1pm weekdays, 1 & 2 pm weekends **Sculpture Garden**
Permanent Collection: AS; AF; NAT/AM: costumes, textiles; AM & EU: ptgs, dec/art, gr, drgs, phot

The oldest museum west of the Alleghenies, the Cincinnati Art Museum's collection includes the visual arts of the past 6,000 years from almost every major civilization in the world. **NOT TO BE MISSED:** "Undergrowth with Two Figures," Vincent van Gogh, 1890.

ON EXHIBIT 2001

10/29/2000 to 01/14/2001 **EUROPEAN MASTERPIECES: FIVE CENTURIES OF PAINTINGS FROM THE NATIONAL GALLERY OF VICTORIA, AUSTRALIA**
Works from the 15th to the 20th century including El Greco, Rembrandt, Gainsborough, Reynolds, Monet, Manet, Picasso, Bonnard and Hockney. Adult Admission $12. *Will Travel*

02/18/2001 to 05/06/2001 **HALF PAST AUTUMN: THE ART OF GORDON PARKS**
All aspects of his varied career will be included in the first traveling Gordon Parks retrospective. Considered by many to be an American renaissance man, Parks, a filmmaker, novelist, poet and musician is best known as a photojournalist whose powerful images deliver messages of hope in the face of adversity. *Will Travel*

Cincinnati Art Museum- continued

03/01/2001 to 05/27/2001 THE HUMAN COMEDY: DAUMIER AND HIS CONTEMPORARIES
Drawn from the CAM Permanent collection, these lithographs set a standard for social satire.

06/17/2001 to 09/02/2001 TREASURES FOR A QUEEN: A MILLENNIUM GIFT TO CINCINNATI
The exhibit pays tribute to the Queen City's most astute collectors who have donated significant masterworks to the Museum. It covers all media, ancient, African, the Americas, and Asian art.

06/30/2001 to 09/23/2001 AN ADDED DIMENSION: SCULPTORS AS PRINTMAKERS
Fifty prints by artists working in the last half of the 20th century who are known for their sculpture.

Contemporary Arts Center

115 E. 5th St., Cincinnati, OH 45202-3998

☎: 513-345-8400 ◘ www.spiral.org
Open: 10-6 Mo-Sa, 12-5 Su **Closed:** LEG/HOL!
Free Day: Mo **ADM: Adult:** $3.50 **Children:** Free under 12 **Students:** $2.00 **Seniors:** $2.00
♿ Ⓟ: Pay garage 1 block away under Fountain Square **Museum Shop**
Group Tours: 513-345-8400
Permanent Collection: Non-collecting Institution

This is one of the first contemporary art museums in the United States, founded in 1939. Art of today in all media including video is presented.

ON EXHIBIT 2001

to 03/25/2001 VIDEO INSTALLATION FESTIVAL: SCOPOPHILIA: PLEASURE IN LOOKING
A five part exhibition starting in November 2000, and continuing 1/3/01-1/28/01, 1/31/01-2/25-01, 2/28/01-3/25/01. The presentations employ video, film and multi-media.

09/01/2000 to 01/14/2001 LEAF LEAP (ALL THE WORLD'S LEAVES) INTERACTIVE ART FOR CHILDREN AND FAMILIES

11/11/2000 to 01/14/2001 ANTONI TAPIES: SECRET SCRIBBLES
The Spanish artist Tapies speaks through works that are rich in symbolism in both sculptures and mixed media paintings.

01/03/2001 to 01/28/2001 DOMINIQUE GONZALEZ-FOERSTER, PHILIPPE PARRENO, PIERRE HUYGHE: ABOUT (1999)
Three separate Parisian artists' works are layered so that as they play separately, viewers can stil see the glow from the two off-view pieces as the third takes center stage. This unique video, commissioned by Contemporary Arts Center Trustee Andrew Stillpass, suggests the voyeuristic tendencies of viewers who may feel as if they are spying into someone's private life.

01/03/2001 to 01/28/2001 JEREMY BLAKE: BUNGALOW 8 (1999)
Transforming from computer-generated columns of colored blocks like paint swatches to scenes suggesting burning incense balls and starlit nights, Jeremy Blake provokes the imagination with his dream-like computer paintings. Black Swan, Façade and Hotel Safe, three separate works that comprise Bungalow 8, straddle the border between photography and painting, creating an environment that challenges the viewer's sense of reality.

01/20/2001 to 04/01/2001 CARTER SMITH: SHIBORI UNBOUND
Smith tie-dyes more than 20,000 yards of fabric per year, each distinct in itself.

01/20/2001 to 04/01/2001 EILEEN COWIN: STILL (and all)
The notion of truth in photography is put to the test and concepts of truth versus fiction in Cowin's work. She uses images which summon memories and symbols found in everyday life.

01/31/2001 to 02/25/2001 GILLIAN WEARING: DRUNK (1999)
Stumbling into a stark white room, a drunkard laughs and soon is joined by another, who also seems to be enjoying the silliness sometimes associated with intoxication. With Drunk, filmed in luscious black and white, British artist Gillian Wearing continues her project of documenting neighborhood carousers, who slip easily from frame to frame. Walking the line between classic documentary and contemporary fiction, Wearing's subjects are displaced from their original context.

Contemporary Arts Center- continued

01/31/2001 to 02/25/2001 PIPILOTTI RIST: EXTREMITIES (1999)
Like a disco ball scatters its broken light around a room, so Pipilotti Rist tosses about eyes, noses, mouths, breasts and penises in Extremities. With just two projectors, the imagery dances and floats about all four walls producing a dazzling environment that is simultaneously hypnotizing and relaxing. Rist recently had a retrospective at the Musée des Beaux-Arts de Montréal, a solo exhibit at New York's Luhring Augustine Gallery and the Musée de la Ville de Paris.

02/07/2001 to 06/07/2001 NANCY DAVIDSON: CRYSTAL BLUE PERSUASION
Balloons make people smile. Fitted into lingerie, corsets and fishnet stockings, they become a tribute to femininity and elicit humorous responses.

02/28/2001 to 03/25/2001 JANE & LOUISE WILSON: GAMMA (1999)
Using abstracted imagery to investigate an abandoned British-based American military facility, sisters Jane and Louise Wilson create a world that is darkly surreal. Employing some of their signature stylistic devices—corner diptychs, Rorschach imagery, spinning machinery and scanning cameras—the Wilsons have developed a somber reminder of some of the world's darker days. Gamma was recently part of the Carnegie International.

02/28/2001 to 03/25/2001 PHYLLIS BALDINO: NANOCADABRA (1999)
With the advent of nanotechnology, scientists are only beginning to realize the possibilities of molecularly scaled motors, sensors, gear trains, pumps and atomic points. Phyllis Baldino's nanocadabra visualizes the impending concepts of nanotechnology, giving form to nonexistent objects. In nanocadabra, Baldino depicts well over 50 make-believe microscopic technological developments and projects them onto four giant seven foot screens.

04/07/2001 to 06/10/2001 GERDA STEINER & JORG LENZLINGER: THE SEED SOUNDS OF THE VEGETATIVE NERVOUS SYSTEM OF THE HYDROPONIC NECTAR-LAKE
These Swiss artists create a giant garden with crystal flowers, artificial arrangements and live vegetation. The colors of the crystal flowers are formed with fertilizer and salt and will "grow" at the exhibition. *Will Travel*

04/07/2001 to 06/17/2001 DAVID BUNN: DOUBLE MONSTER
Bunn has used the retired library card catalog and developed visually and lyrically inspiring work. He creates poetry that pays homage to the cast off and unwanted.

06/23/2001 to 08/19/2001 ADRIAN PIPER: A RETROSPECTIVE 1965-2000
Piper's work offers insight to defeating racist and sexist attitudes. Included will be "pre-conceptual" paintings, photographs from the late 60's, installations and drawings from the 80's, and explorations of friendship, mortality and spirituality. The video portion hints at her politically charged multi-media work

06/23/2001 to 08/26/2001 BARRE SAETHRE
The Norwegian artist adds mystery to his familiar living environment by incorporating hidden motion pictures into unexpected places. The hidden video's often confront intimacy and sexuality.

06/23/2001 to 08/26/2001 PAUL HENRY RAMIREZ: ELEVATIOUS TRANSCENDSUALISTIC
Dots, squiggles, lines, drips and spatters, all cheerfully colored. The forms are suggestive of body parts which sprout hair or excrete fluids.

Taft Museum of Art

316 Pike Street, Cincinnati, OH 45202-4293

☎: 513-241-0343 ◙ www.taftmuseum.org
Open: 10-5 Mo-Sa, 1-5 Su & HOL! **Closed:** 1/1, THGV, 12/25
Free Day: We **ADM: Adult:** $4.00 **Children:** Free under 8 **Students:** $2.00 **Seniors:** $2.00
& ℗: Limited free parking **Museum Shop**
Group Tours: 513-241-0343, x17 **Docents** **Tour times:** by appt, 10 am to 4 pm
Permanent Collection: PTGS; CH: Kangzi-period cer; FR/REN: Limoges enamels; EU & AM: furniture 19

Collections include masterpieces by Rembrandt, Hals, Gainsborough, Turner and Corot, arranged within the intimate atmosphere of the 1820 Baum-Longworth-Taft house, a restored Federal-period residence. **NOT TO BE MISSED:** "At The Piano" 1858-59 by James A. McNeill Whistler; French Gothic ivory Virgin and Child from the Abbey Church of St. Denis, ca. 1260.

Taft Museum of Art - continued

ON EXHIBIT 2001

10/20/2000 to 01/28/2001 SMALL PAINTINGS FROM THE TAFT COLLECTION
Landscapes, portraits and scenes of everyday life are the focus of the founder's collection.

11/17/2000 to 02/19/2001 ! HEAVEN AND NATURE SING: AN ITALIAN BAROQUE NATIVITY FROM THE COLLECTION OF FRANCESCA PEREZ DE OLAQUER ANGELON (tentative)
Emphasizing the place of the Christmas story in the everyday lives of people.

12/08/2000 to 02/19/2001 HEAVEN AND EARTH SEEN WITHIN: SONG CERAMICS FROM THE BARRON COLLECTION
These Song dynasty ceramics (960-1279) include white wares, celadons, brown and black glazed wares.

02/09/2001 to 05/27/2001 FOCUS EXHIBITION FROM THE RAIBLE-HOSKINS COLLECTION
Late 19th and early 20th century French graphics.

03/09/2001 to 05/20/2001 ! DRAWINGS AND WATERCOLORS BY JOHN SINGER SARGENT FROM THE CORCORAN GALLERY OF ART
The exhibition will trace portrait studies, landscapes and preparatory drawings for his mural at the Museum of Fine Arts, Boston.

CLEVELAND

Cleveland Museum of Art

11150 East Blvd, Cleveland, OH 44106

☎: 216-421-7350 ◘ www.clevelandart.org
Open: 10-5 Tu, Th, Sa, Su, 10-9 We, Fr **Closed:** Mo, 1/1, 7/4, THGV, 12/25
& ℗: Pay and street **Museum Shop** ¶¶
Group Tours: 216-421-7340, ext 380 **Docents** **Tour times:** by appt **Sculpture Garden**
Permanent Collection: ANCIENT: Med, Egt, Gr, R; EU; AM; AF; P/COL; OR; phot, gr, text, drgs

One of the world's major art museums, The Cleveland Museum of Art is known for the exceptional quality of its collections with exquisite examples of art spanning 5,000 years. Especially noteworthy are the collections of Asian and Medieval European art and the renovated 18th-20th c galleries. A portion of the museum includes a wing designed in 1970 by Marcel Breuer.

Some special exhibitions have admission fees. **NOT TO BE MISSED:** Guelph Treasure, especially the Portable Altar of Countess Gertrude (Germany, Lower Saxony, Brunswick, c 1040; gold, red porphyry, cloisonné, enamel, niello, gems, glass, pearls; "La Vie" by Picasso; "Burning of the Houses of Parliament" by J. M. W. Turner; Frans Hals' "Tideman Roostermin;" works by Faberge.

ON EXHIBIT 2001

10/21/2000 to 01/93/2001 YASUHIRO ISHIMOTO PHOTOGRAPHS: TRACES OF MEMORY
This selection of his recent work concentrates on evocative, abstract studies of clouds, leaves and footprints.

11/12/2000 to 02/04/2001 VICTOR SCHRECKENGOST AND 20TH-CENTURY DESIGN
For 93 years the artist has pioneered work in painting, ceramics, sculpture and industrial design. This is the first retrospective of his work as a major contributor to 20th-century design.

12/17/2000 to 02/11/2001 FABRIC OF ENCHANTMENT: INDONESIAN BATIK FROM THE NORTH COAST OF JAVA FROM THE INGER MCCABE ELLIOT COLLECTION
The development of batik is told by examination of wearers and makers.

02/25/2001 to 05/06/2001 CONSERVING THE PAST FOR THE FUTURE (working title)
The four main sections will be: what is conservation; the role of conservation at the Cleveland Museum of Art; examination technique; treatments.

Cleveland Museum of Art- continued

03/18/2001 to 06/03/2001 ANTIOCH: THE LOST ANCIENT CITY
Included are some of the finer mosaics and a variety of objects including coins, frescoes, glass sculpture and metalwork within their architectural and cultural environments.

05/27/2001 to 08/05/2001 THE MODEL WIFE
Nine photographers examine a sub-genre of portraiture: the portrait of the wife. Included are Baron Adolph de Mayer in the 19th century as well as Alfred Stieglitz, Weston, Callahan, Gowin, Fukase, Freidlander, Furuya and Nixon.

07/15/2001 to 09/16/2001 JAPANESE SCREENS FROM THE CLEVELAND MUSEUM OF ART (working title)
Screens from the 15th to the early 19th centuries. Included will be Japanese style colorful works and more subdued ink painting of Chinese subjects. The exhibition will be shown in two sections, each 4 weeks long.

08/26/2001 to 10/28/2001 FRENCH 18TH AND 19TH CENTURY PRINTS FROM THE CLEVELAND MUSEUM OF ART
The exhibition compliments Muriel Butkin's collection and features the 1890 color lithography in France including Toulouse-Lautrec and Bonnard.

08/26/2001 to 10/28/2001 FRENCH MASTER DRAWINGS FROM THE COLLECTION OF MURIEL BUTKIN
18th and 19th century works by masters including Boucher, Saint-Aubin, Gericault, Millet and Degas.

10/21/2001 to 01/06/2002 PICASSO: THE ARTIST'S STUDIO
Sixty paintings and a limited number of works on paper represent the styles, periods and genre of his work.

11/18/2001 to 01/27/2002 THE STAMP OF IMPULSE: ABSTRACT IMPRESSIONIST PRINTS
Prints from 1942-1975 surveying the diverse approach and stylistic and technical experimentation. Included are Pollock, de Kooning, Gottlieb, Diebenkorn and Oliveira.

COLUMBUS

Columbus Museum of Art

480 East Broad Street, Columbus, OH 43215

✆: 614-221-6801 ◙ www.columbusart.mus.oh.us
Open: 10-5:30 Tu, We, Fr-Su, 10-8:30 Th **Closed:** Mo, LEG/HOL!
Sugg./Contr.: Yes
Free Day: Th 5:30-8:30 **ADM: Adult:** $4.00 **Children:** 5 and under free; 6 and older $2.00 **Students:** $2.00 **Seniors:** $2.00
& **℗:** $2.00; free for members **Museum Shop** **❮❮:** Palette Café
Group Tours: 614-629-0359 **Docents Tour times:** Fr noon, Su 2 **Sculpture Garden**
Permanent Collection: EU & AM: ptgs 20; Reg

Located in downtown Columbus in a Renaissance-revival building, the Museum is an educational and cultural center for the people of central Ohio, dedicated to the pursuit of excellence in art through education, collections, and exhibitions. Features in-depth collections connected to this region including wood carvings by Columbus Folk Artist Elijah Pierce and paintings by Columbus native George Bellows. **NOT TO BE MISSED:** Eye Spy: Adventures in Art, an interactive exhibition for children and families. On view through 2001.

ON EXHIBIT 2001

11/15/1998 through 2001 EYE SPY: ADVENTURES IN ART
An interactive center featuring 4 areas there through games, computer stations, and "make and take" art projects, visitors take a behind-the-scenes look at museums, learn about Dutch paintings of the 1600's, the carvings of Elijah Pierce, and ancient treasures from Mexico.

11/04/2000 to 02/07/2001 A BOUNTIFUL PLENTY: FOLK ART FROM THE SHELBURNE MUSEUM
One of America's premiere collections of folk art is that of Electra Havermeyer Webb. She was a visionary collector who established folk art as a respected and serious field.

Columbus Museum of Art - continued
01/06/2001 to 03/2001 INSTALLATION BY ILYA AND EMILIA KABOKOV

01/13/2001 to 04/29/2001 ALCHEMY OF ENTRANCEMENT: ILLUMINATED PHOTOGRAPHS BY CONNIE SULLIVAN
A new series including processes such as 3-D technology.

02/23/2001 to 04/15/2001 YOUNG AMERICA: THE VIEW FROM THE EAST
The paintings and sculptures from the 18th and 19th centuries reflect life in New England and the mid-Atlantic regions and reveal a growing self awareness of optimism of the new nation. *Will Travel*

04/06/2001 to 05/20/2001 THE FRAME IN AMERICA: 1860-1960
The tools, materials and methods used in gilding and frame manufacturing. Included are Whistler's reed frames, Renaissance frames by Stanford White and painted frames by American Modernists John Marin and Lee Gatch.

05/05/2001 to 09/02/2001 THE ART OF HUMANE PROPAGANDA: PHOTOGRAPHS OF THE FARM SECURITY ADMINISTRATION DURING THE GREAT DEPRESSION
Vintage prints and photographs by Louis Hine which were used to make the public aware of the deplorable conditions in rural areas to support the progressive agricultural programs of the Roosevelt administration.

06/08/2001 to 08/25/2001 HOPE PHOTOGRAPHS
These bear witness to the fact that art can overcome contemporary malaise. The artists, documentary and journalistic photographers as well as fine arrt practitioners include works from the second half of the 20th century. Included are works by Adams, Peress, Garduno, Sultan, Nixon, Michaels, Hiro, Callahan, Eggleston, Webb, Steernfeld, Goldin, Meyerowitz, Solomon, and Sherman.

10/08/2001 to 12/02/2001 CHARASAMVARA MANDALA

Schumacher Gallery
Affiliate Institution: Capital University
2199 East Main Street, Columbus, OH 43209-2394

☎: 614-236-6319
Open: 1-5 Mo-Fr, 2-5 Sa **Closed:** Su, LEG/HOL!; ACAD!; Closed May through August & University holidays
 ♿ ℗
Permanent Collection: ETH; AS; REG; CONT; PTGS, SCULP, GR 16-19

In addition to its diverse 2000 object collection, the gallery, located on the 4th floor of the University's library building, hosts exhibitions which bring to the area artworks of historical and contemporary significance.

Wexner Center for the Arts
Affiliate Institution: The Ohio State University
1871 N. High Street, Columbus, OH 43210-1393

☎: 614-292-3535 ▣ www.wexarts.org
Open: 10-6 Tu, We, Fr-Sa, 10-9 Th,12-6 Su **Closed:** Mo, LEG/HOL!
Free Day: Th 5-9 **ADM: Adult:** $3.00 **Children:** Free under 12 **Students:** $2.00 **Seniors:** $2.00
♿ ℗: pay garage nearby **Museum Shop** ‖: Café 8am-4 pm Mo-Fr; limited service during exhibitions 4pm-8pm Thurs; 11am-3pm Sa; Noon-4pm Su
Group Tours: 614-292-6982 **Docents** **Tour times:** 1:00 Su
Permanent Collection: Small Collection of ART OF THE 70's

Located on the campus of The Ohio State University, the Wexner Center is a multidisciplinary contemporary arts center dedicated to the visual, performing, and media arts with a strong commitment to new work. Its home, designed by Peter Eisenmann and the late Richard Trott, has been acclaimed as a landmark of postmodern architecture. **NOT TO BE MISSED:** Maya Lin's Groundswell, a Permanent outdoor sculpture made of shattered glass.

OHIO

Wexner Center for the Arts - continued

ON EXHIBIT 2001

01/27/2001 to 04/15/2001 IMAGINARY FORCES
A Los Angeles based firm is known for its virtuosic editing and animation techniques and metaphoric imagery.

01/27/2001 to 04/15/2001 PERFECT ACTS OF ARCHITECTURE
Between 1977 and 1987 a sluggish world economy curtailed new building. The "paper architecture" of incomparable beauty and depth erupted. Five architects are identified in this exhibition, Rem Koolhaas, Bernard Tschumi, Peter Eisenman, Daniel Libeskind, and Thom Mayne. These have all earned international reputation for their built works.

01/27/2001 to 04/15/2001 THE PREDATOR: FABIAN MARCACCIO AND GREGG LYNN
Wexner Residency award recipients they have collaborated on a painting/architecture inspired by the movie "The Predator." They join these interests in cultural, technical and intellectual pursuits to create an overwhelming spectacle.

01/27/2001 to 04/15/2001 SCOTT BURTON FURNITURE
Burton's furniture was highly acclaimed and featured at the Venice Biennale and Documenta.

05/12/2001 to 08/12/2001 AS PAINTING: DIVISION AND DISPLACEMENT
New perspectives on the evolution of painting in the U.S. and Europe since the 1960's. Painting's relationships with other media will feature established artists and emerging or lesser known painters.

05/12/2001 to 08/12/2001 JOHAN VAN DER KEUKEN: FROM THE BODY TO THE CITY
Although he has been widely honored as a filmmaker, his gallery installations have never been on view in the U.S.

DAYTON

Dayton Art Institute
456 Belmonte Park North, Dayton, OH 45405
☎: 937-223-5277 **◉** www.daytonartinstitute.org
Open: 10-5 daily, 10-9 Th
 ♿ Ⓟ **Museum Shop** **⎮⎮:** Café Monet 11-4 daily, 5-8:30 Th
Group Tours: 937-223-5277, ext 337 **Docents** **Tour times:** Tu-Su 12 & 2, Th 7 **Sculpture Garden**
Permanent Collection: AM; EU; AS; OCEANIC; AF; CONT; PRE/COL

The Dayton Art Institute is located at the corner of Riverview Avenue and Belmonte Park North in a Edward B. Green designed Italian Renaissance style building built in 1930. **NOT TO BE MISSED:** "Water Lilies," by Monet; "Two Study Heads of an Old Man" by Rubens; "St. Catherine of Alexandria in Prison," by Preti; "High Noon," by Hopper.

ON EXHIBIT 2001
12/16/2000 to 03/04/2001 OUT OF AFRICA: MASTERWORKS FROM THE DAYTON COLLECTION

Wright State University Galleries
Affiliate Institution: Wright State University
A 128 CAC Colonel Glenn Highway, Dayton, OH 45435
☎: 937-775-2978 **◉** www.wright.edu/artgalleries
Open: 10-4 Tu-Fr, 12-5 Sa, Su **Closed:** ACAD!
♿ Ⓟ
Permanent Collection: PTGS, WORKS ON PAPER, SCULP 20

The Museum is located on the Wright State University campus.

Wright State University Galleries- continued
ON EXHIBIT 2001

01/02/2001 to 01/28/2001 PETAH COYNE
A recent body of work which is cumulatively titled "Fairy Tales" is dominated by the element of hair which entangles, groups, consumes, and strengthens the objects about which it is wrapped.

02/11/2001 to 03/18/2001 A THOUSAND STORIES: CONTEMPORARY NATIVE AMERICAN ARTISTS
Painting, printmaking, sculpture and installation with video are presented.

04/01/2001 to 05/06/2001 THE STILL LIFE PROJECT: THE ZEUXIS GROUP
An association of 19 still life painters that explores the many possibilities of the genre today.

GRANVILLE

Denison University Gallery
Burke Hall of Music & Art, Granville, OH 43023
℡: 740-587-6255
Open: 1:00-4 daily **Closed:** ACAD!
&: Includes parking on ground level ℗
Group Tours: on request
Permanent Collection: BURMESE & SE/ASIAN; EU & AM: 19; NAT/AM

Located on the Denison University Campus.

KENT

Kent State University Art Galleries
Affiliate Institution: Kent State University
Kent State University, School of Art, Kent, OH 44242
℡: 330-672-7853
Open: 10-4 Mo-Fr; 2-5 Su **Closed:** Sa, ACAD!
& Museum Shop
Permanent Collection: GR & PTGS:Michener coll; IGE COLL:Olson photographs; GROPPER PRINTS: (political prints)

Operated by the School of Art Gallery at Kent State University since its establishment in 1972, the gallery consists of two exhibition spaces both exhibiting Western and non-Western 20th century art and craft.

LAKEWOOD

Cleveland Artists Foundation at the Beck Center for the Arts
17801 Detroit Ave, Lakewood, OH 44107
℡: 216-227-9507 ◙ www.clevelandartist.org
Open: 1-6 Tu, Th, Fr, Sa **Closed:** Su, Mo, We LEG/HOL!
& ℗: Free
Group Tours: by appt.
Permanent Collection: Reg. Ptgs, sculpt, gr

The Cleveland Artists Foundation is a non-profit arts organization located at the Beck Center for the Arts. The Cleveland Artists Foundation shows five exhibits a year on art of the Northeast Ohio region.

OHIO

Cleveland Artists Foundation at the Beck Center for the Arts- continued

ON EXHIBIT 2001

12/09/2000 to 02/25/2001 SUPERIOR QUALITY: RORIMER BROOKS DESIGN IN CLEVELAND

03/19/2001 to 05/27/2001 GEOMETRIC ABSTRACTIONISTS

06/09/2001 to 08/26/2001 WORKS FROM THE CAF COLLECTION

09/2001 to 10/2001 THE SECOND OHIO PRINT BIENNIAL

11/2001 to 12/2001 PHOTOGRAPHY EXHIBIT

OBERLIN

Allen Memorial Art Museum
Affiliate Institution: Oberlin College
87 North Main Street, Oberlin, OH 44074
(: 440-775-8665 **◙** www.oberlin.edu/-allenart
Open: 10-5 Tu-Sa,1-5 Su **Closed:** Mo, LEG/HOL!
Vol./Contr.: Yes
&: Through courtyard entrance **℗:** Free **Museum Shop**
Group Tours: 440-775-8048 **Sculpture Garden**
Permanent Collection: DU & FL: ptgs; CONT/AM: gr; JAP: gr; ISLAMIC: carpets

Long ranked as one of the finest college or university art collections in the nation, the Allen continues to grow in size and distinction. The museum's landmark building designed by Cass Gilbert was opened in 1917. **PLEASE NOTE:** The Weitzheimer/Johnson House, one of Frank Lloyd Wright's Usonian designs, was recently opened. It is open on the first Sunday and third Saturday of the month from 1-5pm with tours on the hour. Admission is $5.00 pp with tickets available at the Museum. **NOT TO BE MISSED:** Hendrick Terbrugghen's "St. Sebastian Attended by Irene," 1625; Modigliani "Nude With Coral Necklace."

OXFORD

Miami University Art Museum
Affiliate Institution: Miami University
Patterson Ave, Oxford, OH 45056
(: 513-529-2232
Open: 11-5 Tu-Su **Closed:** Mo, LEG/HOL! ACAD!
& **℗**
Permanent Collection: AM: ptgs, sculp; FR: 16-20; NAT/AM; Ghandharan, sculp

Designed by Walter A. Netsch, the museum building is located in an outstanding natural setting featuring outdoor sculpture.

ON EXHIBIT 2001
Through 08/2001 WILLIAM HOLMES McGUFFEY: BUILDING FOR THE FUTURE
This exhibition offers visitors an opportunity to see the most important objects from the McGuffey Museum while the University implements Phase I of a Historic Preservation Master Plan. The 1833 house is a National Historic Landmark.

Miami University Art Museum - continued

11/03/2000 to 01/28/2001 MILLENNIUM MESSAGES
Part of the Presidential Millennium Series for the Arts, this exhibition features the work of 20 to 25 major artists, architects and designers who have been invited to make time capsules filled with either existing artifacts or specially made ones to convey 20th century achievements, values, or issues.

10/31/2000 to 01/07/2001 JACK MEANWELL: RECENT WORKS
Jack Meanwell, an established Cincinnati artist, paints dramatic landscapes and figures with vivid bold colors and energetic brushstrokes. His bright, abstract images are infused with power and originality. Meanwell achieves the desired effect by using big brushes, oversize chalks and blunt pencils.

PORTSMOUTH

Southern Ohio Museum and Cultural Center

825 Gallia Street, Portsmouth, OH 45662

☎: 740-354-5629
Open: 10-5 Tu-Fr, 1-5 Sa, Su **Closed:** Mo, LEG/HOL!
Free Day: Fr **ADM: Adult:** $1.00 **Children:** $0.75 **Students:** $0.75 **Seniors:** $1.00
& **℗:** Free on street and municipal lot **Museum Shop**
Group Tours: 740-354-5629 **Docents** **Tour times:** by arrangement
Permanent Collection: PORTSMOUTH NATIVE ARTIST CLARENCE CARTER; ANT: doll heads

Constructed in 1918, this beaux art design building is located in the heart of Portsmouth.

ON EXHIBIT 2001

02/09/2001 to 03/23/2001 THE OBJECT CONSIDERED
Contemporary still life from 31 artists from Ohio, Indiana and Illinois.

04/06/2001 to 05/19/2001 HOT AND COOL: CONTEMPORARY GLASS WORKS
Examples of "hot" processes like marquetry, fusing, slumping, casting and enameling as well as "cool" processes like polishing, cutting, engraving, grinding and sandblasting. These prove that glassmaking has moved beyond craft to become an exciting medium.

07/2001 to 08/2001 OHIO DESIGNER CRAFTSMEN BEST OF 2001
A huge juried exhibition featuring all mediums.

SPRINGFIELD

Springfield Museum of Art

107 Cliff Park Road, Springfield, OH 45501

☎: 937-325-4673 ◘ www.spfld-museum-of-art.org
Open: 9-5 Tu, Th, Fr, 9-9 We, 9-3 Sa, 2-4 Su **Closed:** Mo, MEM/DAY, 7/4, LAB/DAY, THGV WEEKEND, 12/24-1/1
& ℗ **Museum Shop**
Group Tours: 937-324-3729 **Docents** **Tour times:** by appt
Permanent Collection: AM & EU: 19,20; ROOKWOOD POTTERY; REG: ptgs, works on paper

Located in Cliff Park along Buck Creek in downtown Springfield, this 54 year old institution is a major and growing arts resource for the people or Southwest Ohio. Its 1,400 piece Permanent collection attempts to provide a comprehensive survey of American art enhanced by works that represent all of the key movements in the development of Western art during the past two centuries. **NOT TO BE MISSED:** Gilbert Stuart's "Portrait of William Miller," 1795.

OHIO

Springfield Museum of Art - continued

ON EXHIBIT 2001

03/13/2000 to 04/15/2001 NANCY FLETCHER CASSELL: RECENT WORK
Cincinnati installation artist Nancy Fletcher Cassell transforms the Chakeres Gallery with an array of her organic, environmental and sensual drawings.

04/21/2000 to 05/27/2001 GEORGE HAGEMAN: RECENT WORK
Formally derived from Oriental prototypes and decorated with traditional American salt glaze techniques, Dayton (Ohio's) George Hageman's ceramic vessels are evocative, sophisticated and beautiful.

04/21/2000 to 05/27/2001 TOMOKO PARRY: RECENT WORKS
This Japanese-American Artist, now living in Dayton Ohio presents 30 of her expressive, lush and lavish floral watercolors and drawing in her first, solo exhibition.

TOLEDO

Toledo Museum of Art
2445 Monroe Street, Toledo, OH 43697
☎: 419-255-8000 **◙** www.toledomuseum.org
Open: 10-4 Tu-Th, Sa, 10-10 Fr, 11-5 Su **Closed:** Mo, 1/1, 7/4, THGV, 12/25
& **℗:** $1.00 in lot on Grove St. **Museum Shop** **¶**
Group Tours: x 352 **Docents** **Tour times:** by appt
Permanent Collection: EU: glass, ptgs, sculp, dec/art; AM: ptgs; AF;IND;OR **∩**

Founded in 1901 by Edward Drummond Libbey of Libbey Glass, the Museum is internationally known for the quality and depth of its collections. Housed in a perfectly proportioned neo-classical marble building designed by Edward Green, the Museum features American, European, African, Chinese, and Indian art, along with strength in glass and decorative arts. Award winning architect Frank Gehry designed the adjacent Center for the Visual Arts which opened in 1993. **NOT TO BE MISSED:** "The Crowning of St. Catherine" Peter Paul Rubens, 1633; "The Architect's Dream" Thomas Cole, 1840.

ON EXHIBIT 2001

11/03/2000 to 01/07/2001 WILLIAM BLAKE: ILLUSTRATIONS OF THE BOOK OF JOB
"The Book Of Job"(1825) is the most important set of line engravings executed by Blake. To highlight this major work, 60 watercolors, drawings and engravings have been assembled to investigate the position, aesthetic and spiritual implications of this work in Blake's career.

12/22/2000 to 03/11/2001 THE MONUMENTAL PARIS OF CHARLES MERYON
Widely recognized as the greatest printmaker of the 19th century. The museum houses the most significant collection in this country.

02/03/2001 to 04/01/2001 dada Dada dada daDA dada
Enjoy the chaos and irrationality of Dada. The artists working in the early years of the 20th century attempted to break down all barriers in the definition of art. Also included will be dada poetry and sounds.

03/02/2001 to 05/27/2001 EGYPTIAN TREASURES FROM THE BRITISH MUSEUM
Covering a time span of 3,000 years the exhibition contains a wide range of objects, large and small, from temple and tomb of outstanding quality.

04/13/2001 to 07/01/2001 DON'T FEED THE BOOKS: BIRDS, BUGS, AND BESTIARIES IN THE BAREISS COLLECTION
Traditional and modern depictions of animals. Historically the bestiary is a mixture of fact, myth, rumor, fable and legend. So will be this exhibition.

Toledo Museum of Art - continued

04/18/2001 to 06/03/2001 FRAMING THE DREAM: GEORGE W. STEVENS
As second director of the Museum, Stevens was a driving force in shaping the Museum and its educational programs.

08/05/2001 to 01/05/2002 STAR WARS: THE MAGIC OF MYTH
Original artwork, props, models, costumes, characters and other artifacts used to create the original Star Wars Trilogy. *Will Travel*

08/10/2001 to 10/07/2001 BRICKS AND MORTAR: AN INSTITUTION EVOLVES
Photographs and documents tracing the building from a rented commercial space to a converted house, to a marble building.

11/18/2001 to 01/06/2002 LITHOGRAPHS BY JAMES MCNEILL WHISTLER FROM THE COLLECTION OF STEVEN BLOCK
Whistler elevated lithographs from a commercial to a fine art and conveyed the luminous qualities of the Impressionists in his images.

YOUNGSTOWN

Butler Institute of American Art
524 Wick Ave, Youngstown, OH 44502

☎: 330-743-1711 **◎** www.butlerart.com
Open: 11-4 Tu-Th-Sa, 11-8 We, 12-4 Su **Closed:** Mo, 1/1, EASTER, 7/4, THGV, 12/25
& **℗:** adjacent **Museum Shop** ⅋: adjacent
Group Tours: 330-743-1711, ext 114 **Docents** **Tour times:** by appt **Sculpture Garden**
Permanent Collection: AM: ptgs 19,20; EARLY/AM: marine coll; AM/IMPR; WESTERN ART; AM: sports art

Dedicated exclusively to American Art, this exceptional museum, containing numerous national artistic treasures is often referred to as "America's Museum." It is housed in a McKim, Mead and White building that was the first structure erected in the United States to house a collection of American art. **NOT TO BE MISSED:** Winslow Homer's "Snap the Whip," 1872, oil on canvas.

ZANESVILLE

Zanesville Art Center
620 Military Road, Zanesville, OH 43701

☎: 740-452-0741
Open: 10-5 Tu, We, Fr, 10-8:30 Th, 1-5 Sa, Su **Closed:** Mo, LEG/HOL
& ℗ **Museum Shop** **Docents**
Permanent Collection: ZANESVILLE: cer; HAND BLOWN EARLY GLASS; CONT; EU

In addition to the largest public display of Zanesville art pottery (Weller, Roseville & J. B. Owens), the Art Center also has a generally eclectic collection including Old and Modern Masters, African, Oriental and European, Indian, Pre-Columbian, Mexican and regional art. **NOT TO BE MISSED:** Rare areas (unique) hand blown glass & art pottery; 300 year old panel room from Charron Garden, London.

OKLAHOMA

Charles B. Goddard Center for Visual and Performing Arts

First Ave & D Street SW, Ardmore, OK 73401
☎: 405-226-0909
Open: 9-4 Mo-Fr, 1-4 Sa, Su **Closed:** LEG/HOL!
&: North parking and entrance ⓟ
Permanent Collection: PTGS, SCULP, GR, CONT 20; AM: West/art; NAT/AM

Works of art by Oklahoma artists as well as those from across the United States & Europe are featured in this multicultural center.

Woolaroc Museum

Affiliate Institution: The Frank Phillips Foundation, Inc
State Highway, 123, Rt 3, Box 2100, Bartlesville, OK 74003
☎: 918-336-0307 ◙ www.woolaroc.org
Open: 10-5 Tu-Su, Mem day-Lab day 10-5 daily **Closed:** Mo, THGV, 12/25
ADM: Adult: $5.00 **Children:** Free under 12 **Students:** $4.00 **Seniors:** $4.00
& ⓟ **Museum Shop** ¶¶: Snack bar w/sandwiches, etc.
Group Tours: school 6th grade & und free, gr 7-12 $2 **Sculpture Garden**
Permanent Collection: WEST: ptgs; sculp, firearms

Brilliant mosaics surround the doors of this museum situated in a wildlife preserve. The large Western art collection includes Remington, Russell, Leigh and others. On the upper level is the Woolaroc monoplane, winner of the 1927 race across the Pacific to Hawaii. **NOT TO BE MISSED:** The Lodge is a separate building. The original country home of oilman Frank Phillips called his Lodge (built in 1926-27) is completely restored.

Five Civilized Tribes Museum

Agency Hill, Honor Heights Drive, Muskogee, OK 74401
☎: 918-683-1701 ◙ thefivecivilizedtribesmseum.org
Open: 10-5 Mo-Sa, 1-5 Su **Closed:** 1/1, THGV, 12/25
ADM: Adult: $2.00 **Children:** Free under 6 **Students:** $1.00 **Seniors:** $1.75
& ⓟ **Museum Shop** **Docents**
Permanent Collection: NAT/AM

Built in 1875 by the US Government as the Union Indian Agency, this museum was the first structure ever erected to house the Superintendency of the Cherokee, Chickasaw, Choctaw, Creek and Seminole Tribes.

NORMAN

Fred Jones Jr. Museum of Art
Affiliate Institution: University of Oklahoma
410 West Boyd Street, Norman, OK 73019-0525
☎: 405-325-3272 **◙** www.ou.edu/fjjma
Open: 10-4:30 Tu, We, Fr, 10-9 Th, 12-4:30 Sa, Su, Summer 12-4:30 Tu-Su **Closed:** Mo, LEG/HOL!; ACAD!; HOME FOOTBALL GAMES 10-4:30
&. **℗:** Free passes available at admission desk **Museum Shop**
Docents Tour times: 10 days advance notice req.
Permanent Collection: AM: ptgs 20; NAT/AM; PHOTO; cont cer; GR 16-present

Considered one of the finest university museums in the country with a diverse Permanent collection of nearly 6000 objects, it also hosts the states most challenging exhibitions of contemporary art. **NOT TO BE MISSED:** State Department Collection.

OKLAHOMA CITY

National Cowboy Hall of Fame and Western Heritage Center
1700 N.E. 63rd Street, Oklahoma City, OK 73111
☎: 405-478-2250 **◙** www.cowboyhalloffame.com
Open: 9-5 daily (Lab/Day-Mem/Day), 8:30-6 daily (Mem/Day-Lab/Day) **Closed:** 2/25, Thgvng, 1/1
ADM: Adult: $8.50 **Children:** 6-12 $4.00 **Seniors:** $7.00
&. ℗ **Museum Shop** ¶: overlooking gardens
Group Tours: ext. 277 **Docents Tour times:** 10:30; 11:00; 1:30 **Sculpture Garden**
Permanent Collection: WEST/ART

Housing the largest collection of contemporary Western art available for public view, this unusual and unique museum features work by Frederic Remington, Charles M. Russell, Charles Schreyvogel, Nicolai Fechin, and examples from the Taos School. Cowboy and Native historical exhibits from the Museum's impressive holdings are on display. New galleries are opening as expansion continues. Westerntown (14,000 sf), American Cowboy Gallery, American Rodeo Gallery now open. Joe Grandee Museum of the Frontier West. **NOT TO BE MISSED:** Gerald Balclair's 18' Colorado yule marble "Canyon Princess;" Wilson Hurley's 5 majestic landscape paintings, 7 ft bronze of former President Ronald Reagan.

Oklahoma City Art Museum
3113 Pershing Blvd, Oklahoma City, OK 73107
☎: 405-946-4477 **◙** www.oakhartmuseum.com
Open: 10-5 Tu-Sa, 10-9 Tu, 1-5 Su, Fairgrounds 10-8 Th **Closed:** Mo, LEG/HOL!
ADM: Adult: $3.50 **Children:** Free under 12 **Students:** $2.50 **Seniors:** $2.50
&. ℗ **Museum Shop** ¶: Lobby Bistro **Docents Sculpture Garden**
Permanent Collection: AM: ptgs, gr 19,20; ASHCAN SCHOOL COLLECTION

The Museum complex includes the Oklahoma City Art Museum at the Fairgrounds built in 1958 (where the design of the building is a perfect circle with the sculpture court in the middle). **NOT TO BE MISSED:** Works by Washington color school painters and area figurative artists are included in the collection of modern art from the former Washington Gallery.

OKLAHOMA

OMNIPLEX

2100 NE 52nd, Oklahoma City, OK 73111

☏: 405-609-6664 ◙ www.omniplex.org
Open: 9-6 Tu-Sa, 11-6 Su (Mem/Day-Lab/Day), 9:00-5 Tu-Fr, 9-6 Sa,11-6 Su (Winter months) **Closed:** THGV, 12/25, Mo (except Mo holidays)
ADM: Adult: $6.50 + tax **Children:** 3-12, $5.25 + tax **Students:** $6.50 **Seniors:** $5.75
& ℗: Free **Museum Shop** ⑪: Limited
Group Tours: 405-602-3732; 800-532-7652
Permanent Collection: VARIED; REG; AF; AS

Omniplex includes the Kirkpatrick Science and Air Space Museum; the International Photography Hall of Fame and Museum; Red Earth Indian Center as well as the Kirkpatrick Planetarium; Conservatory and Botanical Garden and numerous galleries. **NOT TO BE MISSED:** Sections of the Berlin Wall; traveling exhibits.

SHAWNEE

Mabee-Gerer Museum of Art

1900 West MacArthur Drive, Shawnee, OK 74801
☏: 405-878-5300
Open: 10-4 Tu-Sa, 1-5 Su **Closed:** 1/1, GOOD FRI, HOLY SA, EASTER, THGV, 12/25
Sugg./Contr.: ADM: Adult: $3.00 **Children:** $1.00 **Students:** $3.00 **Seniors:** $3.00
&: Ground level ramp access from parking ℗: Free **Museum Shop** **Sculpture Garden**
Permanent Collection: EU: ptgs (Med-20); AN/EGT; NAT/AM; GRECO/ROMAN; AM: ptgs

The oldest museum collection in Oklahoma. **NOT TO BE MISSED:** Egyptian mummy 32nd Dynasty and associated funerary and utilitarian objects.

TULSA

Gilcrease Museum

1400 Gilcrease Museum Road, Tulsa, OK 74127-2100
☏: 918-596-2700 ◙ www.gilcrease.org
Open: 9-5 Tu-Sa, 1-5 Su and Holidays, Mem Day-Lab Day open Mo **Closed:** Mo 12/25
Sugg./Contr.: ADM: Adult: $3.00 (Fam $5) **Children:** Free under 18
& ℗: Free **Museum Shop** ⑪: Rendezvous open 11-2 Tu-Su, Res.918-596-2720
Group Tours: 918-596-2712 **Docents** **Tour times:** 2pm daily **Sculpture Garden**
Permanent Collection: THOMAS MORAN, FREDERIC REMINGTON, C.M. RUSSELL, ALBERT BIERSTADT, ALFRED JACOB MILLER, GEORGE CATLIN, THOMAS EAKINS

Virtually every item in the Gilcrease Collection relates to the discovery, expansion and settlement of North America, with special emphasis on the Old West and the American Indian. The Museum's 460 acre grounds include historic theme gardens. **NOT TO BE MISSED:** "Shoshone Falls on the Snake River, Idaho," by Thomas Moran.

Philbrook Museum of Art Inc

2727 South Rockford Road, Tulsa, OK 74114

☎: 918-749-7941 or 800-324-7941 ◙ www.philbrook.org
Open: 10-5 Tu-Sa, 10-8 Th 11-5 Su **Closed:** Mo, LEG/HOL
Free Day: Twice each year (May and Oct) **ADM: Adult:** $5.00 plus tax **Children:** Free 12 & under
Students: $3.00 plus tax **Seniors:** $3.00 plus tax
♿ ℗: Free **Museum Shop** ‖: 11-2 Tu-Su, Su Brunch, Cocktails 5-7 Th
Group Tours: 918-749-5309 **Docents** **Tour times:** Upon request **Sculpture Garden**
Permanent Collection: NAT/AM; IT/REN: ptgs, sculp; EU & AM: ptgs 19-20;

An Italian Renaissance style villa built in 1927 on 23 acres of formal and informal gardens and grounds. The collections, more than 6000 works, are from around the world, more than half of which are by Native-Americans. Visitors enter a 75,000 square foot addition via a striking rotunda which was completed in 1990 and is used for special exhibitions, a shop, a restaurant.

ON EXHIBIT 2001

06/18/2000 to 01/14/2001 THE AGE OF CARICATURE: BRITISH SATIRICAL PRINTS FROM THE PERMANENT COLLECTION

03/27/2001 to 05/20/2001 WOVEN WORLDS: BASKETRY FROM THE CLARK FIELD COLLECTION OF NATIVE AMERICAN ART

06/10/2001 to 08/19/2001 WILLIAM MORRIS: MYTH, OBJECT AND THE ANIMAL
Sculptures of birds and beasts as well as 2 site specific installations in glass.

09/09/2001 to 11/04/2001 THE GILDED AGE: TREASURES FROM THE SMITHSONIAN'S NATIONAL MUSEUM OF AMERICAN ART
American paintings and sculpture from 1880-1915 highlighting the period when artists traveled abroad in large numbers.
Will Travel

OREGON

Coos Art Museum
235 Anderson, Coos Bay, OR 97420
€: 541-267-3901
Open: 10-4 Tu-Fr, 1-4 Sa **Closed:** Su, Mo, LEG/HOL!
&: Complete facilities ℗: Free **Museum Shop**
Permanent Collection: CONT: ptgs, sculp, gr; AM; REG

This cultural center of Southwestern Oregon is the only art museum on the Oregon coast. It's collection includes work by Robert Rauschenberg, Red Grooms, Larry Rivers, Frank Boyden, Henk Pander and Manuel Izquierdo. Newly added is the Prefontaine Room, a special memorial to the late Olympic track star who was a native of Coos Bay. **NOT TO BE MISSED:** "Mango, Mango," by Red Grooms.

University of Oregon Museum of Art
Affiliate Institution: University of Oregon
1430 Johnson Lane, Eugene, OR 97403
€: 541-346-3027 ◙ www.uoma.uoregon.edu
Open: 12-5 Th-Su, 12-8 We **Closed:** Mo, Tu, 1/ 1, 7/4, THGV, 12/25, ACAD
Free Day: We 5-8 **ADM: Adult:** $3.00
& **Museum Shop**
Group Tours: 541-346-0968 **Docents** **Tour times:** 2 pm Su
Permanent Collection: CONT: ptgs, phot, gr, cer; NAT/AM

Enjoy one of the premier visual art experiences in the Pacific Northwest. The second largest museum of in the state, the museum collection features more than 12,500 objects from throughout the world as well as contemporary Northwest art and photography. **NOT TO BE MISSED:** Museum Fountain Courtyard.

Favell Museum of Western Art and Indian Artifacts
125 West Main Street, Klamath Falls, OR 97601
€: 541-882-9996 ◙ www.favellmuseum.com
Open: 9:30-5:30 Mo, Sa **Closed:** Su, LEG/HOL!
ADM: Adult: $4.00 **Children:** $2.00 (6-16) **Seniors:** $3.00
& ℗ **Museum Shop Docents**
Permanent Collection: CONT/WEST: art; NAT/AM; ARTIFACTS; MINI FIREARMS

The museum is built on an historic campsite of the Klamath Indians. There are numerous artifacts—some of which have been incorporated into the stone walls of the museum building itself.

Douglas F. Cooley Memorial Art Gallery
Affiliate Institution: Reed College
3203 S.E. Woodstock Blvd., Portland, OR 97202-8199
℡: 503-777-7790 ◙ www.reed.edu/resources/gallery
Open: 12-5 Tu-Su **Closed:** Mo, LEG/HOL
& ℗: Adjacent
Permanent Collection: AM: 20; EU: 19

The gallery is committed to a program that fosters a spirit of inquiry and questions the status quo.

Portland Art Museum
1219 S.W. Park Ave., Portland, OR 97205
℡: 503-226-2811 ◙ www.pam.org/pam/
Open: 10-5 Tu-Su, 10-9 We (begin Oct thru winter) & 1st Th **Closed:** Mo, 12/25, Easter
ADM: Adult: $7.50 **Children:** Free under 5; $4 through 18 **Students:** $4.00 **Seniors:** $6.00
&: Ramp to main lobby, elevator to all floors **Museum Shop**
Group Tours: 506-276-4289 **Sculpture Garden**
Permanent Collection: NAT/AM, Asian, Cameroon, European, English Silver, American; Sculpture, Print;
Contemporary; and Northwest Regional ⌒

Don't miss the world-famous collections of the oldest art museum in the Pacific Northwest, with treasures spanning 35 centuries of European, American, Asian and contemporary art. **NOT TO BE MISSED:** Special Traveling Exhibition.

ON EXHIBIT 2001
09/30/2000 to 01/03/2001 OREGON'S 20TH CENTURY IN PHOTOGRAPHY
Drawn from the Permanent collections featured are important photographs made in Oregon in the past 100 years. Included are turn of the century platinum prints.

10/21/2000 to 01/10/2001 IN SEARCH OF THE PROMISED LAND: PAINTINGS BY FREDERIC EDWIN CHURCH

11/01/2000 to 01/10/2001 PAINTING REVOLUTION: KANDINSKY, MALEVICH AND THE RUSSIAN AVANT-GARDE
A unique exhibition from 13 Russian museums showing the style of painting that emphasized purer form—of colors, shapes and textures.

01/27/2001 to 04/08/2001 EMPIRE OF THE SULTANS: OTTOMAN ART FROM THE KHALILI COLLECTION
Every aspect of Ottoman art and the dynasty which spanned from the 13th century until 1922. Included are metalwork, armor, astronomical devices, illuminated manuscripts with gold leaf and delicate painting, and decorative arts including porcelain, carpets, silver, glass and brass objects.

04/26/2001 to 06/22/2001 REMINGTON, RUSSELL AND THE LANGUAGE OF WESTERN ART
A look at the two artists who have shaped our view of the American West in the 19th century.

OREGON

Museum at Warm Springs, Oregon

Affiliate Institution: Confederated Tribes of the Warm Springs Reservation

2189 Hwy 26, Warm Springs, OR 97761

☎: 541-553-3331

Open: 9am Open, Winter 5pm close; Summer 6pm close **Closed:** 12/25, 1/1, THGV
ADM: Adult: $6.00 **Children:** $3.00 5-12; Free under 5 **Seniors:** $5.00
&: Fully wheelchair accessible ℗ **Museum Shop**
Permanent Collection: NAT/AM: art, phot, artifacts

The Museum at Warm Springs draws from a rich collection of native artwork, photographs and stories that tell the long history of the three tribes (Wasco, Warm Springs and Paiute) that comprise the Confederate Tribes of Warm Springs. It is architecturally designed to evoke a creekside encampment among a stand of cottonwoods. **NOT TO BE MISSED:** A trio of traditional buildings built by tribal members; the tule mat wickiup, or house of the Paiutes, the Warm Springs summer teepee, and the Wasco wooden plank house.

ALLENTOWN

Allentown Art Museum

Fifth & Court Street, Allentown, PA 18105

℡: 610-432-4333 ⊙ www.regionline.com/~atownart
Open: 11-5 Tu-Sa, 12-5 Su **Closed:** Mo, LEG/HOL!
ADM: Adult: $4.00 **Children:** Free under 12 **Students:** $2.00 **Seniors:** $3.00
& ℗**:** On street meters and several pay garages **Museum Shop** ⑪**:** small cafe
Group Tours: 610-432-4333,ext. 32 **Docents** **Tour times:** by appt
Permanent Collection: EU: Kress Coll; AM; FRANK LLOYD WRIGHT: library; OM: gr; gem collection ◠

Discover the intricate and visual riches of one of the finest small art museums in the country. **NOT TO BE MISSED:** "Piazetti in Venice," by Canaletto.

AUDUBON

Mill Grove, The Audubon Wildlife Sanctuary

Pawlings and Audubon Roads, Audubon, PA 19407-7125

℡: 610-666-5593 ⊙ www.montcopa/org
Open: 10-4 Tu-Sa, 1-4 Su grounds open dawn to dusk Tu-Su **Closed:** Mo, 1/1, EASTER, 7/4, THGV, 12/24, 12/25, 12/31
Vol./Contr.: Yes &**:** first floor only ℗ **Museum Shop**
Group Tours: by appt 610-666-5593
Permanent Collection: JOHN JAMES AUDUBON:all major published artwork, (complete 19th C editions) and related items

Housed in the 1762 National Historic Landmark building which was the first American home of John James Audubon, artist/naturalist. This site is also a wildlife sanctuary complete with nature trails and feeding stations. Grounds self-guide map Free. **NOT TO BE MISSED:** Exceptionally large oil painting by Audubon called "Eagle and the Lamb."

BETHLEHEM

Lehigh University Art Galleries

Affiliate Institution: Zoellner Arts Center
420 East Packer Ave, Bethlehem, PA 18015-3007

℡: 610-758-3615
Open: 11-5 We-Sa; 1-5, Su; Some galleries are open late, others closed weekends ! **Closed:** Mo, Tu, LEG/HOL!
& ℗**:** Limited-on street; attached parking grarage $1.00 fee **Museum Shop** ⑪**:** In Iacocca Bldg. open until 2 pm
Sculpture Garden
Permanent Collection: EU & AM: ptgs; JAP: gr; PHOT

The Galleries do not permanently exhibit all the important works in its collections. Call to inquire. **NOT TO BE MISSED:** Outdoor sculpture throughout 3 Campuses, including work by Henry Moore, David Cerulli and Menash Kadishman.

ON EXHIBIT 2001

11/29/2000 to 02/25/2001 FOUR OUTSIDER ARTISTS: "THE END IS A NEW BEGINNING" AN INSTALLATION AT THE TURN OF MILLENNIUM
An installation exhibition by three of America's most notable self-taught "outsider" vionary artists, all of whom have been nationally and internationally acclaimed. Each artist's particular vision includes ritualistic constructions, two- and three-dimensional works, folk art and expressions connected to the coming of the new millennial age.

PENNSYLVANIA

Lehigh University Art Galleries- continued
03/14/2001 to 06/10/2001 BASEBALL ART FROM THE GLADSTONE COLLECTION
Included are works by John Marin, Ben Shahn, William Merrit Chase, Claus Oldenburg and Robert Rauchenberg. Ranging from fine art to folk art, the collection includes paintings, prints, sculpture and memorabilia that traces the history of America's National pastime.

BRYN ATHYN

Glencairn Museum: Academy of the New Church
1001 Cathedral Road, Bryn Athyn, PA 19009
☎: 215-938-2600 ◙ www.glencairnmuseum.org
Open: 9-5 Mo-Fr by appt, 2-5 selected second Su each month (Sept.-Nov; Feb-May) **Closed:** Sa, LEG/HOL!
ADM: Adult: $5.00 **Children:** under 5 free **Students:** $2.00 **Seniors:** $4.00
& ℗
Group Tours: 215-914-2993
Permanent Collection: MED, GOTHIC & ROMANESQUE: sculp; STAINED GLASS; EGT, GRK & ROMAN: cer, sculp; NAT/AM

Glencairn is a unique structure built in the Romanesque style using building processes unknown since the middle ages. It is the former home of Raymond and Mildred Pitcairn. **NOT TO BE MISSED:** French Medieval stained glass and sculpture.

CARLISLE

Trout Gallery, Weiss Center for the Arts
Affiliate Institution: Dickinson College
High Street PO Box 1773, Carlisle, PA 17013
☎: 717-245-1344 ◙ www.dickinson.edu/departments/trout
Open: 10-4 Tu-Su **Closed:** Mo, LEG/HOL!; ACAD!
& ℗
Group Tours: 717-245-1492
Permanent Collection: GR; 19,20; AF

The exhibitions and collections here emphasize all periods of art history. **NOT TO BE MISSED:** Gerofsky Collection of African Art and the Carnegie Collection of prints. Rodin's "St. John the Baptist" and other gifts from Meyer P. and Vivian Potamkin.

CHADDS FORD

Brandywine River Museum
U.S. Route 1, Chadds Ford, PA 19317
☎: 610-388-2700 ◙ www.brandywinemuseum.org
Open: 9:30-4:30 Daily **Closed:** 12/25
ADM: Adult: $5.00 **Children:** Free under 6 **Students:** $2.50 **Seniors:** $2.50
& ℗ **Museum Shop** ‖: 10-3 (Closed Mo and Tu, Jan through Mar)
Group Tours: 610-388-8366
Permanent Collection: AM: ptgs by three generations of the Wyeth Family

Situated in a pastoral setting in a charming converted 19th century grist mill, this museum is devoted to displaying the works of three generations of the Wyeth family and other Brandywine River School artists. Particular focus is also placed on 19th c American still-life & landscape paintings and on works of American illustration.

Brandywine River Museum - continued
ON EXHIBIT 2001
11/24/2000 to 01/14/2001 A BRANDYWINE CHRISTMAS
The museum celebrates the season with holiday diplays: an extensive O-gauge model railroad, a Victorian dollhouse, antique dolls from the collecion of Ann Wyeth McCoy, and thousands of natual "critter" ornaments on holiday trees.

01/28/2001 to 03/16/2001 FRAME IN AMERICA
More than 100 American frames that chronicles one of the most prolific and creative periods of American frame design.

03/24/2001 to 05/20/2001 WINSLOW HOMER AND HIS CONTEMPORARIES: AMRICAN PRINTS FROM THE METROPOLITAN MUSEUM OF ART

04/01/2001 to 11/19/2001 N. C. WYETH HOUSE AND STUDIO TOURS

09/08/2001 to 11/18/2001 WILLIAM TROST RICHARDS IN CHESTER COUNTY

11/23/2001 to 01/06/2002 THE SPIRIT OF DICKENS: "A CHRISTMAS CAROL" IN PICTURES

CHESTER

Widener University Art Collection and Gallery
Affiliate Institution: Widener University
14th and Chestnut Street, Chester, PA 19013
☎: 610-499-1189 ◙ www.widener.edu
Open: 10-4:30 We-Sa, 10-7 Tu (call for summer hours) **Closed:** Su, Mo, LEG/HOL
&. ℗: on street parking in addition to various university parking lots
Permanent Collection: AM & EU: ptgs 19, 20

The Gallery is located in the new University Center on 14th St on the main campus. It includes in its holdings the Widener University Collection of American Impressionist paintings, the Alfred O. Deshong Collection of 19th and 20th c European and American painting, 19th c Asian art, and pre-Columbian, and African pottery. **PLEASE NOTE:** Children under 16 must be accompanied by an adult.

COLLEGEVILLE

Philip and Muriel Berman Museum of Art at Ursinus College
Main Street, Collegeville, PA 19426-1000
☎: 610-409-3500 ◙ www.ursinus.edu
Open: 10-4 Tu-Fr, Noon-4:30 Sa, Su **Closed:** Mo, LEG/HOL!
Vol./Contr.: Yes
&. ℗: On campus adjacent to Museum
Group Tours: 609-409-3500 **Docents Tour times:** by appt **Sculpture Garden**
Permanent Collection: AM: ptgs 19,20; EU: ptgs 18; JAP: ptgs; PENNSYLVANIA GERMAN ART: cont outdoor sculp

With 145 works from 1956-1986, the Berman Museum of Art holds the largest private collection of sculpture by Lynn Chadwick in a U.S. museum, housed in the original Georgian Style stone facade college library built in 1921. **NOT TO BE MISSED:** "Seated Couple on a Bench" (1986 bronze), by Lynn Chadwick (English b. 1914).

ON EXHIBIT 2001
01/26/2000 to 04/08/2001 BEYOND THE WALL: 10 ARTISTS FROM BERLIN

10/10/2000 to 01/21/2001 PHILADELPHIA WATER COLOR CLUB 100TH ANNIVERSARY EXHIBITION
The year 2000 is the 100th anniversary of the Club.

PENNSYLVANIA

Philip and Muriel Berman Museum of Art at Ursinus College - continued
01/16/2001 to 03/09/2001 SCUPTURE BY CARL MILLES
Milles, best known in Sweden then worked with Rodin who directly influenced his work. As resident sculptor at Cranbrook Academy he became known as a premier designer of major public fountains.

03/13/2001 to 04/19/2001 ZELDA: BY HERSELF

09/08/2001 to 11/11/2001 CHALLENGE VI: LATHE-TURNED OBJECTS

11/17/2001 to 02/10/2002 CHESTER BEACH: THE FIGURE IN BRONZE

DOYLESTOWN

James A. Michener Art Museum
138 South Pine Street, Doylestown, PA 18901
☎: 215-340-9800 ◘ www.michenerartmuseum.org
Open: 10-4:30 Tu-Fr, till 9pm We, 10-5 Sa, Su **Closed:** Mo, LEG/HOL!
ADM: Adult: $5.00 **Children:** Free under 12 **Students:** $1.50 **Seniors:** $4.50
ᵬ ℗: Free **Museum Shop** ¶: Blu's Café
Group Tours: ext 126 **Docents** **Tour times:** 2pm, Sa, Su, & by appt
Sculpture Garden
Permanent Collection: AM: Impr/ptgs 19-20; BUCKS CO: 18-20; AM: Exp 20; SCULP 20; NAKASHIMA READING ROOM; CREATIVE BUCKS COUNTY

Situated in the handsomely reconstructed buildings of the antiquated Bucks County prison, the Museum features the finest collection of Pennsylvania Impressionist art in public or private hands and a wonderful collection of 19th and 20th century American art. **NOT TO BE MISSED:** Spectacular 22-foot mural, "A Wooded Watershed" by Daniel Garber.

ON EXHIBIT 2001
09/03/2000 to 02/11/2001 IN LINE WITH AL HIRCHFELD: AN AL HIRSCHFELD RETROSPECTIVE

10/99/2000 to 01/09/2001 INTIMATE VISTAS: THE POETIC LANDSCAPES OF WILLIAM LANGSON LATHROP
Lathrop was one of the most respected landscape painter in the beginning of the 20th C. He and his wife were instrumental in the formation of the New Hope Art Colony. Many of the works shown here have never been exhibited before.

12/16/2000 to 03/18/2001 BUCKS COUNTY FRAMEMAKERS

02/24/2001 to 05/20/2001 THE PHOTOGRAPHY OF ALFRED STEIGLITZ: GEORGIA O'KEEFFE'S ENDURING LEGACY

03/31/2001 to 05/24/2001 THE GIFT OF SYMPATHY: THE ART OF MAXO VANKA

04/21/2001 to 07/15/2001 THE DRAWINGS OF BEN SOLEWAY

EASTON

Lafayette College Art Gallery, Williams Center for the Arts
Hamilton and High Streets, Easton, PA 18042-1768
☎: 610-330-5361 ◘ www.lafayette.edu
Open: 10-5 Tu, Th, Fr; 10-8 We; 12-5 Mo, Su Sep-May **Closed:** Su, Mo, ACAD!
ᵬ ℗: On-street
Permanent Collection: AM: ptgs, portraits, gr

Located in Easton, Pennsylvania, on the Delaware River, the collection is spread throughout the campus. **NOT TO BE MISSED:** 19th c American history paintings and portraits.

ERIE

Erie Art Museum
411 State Street, Erie, PA 16501

☎: 814-459-5477 **◙** www.erieartmuseum.org
Open: 11-5 Tu-Sa, 1-5 Su **Closed:** Mo, LEG/HOL!
Free Day: We **ADM: Adult:** $2.00 **Children:** $.50 (under 12) **Students:** $1.00 **Seniors:** $1.00
& **℗:** Street parking **Museum Shop**
Group Tours: 814-459-5477 **Docents** **Tour times:** 11-5
Permanent Collection: IND: sculp; OR; AM & EU: ptgs, drgs, sculp gr; PHOT

The museum is located in the 1839 Greek Revival Old Customs House built as the U. S. Bank of PA. Building plans are underway to provide more gallery space in order to exhibit works from the 4,000 piece Permanent collection. **NOT TO BE MISSED:** Soft Sculpture installation "The Avalon Restaurant."

ON EXHIBIT 2001
12/05/2000 to 02/02/2001 PHOTOGRAPHS BY LISA AUSTIN
Three generations of Erie families with specific frame sizes accounting for each generation.

01/19/2001 to 03/18/2001 WORKS BY CLAUDIA KLEEFELD
An American figure painter, Kleefield's oil paintings are contemplative, mysterious glimpses of candid "behind the scenes" moments which leaves the viewer to wonder and explore the story behind the picture.

GREENSBURG

Westmoreland Museum of American Art
221 North Main Street, Greensburg, PA 15601-1898

☎: 412-837-1500 **◙** www.wmuseumaa.org
Open: 11-5 We-Su, 11-9 Th **Closed:** Mo, Tu, LEG/HOL!
Sugg./Contr.: ADM: Adult: $3.00 **Children:** Free under 12
& **℗:** Free **Museum Shop**
Docents **Tour times:** by appt
Permanent Collection: AM: ptgs (18-20), sculp, drgs, gr, fruniture, dec/art

This important collection of American art is located in a beautiful Georgian style building situated on a hill overlooking the city. **NOT TO BE MISSED:** Portraits by William Merritt Chase and Cecilia Beaux; Largest known collection of paintings by 19th century southwestern Pennsylvania artists.

HARRISBURG

State Museum of Pennsylvania
3rd and North Streets, Harrisburg, PA 17108-1026

☎: 717-787-7789
Open: 9-5 Tu-Sa, 12-5 Su **Closed:** Mo, LEG/HOL
&: 717-787-4979 **Museum Shop**
Group Tours: 717-772-6997 **Docents** **Tour times:** !
Permanent Collection: VIOLET OAKLEY COLL; PETER ROTHERMEL MILITARY SERIES; PA: cont

A newly renovated Art Gallery collecting, preserving, and interpreting contemporary art & historical works relating to Pennsylvania's history, culture and natural heritage is the main focus of this museum whose collection includes 4,000 works of art from 1650 to the present produced by residents/natives of Pennsylvania. **NOT TO BE MISSED:** The 16' x 32' "Battle of Gettysburg: Pickett's Charge," by P. F. Rothermel (the largest battle scene on canvas in North America).

INDIANA

University Museum
Affiliate Institution: Indiana University
John Sutton Hall, Indiana University of Pennsylvania, Indiana, PA 15705-1087
☎: 724-357-6495 ◙ www.iup.edu/fa/museum
Open: 11-4 Tu-Fr, 7-9 Th, 1-4 Sa, Su **Closed:** Mo, ACAD!
& ℗: Metered lot just East of the Student Center (next to the football stadium)
Group Tours: 724-357-6495
Permanent Collection: AM: 19,20; NAT/AM; MILTON BANCROFT: ptgs & drgs; INUIT: sculp

The University Museum at Indiana University of Pennsylvania, one of just three university museums in Pennsylvania, offers a diverse program of changing exhibits, related cultural events, and educational activities to the university community and residents of the four-county area. Each year, the museum stages more than ten exhibitions, designed to appeal to a variety of interests. Local, regional and international artists display contemporary works in a wide range of media. Special interdisciplinary exhibits explore the cultural heritage of the region and other themes from an aesthetic viewpoint. Rotating displays drawn from the museum's Permanent collection round out the exhibit schedule. The museum's Permanent collection, started in 1946 and refined during the early 1990s, consists of more than 5,000 works. An active program of new acquisitions focuses on American fine and folk art and native arts of North and Central America.

LEWISBURG

Bucknell Art Gallery
Affiliate Institution: Bucknell University
Seventh Street and Moore Ave, Lewisburg, PA 17837
☎: 570-577-3792
Open: 11-5 Mo-Fr, 1-4 Sa, Su **Closed:** LEG/HOL!
& ℗: Free **Museum Shop** ‖: Not in museum but in bldg. **Docents**
Permanent Collection: IT/REN: ptgs; AM: ptgs 19,20; JAP

The Permanent collection, which numbers approximately 8,000 objects has been established primarily through large bequests and gifts. Most impressive are the 24 items from the Samuel H. Kress Foundation,including the earliest documented painting by Pontormo, "Cupid and Apollo," a very early Rosso Fiorentino, "Madonna and Child," and works by Tintoretto, Veronese, Francesco Cossa, Agostino Tassi and Andrea Sansovino; the Andrew J. Sordoni Collection of Japanese art which includes 500 objects, mostly 19th century netsuke, okimono, and inro boxes of extremely high quality; and the Cook Collection of 156 musical instruments from all over the world and dating back as far as the 18th century. **NOT TO BE MISSED:** "Cupid and Apollo," by Pontormo.

LORETTO

Southern Alleghenies Museum of Art
Affiliate Institution: Saint Francis College
Saint Francis College Mall, P. O. Box 9, Loretto, PA 15940
☎: 814-472-3920 ◙ www.sama-sfc.org
Open: 10-5 Tu-Fr, 1:00-5:00 Sa, Su **Closed:** Mo, LEGHOL
& ℗ **Museum Shop** ‖: Nearby and on college campus
Group Tours: by appt **Docents** **Tour times:** by appt **Sculpture Garden**
Permanent Collection: AM: ptgs 19, 20; sculp; drwg; gr

Southern Alleghenies Museum of Art - continued

The museum was founded in 1976 to bring museum services to a geographically isolated rural region and to provide the audience with an opportunity to view important trends in American Art. The Museum received accreditation from the American Association of Museums in 1995. Also: Southern Alleghenies Museum of Art, Brett Bldg, 1210 11th Ave, Altoona, PA 16602; 814-946-4464. Southern Alleghenies Museum of Art at Johnstown, Pasquerilla Performing Arts Center, University of Pittsburgh at Johnstown, PA 15904; 814-946-4464. Southern Alleghenies Museum of Art at Ligonier Valley, One Boucher Lane, Route 711S, Ligonier, PA 15658; 724-238-6015. **NOT TO BE MISSED:** John Sloan's "Bright Rocks."

MERION STATION

Barnes Foundation
300 North Latch's Lane, Merion Station, PA 19066

C: 610-667-0290
Open: 9:30-5 Fr, Sa; 9:30-5-Su (Sept to June); 9:30-5 We-Fr July & Aug, Adv Reser only **Closed:** Mo-We, Mo-Th, 12/25
ADM: Adult: $5.00, additional $7.00 for audio
& Ⓟ **Museum Shop**
Group Tours: 610-667-0290
Permanent Collection: FR: Impr, post/Impr; EARLY FR MODERN; AF; AM: ptgs,sculp 20

The core of the collection includes a great many works by Renoir, Cezanne, and Matisse, but also contains works by Picasso, van Gogh, Seurat, Braque, Modigliani, Soutine, Monet and Manet. Various traditions are displayed in works by El Greco, Titian, Courbet, Corot, Delacroix and others. Works also include American antique furniture, ironwork, ceramics and crafts. The building has just undergone a 3 year, $12 million renovation. **NOT TO BE MISSED:** This outstanding collection should not be missed.

MILL RUN

Fallingwater
Rt. 381, Mill Run, PA 15464

C: 724-329-8501 Ⓞ www.paconserve.org
Open: 11/21-12/20, 2/27-3/14, weekends only, Xmas week 10-4 Tu-Su, Closed Jan/Feb **Closed:** Mo, some LEG/HOL!
ADM: Adult: $8.00 Tu-Fr; $12 wknds
& Ⓟ: Free **Museum Shop** ⁋: Open 5/1-11/1 **Sculpture Garden**
Permanent Collection: ARCH; PTGS; JAP: gr; SCULP; NAT/AM

Magnificent is the word for this structure, one of Frank Lloyd Wright's most widely acclaimed works. The key to the setting of the house is the waterfall over which it is built. Fallingwater is undergoing some renovation. Special hours are listed. 3/15-11/15 hours will be 10-4 Tu-Su 11/1-4/1 weekends only. **NOT TO BE MISSED:** View of the House from the Overlook.

PENNSYLVANIA

African-American Museum in Philadelphia
701 Arch Street, Philadelphia, PA 19106
℡: 215-574-0380 ◙ www.aampmuseum.org
Open: 10-5 Tu-Sa, 12-5 Su **Closed:** Mo, LEG/HOL
Free Day: Martin Luther King Jr. Day **ADM: Adult:** $6.00 **Children:** $4.00 **Students:** $4.00 **Seniors:** $4.00
& ℗: Pay parking nearby **Museum Shop**
Group Tours: x228
Permanent Collection: JACK FRANK COLL: phot; PEARL JONES COLL: phot drgs, dec/art: JOSEPH C. COLEMAN personal papers, photos and awards

A diverse and unique showplace, this is the first museum built by a major city to house and interpret collections of African-American art, history, and culture primarily in, but not limited to the Commonwealth of Pennsylvania. The museum contains over 300,000 objects.

ON EXHIBIT 2001
09/14/2000 to 04/01/2001 BIENNIAL EXHIBITION
Highlighting the regions finest artists working in several disciplines.

Institute of Contemporary Art
Affiliate Institution: University of Pennsylvania
118 South 36th Street at Sansom, Philadelphia, PA 19104-3289
℡: 215-898-7108 ◙ www.upenn.edu/ica
Open: 10-5 We, Fr-Su, 10-7 Th **Closed:** Mo, Tu, 1/1, 12/25
Free Day: Su 10-12 **ADM: Adult:** $3.00 **Children:** $2.00, Free under 12 **Students:** $2.00 **Seniors:** $2.00
& ℗: lots nearby
Group Tours: 215-898-7108 **Docents** **Tour times:** Th, 5:15
Permanent Collection: non-collecting institution

The Museum was founded in 1963 and is one of the premier institutions solely dedicated to the art of our time.

La Salle University Art Museum
Affiliate Institution: LaSalle University
20th and Olney Ave, Philadelphia, PA 19141
℡: 215-951-1221
Open: 11-4 Tu-Fr, 2-4 Su, Sep-Jul **Closed:** Sa, ACAD! & ℗: Campus lot
Permanent Collection: EU: ptgs, sculp, gr 15-20; AM: ptgs

Many of the major themes and styles of Western art since the Middle ages are documented in the comprehensive collection of paintings, prints, drawings and sculpture at this museum.

Museum of American Art of the Pennsylvania Academy of the Fine Arts
Broad Street and Cherry Street, Philadelphia, PA 19102
℡: 215-972-7600 ◙ www.pafa.org
Open: 10-5 Tu-Sa, 11-5 Su **Closed:** LEG/HOL!
Free Day: Su 3-5 **ADM: Adult:** $5.00 **Children:** $3.00 Free under 5 **Students:** $3.00 **Seniors:** $4.00
& ℗: Public parking lots near ($2.00 discount at Parkway Corp. lots at Broad & Cherry and 15th & Cherry); some street parking **Museum Shop** ‖ **Group Tours:** 215-972-1667 **Docents** **Tour times:** Tu-Fr 11:30-1:30; Su & Su 12-2pm
Permanent Collection: AM: ptgs, sculp 18-20 ⌒

The Museum of American Art is housed in a Victorian Gothic masterpiece designed by Frank Ferness and George Hewitt located in the heart of downtown Philadelphia. Its roster of past students includes some of the most renowned artists of the 19th & 20th centuries.

Museum of American Art of the Pennsylvania Academy of the Fine Arts
- continued

ON EXHIBIT 2001

06/2001 to 09/2001! HERO WORSHIP?: REDEFINING HISTORY PAINTING IN THE TWENTIETH CENTURY
A thematic exhibition exploring the changing tradition of history painting from the postwar years through the present day. Artists included are Bo Bartlett, Eric Fischl, Vincent Desiderio, Sidney Goodman, Jacob Lawrence, Horace Pippin, Mark Tansey, and Grant Wood. *Will Travel*

10/14/2000 to 01/07/2001 AMERICAN WATERCOLORS AT THE PENNSYVANIA ACADEMY

10/14/2000 to 01/07/2001 AMERICAN WATERCOLORS AT THE PENNSYLVANIA ACADEMY: A CENTENNIAL CELEBRATION
18th-20th C. watercolors from the collection and local private collections.

10/31/2000 to 01/14/2001 PHILADELPHIA: ABOUT FACE

11/11/2000 to 02/25/2001 SELECTIONS FROM THE HAROLD A. & ANN R. SORGENTI COLLECTION OF CONTEMPORARY AFRICAN-AMERICAN ART
Installation of paintings, sculpture, and graphics from this major private collection currentoy on loan to PAFA.

02/10/2001 to 04/14/2001 NEW * LAND * MARKS: PUBLIC ART, COMMUNITY AND THE MEANING OF PLACE

03/02/2001 to 05/06/2001 NEYSA GRASSI

Summer 2001 to TBA ! KULICKE AND COMPANY

06/15/2001 to 09/02/2001 VIRGIL MARTI
Site specific works for the Tyler School.

06/29/2001 to 09/30/2001 AMERICAN SPECTRUM: PAINTING AND SCULPTURE FROM THE SMITH COLLEGE MUSEUM OF ART

09/2001 to 01/2002 PROCESS ON PAPER: EAKINS PAINTINGS FROM THE BREGLER COLLECTION
The first it's kind, the exhbition examines the importance of drawing in Eakin's artistic and teaching practices. *Brochure*

10/2001 to 02/2002 CECILIA BEAUX IN PHILADEPHIA
The exhibit features selected paintings, oil sketches, and graphics by Beaux, as well as related archival materials.

Philadelphia Museum of Art
26th Street & Benjamin Franklin Parkway, Philadelphia, PA 19130
☎: 215-763-8100 ◙ www.philamuseum.org
Open: 10-5 Tu-Su, 10-8:45 We **Closed:** Mo, LEG/HOL!
Free Day: Su 10-1 **ADM: Adult:** $8.00 **Children:** $5.00 **Students:** $5.00 **Seniors:** $5.00
& ⓟ: Free **Museum Shop** ‖: Tu-Sa 11:30-2:30, We 5-7:30, Su 11-3:30
Docents **Tour times:** on the hour 10-3 **Sculpture Garden**
Permanent Collection: EU: ptgs 19-20; CONT; DEC/ART; GR; AM: ptgs, sculp 17-20 ☊

With more than 400,000 works in the Permanent collection the Philadelphia Art Museum is the 3rd largest art museum in the country. Housed within its more than 200 galleries are a myriad of artistic treasures from many continents and cultures. **NOT TO BE MISSED:** Van Gogh's "Sunflowers;" A Ceremonial Japanese Teahouse; Medieval & Early Renaissance Galleries (25 in all) which include a Romanesque cloister, a Gothic chapel, and a world-class collection of early Italian & Northern paintings.

ON EXHIBIT 2001

10/22/2000 to 01/14/2001 VAN GOGH PORTRAITS
The Detroit Institute, The Boston Museum of Fine Arts, and the Philadelphia Museum have five major portraits. These will be joined by pivotal works from each part of his life. His intense portraits of friends in Paris as well as his success in capturing of his mostly poor and unnamed subjects earlier. *Will Travel*

PENNSYLVANIA

Rodin Museum

Benjamin Franklin Parkway at 22nd Street, Philadelphia, PA 19130

☎: 215-763-8100 ◉ www.rodinmuseum.org
Open: 10-5 Tu-Su **Closed:** Mo, LEG/HOL!
Sugg./Contr.: ADM: Adult: $3.00 **Students:** $3.00 **Seniors:** $3.00
& ℗**:** Free on-street **Museum Shop Docents Sculpture Garden**
Permanent Collection: RODIN: sculp, drgs

The largest collection of Rodin's sculptures and drawings outside of Paris is located in a charming and intimate building designed by architects Paul Cret and Jacques Greber. **NOT TO BE MISSED:** "The Thinker," by Rodin.

Rosenbach Museum & Library

2010 DeLancey Place, Philadelphia, PA 19103

☎: 215-732-1600 ◉ www.rosenbach.org
Open: 11-4 Tu-Su **Closed:** Mo, LEG/HOL! August thru 2nd Tu after Labor Day
Free Day: Bloomsday, June 16th **ADM: Adult:** $5.00 incl guide **Children:** $3.00 **Students:** $3.00 **Seniors:** $3.00
Museum Shop Docents
Permanent Collection: BRIT & AM: ptgs; MINI SCALE DEC/ARTS; BOOK ILLUSTRATIONS; Rare books and Manuscripts

In the warm and intimate setting of a 19th-century townhouse, the Rosenbach Museum & Library retains an atmosphere of an age when great collectors lived among their treasures. It is the only collection of its kind open to the public in Philadelphia. **NOT TO BE MISSED:** Maurice Sendak drawings.

Rosenwald-Wolf Gallery, The University of the Arts

Broad and Pine Streets, Philadelphia, PA 19102

☎: 215-717-6480 ◉ www.uarts.edu
Open: 10-5 Mo, Tu & Th, Fr, 10-8 We, 12-5 Sa, Su (10-5 weekdays Jun & Jul) **Closed:** ACAD!
& ℗**:** Pay garages and metered parking nearby
Group Tours: 215-717-6480
Permanent Collection: non-collecting institution

This is the only university in the nation devoted exclusively to education and professional training in the visual and performing arts. The gallery presents temporary exhibitions of contemporary art.

ON EXHIBIT 2001

02/19/2001 to 03/10/2001 CLAIRE VAN VLIET

03/19/2001 to 04/8/2001 DANIEL JOCZ: UNCOMMON SENSE

04/14/2001 to 05/12/2001 SACKNER COLLECTION

University of Pennsylvania Museum of Archaeology and Anthropology

Affiliate Institution: University of Pennsylvania
33rd and Spruce Streets, Philadelphia, PA 19104

☎: 215-898-4000 ◉ www.upenn.edu/museum
Open: 10-4:30 Tu-Sa, 1-5 Su **Closed:** Mo, LEG/HOL, closed Su Mem day-Lab day
ADM: Adult: $5.00 **Children:** Free under 6 **Students:** $2.50 **Seniors:** $2.50
& ℗ **Museum Shop** ¶¶
Group Tours: 215-898-4015 **Docents Tour times:** 1:30 Sa, Su (mid Sep-mid May)! **Sculpture Garden**
Permanent Collection: GRECO/ROMAN; AF; AN/EGT; ASIA; MESOPOTAMIA; MESOAMERICAN; POLYNESIAN; AMERICAS

University of Pennsylvania Museum of Archaeology and Anthropology - continued

Dedicated to the understanding of the history and cultural heritage of humankind, the museum's galleries include objects from China, Ancient Egypt, Mesoamerica, South America, North America (Plains Indians), Polynesia, Africa, and the Greco Roman world. **NOT TO BE MISSED:** Monumental archtetural pieces from the Palace of Merenptah.

ON EXHIBIT 2001

10/10/1999 to 02/25/2001 POMO INDIAN BASKET WEAVERS: THEIR BASKETS AND THE ART MARKET
125 superb examples of turn-of-the-century California Pomo basketry looks at the complex relationship of between art, artist and society, tradition and change and the outside market forces which influenced the Native American traditions in the 19th and 20th C.

04/16/2000 to 01/25/2001 CELEBRITY EYES IN A MUSEUM STOREROOM (tentative title)
In celebration of the millennium and the groundbreaking for the new Culture storage and Study Wing, international celebrities from diverse fields were invited to visit. Included are Kevin Bacon, actor Robert Runcie, 102nd Archbishop of Canterbury and Maha Chakri Sirindhorn, Princess of Thailand.

Woodmere Art Museum
9201 Germantown Ave, Philadelphia, PA 19118
℡: 215-247-0476
Open: 10-5 Tu-Sa, 1-5 Su **Closed:** Mo, 1/1, EASTER, 7/4, THGV, 12/25
ADM: Adult: $5.00 **Children:** Free under 12 **Students:** $3.00 **Seniors:** $3.00
♿ Ⓟ: Free **Museum Shop**
Group Tours: 215-247-0948
Permanent Collection: AM:ptgs 19,20, prints, gr, drgs; EU (not always on view); Art & Artists from the Philadelphia region

The Woodmere Art Museum, located in a mid 1850's Victorian eclectic house, includes a large rotunda gallery. The collection of local, Philadelphia area and Pennsylvania Impressionist art is outstanding. **NOT TO BE MISSED:** Benjamin West's "The Death of Sir Phillip Sydney."

ON EXHIBIT 2001

Spring 2001 to TBA ! ROBERT VENTURI: MOTHER'S HOUSE
Venturi is one of the world's most esteemed architects. Featured will be preliminary models and drawings for his mother's Chestnut Hill home.

02/2001 to 03/2001 61 ST ANNUAL JURIED EXHBITION

09/10/2000 to 01/28/2001 WOMEN IN THE HISTORY OF PHILIDELPHIA FINE ARTS: AN HISTORICAL SURVEY
An ambitious survey using works from the collection as well as loans of the work of women artists throughout the history of Philadelphia. *Catalog*

09/10/2000 to 01/21/2001 FROM WEST TO WYETH: SIXTY YEARS OF COLLECTING AND EXHIBITING THE ART OF PHILADELPHIA
In celebration of the Museum's 60th anniversary, and to present an historical array of art from the 18th Century to the present.

PITTSBURGH

Andy Warhol Museum
117 Sandusky Street, Pittsburgh, PA 15212-5890
℡: 412-237-8300 ▣ www.warhol.org and www.warholstore.com
Open: 10-5 We-Su; until 10pm Fri **Closed:** Mo, Tu
ADM: Adult: $7.00 **Children:** $4.00 **Students:** $4.00 **Seniors:** $6.00
♿: Ramp, elevators, restrooms Ⓟ: Museum lot, Sandusky St. $3.00 **Museum Shop** ⅼ: Cafe
Group Tours: 412-237-8347
Permanent Collection: ANDY WARHOL ARTWORKS

Andy Warhol Museum- continued

The most comprehensive single-artist museum in the world, this 7 story museum with over 40,000 square feet of exhibition space permanently highlights artworks spanning every aspect of Warhol's career.

A unique feature of this museum is a photo booth where visitors can take cheap multiple pictures of themselves in keeping with the Warhol tradition. **NOT TO BE MISSED:** Rain Machine, a 'daisy waterfall' measuring 132' by 240'; "Last Supper" paintings; 10' tall "Big Sculls" series.

ON EXHIBIT 2001

11/05/2000 to 01/28/2001 THE ART OF JEAN COCTEAU

Carnegie Museum Of Art

4400 Forbes Ave, Pittsburgh, PA 15213

(: 412-622-3131 **◙** www.clpgh.org
Open: 10-5 Tu-Sa, 1-5 Su, 10-5 Mo, 10-9 Fr July/Aug only **Closed:** LEG/HOL!
ADM: Adult: $6.00 **Children:** $4.00 **Students:** $4.00 **Seniors:** $5.00
& ℗: Pay garage **Museum Shop** **Ⅱ:** cafe open weekdays; coffee bar daily
Group Tours: 412-622-3289 **Docents** **Tour times:** 1:30 Tu-Sa, 3 Su **Sculpture Garden**
Permanent Collection: FR/IMPR: ptgs; POST/IMPR: ptgs; AM: ptgs 19,20; AB/IMPR; VIDEO ART

The original 1895 Carnegie Institute, created in the spirit of opulence by architects Longfellow, Alden and Harlowe, was designed to house a library with art galleries, the museum itself, and a concert hall. A stunning light filled modern addition offers a spare purity that enhances the enjoyment of the art on the walls. **NOT TO BE MISSED:** Claude Monet's "Nympheas" (Water Lilies).

Frick Art Museum

7227 Reynolds Street, Pittsburgh, PA 15208

(: 412-371-0600
Open: 10-5:30 Tu-Sa, 12-6 Su **Closed:** Mo LEG/HOL!
& ℗: Free **Museum Shop**
Group Tours: 412-371-0600, ext. 158 **Docents** **Tour times:** We, Sa, Su 2pm
Permanent Collection: EARLY IT/REN: ptgs; FR & FLEM: 17; BRIT: ptgs; DEC/ART

The Frick Art Museum features a Permanent collection of European paintings, sculptures and decorative objects and temporary exhibitions from around the world.

Clayton House: Admission, **Adults;** $6.00 **Seniors:** $5.00 **Students:** $4.00
Car and Carriage Museum: Adults; $4.00 **Seniors:** $3.00 **Students:** $2.00
Combination admission: Adults; $7.00 **Seniors:** $6.00 **Students:** $5.00

Hunt Institute for Botanical Documentation

Affiliate Institution: Carnegie Mellon University
Pittsburgh, PA 15213-3890

(: 412-268-2440 **◙** www.huntbot.andrew.cmu.edu/HIBD
Open: 9-12 & 1-5 Mo-Fr **Closed:** Sa, Su, LEG/HOL!,12/24-1/1
& ℗: Pay parking nearby **Museum Shop**
Permanent Collection: BOTANICAL W/COL 15-20; DRGS; GR

30,000 botanical watercolors, drawings and prints from the Renaissance onward represented in this collection.

ON EXHIBIT 2001

10/30/2000 to 02/28/2001 GIFTS OF WINTER

04/2001 to 07/2001 DAMODAR LAL GURJAR

10/30/2001 to 02/28/2002 10TH INTERNATIONAL EXHIBITION OF BOTANICAL ART & ILLUSTRATION

Mattress Factory Ltd

500 Sampsonia Way, satellite bldg at 1414 Monterey, Pittsburgh, PA 15212

☎: 412-231-3169 ◙ www.mattress.org
Open: 10-5 Tu-Sa, 1-5 Su; closed August **Closed:** Mo, 1/1, EASTER, LEG/HOL; August
Sugg./Contr.: Yes
Free Day: Th **ADM: Adult:** $6.00 **Children:** under 12 Free **Students:** $5.00 **Seniors:** $3.00
&. ℗ **Museum Shop Sculpture Garden**
Permanent Collection: Site-specific art installations completed in residency

A museum of contemporary art that commissions, collects and exhibits site-specific art installations. Founded in 1977 in a six story warehouse in the historic Mexican War Streets of Pittsburgh's North Side. **NOT TO BE MISSED:** Yayoi Kusama, "Repetitive Vision" 1997 and James Torrell: Permanent installations.

ON EXHIBIT 2001
10/08/2000 to 07/31/2001 TWO PART EXHIBITION: VISUAL SOUND
Artists are Patrice Carre, Takehisa Kosugi and Robin Minard.

03/04/2001 to 12/01/2001 TWO PART EXHIBITIONS
Artists included are Terry Fox, Rolf Julius, Christina Kubisch, Hans Peter Kuhn, Akio Suzuki, and Qin Yulen.

READING

Freedman Gallery

Affiliate Institution: Albright College
Center for the Arts, 13th and Bern Streets, Reading, PA 19604

☎: 610-921-2381
Open: 12-8 Tu; 12-6 We-Fr, 12-4 Sa, Su; Summer 12-4 We-Su **Closed:** Mo, LEG/HOL!, ACAD! Summer Mo, Tu
&. ℗
Group Tours: 610-921-7541
Permanent Collection: CONT: gr, ptgs

The only gallery in Southeastern Pennsylvania outside of Philadelphia that presents an on-going program of provocative work by today's leading artists. **NOT TO BE MISSED:** Mary Miss Sculpture creates an outdoor plaza which is part of the building.

SCRANTON

Everhart Museum

1901 Mulberry Street, Nay Aug Park, Scranton, PA 18510

☎: 570-346-7186 ◙ www.everhart-museum.org
Open: 12-5 We-Su; Thurs until 8pm **Closed:** THGV, 12/25
Sugg./Contr.: ADM: Adult: $5.00 **Children:** $2.00, Free under 6 **Students:** $3.00 **Seniors:** $3.00
&. ℗ **Museum Shop Tour times:** by appt
Permanent Collection: AM: early 19,20; AM: folk, gr; AF; Glass; Nat/Hist

This art, science, and natural history museum is the only wide-ranging museum of its type in Northeastern Pennsylvania.

PENNSYLVANIA

UNIVERSITY PARK

Palmer Museum of Art
Affiliate Institution: The Pennsylvania State University
Curtin Road, University Park, PA 16802-2507

℡: 814-865-7672 **◙** www.psu.edu/dept/palmermuseum
Open: 10-4:30 Tu-Sa, 12-4 Su **Closed:** Mo, LEG/HOL!, 12/25-1/1
Vol./Contr.: Yes
♿ **℗:** Limited meter, nearby pay **Museum Shop** ¶: Java Market next door
Group Tours: 814-865-7672 **Sculpture Garden**
Permanent Collection: AM; EU; AS; S/AM: ptgs, sculp, works on paper, ceramics

A dramatic and exciting facility for this collection of 35 centuries of artworks. **NOT TO BE MISSED:** The building by Charles Moore, a fine example of post-modern architecture.

ON EXHIBIT 2001
10/24/2000 to 02/25/2001 AN INTERLUDE AT GIVERNY: THE FRENCH CHEVALIER BY FREDERICK MACMONNIES
Macmonnis was known as a figurative sculptor, but was also a painter who contributed works to the annual Salons in Paris in the early 1900's.

VALLEY FORGE

Wharton Esherick Museum
Horseshoe Trail; Mail Address Box 595, Paoli, PA 19301; Valley Forge, PA 19301

℡: 610-644-5822
Open: 10-4 Mo-Fr, 10-5 Sa, 1-5 Su (Mar-Dec) **Closed:** LEG/HOL!
ADM: Adult: $6.00 **Children:** $3.00 under 12 **Seniors:** $6.00
♿ ℗ **Museum Shop**
Tour times: Hourly, (reservations required)
Permanent Collection: WOOD SCULP; FURNITURE; WOODCUTS; PTGS

Over 200 works in all media, produced between 1920-1970 which display the progression of Esherick's work are housed in his historic studio and residence. **NOT TO BE MISSED:** Oak spiral stairs.

WILKES-BARRE

Sordoni Art Gallery
Affiliate Institution: Wilkes University
150 S. River Street, Wilkes-Barre, PA 18766-0001

℡: 570-408-4325
Open: 12-4:30 daily **Closed:** LEG/HOL!
♿ ℗
Permanent Collection: AM: ptgs 19,20; WORKS ON PAPER

Located on the grounds of Wilkes University, in the historic district of downtown Wilkes-Barre, this facility is best known for mounting both historical and contemporary exhibitions.

KINGSTON

Fine Arts Center Galleries, University of Rhode Island

105 Upper College Road, Suite 1, Kingston, RI 02881-0820

☎: 401-874-2775 or 2627 ◙ www.uri.edu

Open: Main Gallery 12-4 & 7:30-9:30 Tu-Fr, 1-4 Sa, Su, Phot Gallery 12-4 Tu-Fr, 1-4 Sa, Su **Closed:** LEG/HOL!; ACAD!
& ℗

Docents Tour times: !

Permanent Collection: non-collecting institution

A university affiliated 'kunsthalle' distinguished for the activity of their programming (20-25 exhibitions annually) and in generating that programming internally. Contemporary exhibitions in all media are shown as well as film and video showings. The Corridor Gallery is open from 9-9 daily.

ON EXHIBIT 2001

12/06/2000 to 01/16/2001 INVESTIGATING THE DEPARTMENT OF "SPECIAL COLLECTIONS"

An exhibition which will reveal the previously unknown Permanent collections.

NEWPORT

Newport Art Museum

76 Bellevue Avenue, Newport, RI 02840

☎: 401-848-8200

Open: 10-4 Mo-Sa, 12-4 Su (Col Day-Mem Day Mo-Sa, 12-5 Su) **Closed:** THGV, 12/25, 1/1

Free Day: Sa, 10-12 **ADM: Adult:** $4.00 **Children:** Free under 5 **Students:** $2.00 **Seniors:** $3.00

& ℗ **Museum Shop**

Group Tours: by appt **Docents Tour times:** Sa, Su aft !

Permanent Collection: AM: w/col 19,20

Historic J. N. A. Griswold House in which the museum is located was designed by Richard Morris Hunt in 1862-1864.

Redwood Library and Athenaeum

50 Bellevue Avenue, Newport, RI 02840

☎: 401-847-0292 ◙ www.redwood1747.org

Open: 9:30-5:30 Mo, Fr, Sa, Tu, Th 9:30-8, 1-5 Su **Closed:** LEG/HOL!

Sugg./Contr.: $3 per person

&: all except restroom ℗

Docents Tour times: 10:30 Mo-Fri

Permanent Collection: AM: gr, drgs, phot, portraits, furniture, dec/art 18,19

Established in 1747, this facility serves as the oldest circulating library in the country. Designed by Peter Harrison, considered America's first architect, it is the most significant surviving public building from the Colonial period. **NOT TO BE MISSED:** Paintings by Gilbert Stuart and Charles Bird King.

RHODE ISLAND

David Winton Bell Gallery
Affiliate Institution: Brown University
List Art Center, 64 College Street, Providence, RI 02912
☎: 401-863-2932 **◙** www.brown.edu/facilities/david-winton-bell-gallery
Open: 11-4 Mo-Fr, 1-4 Sa-Su **Closed:** 1/1, THGV, 12/25
& **Ⓟ:** On-street
Permanent Collection: GR & PHOT 20; WORKS ON PAPER 16-20; CONT: ptgs

Located in the List Art Center, an imposing modern structure designed by Philip Johnson, the Gallery presents exhibitions which focus on the arts and issues of our time.

ON EXHIBIT 2001
01/27/2001 to 03/11/2001 FALSE WITNESS: JOAN FONTEUBERIA AND KAHN SELESNIK

Museum of Art
Affiliate Institution: Rhode Island School of Design
224 Benefit Street, Providence, RI 02903
☎: 401-454-6500 **◙** www.risd.edu
Open: 10-5 Tu-Su;110-9 third Th monthly (free 5-9) **Closed:** LEG/HOL!
Free Day: Sa **ADM: Adult:** $5.00 **Children:** $1.00 (5-18) **Students:** $2.00 **Seniors:** $4.00
& **Ⓟ:** Nearby pay, 1/2 price with museum adm **Museum Shop**
Group Tours: 401-454-6534 **Sculpture Garden**
Permanent Collection: AM & Eur: ptgs, dec/art; JAP: gr, cer; LAT/AM

The museum's outstanding collections are housed on three levels: in a Georgian style building completed in 1926, in Pendleton House, completed in 1906, and in The Daphne Farago Wing, a center dedicated to the display and interpretation of contemporary art in all media. **NOT TO BE MISSED:** Manet "Potrait of Berthe Morisot."

ON EXHIBIT 2001
02/2001 Ongoing ROMAN SCULPTURE FROM THE PERMANENT COLLECTION
A reassessment of the small exceptional holdings in the light of new findings.

09/29/2000 to 01/07/2001 PRESSING ON: THE GRAPHIC WORK OF WILMER JENNINGS
A painter, printmaker and designer who worked for the Imperial Jewelry Company. He is the third generation of African American artists active in the state.

11/03/2000 to 02/18/2001 CLOTH WITHOUT WEAVING: BEATEN BARK CLOTH FROM THE PACIFIC ISLANDS
Strips of under bark of the paper mulberry tree beaten together with mallets they resemble papyrus in structure. Also known as "tapa cloth" and used in Indonesia, Polynesia and Papua New Guinea.

01/12/2001 to 04/08/2001 PARIS TO PROVIDENCE: FASHION, ART, AND THE TIROCCHI DRESSMAKERS' SHOP
The Italian sisters sold French couture clothes from 1947-1990. They reflect the Paris modernist art world of the 20's and 30's.

02/02/2001 to 04/15/2001 A VIEW BY TWO: CONTEMPORARY JEWELRY
Fourteen innovative jewelry makers from America, Austria, Germany, Italy, The Netherlands and Switzerland. The Museum's collection of historic jewelry will also be on view.

06/2001 to 08/2001 PAINTINGS BY WILLIAM CONGDON
Congdon scetched skyskrapers, piazzas, and Venetian palaces into densely layered pigment surfaces.later turning to landscape painting.

Rhode Island Black Heritage Society

202 Washington Street, Providence, RI 02903

℡: 401-751-3490
Open: 10-5 Mo-Fr, 10-2 Sa & by appt **Closed:** LEG/HOL!
 ♿ **℗:** on street and nearby pay garages **Museum Shop**
Permanent Collection: PHOT; AF: historical collection

The Society collects documents and preserves the history of African-Americans in the state of Rhode Island with an archival collection which includes photos, rare books, and records dating back to the 18th century. **ONGOING:** Permanent Exhibítion—CREATIVE SURVIVAL **NOT TO BE MISSED:** Polychrome relief wood carvings by Elizabeth N. Prophet

SOUTH CAROLINA

CHARLESTON

City Hall Council Chamber Gallery
Broad & Meeting Streets, Charleston, SC 29401
℡: 803-724-3799
Open: 9-5 Mo-Fr, closed 12-1 **Closed:** Sa, Su LEG/HOL!
Vol./Contr.: Yes
 Docents Tour times: 9-5 (closed 12-1)
Permanent Collection: AM: ptgs 18,19

What is today Charleston's City Hall was erected in 1801 in Adamsesque style to be the Charleston branch of the First Bank of the United States. **NOT TO BE MISSED:** "George Washington," by John Trumbull is unlike any other and is considered one of the best portraits ever done of him.

Gibbes Museum of Art
135 Meeting Street, Charleston, SC 29401
℡: 843-722-2706 ◙ www.gibbes.com
Open: 10-5 Tu-Sa, 1-5 Su **Closed:** Mo, LEG/HOL!
ADM: Adult: $6.00 **Children:** $3.00 **Students:** $5.00 **Seniors:** $5.00
&: Right side of museum **℗:** Municipal **Museum Shop**
Group Tours: 843-722-2706, ext 25 **Docents Tour times:** Tu & Sa 2:30pm **Sculpture Garden**
Permanent Collection: AM: reg portraits, miniature portraits; JAP: gr

Charleston's only fine arts museum offers a nationally significant collection of American art from the 1700 to the present, a miniature portrait collection (the oldest and finest in the country), Japanese prints, and a variety of traveling exhibitions. **NOT TO BE MISSED:** "John Moultie and Family" ca 1782 by John Francis Rigaud.

ON EXHIBIT 2001

01/21/2001 to 03/18/2001 FROM SHIP TO SHORE: MARINE PAINTING FROM THE BUTLER INSTITUTE OF AMERICAN ART
Over 60 paintings, ranging from ship portraiture to ocean views, highlight the general fascination with marine culture since colonial times. Included are works by William Bradford, Alfred Thompson Bricher, James Butterworth and William Trost Richards. *Will Travel*

04/03/2001 to 06/10/2001 FRANK STELLA EXHIBITION: PRINTS FROM THE NINETIES
Bold new work in which he created a complex new process with Tyler Graphics. The results were multifacetted works which exploded with color.

06/30/2001 to 09/02/2001 SPOTLIGHT 2001A; AMERICAN CRAFTS COUNCIL/SOUTHEAST JURIED EXHIBITION.

09/23/2001 to 11/18/2001 SPIRIT OF THE MASK
Masks from around the world with explanation of their uses: Carnival, fertility, celebration, dance, death healing, religion, social control, and theater.

COLUMBIA

Columbia Museum of Arts
Main at Hampton, Columbia, SC 29202
℡: 803-799-2810 ◙ www.columbiamuseum.org
Open: 10-5 Tu-Fr, 10-9 We, 10-5 Sa, 1-5 Su **Closed:** Mo, 1/1, THGV, 12/24 9OPEN 1/2 DAY, 12/25
Free Day: 1st Sa of the month **ADM: Adult:** $4.00 **Children:** Free under 6 **Students:** $2.00 **Seniors:** $2.00
 ℗ **Museum Shop**
Group Tours: 803-343-2208 **Docents Tour times:** regular public tours, Sa 1pm; Su 2pm; We 6:15, Th 12:15
Permanent Collection: KRESS COLL OF MED, BAROQUE & REN; AS; REG

Columbia Museum of Arts- continued

The museum emphasizes a broad spectrum of European and American fine arts dating from the 14th C to the present. It also has one of the Southeast's most important collections of Italian Renaissance and Baroque paintings, sculpture and decorative art by the Old Masters.

FLORENCE

Florence Museum of Art, Science & History

558 Spruce Street, Florence, SC 29501

✆: 843-662-3351
Open: 10-5 Tu-Sa, 2-5 Su **Closed:** Mo, LEG HOL
&.: Limited, not all areas accessible ℗ **Museum Shop Docents**
Permanent Collection: AM/REG: ptgs; SW NAT/AM; pottery; CER

Founded to promote the arts and sciences, this museum, located in a 1939 art deco style building originally constructed as a private home, is surrounded by the grounds of Timrod Park. **NOT TO BE MISSED:** "Francis Marion Crossing to Pee Dee," by Edward Arnold.

GREENVILLE

Bob Jones University Collection of Sacred Art

Jones University, Greenville, SC 29614

✆: 864-242-5100 ◙ www.bju.edu/artgallery/
Open: 2-5 Tu-Su **Closed:** Mo, 1/1, 7/4, 12/20 thru 12/25, Commencement Day (early May)
ADM: Adult: $5.00 **Children:** Free 6-12, under 6 not admitted **Students:** Free
& ℗: Nearby **Museum Shop Group Tours:** ext 1050
Permanent Collection: EU: ptgs including Rembrandt, Tintoretto, Titian, Veronese, Sebastiano del Piombo

One of the finest collections of religious art in America.

ON EXHIBIT 2001

12/01/2000 to 01/07/2001 CHRISTMAS EXHIBITON: THE CHRISTMAS STORY IN ART
Each work will illustrate some aspect of the events surrounding the birth of Christ.

01/16/2001 to 02/28/2001 JOHN THE BAPTIST AND THE BAROQUE VISION

03/13/2001 to 04/15/2001 THE STORY OF CHRIST'S DEATH, BURIAL, RESURRECTION AND ASCENSION

Greenville County Museum of Art

420 College Street, Greenville, SC 29601

✆: 864-271-7570 ◙ www.greenvillemuseum.org
Open: 10-5 Tu-Sa, 1-5 Su **Closed:** Mo, LEG/HOL!
Vol./Contr.: Yes
& ℗ **Museum Shop**
Permanent Collection: AM: ptgs, sculp, gr; REG

The Southern Collection is nationally recognized as one of the countries best regional collections. It provides a survey of American art history from 1726 to the present through works of art that relate to the South. The Museum resettle acquired 24 watercolors by Andrew Wyeth which the artist described as one of the best collections of his watercolors in any public museum in this country.

SOUTH CAROLINA

MURRELLS INLET

Brookgreen Gardens
1931 Brookgreen Gardens Drive, Murrells Inlet, SC 29576
☎: 843-235-6000 or 800-849-1931 ◙ www.brookgreen.org
Open: 9:30-4:45 daily, call for summer hours **Closed:** 12/25
ADM: Adult: $8.50 **Children:** $4.00 5-12 **Students:** $7.50 **Seniors:** $7.50
🚻 ⓟ **Museum Shop** ⅞: Terrace Cafe open year round
Group Tours: 800-849-1931 **Docents Sculpture Garden**

The first public sculpture garden created in America is located on the grounds of a 200-year old rice plantation. It is the largest Permanent outdoor collection of American Figurative Sculpture in the world with 542 works by 240 American sculptors on Permanent display. **NOT TO BE MISSED:** "Fountain of the Muses," by Carl Milles.

SPARTANBURG

Spartanburg County Museum of Art
385 South Spring Street, Spartanburg, SC 29306
☎: 864-582-7616 ◙ www.spartanarts.org
Open: 9-5 Mo-Fr, 10-2 Sa, 2-5 Su **Closed:** LEG/HOL!, EASTER, 12/24
🚻 ⓟ: Adjacent to the building **Museum Shop**
Group Tours: 864-583-2776
Permanent Collection: AM/REG: ptgs, gr, dec/art

A multi-cultural Arts Center that presents 20 exhibits of regional art each year. **NOT TO BE MISSED:** "Girl With The Red Hair," by Robert Henri.

ON EXHIBIT 2001

01/08/2001 to 03/05/2001 A CELEBRATION OF AFRICAN-AMERICAN ARTISTS: WINSTON WINGO AND LEO TWIGGS

03/26/2001 to 04/23/2001 CONTEMPORARY ICONS: THREE VIEWS
Works from mixed media to paintings by Peter Lenzo, David Linn, and Heidi Darr-Hope will be presented.

05/07/2001 to 06/24/2001 NARRATIVE PERSPECTIVES: TERESA PRATER

07/02/2001 to 08/26/2001 ARTISTS GUILD: JURIED SHOW

09/03/2001 to 10/28/2001 EAST MEETS WEST: DIFFERENT YET SIMILAR
Paintings by Michiko Itatani and charcoal and ink washes by Zhi Linn will be presented.

11/05/2001 to 12/30/2001 2001 INAUGURAL JURIED SHOW: ARTISAN INVITATIONAL—FINE ARTS AND CRAFTS

BROOKINGS

South Dakota Art Museum
Medary Ave at Harvey Dunn Street, Brookings, SD 57007-0899
☎: 605-688-5423 ◙ http://sdartmuseum.sdstate.edu
Open: 8-5 Mo-Fr, 10-5 Sa, 1-5 Su, Holidays **Closed:** 1/1, THGV, 12/25
Vol./Contr.: yes
&: Elevator service to all 3 levels from west entrance ℗ **Museum Shop**
Group Tours: 605-688-5423 **Docents** **Tour times:** 605-688-5423 **Sculpture Garden**
Permanent Collection: HARVEY DUNN: ptgs; OSCAR HOWE: ptgs; NAT/AM; REG 19, 20, marghab Linens

Many of the state's art treasures including the paintings by Harvey Dunn of pioneer life on the prairie, a complete set of Marghab embroidery from Madeira, outstanding paintings by regional artist Oscar Howe, and masterpieces from Sioux tribes are displayed in the 6 galleries of this museum established in 1970.

MITCHELL

Middle Border Museum of American Indian and Pioneer Life
1311 S. Duff St. PO Box 1071, Mitchell, SD 57301
☎: 605-996-2122
Open: 8-6 Mo-Sa & 10-6 Su (Jun-Aug), 9-5 Mo-Fr & 1-5 Sa,Su (May-Sep), by appt (Oct-Apr) **Closed:** 1/1, THGV, 12/25
ADM: Adult: $3.00 **Children:** Free under 12 **Seniors:** $2.00
&: Partially, the art gallery is not wheelchair accessible ℗ **Museum Shop** **Sculpture Garden**
Permanent Collection: AM: ptgs 19,20; NAT/AM

This Museum of American Indian and Pioneer Life also has an eclectic art collection in the Case Art Gallery, the oldest regional art gallery including works by Harvey Dunn, James Earle Fraser, Gutzon Borglum, Oscar Howe, Charles Hargens, Anna Hyatt Huntington and many others. **NOT TO BE MISSED:** Fraser's "End of the Trail" and Lewis and Clark statues.

Oscar Howe Art Center
119 W. Third, Mitchell, SD 57301
☎: 605-996-4111
Open: 9-5 Mo-Sa **Closed:** Su, LEG/HOL!
Vol./Contr.: ADM: Adult: $2.50 **Children:** $1.00 **Seniors:** $2.00
℗ **Museum Shop**
Group Tours: 605-996-4111 **Docents** **Tour times:** Upon request
Permanent Collection: OSCAR HOWE: ptgs, gr

Housed in a beautifully restored 1902 Carnegie Library, the Oscar Howe Art Center displays both a collection of work by Yanktonai Sioux artist Oscar How and rotating exhibits of work by regional artists. **NOT TO BE MISSED:** "Sun and Rain Clouds Over Hills," dome mural painted by Oscar Howe in 1940 as a WPA project (Works Progress Administration).

SOUTH DAKOTA

Heritage Center Inc
Affiliate Institution: Red Cloud Indian School
Pine Ridge, SD 57770

☎: 605-867-5491 ◙ www.basic.net/rcheritaqe
Open: 9-5 Mo-Fr **Closed:** Sa, Su, EASTER, THGV, 12/25
🚻 ℗ **Museum Shop**
Permanent Collection: CONT NAT/AM; GR; NW COAST; ESKIMO: 19,20

The Center is located on the Red Cloud Indian school campus in an historic 1888 building built by the Sioux and operated by them with the Franciscan and Jesuit sisters. The Holy Rosary Mission church built in 1998 has stained glass windows designed by the students.

Dahl Arts Center
713 Seventh Street, Rapid City, SD 57701

☎: 605-394-4101
Open: 9-5 Mo-Sa, 1-5 Su **Closed:** LEG/HOL!
🚻 ℗: Metered **Museum Shop**
Permanent Collection: CONT; REG: ptgs; gr 20

The Dahl presents a forum for all types of fine arts: visual, theatre, and music, that serve the Black Hills region, eastern Wyoming, Montana, and Western Nebraska. **NOT TO BE MISSED:** 200 foot cyclorama depicting the history of the US.

The Journey Museum
Affiliate Institution: SD School of Mines & Technology's Museum of Geology
222 New York Street, Rapid City, SD 57701

☎: 605-394-6923
ADM: Adult: $6.00 **Children:** 11-17 $4.00 **Seniors:** $5.00

Sioux Indian Museum
222 New York Street, Rapid City, SD 57701

☎: 605-394-2381 ◙ www.journeymuseum.org
Open: 8-7daily summer; 10-4 Mo-Sa, 11-4 Su winter **Closed:** 1/1, THGV, 12/25
Vol./Contr.: Yes see web site!
🚻 ℗ **Museum Shop**
Group Tours: 605-394-6923
Permanent Collection: SIOUX ARTS

The rich diversity of historic and contemporary Sioux art may be enjoyed in the Journey Museum, location of the Sioux Indian Museum. This museum with rotating exhibitions, and interactive displays dramatically reveal the geography, people and historical events that shaped the history and heritage of the Black Hills area. **NOT TO BE MISSED:** THE JOURNEY, Black Hills History thru sight, sound and touch.

Washington Pavilion of Arts and Sciences

Affiliate Institution: Visual Arts Center
301 S. Main Ave., Sioux Falls, SD 57104

☎: 605-367-7397, x2341 ◙ www.washingtoonpavillion.org
Open: 9-5 Mo-Sa, 1-5 Su & HOL **Closed:** THGV, 12/25
Sugg./Contr.: ADM: Adult: $3.00 **Children:** $1.00
♿ ℗ **Museum Shop** ⑪
Group Tours: ext 2319 **Docents Sculpture Garden**
Permanent Collection: REG/ART: all media

Opening in June 1999 is the 250,000 square foot Washington Pavilion of the Arts and Science featuring the Visual Arts Center, Kirby Science Discovery Center, Wells Fargo Cinedome and the Husby Performing Arts Center. **NOT TO BE MISSED:** The Washington Pavilion of Arts and Sciences is the region's newest and largest cultural and educational center. The Washington Pavillion includes the Husby Performing Arts Center, the Kirby Science Discovery Center, Wells Fargo Cinedome Theater and the Visual Arts Center. The facility also houses Leonardo's Café and the Discovery Store gift shop. For more information, call 605-367-7397 or 1-877-WashPay (Toll free in SD, ND, NE, IA, and MN) Visit our website at www.washingtonpavilion.org.

University Art Galleries

Affiliate Institution: University of South Dakota
Warren M. Lee Center, 414 E. Clark Street, Vermillion, SD 57069-2390

☎: 605-677-5481 ◙ www.usd,.edu/cfa/art/gallery.
Open: 10-4 Mo-Fr, 1-5 Sa, Su **Closed:** ACAD!
♿ ℗
Group Tours: 605-677-5481
Permanent Collection: Sioux artist OSCAR HOWE; HIST REG/ART

The University Art Galleries, established in 1976, exists in recognition of a commitment to the visual arts which may be traced to the founding of the University in 1862. The University Art Galleries' major purpose is to support the formal educational process of the University, but its impact extends beyond the academic community to serve artists and audiences in South Dakota and the region. The University Art Galleries is responsible for the operation of the Main Gallery, Gallery 110, several on-campus exhibition spaces, the University Permanent Collection, the Campus Beautification Project, and a touring exhibition program.

CHATTANOOGA

Hunter Museum of American Art
10 Bluff View, Chattanooga, TN 37403-1197

℡: 423-267-0968 ◎ www.huntermuseum.org
Open: 10-4:30 Tu-Sa, 1-4:30 Su **Closed:** Mo, LEG/HOL!
Free Day: 1st Fr of month **ADM: Adult:** $5.00 **Children:** $2.50, 3-12 **Students:** $3.00 **Seniors:** $4.00
⑤ ⑫ **Museum Shop**
Group Tours: 423-267-0968 **Docents** **Sculpture Garden**
Permanent Collection: AM: ptgs, gr, sculp, 18-20

Blending the old and the new, the Hunter Museum consists of a recently restored 1904 mansion with a 1975 contemporary addition.

ON EXHIBIT 2001

12/02/2000 to 02/11/2001 MIRIAM SHAPIRO
The first retrospective exhibition of the artist's works on paper. *Will Travel*

02/2001 to 03/18/2001 WILLIAM SCARBROUGH

02/10/2001 to 03/18/2001 DAVID BLERK: INSPIRED BY THE PAST TO RECONSIDER THE PRESENT

03/2001 to 05/2001 COLLABORATIVE WITH HOUSTON MUSEUM (titled to be decided)

03/31/2001 to 05/27/2001 100 YEARS OF VAN BRIGGLE POTTERY

06/2001 to 09/2001 MILLENNIUM GLASS: AN INTERNATIONAL SURVEY OF STUDIO GLASS

KNOXVILLE

Knoxville Museum of Art
1050 World's Fair Park Drive, Knoxville, TN 37916-1653

℡: 615-525-6101 ◎ www.knoxart.org
Open: 10-5 Tu-Th, Sa, 10-9 Fr, 12-5 Su **Closed:** Mo, LEG/HOL!
ADM: Adult: $4.00 **Children:** $1 under12; $2 13-17 **Students:** $3.00 **Seniors:** $3.00
⑤ ⑫: Free parking across the street **Museum Shop** ¶
Group Tours: 865-525-6101 ext. 228 **Docents** **Tour times:** 3pm Su for focus exh.
Permanent Collection: CONT; GR ; AM: 19

Begun in 1961 as the Dulin Gallery of art, located in an antebellum mansion, the Museum because of its rapidly expanding collection of contemporary American art then moved to the historic Candy Factory. It now occupies a building designed in 1990 by Edward Larabee Barnes. **PLEASE NOTE:** Some exhibitions have admission charge. **NOT TO BE MISSED:** Historic Candy Factory next door; the nearby Sunsphere, trademark building of the Knoxville Worlds Fair.

ON EXHIBIT 2001

Spring 2001 ! THE KELLY COLLECTION OF AMERICAN ILLUSTRATION

Fall 2001 ! TIBETAN ART

MEMPHIS

Dixon Gallery & Gardens
4339 Park Ave, Memphis, TN 38117
📞: 901-761-5250 ◎ www.dixon.org
Open: 10-5 Tu-Sa, 1-5 Su, Gardens only Mo 1/2 price **Closed:** Mo, LEG/HOL!
Free Day: Tu, seniors only **ADM: Adult:** $5.00 **Children:** $1.00 under 12 **Students:** $3.00 **Seniors:** $4.00
♿ ℗: Free **Museum Shop**
Docents Drop-in Tours: Yes, but no docent; docent-led tours by appt. only **Tour times:** Museum hours
Sculpture Garden
Permanent Collection: FR: Impr, 19; GER: cer

Located on 17 acres of woodlands and formal gardens, the Dixon was formerly the home of Hugo and Margaret Dixon, collectors and philanthropists.

Memphis Brooks Museum of Art
Overton Park, 1934 Poplar Ave., Memphis, TN 38104-2765
📞: 901-544-6200 ◎ www.brooksmuseum.org
Open: 10-4 Tu-Fr, 10-8 first We of each month, 10-5 Sa, 11:30-5 Su **Closed:** Mo, 1/1, 7/4, THGV, 12/25
ADM: Adult: $5.00 **Children:** $2.00 (7-17) **Students:** $2.00 **Seniors:** $4.00
♿ ℗: Free **Museum Shop** ‖: Brushmark ‖; Lunch 11:30-2:30; Cocktails and dinner 5-8, first We of each month
Group Tours: 901-544-6215 **Docents Tour times:** 10:30, 1:30 Sa; 1:30 Su
Permanent Collection: IT/REN, NORTHERN/REN, & BAROQUE: ptgs; BRIT & AM: portraits 18,19; FR/IMPR; AM: modernist

Founded in 1916, this is the mid-south's largest and most encyclopedic fine arts museum. Works in the collection range from those of antiquity to present day creations. **NOT TO BE MISSED:** Global Survey Galleries.

ON EXHIBIT 2001
11/19/2000 to 01/28/2001 REMINGTON, RUSSELL AND THE LANGUAGE OF WESTERN ART
Many early artists explored the frontier collecting imagery for their work, viewing themselves as participants in the frontier experience as well as recorders thereof. It was the pioneering efforts of Western landscape artists such as George Catlin, John M. Stanley, Thomas Moran and Albert Bierstadt, that opened the doors for the next generation of Western artists who would carry the traditions into the twentieth century. This exhibition, curated by noted Western scholar Peter Hassrick, focuses on the work of two of the most successful and popular artists of this new regime. Both Charles Russell and Frederic Remington were widely appreciated for their portrayal and interpretation of the American cowboy, but Remington's images of the Southwest catapulted him to stardom in the eyes of the late 19th century American public.

03/2001 to 05/2001 ! MASTERPIECES FROM THE SCOTTISH NATIONAL GALLERY OF ART
The Scottish National Gallery of Art in Edinburgh houses the national collections of Scottish and international Old Masters. To coincide with the temporary deinstallation of one wing, the Gallery is circulating some of these paintings. This exhibition, a truly exceptional opportunity, is comprised of approximately 45 works, including those by Perugino, Verrochio, Veronese, Canaletto, El Greco, Goya, Boucher, Gainsborough, Constable and Turner, among others.

04/14/2001 to 06/30/2001 PICTURES TELL THE STORY: ERNEST C. WITHERS
This exhibition is the first of its kind to completely survey the photographic career of Ernest C. Withers. For half a century, Withers has made his living as a photographer, and for more than forty of those years, he has emblazoned his business advertisements with the words "Pictures Tell the Story." The story of Withers provides a compelling social history of the African American experience from the late 1940s to the 1970s. Included in the exhibition are Withers' well-known images of the civil rights movement, but also his photographs of musical entertainers, baseball players of the Diamond League and the images he calls "Good Times in Memphis." Organized by the Chrysler Museum of Art, Norfolk, VA.

MURFREESBORO

Baldwin Photographic Gallery
Affiliate Institution: Middle Tennessee State University Learning Resources Center
Murfreesboro, TN 37132

℄: 615-898-5628
Open: 8-4:30 Mo-Fr, 8-noon Sa, 6-10pm Su **Closed:** EASTER, THGV, 12/25
&: 1st floor complete with special electric door **℗:** Free parking 50 yards from gallery
Permanent Collection: CONT: phot

A college museum with major rotating photographic exhibitions.

NASHVILLE

Cheekwood-Tennessee Botanical Garden and Museum of Art
1200 Forrest Park Drive, Nashville, TN 37205-4242

℄: 615-356-8000 ◙ www.cheekwood.org
Open: 9-5 Mo-Sa, 11-5 Su (Grounds open 11-5 Su) **Closed:** 1/1, THGV, 12/25
ADM: Adult: $8.00 **Children:** $5.00 (6-17) **Students:** $7.00 **Seniors:** $7.00
& ℗ **Museum Shop** ⑪: 11-2 **Group Tours:** 615-353-2155 **Sculpture Garden**
Permanent Collection: AM: ptgs, sculp, dec/art 19-20

One of the leading cultural centers in the South, the Museum of Art is a former mansion built in the 1930s. Located in a luxuriant botanical garden, it retains a charming homelike quality. **NOT TO BE MISSED:** New Contemporary Galleries and Sculpture Garden trail.

ON EXHIBIT 2001
08/24/2001 to 11/18/2001 AMERICAN IMPRESSIONISTS ABROAD AND AT HOME
Thirty-nine works by 27 artists will illuminate the training that American Impressionists undertook abroad and at home; the complex attractions of Europe and America; the significance of the subjects they depicted and their various responses to French Impressionism.

Fisk University Galleries
1000 17th Avenue North, Nashville, TN 37208-3051

℄: 615-329-8720 ◙ www.fisk.edu/~gallery/arthome.html
Open: 10-5 Tu-Fr; 1-5 Sa-Su, Summer closed Su **Closed:** Mo, ACAD!, Su summer
Vol./Contr.: Yes & ℗ **Museum Shop**
Permanent Collection: EU; AM; AF/AM: AF

The Galleries are located on the historic campus of Fisk University and housed in a historical (1888) building and in the University Library. **NOT TO BE MISSED:** The Alfred Stieglitz Collection of Modern Art.

Parthenon
Centennial Park, Nashville, TN 37201

℄: 615-862-8431 ◙ www.parthenon.org
Open: 9-4:30 Tu-Sa, 12:30-430 Su (April-Sept Su 12:30-8) **Closed:** Mo, LEG/HOL!
ADM: Adult: $2.50 **Children:** $1.25, 4-17 **Students:** $1.25 **Seniors:** $1.25
& ℗: Free **Museum Shop** **Docents** **Tour times:** !
Permanent Collection: AM: 19,20; The Cowan Collection

First constructed as the Art Pavilion for the Tennessee Centennial Exposition, in 1897, The Parthenon is the world's only full size reproduction of the 5th c B.C. Greek original with the 42 foot statue of Athena Parthenos. **NOT TO BE MISSED:** "Mt. Tamalpais," by Albert Bierstadt; "Autumn in the Catskills" by Sanford Gifford.

Tennessee State Museum-Polk Culture Center

5th and Deaderick, Nashville, TN 37243-1120

(: 615-741-2692 ◙ www.tnmuseum.org
Open: 10-5 Tu-Sa; 1-5 Su **Closed:** Mo, 1/1, Easter, THGV, 12/25
Vol./Contr.: Yes
& **(P):** parking meters and paid lots **Museum Shop**
Group Tours: Tu-Fr for school groups 615-741-0830
Permanent Collection: artifacts and art relating to Tennessee's history, beginning with prehistoric peoples and going through the early 1900s.

General History museum with collections of decorative arts. **NOT TO BE MISSED:** Outstanding collections of quilts and silver.

ON EXHIBIT 2001

06/25/2000 to 06/23/2001 THE KOREAN CONFLICT: A HOT SPOT IN THE COLD WAR

01/02/2001 to 04/01/2001 TO CONSERVE A LEGACY: AMERICAN ART FROM HISTORICALLY BLACK COLLEGES AND UNIVERSITIES
The collections of 6 historically Black colleges will be showcased in a exhibition of over 150 artworks. *Will Travel*

05/04/2001 to 07/01/2001 NOTABLE AMERICANS FROM THE NATIONAL PORTRAIT GALLERY
Including 75 portraits by the most important portrait artists in the past 200 years.

Vanderbilt University Fine Arts Gallery

23rd at West End Ave, Nashville, TN 37203

(: 615-322-0605 ◙ www.vanderbilt.edu/AnS/finearts/gallery.html
Open: 12-4 Mo-Fr, 1-5 Sa, Su, Summer 12-4 Tu-Fr; 1-5 Sa **Closed:** Note summer hours ACAD!
(P)
Permanent Collection: OR: Harold P. Stern Coll; OM & MODERN: gr (Anna C. Hoyt Coll); CONTINI-VOLTERRA PHOT ARCHIVE; EU: om/ptgs (Kress Study Coll)

The history of world art may be seen in the more than 5,000 works from over 40 countries and cultures housed in this university gallery. Rich in contemporary prints and Oriental art, this historical collection is the only one of its kind in the immediate region. **NOT TO BE MISSED:** "St. Sebastian," 15th century Central Italian tempera on wood.

OAK RIDGE

Oak Ridge Arts Center

201 Badger Avenue, Oak Ridge, TN 37830

(: 423-482-1441
Open: 9-5 Tu-Fr, 1-4 Sa-Mo **Closed:** LEG/HOL!
Vol./Contr.: Yes
& **(P) Docents**
Permanent Collection: AB/EXP: Post WW II

Two galleries with monthly changing exhibitions, educational programming and art lectures. Call for schedule.

TEXAS

Grace Museum, Inc
102 Cypress, Abilene, TX 79601
📞: 915-673-4587
Open: 10-5 Tu, We, Fr, Sa, 10:30 Th, 1-5 Su (closed Su, May 30-Sept 5) **Closed:** Mo, LEG/HOL!
Free Day: Th 5-8:30 **ADM: Adult:** $3.00 **Children:** $1.00 (4-12) **Students:** $2.00 **Seniors:** $2.00
 ♿ ℗ **Museum Shop**
Permanent Collection: TEXAS/REG; AM: gr, CONT: gr; ABELINE, TX, & PACIFIC RAILWAY: 18-20

The museums are housed in the 1909 'Mission Revival Style' Railroad Hotel. **NOT TO BE MISSED:** Children's Museum.

ON EXHIBIT 2001

11/18/2000 to 01/13/2001	BIG COUNTRY ART ASSOCIATION ART COMPETITION
01/13/2001 to 03/17/2001	BENINI: BEYOND DIMENSION
01/13/2001 to 04/07/2001	TERMESPHERES: THE GEOMETRY OF VISUAL SPACE
01/20/2001 to 04/14/2001	THE WORLD OF CLEMENTINE HUNTER
03/08/2001 to 04/15/2001	YOUTH ART MONTH
03/17/2001 to 06/09/2001	A CLOSER LOOK … WORKS BY CLINT HAMILTON
03/17/2001 to 06/09/2001	SELECTIONS FROM THE PERMANENT COLLECTION
03/30/2001 to 03/31/2001	ART IN BLOOM

Old Jail Art Center
Hwy 6 South, Albany, TX 76430
📞: 915-762-2269 ◙ www.albanytexas.com
Open: 10-5 Tu-Sa, 2-5 Su **Closed:** Mo, LEG/HOL!
♿: Except 2 story original jail building ℗ **Museum Shop Sculpture Garden**
Permanent Collection: AS, EU, BRIT cont, Mod, P/COL

The Old Jail Art Center is housed partly in a restored 1878 historic jail building with a small annex which opened in 1980 and new wings added in 1984 and 1998 featuring a courtyard, sculpture garden and educational center. **NOT TO BE MISSED:** "Young Girl With Braids," by Modigliani; 37 Chinese terra cotta tomb figures.

Amarillo Museum of Art
2200 S. Van Buren, Amarillo, TX 79109
📞: 806-371-5050
Open: 10-5 Tu-Fr, 1-5 Sa, Su **Closed:** Mo, LEG/HOL!
♿ ℗ **Docents Tour times:** by appt **Sculpture Garden**
Permanent Collection: CONT AM; ptgs, gr, phot, sculp; JAP gr; SE ASIA sculp, textiles

Opened in 1972, the Amarillo Museum of Art is a visual arts museum featuring exhibitions, art classes, tours and educational programs. The building was designed by Edward Durell Stone.

Amarillo Museum of Art - continued

ON EXHIBIT 2001

06/24/2001 to 08/12/2001 SUNLIGHT AND SHADOW: AMERICAN IMPRESSIONISM, 1885-1945
The artists represented in this exhibition made valuable contributions to the art of their era.

ARLINGTON

Arlington Museum of Art
201 West Main St., Arlington, TX 76010

☎: 817-275-4600
Open: 10-5 We-Sa **Closed:** Su, Mo, Tu, LEG/HOL, 12/25-1/2!
Vol./Contr.: Yes
&: Partial **Museum Shop**
Docents Tour times: Occasional
Permanent Collection: Non-collecting institution

Texas contemporary art by both emerging and mature talents is featured in this North Texas museum located between the art-rich cities of Fort Worth and Dallas. It has gained a solid reputation for showcasing contemporary art in the six exhibitions it presents annually.

ON EXHIBIT 2001

01/22/2001 to 02/24/2001 SERIOTOON: RACHEL HECKER, JOHN HERNANDEZ AND ROGER SHIMOMURA
These three artists (from Houston, San Antonio and Lawrence, KS, respectively) all use cartoon imagery to comment on issues encompassing race, gender, economics and the politics of life in the United States.

03/03/2001 to 04/21/2001 PRIVATE COLLECTIONS: ARTISTS, CURATORS AND COLLECTORS
An informal examination of the collecting habits of artists, curators, and private collectors in the Metroplex area. This show features some of the favorite works collected by three artists, three curators, and three art collectors.

Center for Research in Contemporary Arts
Fine Arts Bldg, Cooper Street, Arlington, TX 76019

☎: 817-273-2790
Open: 10-3 Mo-Th, 1-4 Sa-Su **Closed:** ACAD!
Ⓟ
Permanent Collection: Non-collecting institution

A University gallery with varied special exhibitions.

AUSTIN

Austin Museum of Art-Downtown
823 Congress Avenue, Austin, TX 78701

☎: 512-495-9224 ◙ www.amoa.org
Open: 10-6 Tu-Sa, 10-8 Th, 12-5 Su **Closed:** Mo, LEG/HOL
ADM: Adult: $3.00, $1 day Th **Children:** Free under 12 **Students:** $2.00 **Seniors:** $2.00
& Museum Shop Docents Tour times: 2 pm Sa during exhibitions
Group Tours: 512-495-9224 ext. 224
Drop-in Tours: free public exhibition tours on the last Sa of each month at 2 Ⓟ: in the 823 Parking Garage on 9th St.
Permanent Collection: AM: ptgs 19, 20; WORKS ON PAPER, photo. Approximately 300 items focusing on American visual art significant to our time and region, inclusive of Mexico and the Caribbean.

An additional facility for the Museum

TEXAS

Austin Museum of Art-Downtown- continued

ON EXHIBIT 2001

12/09/2000 to 02/04/2001 NEW WORKS IV: LUCA BUVOLI
Luca Buvoli's newest project, Flying: A Practical Guide for Beginners, will be presented as fourth exhibition in the Museum's New Works Series. In this exhibition, which includes his latest animated film as well as sculptural displays and hand-drawn diagrams, Buvoli explores one of man's most ancient dreams, the ability to fly without the aid of mechanical devices.

12/09/2000 to 02/04/2001 NIC NICOSIA: REAL PICTURES 1979-1999
This retrospective presents 50 color and black-and-white photographs, three video/film works, and a video installation by Nic Nicosia exposing the inevitable highs and lows of American life in an ordinary suburban landscape.

02/17/2001 to 04/29/2001 EDWARD RUSCHA: EDITIONS 1959-1999
An influential voice in post-war Ameican painting, Edward Ruscha has also been one of contemporary art's most significant graphic artists, creating a body of editioned work that is uniquely American in both subject and sensibility. Edward Ruscha: Editions 1959-1999 is the first comprehensive museum presentation of the artist's prints, photographs, and artist books since the 1970s and highlights his unique combination of language, image, and idea.

05/12/2001 to 07/15/2001 IMAGES OF THE SPIRIT: PHOTOGRAPHS BY GRACIELA ITURBIDE
Images of the Spirit is the first major U.S. retrospective of one of the most important photographers working in Mexico today. Graciela Iturbide combines history, portraiture, and a penetrating lyricism in photographs that seek out the underlying Indian reality in contemporary Mexico. The exhibition spans Iturbide's career.

05/12/2001 to 07/15/2001 NEW WORKS V: SALOMON HUERTA
New Works V features paintings by Salomón Huerta, a Chicano artist working in Los Angeles who was recently featured in the 2000 Whitney Biennial survey of American art. With a characteristically precise and realistic style, Huerta's "portraits" challenge pictorial practices and confront preconceived beliefs about identity by presenting full-length or compact head shots of the backs of subjects, thus concealing the individual's distinguishing features.

Austin Museum of Art-Laguna Gloria
3809 W. 35th Street, Austin, TX 78703

☎: 512-458-8191 ◉ www.amo2.org
Open: 10-5 Tu-Sa, 10-8 Th, 1-5 Su **Closed:** Mo, LEG/HOL!
ADM: Adult: $2.00, $1.00 Th **Children:** Free under 16 **Students:** $1.00 **Seniors:** $1.00
♿ Ⓟ: Free **Museum Shop**
Group Tours: 512-495-9224, ext 224 **Sculpture Garden**
Permanent Collection: AM: ptgs 19,20; WORKS ON PAPER, photo

The Museum is Located on the 1916 Driscoll Estate which is listed in the National Register of Historic Places located in Mediterranean style villa on the banks of Lake Austin. **PLEASE NOTE:** THE GALLERIES AT THE MUSEUM AT LAGUNA GLORIA WILL UNDERGO RESTORATION BEGINNING IN JUNE 2000. **NOT TO BE MISSED:** The beautiful setting.

Jack S. Blanton Museum of Art
Affiliate Institution: University of Texas at Austin
Art Bldg 23rd & San Jacinto; Humanities Reearch Center 21st & Guadalupe, Austin, TX 78712

☎: 512-471-7324 ◉ www.utexas.edu/cofa/hag
Open: 9-5 Mo, Tu, We, Fr, 9-9 Th, 1-5 Sa, Su **Closed:** MEM/DAY, LAB/DAY, THGV, XMAS WEEK
♿ Ⓟ **Museum Shop**
Group Tours: 512-471-5025 **Docents**
Permanent Collection: LAT/AM; CONT; GR; DRGS

Jack S. Blanton Museum of Art- continued

The encyclopedic collection of this university gallery, one of the finest and most balanced in the southern U.S., features an artistic, cultural and historical record of Western European and American Art dating from antiquity to the present. Including 13,000 works spanning the history of western civilization. Please Note: selections from the Permanent collection are shown at the Harry Ransom Center (21st and Guadalupe) while temporary exhibitions and the Clark room are in the art building. A current ongoing search for a architectural firm to create a new state of the art building to open in 2004 is underway. **NOT TO BE MISSED:** The Mari and James A. Michener Collection of 20th c. American Art; C. R. Smith Collection of Western American Art; Contemporary Latin American Collection.

BEAUMONT

Art Museum of Southeast Texas

500 Main Street, Beaumont, TX 77701

☎: 409-832-3432 ◙ www.amset.org
Open: 9-5 Mo-Sa, 12-5 Su **Closed:** LEG/HOL!
♿ ℗: Free **Museum Shop** ❚❘
Docents Tour times: We, noon **Sculpture Garden**
Permanent Collection: AM: ptgs, sculp, dec/art, FOLK: 19,20

This new spacious art museum with 4 major galleries and 2 sculpture courtyards is located in downtown Beaumont.

COLLEGE STATION

MSC Forsyth Center Galleries

Affiliate Institution: Texas A & M University
Memorial Student Center, Joe Routt Blvd, College Station, TX 77844-9081

☎: 409-845-9251 ◙ www.charlotte.tamu.edu/services/forsyth
Open: 9-8 Mo-Fr, 12-6 Sa-Su, 10-4:30 Mo-Fr, 12-4:30 Sa, Su May-Aug **Closed:** 7/4, THGV, 12/25-1/2
♿ ℗: Underground
Docents Tour times: by appt
Permanent Collection: EU, BRIT,& AM; glass; AM: western ptgs

The Gallery is particularly rich in its collection of American Art glass, and has one of the finest collections of English Cameo Glass in the world. **NOT TO BE MISSED:** Works by Grandma Moses.

Texas A&M University/J. Wayne Stark University Center Galleries

Mem Student Ctr. Joe Routt Blvd, College Station, TX 77844-9083

☎: 409-845-6081 ◙ www.starktamued
Open: 9-8 Tu-Fr, 12-6 Sa-Su **Closed:** Mo, ACAD
♿ ℗
Permanent Collection: REG; GER 19

A University gallery featuring works by 20th century Texas artists.

ON EXHIBIT 2001
01/28/2001 to 03/25/2001 SUNLIGHT AND SHADOW: AMERICAN IMPRESSIONISM, 1885-1945
The artists represented in this exhibition made valuable contributions to the art of their era.

TEXAS

CORPUS CHRISTI

Art Museum of South Texas
1902 N. Shoreline, Corpus Christi, TX 78401
☏: 512-884-3844
Open: 10-5 Tu-Sa, 1-5 Su **Closed:** Mo, 1/1, 7/4, THGV, 12/25
Free Day: Th **ADM: Adult:** $3.00 **Children:** $1.00 (2-12) **Students:** $2.00 **Seniors:** $2.00
& ℗: Free **Museum Shop** ⅓ **Sculpture Garden**
Permanent Collection: AM; REG

The award winning building designed by Philip Johnson, has vast expanses of glass which provide natural light for objects of art and breathtaking views of Corpus Christi Bay.

Asian Cultures Museum and Educational Center
1809 North Chaparral, Corpus Christi, TX 78412
☏: 512-882-2641
Open: 12-5 Tu-Sa **Closed:** Su, Mo, LEG/HOL!, EASTER
Vol./Contr.: ADM: Adult: $4.00 **Children:** $2.50, 6-15 **Students:** $3.50 **Seniors:** $3.50
& ℗: Street **Museum Shop**
Docents Tour times: by request
Permanent Collection: JAP,CH,IND,AS CUL

An oasis of peace and tranquility as well as a resource of Asian history and information for the Corpus Christi Community. **NOT TO BE MISSED:** Cast bronze Buddha weighing over 1500 lb.

DALLAS

African American Museum
3536 Grand Avenue, Dallas, TX 75210
☏: 214-565-9026
Open: 12-5 Th-Fr, 10-5 Sa, 1-5 Su **Closed:** Mo, LEG/HOL!
& ℗ **Museum Shop** ⅓
Group Tours: 214-565-9026, ext 328 **Docents Tour times:** by appt **Sculpture Garden** ⸰
Permanent Collection: AF/AM: folk

The African American Museum collects, preserves, exhibits and researches artistic expressions and historic documents which represent the African-American heritage. Its mission is to educate and give a truer understanding of African-American culture to all.

Biblical Arts Center
7500 Park Lane, Dallas, TX 75225
☏: 214-691-4661 ▣ www.biblicalarts.org
Open: 10-5 Tu-Sa, 10-9 Th, 1-5 Su **Closed:** Mo, 1/1, THGV, 12/24, 12/25
ADM: Adult: $4.00 **Children:** $2.50 (6-12) **Students:** $3.00 (13-18) **Seniors:** $3.50
& ℗ **Museum Shop**
Permanent Collection: BIBLICAL ART

The sole purpose of this museum is to utilize the arts as a means of helping people of all faiths to more clearly envision the places, events, and people of the Bible. The building, in Romanesque style, features early Christian era architectural details. **NOT TO BE MISSED:** "Miracle at Pentecost," painting with light and sound presentation.

Dallas Museum of Art

1717 N. Harwood, Dallas, TX 75201

☎: 214-922-1200 ◉ www.dma-art.org
Open: 11-4 Tu, We, Fr, 11-9 T, 11-5 Sa, Su **Closed:** Mo, 1/1, THGV, 12/25
Free Day: Th after 5, spec exch
♿ ℗: Large underground parking facility **Museum Shop** ❚❚: 2 rest
Group Tours: 214-922-1331 **Docents** **Tour times:** Tu, Fr 1pm, Sa, Su 2pm, Th 7pm **Sculpture Garden**
Permanent Collection: P/COL; AF; AM: furniture; EUR: ptgs, sculp, Post War AM; AF; AS; CONT

Designed by Edward Larabee Barnes, the 370,000 square foot limestone building houses a broad and eclectic Permanent collection. The art of the Americas from the pre-contact period (which includes a spectacular pre-Columbian gold Treasury of more than 1,000 works) through the mid-20th century is outstanding. **NOT TO BE MISSED:** "The Icebergs" by Frederick Church; Claes Oldenburg's pop art "Stake Hitch in the Barrel Vault;" Colonial and post-Colonial decorative arts: early and late paintings by Piet Mondrian.

ON EXHIBIT 2001

through 01/28/2001 GUNTHER GERZSO REMEMBERED, 1915-2000
An exhibition of 12 paintings celebrating the memory of artist Gunther Gerzso, who died in March of this year, is on view in the Museum's Tower Gallery on the fourth floor. Gunther Gerzso Remembered, 1915-2000 presents a focused view of the work of this surrealist, who is also featured in the DMA's special exhibition Modern Masters of Mexico: Frida Kahlo, Diego Rivera, The Gelman Collection.

10/08/2000 to 01/28/2001 THE JACQUES AND NATASHA GELMAN COLLECTION OF MODERN MEXICAN PAINTING
Jacques and Natasha Gelman assembled one of the most important collections of Mexican modernist painting in private hands. Containing masterpieces by giants of Mexican modernism such as Diego Rivera, Frida Kahlo, Rufino Tamayo, José Clemente Orozco, David Alfaro Siqueiros, and Carlos Mérida, the collection reflects the personal tastes of the collectors and includes a number of portraits, both of the Gelmans and self-portraits of the artists. Most notable are a striking group of self-portraits by Frida Kahlo.

02/25/2001 to 05/27/2001 HENRY MOORE RETROSPECTIVE
A major international exhibition organized by the Dallas Museum of Art with the collaboration of the Henry Moore Foundation and the participation of the Fine Arts Museums of San Francisco, this exhibition will be the first major retrospective of Moore's work to occur in the United States in almost 20 years.

Meadows Museum

Affiliate Institution: SMU School of the Arts

Bishop Blvd. at Binkley Ave., Dallas, TX 75275-0356

☎: 214-768-2516 ◉ www.smu.edu/meadows/museum
Open: 10-5 Mo, Tu, Fr, Sa, 10-8 Th, 1-5 Su **Closed:** We, 1/1, EASTER, 7/4, THGV, 12/25
Vol./Contr.: Yes
♿ ℗ **Museum Shop**
Group Tours: 214-823-7644 **Docents** **Tour times:** 2pm, Su, Sept-May **Sculpture Garden**
Permanent Collection: SP; ptgs, sculp, gr, drgs; AM: sculp 20,

The collection of Spanish Art is the most comprehensive in the US with works from the last years of the 10th century through the 20th century. **NOT TO BE MISSED:** "Sibyl With Tabula Rasa" by Diego Rodriquez de Silva y Velazquez, Spanish, 1599-1660.

TEXAS

El Paso Museum of Art
1211 Montana Ave, El Paso, TX 79902-5588
℡: 915-541-4040
Open: 9-5 Tu, We, Fr, Sa, 9-9 Th, 1-5 Su **Closed:** Mo, LEG/HOL!
&. Ⓟ: Free **Museum Shop**
Permanent Collection: EU: Kress Coll 13-18; AM; MEX: 18,19; MEX SANTOS: 20; REG

The museum houses the renowned Permanent Kress collection of works by European masters; one of the most important concentrations of Mexican Colonial art; American painting (1800 to the present); and over 2000 works on paper by Dürer, Degas, Miro, Benton, Rivera and Orozco. Two changing galleries display work by recognized contemporary regional artists.

FORT WORTH

Amon Carter Museum
3501 Camp Bowie Blvd, Fort Worth, TX 76107-2695
℡: 817-738-1933 ◙ www.cartermuseum.org
Open: 10-5 Tu-Sa, 12-5 Su! Call for Info **Closed:** Mo, 1/1, 7/4, THGV,12/25
&.: Lancaster Ave main entrance Ⓟ: Free **Museum Shop**
Permanent Collection: AM: ptgs, sculp, gr, phot 19,20

While the Amon Museum building is closed for expansion, visitors may still view exceptional works of American art from one of the country's premier collections. In addition to the paintings, sculpture, photographs, and works on paper in the gallery, the space includes a store and models of architect Philip Johnson's expansion plan. The new Museum will open in fall 2001. **NOT TO BE MISSED:** Frederic Remington, Charles M. Russell, Georgia O'Keeffe, Grant Wood

Kimbell Art Museum
3333 Camp Bowie Blvd, Fort Worth, TX 76107-2792
℡: 817-332-8451 ◙ www.kimbellart.org
Open: 10-5 Tu-Th, Sa, 12-8 Fr, 12-5 Su **Closed:** Mo, 1/1, 7/4, THGV, 12/25
Free Day: No charge for Permanent exhibitons **ADM: Adult:** $10.00 **Children:** 6-12 $6.00 **Students:** $8.00
Seniors: $8.00
&. Ⓟ **Museum Shop** ¶
Group Tours: 817-332-8451, ext. 229 **Docents** **Tour times:** 2pm Tu-Fr, Su, exh tours 2pm Su, 3:00 Su **Sculpture Garden**
Permanent Collection: EU: ptgs, sculp 14-20; AS; AF; Med/Ant

Designed by Louis I. Kahn, this classic museum building is perhaps his finest creation and a work of art in its own right. It was the last building completed under his personal supervision. It is often called "America's best small museum." The Permanent collection of the Museum is free. Admission is for Special exhibitions. **NOT TO BE MISSED:** "The Cardsharps" by Caravaggio, "Portrait of a Yount Jew" by Rembrandt

Modern Art Museum of Fort Worth
1309 Montgomery Street, Fort Worth, TX 76107
℡: 817-738-9215 ◙ www.mamfw.org
Open: 10-5 Tu-Fr, 11-5 Sa, 12-5 Su **Closed:** Mo, LEG/HOL!
&. Ⓟ **Museum Shop**
Docents **Tour times:** Sa pm **Sculpture Garden**
Permanent Collection: AM; EU; CONT; ptgs, sculp, works on paper, photo, 14 new works by Modern and Contemporary photographers and artists.

Modern Art Museum of Fort Worth - continued

Chartered in 1892 (making it one of the oldest museums in the western U.S.), this museum has evolved into a celebrated and vital showcase for works of modern and contemporary art. Great emphasis at the Modern is placed on the presentation of exceptional traveling exhibitions making a trip to this facility and others in this "museum rich" city a rewarding experience for art lovers. **NOT TO BE MISSED:** Important collections of works by Robert Motherwell, Jackson Pollock, Morris Louis and Milton Avery as well as contemporary photography.

ON EXHIBIT 2001

09/24/2000 to 01/14/2001 WAYNE THIEBAUD: A PAINTINGS RETROSPECTIVE
This exhibition marks the first full retrospective in over 15 years of the work of well-known American figurative painter Wayne Thiebaud, and celebrates the artist's 80th birthday. Approximately 100 major paintings, watercolors and pastels will trace the course of his career from the late 1950s, when he first began to emerge as a mature artist, to the present day, as he continues to work with great vigor and invention. *Catalog*

02/04/2001 to 05/06/2001 ULTRA BAROQUE: ASPECTS OF CONTEMPORARY LATIN AMERICAN ART
Organized by the Museum of Contemporary Art, San Diego, this exhibition offers an in-depth look at Latin American art today as it explores the contemporary culture of this vast region of the world. ULTRA BAROQUE provides a critical analysis of the Baroque in Latin America and the use of the Baroque theme as an important cultural metaphor. The exhibition seeks to explore the important differences reflected in the work of a wide range of contemporary artists from South America, Mexico, the Caribbean, and the United States. *Catalog*

07/01/2001 to 09/20/2001 ED RUSCHA
Wit, graphic skill and a focus on language, vernacular culture and mass media characterize the work of Los Angeles-based American artist Edward Ruscha. This exhibition constitutes his first American museum retrospective since 1982. A selection of approximately 75 works from the early 1960s to the present reveal Ruscha's development of a distinct vision with parallels to Pop Art, Photo-Realism, Conceptual Art and today's media-based imagery and renewed focus on painting. This exhibition stresses both the art historical importance of Ruscha's work and its strong relevance to international contemporary art. *Catalog Will Travel*

Modern at Sundance Square

Affiliate Institution: The Modern Art Museum
410 Houston Street, Fort Worth, TX 76102

☎: 817-335-9215 ◙ www.mamfw.org
Open: 11-6 Mo-Th, 11-10 Fr & Sa, 1-5 Su **Closed:** LEG/HOL
& **Museum Shop**
Permanent Collection: AM, EU CONT ptg, sculp, works on paper, CONT photo
Opened in 1995 in the historic Sanger Building in downtown Fort Worth as an annex for both the Permanent collections and temporary exhibitions of the Modern Art Museum.

Sid Richardson Collection of Western Art

309 Main Street, Fort Worth, TX 76102

☎: 817-332-6554(888-332-6554) ◙ www.sidrmuseum.org
Open: 10-5 Tu, We, 10-8 Th, Fr, 11-8 Sa, 1-5 Su **Closed:** Mo, LEG/HOL!
& Ⓟ: 3 hours free at Chisholm Trail Lot-4th and Main with ticket validation. **Museum Shop**
Permanent Collection: AM/WEST: ptgs

Dedicated to Western Art the museum is located in historic Sundance Square in a reconstructed 1890's building. The area, in downtown Fort Worth, features restored turn-of-the-century buildings housing shops, restaurant, theater and museum. **NOT TO BE MISSED:** 60 Remington and Russell paintings on Permanent display.

TEXAS

Contemporary Arts Museum
5216 Montrose Boulevard, Houston, TX 77006-6598

℘: 713-284-8250 ◙ www.camh.org
Open: 10-5 Tu-Sa, 10-9 Th, 12-5 Su **Closed:** Mo, 1/1, THGV, 12/25
& ℗: On-street parking **Museum Shop** ⑪: Starbucks cafe **Sculpture Garden**
Permanent Collection: Non-Collecting Institution

Located in a metal building in the shape of a parallelogram this museum is dedicated to presenting the art of our time to the public.

Menil Collection
1515 Sul Ross Street, Houston, TX 77006

℘: 713-525-9400 ◙ www.menil.org
Open: 11-7 We-Su **Closed:** Mo, Tu, LEG/HOL!
& ℗ **Museum Shop Sculpture Garden**
Permanent Collection: PTGS, DRGS, & SCULP 20; ANT; TRIBAL CULTURES; MED; BYZ

The Menil Collection was founded to house the art collection of John and Dominique de Menil. Considered one of the most important privately assembled collections of the 20th c. it spans human creative efforts from antiquity to the modern era. The Renzo-Piano designed Museum building is renowned for its innovative architecture and naturally-illuminated galleries. **NOT TO BE MISSED:** In collaboration with the Dia Center for the Arts, NY, the Cy Twombly Gallery designed by Renzo Piano is a satellite space featuring works in all media created by Cy Twombly. Dan Flavin flourescent-light installation at Richmond Hall.

ON EXHIBIT 2001
09/20/2000 to 01/07/2001 CY TWOMBLEY: THE SCULPTURE
Organized by The Menil Collection and the Kunstmuseum Basel, the exhibition will present a comprehensive selection of 65 of the artist's three-dimensional works, including many sculptures never before publicly exhibited. Known primarily as a painter and exhibited throughout the world, Twombly, working in plaster, stone, and bronze, began making sculpture of great poetic intensity in the late 1940s, and continued with a limited production for the remainder of the 1950s. *Catalog. Will Travel.*

09/07/2000 to 01/14/2001 FROM ABOVE: PHOTOGRAPHS OF HOUSTON BY ALEX MacLEAN
Startling views of Houston, taken from the perspective of Alex MacLean's single-engine Cessna. From the Ship Channel to the suburban prairie, MacLean's photographs reveal landscapes as abstract compositions, providing a vital perspective on the relationship between natural and manmade environments.

01/26/2001 to 05/13/2001 POP ART: US/UK CONNECTIONS, 1956-1966
Though the term originated in Britain, Pop Art burst onto the global art scene as a meditation on and celebration of American popular culture and mass media. As the British artist Richard Hamilton observed at the time, what Rome, Florence, and Venice were to the Renaissance, so Madison Avenue, Hollywood, and Detroit were to Pop. *Catalog.*

Museum of Fine Arts, Houston
1001 Bissonnet, Houston, TX 77005

℘: 713-639-7300 ◙ www.mfah.org
Open: 10-7 Tu, We, Sa; 10-9 Th-Fr; 12:15-7 Su **Closed:** Mo, 1/1, 7/4, LAB/DAY, THGV, 12/25
Free Day: Th **ADM: Adult:** $5.00 **Children:** Free under 5, 6-18 $2.50 **Students:** $2.50 **Seniors:** $2.50
& ℗: Free **Museum Shop** ⑪
Group Tours: 713-639-7324 **Docents Tour times:** 12 Tu-Fr Oct-May and by appt **Sculpture Garden**
Permanent Collection: STRAUS COLL OF REN & 18TH C WORKS; BECK COLL: Impr; GLASSELL COLL: Af gold

310

Museum of Fine Arts, Houston- continued

Over 40,000 works are housed in the largest and most outstanding museum in the southwest. IMPRESSIONIST AND MODERN PAINTING: THE JOHN AND AUDREY JONES BECK COLLECTION. NOT TO BE MISSED: Audrey Jones Beck building opened March 2000, designed by Rafael Moneo housing European art from antiquity to 1920, American art to 1945. Bayou Bend Collection and Gardens, a 28 room house with 5,000 works of fine and decorative American arts from colonial to MID 19TH c. Separate admission and hours. 713-639-7750. Rienzi, a newly opened house museum showcasing an important collection of 18th and 19th C European art and antiques and English porcelain. Separate admission and hours. 713-639-7800.

ON EXHIBIT 2001

ONGOING: AFRICAN GOLD: SELECTIONS FROM THE GLASSELL COLLECTION

10/22/2000 to 1/28/2001 ROMANTICS, REALISTS, REVOLUTIONARIES: MASTERPIECES OF NINETEENTH CENTURY GERMAN PAINTING FROM THE MUSEUM OF FINE ARTS, LEIPZIG
Houston's "Sister City," Leipzig, Germany, possesses a very important collection of nineteenth-century German paintings in the Museum der Bildenden Künste (Museum of Fine Arts). During the construction of the Leipzig museum's new building, a representative selection (75 paintings and 10 works on paper) will travel to Houston. The exhibition will focus on all of the main artists and movements from roughly 1800 to 1900, beginning with the avid interest in Italy on the part of many German painters early in the nineteenth century.

12/17/2000 to 03/04/2001 WALKER EVANS
Walker Evans unprecedented study of contemporary American society directly and unsentimentally portrays who we were and, to a large extent, who we still are. Bringing together the finest surviving photographs from each decade drawn from more than twenty private and public collections, Walker Evans will prominently feature and carefully examine Evans's brilliant documentation of America and the heretofore unexhibited color Polaroid prints from 1973-74.

12/12/2000 to 03/09/2001 WILLIAM MERRITT CHASE: MODERN AMERICAN LANDSCAPES, 1886-1890
The exhibition brings together approximately 35 carefully selected oils and pastels by William Merritt Chase (1849-1916), among the most important American artists of the Gilded Age and a proponent of American Impressionism. The exhibition investigates a discrete segment of Chase's subject matter—the landscapes that he created from 1886-1891, the subjects of which are Brooklyn and Manhattan parks, views of New York harbors and bays, and a few "domestic" outdoor scenes that locate Chase's Brooklyn base of operation.

01/21/2001 to 04/14/2001 MONET, RENOIR, AND THE IMPRESSIONIST LANDSCAPE
European landscape painting became the most exciting genre of painting in the second half of the nineteenth century. Monet, Renoir, and the Impressionist Landscape illustrates the rise of landscape painting as the dominant genre of the avant-garde—one of the great dramas of nineteenth-century painting. This exhibition opens with one of Monet's finest early works, Rue de la Bavolle, Honfleur (1864), placed within the context of the Realist landscape style of Corot, Daubigny, and Courbet. The exhibition then tracks the evolution of the Impressionist experiment and concludes with an examination of the Impressionist influence on the next generation of landscape painters.

03/11/2001 to 06/24/2001 STAR WARS: THE MAGIC OF MYTH
Lucasfilm Ltd. has made available, for the first time, a selection of original conceptual and production artwork, characters, costumes, large-scale models, and props used to create the original Star Wars trilogy—Star Wars: A New Hope, The Empire Strikes Back, and Return of the Jedi. Additional artifacts from Star Wars: Episode I—The Phantom Menace, including a costume and drawings, are also included. *Book Will Travel*

Rice University Art Gallery
6100 Main Street, MS-21, Houston, TX 77005
✆: 713-527-6069 ◉ www.rice.edu-ruag
Open: 11-5 Tu-Sa, 11-8 Th 12-5 Su **Closed:** Mo, ACAD, Summer
& ℗ ¶: Cafeteria on campus **Group Tour:** 713-348-6069
Permanent Collection: Rotating Exhibitions
Permanent Collection: Rotating Exhibitions

The Gallery features changing exhibitions of contemporary art with an emphasis on site-specific installations.

TEXAS

Cowboy Artists of America Museum
1550 Bandera Hwy, Kerrville, TX 78028
℄: 830-896-2553 **◉** www.caamuseum.com
Open: 9-5 Mo-Sa, 1-5 Su **Closed:** 1/1, EASTER, THGV, 12/25
ADM: Adult: $3.00 **Children:** $1.00 (6-18) **Seniors:** $2.50
৬ ℗: Free Museum Shop
Docents Tour times: daily ! **Sculpture Garden**
Permanent Collection: AM/WESTERN: ptgs, sculp

Located on a hilltop site just west of the Guadalupe River, the museum is dedicated to perpetuating America's western heritage. Exhibitions change quarterly.

Longview Museum of Fine Arts
215 E. Tyler St, Longview, TX 75601
℄: 903-753-8103 **◉** WWW.LMFA.ORG
Open: 10-4 Tu-Fr, 12-4 Sa **Closed:** Mo, Su, 12/25, 1/1
Free Day: No charge for Permanent exhibitons **Vol./Contr.: Adults:** $3.00 **Students:** $1.00
৬ ℗: Adjacent to the building **Museum Shop**
Group Tours: 903-753-8103
Permanent Collection: CONT TEXAS ART (1958-1999)

Located in downtown Longview, this renovated building was used by many businesses in the city's history. **NOT TO BE MISSED:** Millennium celebration highlighting LMFA's fine art Permanent collection since 1959.

Museum of East Texas
503 N. Second Street, Lufkin, TX 75901
℄: 409-639-4434
Open: 10-5 Tu-Fr, 1-5 Sa-Su **Closed:** Mo, LEG/HOL!
৬ ℗ Museum Shop
Permanent Collection: AM, EU, & REG: ptgs

The Museum is housed in St. Cyprians Church, whose original Chapel was built in 1906. An award winning wing was completed in 1990. **NOT TO BE MISSED:** Historic photographic collection covering a period of over 90 years of Lufkin's history.

Michelson Museum of Art
216 N. Bolivar, Marshall, TX 75670
℄: 903-935-9480
Open: 12-5 Tu-Fr, 1-4 Sa-Su **Closed:** Mo, EASTER, MEM/DAY, 7/4, THGV, 12/25
Vol./Contr.: Yes **Docents Tour times:** 12-5 daily
Permanent Collection: Works of Russian American artist Leo Michelson, 1887-1978, Milton Avery (1885-1965), David Burliuk (1882-1967), Abraham Walkowitz (1878-1965), John Edard Costigan (1888-1972)

Michelson Museum of Art - continued
The historic Southwestern Bell Telephone Corporation building in downtown Marshall is home to this extensive collection.

ON EXHIBIT 2001

11/09/2000 to 01/26/2001 SURVEY OF TEXAS ARTISTS, 1890-1945

03/12/2001 to 05/13/2001 TEXAS WATERCOLOR SOCIETY TRAVELING EXHIBIT

06/16/2001 to 07/31/2001 NATIONAL WATERCOLOR TRAVELING EXHIBIT

MCALLEN

McAllen International Museum
1900 Nolana, McAllen, TX 78504

(: 956-682-1564 ◙ www.hiline.net/mim
Open: 9-5 Mo-We, Sa; Th 12-8; Su 1-5 **Closed:** Mo, THGV, 12/25
Free Day: Sa 9-1 **ADM: Adult:** $2:00 **Children:** $1.00 under 13 **Students:** $1.00 **Seniors:** $1.00
& ℗ **Museum Shop** ⁝⁝: small café
Group Tours: 956-682-1564, ext. 116 **Docents** **Tour times:** 8:30-11, 12-2:30
Permanent Collection: LAT/AM: folk; AM; EU: gr 20

The museum caters to art & science on an equal level. See the hands-on mobile exhibits.

MIDLAND

Museum of the Southwest
1705 W. Missouri Ave, Midland, TX 79701-6516

(: 915-683-2882
Open: 10-5 Tu-Sa, 2-5 Su **Closed:** Mo, LEG/HOL!
& ℗
Docents **Tour times:** on request **Sculpture Garden**
Permanent Collection: REG; GR; SW

The Museum of the Southwest is an educational resource in art including a Planetarium and Children's Museum. It focuses on the Southwest. Housed in a 1934 mansion and stables, the collection also features the Hogan Collection of works by founder members of the Taos Society of Artists. **NOT TO BE MISSED:** "The Sacred Pipe," by Alan Houser, bronze.

ORANGE

Stark Museum of Art
712 Green Ave, Orange, TX 77630

(: 409-883-6661
Open: 10-5 We-Sa, 1-5 Su **Closed:** Mo, Tu, 1/1, EASTER, 7/4, THGV, 12/25
& ℗ **Museum Shop**
Docents **Tour times:** by appt **Sculpture Garden**
Permanent Collection: AM: 1830-1950; STEUBEN GLASS; NAT/AM; BIRDS BY DOROTHY DOUGHTY & E.M. BOEHM, REMINGTON, RUSSELL, TAOS SOCIETY OF ARTISTS

Stark Museum of Art- continued

In addition to Great Plains and SW Indian crafts the Stark houses one of the finest collections of Western American art in the country. The museum also features the only complete Steuben Glass collection of "The US in Crystal." **NOT TO BE MISSED:** Bronze Sculptures by Frederic Remington.

ON EXHIBIT 2001
06/2000 to 05/2001 STARK LEGACY: A PERSONAL COLLECTION
Featuring works by early 20th century American artists, this exhibition features 70 paintings from the personal collection of the late Nelda C. Stark, who with her husband H. J. Lutcher Stark assembled one of the largest art holdings of its kind in Texas. The exhibition includes important canvases by W. H. Dunton, E. M. Hennings, E. I. Couse, and other founders of the Taos Society of Artists, as well as historic paintings by Thomas Moran and Frederic Remington.

SAN ANGELO

San Angelo Museum of Fine Arts
One Love Street, San Angelo, TX 76903
☎: 915-653-3333 ◙ http://web2.airmail.net/samfa
Open: 10-4 Tu-Sa, 1-4 Su **Closed:** Mo, LEG/HOL!
ADM: Adult: $2.00 **Children:** Free under 6 **Seniors:** $1.00 **Military:** Free **Local Students:** FreeGroup
& ℗: On-site **Museum Shop Sculpture Garden**
Tour: 915-653-3333 **Drop-in Tours**
Permanent Collection: AM: cont cer; REG; MEX: 1945-present

The new San Angelo Museum of Fine Arts and Education Center is a 30,000 square foot building constructed of native exas limstone topped with a soaring spavine-vaulted, copper-clad roof, which dips in the middle and rises to an elevation of 65 feet at is east elevation. The building's long rectangular profile reinforces the adjacent streetscape and helps to create a grand avenue to the nearby Paseo de Santa Angela. The education wing includes a ceramics studio and outdoor kiln yard for use by Angelo State University as well as an additional art studio and educator's office for the use of the museum's educational programming. Other features of the museum include: a multi-purpose meeting room capable of seating 300 people, a library, unique walk-in and visible colletions storage areas, three flexible gallery spaces, a 4,000 square foot roof-top sculpture garden, a dramatic atrium lobby and complete handiapped accessibility throughout. **NOT TO BE MISSED:** "Figuora Accoccolata," by Emilio Greco.

SAN ANTONIO

McNay Art Museum
6000 N. New Braunfels Ave, San Antonio, TX 78209-4618
☎: 210-805-1757 ◙ www.mcnayart.org
Open: 10-5 Tu-Sa, 12-5 Su **Closed:** Mo, 1/1, 7/4, THGV, 12/25
& ℗ **Museum Shop Docents Sculpture Garden**
Permanent Collection: FR & AM: sculp 19,20; SW: folk ; GR & DRGS: 19,20; THEATER ARTS

Devoted to the French Post-Impressionist and early School of Paris artists, the McNay Art Museum also has an outstanding theatre arts collection containing over 20,000 books and drawings as well as models of stage sets. It is located on beautifully landscaped grounds in a classic mediterranean style mansion.

San Antonio Museum of Art
200 West Jones Street, San Antonio, TX 78215

☎: 210-978-8100 ◙ www.sa-museum.org
Open: 10-9 Tu, 10-5 We-Sa, 12-5 Su **Closed:** Mo, THGV, 12/25
ADM: Adult: $5.00 **Children:** $1.75 (4-11) **Students:** $4.00 **Seniors:** $4.00
& ℗: Free **Museum Shop** Snack Bar
Group Tours: 210-978-8138 **Docents** **Tour times:** most Su at 2pm **Sculpture Garden**
Permanent Collection: AN/GRK; AN/R; EGT; CONT:ptgs, sculp; LAT/AM; AS; OC; AM:ptgs 18, 19; EU:ptgs, sculp; CONT

The San Antonio Museum of Art is located in the restored turn-of-the-century former Lone Star Brewery. In addition to its other varied and rich holdings it features the most comprehensive collection of ancient art in the south, and the Nelson A. Rockefeller Center for Latin American Art. The Center's collections span four thousand years of Latin American history. **NOT TO BE MISSED:** The spectacular Ewing Halsell Wing for Ancient Art. The Nelson A. Rockefeller Center for Latin American Art.

ON EXHIBIT 2001
09/2000 to 03/2001 TESOROS NUEVOS II: SELECT ACQUISITIONS OF IBERIAN AND LATIN AMERICAN ART
Features a selection of important Latin American and Iberian art works that have been acquired by the Museum since the opening of the Nelson A. Rockefeller Center for Latin American Art in 1998. The works come from various areas of Spain and Latin America, including Guatemala, Mexico and Peru. The earliest works date between 200 B.C. and A.D. 300, while the most recent date around 1980.

10/2000 to 01/2001 FANTIN-LATOUR PRINTS
Features 40 prints and drawings by nineteenth-century French artist Henri Fantin-Latour. Among them are the allegorical works he based on the operas of Richard Wagner and Hector Berlioz. Though best known for his paintings of floral arrangements, Fantin-Latour considerd his works based on these operas to be his greatest accomplishments.

11/28/2000 to 02/25/2001 JOHN GUTMANN: CULTURE SHOCK
Features 60 photographs by John Gutmann, a German painter who took up photography to support himself after emigrating to San Francisco in the early 1930s. Struck by America's uniqueness (including its freedom and obsession with cars), Gutmann turned his camera on all that seemed odd and new to him. The majority of John Gutmann: Culture Shock presents the America that was seen by Gutmann during the 1930s and '40s. Also featured are examples of Gutmann's documentary work in Asia and Europe.

TYLER

Tyler Museum of Art
1300 S. Mahon Ave, Tyler, TX 75701

☎: 903-595-1001
Open: 10-5 Tu-Sa, 1-5 Su **Closed:** Mo, LEG/HOL!
& ℗ **Museum Shop** �"|: Cafe open Tu-F 11-2
Permanent Collection: PHOT; REG 20

The Museum is located in an architecturally award winning building.

TEXAS

Art Center of Waco

1300 College Drive, Waco, TX 76708

℡: 254-752-4371
Open: 10-5 Tu-Sa; 1-5 Su **Closed:** Mo, LEG/HOL!
Sugg./Contr.: ADM: Adult: $2.00 **Children:** $1.00 **Students:** $1.00 **Seniors:** $1.50
&: 1st floor Ⓟ **Museum Shop Sculpture Garden**
Permanent Collection: CONT; REG

Housed in the Cameron Home, The Art Center is located on the McLennan Community College campus. It features an exhibit of sculpture on the grounds. **NOT TO BE MISSED:** "Square in Black," by Gio Pomodoro; "The Waco Door" 6 1/2 ton steel sculpture by Robert Wilson.

Wichita Falls Museum and Art Center

Two Eureka Circle, Wichita Falls, TX 76308

℡: 817-692-0923
Open: 9:30-4:30 Tu-Fr, 10:30-4:30 Sa **Closed:** Su, Mo, LEG/HOL!
ADM: Adult: $4.00 **Children:** Free under 2, $3.00 **Students:** $3.00 **Seniors:** $3.50
& Ⓟ **Museum Shop**
Permanent Collection: AM: gr; CONT

The art collection has the singular focus of representing the history of American art through the medium of print making. **NOT TO BE MISSED:** The "Magic Touch Gallery" featuring hands-on science and the "Discovery Gallery" emphasizing family programming. Also high energy, high tech laser programs and planet shows in the planetarium.

LOGAN

Nora Eccles Harrison Museum of Art
Affiliate Institution: Utah State University
650 N. 1100 E., Logan, UT 84322-4020

☎: 801-797-0163
Open: 10:30-4:30 Tu, Th, Fr, 10:30-8 We, 2-5 Sa-Su **Closed:** Mo, LEG/HOL!
 ♿ **Ⓟ:** Within one block ⅋
Group Tours: 801-797-0165 **Docents Sculpture Garden**
Permanent Collection: NAT/AM; AM: cont art, cer 20

The Nora Eccles Harrison Museum of Art is the major center for the exhibition of the visual arts in Northern Utah. Emphasizing the breadth of artistic expression and the history of art in the western United States, the Museum's Permanent collections include 20th century American sculpture, ceramics, paintings, graphic arts, photographs, and American Indian arts. Selections from the collection are always on view and are rotated periodically to reflect the continuing growth and refinement of the collection. In addition to installations of its Permanent holdings, the Museum organizes temporary and traveling exhibitions and serves as a venue for exhibitions of national and international stature. Artist talks, films, docent tours, and educational activities are additional dimensions of the Museum's programs which are designed to interpret, present, and foster the development of the visual arts. **NOT TO BE MISSED:** "Untitled" (Standing Woman), 1959, by Manuel Neri.

SALT LAKE CITY

Salt Lake Art Center
20 S.W. Temple, Salt Lake City, UT 84101

☎: 801-328-4201
Open: 10-5 Tu-Th, 10-9 Fr, 10-5 Sa, 1-5 Su **Closed:** Mo, LEG/HOL!
Sugg./Contr.: ADM: Adult: $2.00pp
 ♿ **Ⓟ:** Paid on street parking **Museum Shop** ⅋ **Docents**
Permanent Collection: REG: all media

The 60 year old art center is located in the Bicentennial complex in the heart of downtown Salt Lake City.

Utah Museum of Fine Arts
101 AAC, University of Utah, Salt Lake City, UT 84112

☎: 801-581-7332
Open: 10-5 Mo-Fr, 2-5 Sa, Su **Closed:** LEG/HOL!
 ♿ **Ⓟ:** Free on campus parking Sa & Su; metered parking on weekdays **Museum Shop** **Sculpture Garden**
Permanent Collection: EU & AM: ptgs 17-19; AF; AS; EGT

With a Permanent collection of over 10,000 works spanning a broad spectrum of the world's art history, this major Utah cultural institution is a virtual artistic treasure house containing the only comprehensive collection of art in the state or the surrounding region. **NOT TO BE MISSED:** "Dance Around The Maypole" by Pieter Breughel, the Younger.

UTAH

Springville Museum of Art
126 E. 400 S., Springville, UT 84663

☎: 801-489-2727
Open: 10-5 Tu-Sa, 2-5 Su, 10-9 We **Closed:** Mo, 1/1, 12/25
& ℗ **Museum Shop**
Permanent Collection: UTAH: ptgs, sculp

The museum, housed in a Spanish colonial revival style building, features a collection noted for the art of Utah dating from pioneer days to the present.

BENNINGTON

Bennington Museum

W. Main Street, Bennington, VT 05201

☎: 802-447-1571 ◙ benningtonmuseum.com
Open: 9-5 daily, Nov 1-May 31, 9-6 June 1-Oct 31 **Closed:** THGV, 12/25, 1/1
ADM: Adult: $6.00, family $13 **Children:** Free under 12 **Students:** $5.00 **Seniors:** $5.00
&: fully accessible ℗ **Museum Shop** Historic Building
Permanent Collection: AM: dec/art; MILITARY HIST; AM: ptgs; furniture, glass, tools, toys, dolls, New Bennington
Pottery Gallery; Bennington Flag; Martin-WASP touring car

Visitors can imagine days gone by while gazing at a favorite Grandma Moses painting at the Bennington
Museum, one of the finest regional art and history museums in New England. The original museum building
is the 1855 St. Francis de Sales church. **NOT TO BE MISSED:** Largest public collection of Grandma Moses
paintings and memorabilia

BURLINGTON

Robert Hull Fleming Museum

Affiliate Institution: University of Vermont
61 Colchester Ave., Burlington, VT 05405

☎: 802-656-0750 ◙ www.uvm.edu/~fleming
Open: 9-4 Tu-Fr, 1-5 Sa, Su (summer May 1st-Labor/Day 12-4 Th, Fr, 12-5 Sa, Su) **Closed:** Mo, LEG/HOL!, ACAD!
ADM: Adult: $3.00, Fam $5.00 **Children:** $2.00 **Students:** $2.00 **Seniors:** $2.00
& ℗ **Museum Shop**
Permanent Collection: AN/EGT; CONT; Eu & Am; MID/EAST; AS; AF

Vermont's primary art and anthropology museum is located in a 1931 McKim, Mead and White building.
NOT TO BE MISSED: Assyrian Relief.

MANCHESTER

Southern Vermont Art Center

West Road, Manchester, VT 05254

☎: 802-362-1405 ◙ www.svac.org
Open: Winter 10-5 Mo-Sa: Summer 10-8:30 Tu,10-5 We-Sa; 12-5 Su **Closed:** Mo, Su, in winter; Mo in summer; 1/1,
COLUMBUS DAY, 12/25
Free Day: Sa, 10-1 **ADM: Adult:** $3.00 **Children:** Free under 13 **Students:** $0.50 **Seniors:** $3.00
&: partial ℗ **Sculpture Garden**
Permanent Collection: PTGS, SCULP, PHOT, GR; CONT: 20

Built in 1917, by Mr. & Mrs. W. M. Ritter of Washington D.C. the Art Center is housed in a Georgian Colonial
Mansion located on 450 acres on the eastern slope of Mt. Equinox. Included in the facility is a theater with
dance, music and film programs. **NOT TO BE MISSED:** Works by Winslow Homer and Ogden Pleissner.

MIDDLEBURY

Middlebury College Museum of Art

Middlebury College, Middlebury, VT 05753

☎: 802-443-5007 ◘ www.middlebury.edu/~museum
Open: 10-5 Tu-Fr, 12-5 Sa, Su **Closed:** Mo, ACAD!, 12/18-1/1
&. ℗: Free **Museum Shop** ¶
Group Tours: 802-443-5007
Permanent Collection: Anc/R/Grk; ceramic, sculp, cer. sculp; EU, AM sculp, drg ptgs, photos, and Cont all media

Designed by the New York firm of Hardy Holzman Pfeiffer Associates, the new (1992) Center for the Arts also includes a theater, concert hall, music library and dance studios. It is located midway between Rutland and Burlington. **NOT TO BE MISSED:** "Bimbo Malato (Sick Child)," 1893 by Medardo Rosso (wax over plaster).

Sheldon Art Museum, Archeological and Historical Society

1 Park Street, Middlebury, VT 05753

☎: 802-388-2117 ◘ www.middlebury.edu/~shel-mus
Open: 10-5 Mo-Sa, June-Oct, 12-4 some Su, 10-5 Mo-Fr late Oct-late May **Closed:** some Su, LEG/HOL!, 1/1, MEM/DAY, 7/4, LAB/DAY, THGV
ADM: Adult: $4.00, $8.00 fam **Children:** $1.00 6-18 **Students:** $3.50 **Seniors:** $3.50
&. ℗: Public parking nearby **Museum Shop** **Docents**
Permanent Collection: DEC/ART; PER/RMS; ARTIFACTS

Regional Vermont's exciting and interesting history is interpreted in this century old museum located in the 1829 Judd Harris house and Fletcher History Center. **NOT TO BE MISSED:** Portraits by itinerant artist Benjamin Franklin Mason.

MONTPELIER

T. W. Wood Gallery and Arts Center

Affiliate Institution: Vermont College
College Hall, Montpelier, VT 05602

☎: 802-828-8743
Open: 12-4 Tu-Su **Closed:** Mo, LEG/HOL!
ADM: Adult: $2.00 **Children:** Free under 12 **Seniors:** Free
Group Tour: 802-828-8743
&. ℗: on street **Museum Shop**
Permanent Collection: THOMAS WATERMAN WOOD: ptgs; PORTRAITS; WPA WORKS

Included in the more than 200 oils and watercolors in this collection are the works of Thomas W. Wood and his American contemporaries of the 1920s and 30s including A. H. Wyant and Asher B. Durand. **NOT TO BE MISSED:** Exhibits of Vermont's artists and crafts people.

SHELBURNE

Shelburne Museum

U.S. Route 7, Shelburne, VT 05482

☎: 802-985-3346 ◙ www.shelburnemuseum.org
Open: 10-5 Mo-Su Late-May through Late-Oct **Closed:** 1/1, Easter, THGV, 12/25
Free Day: June, 1/2 price for Vermont residents **ADM: Adult:** $17.50 **Children:** $7.00 (6-14) **Students:** $10.50
&: Limited (certain buildings are Handicap accessible) ℗: Free **Museum Shop** ¶
Group Tours: 802-985-3348, ext 3392 **Docents** **Tour times:** 1 pm late-Oct-late May
Permanent Collection: FOLK; DEC/ART; HAVERMEYER COLL, AMERICANA, PTGS

Thirty-seven historic and exhibition buildings on 45 scenic acres combine to form this nationally celebrated collection of American folk art, artifacts, and architecture. **NOT TO BE MISSED:** Steamboat Ticonderoga, 1950s exhibit: Welcome Home to Post-War Vermont

ST. JOHNSBURY

St. Johnsbury Athenaeum

11 Main Street, St. Johnsbury, VT 05819

☎: 802-748-8291 ◙ www.stjathenaeum.org
Open: 10:00-8:00 Mo, We, 10:00-5:30 Tu, Fr, 9:30-4 Sa **Closed:** Su, LEG/HOL!
ADM: Adult: $2.00pp
& ℗: Limited **Museum Shop**
Group Tour: 802-748-8291 **Docents**
Permanent Collection: AM: ptgs 19; Hudson River School

The Athenaeum was built as a public library and presented to the townspeople of St. Johnsbury by Horace Fairbanks in 1871. In 1873 an art gallery, which today is an authentic Victorian period piece, was added to the main building. The collection of American landscapes and genre paintings is shown as it was in 1890 in the oldest unaltered art gallery in the US. **NOT TO BE MISSED:** "Domes of The Yosemite," by Albert Bierstadt

VIRGINIA

CHARLOTTESVILLE

Bayly Art Museum of the University of Virginia

Rugby Road, Thomas H. Bayly Memorial Bldg, Charlottesville, VA 22903-2427

☎: 804-924-3592 ☑ www.virginia.edu/-bayly/bayly.html
Open: 1-5 Tu-Su **Closed:** Mo, 12/24-1/2
Sugg./Contr.: ADM: Adult: $3.00 **Seniors:** $3.00
& Ⓟ: Limited parking behind the museum **Museum Shop**
Group Tours: 804-924-7458 **Docents**
Permanent Collection: NAT/AM; MESO/AM; AF; DEC/ART 18; OM: gr; AM:ptgs, sculp, works on paper, phot 20; P/COL

This handsome Palladian-inspired building is located on the grounds of Jefferson's University of Virginia. With its wide ranging collection it serves as a museum for all ages and interests, for art lovers and scholars alike.

ON EXHIBIT 2001

11/18/2000 to 01/14/2001 THE MYSTICAL ARTS OF TIBET
Sacred objects from the personal collection of the Dalai Lama as well as ancient objects from the monastery, contemporary objects made by Tibetan refugees, and 21 photos from the Tibet Image Bank, London.

Second Street Gallery

201 2nd Street, NW, Charlottesville, VA 22902

☎: 804-977-7284 ☑ www.avenue.org/ssg
Open: 10-5 Tu-Sa, 1-5 Su **Closed:** Mo, LEG/HOL!
& Ⓟ: On-street parking; back lot
Group Tours: 804-977-7284
Permanent Collection: Non-collecting Contemporary art space

Nationally known for its innovative programming since its founding in 1973, Second Street Gallery presents the best of contemporary art by local, regional, and national artists working in a variety of media, from painting and photography to sculpture and site-specific installations. In addition, Second Street Gallery offers a full calendar of educational activities that complement is exhibition season.

CLIFTON FORGE

Allegheny Highlands Arts and Craft Center

439 East Ridgeway Street, Clifton Forge, VA 24422

☎: 703-862-4447
Open: 10:30-4:30 Mo-Sa May-Dec, 10:30-4:30 Tu-Sa Jan-Apr **Closed:** THGV, 12/24, 12/25, 12/30, 1/1-1/16/01
& Ⓟ Museum Shop
Group Tours: on request **Historic Building**
Permanent Collection: Non-collecting institution

Housed in an early 1900's building, the galleries' changing exhibits feature works produced by Highlands and other artists.

ON EXHIBIT 2001

02/27/2001 to 03/31/2001 LESLYE BLOOM—COMPUTAGE: "COMPUTERS ARE EASY, ART IS HARD"

04/03/2001 to 04/28/2001 AIE RESIDENCY AND ANNUAL HIGH SCHOOL AREA ART COMPETITION

05/01/2001 to 05/26/2001 JONI PIENKOWSKI

06/26/2001 to 07/28/2001 3 SCULPTORS "STICKS, STONES AND STEEL" (RICHARD GANS, FRED CRIST, JIM HUDSON)

Allegheny Highlands Arts and Craft Center - continued
07/31/2001 to 08/25/2001 ALLEN HICKMAN "TRAINS AND THINGS/UNDER ALLAN'S STEAM"

08/28/2001 to 10/13/2001 MICHAEL FARRAR: OIL WASHES AND WATERCOLORS

10/19/2001 to 11/10/2001 FALL FESTIVAL: ANNUAL OPEN AREA ART COMPETITION

11/13/2001 to 12/22/2001 CHRISTMAS GLAD RAGS—CHRISTMAS INVITATIONAL

DANVILLE

Danville Museum of Fine Arts & History
975 Main Street, Danville, VA 24541

☎: 804-793-5644
Open: 10-5 Tu-Fr, 2-5 Sa, Su **Closed:** Mo, LEG/HOL!
Sugg./Contr.: ADM: Adult: $2.00 **Children:** $1.00 **Students:** $1.00 **Seniors:** $1.00
 &. ℗ **Museum Shop Docents Tour times:** by appt
Permanent Collection: REG: portraits, works on paper, dec/art, furniture, textiles

The museum, located in Sutherlin Mansion built about 1857, was the residence of Confederate President Jefferson Davis for one week in April 1865. **NOT TO BE MISSED:** Restored Victorian Parlor.

FREDERICKSBURG

Belmont, The Gari Melchers Estate and Memorial Gallery
224 Washington St., Fredericksburg, VA 22405

☎: 540-654-1015 · ◙ www.mwc.edu/belmont
Open: 10-5 Mo-Sa, 1-5 Su **Closed:** 1/1, THGV, 12/24, 12/25, 12/31
ADM: Adult: $4.00 **Children:** Free under 6 **Seniors:** $3.00
&.: Very limited (with prior notice assistance will be provided) ℗ **Museum Shop**
Group Tours: 540-654-1841 **Docents Tour times:** on the hour and half hour
Permanent Collection: EU & AM: ptgs (mostly by Gari Melchers)

This 18th century estate features many paintings by Gari Melchers (its former resident). Also on view are works by his American and European contemporaries as well as some old masters. **NOT TO BE MISSED:** Formal gardens restored by the Garden Club of Virginia

HAMPTON

Hampton University Museum
Hampton University, Hampton, VA 23668

☎: 757-727-5308 ◙ www.hamptonu.edu
Open: 8-5 Mo-Fr,12-4 Sa, Su **Closed:** LEG/HOL!, ACAD!
&. ℗ **Museum Shop Group Tours:** 757-727-5508, child 757-727-5024
Permanent Collection: AF; NAT/AM: AM: ptgs 20

The Museum is housed in the spectacular, newly renovated Huntington Building, formerly the University Library. It is the oldest African American museum in the US and one of the oldest museums in Virginia. The collections include over 9,000 objects including traditional African, Native American, Asian and Pacific Island art as well as a fine art collection. **NOT TO BE MISSED:** "The Banjo Lesson," by Henry O. Tanner.

VIRGINIA

Maier Museum of Art

Affiliate Institution: Randolph-Macon Woman's College
2500 Rivermont Avenue, Lynchburg, VA 24503
☎: 804-947-8136 **▣** www.rmwc.edu/maier
Open: 1-5 Tu-Su Sep-May; 1-4 We-Su, June-Aug **Closed:** Mo, Acad/Hol!
&: Limited (no handicap bathroom) **℗:** convenient parking adjacent to the museum **Museum Shop**
Group Tours: ext 3 **Docents**
Permanent Collection: AM: ptgs 19,20

19th and 20th century American paintings including works by Gilbert Stuart, Winslow Homer, Thomas Eakins, Thomas Cole, George Bellows, Mary Cassatt, Georgia O'Keeffe, and Andrew Wyeth, are among the many highlights of the Maier Museum of Art. **NOT TO BE MISSED:** George Bellows' "Men of the Docks."

Peninsula Fine Arts Center

101 Museum Drive, Newport News, VA 23606
☎: 757-596-8175 **▣** www.pfac-vol.org
Open: 10-5 Mo-Sa, 1-5 Su; 10-9 Th **Closed:** 1/1, THGV, 12/24/pm, 12/25
Sugg./Contr.: $5.00
&: Limited, 1st fl only incl all galleries and one classroom **℗** **Museum Shop**
Docents Tour times: by appt **Sculpture Garden**
Permanent Collection: Non-collecting institution

Fill your world with art! Check out our ever-changing visual arts exhibitions. Interact with art in the Hands On For Kids gallery. Enjoy special events, studio art school classes and educational programs for all ages. Take home works by regional artists from The Gallery Shop. Located within the Mariners' Museum Park— Open Daily.

ON EXHIBIT 2001

11/11/2000 to 01/07/2001 EGER: PHOTOGRAPHS BY R. LADISLAS DERR
This series of works is based on the artist's visit to Eger, Hungary, where he encountered an old cemetery. The cemetery is made of numbered cement burial boxes for placement of offerings to the deceased. Capturing shadows and light, the artist has juxtaposed these images with antique glass slides of art history subjects adding to the narrative of his work. The images of burial boxes are given added dimension by being mounted in light boxes. These works offer the simplicity of beauty and form, and the complexity of their construction and composition.

11/11/2000 to 01/07/2001 A LEVEL OF INSPIRED LUNACY: SCULPTURE BY STEVE ZAPTON
"Raising common household objects to the level of inspired lunacy if not high art expresses quite directly what I am trying to do with my sculptural pieces. . . . These objects joined together with references to the past, laced with historical anecdotes and then transformed, could be assembled in a not-so-common manner. I try to produce pieces that have wit and humor, simplicity and directness along with a meditative quietness that has traces of human activity."

11/11/2000 to 01/07/2001 NEW VISTAS: PAINTINGS BY JESSE DOMINGUEZ
The seventeenth century saw the emergence of landscape art in the western world. From the 1870s onwards, the century was dominated by the Impressionists who brought the painting of pure landscape to its conclusion in works that examined light and form with minimal concern for subject matter. Based upon visits to France, Spain, and Mexico, the artist has recreated the landscapes of those lands.

NORFOLK

Chrysler Museum of Art
245 West Olney Road, Norfolk, VA 23510-1587

☎: 757-664-6200 **�‍◌** www.chrysler.org
Open: 10-9 We, 10-5 Th-Sa, 1-5 Su **Closed:** Mo, Tu, 1/1, 7/4, THGV, 12/25
ADM: Adult: $7.00 **Children:** $5.00, under 12 Free **Students:** $5.00 **Teachers:** $5.00 **Military:** $5.00
& ℗: Free Museum Shop ‖: Phantoms
Group Tours: 757-664-6269 or 6283 **Docents**
Permanent Collection: GLASS; IT/BAROQUE: ptgs; FR: 19; AN/EGT; AM: sculp, ptgs ∩

Home to one of America's premier art collections spanning 5,000 years of art history in an Italianate-Style building built on the picturesque Hague of the Elizabeth River. There are three historic houses. **NOT TO BE MISSED:** Gianlorenzo Bernini's "Bust of the Savior;" Degas "Dancer With Bouquet."

ON EXHIBIT 2001
09/30/2000 to 01/07/2001 THE ACTOR'S IMAGE: THE JAPAN-VIRGINIA COLLECTION OF UKIYO-E PRINTS

02/16/2001 to 05/06/2001 WILLIAM HOLMAN HUNT

04/22/2001 to 07/29/2001 TO CONSERVE A LEGACY: AMERICAN ART FROM HISTORICALLY BLACK COLLEGES

Hermitage Foundation Museum
7637 North Shore Road, Norfolk, VA 23505

☎: 757-423-2052
Open: 10-5 Mo-Sa, 1-5 Su **Closed:** 1/1, THGV, 12/25
ADM: Adult: $4.00 **Children:** $1.00 **Seniors:** $4.00
& ℗
Group Tours Drop-in Tours
Permanent Collection: OR; EU; AS; 16,17

Nestled in a lush setting along the Lafayette River is the 12 acre estate of the Hermitage Foundation Museum whose turn-of-the-century English Tudor home appears to have been frozen in time. It is, however, alive with treasures from the past. **NOT TO BE MISSED:** 1,400 year old Buddha.

RADFORD

Radford University Galleries
200 Powell Hall, Radford, VA 24142

☎: 540-831-5754 **◌** www.runet,edu/~rumuseum
Open: Sept-April 10-5 Mo-Fr, 1-4 Su (5/1-7/30 Mo-Fr 10-4) **Closed:** Sa, Mo, August, ACAD
& ℗
Docents Tour times: by appt **Sculpture Garden**
Permanent Collection: Cont works in all media

Located in the New River Valley, the gallery is noted for the diversity of its special exhibitions.

Anderson Gallery, School of the Arts

Affiliate Institution: Virginia Commonwealth University
907 1/2 W. Franklin Street, Richmond, VA 23284-2514
℡: 804-828-1522 ◙ www.vcu.edu/artweb/gallery/index.html
Open: 10-5 Tu-Fr, 1-5 Sa, Su **Closed:** Mo, LEG/HOL! ACAD!
Vol./Contr.: ADM: Adult: $3.00 **Children:** $1.00 **Students:** $1.00 **Seniors:** $1.00
&.: no elevator; museum has 3 floors ℗: Metered on-street parking **Museum Shop**
Permanent Collection: CONT: gr, phot, ptgs, sculp

The gallery is well known in the US and Europe for exhibiting work of nationally and internationally renowned artists.

Marsh Art Gallery, University of Richmond

George M. Modlin Center for the Arts, Richmond, VA 23173
℡: 804-289-8276 ◙ www.richmond.edu/cultural/museums
Open: 1-5 Tu-Sa **Closed:** Su, Mo, ACAD !
&. ℗: Free ¶: College Cafeteria
Permanent Collection: AM: AS: EU: cer,drgs,gr,photo,ptg,sculp

The new galleries feature outstanding exhibitions of contemporary and historical art. **NOT TO BE MISSED:** The new Cram-inspired building designed by the architectural firm of Marcellus, Wright, Cox and Smith.

ON EXHIBIT 2001

01/16/2001 to 07/23/2001 DAVID FeBLAND: TWIST AND SHOUT
Contemporary New York artist David FeBland presents works created as a site-specific installation for the Marsh Art Gallery. Featuring the figure in motion extracted out of time and place in the cityscape, each of the four paintings distills the interaction of energetic characters in public urban America on a grand scale.

01/19/2001 to 03/09/2001 LEWIS WICKES HINE: THE FINAL YEARS
Organized by the Brooklyn Museum of Art, New York, this is the final stop of the national tour of this exhibition of over 100 photographs by Lewis Wickes Hine (1874-1940). Focusing on his work in the 1930s, these prints capture the continued struggle of the working class during the Great Depression, provide the opportunity to compare Hine's earlier images with his last work.

02/20/2001 to 03/25/2001 JOHN W. WINKLER (1890-1979): AMERICAN MASTER OF THE ETCHED LINE
Highlighting the recent gift to the Marsh Art Gallery collection, this exhibition of prints by John W. Winkler is primarily of the people and scenes of San Francisco.

03/22/2001 to 06/23/2001 NELL BLAINE: SENSATIONS OF NATURE
Co-organized by the Marsh Art Gallery and the Cape Ann Historical Museum, Gloucester, Massachusetts, this is Nell Blaine's first major retrospective exhibition since her death. A native of Richmond, Blaine (1922-1996) was an important member of the second generation of the New York School. Coming to prominence with her abstractions as one of the few women involved in Abstract Expresionism, she is more widely known and acknowledged for her oils and watercolors of gardens, landscapes, and flower-filled still lifes.

03/29/2001 to 06/23/2001 STEFANO DELLA BELLA, BAROQUE PRINTMAKER: THE I. WEBB SURRATT, JR. PRINT COLLECTION
As part of the Baroque Festival of the Arts at the University of Richmond, this exhibition presents prints by Stefano della Bella (Italian, 1610-1664) from the I. Webb Surratt, Jr. Print Collection of the Marsh Art Gallery. Della Bella was a prolific creator of landscapes, marines, city scenes, battles, animal studies, mythological subjects, and fantasies.

Virginia Museum of Fine Arts

2800 Grove Ave, Richmond, VA 23221-2466

☎: 804-367-0844 ▣ www.vmfa.state.va.us
Open: 11-5 Tu-Su, 11-8 Th **Closed:** Mo, 1/1, 7/4, THGV, 12/25
Vol./Contr.: $4.00 pp
♿ Ⓟ: Free **Museum Shop** ⑪
Group Tours: 804-367-0859 **Docents** **Tour times:** 2:30 Tu-Su, 6pm Th except summer **Sculpture Garden**
Permanent Collection: AM: ptgs, sculp; LILLIAN THOMAS PRATT COLL OF JEWELS BY PETER CARL FABERGE; EU: all media (Ren to cont) ☊

Diverse collections and outstanding special exhibits abound in the internationally prominent Virginia Museum which houses one of the largest collections in the world of Indian, Nepalese, and Tibetan art. It also holds the Mellon Collection of British sporting art and the Sydney and Francis Lewis Collection of late 19th and early 20th century decorative arts, contemporary American paintings and sculpture. **NOT TO BE MISSED:** "Caligula," Roman, AD 38-40 marble 80' high. Also the largest public collection of Faberge Imperial Easter eggs in the West.

ON EXHIBIT 2001

03/06/2001 to 05/27/2001 MARTIN PURYEAR
Martin Puryear is widely recognized as one of the foremost sculptors working in the United States today. His powerful, elemental pieces are essentially abstract works that suggest organic and animal forms and reference African, Asian and Scandinavian cultures. The exhibition presents a select group of Puryear's sculptures representing the very best of his creative achievement during the past 10 years.

ROANOKE

Art Museum of Western Virginia

One Market Square, Roanoke, VA 24011

☎: 540-342-5760 ▣ www.artmuseumroanoke.org
Open: 10-5 Tu-Sa, 1-5 Su (10-2 12/24,12/31) **Closed:** Mo, 1/1, 12/25
♿ Ⓟ: Pay **Museum Shop Sculpture Garden**
Permanent Collection: AM & EU: ptgs 20; AM: folk, gr, phot

The collection reflects all cultures formerly and presently found there. By collecting, exhibiting, preserving and interpreting works of art, the Museum plays a significant role in the cultural history of the region. Exhibitions are of both national and regional significance. **NOT TO BE MISSED:** Sidewalk Art Show, June 3-4. 2000.

SWEET BRIAR

Sweet Briar College Art Gallery

Sweet Briar College, Sweet Briar, VA 24595

☎: 804-381-6248 ▣ www.artgallery.sbc.edu
Open: Pannell: 12-9:30 Mo-Th, 12-5 Fr-Su, Babcock: 9-9 daily **Closed:** Mo, ACAD!
♿ Ⓟ Museum Shop ⑪: On campus **Sculpture Garden**
Permanent Collection: JAP: woodblock prints; EU: gr, drgs 19; AM: ptgs 20

Th exterior design of the 1901 building is a rare collegiate example of Ralph Adams Cram Georgian Revival Style architecture. **NOT TO BE MISSED:** "Daisies and Anemones," by William Glackens.

VIRGINIA

Contemporary Art Center of Virginia
2200 Parks Avenue, Virginia Beach, VA 23451
(: 757-425-0000 ◙ www.cacv.org
Open: 10-4 Tu-Sa, 12-4 Su **Closed:** Mo, LEG/HOL!
ADM: Adult: $3.00 **Children:** $1.00, under 4 free **Students:** $2.00 **Seniors:** $2.00
&. ℗ **Museum Shop** **Group Tour:** ext. 22 **Docents** **Sculpture Garden**
Permanent Collection: Non-collecting institution

This non-profit center exists to foster awareness and understanding of the significant art of our time.

ON EXHIBIT 2001

12/08/2000 to 02/11/2001 JOSE BEDIA
A resident of Miami, José Bedia was born in Havana, Cuba, in 1959 and lived there until his departure in 1991. Combining cultural elements of the Kongo religion, Palo Monte, with formal elements taken from his affinity for Native American images, Bedia brings primitivism into a contemporary realm. In his artwork, Bedia has illustrated his unique vision as a contemporary artist, while preserving the historical significance of ancient customs. Included in this exhibition are paintings, drawings, artist's sketchbooks and a room-sized installation.

12/08/2000 to 02/11/2001 LANDSHAPES
According to curator Sarah Tanguy, "The eight artists in Landshapes have each intervened in the land with an ephemeral act, and documented it through photography. More than the traditions of landscape photography, they draw on sculpture and installation, as well as aspects of Conceptualism, Minimalism and Performance for their artistic approaches." Selected artists include: Marlene Creates (Canada), Quisqueya Henriquez (Cuba), Francisco Infante-Arana & Nona Goriuna (Russia), Magdalena Jetlová (Czech Republic), Yuri Nagawara (Japan), Lorie Novak (U.S.), Jorma Puranen (Finland) and Jim Sanborn (U.S.).

Abby Aldrich Rockefeller Folk Art Center
307 S. England Street, Williamsburg, VA 23185
(: 757-220-7698 ◙ www.colonialwilliamsburg.org
Open: 11-5 daily 1/5-3/20; 10-5 3/21-12/3
ADM: Adult: $10.00, combine
&. ℗: Free **Museum Shop** ¶: Cafe in Dewitt Wallace Gallery (separate building)
Permanent Collection: AM: folk

Historic Williamsburg is the site of the country's premier showcase for American folk art. The museum, originally built in 1957 and reopened in its new building in 1992, demonstrates folk art's remarkable range and inventiveness in textiles, paintings, and decorative arts. The DeWitt Wallace Gallery houses the collection of English and American Decorative arts and is included in the Museums ticket cost.

Muscarelle Museum of Art
College of William and Mary, PO Box 8795, Williamsburg, VA 23187-8795
(: 757-221-2700 ◙ www.wm.edu/muscarelle
Open: 10-4:45 Mo-Fr, 12-4 Sa-Su **Closed:** LEG/HOL!
Vol./Contr.: Yes &. ℗ **Museum Shop**
Group Tours: 757-221-2703 **Docents** **Tour times:** by appt
Permanent Collection: BRIT & AM: portraits 17-19; O/M: drgs; CONT: gr; AB; EU & AM: ptgs

The 'world's first solar painting' by Gene Davis, transforms the south facade of the Museum into a dramatic and innovative visual statement when monumental tubes, filled with colored water are lit from behind. **NOT TO BE MISSED:** "Portrait of William Short" by Rembrandt Peale; "Teacup and Bread on Ledge" by John Frederick Peto; "Moonlit Landscape" by Henry Osawa Tanner.

BELLEVUE

Bellevue Art Museum
510 Bellevue Way, Bellevue, WA 98004
℄: 425-454-3322 ◙ www.bellevueart.org
Open: 12-8 Tu Sa, 10-5, W-Fr, 12-5 Su **Closed:** Mo, 1/1, EASTER, 7/4, MEM/DAY, LAB/DAY, THGVG, 12/25; THE MUSEUM IS CLOSED BETWEEN EXHIBITIONS
ADM: Adult: $3.00 **Children:** Free under 12 **Seniors:** $2.00
& ℗: Free
Group Tours: 425-454-3322, ext. 100 **Docents Tour times:** 2:00 daily
Permanent Collection: Non-collecting institution

Located across Lake Washington about 10 minutes drive from Seattle, the museum is a place to see, explore and make art.

BELLINGHAM

Whatcom Museum of History & Art
121 Prospect Street, Bellingham, WA 98225
℄: 360-676-6981 ◙ www.cob.org.museum
Open: 12-5 Tu-Su **Closed:** Mo, LEG/HOL!
& **Museum Shop**
Permanent Collection: KINSEY: phot coll; HANSON: Naval arch drgs; NW/COAST: ethnography; VICTORIANA

An architectural and historic landmark, this museum building is situated in a 1892 former City Hall on a bluff with a commanding view of Bellingham Bay.

CLARKSTON

Valley Art Center, Inc
842-6th Street, Clarkston, WA 99403
℄: 509-758-8331
Open: 9-4 Mo-Fr, by appt other times **Closed:** Sa, Su, 7/4, THGV, 12/25-1/1
&: Building accessible EXCEPT for restrooms ℗ **Museum Shop**
Permanent Collection: REG; NAT/AM

Valley Art Center is located in southeast Washington at the Snake and Clearwater Rivers in the heart of the city's historic district made famous by Lewis and Clarke. **NOT TO BE MISSED:** Beadwork, Piute Cradle Board Tatouche.

GOLDENDALE

Maryhill Museum of Art
35 Maryhill Museum Drive, Goldendale, WA 98620
℄: 509-773-3733 ◙ www.maryhillmuseum.org
Open: 9-5 daily, Mar 15-Nov 15 **Closed:** Open HOL
ADM: Adult: $6.50 **Children:** Free under 6 **Students:** $1.50 **Seniors:** $6.00
& ℗: Free **Museum Shop** ¶: cafe, picnic grounds
Group Tours: 509-773-3733 **Sculpture Garden**
Permanent Collection: AUGUST RODIN SCULP; ORTHODOX ICONS: 18; BRIT: ptgs; NAT/AM: baskets, dec/art; FURNISHINGS OF QUEEN MARIE of ROMANIA; INTERNATIONAL CHESS SETS

WASHINGTON

Maryhill Museum of Art- continued
Serving the Pacific Northwest, the Maryhill Museum is a major cultural resource in the Columbia River Gorge region. **NOT TO BE MISSED:** Theatre de la Mode: 1946 French Fashion collection.

LONGVIEW

Art Gallery, Lower Columbia College Fine Arts Gallery
1600 Maple Street, Longview, WA 98632
✆: 360-577-2300
Open: 10-4 Mo, Tu, Fr, 10-8 We, Th, Sept-June **Closed:** Sa, Su, LEG/HOL, ACAD/HOL
 ♿ ♲ cafeteria in student center
Group Tours: 360-577-2314
Permanent Collection: Non-collecting institution

A College Gallery that features temporary exhibitions by local, regional, and national artists.

ON EXHIBIT 2001
01/07/2001 to 02/03/2001 PHIL BORGES, "THE ENDURING SPIRIT"
An exhibit presented along with Amnesty International featuring photos of individuals struggling to survive in cultures where basic human rights are not necessarily guaranteed.

02/11/2001 to 03/09/2001 MICHAEL DAILEY
Abstract minimalist paintings of intense color by University of Washington Professor Emeritus Michael Dailey

OLYMPIA

Washington State Capitol Museum
211 West 21st Avenue, Olympia, WA 98501
✆: 360-753-2580 ▣ www.wshs.org
Open: 10-4 Tu-Fr, 12-4 Sa-Su **Closed:** Mo, LEG/HOL!
ADM: Adult: $2.00, $5.00 Families **Students:** $1.00 **Seniors:** $1.75
 ♿ **Museum Shop**
Docents Tour times: by appt
Permanent Collection: REG: NAT/AM: 18,19

The Museum is housed in the Lord Mansion, a 1924 Italian Renaissance Revival Style building. It also features a Permanent exhibit on the history of Washington State government and cultural history. **NOT TO BE MISSED:** Southern Puget Sound American Indian exhibit welcome healing totem pole figure. Sesquicentennial Exhibits: Olympia through Artists' Eyes and Olympia through Children's Eyes

PULLMAN

Museum of Art
Washington State University, Pullman, WA 99164
✆: 509-335-1910 ▣ www.wsu.ed/artmuse
Open: 10-4 Mo-Fr, 10-10 Tu, 1-5 Sa-Su **Closed:** ACAD!
 ♿: Parking permits may be purchased at Parking Services, adjacent to the Fine Arts Center
Permanent Collection: NW: art; CONT/AM & CONT/EU: gr 19

The WSU Museum of Art, in the university community of Pullman, presents a diverse program of changing exhibitions, including paintings, prints, photography, and crafts.

Frye Art Museum
704 Terry Avenue, Seattle, WA 98104

☎: 206-622-9250 ◙ www.fryeart.org
Open: 10-5 Tu-Sa, 10-9 Th, 12-5 Su **Closed:** Mo, 1/1, THGV, 12/25, 7/4
Sugg./Cont.: $6.00
🚻 ⓟ: Free across from Museum **Museum Shop** 🍽: 11-4 Tu-Sa, 11-7:30 Th, 12-4 Su
Group Tours: 2 weeks adv res **Drop-in Tours:** 12:30-3 Su **Sculpture Garden**
Permanent Collection: AM Realist 19-20; EU Realist ptgs, Munich School, CONT Realists

A mid-sized museum representing representational art from Colonial times to the present. Hailed by the press as a "little gem of a museum" it presents European and American art. Charles and Emma Frye bequeathed their collection to create a free public art museum. **NOT TO BE MISSED:** von Stuck's "Sin"

ON EXHIBIT 2001
11/10/2000 to 01/07/2001 ROBERT VAN VRANKEN
Paintings and constructions that engage the viewer's sense of reality.

12/09/2000 to 02/11/2001 REPRESENTING LA: CONTEMPORARY REPRESENTATIONAL ARTISTS FROM LOS ANGELES
Major exhibition featuring contemporary realist artists living and working in Los Angeles.

12/22/2000 to 01/28/2001 MARY TIFT

01/12/2001 to 03/04/2001 LILLIAN BROCA

02/24/2001 to 04/02/2001 AMERICAN MASTERS FROM PERMANENT COLLECTION

03/09/2001 to 05/06/2001 ANOTHER LOOK: ALAN ROHAN CRITE, ARTIST-REPORTER

04/21/2001 to 06/03/2001 RUTH WEISBERG: MONOTYPES; AMERICAN MASTERS

05/11/2001 to 07/08/2001 DOMENIC CRETARA: PAINTINGS

06/16/2001 to 09/09/2001 AMERICAN SCENE: PAINTINGS, SCULPTURE, AND DRAWINGS FROM THE NATIONAL MUSEUM OF AMERICAN ART

07/13/2001 to 09/02/2001 GARY FAIGIN: PAINTINGS AND DRAWINGS

09/08/2001 to 11/04/2001 BO BARTLETT: THE HEROIC GESTURE

09/22/2001 to 01/13/2001 WITNESS AND LEGACY

11/09/2001 to 01/06/2002 SELECTIONS FROM SAFECO COLLECTION

Henry Art Gallery
Affiliate Institution: University of Washington
15th Ave. NE & NE 41st Street, Seattle, WA 98195-3070

☎: 206-543-2280 ◙ www.henryart.org
Open: 11-5 Tu, We, Fr-Su, 11-8 Th **Closed:** Mo, 1/1, 7/4, THGV, 12/25
Free Day: Th, 5-8 pay what you wish **ADM: Adult:** $5.00 **Children:** Free under 12 **Seniors:** $3.50
🚻 ⓟ: Pay **Museum Shop** 🍽
Group Tours: 206-616-8782 **Docents** **Tour times:** 2nd Sa, 3rd Th each month, 2pm **Sculpture Garden**
Permanent Collection: PTGS: 19,20; PHOT; CER; ETH: textiles & W./Coast

The major renovation designed by Charles Gwathmey of Carl F. Gould's 1927 building reopened in April 1997. The expansion adds 10,000 square feet of galleries and additional visitor amenities and educational facilities.

WASHINGTON

Nordic Heritage Museum
3014 N.W. 67th Street, Seattle, WA 98117

☎: 206-789-5707 ◙ www.nordicmuseum.com
Open: 10-4 Tu-Sa, 12-4 Su **Closed:** Mo, 12/24, 12/25, 1/1
Free Day: 1st Tu of each month **ADM: Adult:** $4.00 **Children:** $2.00 (6-16) **Students:** $3.00 **Seniors:** $3.00
&. ℗: Free **Museum Shop**
Permanent Collection: SCANDINAVIAN/AM: folk; PHOT

Follow the immigrants journey across America in this museum located in Ballard north of the Ballard Locks.
NOT TO BE MISSED: "Dancing Angels" original bronze sculpture by Carl Milles.

ON EXHIBIT 2001
12/01/2000 to 01/31/2001 STEVE JENSEN-NORWEGIAN AMERICAN SCULPTOR

Seattle Art Museum
100 University Street, Seattle, WA 98101-2902

☎: 206-625-8900 ◙ www.seattleartmuseum.org
Open: 10-5 Tu-Su, 10-9 Th, open Mo on Holidays **Closed:** Mo, except Hols, THGV, 12/25, 1/1
Free Day: 1st Tu, Sr. 1st Fr **ADM: Adult:** $6.00 **Children:** Free under 12 **Students:** $4.00 **Seniors:** $4.00
&. ℗: Limited pay parking **Museum Shop** ¶¶
Group Tours: 206-654-3123 **Docents Tour times:** 2 Tu-Su, 7 Th, Sp exh 1 Tu-Su, 6 Th **Sculpture Garden**
Permanent Collection: AS; AF; NW NAT/AM; CONT; PHOT; EU: dec/art; NW/CONT

Designed by Robert Venturi, architect of the new wing of the National Gallery in London, this stunning new five story building is but one of the reasons for visiting the outstanding Seattle Art Museum. The new downtown location is conveniently located within walking distance of many of Seattle's most interesting landmarks including Pike Place Market, and Historic Pioneer Square. The Museum features 2 complete educational resource centers with interactive computer systems. **NOT TO BE MISSED:** NW Coast Native American Houseposts; 48' kinetic painted steel sculpture "Hammering Man" by Jonathan Borofsky.

ON EXHIBIT 2001
ONGOING AFRICAN WAX PRINT CLOTHS
A collection of 53 examples of cotton fabric printed in dazzling colors and used for both traditional and Western clothing in West Africa.

ONGOING THE RETURN OF ANCIENT AMERICAN ARTWORKS
The ancient cultures of Meso- and South America, like their Egyptian and Sumerian counterparts, were among the most highly developed in the world in terms of architecture, metalwork, ceramics and textiles. Artworks on display range from 500 to 3,000 years old and include objects from the Aztec, Chimu, Colima, Mayan, Olmec and Veracruz cultures.

ONGOING ELEGANT PLAIN ART FROM THE SHAKER WORLD AND BEYOND
An installation comparing spare Shaker objects with functional art from Africa, Oceania and Native America. A "Year of America" exhibition.

ONGOING IS EGYPTIAN ART AFRICAN?
Visitors are invited to compare ancient Egyptian deities to sub-Saharan masqueraders and to view examples of personal adornment, posture and divine kingship that are shared over different parts of the continent. Claims for and against the African-ness of Egyptian art will be provided for visitors to evaluate.

ONGOING KILN ART FOR PALACES, PRIESTS AND THE PROLETARIAT: KOREAN CERAMICS OF THE KORYO AND CHOSON PERIODS
Ink paintings by three major Korean artists of the nineteenth century have been incorporated into the ongoing installation of select works from SAM's collection and from local private collections.

ONGOING WOMEN FROM UTOPIA: CONTEMPORARY AUSTRALIAN ABORIGINAL ART
Four women from an Australian station illustrate the intricate life that exists from an Aboriginal point of view. Leaves, lizards, yams, seeds and rock holes take shape in canvases from the 1990s.

Seattle Art Museum - continued
Through 04/29/2001 LANGUAGE LET LOOSE
An exhibition focused on the powerful use of words in art. Built around the video/sound installation House of Cards by Seattle artist Garry Hill, it also includes work by Walker Evans, Jasper Johns, Robert Rauschenberg and others.

10/05/2000 to 04/29/2001 CREATING PERFECTION: SHAKER OBJECTS AND THEIR AFFINITIES
This exhibition of 100 objects, primarily furniture and textiles and about 40 works on paper, explores the reductive urge that strips away ornament and communicates with essentials. It juxtaposes nineteenth-century Shaker objects with post-1950 art characterized by spare, minimal forms that rely on shape, repetition, unified color and surface for their power.

11/02/2000 to 02/25/2001 DOCUMENTS NORTHWEST/THE PONCHO SERIES: MIND GARDEN
A mixed-media installation by nationally known artist Ginny Ruffner, that includes glass, steel and organic forms (such as steel sculptures, giant metal chains, metal leaves holding blown-glass balls and a carpet of rose petals).

12/14/2000 to 03/18/2001 JOHN SINGER SARGENT
The first major exhibition of Sargent's work on the West Coast includes 120 works by the American expatriate society portrait painter. The special exhibition includes portraits of the Wertheimer family (from a traveling exhibition organized by the Jewish Museum in New York City); charcoal drawings from Harvard's Fogg Museum; watercolors and oil sketches; and additional drawings and informal portraits. A "Year of America" exhibition.

05/10/2001 to 08/12/2001 TREASURES FROM A LOST CIVILIZATION: ANCIENT CHINESE ART FROM SICHUAN
The first comprehensive U.S. exhibition of ancient bronzes from a recently discovered Bronze Age civilization and other ancient cultures in Sichuan, China. As a result of the discovery, the history of early China may now be drastically revised. The exhibition includes 128 bronzes, jades and clay sculptures dating from the 13th century B.C. to the third century A.D., many shown for the first time outside of China. *Will Travel.*

Seattle Asian Art Museum
Volunteer Park, 1400 East Prospect Street, Seattle, WA 98101
☎: 206-625-8900 ◉ www.seattleartmuseum.org
Open: 10-5 Tu-Su, 10-9 Th **Closed:** Mo, LEG/HOL
Free Day: 1st Th, Sr 1st Fr, 1st Sa **ADM: Adult:** $3.00 **Children:** Free under 12
♿ ℗: Free **Museum Shop**
Group Tours: 206-654-3123 **Docents Tour times:** !
Permanent Collection: WONDERS OF CLAY AND FIRE: CHINESE CERAMICS THROUGH THE AGES (WITH PARTIAL ROTATION) A comprehensive survey of chinese ceramic history from the fifth millennium BC through the 15th c AD

The historical preservation of the Carl Gould designed 1932 building (the first Art-Deco style art museum in the world) involved uniting all areas of the structure including additions of 1947, 1954, and 1955. Now a 'jewel box' with plush but tasteful interiors perfectly complementing the art of each nation. 900 of the 7000 objects in the collection are on view.

ON EXHIBIT 2001
ONGOING EXPLORE KOREA: A VISIT TO GRANDFATHER'S HOUSE
A presentation of a traditional Korean home, including kitchen, men's and women's quarters. Visitors can enter the rooms and participate in hands-on activities. (NB: For this exhibition, grandparents are admitted free when accompanied by grandchildren ages 12 and under.)

ONGOING (with partial rotations) WONDERS OF CLAY AND FIRE: CHINESE CERAMICS THROUGH THE AGES
A comprehensive survey of Chinese ceramic history, from the fifth millennium B.C. through the fifteenth century A.D., with remarkable objects on loan from the private Jirutang Collection and Jinglexuan Collection.

Through 01/21/2001 THE ART OF PROTEST
A cross-cultural exhibition of works from the museum's collection that address social and political issues and were meant to incite social change. The exhibit samples art from many media, cultures and periods, including works from Europe, North America, Asia and Africa from the fifteenth through the twentieth centuries.

Seattle Asian Art Museum - continued

11/02/2000 to 07/08/2001 HIRADO PORCELAIN OF JAPAN
Approximately 100 pieces of exquisite porcelain produced in the Hirado area of Kyushu, Japan, in an exhibit from the Kurtzman Family Collection. Almost all of the porcelains on view were produced in the nineteenth century, when Hirado ware was renowned—especially in the Victorian West—as desirable export ware.

03/2001 to 05/27/2001 THE EMBODIED IMAGE: CHINESE CALLIGRAPHY FROM THE JOHN B. ELLIOTT COLLECTION
An exhibition of Chinese calligraphy from the John B. Elliott Collection, which is the only collection outside China and Japan that properly represents the 1,600-year history of this prized and widely practiced art form. Contains masterpieces by most of the leading calligraphers.

07/2001 to 07/2002 CHINESE FURNITURE
An exhibition of celebrated furniture of the Ming and Qing dynasties from SAM's collection.

07/2001 to 07/2002 CHINESE PAINTINGS FROM LOCAL COLLECTIONS (TWO PARTS)
The first major exhibition of Chinese paintings from private collections in the Seattle area.

07/01/2000 to 01/01/2001 SHEER REALITIES: POWER, BODY AND CLOTHING IN THE 19TH CENTURY PHILIPPINES
75 to 100 items will look at the action between the external indigenous cultural influences of the Philippines over the past century. They will be shown with other materials including hardwoods, ivories, silver, etc.

SPOKANE

Cheney Cowles Museum

2316 W. First Avenue, Spokane, WA 99204
(: 509-456-3931
Open: 10-5 Tu-Sa, 10-9 We, 1-5 Su **Closed:** Mo, LEG/HOL!
Free Day: We, 1/2 price **ADM: Adult:** $4.00 **Fam:** $10 **Children:** $2.50, 6-16 **Students:** $2.50 **Seniors:** $2.50
& ℗ **Museum Shop**
Permanent Collection: NW NAT/AM; REG; DEC/ART

The mission of the Cheney Cowles Museum is to actively engage the people of the Inland Northwest in life-long learning about regional history, visual arts, and American Indian and other cultures especially those specific to the region.

TACOMA

Tacoma Art Museum

12th & Pacific (downtown Tacoma), Tacoma, WA 98402
(: 206-272-4258
Open: 10-5 Tu-Sa, 10-7 Th, 12-5 Su **Closed:** Mo, 1/1, THGV, 12/25
Free Day: Tu **ADM: Adult:** $3.00 **Children:** Free under 12 **Students:** $2.00 **Seniors:** $2.00
& ℗: Street parking **Museum Shop**
Permanent Collection: CONT/NW; AM: ptgs

The only comprehensive collection of the stained glass of Dale Chihuly in a public institution. **NOT TO BE MISSED:** Chihuly Retrospective Glass Collection.

Tacoma Public Library/Thomas Handforth Gallery
1102 Tacoma Avenue South, Tacoma, WA 98402

℡: 206-591-5666 **◙** www.tpl.lib.wa.us
Open: 9-9 Mo-Th, 9-6 Fr-Sa **Closed:** Su, LEG/HOL!
&. **℗**
Permanent Collection: HISTORICAL; PHOT; ARTIFACTS

Built in 1903 as an original Andrew Carnegie Library, the Gallery has been serving the public since then with rotating exhibits by Pacific Northwest artists and touring educational exhibits. **NOT TO BE MISSED:** Rare book room containing 750 prints including "North American Indian," by Edward S. Curtis

WALLA WALLA

Sheehan Gallery
Affiliate Institution: Whitman College
900 Isaacs- Olin Hall, Walla Walla, WA 99362

℡: 509-527-5249
Open: 10-5 Tu-Fr, 1-4 Sa-Su **Closed:** Mo, ACAD!
&.: Enter from parking lot **℗:** On campus
Permanent Collection: SCROLLS; SCREENS; BUNRAKY PUPPETS; CER
The Sheehan Gallery administrates the Davis Collection of Oriental Art which is not on Permanent display.

WEST VIRGINIA

CHARLESTON

Sunrise Museum
746 Myrtle Road, Charleston, WV 25314
C: 304-344-8035 ◙ (under construction) sunrisemuseum.org
Open: 11-5 We-Sa, 12-5 Su **Closed:** Mo, Tu, LEG/HOL!
ADM: Adult: $3.50 **Students:** $2.50 **Seniors:** $2.50
& ℗ **Museum Shop Sculpture Garden**
Permanent Collection: AM: ptgs, sculp, gr; SCI COLL

This multimedia center occupies two historic mansions overlooking downtown Charleston. Featured are a Science Hall, Planetarium, and an art museum.

HUNTINGTON

Huntington Museum of Art, Inc
2033 McCoy Road, Huntington, WV 25701-4999
C: 304-529-2701 ◙ www.hmoa.org
Open: 10-5 Tu-Sa, 12-5 Sa **Closed:** Mo, 1/1, 7/4, THGV, 12/25
& ℗ **Museum Shop**
Docents Tour times: 10:30, 11:30 Sa; 2, 3 Su **Sculpture Garden**
Permanent Collection: AM: ptgs, dec/art 18-20; GLASS; SILVER

The serene beauty of the museum complex on a lovely hilltop surrounded by nature trails, herb gardens, an outdoor amphitheater and a sculpture courtyard is enhanced by an extensive addition designed by the great architect Walter Gropius. The Museum is home to the state's only plant conservatory.

ON EXHIBIT 2001
01/13/2001 to 03/18/2001 CONTEMPORARY PAINTING AND SCULPTURE FROM THE PERMANENT COLLECTION

01/27/2001 to 06/24/2001 FOLK ART FROM THE PERMANENT COLLECTION

02/03/2001 to 04/15/2001 THE FACE OF JUSTICE: PORTRAITS OF JOHN MARSHALL

05/05/2001 to 07/29/2001 THE PERPETUAL WELL: CONTEMPORARY ART FROM THE COLLECTION OF THE JEWISH MUSEUM

07/14/2001 to 12/30/2001 THE DAYWOOD COLLECTION—SALON STYLE

08/18/2001 to 10/27/2001 MATERIALS: CLAY

11/10/2001 to 01/19/2002 MATERIALS: WOOD

BELOIT

Wright Museum of Art
Affiliate Institution: Beloit College
700 College Street, Beloit, WI 53511

☏: 608-363-2677 ◙ www.beloit.edu/~museum/index/index.html
Open: 11-4 Tu-Su **Closed:** Mo, ACAD!
♿ ℗ **Museum Shop**
Historic Building Sculpture Garden
Permanent Collection: AS; KOREAN: dec/art, ptgs, gr; HIST & CONT: phot

The Wright Museum of Art had its beginnings in 1892. Over the years, the museum has obtained a large collection of Asian decorative arts, a large collection of Chinese snuff bottles, Japanese woodblock prints, Japanese sword fittings, Japanese sagemono and netsuke, Korean ceramics and Bhuddist sculpture and a wide variety of important works by major artists.

MADISON

Elvehjem Museum of Art
Affiliate Institution: University of Wisconsin-Madison
800 University Ave, Madison, WI 53706-1479

☏: 608-263-2246
Open: 9-5 Tu-Fr 11-5 Sa, Su **Closed:** Mo, 1/1, THGV, 12/24, 12/25
♿: Use Murray St. entrance, elevator requires security assistance ℗: University lots 46 and 83 on Lake Street and City Lake St and Madison ramps. **Museum Shop Docents Tour times:** !
Permanent Collection: AN/GRK: vases & coins; MIN.IND PTGS: Earnest C. & Jane Werner Watson Coll; JAP: gr (Van Vleck Coll); OR: dec/arts; RUSS & SOVIET: ptgs (Joseph E. Davies Coll)

More than 15,000 objects that date from 2300 B.C. to the present are contained in this unique university museum collection.

ON EXHIBIT 2001
12/16/2000 to 02/11/2001 ITALY: IN THE SHADOW OF TIME. PHOTOGRAPHS BY LINDA BUTLER
Linda Butler's sensitive photographs of landscapes and architecture, interiors and still lifes convey a sense of quiet deliberation on these objects. The black-and-white photographs capture ephemeral beauties of light and composition. *Catalog*

02/17/2001 to 04/15/2001 A WRITER'S VISION: PRINTS, DRAWINGS, AND WATERCOLORS BY GUNTER GRASS
Nobel Prize-winning author Günter Grass created these works on paper between 1972 and 1996; this includes prints related to some of Grass's best-known books: "The Tin Drum," "The Rat," "The Flounder," and "A Distant Field."

02/10/2001 to 05/20/2001 PROGRESSIVE PRINTMAKERS: WISCONSIN ARTISTS AND THE PRINT RENAISSANCE
The University of Wisconsin has a nationwide reputation as a center for the study of printmaking. This exhibition and the accompanying catalog survey the work of the artists who taught at the university from immediately after World War II to the present. The variety of their work and its technical excellence and innovation set new standards for printmaking and contributed to the renaissance of printmaking in the last half of this century. *Catalog*

WISCONSIN

Elvehjem Museum of Art - continued
03/10/2001 to 05/01/2001 HEAVEN AND EARTH SEEN WITHIN: SONG CERAMICS FROM THE ROBERT BARRON COLLECTION
Considered the sublime expression of the potter's art by connoisseurs and collectors of Chinese ceramics, Song-Dynasty (960-1279) wares are compelling in their elegant forms, understated monochrome glazes, and ornamentation derived from nature. The sixty-three objects in this small-scale exhibition present a rare opportunity to survey the unique types of ceramics produced at the most important kiln sites responding to court taste as well as to the demand for popular wares. Catalog

Madison Art Center
211 State Street, Madison, WI 53703

(: 608-257-0158 ◙ madisonartcenter.org
Open: 11-5 Tu-Th, 11-9 Fr, 10-9 Sa, 1-5 Su **Closed:** Mo, LEG/HOL!
& ℗: Pay **Museum Shop**
Permanent Collection: AM: works on paper, ptgs, sculp; JAP; MEX; CONT

Located in the Old Capitol theatre, the Madison Art Center offers modern and contemporary art exhibitions and highlights from its Permanent collections. **NOT TO BE MISSED:** "Serenade" by Romare Bearden.

ON EXHIBIT 2001
12/03/2000 TO 02/11/2001 BRAD KAHLHAMER
Kahlhamer paints large-scale images of the grand American landscape. Challenging this tradition with the energy of action painting and acid colors, Kahlhamer draws from his personal experience to create narratives with a recurring cast of characters. His paintings allow him to explore his Native American heritage as filtered through contemporary mainstream American culture and his experience of being adopted by a German-American family without knowledge of his tribal affiliation.

MANITOWOC

Rahr-West Art Museum
610 North Eighth Street, Manitowoc, WI 54220

(: 920-683-4501 ◙ link from www.manitowoc.org
Open: 10-4 Mo, Tu, Th, Fr, 10-8 We, 11-4 Sa-Su **Closed:** LEG/HOL!
& ℗: Free
Permanent Collection: AM: ptgs, dec/art 19; OR: ivory, glass; CONT: ptgs

Built between 1891 & 1893, this Victorian mansion combines with the West Wing added in 1975 and 1986. These showcase the Museum's 19th and 20th C. art and antiques while the West Gallery rotates a schedule of regional and nationally touring exhibitions. **NOT TO BE MISSED:** "Birch and Pine Tree No 2," by Georgia O'Keeffe; "La Petite Boudeuse," 1888 by William Adolphe Bougereau.

ON EXHIBIT 2001
11/19/2000 to 01/07/2001 CHRISTMAS IN THE MANSION
This annual event displays the imaginative splendor of Christmas using the magnificent setting of the Rahr Mansion.

12/17/2000 to 01/14/2001 LADIES OF THE LAKE QUILTERS EXHIBITION
This local quilting group creates an exhibition of work every three years of varied styles and patterns. It offers a wonderful opportunity to learn and see new works to those interested in quilting, but have not ventured into this medium.

02/04/2001 to 02/18/2001 THE ART OF TABLESETTINGS
This traditional community exhibition brings out the creative drive in everyone. This exhibition offers dining at its most unexpected.

Charles Allis Art Museum

1801 North Prospect Avenue, Milwaukee, WI 53202

☎: 414-278-8295
Open: 1-5 We-Su, 7-9 We **Closed:** LEG/HOL!
ADM: Adult: $2.00
Permanent Collection: CH: porcelains; OR; AN/GRK; AN/R; FR: ptgs 19

With its diverse collection this museum is housed in a 1909 Tudor style house.

Milwaukee Art Museum

750 North Lincoln Memorial Drive, Milwaukee, WI 53202

☎: 414-224-3200 ◙ www.mam.org
Open: 10-5 Tu, We, Fr, Sa, 12-9 Th, 12-5 Su **Closed:** Mo, 1/1, THGV, 12/25
ADM: Adult: $5.00 **Children:** Free under 12 **Students:** $3.00 **Seniors:** $3.00
& ℗ **Museum Shop** ‖
Group Tours: 414-224-3825 **Sculpture Garden**
Permanent Collection: CONT:ptgs, sculp; GER; AM:folk; AM:ptgs 19, 20; EU:ptgs 19, 20; AM:dec/art; EU:folk; Haitian art

The Milwaukee Museum features an exceptional collection housed in a 1957 landmark building by Eero Saarinen, which is cantilevered over the Lake Michigan shoreline. A dramatic addition designed by Santiago Calatrava is scheduled to open in 2000. **NOT TO BE MISSED:** Zurburan's "St. Francis."

Patrick & Beatrice Haggerty Museum of Art

Affiliate Institution: Marquette University
13th & Clybourn, Milwaukee, WI 53233-1881

☎: 414-288-1669 ◙ www.mu.edu/haggerty
Open: 10-4:30 Mo-Sa, 12-5 Su, 10-8 Th **Closed:** 1/1, EASTER, THGV, 12/25
& **Museum Shop**
Group Tours: 414-288-5915 **Sculpture Garden**
Permanent Collection: PTGS, DRWG, GR, SCULP, PHOT, DEC/ART 16-20; ASIAN, TRIBAL

Selections from the Old Master and modern collections are on exhibition continuously.

UWM Art Museum

3253 N. Downer Avenue, Milwaukee, WI 53211

☎: 414-226-6509
Open: 10-4 Tu-Fr, 12-8 We, 1-5 Sa-Su **Closed:** Mo LEG/HOL!
&: Automatic doors in front and elevators inside ℗: Meters in front of building.
Permanent Collection: AM & EU: works on paper, gr; RUSS: icons; REG: 20

The museum works to provide its audience with an artistic cultural and historical experience unlike that offered by other art institutions in Milwaukee. It's three spaces on the campus provide the flexibility of interrelated programming.

WISCONSIN

Villa Terrace Decorative Arts Museum
2220 North Terrace Ave, Milwaukee, WI 53202
☎: 414-271-3656
Open: 12-5 We-Su **Closed:** Mo, Tu, LEG/HOL!
ADM: Adult: $2.00 **Children:** Free under 12 **Students:** $2.00 **Seniors:** $2.00
&: To first floor galleries **℗**
Permanent Collection: DEC/ART; PTGS, SCULP, GR 15-20

Villa Terrace Decorative Arts Museum with its excellent and varied collections is located in a historic landmark building.

OSHKOSH

Paine Art Center and Arboretum
1410 Algoma Blvd, Oshkosh, WI 54901
☎: 920-235-6903
Open: 11-4 Tu-Su, 11-7 Fr extended hours apply Mem/Day-Lab/Day **Closed:** Mo, LEG/HOL!
ADM: Adult: $5.00 **Children:** Free under 12 **Students:** $2.00 **Seniors:** $2.50
& **℗:** On-street parking **Museum Shop**
Group Tours: ext 21 **Docents** **Tour times:** by appt **Sculpture Garden**
Permanent Collection: FR & AM: ptgs, sculp, gr 19,20; OR: silk rugs, dec/art

Collections of paintings, sculpture and decorative objects in period room settings are featured in this historic 1920's Tudor Revival home surrounded by botanic gardens. **NOT TO BE MISSED:** "The Bronco Buster," sculpture by Frederic Remington.

RACINE

Charles A. Wustum Museum of Fine Arts
2519 Northwestern Ave, Racine, WI 53404
☎: 424-636-9177
Open: 1-5 Tu, We, Fr-Su, 1-9 Mo, Th **Closed:** LEG/HOL!, 12/19/94-1/7/95
&: main floor only **℗:** Free **Museum Shop** **Sculpture Garden**
Permanent Collection: SCULP; WPA works on paper; Crafts

In an 1856 Italianate style building on acres of landscaped sculpture gardens you will find Racine's only fine arts museum. It primarily supports active, regional living artists.

SHEBOYGAN

John Michael Kohler Arts Center
608 New York Avenue, PO Box 489, Sheboygan, WI 53082-0489
☎: 920-458-6144 **◉** www.jmkac.org
Open: 10-5 Mo-We, Fr, 10-9 Tu, Th, 12-5 Sa, Su **Closed:** 12/31, 1/1, EASTER, MEM/DAY, THGV, 12/24, 12/25
& **℗** **Museum Shop** **℣**
Group Tours: ext 109 **Docents** **Tour times:** ! **Sculpture Garden**
Permanent Collection: CONT: cer; DEC/ART

Located in a newly expanded facility with eleven galleries, this multi-arts facility presents contemporary American art with emphasis on craft-related forms, folk traditions, new genres, and the work of self-taught artists.

Leigh Yawkey Woodson Art Museum

700 North Twelfth Street, Wausau, WI 54403-5007

☎: 715-845-7010 ◙ www.lywam.org
Open: 9-4 Tu-Fr, 12-5 Sa-Su **Closed:** Mo, LEG/HOL!
♿ ℗: Free
Docents Tour times: ! 9am-4pm **Sculpture Garden**
Permanent Collection: GLASS 19,20; STUDIO GLASS; PORCELAIN; WILDLIFE; ptgs, sculp

An English style residence surrounded by gracious lawns and gardens. A new sculpture garden features Permanent installations and annually the garden will exhibit 10-15 temporary pieces.

ON EXHIBIT 2001

06/2000 to 05/2001 ART/NATURE/NURTURE
12 contemporary sculptors respond to the natural world through use of natural materials.

11/18/2000 to 01/14/2001 FROM EARTH AND SOUL: THE EVANS COLLECTION OF ASIAN CERAMICS
Examples from the major ceramic centers of east Asia including Thailand, Vietnam, the Philippines, Cambodia, Korea and China spanning the 6th to the 19th C.

11/18/2000 to 01/14/2001 KENRO IZU: LIGHT OVER ANCIENT ANGKOR
This exhibition brings together 65 platinum-palladium prints of Cambodia by New York-based Japanese photographer Kenro Izu. In Izu's highly textured and detailed photographs, the hewn and carved stone buildings of Angkor Wat—a sprawling 12th-century temple compound—appear delicate and vulnerable, while the invasive roots of native trees and the unrelenting sun are shown to be the true masters of the land.

01/20/2001 to 04/21/2001 SPIRIT OF THE MASK
Masking is a worldwide tradition, and this comprehensive exhibition of 95 masks dating from the early 1900s from five continents, more than thirty countries, and six Native American tribes proves it.

04/07/2001 to 06/17/2001 CARL RUNGIUS: ARTIST, SPORTSMAN
Carl Rungius, one of North America's most notable big game animal painters, places his beautifully rendered mammals in loosely sketched settings of open vistas and bright skies reminiscent of scenes he knew well, thanks to hunting and painting trips to remote regions of Wyoming, Alaska, and the Canadian Rockies during the early 1900s and to views seen from a studio he built in Banff.

06/23/2001 to 08/26/2001 THE JOHN A. AND MARGARET HILL COLLECTION OF AMERICAN WESTERN ART
The Hill Collection concentrates on works of the 20th century, including the Taos Society of Artists, the Santa Fe School, and American regionalists. Among this broad survey of 76 works are landscapes, portraits of cowboys and Native Americans, architectural subjects and small bronzes.

06/23/2001 to 08/26/2001 SILVER BLOSSOMS, TURQUOISE MOUNTAINS: EARLY 20TH CENTURY SOUTHWEST INDIAN JEWELRY
Silver Blossoms, Turquose Mountains offers a glimpse of the Southwest's natural beauty through historic jewelry created by the four major Indian groups: Navajo, Hopi, Zuni, and Rio Grande Puebloan.

09/08/2001 to 11/04/2001 BIRDS IN ART
Birds in oil, acrylic, watercolor. Batik and bronze birds. Birds in marble and exotic woods. Backyard birds and birds of prey. Birds at rest and on the wing. Artists from around the world bring their personal interpretations of birds from around the world to the 26th annual presentation of Birds in Art.

11/10/2001 to 01/27/2001 THE WORLD OF WILLIAM JOYCE and DAVID WIESNER: TUESDAY
Both William Joyce and David Wiesner rank as masters among juvenile fantasists, that group of authors and illustrators whose eccentricities and absurdities tap into a child's—and adult's—need for and delight in fantastic and swashbuckling fun when they cozy up to a picture book. A total of 96 works promise to transport young and old alike on a merry romp into the imaginative and stimulating world of children's book illustration.

WEST BEND

West Bend Art Museum

300 South 6th Ave, West Bend, WI 53095

☎: 414-334-9638 **◙** www.whartmuseum.com
Open: 10-4:30 We-Sa, 1-4:30 Su **Closed:** Mo, Tu, LEG/HOL!
♿ ⓟ
Docents Tour times: 8am-4:30pm **Sculpture Garden**
Permanent Collection: WISCONSIN ACADEMIC ART WORK; REG: 1850-1950

This community art center and museum is dedicated to the work of Wisconsin's leading artists from Euro-American settlement to the present and features changing exhibitions of regional, national and international art. **NOT TO BE MISSED:** The colossal 1889 painting "The Flagellants" measuring approximately 14' x 26' first exhibited in the US at the 1893 Chicago Worlds Fair, The Columbian Exposition.

ON EXHIBIT 2001
11/29/2000 to 01/07/2001 WEST BEND ART MUSEUM FRIENDS EXHIBITION

BIG HORN

Bradford Brinton Memorial Museum
239 Brinton Road, Big Horn, WY 82833

☎: 307-672-3173 ◙ www.bradfordbrintonmemorial.com
Open: 9:30-5 daily May 15-LAB/DAY, other months by appt
ADM: Adult: $3.00 **Children:** Free under 12 **Students:** $2.00 **Seniors:** $2.00
ḝ Ⓟ **Museum Shop**
Permanent Collection: WESTERN ART; DEC/ART; NAT/AM: beadwork

Important paintings by the best known Western artists are shown in a fully furnished 20 room ranch house built in 1892 and situated at the foot of the Big Horn Mountain. **NOT TO BE MISSED:** "Custer's Fight on the Little Big Horn," by Frederic Remington.

CASPER

Nicolaysen Art Museum
400 East Collins Drive, Casper, WY 82601-2815

☎: 307-235-5247
Open: 10-5 Tu-Su, 10-8 Th **Closed:** Mo, 1/1; THGV; 12/24; 12/25
Free Day: 1st and 3rd Th, 4-8 **ADM: Adult:** $2.00 **Children:** $1.00 under 12 Students: $1.00 **Seniors:** $2.00
ḝ Ⓟ **Museum Shop**
Docents Tour times: !
Permanent Collection: CARL LINK ILLUSTRATIONS; REG

The roots of this Museum reside in the commitment of Wyoming people to the importance of having art and culture as an integral part life. **NOT TO BE MISSED:** The Discovery Center, an integral part of the museum, complements the educational potential of the exhibitions.

CHEYENNE

Wyoming State Museum
Barrett Building, 2301 Central Ave., Cheyenne, WY 82002

☎: 307-777-7022 ◙ http://spacr.state.wy.us/cr/wsm/
Open: 9-4:30 Tu-Sa **Closed:** Su, Mo, LEG/HOL
ḝ Ⓟ: Free in lot north of Barrett Bldg. Metered parking on nearby streets. **Museum Shop**
Group Tours: 307-777-7021
Permanent Collection: 100,000 artifacts relating to Wyoming's heritage.

Ten galleries which tell the story of Wyoming's human and natural history from prehistoric to modern times. **NOT TO BE MISSED:** Hands on history room with interactive exhibits.

CODY

Buffalo Bill Historical Center

720 Sheridan Ave., Cody, WY 82414

☎: 307-587-4771 **◙** www.bbhc.org

Open: 7am-8pm daily June-Sept 19; 8-8 daily May; 8-5 daily Nov-Mar,! **Closed:** THGV, 1/1, 12/25
Free Day: 1st Sa in May **ADM: Adult:** $10.00 **Children:** 6-17, $4.00 **Students:** $8.00
& ℗ **Museum Shop** ⑪: "Great Entertainer Eatery" **Sculpture Garden**
Historic Building: Buffalo Bill Cody's boyhood home **Drop-in Tours**
Permanent Collection: WESTERN/ART: 19,20; AM: firearms; CULTURAL HISTORY OF THE PLAINS INDIANS

The complex includes the Buffalo Bill, Plains Indian, and Cody Firearms museums as well as the Whitney Gallery which contains outstanding paintings of the American West by such artists as George Catlin, Albert Bierstadt, Frederic Remington and contemporary artists including Harry Jackson and Fritz Scholder. **NOT TO BE MISSED:** The Whitney Gallery of Western Art.

ON EXHIBIT 2001

ONGOING NOVEL ADVENTURES: THE LIFE AND WRITINGS OF GENERAL CHARLES KING
Located in the Harold McCracken Research Library of the Center, this exhibition features the literary novels of General Charles King (1844-1933), an officer of the U.S. 5th Cavalry. King's novels were of Victorian ideals, morals and views played out on western frontiers, the Civil War and the Spanish Philippines. Also featured in the exhibition are illustrations within King's books.

ONGOING WHERE THE BUFALO ROAM
As a partnership between the Buffalo Bill Historical Center and Yellowstone National Park, a special natural history exhibition has been developed. The focus of the exhibition is the Yellowstone bison herd, its significance as the last free-roaming herd of wild bison in North America, and its place in the Yellowstone ecosystem.

COLTER BAY

Grand Teton National Park, Colter Bay Indian Arts Museum

Colter Bay, WY 83012

☎: 307-739-3591 **◙** www.nps.gov/grte/

Open: 8-5 daily mid-May to June; 8-8 June to Labor Day; 8-5 Labor Day to Oct. 1 **Closed:** Oct. 1 to mid-May
& ℗ **Museum Shop** **Group Tours**
Permanent Collection: NAT/AM: artifacts, beadwork, basketry, pottery, musical instruments; Reservation period pieces from tribes throughout the entire United States

Organized into categories and themes, the Davis I. Vernon collection of Indian art housed in this museum is a spectacular assembly of many art forms including porcupine quillwork, beadwork, basketry, pottery, masks, and musical instruments. **NOT TO BE MISSED:** Warfare and Clothing exhibits

JACKSON HOLE

National Museum of Wildlife Art

P O Box 6825, Jackson Hole, WY 83002

☎: 307-733-5771 ◙ www.wqildlifeart.org
Open: 9-5 daily winter, 8-5 daily summer, 9-5 Mo Sa Spring/Fall, 1-5 Su Spring/Fall **Closed:** THGV, 12/25, Columbus, Veterans
ADM: Adult: $6.00 **Children:** Free under 6 **Students:** $5.00 **Seniors:** $5.00
& ℗: Free **Museum Shop** ▮▮: cafe **Docents Tour times:** daily
Permanent Collection: WILDLIFE ART AND ARTIFACTS

One of the few museums in the country to feature wildlife, the collection is styled to sensitize visitors to Native American wildlife and the habitat necessary to sustain this priceless natural heritage. It is exhibited in a new facility. **PLEASE NOTE:** The museum offers special admission rates for families. **NOT TO BE MISSED:** Works by Carl Rungius.

ON EXHIBIT 2001
08/18/2000 to 01/07/2001 POWERFUL IMAGES: PORTRAYALS OF NATIVE AMERICA
Organized by Museums West, a consortium of ten North American museums, including the NMWA. This consortium is dedicated to history, art and cultures of the West. Powerful Images from the museums' cumulative wealth of material offering both Native and non-Native American perspectives.

ROCK SPRINGS

Community Fine Arts Center

Affiliate Institution: Rock Springs Library
400 "C" Street, Rock Springs, WY 82901

☎: 307-362-6212
Open: 9-12 & 1-5 Mo-Fr ; We 6-9; 10-12 & 6-9 Sa **Closed:** Su, LEG/HOL !
& ℗
Group Tours Drop-in Tours
Permanent Collection: AM: 19, 20

The art gallery houses the nationally acclaimed Rock Springs High School Collection, and is owned by Rock Springs School District #1. **NOT TO BE MISSED:** Loren McIver's "Fireplace," the first American women to exhibit at the Venice Biennial (1962). Norman Rockwell's "Willie Gillis: New Year's Eve" and Grandma Moses' "Staughton, Virginia."

Selected Listing of Traveling Exhibitions

A BOUNTIFUL PLENTY FROM THE SHELBURNE MUSEUM: FOLK ART TRADITIONS IN AMERICA
11/04/2000 to 02/07/2001 Columbus Museum of Art, Columbus OH
09/09/2001 to 01/13/2002 Kalamazoo Institute of Arts, Kalamazoo MI

A CERAMIC CONTINUUM: FIFTY YEARS OF THE ARCHIE BRAY INFLUENCE
08/25/2000 to 10/28/2001 Boise Art Museum, Boise ID
02/17/2002 to 04/14/2002 Dahl Arts Center, Rapid City SD

ADRIAN PIPER: A RETROSPECTIVE 1965-2000
10/26/2000 to 01/21/2001 New Museum of Contemporary Art, New York, NY
06/23/2001 to 08/19/2001 Contemporary Arts Center, Cincinnati, OH

AFRICAN AMERICAN WORKS ON PAPER
06/02/2001 to 07/29/2001 Mulvane Art Museum, Topeka, KS
10/21/2001 to 12/16/2001 Muskegon Museum of Art, Muskegon, MI

AFTERGLOW IN THE DESERT: THE ART OF FERNAND LUNGREN
01/21/2001 to 03/24/2001 Laguna Art Museum, Laguna Beach, CA
04/11/2001 to 06/10/2001 Palm Springs Desert Museum, Palm Springs, CA

AMERICAN IMPRESSIONISTS ABROAD AND AT HOME
01/27/2001 to 04/22/2001 San Diego Museum of Art, San Diego, CA
05/11/2001 to 08/05/2001 Delaware Art Museum, Wilmington, DE
08/24/2001 to 11/18/2001 Cheekwood - Tennessee Botanical Garden and Museum of Art, Nashville, TN
12/07/2001 to 03/03/2002 Orlando Museum of Art, Orlando, FL

AMERICAN LANDSCAPES FROM THE PAINE ART CENTER & ARBORETUM
03/16/2001 to 05/06/2001 Dane G. Hansen Memorial Museum, Logan, KS
08/19/2001 to 10/28/2001 Canton Museum of Art, Canton, OH

AMERICAN SPECTRUM: PAINTING AND SCULPTURE FROM THE SMITH COLLEGE MUSEUM OF ART
10/28/2000 to 01/07/2001 Norton Museum of Art, West Palm Beach, FL
06/29/2001 to 09/30/2001 Museum of American Art of the Pennsylvania Academy of the Fine Arts, Philadelphia, PA

AN AMERICAN CENTURY OF PHOTOGRAPHY FROM DRY-PLATE TO DIGITAL: THE HALLMARK
PHOTOGRAPHIC COLLECTION
10/14/2000 to 01/07/2001 Joslyn Art Museum, Omaha, NE
02/09/2001 to 04/22/2001 Delaware Art Museum, Wilmington, DE
09/23/2001to 01/06/2002 Columbus Museum, Columbus, GA

ANTIOCH: THE LOST ANCIENT CITY
10/08/2000 to 02/04/2001 Worcester Art Museum, Worcester, MA
03/18/2001 to 06/03/2001 Cleveland Museum of Art, Cleveland, OH
09/16/2001 to 12/30/2001 Baltimore Museum of Art, Baltimore, MD

BEN SHAHN'S NEW YORK: THE PHOTOGRAPHY OF MODERN TIMES
11/14/2000 to 01/24/2001 Grey Art Gallery, New York, NY
04/19/2001 to 06/10/2001 David and Alfred Smart Museum of Art, Chicago, IL

BEYOND THE MOUNTAINS: THE CONTEMPORARY AMERICAN LANDSCAPE
11/18/2000 to 01/14/2001 Fort Wayne Museum of Art, Fort Wayne, IN
02/09/2001 to 03/29/2001 Lyman Allyn Museum of Art at Connecticut College, New London, CT

CY TWOMBLY: THE SCULPTURE
09/20/2000 to 01/07/2001 Menil Collection, Houston, TX
05/06/2001 to 07/29/2001 National Gallery of Art, Washington, DC

DEGAS AND AMERICA: THE EARLY COLLECTORS
03/03/2001 to 05/27/2001 High Museum of Art, Atlanta, GA
06/17/2001 to 09/09/2001 Minneapolis Institute of Arts, Minneapolis, MN

DREAMS AND DISILLUSION: KAREL TIEGE AND THE CZECH AVANT-GARDE
11/15/2000 to 04/01/2001 Wolfsonian/Florida International University, Miami Beach, FL
05/01/2001 to 07/07/2001 Grey Art Gallery, New York, NY

DUANE HANSON: VIRTUAL REALITY
01/28/2001 to 04/01/2001 San Jose Museum of Art, San Jose, CA
04/20/2001 to 06/24/2001 Nevada Museum of Art/E. L. Weigand Gallery, Reno, NV

EGYPTIAN TREASURES FROM THE BRITISH MUSEUM
10/07/2000 to 01/02/2001 Bowers Museum of Cultural Art, Santa Ana, CA
03/02/2001 to 05/27/2001 Toledo Museum of Art, Toledo, OH

EMPIRE OF THE SULTANS: OTTOMAN ART FROM THE KHALILI COLLECTION
01/27/2001 to 04/08/2001 Portland Art Museum, Portland, OR
08/01/2001 to 10/07/2001 Asian Art Museum of San Francisco, San Francisco, CA

GRANDMA MOSES IN THE 21ST CENTURY
06/30/2001 to 08/26/2001 San Diego Museum of Art, San Diego, CA
12/07/2001 to 01/27/2002 Brooklyn Museum of Art, Brooklyn, NY

HALF PAST AUTUMN: THE ART OF GORDON PARKS
02/18/2001 to 05/06/2001 Cincinnati Art Museum, Cincinnati, OH
06/23/2001 to 09/23/2001 Oakland Museum of California, Oakland, CA

HENRY MOORE
02/25/2001 to 05/27/2001 Dallas Museum of Art, Dallas, TX
10/21/2001 to 01/27/2002 National Gallery of Art, Washington, DC

JULIAN STANCZAK RETROSPECTIVE
12/06/2000 to 02/11/2001 Lowe Art Museum, Coral Gables, FL
05/2001 to 08/2001 Frederick R. Weisman Museum of Art, Malibu, CA

LINDA MCCARTNEY'S SIXTIES: PORTRAIT OF AN ERA
01/19/2001 to 03/18/2001 Delaware Art Museum, Wilmington, DE
03/24/2001 to 05/27/2001 Fort Wayne Museum of Art, Fort Wayne, IN

LITHOGRAPHS BY JAMES MCNEILL WHISTLER FROM THE COLLECTION OF STEVEN BLOCK
01/12/2001 to 03/04/2001 Wadsworth Atheneum Museum of Art, Hartford, CT
11/18/2001 to 01/06/2002 Toledo Museum of Art, Toledo, OH

LURE OF THE WEST
01/20/2001 to 03/18/2001 University of Iowa Museum of Art, Iowa City, IA
10/02/2001 to 12/16/2001 Huntington Library, Art Collections and Botanical Gardens, San Marino, CA

MICHAEL MAZUR: A PRINT RETROSPECTIVE
11/12/2000 to 02/16/2001 Jane Voorhees Zimmerli Art Museum, New Brunswick, NJ
03/17/2001 to 06/03/2001 Minneapolis Institute of Arts, Minneapolis, MN

NORMAN ROCKWELL: PICTURES FOR THE AMERICAN PEOPLE
01/27/2001 to 05/06/2001 Phoenix Art Museum, Phoenix, AZ
06/09/2001 to 10/08/2001 Norman Rockwell Museum at Stockbridge, Stockbridge, MA

NOTABLE AMERICANS FROM THE NATIONAL PORTRAIT GALLERY
05/04/2001 to 07/01/2001 Tennessee State Museum-Polk Culture Center, Nashville, TN
11/16/2001 to 01/27/2002 Speed Art Museum, Louisville, KY

PICASSO: THE ARTIST'S STUDIO
06/09/2001 to 09/23/2001 Wadsworth Atheneum Museum of Art, Hartford, CT
10/21/2001 to 01/06/2002 Cleveland Museum of Art, Cleveland, OH

REMINGTON, RUSSELL AND THE LANGUAGE OF WESTERN ART

Selected Listing of Traveling Exhibitions

02/16/2001 to 04/08/2001 Society of the Four Arts, Palm Beach, FL
04/26/2001 to 06/22/2001 Portland Art Museum, Portland, OR
07/2001 to 09/2001 Bowers Museum of Cultural Art, Santa Ana, CA

RODIN'S OBSESSION: THE GATES OF HELL, SELECTIONS FROM THE IRIS AND B. GERALD CANTOR
COLLECTION
01/20/2001 to 03/25/2001 Frederick R. Weisman Museum of Art, Malibu, CA
10/2001 to 12/2001 Hofstra Museum, Hempstead, NY

STAR WARS: THE MAGIC OF MYTH
03/11/2001 to 06/24/2001 Museum of Fine Arts, Houston, Houston, TX
08/05/2001 to 01/05/2002 Toledo Museum of Art, Toledo, OH

SUNLIGHT AND SHADOW
01/28/2001 to 03/25/2001 Texas A&M University/J. Wayne Stark University Center Galleries, College Station, TX
06/24/2001 to 08/12/2001 Amarillo Museum of Art, Amarillo, TX
08/31/2001 to 10/31/2001 Dane G. Hansen Memorial Museum, Logan, KS
11/11/2001 to 12/30/2001 Wiregrass Museum of Art, Dothan, AL
10/20/2002 to 03/10/2002 University of Kentucky Art Museum, Lexington, KY

THE FRAME IN AMERICA: 1860-1960
04/06/2001 to 05/20/2001 Columbus Museum of Art, Columbus, OH
11/10/2001 to 01/13/2002 San Diego Museum of Art, San Diego, CA

THE GILDED AGE: TREASURES FROM THE SMITHSONIAN AMERICAN ART MUSEUM
03/28/2001 to 06/17/2001 Iris and B. Gerald Cantor Center for Visual Arts at Stanford University, Stanford, CA
09/09/2001 to 11/04/2001 Philbrook Museum of Art Inc, Tulsa, OK

THE HUMAN FACTOR: FIGURATION IN AMERICAN ART
12/03/2000 to 02/04/2001 Albany Museum of Art, Albany, GA
07/28/2001 to 09/23/2001 Charles H. MacNider Museum, Mason City, IA

THE PHOTOGRAPHY OF ALFRED STIEGLITZ: GEORGIA O'KEEFFE'S ENDURING LEGACY
02/24/2001 to 05/20/2001 James A. Michener Art Museum, Doylestown, PA
09/08/2001 to 11/04/2001 Norton Museum of Art, West Palm Beach, FL

THE STAMP OF IMPULSE: ABSTRACT IMPRESSIONIST PRINTS
04/21/2000 to 06/17/2001 Worcester Art Museum, Worcester, MA
11/18/2001 to 01/27/2002 Cleveland Museum of Art, Cleveland, OH

TONY DELAP
10/14/2000 to 01/14/2001 Orange County Museum of Art, Newport Beach, CA
04/22/2001 to 07/08/2001 San Jose Museum of Art, San Jose, CA

WILLIAM KENTRIDGE
06/07/2001 to 09/16/2001 New Museum of Contemporary Art, New York, NY
10/20/2001 to 01/20/2002 Museum of Contemporary Art, Chicago, IL

WRAPPED IN PRIDE: GHANIAN KENTE AND AFRICAN AMERICAN IDENTITY
11/19/2000 to 02/25/2001 Anchorage Museum of History and Art, Anchorage, AK
10/31/2001 to 01/13/2002 Oakland Museum of California, Oakland, CA
02/23/2002 to 06/16/2002 Michael C. Carlos Museum, Atlanta, GA

YES YOKO ONO
10/18/2000 to 01/14/2001 Japan Society Gallery, New York, NY
03/10/2001 to 06/17/2001 Walker Art Center, Minneapolis, MN

ZELDA BY HERSELF
03/13/2001 to 04/19/2001 Philip and Muriel Berman Museum of Art at Ursinus College, Collegeville, PA
09/22/2001 to 11/11/2001 Mitchell Museum, Mount Vernon, IL

acoustiguide

Discount Coupon

Present this coupon at the Acoustiguide counter
and receive $1 off your Acoustiguide audio tour rental.

Discount Coupon

Selected Listing of Acoustiguide Exhibitions

Selected Acoustiguide Special Exhibition Audio Programs 2001

Brooklyn Museum of Art – Gold of the Nomads: Scythian Gold in the Ukraine, Brooklyn Collects

Bowers Museum of Cultural Art – Egyptian Treasures from the British Museum

Carnegie Museum of Art, Pittsburgh – Aluminum by Design: Jewelry to Jets

Center for Creative Photography, University of Arizona – Indivisible

Detroit Institute of Art – Royal Tombs of Ur

Field Museum of Chicago – Kremlin Gold: 100 Years of Russian Jewels

Fine Arts Museums of San Francisco – Toulouse-Lautrec, Henry Moore

Ft. Lauderdale Museum of Art – Treasures of Topkapi

Frist Center for the Visual Arts, Nashville – Masterworks: Paintings from the Collection of the Art Gallery of Ontario, An Enduring Legacy: Art of the Americas from Nashville Collections

Indianapolis Museum of Art – Gifts of the Tsars

Kimbell Museum of Art – From Renoir to Picasso: Masterpieces of the Orangerie

Los Angeles County Museum of Art – The Road to Aztlan: Art from a Mythic Homeland

Museum of Contemporary Art, Chicago – Ed Ruscha

Museum of Modern Art – MoMA2000: Open Ends

National Gallery of Art – Art Nouveau, Modern Art in America: Alfred Stieglitz and his New York Galleries

Norton Museum of Art, West Palm Beach – Triumph of French Painting

Pacific Asia Museum – Chinese Ceramics

The Phillips Collection – Wayne Thiebaud

Seattle Art Museum – John Singer Sargent, Treasures from Sichuan Province

Solomon R. Guggenheim Museum – Giorgio Armani, Global Guggenheim

Toledo Museum of Art – Eternal Egypt: Masterpieces of Ancient Art from the British Museum

Virginia Museum of Fine Arts – Impressionist Landscape

The Walters Art Gallery – Manet: The Still Life Paintings

Acoustiguide U.S. Permanent Collection Audio Programs

Allentown Art Museum
Amon Carter Museum
Birmingham Museum of Art
Brooklyn Museum of Art
The Chrysler Museum
Detroit Institute of Arts
The Frick Collection
Isabella Stewart Gardner Museum
Mashantucket Pequot Museum
Mid-Atlantic Center for the Arts
Mingei International Museum
The Mint Museum, Charlotte
Museum of American Folk Art
Museum of Contemporary Art, Chicago
Museum of Modern Art, New York
National Gallery of Art, Washington, D.C.
The Nelson-Atkins Museum of Art
New York Historical Society
Norton Museum of Art
Pennsylvania Academy for the Fine Arts
Portland Art Museum
Santa Barbara Museum of Art
Solomon R. Guggenheim Museum
Storm King Art Center
The Toledo Museum of Art
Virginia Museum of Fine Arts
Walker Art Center

Alphabetical Listing of Museums

Alphabetical Listing of Museums

Alphabetical Listing of Museums

Alphabetical Listing of Museums

Alphabetical Listing of Museums

Alphabetical Listing of Museums

Alphabetical Listing of Museums

Alphabetical Listing of Museums

ABOUT THE AUTHOR

Judith Swirsky has been associated with the arts in Brooklyn as both staff and volunteer for more than forty years. The recipient of many awards, she has held both curatorial and volunteer administrative positions at The Brooklyn Museum. While Executive Director of the Grand Central Art Galleries Educational Association she coordinated the 1989 Moscow Conference. She is now an independent curator and artists' representative. She is listed in *Who's Who of American Women.*